Praise for *Michael Kammen's*

VISUAL SHOCK

"A who-what-why of controversial art."
—*Chicago Tribune*

"Fascinating. . . . Pulitzer Prize–winning historian Kammen chronicles both particle and wave in this kaleidoscopic survey of art-related battles."
—*Booklist* (starred review)

"An accessible, understandable look at the important dance between art, society and politics."
—*The Sunday Gazette* (Schenectady, NY)

"A useful overview of artistic controversies in America."
—*The Baltimore Sun*

"Expansively researched. . . . Balances scholarly investigation and insightful analysis. . . . Kammen's highly informed analysis will prove an invaluable contribution to American cultural history."
—*Publishers Weekly*

Michael Kammen
VISUAL SHOCK

Michael Kammen, the Newton C. Farr Professor of American History and Culture at Cornell University, is a past president of the Organization of American Historians. He is the author or editor of numerous works, including *People of Paradox: An Inquiry Concerning the Origins of American Civilization*, which won the Pulitzer Prize for History, and *A Machine That Would Go of Itself: The Constitution in American Culture*, awarded the Francis Parkman Prize and the Henry Adams Prize. He has lectured throughout the world.

VISUAL SHOCK

*A History of Art Controversies
in American Culture*

Michael Kammen

VINTAGE BOOKS
A DIVISION OF RANDOM HOUSE, INC.
NEW YORK

FIRST VINTAGE BOOKS EDITION, NOVEMBER 2007

The Library of Congress has cataloged the Knopf edition as follows:
Kammen, Michael G.
Visual shock : a history of art controversies in American culture / Michael Kammen.—1st ed.
p. cm.
Includes bibliographical references and index.
1. Art and society—United States—History—19th century. 2. Art and society—United States—History—20th century. 3. Art, American—19th century—Public opinion. 4. Art, American—20th century—Public opinion. I. Title.
N72.S6K225 2006
306.4′70973—dc22 2005044750

Vintage ISBN: 978-1-4000-3464-2

Author photograph © Robert Barker

www.vintagebooks.com

Printed in the United States of America
10 9 8 7 6 5 4 3 2 1

For *Carol*, once again

From women's eyes this doctrine I derive:
They sparkle still the right Promethean fire;
They are the books, the arts, the academes,
That show, contain, and nourish all the world.

Love's Labours Lost, IV, iii, 354–57

CONTENTS

We're painters who believe above all that art of any kind is an expression of individual ideas of life, the seamy side. It is vulgar.

—Robert Henri (1907)

The exhibition had been calculated from the beginning as a mental jolt to stir America out of its long esthetic complacency.

—Milton Brown on the 1913 Armory Show

When, because of their remoteness, the objects acknowledged by the cultivated to be works of fine art seem anemic to the mass of people, esthetic hunger is likely to seek the cheap and the vulgar.

—John Dewey (1934)

I threw the bottle rack and the urinal into their faces as a challenge, and now they admire them for their aesthetic beauty.

—Marcel Duchamp (1946)

Art is meant to disturb.

—Georges Braque (1947)

As long as artists are at liberty to feel with high personal intensity, as long as our artists are free to create with sincerity and conviction, there will be healthy controversy and progress in art.

—President Dwight D. Eisenhower (1954)

The problem for a hopeful scene-making artist in the early sixties was how best to be disagreeable. What he needed was to find a body of subject matter sufficiently odious to offend even lovers of art.

—Roy Lichtenstein (1963)

If the painting doesn't upset you, it probably wasn't a good painting to begin with.

—Robert Rauschenberg (n.d.)

Isn't controversy part of what modern art is all about?

—George Sugarman (1977)

That's what art is about—its shock value.

—Karen Finley (1990)

INTRODUCTION

This inquiry interweaves four central themes broadly defined. First, I find that art controversies matter because they are so symptomatic of social change as a highly visible but contested process. Hence we must reach back and notice the earliest disputes as well as more recent and familiar ones. Episodes ever since the 1830s and 1840s have evinced a tension between the desire for distinctively American art and enduring esteem for Old World criteria of excellence. Looking back a century and more also illuminates the constant bewilderment caused in the United States by the several phases of modernism—and consternation to a considerably greater degree than in Europe. Concern about such evanescent qualities as "beauty," "authenticity," and "decency" has long been present, but the prevalence and particular manifestations of such matters have altered over time.

Second, I shall frequently refer to the changing role and expectations for art in a democratic society. The ongoing democratization of American culture during the course of several generations has inevitably made controversies more likely to occur. An incrementally expanding number of artists, museums, galleries, and critics makes a significant difference. Augmented public access to art matters even more, perhaps: greater numbers of people visit museums; exhibitions travel to multiple sites; and increasing amounts of art are displayed outside museums in civic spaces. As freedom of expression is perceived to increase, so do calls for what amounts to censorship. "That should be removed" has become a familiar demand or refrain in recent decades.[1] Although egalitarianism is surely a positive good, friction is more likely to occur when private individuals (who are not professionals) feel ever more comfortable voicing critical views, and when taxpayers' money is being spent on very large works of art that are less and less likely to seem meaningful, attractive, or even comprehensible.

Third, the character of what is implied by *controversy* as a cultural phenomenon becomes ever more expansive and inclusive with the passage of time. Readers attentive to historical change will notice how and

by whom controversies are initiated: at first from within the art world itself because of vested interests and resistance to innovation; then from public figures and religious groups who carry weight with office-holders; more recently, and powerfully, from the media. We are obliged to ask (as a litmus test for inclusion) how often the general public is really paying attention. Did a controversy make the front page, or was it confined to those sections devoted to "arts and leisure" or primarily to art journals? Our attention will largely be directed to those episodes where all three venues became flash points. We seek conflicts that captured the public eye. But we will certainly notice that the "public" is no more monolithic than the "art world." Pluralism and factionalism abound within both. Usage of the phrase *art world* varies from one voice to the next, of course. My own preference is an inclusive one: those prominent institutions, galleries, and individuals whose values, attitudes, assumptions, and historical experiences shape the way we perceive art.[2]

Fourth, we should ask whether controversy is necessarily a negative condition, an undesirable phenomenon to be avoided if possible. Not at all, in my view, even though these conflicts sometimes had unwanted or unfortunate consequences. Conflict can certainly be stressful, push people (ranging from artists to museum administrators) into serious situations, and agitate civil society. Yet conflict can also be enlightening and educational, at least in retrospect, especially when individuals modify their mind-sets or, better still, have a change of heart. Some examples? How about the Vietnam Veterans Memorial; or huge public sculptures by Picasso in Chicago and by Calder in Grand Rapids; or the Lincoln Memorial; or Hiram Powers's statue called *The Greek Slave*, the most famous work of sculpture in nineteenth-century America; or the architecture of such museums as the Guggenheim in Manhattan and the Hirshhorn in Washington; or murals by Diego Rivera, Anton Refregier, and others; or Judy Chicago's *Dinner Party*? For more, please click on "continue."

Ultimately this project highlights patterns in the increasing politicization of art in America; and perceiving those patterns calls attention in yet another way to change over time. We need to differentiate between art as social satire or social realism, both of which have been around for quite a long time and certainly *can* stir controversy, and art as overt political protest, which arrived relatively recently in the United States, first in the 1930s and later in the 1960s owing to the war in Vietnam and other provocations.

Beyond the recognition that art has become politicized, we must also notice that the pursuit of certain public policies, in the broadest sense, has clearly helped to trigger numerous conflicts. I have in mind Cold War cultural competition, anti-Communism as a foil for modernism, hostility to images that can be construed as obscene or pornographic, even when we believe that they are not (recall the Meese Commission Report in 1986), and the angry perception that government is doing too little in support of HIV/AIDS research.[3] A two-volume report issued in 1994 by People for the American Way clearly showed that social friction caused by controversial art was increasing rather than declining. And 31 percent of the challenges were made against art that addressed political issues. Moreover, in three cases out of five, challengers enjoyed at least some success in removing, restricting, altering, limiting access to, or cutting off funding for works they considered blasphemous, obscene, or politically incorrect.[4] The situation gives pause, and cause for concern. Its origins are deeply rooted in our past.

When plans for the Washington Monument were unveiled and scrutinized in the 1840s, issues arose concerning its design as well as its sheer size. Was an Egyptian obelisk the optimal form for a modern young republic? Yes, according to some, but decidedly not to others. Would the astounding scale of this projected shaft, more than five hundred feet, be overwhelming in relation to the raw, undeveloped scale of the capital city that Alexis de Tocqueville referred to as an "arid plain"? Would it even be affordable? Once again, a mixed response. Might the proposed ring of Doric columns enclosing a vast rotunda seem too grandiose? Most likely. A century and a half later, when plans were unveiled for a World War II memorial in Washington, comparable questions were raised about its ambitious expanse and elaborate design. Moreover, it would actually bisect the Mall, which had increasingly been perceived during the twentieth century as unobstructed "sacred space." Critics made unfavorable comparisons with fascist grandiosity in Europe. Like the supertall monument to the first president located just to the west since 1885, perhaps the World War II Memorial, warmly debated for well over a decade, smacked more of imperial grandeur than of republican sacrifice—more about memories of militaristic glory than about fighting for freedom.[5]

When Thomas Eakins completed *The Gross Clinic* in 1875, his mas-

terfully realistic painting of a distinguished surgeon at work, and sub-
mitted it for display at the Centennial Exhibition in Philadelphia,
those in charge felt repulsed by its bloody display and shunted it off to
a local hospital for hanging. It was too big, bold, and gory. Briefly put,
they felt it was undignified and aggressively in bad taste (fig. 1). When
Judy Chicago's major piece of installation art, *The Dinner Party*, made

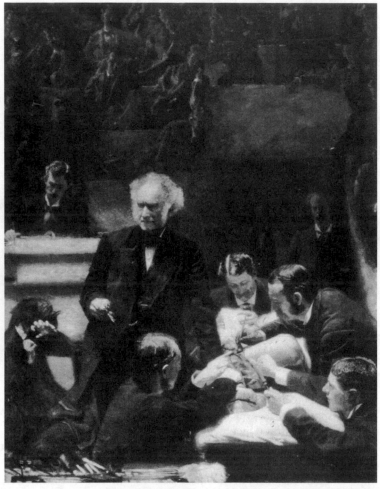

1. Thomas Eakins, *The Gross Clinic* (1875).
The Jefferson Medical College of Thomas Jefferson University, Philadelphia.

its debut in San Francisco in 1979, many viewers were dismayed or shocked. Thirty-nine ceramic place-settings with predominantly vaginal motifs honoring historic women seemed to essentialize their gender. Surely females must be more than the sum of their private parts. Once again a similar verdict was handed down: too big, bold, and aggressive. Moreover, some African-American women were upset because the place-setting for the abolitionist Sojourner Truth was unlike most of the others. They asked with annoyance: did Judy Chicago think that women of color were physiologically different from white women? So the projected venues for this unprecedented triangular display (an emblematic maidenhead?) in cities like Seattle and Rochester were abruptly canceled. Museum directors—some at least, at certain times—sought to *avoid* controversy.[6]

What can we learn from these apparent continuities that extend from the historically envisioned Mall to the modern museum—from the age of Andrew Jackson to the Reagan/Bush era? Should we conclude that grandiose memorials and artistic iconoclasm have long been taboo in the United States? Not entirely. Rather, we do need to keep in mind that art-related controversies in this country did not simply begin and commonly recur in recent years with photographers Robert Mapplethorpe and Andres Serrano, nor with performance artist Karen Finley and litigation involving the "NEA Four," nor with the exhibitions known as "Sensation" at the Brooklyn Museum of Art in 1999 and the disputed display of flashy motorcycles at the Guggenheim Museum a year earlier. On the one hand, controversies caused by art in America actually date back almost two centuries, and the provocations range from nudity (male and female) to gigantism. On the other hand, during the 1960s, startling changes occurred in the art world, in society and politics as well, and as a consequence the diversity and intensity of art-related issues increased dramatically during the 1970s and have expanded ever since.[7] Recent developments are far more familiar than their predecessors, of course, but the complex lineage between early and later episodes is not familiar at all.

One of the most significant shifts that has occurred since the 1960s, yet is least understood by the lay public, is the increasing alienation of large numbers of artists from the museum world and their desire to be independent of it. That is peculiar and paradoxical, of course, because institutional recognition and support can be vitally important. So artists want to escape and transcend the museum's putative "hegemony" even as they remain dependent upon it in crucial ways. Pre-

cisely because many artists have become anti-institutional, their hostility has caused or aggravated many of the tensions that erupt as particular controversies. For more than a generation now, radical critics have been seeking changes in the ways art functions in society, even when that art appears in a museum. As Douglas Crimp, an astute critic, has written: "the target of my critique of the museum is the formalism that it appeared inevitably to impose on art by removing it from any social context."[8]

For all of the nineteenth century and much of the twentieth, a critical function of the art museum was to provide the visitor with a sense of structure and impose order: chronological, national, and stylistic. As early as the 1930s, however, museums found it increasingly challenging to do so successfully. Referring to Picasso's eclecticism in terms of style and materials, for example (painting, graphics, sculpture, and ceramics), Rosalind Krauss alludes to that part of Picasso's era now becoming our own: "its disorientation within the labyrinth of the museum, its promiscuous attraction to any and all styles, its yielding to the glamour of the object as photographed, advertised, reproduced."[9]

The purpose of this project is to provide what might be called "full historical disclosure" by indicating the nature, diversity, and persistence of major disputes generated by art since the 1830s, but also to reveal what has changed and why. Ever since the 1960s, museums and galleries, civic spaces and films, sculpture and architecture have become more visually provocative—virtual touchstones for tumultuous shock. There have been notable years when art fissured a fiercely contested fault line in American culture: 1966, 1989–90, and 1998–99 come promptly to mind. But it is crucial to recall that those were not the first: 1842, 1858, 1908, 1913, 1936, and 1947 should *also* occur to us.

Needless to say, Americans are not singular. Europeans, too, have had a notable history of art-related contretemps, especially since the 1860s. The causes seem to have been predictably familiar: ideological differences, obscenity, stylistic radicalism, and religious offense. Jacques-Louis David, the most important European painter between 1785 and 1815, was invited by the National Convention in France to organize the funeral of Jean-Paul Marat, the doctor turned radical journalist who was murdered in 1793 by Charlotte Corday. David's grim painting, *The Death of Marat* (1793), began as a sobering altarpiece; and the citizens of Paris were encouraged to bring themselves

and their children to gaze at the gory image in order to be imbued with a mix of awe, reverence, and revolutionary fervor. As France underwent its imperial transformations during the Napoleonic era, however, the image became a highly charged and problematic icon. David had retained it personally, yet at his death in 1825 it remained too controversial. Although included in the catalog of his work, it could not be offered for sale.[10]

The Death of Sardanapalus by Eugène Delacroix (1828) is a large, violent, and orgiastic painting based upon the climax of Lord Byron's 1827 play. It caused great offense to the establishment mainly because it violated all the artistic criteria of classicism, entrenched for more than a generation. Gustave Courbet's *Return from the Conference* (1863) depicted drunken priests and was doubly rejected by the official Salon *and* by the Salon des Refusés because of its flagrant anticlericalism. Courbet knew full well that it would prompt an intense brouhaha. He declared that he painted it to probe "the degree of liberty that our time grants us." Also in 1863, Édouard Manet produced two of the most notoriously inflammatory paintings in the entire history of art: *Olympia*, a nude prostitute, and *Déjeuner sur l'herbe*, a bizarre picnic scene with fully clothed men and undressed women conversing ever so casually on a bosky lawn.[11]

Manet's contemporary, Edgar Degas, declared that "a painting calls for as much cunning, roguishness, and wickedness as the committing of a crime." European painters in succeeding generations, especially those with innovative or antisocial impulses, would echo those sentiments. Maurice de Vlaminck, for example, a French Fauvist of Flemish descent, explained: "What I could have done only by throwing a bomb which would have led to the scaffold—I attempted to realize in art, in painting, by using colors of maximum purity. Thus I satisfied my desire to destroy old conventions, to 'disobey' in order to recreate a feeling, living, and liberated world." On another occasion he added that he "wished to burn down the École des Beaux-Arts and to render my impressions without any thought for what had been achieved in the past." A very large and intense work by the young Belgian artist James Ensor, *Christ's Entry into Brussels in 1889* (1888), seemed so wildly blasphemous that it could not be shown during his lifetime (1860–1949).[12]

There is a tendency to assume that most art controversies are sparked by rebellious artists, or by uncultured philistines who cannot comprehend new trends in art, or else by politicians with reactionary agendas and ideological axes to grind. The historical reality has been

far more complex and intriguing on both sides of the Atlantic. Quite often conflicts have been generated by conservative art organizations, museum curators, and academicians solidly ensconced in the so-called art world. At the close of the nineteenth century a group of innovative American artists balked at narrow-minded dominance by the tradition-oriented National Academy of Design in New York. The rebels became known in 1897–98 as The Ten and described their association as a "secession," inspired by the secessionist movements that had brought "more vital art" to France, Austria, and Germany.[13]

The press quickly seized upon the term *secession* when reporting this divisive split within the art world, a pattern that would frequently recur. Doing so attracted attention and sold papers. The lay public took notice. As the sociologist Pierre Bourdieu observed in a colloquy with the contemporary artist Hans Haacke, "If, when one wants to transmit a message, there is no response in journalistic circles—if it doesn't interest journalists—then the message is not transmitted. Journalists have been the screen or filter between all intellectual action and the public. . . . Successful protests are not necessarily those that mobilize the most people, but those that interest the most journalists."[14] When the radical group known as the Ashcan School (or The Eight) rebelled in 1908–10 against the National Academy *and* the views of The Ten, Robert Henri, their leader, used the press to garner attention for his friends as a unified band with an alternative vision of native subject matter as well as style. Note the bold headline that appeared across the *New York World Magazine* on February 2, 1908:

New York's Art War and the Eight Rebels Who Have Dared to Paint Pictures of New York Life (Instead of Europe) and Who Are Holding Their Rebellious Exhibition All by Themselves[15]

Beginning in 1936 with the advent of Henry Luce's *Life* magazine, mass circulation weeklies in the United States started paying more attention to modern art. A young Salvador Dalí appeared on the cover of *Time* magazine on December 14, 1936, because a major exhibition of Surrealism caused a stir—prompting public bewilderment and even anger.[16] Between 1944 and 1947 more than a dozen articles about Picasso and his work appeared in *Time* and *Newsweek*. Although those magazines often mocked modern art, they most certainly kept it in the public eye. In 1946, when the State Department purchased more than $49,000 worth of contemporary American art for display abroad, sev-

eral conservative newspapers and *Look* magazine ran contemptuous stories that forced an embarrassed secretary of state, George C. Marshall, to cancel the projected two-year tour. He had given reluctant approval to begin with, and the press's reproduction of selected images prompted Harry S. Truman to snap: "If that's art, I'm a Hottentot."[17]

By the second half of the twentieth century, the media began taking the initiative even more aggressively, not merely by covering art controversies but by actually helping to create them. *Time, Newsweek,* and many other popular magazines noticed that art-related disputes enhanced sales. Andrew Wyeth's "secret" *Helga* paintings supplied a prime example of journalistic sensationalism in 1986–87.[18] Two years later the *Washington Times,* a conservative paper run by the Unification Church of Sun Myung Moon, brought Andres Serrano's *Piss Christ* to the attention of Congress, and the following year it did the same when the University of the District of Columbia contemplated providing a permanent home for Judy Chicago's *The Dinner Party* (prompting an exposé on C-SPAN), thereby helping to quash the deal. Word of an impending exhibition known as "Sensation" came to the attention of Mayor Rudolph Giuliani in 1999 only because the New York *Daily News* ran a very negative story well before it even opened, precipitating notoriety and poking open a political hornet's nest.[19]

Social theorists have developed the notion of "moral panic": moments when societies create or envision folk devils onto which they project an array of anxieties. The media have played a critical role in exacerbating such hysteria because they often function in their quest for hype and enhanced sales as agents of social indignation. Leaders engaged in moralistic crusades, ranging from Anthony Comstock at the turn of the twentieth century to the Reverend Donald Wildmon of the American Family Association in recent times, have sought to censor or regulate what seemed blasphemous or prurient to them and their associates. Wildmon may have achieved even greater success than Comstock, however, because he became so adept at mobilizing politicians and the press on behalf of his causes. Even when media outlets are not engaged in a willful campaign of their own, merely reporting certain forms of hyperbolic news and views can be sufficient to generate concern, indignation, or outright hostility.[20]

In order to appreciate the accelerated pace of controversial episodes since the 1960s, we must also note the transformation of the American museum. It went from being a tradition-oriented and historically "bounded" institution catering largely to an educated elite to a

democratized one that augmented its departments of education and put up blockbuster exhibitions to increase attendance and expand its audience. In the process quite a few museum directors became more than willing to welcome predictably provocative shows because they recognized that notoriety attracts crowds.[21] That became especially evident, for example, when the Phoenix Art Museum displayed "Old Glory: The American Flag in Contemporary Art" (1996) and the Brooklyn Museum of Art accepted "Sensation: Young British Artists from the Saatchi Collection" (1999).

The advent of public art, often involving very large and abstract pieces of sculpture, also added to the buzz of controversy because such works were not sequestered within institutional walls. They occupied civic space and their (quite literally) high visibility tended to vex the very people who worked there as well as critics who found them ugly, outrageous, or simply incomprehensible. It seemed to many people that "beauty" as a basic criterion for art had become utterly passé, a casualty of the quest for challenging trendiness. No one is compelled to enter an art museum, but public art is more difficult to avoid, particularly when it is located in front of a large federal building, as Richard Serra's *Tilted Arc* was in lower Manhattan (1981–89) and as Robert Motherwell's *New England Elegy* is in Boston (1966). *Public art* as we now understand and use that term dates from the mid-1960s. It has provoked some of the stormiest battles of the past generation; yet we need to remember that "disagreeable" public art, particularly murals, predates that decade. Even the Statue of Liberty prompted some derogatory comments when it was dedicated in 1886.[22]

From the mid-1960s through the 1980s, whenever the U.S. government used taxpayer dollars to commission an artist to create a sculpture, a mural, or a tapestry for a federal building, procedures became sufficiently complicated that the question arose in some minds whether government patronage of the arts could actually survive in a democracy.[23] The issue is really much older and broader than that, however. At the start of the twentieth century the Boston Public Library had an educational and democratic mission that conflicted with and ultimately contested the anti-Semitic content of murals designed by John Singer Sargent for the interior.[24]

The proper role of art in a democratic society has posed persistent issues. The pioneering Armory Show in 1913, which introduced Post-Impressionism to the United States, prompted a memorable dialogue between the eminent attorney John Quinn, an avid supporter of mod-

ernism, and members of Congress about the need to democratize the duty on all types of imported art by making it less prohibitive. When the National Endowment for the Arts (NEA) had its genesis in 1965, Gifford Phillips delivered a keynote address that struck a significant historical note:

A favorite subject for public debate has now emerged in the United States—the proper place of the arts in a democratic society. It is argued so frequently and so vehemently that one wonders what shirt-sleeve democrats of the frontier era would have thought of the concern being given to matters they always regarded as frivolous, if not un-American.

As the twenty-first century began, art critic Michael Kimmelman declared that "official art in a democracy requires consensus opinion, an aesthetic common denominator." Many might agree in principle, yet dissensus has been the norm for decades, and future prospects for a democratic consensus are not promising.[25]

Contemporary art's diversity and apparent ambiguity complicate the quest for democratization because the purpose, meaning, and quality of so much work remains unclear—quite often deliberately so. Many modern artists (and some critics) are wedded to the idea that art *ought* to be at least somewhat enigmatic if not downright mysterious, and that outlook became notably prominent with the rise of Abstract Expressionism. In 1951 painter Adolph Gottlieb proclaimed that "any conclusion can apply to any work of art," and critic Max Kozloff observed in 1965, looking back, that "ambiguity of concept, execution, role and meaning, became a touchstone of comment as it never was before." This pattern persisted well into the next generation of artists. As Robert Hughes has written of Jasper Johns's many flag paintings: "this very ambiguity, set in such a frame, set up a whisper of disturbance."[26] Disturbance and "disturbation" will become keywords in the discussion that follows.

Some might be inclined to argue that the possibility of multiple meanings implies or encourages individual opportunity and validates pluralism in judgment and therefore the democratization of art. I would like to agree, but considering the intensification of controversy we must also recognize that the lay public tends to be troubled (when it is not utterly baffled) by ambiguity in art. Wanting to believe that meaningful truth exists and really can be ascertained, as though

assisted by a kind of lodestone cultural compass, nonprofessionals pre-
fer the comfort of "right" answers. When ambiguity becomes a widely
welcomed aspect of art for insiders, public aspirations for concreteness
and assurance are swiftly dashed.[27] It is neither accidental nor coinci-
dental that many of the most controversial artists of our time have
explicitly declared the desirability of ambiguity. Andres Serrano
remarked that "the work is meant to be open to interpretation, as I
always say it is," and Richard Serra testified about his enigmatic *Tilted
Arc* that "a multitude of readings is possible."[28]

Serra also declared that he wanted *Tilted Arc* to be "confronta-
tional," and that has been true of many other highly minatory works by
this minimalist sculptor (see fig. 2). Moreover, it has been one of the
dominant attributes of art for two generations now. One might even
argue that the common denominator—a constant—during the swift
shift from one "ism" to the next has been the desire to shock. Looking
back to his brazenly tongue-in-cheek painting titled *Washington Cross-
ing the Delaware* (1953), Larry Rivers explained that "I was energetic
and egomaniacal and what is more important, cocky and angry enough

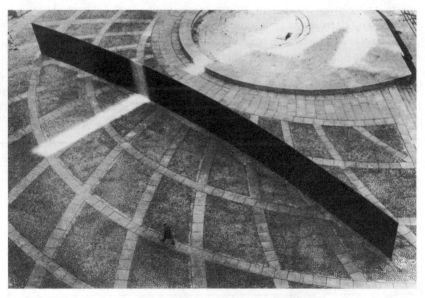

2. Richard Serra, *Tilted Arc* (1981).
Courtesy of Richard Serra. Photo by Susan Swider.

to want to do something no one in the New York art world would doubt was *disgusting, dead,* and *absurd.*"[29]

Roy Lichtenstein remarked in an interview that "the problem for a hopeful scene-making artist in the early sixties was how best to be disagreeable. What he needed was to find a body of subject matter sufficiently odious to offend even lovers of art." So he opted for the commonplace: comic book images. Pop artist Robert Rauschenberg insisted that "if the painting doesn't upset you, it probably wasn't a good painting to begin with." Abstract sculptor George Sugarman, whose *Baltimore Federal* raised a ruckus in that city during the later 1970s, asked rhetorically: "Isn't controversy part of what modern art is all about?" Performance artist Karen Finley asserted in 1990, as the case of the NEA Four unfolded, "That's what art is about—its shock value." And photographer Sally Mann, who began making provocative pictures of her three children in the 1980s, quipped in 2002: "I take being iconoclastic sort of seriously. It's my role here."[30]

Although the desire to shock, provoke, and contest has clearly been a salient characteristic of American art since the later 1950s, it would be a serious mistake to assume that this attitude is altogether new. Once again some historical perspective is essential. In 1907 Robert Henri asserted on behalf of the group he championed that they were painters "who believe above all that art of any kind is an expression of individual ideas of life, the seamy side. It is vulgar." In 1908 one press reporter dubbed Henri the "Manet of Manhattan" because of his antagonistic attitude toward the aesthetic status quo. The official emblem chosen by three American painters who organized the Armory Show in 1912–13 was an uprooted and overturned pine tree, a symbol of revolt against convention. The American-born sculptor Jacob Epstein most certainly sought to shock the art world from the time of his precocious London debut in 1908 right through the 1930s. And when Thomas Hart Benton received a commission from the Whitney Museum of American Art in 1931 to paint the murals known as *The Arts of Life in America*, he intended to be boldly caustic as well as colorful, remarking that "I paint sometimes to get people to criticize my work."[31]

Anthony Julius, an astute British barrister and art critic, has written that "iconoclasm is among the principal creative impulses of our times," and he is surely correct; but the phenomenon is not unprecedented, as he demonstrates very well for Europe.[32] It simply became more pervasive and overt beginning in the 1950s and accelerating

quite noticeably in the 1960s. Kate Millett created her installation piece *The American Dream Goes to Pot* for a radical antiwar exhibition in 1970 (fig. 3). When it was re-created in 1994 for the expansive show "Old Glory: The American Flag in Contemporary Art," which was calmly received in Cleveland in 1994 but caused an uproar in Phoenix, she recalled that "we were deliberately trying to be controversial."[33]

Her historical memory was sound. But we need to extend our own vision even farther back in time. Initiatives from earlier eras matter every bit as much as the transformations and innovations that have occurred since the 1960s. From its creation in 1929 the Museum of Modern Art (MoMA) aspired to "shake the public out of its lethargy toward the arts of its own day," and what the museum offers has consistently included "built-in shock value." MoMA historian Russell Lynes summed up the rhetorical dialogue: " 'You call that art!' the public says

3. Kate Millett, *The American Dream Goes to Pot* (1970).
Courtesy of Kate Millett.

(not asks), and the Museum replies in ringing tones, 'Yes, we call that art!' "[34]

Beginning in the 1960s and then intensifying in the 1970s, owners and directors of commercial art galleries quite often deliberately sought to mount the work of potentially provocative artists—to an unprecedented degree—and by the later 1980s and 1990s the heads of some major museums and arts councils felt inclined to follow suit. In 1989 the director of the Ohio Arts Council commented that "art, most of the time, is going to be controversial. That is what art is supposed to be about—continued questioning, prodding, controversy." That same year Greg Kucera, the owner of a gallery in Seattle, assembled a twenty-artist show titled "Taboo." As he remarked in one interview: "We live in a world where diversity of opinion gives this culture its richness." Without the right to examine controversial and sometimes disturbing works of art, "we would be fascists."[35]

One net effect, of course, has been to assure collectors and clients that provocative art is not only acceptable but even desirable and a solid investment besides. Finally, as critic Donald Kuspit wrote in 1981 in an overly formulaic yet highly symptomatic commentary, radically new art *needed* to seem arbitrary and incomprehensible.

A new art must be experienced as uncategorizable and as such anti-social—the two go hand in hand—for it finally to make fresh ideological sense, i.e., seem to possess a new point of view. The difficulty in placing the art is a necessary part of its mystique. . . . To appear ideologically advanced, the art had to seem arbitrary—this arbitrariness is part of its dynamic character. New art seems flawed because no clear reason for its difference from other art can be seen: it is not understood as a logical development from earlier art and so it seems radically novel if not radically meaningful. That comes later.[36]

Starting in the 1960s, art and society underwent increased democratization in tandem. Hence the Pop artist Claes Oldenburg produced a credo in 1967 that seemed antiestablishment and fresh yet timely, including these assertions: "I am for an art that imitates the human, that is comic, if necessary, or violent, or whatever is necessary. I am for an art that takes its form from the lines of life itself, that twists and extends and accumulates and spits and drips, and is heavy and coarse and blunt and sweet and stupid as life itself."[37] Robert Henri *redivivus*.

When other artists followed suit, and sometimes were even more overtly outré than Oldenburg himself, symmetry and congruence between the world of art and the "real world" got bent out of shape. When art was gradually rendered more extremist as the "world" changed (though somewhat less dramatically), dissonance and disconnects with the public became inevitable. Disrespect from ordinary folks and politicians clashed with cordial praise from critics and art administrators. Their respective directions diverged at a time when public interest in art actually heightened, and consequently each side would have to raise its voice to make itself heard and its views prevail.

A closing word about structure. I have organized this project topically within a chronological framework. So we will begin with the early republic, rickrack along, and close in the present century. Certain key episodes might readily have fit in more than one chapter. Hence the story of Edward Kienholz's flamboyant and highly contentious exhibition in Los Angeles in 1966 could very well have gone in Chapter 5, on political ideology, or Chapter 8, on the transformation of the art museum. I have situated it in Chapter 6, however, devoted to the pivotal 1960s. Similarly, the State Department's 1946–47 exhibition of contemporary developments, "Advancing American Art," might well have gone in Chapter 5, but I have chosen to locate it in Chapter 3, concerning American resistance to modernism. The same is true of Congressman George Dondero's impassioned Cold War crusade against Communism in American art; and because of his importance to several of our episodes, he will make more than one appearance, not so much as a star but as a gassy yet fiery comet that eventually burned itself out. (Vladimir Nabokov wrote in *The Gift* that the word *cosmic* is always in danger of losing its *s*.) I trust that these placements will turn out to seem sensible rather than arbitrary.

VISUAL SHOCK

CHAPTER I

Monuments, Memorials, and Americanism

Although the particulars have now grown hazy, older portions of the American public recall that the genesis of the Vietnam Veterans Memorial in 1980–83 prompted considerable controversy. It seemed quite shocking at the time that the design competition could be won by a twenty-one-year-old architecture student. Even more provocative, because her plan seemed so austerely postmodern, it failed to fulfill customary notions of what a suitably heroic memorial should look like. Hence the harsh criticism that a "black gash of shame" actually *dishonored* those who had died in Southeast Asia (fig. 4). A mere list of names placed in a wide-angle pit, with a plaque referring only to an "era" rather than an actual war? Could the nation do no better?

Although H. Ross Perot had initially funded the design competition, he joined traditionalists in denouncing Maya Lin's winning entry and calling for a representational monument showing U.S. soldiers and an American flag. Secretary of the Interior James Watt, who had the power to veto the whole project, allowed it to go forward, but only on condition that a compensatory statue be commissioned and situated nearby (fig. 5). Watt forced his compromise on the federal Fine Arts Commission, which genuinely did not want to upstage Lin's design with what commission chairman and National Gallery of Art director J. Carter Brown called a "piece of schlock."[1]

By 1983 the interchange between Maya Lin and Frederick Hart, the sculptor for the figural addition, served only to intensify ill-feelings underlying two conflicting visions of what might be the most appropriate ways to memorialize a massive number of deaths in an unpopu-

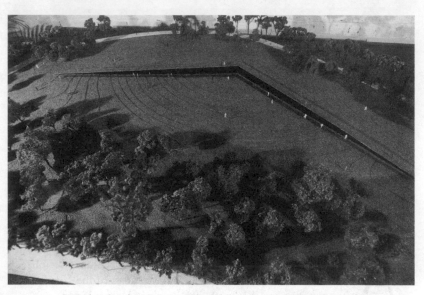

4. Site plan for the Vietnam Veterans Memorial, Washington, D.C.
Division of Prints and Photographs, Library of Congress.

5. Frederick Hart, *The Three Servicemen* (1984), Washington, D.C.
Division of Prints and Photographs, Library of Congress.

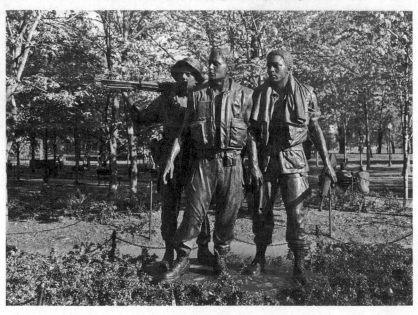

lar war. When asked her opinion of Hart's work, Lin candidly replied: "Three men standing there before the world—it's trite, it's a generalization, a simplification. Hart gives you an image—he's illustrating a book." Hart became even harsher when asked whether "realism" was the only way to reach the disaffected veterans and politicians.

The statue is just an awkward solution we came up with to save Lin's design. I think this whole thing is an art war. . . . The collision is all about the fact that Maya Lin's design is elitist and mine is populist. People say you can bring what you want to Lin's memorial. But I call that brown bag esthetics. I mean you better bring something, because there ain't nothing being served.[2]

In the decades since those two interviews took place, Americans have voted with their feet, but more powerfully with their hearts and minds. Lin is a winner.

In 1987 Congress finally began its initial and pedestrian reaction to long-standing requests for a World War II memorial situated in a suitable place of honor in Washington, D.C. By the mid-1990s likely designs received a critical response for several reasons: first, they seemed too grandiose and therefore reminiscent of conservative monuments in Europe; second, they would likely obstruct the widely cherished two-mile vista between the U.S. Capitol and the Lincoln Memorial; and third, they would bisect the Mall by straddling its entire width. There were traditionalists on *both* sides of the issue: those who wished to preserve the uncluttered "purity" of the Mall and those eager to honor the "greatest generation" with a genuinely worthy plan consistent in merit with others in that coveted location. This conflict boiled up a full head of steam between 1997 and 2000, but Friedrich St. Florian's winning design finally received presidential approval when many pleaded that World War II veterans were rapidly dying and *something* should be completed before they had disappeared entirely (fig. 6).[3]

Too few Americans are aware that most of the issues raised between 1980 and 2000 had been hashed out long before when initial plans were unveiled for the Washington Monument and the Lincoln and Jefferson memorials. Moreover, major statues meant to honor Wash-

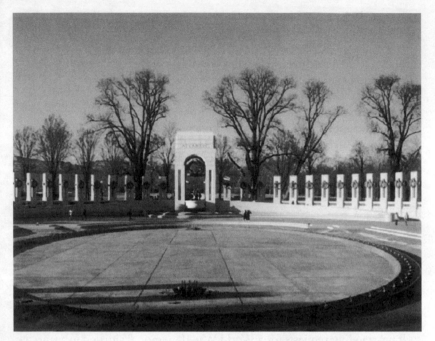

6. Friedrich St. Florian, The World War II Memorial (2004),
Washington, D.C.

ington and Lincoln had also aroused the most intense feelings on sim-
ilar grounds: sheer size (gigantism), style (classical versus "modern"),
location, and even nudity in the case of Horatio Greenough's seated
George Washington, commissioned by Congress in 1833, completed in
Florence, Italy, in 1839, and placed in the Capitol Rotunda in 1841.
Scale, style, site, and apparel (or lack thereof) would become persistent
and volatile issues in American art ever after. *Monumental* is a more
neutral euphemism for *gigantic* and *colossal*, of course. Many artists,
sculptors, and architects who we might find guilty of gigantism were
only striving to do monumental work. Suitable scale seems to lie in the
eye of the beholder yet also reveals the ambitious needs of a principal
stakeholder.[4]

Greenough's *Washington* touched off one of the earliest conflicts in
the United States involving aesthetic criteria, and one of the most rep-
resentative. A particularly problematic question involved style: how
should the Father of His Country be depicted, as an idealized deity or

as a revered native statesman? Classical or "American"? Godlike and spiritual or secular yet like-no-other? Greenough's solution turned out to be a hybrid: the head based upon Houdon's life mask certainly resembled Washington, but the body evoked Jupiter and Roman statuary (fig. 7). Hence the work got nicknamed George Jupiter Washington when it wasn't given more insulting designations. Greenough's inspiration was actually the Elean *Zeus* by Phidias, one of the greatest Greek sculptors, a work known only by description. Greenough was apparently seeking purity and simplicity rather than the pomposity that so many critics seemed to see in the statue. The snarls that ensued would demonstrate that compromise leaves almost no one satisfied.[5]

Greenough's statue as well as Robert Mills's Washington Monument emerged in the wake of failed attempts to commemorate the centennial of the founder's birth by unearthing his body from Mount Vernon for reburial in the Capitol crypt in 1832. The cult of Washington as a superheroic if not immortal figure remained exceedingly strong, though strife persisted over the relative merits of his role as a

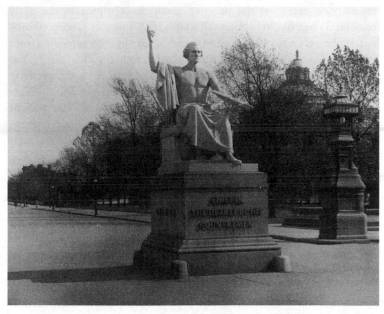

7. Horatio Greenough, *George Washington* (1841), Washington, D.C.
Division of Prints and Photographs, Library of Congress.

symbol of national unity and his symptomatic value to southerners as a Virginia-based protochampion of states' rights. The Nullification Crisis early in the 1830s, prompted by South Carolina's threatened secession over tariff issues, added sectionalism to the mix of aesthetic differences and complicated them. Similarly it has long been forgotten that several significant sources of friction in the decade following 1911 involving the Lincoln Memorial arose from sectional tensions left unresolved by the Civil War. That monument, which is virtually devoid of references to slavery and the conflict it generated, was meant to serve as an emblem of national unification. The intertwined boughs of southern pine and northern laurel that gracefully encircle the frieze provide just one indication of that quest. (Because laurel is a symbol of victory, of course, the northern Republicans who called the shots enjoyed a not-so-subtle triumph.)

Serious debate would persist for more than a century following the 1820s: namely, whether monuments and architecture in the United States should pursue styles that feel native and new or should appropriate motifs from antique Greece and Rome. Horatio Greenough received interesting and revealing advice as he embarked upon his impassioned career as the premier American sculptor in the early republic. When he first attempted to model a figure of George Washington, he received wise counsel from a patron, the novelist James Fenimore Cooper: "Aim rather at the natural than the classical."[6] That same heated issue would stay situated at the core of a decade-long quarrel over the most suitable design for the Lincoln Memorial. "Natural" meant more than avoiding stylistic imitation of the ancient world. It also meant having a heroic figure clothed in modern dress, and standing rather than seated like some emperor, Roman or Napoleonic.

Greenough got mixed signals, however, because his fellow New Englander Edward Everett advised him to "go to the utmost limit of size. . . . I want a colossal figure." That muscular word *colossal* and its synonyms would recur over and over again in intensely heated discussions about the Washington Monument, the Lincoln and Jefferson memorials, and the memorial for Franklin Delano Roosevelt finally unveiled in 1997. Midwestern opponents of the Lincoln Memorial design that ultimately prevailed (albeit scaled back in size owing to considerations of cost and weight) pleaded instead for a "colossal statue" of the man who saved the Union. But in 1969 William Walton, chairman of the Fine Arts Commission, epitomized more than a cen-

tury of polemics when he wrote to the chairman of the FDR Memorial Commission, a member of Congress: "I urge that we get away from bigness as a manner of memorializing great men. A man's place in history is never determined by the size of his monument."[7]

When Fenimore Cooper discovered the dimensions that Greenough had in mind, he considered them grandiose and advised his friend accordingly. The sculptor stuck with Everett's wishes, however, which reinforced his own aspiration, and designed a massive marble chair from which his seated Washington figuratively contemplated the ship of state he had brought into being. His gestures followed a classical formula seemingly well suited to a brand-new republic. Whereas Washington's right hand points heavenward, the source of law by which men live, the left hand returns his sword to the people because he has completed his service to them. It was not such a bad compromise, actually, between imperatives ancient and modern.[8]

Skeptics scoffed that the oversize statue would not even be able to enter the Capitol for placement in the Rotunda. They were wrong, and initial responses to the monumental piece in 1841–42 seemed more favorable than not, though critics certainly made themselves known. When Greenough arrived from Florence in 1842 and saw how dim the Rotunda lighting was, however, he tried to have torches illuminate his work; but they only made matters worse. Flickering lights in a dim chamber do not enhance greatness. He then pleaded with Congress to move the monument out of doors so that it could be bathed in natural sunlight—a serious error, as it turned out—and that is when the harshest condemnations began to be heard. Maximum visibility only encouraged calumny.[9]

Fierce blasts came from Senator Charles Sumner of Massachusetts, who had offered stiffer warnings than Cooper's concerning size as well as nudity, and from Philip Hone, the former mayor of New York, who recorded the following in his diary:

> It looks like a great herculean Warrior—like Venus of the bath, a grand Martial Magog—undraped, with a huge napkin lying on his lap and covering his lower extremities and he is preparing to perform his ablutions in the act of consigning his sword to the care of the attendant. . . . Washington was too prudent, and careful of his health, to expose himself thus in a climate so uncertain as ours, to say nothing of the indecency of such an exposure on which he was known to be exceedingly fastidious.

Nathaniel Hawthorne was pithier: "Did anyone ever see Washington naked? It is inconceivable. He had no nakedness, but I imagine was born with his clothes on and his hair powdered, and made a stately bow on his first appearance in the world." Being unclothed from the waist up was nude enough for the 1840s but particularly so for the Father of His Country, a man renowned for his dignified reserve as well as other self-possessed qualities. On this matter also, however, consensus could not be achieved. Ralph Waldo Emerson described the work as "simple & grand, nobly draped below & nobler nude above."[10] He declared that it "greatly contents me. I was afraid it would be feeble but it is not." In many different ways and for numerous reasons, nudity would become a prime cause of controversy during the century and a half that followed.

Once it was determined that *Washington* would sit out of doors, exposed to extremes of weather and the uncontrollable excretions of birds, the figure became a prime target for pranksters. One inserted "a large 'plantation' cigar between the lips of *pater patriae*, while another had amused himself with writing some stanzas of poetry, in a style rather more popular than elegant, upon a prominent part of the body of the infant Hercules." Exactly which body part is unclear; but quite obviously political graffiti did not originate the day before yesterday. This monumental statue increasingly became an occasion for mockery, and Greenough's poignant letter to Robert Winthrop in 1847 sums up his frustration at having his motives and skills misunderstood by a nation so lacking in artistic sophistication.

A colossal statue of a man whose career makes an epoch in the world's history is an immense undertaking. To fail in it is only to prove that one is not as great in art as the hero himself was in life. Had my work shown a presumptuous opinion that I had an easy task before me—had it betrayed a yearning rather after the wages of art than the honest fame of it, I should have deserved the bitterest things that have been said of it and of me. But containing as it certainly *must* internal proof of being the *utmost effort* of my mind at the time it was wrought, its failure fell not on me but on those who called me to the task.[11]

Washington's state of undress also made him appear pagan—not exactly proper in a society where evangelical Christianity enjoyed wide

appeal. Although Henry Wadsworth Longfellow and many others praised it, the statue continued to inspire wags and scoffers throughout the remainder of the nineteenth century. The early rumor that it was too large to pass through the door of the Capitol gradually became a popular legend. Stories were repeated that it had to be moved outside because it threatened the very foundation of that big building and even that it sank the first ship that attempted to load it for "home" in Leghorn, Italy. The ultimate insult occurred in 1908 when Congress ordered that it be moved to the Smithsonian Institution's "Castle," ironic in turn because of Greenough's disdain for the Gothic style.[12] A monumental mismatch of art and architecture.

During the later twentieth century, when certain works of public sculpture became crazily controversial, such as Claes Oldenburg's *Free Stamp* in Cleveland, their defenders insisted that they could not be moved because they were "site specific," that is, designed with a very particular place in view. To change their venue would be tantamount to destroying them. This, too, was not a new issue. Greenough had been commissioned to create his work specifically for the Capitol Rotunda.

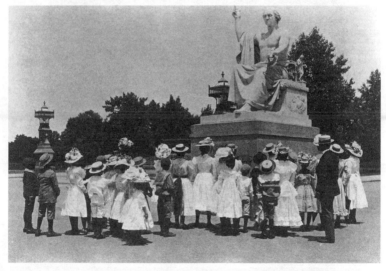

8. Frances Benjamin Johnston, Greenough's *George Washington* admired by children on the U.S. Capitol plaza (1890s).
Division of Prints and Photographs, Library of Congress.

It got moved outside at the sculptor's own request, though swiftly to his profound regret; and it was resituated once again more than half a century after his death. Relocation alone, however, had not denigrated it. Dissensus already had. The country simply could not agree on the most suitable aesthetic for honoring its foremost citizen with a prominently placed statue (fig. 8).

In 1833, when Congress initially gave Greenough this coveted professional opportunity, a private association also had under way a plan to erect a major monument commemorating the first president. The

9. Robert Mills (1781–1855) and his wife,
Eliza Barnwell Smith.
Courtesy of the Archives of American Art.

initial document to be released, drafted hastily by Robert Mills (appointed by Andrew Jackson to be the nation's official architect [fig. 9]), envisioned a massive, four-sided rusticated pyramid, a thousand feet square at the base, soaring to a height of 650 feet, and supporting a "collossian" statue of George Washington, the whole thing insanely envisioned as a thousand feet tall. At each corner there would be obelisks 45 feet square and 350 feet tall, with the pyramid separated into seven "grand states of terraces" diminishing in height as they ascended. The rest of Mills's description might be succinctly summarized as seeking the sublime through "shock and awe." The proportions were simply mind-boggling, even by modern standards.[13]

Because fund-raising proceeded privately and poorly, and because there were competing plans, no progress occurred for more than a decade, a harbinger of woeful delays to come. In 1845 the Washington National Monument Society approved Mills's revised design, slightly more modest than his first but stupendously grand nevertheless. It called for an Egyptian obelisk rising well over five hundred feet in the air, surrounded by a massive, circular, and Doric pantheonlike rotunda, itself sitting on a deep base and entered through a portico four columns wide and two deep (fig. 10). Because the circular-pantheon concept came from Rome, Mills had managed to fuse all three of the ancient civilizations deeply admired for their symbolic cachet by many Americans during the first half of the nineteenth century.[14]

So much stylistic fusion caused considerable confusion, however. Some critics objected to the impurity of combining an obelisk with a colonnade. And the cost of such an undertaking was unthinkable in any case. So in 1848 the society proceeded with the obelisk alone, though even that would remain an unfinished stump from 1854 until 1884 because Congress did not authorize funds to complete the undertaking until the centennial of Independence in 1876. One year earlier, in 1875, the *New York Tribune* called the curtailed curiosity an "abortion." Still others, shifting the imagery, designated it a "big furnace chimney." Both analogies were fairly apt (fig. 11).[15]

The authorities had been able to agree on very few basic questions. In response to whether there should be any shaft at all, one senator proclaimed in 1832 that George Washington's monument "is in our hearts." Others, however, had argued for some sort of cenotaph or column rather than an equestrian statue because Europe already had lots of the latter. A huge column would be preferable because "we might

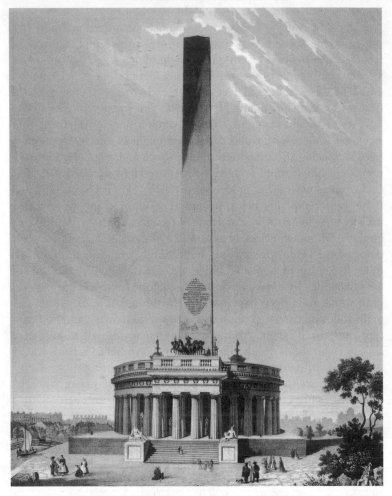

10. Robert Mills's plan for a monument to George Washington (1845), Washington, D.C.
Division of Prints and Photographs, Library of Congress.

erect the largest and finest in the world," whereas there would be "a hundred [equestrians] to rival us." Many preferred an obelisk to a column, however, because it is easier to inscribe writing on the flat surfaces of an obelisk; and so the debate went round and round for more than half a century.[16]

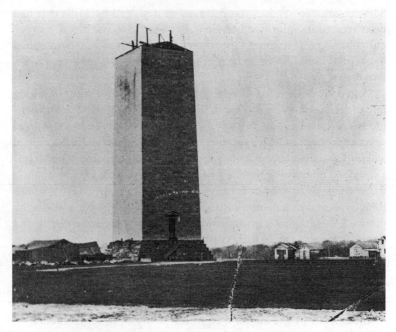

11. The Washington Monument under construction (ca. 1855).
Division of Prints and Photographs, Library of Congress.

The painter Thomas Cole entered these thoughts in his notebook on October 10, 1835.

> As to the design of such a monument, I would say, let it not be a statue; for however great its size, its many parts and projections would render it less durable than something more simple: time would destroy the original beauty of the sculpture of a statue. I would not have a column; for that is only an architectural member, and not a complete whole. Although it were crowned with a statue, it would not appear to me either consistent or in good taste. A pyramid would answer in durability of structure; but that is unmeaning. To my mind a colossal altar would be the most appropriate, and the most capable of uniting beauty of form with durability. Let it be hundreds of feet in height; let a fire burn upon it perpetually; let it never expire while the nation recognized Washington as the Father of his country.[17]

The remarkable Washington Monument designed by Mills that had been erected in Baltimore between 1815 and 1829 was already a very tall column, 220 feet high. So the next effort, national rather than local, would surely need to be more than twice as tall, and shaped differently, of course.[18]

And so it came to be, though not an altar and not without a long line of serious skeptics and harsh dissenters. Here is what one anonymous critic had to say in 1855, writing for the preeminent journal devoted to the arts. The author clearly assumed that Mills's original and highly elaborate plan from 1845 had not yet been abandoned. "It is a tasteless, unmeaning jumble of columns surmounted by an obelisk; there seems to have been no aim in its design, except to erect something *high*, and to accomplish this, to sacrifice every noble and worthy motive belonging to a work of this character. What have Greek and Egyptian symbols to do with Washington?"[19]

That was a representative view for a full generation. Here is what *The Nation* had to say a decade later.

> The obelisk has generally been injured in effectiveness as a monument by the addition to its simplicity of other members, making it part of a composition. The simplest and lowest base is the best. And any attempt at union between this and other architectural forms is sure to fail, as in the noted instance of that most inappropriate and offensive design for the great monument to Washington at our national capital; a circular temple, over a hundred feet high, surrounding the base of an obelisk-shaped tower rising four hundred feet above the temple's roof.[20]

By the mid-1870s, when Congress finally accepted the idea of using public funds to finish a simplified version of what had been proposed two generations earlier and actually been begun in 1848, critics called for the monument to be "characteristically American" even though they could not readily define just what that might actually mean in such a project. In 1873, while the original design languished, a serious plan for an alternative one proposed four Egyptian sphinxes "of colossal proportions [of course] . . . nationalized by the head and breast of our national bird." A bald eagle-sphinx—now that was *really* mix and match.[21]

If stylistic devices from the ancient world had lost some of their appeal, so had sheer size simply to satisfy national chauvinism at great

cost. To some, at least. As work went forward, *American Architect and Building News* sneered that the immense obelisk "will doubtless assert itself to the common mind as a clear achievement (in the vernacular, a *big thing*)." As it turned out, one politically astute man from the Army Corps of Engineers supervised the final design through to completion of the monument and kept it reasonably austere even though he could not resist crowning the 555-foot shaft with a heaven-pointed pyramidion.[22]

Turning to the moment of completion, we get a clear sense of the country's ambivalence about what had ultimately been wrought. After criticizing the obelisk quite fiercely late in 1884, the *New York Times* reversed itself for the monument's dedication a few months later in 1885, acknowledging that there was "something characteristically American" about finishing the tallest structure in the world, even towering above "the highest cathedral spires designed by the devout and daring architects of the Middle Ages."[23] So size still mattered to many people. Big was beautiful because national competitiveness made it a point of pride. And a little touch of antiquity could go a long way. Somehow the Washington Monument managed to seem, well, monumentally American.

Following the death of Ulysses S. Grant in 1885, an elaborate tomb site became virtually inevitable because of his personal popularity and an outpouring of sympathy for his courageous battle with cancer; but the optimal or most logical form it should take was not at all clear. One of the earliest admirers to weigh in was Clarence King, a polymath much admired by Henry Adams. King wrote a prompt and impassioned public plea rejecting Greek, Renaissance, and Gothic models. Instead, almost anticipating the Jefferson dispute that lay more than half a century ahead, he argued that the middle period of the Roman Empire was most suitable for Grant and the United States. The truly fitting tribute, according to King, would be a "round Roman tomb of noble dimensions treated as to its details in Romanesque style."[24]

Although the mausoleum site on Riverside Drive was designated almost immediately, Grant was temporarily buried in Central Park while a debate over design and intensive fund-raising took place. What eventually emerged as Grant's Tomb in 1897 would contain substantial elements of imperial Rome on top of a massive but modified Greek temple below, the whole thing amplified with elements from other

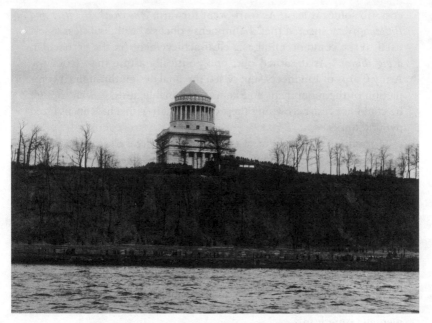

12. The dedication of Grant's Tomb (1897), New York City.
Division of Prints and Photographs, Library of Congress.

stylistic traditions (fig. 12). The net effect was a curious amalgam magnified by gigantism. It pleased some but bitterly disappointed others. Grand it was, indeed Grant-worthy in the eyes of many; but distinctly or definably anything in particular it was not.

Early in the twentieth century, as the nation neared the centennial of Abraham Lincoln's birth, discussion turned to the prospect of a major memorial in his honor. The controversies that ensued for almost a quarter of a century involved all the familiar issues except nudity. No one wished to revisit that one. If Washington stripped to the waist had been difficult for many to accept, the martyred rail-splitter must have seemed well beyond such degradation. In any event, times had changed on that score, but site, size, and style remained tough topics. Many enthusiasts of a memorial, advocates of the McMillan Plan of 1901 for elaborating the topographical heart of Washington, had their

eye on what became the west end of the Mall, eventually known as Potomac Park because it borders the river.

At that time, however, it wasn't a park at all but rather an exceedingly marshy area that had not been drained. "Uncle Joe" Cannon, Speaker of the House, was a midwesterner and a fervent Lincoln fan. Regarding Potomac "Flats" as remote and malarial, he declared that the "monument itself would take fever and ague, let alone a living man." Cannon swore to oppose anything "that will not place that monument where all the people will and must see it." As he warned one powerful Republican in the cabinet, "There is a fight on about the location of the Lincoln Memorial and you keep out of it; it's none of your damned business. So long as I live I'll never let a memorial to Abraham Lincoln be erected in that God damned swamp."[25] Cannon would subsequently do battle with the winning neoclassical design; but

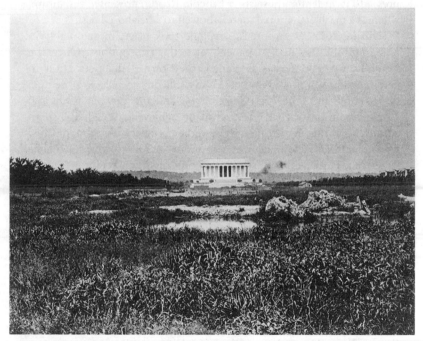

13. The Lincoln Memorial in the marsh, West Potomac Park (mid-1920s), Washington, D.C.
Division of Prints and Photographs, Library of Congress.

still later, in his dotage, he acknowledged that both the site and the style had turned out well! Such honest reversals haven't happened very often (fig. 13).

The next issue to arise was not exactly an "art" controversy, but it did involve both site and style—the question of what is most distinctively American once again. Some advocates of honoring Lincoln's memory proposed to build a seventy-two-mile highway that would connect Washington, D.C., with Gettysburg. Supporters of that alternative argued that doing something useful would honor the Emancipator far more than creating something merely symbolic, and they received considerable support from the nascent automobile industry and touring associations. Curiously, that proposal would surge and then ebb in 1908, yet get revived by impassioned backers once again in 1912. Eventually the idea died following a congressional hearing, but not until it had been thoroughly hashed out in several forums, including the press. To its ardent enthusiasts, a Lincoln Road represented the future, whereas a marble memorial merely bowed to a belabored past.[26]

During 1911–12 an intense struggle took place, most notably in Congress but also in newspapers, over the two options. Once the Republican traditionalists prevailed, they turned their attention to gaining approval for architect Henry Bacon's neoclassical temple design from the Fine Arts Commission and the Lincoln Memorial Commission. That goal was eventually achieved, though it had to surmount challenges from midwesterners, especially, who pleaded for a memorial style that would be more "home-grown" and hence American. Perhaps the most vocal among them was sculptor Gutzon Borglum, a Lincoln enthusiast best known for the four massive presidential heads he created at Mount Rushmore between 1926 and 1939. Borglum actually wanted the opportunity to create a "colossal figure of [Lincoln] in Greek marble" but lost that bid because the political powers gradually lined up behind Bacon and his concept of a temple to anchor the west end of the Mall.[27]

Many aspects of this conflict suggest that two irreconcilable groups of purists sought any possible pretext to ridicule each other. Members of Congress who opposed Bacon's design, for example, pointed out that Lincoln had never even learned the Greek alphabet. How bizarre, then, to honor him with a temple derived from the Parthenon. No one seemed to notice or be bothered, however, by the fact that, in the centennial year of 1909, Lincoln's birthplace, a rustic log cabin (of

14. Lincoln's "birthplace" cabin, Hodgenville, Kentucky (1940).
Division of Prints and Photographs, Library of Congress.

dubious authenticity), had been encased in a white marble, classical temple (fig. 14).

The seated statue designed for the memorial in D.C. by Daniel Chester French appeared as an interior colossus at thirty feet high (including the pedestal). The sculptor had also designed a massive, boxy throne reminiscent of Greenough's for *George Washington*. The facings for the armrests were prominently adorned with the ancient Roman fasces, a symbol of unification, of course. As art critic Royal Cortissoz remarked when he composed the epigram inscribed above Lincoln's head: "The memorial must make common ground for the meeting of the North and South. By emphasizing his saving the union you appeal to both sections. By saying nothing about slavery you avoid rubbing old sores."[28]

When the groundbreaking ceremony occurred on Lincoln's birthday in 1914, a former Confederate cavalry officer, now a U.S. senator from Kentucky, spoke briefly about the reunion of North and South. He regarded the temple, still eight years from completion, as an important emblem of unification. Superficial consensus about the meaning of the memorial masked deep-seated divisions over style, site,

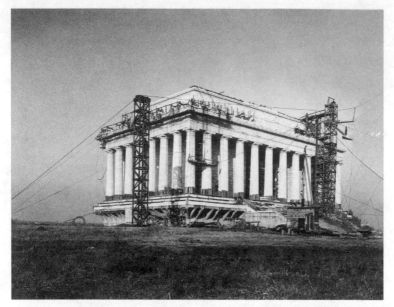

15. The Lincoln Memorial under construction (ca. 1919),
Washington, D.C.
Division of Prints and Photographs, Library of Congress.

the choice of a symbolic structure rather than a road, and even size.
When the footings sank down through the marshy land in search of
bedrock, a prudent decision was made to diminish the building's pro-
jected dimensions and stupendous weight (fig. 15).[29]

Following the dedication on Memorial Day in 1922, an array of
interested observers weighed in with lavish praise as well as scornful
criticism. On the laudatory side, those who had been longing for years
to approve it were joined by converts who confessed their surprise and
pleasure. The *Washington Post* proclaimed the Potomac end of the Mall
the "predestined site" for the memorial and thereby justified its hith-
erto marginal location, away from the hurly-burly because of the "emi-
nent and isolated position Lincoln occupies in our history." In May
1923 the American Institute of Architects awarded Henry Bacon its
gold medal for achievement, only the third time it had done so in its
history. The pageant on that occasion involved eerie floodlighting and
included a torchlight procession in which the honor party was towed
to the memorial on a barge on the reflecting basin. Christopher

Thomas suggests that this served as "an expression of the otherworldliness imputed to the memorial and Lincoln."[30]

Strong and strident dissenting voices were raised by some very distinguished older as well as new members of the architectural community. Louis Sullivan, one of the best known and a midwestern devotee of contemporary design, regarded the memorial with disgust: "Architecture, be it known, is dead," he said. "Let us therefore lightly dance upon its grave, strewing roses as we glide." More lugubrious words followed. Frank Lloyd Wright heaped derision with the mid-American pride of a pioneering modernist: "Depravity sees a Greek temple as [a] fitting memorial to Abraham Lincoln. He is the Greek antithesis. Nothing is Greek about his life or work or thought." Perhaps the young Lewis Mumford, an easterner with eclectic taste, offered the harshest condemnation of all:

> In the Lincoln Memorial . . . one feels not the living beauty of our American past, but the mortuary air of archaeology. The America that Lincoln was bred in, the homespun and humane and humorous America that he wished to preserve, has nothing in common with the sedulously classic monument that was erected to his memory. Who lives in that shrine, I wonder— Lincoln, or the men who conceived it?[31]

What happened in this case followed the pattern of the Washington Monument and anticipated that of the Vietnam Veterans Memorial, for there was surprisingly swift public acceptance and within less than a generation only dim memories survived of the intense disagreements sparked by the commemorative designs. Greenough's *Washington* remained an exception to that pattern. It was fated to be scorned, not feted.

As construction of the Lincoln Memorial was getting under way in 1917, a little-known parallel drama unfolded in Ohio and New York with high intensity and international implications. This conflict hinged starkly upon an issue that had social, cultural, political, and aesthetic dimensions: Should Lincoln be represented in sculpture in idealized fashion as a dignified statesman in his maturity? Or with homely realism as a country lawyer with his potential for greatness yet to be realized? The American Peace Centenary Committee, formed during the centennial of Lincoln's birth in 1909, decided to mark the anniversary of peace with Great Britain (scheduled for 1915) by sending to

16. George Grey Barnard, *Abraham Lincoln* (1917),
Lytle Park, Cincinnati, Ohio.
Photo by Courtney Ritter.

London a replica of Augustus Saint-Gaudens's elegantly brooding
statue of the late president (1879) from Lincoln Park in Chicago.[32]

When no benefactor emerged to bear the cost, Charles P. Taft, half
brother of the former president and of current chief justice William
Howard Taft, offered to supply a replica of a Lincoln statue that he had
commissioned in 1910 by George Grey Barnard for placement in
Cincinnati's Lytle Park. The work was viewed briefly in New York
before being unveiled in Cincinnati less than a week before Congress
declared war on Germany in 1917. The elite in that conservative Ohio
city received the image quite positively even though this was a humble,
almost ungainly version of Lincoln as a man of the people, an unre-
fined commoner with an elongated neck, beardless, looking rather

unworldly (if not world-weary), and perhaps yearning for divine guidance (fig. 16).

Barnard, a midwesterner, explained that his vision of the Emancipator derived from his youth, shaped by the recollections of a grandfather who had known both Lincoln and Stephen A. Douglas. Barnard's image reflected "the mighty man who grew from out of the soil and the hardships of the earth." Traditionalists, however, and especially members of the art establishment detested the work. They were horrified, moreover, at the prospect that this ungainly rustic figure would be the visible emblem of the United States in London. Hostile partisans like Robert Todd Lincoln condemned it as "a monstrous figure which is grotesque as a likeness of President Lincoln and defamatory as an effigy." Curiously, statesmen like Wilson and Roosevelt, as well as major artists like John Singer Sargent and Frederick MacMonnies, rather admired the Barnard statue.[33]

Barnard spoke quite openly about his identification of Lincoln with the working classes, almost as a kind of low-key and unkempt antihero. "He must have stood as the Republic should stand, strong, simple, carrying its weight unconsciously without pride in rank or culture. He is clothed with cloth worn, the history of labor. The records of labor in Lincoln's clothes are the wings of his victory." Swiftly, however, prominent antimodern artists like Kenyon Cox and Frederick Wellington Ruckstull, the latter a cofounder of the National Sculpture Society, mobilized and publicized savage attacks. After seeing Barnard's *Lincoln* in New York, Ruckstull published an indictment. His views seem to have been representative of the appalled nationalists, horrified that an unkempt and earthy Emancipator might be displayed in London and Paris, perhaps permanently, and possibly even in Moscow as well.

Because Lincoln was born in a log-cabin, split rails, built and pushed a flatboat, was a Captain in the Black Hawk War and conformed to the indifference to dress which inevitably was forced upon the pioneers in every frontier region by the hardness of their life, he has been so often represented as a "slouch," as a "hobo-democrat," and as a despiser of elegant social forms, that it has found general credence among the unthinking—to the detriment of our country.[34]

In November 1917 the *Independent*, a widely read journal of opinion, invited readers to rank six statues of Lincoln. The Saint-Gaudens

received 49 percent of the twenty thousand responses. Four others received from 7 to 17 percent of the votes, while Barnard's ranked last with 6 percent. Late in 1918, however, a British centennial committee decided that both statues were acceptable and that each one should be placed in a suitable location. In the summer of 1920 Saint-Gaudens's version was unveiled in London's Parliament Square, to the applause of ranking British and American officials. Ten months earlier, though, Barnard's egalitarian Lincoln was well received in Manchester, a city, as one observer put it, "closer to America in thought than any part of the British Isles." Thus two different representations of American democracy and aesthetic values came to be situated in disparate venues abroad. The dispute at home as to which was preferable persisted. The Saint-Gaudens is moving and more familiar; but Barnard's statue remains an extraordinary work of empathetic art.[35]

Although the idealization of Lincoln in his memorial became consensual within a decade—outside the former Confederacy, at least—it did not forestall a fresh storm forming over a comparable shrine in the later 1930s. The approaching bicentennial of Jefferson's birth in 1943 prompted the organization in 1935 of a memorial commission responsible for selecting a site, an architect, and a design to honor the third president and principal author of the Declaration of Independence. Because Jefferson was considered a founder of the Democratic Party and remained a partisan figure until the early twentieth century, momentum for his memorial and for a suitable site took a while to catch on and get mobilized. Initial proposals in 1936–37 for Hains Point along the Potomac went nowhere, and proponents of the Tidal Basin, also near the Potomac, met with bitter resistance because disciples of Teddy Roosevelt had envisioned that site as a prime location for a memorial to their hero. The Fine Arts Commission (FAC) went to extraordinary lengths in attempting to block the Jeffersonians' bid for Hains Point, even publishing a pamphlet attacking the location as inappropriate.[36]

What helped the FAC succeed on the question of location was the overwhelming grandiosity of the memorial envisioned by the Thomas Jefferson Memorial Commission. Its original plan called for twice the bulk and a structure twenty-one feet higher than the Lincoln Memorial. It would be a case of gigantism yet again. Moreover, the memorial commission had already committed itself to John Russell Pope, a

skilled exponent of classicism who had lost out to Bacon in competition for the Lincoln design in 1912. The Jeffersonians wanted a Roman memorial dedicated to the memory of the father of American classicism and rejected any sort of utilitarian remembrance. They were determined to have a shrine. Early in 1937 the commission accepted Pope's plan for a Pantheon modeled on the Roman temple built by Agrippa and rebuilt by Emperor Hadrian in the second century A.D.[37] Conservatives in the art world offered moderate support, but modernists took great offense and protested vociferously. Letters and derisive manifestos flooded the FAC.

- Milton Horn, president of the American Sculptors Society, wrote: "To Jefferson, to whom simplicity and truth were a motive of life, they have now elected to erect an empty shell which possesses not even the kernel of these; a hollow mockery of a spirit which embodies an ideal; a useless structure to symbolize a useful life. . . . Its growth is not natural to our soil; its derivation is from the dead. Like a cadaver, it cannot function." Echoes of Lewis Mumford on Lincoln's mausoleum.
- Talbot Hamlin and others from the League for Progress in Architecture described a "pompous pile," barren, joyless, and unknown to Jefferson's spirit.
- Frank Lloyd Wright once again provided predictable hostility: "Instead of a monument I advocated a memorial, the difference being that the monument saw life a corpse and the memorial saw the spirit alive, not withstanding. A monument is no real honor to the dead. It is set up to put certain people on good terms with themselves. . . . Thomas Jefferson? Were that gentleman alive today he would be the first to condemn the stupid erudition mistaken in his honor."[38]

Sensitive to this onslaught of opposition, Congress blocked the appropriation of funds for construction, and the memorial commission had to reconsider its priorities. Republicans who did not want to glorify a Democratic founder evoked still other reasons for opposition. How could millions be spent on this project during such a severe depression? And the eloquent Jefferson could be quoted from 1786 when he responded to a proposed sculpture of George Washington: "I think a modern in antique dress is just an object of ridicule." (No one

seems to have cited that line to Horatio Greenough in 1842.) But the memorial commission observed that if Jefferson had been modern and radical, as the enthusiasts for progressive architecture insisted, he made classicism the "modern" of his own time. As Fiske Kimball, an eminent architectural historian, Jefferson specialist, and strong-minded director of the Philadelphia Museum, put it, let us give Jefferson his due, "and then let us turn to the task of infusing the architecture of Washington with modern character."[39]

The commission found itself caught in a crossfire between opponents of the New Deal who really wanted no memorial at all and modernists who admired Jefferson but wanted something utilitarian and functional to honor this innovative and versatile figure. The weakness in that position emerged from recognition that the history of "living memorials" showed, as Kimball observed, that "the utilitarian side soon dominates over the commemorative, even to the extent of completely effacing it." Bitter backing-and-forthing occurred in 1937–38, but the Jeffersonians had a crucial ally who made all the difference. Franklin Delano Roosevelt liked Pope's Pantheon plan. Once FDR endorsed it in 1937 and the Democratic Congress approved a $3 million appropriation early in 1938, the commission's design succeeded. Although bickering continued, the outcome was no longer in doubt.[40]

So neoclassicism won outright. "Colossal" had to be toned down just a bit because engineers projected that if the proposed memorial was actually built at Pope's intended scale, it would sink into the marshy lip of the Tidal Basin. So it ended up big, but not *that* big (fig. 17). When preparations for construction began, a fierce finale ensued that was largely local in nature yet highly visible because it was so risible. Many people in the Washington area enjoyed the scenic beauty of Potomac Park but particularly the several thousand cherry trees given by a grateful Japanese government after Teddy Roosevelt provided successful arbitration in the Russo-Japanese War of 1905–06. The Tidal Basin had been ringed by those trees, and quite a few—some estimates reached as high as seven hundred—would have to be removed to make room for the memorial. Angry citizens, many of them socially prominent women, actually tied themselves to cherry trees in order to forestall the menacing bulldozers, backhoes, and workmen with shovels. Hotel associations, women's clubs, and civic groups voiced their opposition to the violation of a beloved venue. The *Washington Times and Herald* denounced this act of aggression with the same animus it had aimed against the New Deal.[41]

17. The Jefferson Memorial with cherry blossoms (1946),
Washington, D.C.
Division of Prints and Photographs, Library of Congress.

Construction went forward in 1939, and the memorial was dedi-
cated on Jefferson's two hundredth birthday, April 13, 1943. In a very
real sense it was a deeply conservative, tradition-bound structure; but
the memorial commission and FDR seemed vindicated by its solemn
beauty and the serene dignity of Jefferson's statue within. His erect
bearing offered the only nod toward modernity. Daniel Chester
French's Lincoln is seated, like Greenough's *Washington.* Jefferson
stands alone; and he does stand as many Americans had felt their most
admired statesmen should. So after all that contestation this memorial
became a swift success. The rancor from 1936–39 faded more quickly
than such hostilities had previously, perhaps pushed from view by the
immediacy of World War II. Whatever the reason, this controversy
vanished with few traces, along with the displaced cherry trees.

Just across the Potomac the Marine Corps War Memorial, completed in 1954 on the west flank of Arlington National Cemetery, provoked several of the issues that by now seem so familiar. The most prominent, perhaps, involves a curious kind of reversal. This dynamic depiction of six marines raising the American flag amid bitter fighting early in 1945 on Mount Suribachi, Iwo Jima, and supposedly based upon the famous photograph taken by Joe Rosenthal, was realistic down to the most minute detail, yet a large segment of the art world responded negatively because ultrarealism in monuments had become rather passé by the mid-1950s. More symbolic work was then in vogue. Austrian-born sculptor Felix de Weldon began the project in a classical mode, even modeling all of the servicemen in the nude in order to accentuate their physical strain before adding the details of their uniforms and accoutrements (which he described in academic terms as "drapery").[42]

Once again we have a notable instance of American gigantism. In 1947–48, when few observers not involved with the marines regarded de Weldon's design as appropriate, he decided to double the projected scale. At that point the Fine Arts Commission rejected the plan's "colossal size" as excessive. De Weldon persisted doggedly, however, permitting some stylistic adjustments in the configuration of men and eliminating walks and crypts that he had planned but making no concessions at all about size.[43]

The finalized figures cast in 1953 are aggrandized and idealized on a huge scale, standing thirty-two feet tall and struggling to raise a flagpole seventy-eight feet long (from which an actual cloth flag flies). Taken together with its base, the Marine Corps War Memorial achieves the height of a five-story building. It is the largest piece of bronze statuary in the world (fig. 18). The impression is one of Herculean effort undertaken in battle fatigues. And at the time of dedication in November 1954 the Marine Corps released a promotional film about the statue titled *Uncommon Valor.* As critical art historian Albert Boime has observed, the work "succeeds in entirely occupying consciousness and allowing nothing else to mentally coexist with it at the moment of contemplation."[44]

The Marine Corps Memorial Commission, initiated and promoted by the corps' top command rather than by the civilian side of the federal government, involved two controversial features not yet men-

18. Felix de Weldon, The Marine Corps War Memorial (1954),
Arlington, Virginia.
Division of Prints and Photographs, Library of Congress.

tioned, though neither one hinged upon artistic matters. Following
World War II serious consideration was given to folding the corps into
the regular army or navy. Marines no longer seemed to serve a unique
function, and considerable amounts of money could be saved by elimi-
nating the redundancies of an entirely separate administrative struc-
ture. The Marine Corps commander, however, aware of deep-seated
loyalties to a distinctive institution that had begun with the American
Revolution, managed to finesse the issue by energetically pursuing his
objective of a highly visible icon that could solidify the marines' place

as a historically discrete and heroic component of the nation's fighting force.[45]

Even though the private War Memorial Foundation raised the necessary funds and paid for the entire project (the $850,000 cost of actual construction was largely gleaned from members of the corps), the prime site location still required congressional approval. That would be tricky to obtain for historical reasons of sectional chauvinism. The statue's black rectangular base is ringed with the inscribed names of every American conflict in which the marines have been participants, including some rather minor ones. But southern congressmen were not about to let the words *Civil War* appear in the narrative sequence because that was not what southerners called that event. They preferred War Between the States and successfully blocked approval until they got their way.[46]

At some point, apparently during the 1960s and 1970s, the notion of "heroic art" came to seem outdated to many artists. That would contribute significantly to the contretemps between those who admire Maya Lin's austere, minimalist Vietnam Veterans Memorial and those who demanded (and prefer) Frederick Hart's *Three Servicemen* (1984), which was meant to provide representational balance. Some critics have found it curious that instead of being involved in some sort of patriotic or military activity, like the marines on Iwo Jima, Hart's soldiers seem to be engaging the viewer, almost in confrontation but perhaps in conversation (fig. 5). Others, however, have stressed the essential complementarity of the two projects, viewing each one as completing the other.[47]

In at least one important respect, sentiments prominently engaged by the Vietnam Veterans Memorial hark back to a central motive underlying the Lincoln Memorial: a felt need to bind up bitter divisions. The dedication day invocation on November 11, 1982, highlighted these words: "Let the Memorial begin the healing process and forever stand as a symbol of our national unity." Corporal Jan Scruggs, the army veteran of that war who in 1979 initiated the successful campaign to have a privately funded memorial, assured veterans' organizations during the money-raising campaign the following year that the memorial "will stand as a symbol of our unity as a nation and as a focal point for all Americans regardless of their views on Vietnam."[48]

Now that the Vietnam Veterans Memorial has become the most

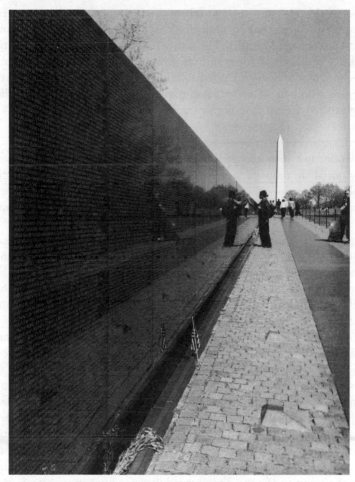

19. Maya Lin, The Vietnam Veterans Memorial (1982),
Washington, D.C.
Division of Prints and Photographs, Library of Congress.

popular in Washington, it is easy to forget just how bitterly it was con-
tested at the outset—far more than the Marine Corps War Memorial.
One veteran described the design as "the most insulting and demean-
ing memorial to our experience that was possible . . . a degrading
ditch." Some actually found the dark stone humiliating: "Black is the
universal color of shame, sorrow and degradation in all races, all soci-

eties worldwide" (fig. 19). For others the fact of sinking the memorial into the earth seemed an admission that the United States had committed crimes in Vietnam. The wall was also reviled as "an open urinal," "a wailing wall for anti-draft demonstrators," a "tribute to Jane Fonda," and a "perverse prank." Those determined to memorialize women who had served in Southeast Asia also felt aggrieved and did not achieve the satisfaction of a separate monument until 1993.[49]

Friction and disputes generated by the prospective Korean War Memorial in 1989–92 were somewhat less noisy yet no less nasty. Political maneuvering and bureaucratic infighting persisted but remained relatively less visible to the general public than the standoff of a decade earlier. More than 54,000 Americans lost their lives in the inconclusive Korean conflict (1950–53) that left the peninsula divided following a cease-fire. By the later 1980s it had come to be called the "forgotten war," but Congress finally remedied that embarrassment by approving a 7.5-acre site near the Lincoln Memorial southwest of the reflecting pool, a kind of symmetrical pendant to the Vietnam Veterans Memorial located on the opposite side.[50]

A team of structural and landscape architects from Pennsylvania State University won an open competition against 540 other entries, selected by a jury comprised of ten Korean War veterans. The design envisioned thirty-eight soldiers moving calmly across a remote and semiwooded mountain ridge toward an American flag. Rather than appearing battle ready, their work is apparently done and they are peacefully homeward-bound. The flag represents that goal: patriotic duty has been fulfilled and they are leaving warlike imperatives behind. That winning schematization was displayed at the White House during the summer of 1989, then turned over for implementation to the Cooper-Lecky architectural firm in Washington, the same group that had handled the realization of Maya Lin's design in 1981–82.[51]

This time, however, Cooper-Lecky made major changes at the behest of the American Battle Monuments Commission, a group of retired military officers who had become increasingly aggressive in lobbying for their goals, which emphasized artistic realism and glory for the U.S. armed forces. Consequently an imperfectly landscaped but thoughtful allegory gave way to a highly realistic scene in which thirty-eight fully equipped and battle-ready "grunts" (the number

being emblematic of the thirty-eighth parallel) are prepared for imminent danger and action against the backdrop of a long wall on which the faces of actual participants, found in the archives, were to be etched. From the perspective of most critics, the only way in which this design represented an improvement involved modestly superior landscaping and numerous pathways to make the memorial more accessible to large numbers of visitors. Some called it a "G.I. Joe battle scene" that glorified war![52]

Those who disapproved of such an intensely militarized configuration regarded the multiple pathways as reminders of an interchange on a major interstate highway. At the close of 1990 the winning design team brought a $500,000 lawsuit in federal court against Cooper-Lecky and the American Battle Monuments Commission in an unsuccessful effort to have their original concept restored. Meanwhile no less than half a dozen federal agencies and commissions passed judgment on both proposals, finding fault with each and vindicating in the process those who had been wondering ever since the 1970s whether

20. Cooper-Lecky architects, The Korean War Memorial (1995),
Washington, D.C.

public art could be successfully created in a democracy whose avenues were so clogged with special interest groups and bureaucratic bodies.[53] Ultimately the Fine Arts Commission, still chaired by J. Carter Brown, reluctantly approved a scaled-down version of the Cooper-Lecky plan. Now nineteen stainless-steel soldiers wearing wind-blown ponchos over full battle gear remained, wary of the enemy though ready for combat and larger than life at seven feet tall—but with the backdrop of actual vignettes faintly visible across a black billboard wall. The FAC had criticized the Cooper-Lecky design for its lack of focus and excessive sprawl. The version approved early in 1992 did achieve greater cohesion than either of the two competitors that had engaged in bitter combat in 1990–91. Even so, the finalized version dedicated on July 27, 1995, still appeared more like an outdoor museum than a proper memorial and received many unfavorable comparisons with the Vietnam Veterans Memorial (fig. 20). The dissenting member of the FAC complained that the design "looks like a football game in the rain."[54]

While this protracted duel between competing firms passed through its most intense phase, observers called the sticky situation a "political quagmire." Funding never became an issue, however, because in 1986 Congress passed the Commemorative Works Act, which requires groups not only to receive site and design approval but to find most of the money they need on their own. The requisite $15 million was raised privately, mainly from Korean War veterans and from Hyundai, the Korean automobile manufacturer. This controversy had been a struggle over how an inconclusive war in an alien land should be presented to the public and remembered by posterity. Because so many other memorials were being proposed and considered at the time, astute observers realized that much was at stake, above all a precedent for future monuments and how they would be chosen.[55]

More than a few authorities began to express doubts about the logic and desirability of open competitions such as the one held in 1989. Perhaps invited competitions limited to a few prestigious firms might be more viable, or else a flat-out commission to one eminent architect with a distinguished track record regarding the objective at hand. By the early 1990s it seemed as though the devotees of totally open, democratic procedures were having second thoughts about the merits of inclusiveness and transparency. In the case of the Korean War Memorial, those qualities, effectively compromised by special interests

and multiple commissions, had caused nothing but trouble and left no one fully satisfied.[56]

Model designs for a Franklin Delano Roosevelt Memorial in Washington first appeared in 1961, seven years after Congress approved the idea, but then received a long series of rejections. Once again a familiar story unfolded: its supporters argued that a great president belonged somewhere on or very near the Mall so that the only man elected president four times would be honored in a manner physically proximate to Washington, Lincoln, and Jefferson. Admirers succeeded in gaining approval for a strip of land along the Potomac quite near the Tidal Basin. Questions of design, however, became more complicated and generated decades of conflict. Everyone finally seemed prepared to move beyond neoclassicism toward modernism, but just *how* to do so would not be easy to determine because innovative work normally lacks the clear criteria that are used to assess customary architecture.

Gigantism emerged yet again as the dominant impulse in an open design competition. A model for what seemed the successful entry in 1961 showed eight concrete steles finished in white marble 172 feet high, elliptically arranged, on which extracts from FDR's speeches and Fireside Chats could be displayed. Besides the predictable complaint that the configuration suggested a surreal vision of "instant Stonehenge," the megaliths looking ready to shield some hapless Flintstones from their foes, a familiar question was heard: Why not honor the president with something useful rather than symbolic—perhaps a totally new kind of playground for children (possibly handicapped children), or a specialized reference library devoted to the Four Freedoms, or a modern recreation building of some sort?[57] Those suggestions went unheeded because by then the laudatory pattern had been too well established: Americans might admire utility, but they honored great leaders with expensive symbolic structures better suited for contemplation than for social improvement.

In 1962 the federal Fine Arts Commission rejected the huge steles, despite warm praise from many architectural critics. In 1964 it approved a revised version, by which time the memorial commission chose to solicit an entirely new plan. In 1966 the pattern of contested success persisted. Marcel Breuer and Herbert Beckhard submitted a scheme using rough granite slabs seventy-three feet high flanked by water. There would be a central cube thirty-two feet high made of

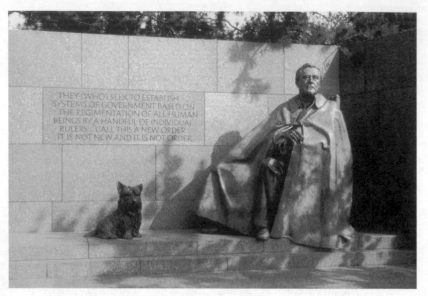

21. The Franklin Delano Roosevelt Memorial (1997). FDR with Fala,
Washington, D.C.
Division of Prints and Photographs, Library of Congress.

black polished granite with a profile of FDR cut into one side. Visitors
would be able to hear recordings of Roosevelt's speeches and chats.
One hostile critic called the design a "transistorized FDR." Another
declared in hearings before the memorial commission that the archi-
tects had "scattered granite to the winds and sown a crop of grossness."
Although the memorial commission approved this plan, the Fine Arts
Commission rejected it, thereby reversing the sequence of ups and
downs four years earlier.[58]

The notion of a small "campus" had been planted, however, divid-
ing the seven acres into a series of defined spaces devoted to phases of
FDR's presidency, such as providing for the jobless and hungry during
the Depression and winning World War II. That concept would even-
tually be realized in the successful design by Lawrence Halprin in
1978, though Congress did not actually appropriate funds to imple-
ment it until 1990, thirty-six years after it first created the FDR
Memorial Commission and planning began (fig. 21). Yet another com-
mon denominator: these matters move very slowly in a democracy.
Wolf von Eckardt, an architectural and design critic, observed in 1982

that "no democracy can function without its experts. Experts, or professionals, are the gears that keep democracy in motion."[59] Yet they and the people's representatives seem to perpetrate a kind of perpetual slow motion.

One other intense issue arose. Disabled Americans protested bitterly because they hoped that this memorial might make FDR a symbolic figure for their cause, one that might win more sympathetic legislation for the disabled from Congress. The finished plans did not show FDR in a wheelchair. In fact, there was no visual cue of any sort acknowledging his crippled condition resulting from polio. The memorial commission rejected such appeals, citing the dilemmas of cost and delay if changes were to be made. Architect Halprin, on the other hand, insisted that cost was not the real issue. "Roosevelt was very desirous of keeping his disability out of the limelight," he explained. "We're not trying to hide it, but it would be going against his desire to evidence it in a sculpture." Disappointed authorities on Roosevelt's life expressed their dismay, agreeing that to depict FDR in several sections of the memorial without ever indicating his disability at all would amount to a denial of history. They lost initially, but at the very last "minute," in July 1997, Congress responded to pressure from the "disability lobby" and passed a joint resolution requiring that Roosevelt be shown in a wheelchair. That statue was unveiled and dedicated in January 2001.[60]

The most recent commemorative controversy centered, once again, on familiar issues: site, scale, and design. Although the challenges offered were heartfelt and hard fought, approval for the World War II Memorial by several different commissions and the president ultimately occurred with somewhat less delay than usual because plausibly worthy venues did not come to mind readily or recommend themselves as alternatives to the midway point on the Mall between the Washington Monument and the Lincoln Memorial, just at the east end of the Reflecting Pool and surrounding the so-called Rainbow Pool.[61]

A member of Congress first proposed the memorial in 1987 when a constituent who happened to be a veteran inquired wistfully about the absence of any monument to the sixteen million who served and the 400,000 who died between 1941 and 1945. Eight years later the idea finally began to receive serious consideration, and four hundred

entries were submitted in the 1996 design competition. A Rhode Island–based architect, Friedrich St. Florian, created the winning entry, and contestation followed swiftly after his design was unveiled at the White House in January 1997. Those upset about the site complained that the location would impede the "sacred" vista along the two-mile ribbon that connects the Capitol with the Lincoln Memorial. They also argued that the 7.4 acres to be set aside for this project would "clutter the Mall" and diminish the space available for major gatherings and rallies such as the March on Washington in 1963.[62]

Questions involving design, site, and scale became intertwined. The plan called for an oval pool encircled by two "parentheses" comprised of fifty-six pillars, one for each American state and territory during the war, along with two forty-three-foot arches on the north and south sides, representing the Atlantic and Pacific theaters of the war. Critics objected that the configuration of these pillars and arches was too reminiscent of earlier European monuments, and that the ensemble smacked of imperialism. An organizer of the National Coalition to

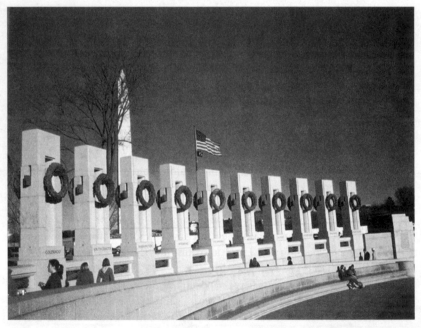

22. Friedrich St. Florian, The World War II Memorial (2004),
Washington, D.C.

Save Our Mall called the design "dehumanizing." According to Judy Scott Feldman, a leading opponent, "triumphal arches and pillars are military triumphal scenes used as long ago as the Roman Empire. World War II was all of America coming together. It was not a war of conquest but a war of liberation. The American way of making memorials has not been to use conquest imagery." That statement is not exactly true if one considers the vast victory arches erected after the Spanish-American War; but memories were deficient on both sides of the issue.[63]

In terms of scale, the fifty-six seventeen-foot-high pillars and the large granite plaza that would occupy a large portion of the 7.4-acre site reminded some of undistinguished and alien memorials in Europe, creating a claustrophobic effect by reducing the amount of open space. Critics called it a "monument to the military entertainment industry complex." Others referred to it as a "permanent movie set" awaiting a "captive audience." Some simply objected to so much paving and complained that the sheer extent of the site would leave too little room for tour buses to park (fig. 22). And the excessive breadth threatened to cross-cut the Mall "from tree line to tree line," an unacceptable option that had been successfully resisted in 1970 when the sculpture garden of the Hirshhorn Museum designed by Gordon Bunshaft had to be turned from a north-south direction to an east-west line that paralleled the Mall rather than slicing across it. The long-standing battle of gigantism was being fought all over again three decades later.[64]

Between 1997 and May 2000, when the Fine Arts Commission approved a scaled-back design, somewhat less grand than St. Florian's original plan, critical responses were still heard from visitors to Washington, from architectural groups, and even from quite a few veterans. An organization called Veterans to Save the Mall launched a TV ad campaign to declare its opposition. As one private individual wrote, expressing the views of many,

> The memorial design is replete with negative symbolism. The architectural design has imperialist and fascist overtones, and hardly evokes the image of the urban and rural America that World War II veterans fought to protect. Furthermore, there is something sinister about the plan's physical division of the Mall, which could make it easier to control and contain demonstrations that might represent a perceived [political] threat. The memorial in its present design is a sorry metaphor for the Amer-

ican dream that World War II veterans, and civilians, fought and
worked to preserve.[65]

Once the National Park Service and President Bill Clinton added
their approval, however, charges of "ugly triumphalism" and "aesthetic
travesty" became less common because the battle had been lost; but
one final issue remained and emerged in 2001. News leaked out in
June that one of the two companies selected to build the memorial,
Tompkins Builders of Washington, D.C., a subsidiary of J.A. Jones,
Inc., of Charlotte, N.C., is actually owned by a German construction
giant that used workers from concentration camps during the war and
had agreed to contribute to a $4.5 billion fund to compensate slave and
forced laborers during the Nazi era. The president of Tompkins,
Edward Small, offered a vigorous response: "Let me tell you this—it's
awful. Me being Jewish, it upsets me to no end. We're hard-working
loyal Americans and these complaints are not only inappropriate,
they're un-American. I wonder how many of the people making the
complaints are driving Volkswagens and Mercedeses and BMW's." A
spokesman for the Battle Monuments Commission explained that the

23. Wreath of honor beneath a baldachin, World War II Memorial.

selection of contractors had been based on bid level, experience on comparable projects, and past performance. After that the work proceeded without interruption.[66]

When the completed memorial opened to the public in late April 2004, a full month prior to the official dedication day, initial accounts barely mentioned any history of controversy. Media reports focused on the responses of placated veterans and curious tourists who appeared on the initial days and were available for quick interviews and sound bites. One elderly veteran confessed to feeling mixed emotions: pride in his military service but bewilderment at what the memorial might mean to younger generations lacking knowledge of the war. But complaints about St. Florian's "classical vocabulary" were gone, and so were court challenges.[67] Because St. Florian had, in fact, lowered his granite plaza into the ground and reduced the height of his pillars, the vista up and down the length of the Mall might be considered interrupted but not obstructed. As quickly as the Jefferson Memorial had gained acceptance, so did the one to those who served in World War II (fig. 23). Well, it won acceptance perhaps, but with tepid praise.

Just when the memorial was becoming a fait accompli, Michael Kimmelman, chief art critic for the *New York Times*, declared that "memorials are intended, even if not explicitly, to stimulate debate. Otherwise they aren't doing their job, which is to keep the subjects memorialized on the public's front burner."[68] A provocative observation, but is it valid? Those who commission memorials expect to feel that they made a wise choice, and those who design them understandably aspire to success. They may very well seek to innovate, but iconoclasm is highly risky in the realm of commemorative memorials. If it backfires, new commissions may not be coming along anytime soon.

Robert Mills, George Grey Barnard, Lawrence Halprin, and Maya Lin all designed monuments quite radical and unexpected for their time and assigned place. Horatio Greenough, Henry Bacon, John Russell Pope, and Felix de Weldon fell back on tradition-oriented types of designs. Yet all eight of them knew full well that they would almost inevitably prompt political as well as artistic debate. Nevertheless, each one hoped the controversy would be brief and that his or her work would enjoy speedy acceptance. Essentially, each design did just that, except for Greenough's and perhaps Barnard's (beyond Cincinnati). Greenough's *Washington* seems to have violated just too many taboos. And as a hybrid—the president's head on a Roman body, and an Italian

work for an American place of honor—it seems to have been destined for dispute and exile from its preassigned place. Precedents and parameters of possibility had thereby been established.

Meanwhile an unresolved dispute involving the possibility of an underground visitors' center for the Washington Monument continued to simmer. The idea was initially debated in 1966 in the context of a landscaping overhaul for the Mall, then resurfaced in 1973 as part of a National Park Service (NPS) proposal. Following two decades of quiescence the concept reemerged in revised form in 1993 but was rejected by congressional budget drafters. In 2001 the NPS introduced its plan once again, this time with guidance from an architectural firm, and won conceptual approval from the National Capital Planning Commission. In the wake of the terrorist attack on September 11, 2001, however, the designation changed from a Washington Monument Visitor Center Plan to a Washington Monument Permanent Security Improvement.[69]

Critics have offered many objections, claiming that the Park Service was hoping to realize a pet project by invoking anxiety about national security. They also argue that an underground center intended to bring tourists by bus from an off-site security screening facility could destabilize soil beneath the monument and clutter the Mall with above-ground structural accessories. Between 2001 and 2003 local engineers testified at hearings that the risks of structural disaster to the monument's fifteen-foot-thick walls from hand-carried explosives are slight given proper security measures, and they have said that adding a tunnel would create greater hazards than it would solve. The National Coalition to Save Our Mall, the same group that led the fight against the World War II Memorial, rejected the notion that the underground proposal really had anything to do with security—insisting that that served only as a pretext, citing the fact that the current proposal is virtually the same as the 1993 version.[70]

Subsequent soil-settlement surveys suggested that building a seventeen-foot-wide tunnel, if done properly, would not adversely affect the stability of the monument. Opponents responded in 2003 by pointing out that the Park Service had issued no detailed plans for an independent expert review and has no intention of doing so. The underground concourse was part of a larger scheme that included stone walls encircling the monument and is intended to replace a temporary ring of concrete barriers erected in the wake of 9/11 that are meant to prevent explosive-laden vehicles from approaching too near.

That is the "clutter" that could violate the integrity of the monument as it has existed since its completion in 1885, which appeals to traditionalists and purists. Hence the beat goes on, and so does conflict concerning the Mall and its memorials as sacred space that should not be violated by change, even in response to new challenges. It's a familiar story, and the antecedent issues deserve much broader attention than they have received.

Believe it or not, a brand-new statue of Abraham Lincoln could cause considerable consternation as recently as 2003, and once again the National Park Service was directly involved. How and why? Because the venue for this monument is the main visitor center at the historic Tredegar Iron Works in Richmond, Virginia. The idea seems to have been conceived by a black historian who supports Confederate heritage groups, but it was implemented, promoted, and paid for by the U.S. Historical Society, a private organization that raised money for the project by selling replicas of the life-size statue, which shows Lincoln seated on a bench with his son Tad. The president made a very brief visit to Richmond on April 4, 1865, just one day after the Confederate government evacuated the city, as a deliberate gesture of reconciliation. The NPS agreed to accept the donation "to be used as outdoor interpretive exhibitry." It would sit on a 2,800-square-foot plaza in front of a granite wall into which words from Lincoln's second inaugural address would be carved: "To bind up the nation's wounds."[71]

Needless to say, when the Sons of Confederate Veterans (SCV) got wind of this enterprise in 2002, the organization protested bitterly, asking whether anyone could imagine a statue of Hitler being placed in Paris, or for that matter one of Churchill being erected in Moscow. Those opposed to the statue explained that they considered its placement at a major Confederate landmark "a gratuitous measure of disrespect to people of Southern heritage." Ron Wilson, national commander of the SCV, declared, "We are going to fight these people everywhere they raise their head." The state's lieutenant governor (and a former mayor of Richmond) responded that the opponents were largely not from Richmond. "They feel they have a right to tell us in Richmond how to do our business. They are wrong. We claim Abraham Lincoln as a brother. We claim Abraham Lincoln as a Virginian."[72]

Many southerners regarded such words as nothing less than treason, of course. On April 5, 2003, while New York sculptor David Frech's statue was being unveiled and dedicated, one hundred members of the SCV went to the Hollywood Cemetery in Richmond, where many of the Confederacy's politicians and civic leaders are buried, as well as eighteen thousand Civil War soldiers. Bragdon Bowling, the Virginia division commander of the SCV, protested that "they have no concept of history and how it might be the wrong place to put the statue. As a Southerner, I'm offended. . . . What's next, a statue of Sherman in Atlanta?" Harold Holzer, a prominent scholar based at the Metropolitan Museum of Art who specializes in Lincoln iconography, found the image entirely appropriate and explained that the statue should serve as a historic symbol of unity and national reconciliation. Well, perhaps one day it will, but not quite yet.[73]

At year's end the principal Richmond newspaper ran a review of the year's most important local news—in verse. The lead item addresses our concern.

> The Southern partisans were in a funk
> Not seen since Reconstruction;
> They hadn't dreamed such awful junk
> Would get a Richmond introduction.
> Yet there it was, that heap of slag—
> A piece of "art" so ugly that you
> Would buckle at the knees and gag—
> The city's own **Abe Lincoln statue.**[74]

The designers of monuments and memorials, most often architects, tend to dream and think big. By the early twentieth century, one could not design and build without winning some sort of competition. The countervailing reality, however, is that funds are never sufficient to fulfill these dreams; and therefore compromises become necessary. More often than not, they result in an improvement. The unavoidable process of negotiation has its positive aspects.

Nudity, Decency, and Morality

Nudity, sexuality, and related matters that might be considered under the catch-all category of "decency" have been pervasive and persistent problems for quite some time in American visual culture. As we have seen, a sculpture of George Washington unclothed from the waist up became a source of public consternation and derision. The issue of decency was neither new nor even distinctively American, though it seems to have been considerably more provocative here than in Europe. A powerful cardinal and his allies at the Vatican accused Michelangelo of immorality and intolerable obscenity because naked figures with their genitalia showing appeared in *The Last Judgment*. When the pope responded that his jurisdiction did not extend to hell, the famous fresco survived untouched—until the Council of Trent, at least, almost a century later. But a cast of Michelangelo's *David* given to Queen Victoria in 1857 had fig leaves discreetly placed over the genitals when the statue was displayed at the Victoria and Albert Museum in London so that visits by aristocratic ladies would not become awkwardly indecorous. That practice ceased only in 1953.

When word reached the board of the Pennsylvania Academy of the Fine Arts in January 1886 that Thomas Eakins had removed the loincloth from a male model during an anatomy lecture attended by women, he was summoned to appear before the Committee on Instruction, interrogated, and then asked to resign his prestigious teaching position as principal instructor at the Life School. Although students there seem to have been deeply divided during this crisis, the

Philadelphia press strongly supported the director's decision, while the art world largely, and perhaps predictably, took Eakins's side.[1]

Although that particular complaint about Eakins is the most familiar one, it actually burst as the climax of a storm that had been building for several years and had as much if not more to do with female nudity, which has been a frequent and noisier precipitant of controversy in American culture, at least until the 1980s. Eakins often had female students pose for each other, and one of them apparently had such uncanny skill that her likeness of a nude model's face was instantly recognizable. When that sketchbook "happened" to be seen by male students and word of the embarrassing snickers reached some parents, antagonism toward Eakins intensified. As one anxious complainant wrote to the president of the academy in 1882:

> Now I appeal to you as a Christian gentleman, educated amidst the pure and holy teaching of our beloved Church, and where the exhortations to purity of mind and body were amongst your earliest *home* teachings, to consider for a moment the effect of the teaching of the Academy, on the young and sensitive minds of both the male and female students. I allude to the Life Class studies, and I know whereof I speak. Would you be willing to take a young daughter of your own into the Academy Life Class, to the study of the *nude figure* of a woman, whom you would shudder to have sit in your parlor clothed and converse with your daughter? Would you be willing to sit there with your daughter, or know she was sitting there with a dozen others, *studying* a nude figure, while the professor walked around criticising that nudity, as to her *roundness in this part*, and the swell of muscles in another? The daughter at home had been shielded from every thought that might lead her young mind from the most rigid chastity. Her mother had never allowed her to see her young naked brothers, hardly her sisters after their babyhood and yet at the age of eighteen or nineteen, for the culture of *high* Art, she had entered class where both *male* and female figures stood before her in their horrid nakedness.[2]

The letter runs on and on and is representative of the accusations and anxieties that swirled through Philadelphia social circles for several years before the final crisis erupted early in 1886. Insider opposition only compounded Eakins's problems. Several among his staff and

some former students from the Philadelphia Sketch Club, where he taught evening classes in the 1870s, contributed testimony that led to his ostracism. Eakins's artistic training in Paris and in medical schools, and his determination that anatomy be understood and described with scientific precision, meant that his sensibilities about the human body were altogether uninhibited, especially when measured by the social norms of the 1880s. Not only were his students sometimes photographed in the nude, there are surviving images from the mid-1880s of Eakins himself, quite naked, carrying an equally undressed female student. Who took these pictures, and why, is unclear, but it is questionable whether more than a few contributed in any way to authentic drawings of the human form. (The best known, of course, provided the basis for Eakins's painting of an all-male swimming party off a rocky ledge.) In the most notorious photograph the female's right arm hangs limp, parallel to Eakins's penis, and her head lolls back over his right arm as though she were a corpse. If this image was intended to serve as a model for some classical death scene following a battle, the painting has not survived.[3]

Despite our admiration for Eakins's immense skill and precision as a painter, especially of portraits and of those muscular men rowing on the Schuylkill River, his compulsion to flout contemporary mores was undoubtedly not merely willful and iconoclastic but ultimately counterproductive and equally adverse for the reputation of the academy, which he surely cared about even if he really was, as Elizabeth Johns has suggested, determined to "explore meanings about physical beauty—its history, its relation to gender, and the fantasy it inspires."[4]

Eakins certainly had his supporters. Some of them created a new school, the Art Students League of Philadelphia, that not only reestablished his role as a prominent teacher but defiantly persisted in the very practices that had precipitated the crisis in 1885–86. Students would model for one another, often fully nude and in front of a camera. Eakins continued to receive invitations to lecture on anatomy and art or perspective from schools in New York and Washington. Controversy had meant banishment from a prestigious academic post, yet it enhanced his reputation in the wider world of American art. Within Philadelphia, however, his unrepentant views and behavior caused only further furor. In 1895 the use of nude models in his Drexel Institute anatomy lectures caused them to be shut down. Some close family members disassociated themselves from him, and Eakins eventually withdrew from teaching altogether.[5]

The art world remains quite divided to this day, not so much over what happened but why. Most observers agree that Eakins's commitment to scientific naturalism was genuine (though even that has been quite recently challenged by art historian Henry Adams) and that his teaching style was arbitrary and heavy-handed. His responses to students' work often went beyond uncompromising honesty—he could be brutally candid. In terms of how the nudity issue all began, however, there are conflicting views. Some say that the lack of a diverse pool of professional models prompted Eakins to advertise for more "respectable" candidates (with chaperones) and that nothing came of that initiative. So eventually, in order to be able to draw varied and interesting body types, the students began to model for one another, much to the alarm of their parents when they learned what was going on. According to this supportive explanation, the episodes arose from economic necessity and the desire for artistic freedom as well as verisimilitude. "I am sure that the study of anatomy is not going to benefit any grown person who is not willing to see or be seen seeing the naked figure," Eakins declared in 1888 in a letter to the Art Students League of New York, "and my lectures are only for serious students wishing to become painters or sculptors." That would remain the essence of Eakins's self-defense.[6]

An alternative view, though perhaps a compatible one, is that Eakins was somehow fascinated with (and even obsessed by) nudity, male as well as female, perhaps even in prurient ways. As one recent authority has written, "At the very least, the survival of such stories and photographs indicates that Eakins was careless, even disdainful of public opinion. For someone charged with the education of young adults—particularly women—this was a dangerously insensitive, not to mention politically inept . . . position. . . . Such behavior could be called poor judgment, or inflexibility; less generously, it might be labeled arrogant, coercive, and intentionally provocative." Henry Adams argues categorically that Eakins was an "exhibitionist-voyeur."[7]

Whatever the true explanation might be, Eakins's willingness to act upon iconoclastic impulses was hardly singular among artists of his generation. John Singer Sargent felt obliged to flee Paris for London following the anger he stirred with his portrait of *Madame Gautreau*, a painting better known as *Madame X* (1884). It shows a fashionable and strikingly attractive young woman wearing a chic black sheath supported by a precarious shoulder strap, and it remains memorably sensuous. (In his initial version the strap had indecently fallen from her

shoulder; the family demanded that Sargent repaint it.) Her expressionless face turned full profile seemed outrageously erotic to many— or astonishingly provocative at the very least. As it happened, young Sargent was eager to make a startling statement; he agonized over the nature of the composition, and the woman had posed reluctantly in any case. She and her family felt scandalized and aggrieved by the overwhelmingly hostile reaction to the portrait when shown at the salon, and Sargent achieved notoriety rather than acclaim as a consequence. During the coming decades, however, he would be in constant demand to paint flattering portraits of American women and their children, especially adolescent daughters. In monetary terms, he made a far better recovery from infamy than did Eakins.[8]

Difficulties created and encountered by the writer Lafcadio Hearn are much less familiar. Born to Irish and Greek parents, educated in France and England, he came to the United States in 1869, became involved in a scandalous affair with a mulatto woman, and settled in Cincinnati, where he unsuccessfully pursued a career as a journalist. In 1874 he apparently became obsessed with the desire to observe an artist paint a female nude, and pestered a friend, quite possibly Frank Duveneck, to smuggle him into his studio, unbeknownst to the model. The sitting and Hearn's voyeuristic scrutiny lasted two full hours, during which he remained undiscovered even while taking copious notes. His published article, "Beauty Undraped," was so delicately phrased that mid-Victorian readers of the *Enquirer* did not seem to take offense. Legs became "limbs," breasts became "bosoms," and nude became "unclad." Although Hearn's escapade avoided censure, the sensuous power of female beauty clearly fascinated him just as it had Eakins and perhaps Sargent, though in different ways for each man. In 1881, for example, Hearn published pieces in New Orleans papers with titles like "A Prize for Beauty" and "Women and Horses."[9]

Hearn's agility in avoiding condemnation for his voyeurism and his fascination with the female body brings to mind the single most important and instructive narrative of that sort in nineteenth-century America: the saga of Hiram Powers's *The Greek Slave*. Although the episode differed in crucial ways from those just described, and Powers might best be accused of classicism rather than voyeurism, it remains astonishing that during the 1840s he could create six life-size versions of a nubile young woman, totally unclothed, and have them displayed in his own country and in England (the source of most of his commissions) with minimal controversy. That he could do so is a tribute both

to his own apparent sincerity and to a carefully crafted public relations campaign. In some cities, such as Cincinnati, separate viewing hours were organized when women could study the statue without men present; but we also have remarkable images of couples and children ambling around *The Greek Slave* at the 1851 Crystal Palace Exhibition in London and subsequently at New York's Dusseldorf Gallery in 1858 (fig. 24).[10]

To appreciate the extent of Powers's success, we must take note of John Vanderlyn's *Ariadne Asleep on the Island of Naxos*, created in Paris (1809–12), one of the earliest fully nude females by an American artist. The painting caused quite a stir in 1815 when first exhibited in the United States. Having recently returned from years of work in Europe, Vanderlyn claimed that he felt bewildered by the controversy. During the 1820s, however, *Ariadne* toured the United States along with other paintings by Vanderlyn, but to very mixed reactions and few sales. Even when the artist's skill received praise in general, *Ariadne*

24. Hiram Powers, *The Greek Slave* (1842) displayed at the Crystal
Palace Exhibition in London (1851).
Division of Prints and Photographs, Library of Congress.

was invariably singled out for opprobrium. In 1826 he received a commission to paint a second version *fully clothed* for placement in the main cabin of the steamer *Albany*, yet two years later a scheduled exhibition in Havana, Cuba, was canceled by a customs agent there. When Asher B. Durand made a fine engraving of the original painting in 1835, he found no audience for it. *Ariadne* was still deemed ill suited for public consumption.[11]

Despite being rejected as licentious by the general public, the picture received the admiration of many artists and critics. It was exhibited without incident at Philadelphia in 1864 and in 1878 was donated to the Pennsylvania Academy of the Fine Arts by a respectable society matron. At last it *seemed* to have achieved validation. As late as 1891, however, more than five hundred Christian women protested against the "flagrant indelicacy of many of the pictures now on exhibition" and specifically asked to have *Ariadne* removed, which was not done. According to legend, she had been the victim of a callous seducer. She may ultimately have been the beneficiary of artistic acceptability long since achieved by Powers's *Greek Slave*.[12]

Like Horatio Greenough, Hiram Powers was an aspiring Yankee sculptor who had chosen to pursue his calling in Florence, the most attractive venue for sculptors because of its rich artistic tradition, proximity to high-quality marble, and experienced stone carvers. By 1841 Powers had finished a model of his first nude statue, *Before the Fall* or *Eve Tempted*, and hoped to find a patron who might purchase and display it publicly. It would not be worked in marble until 1849, when his *Greek Slave* had already been on tour for several years. Powers clearly did not share the prudish views widely held by so many of his evangelical mid-Victorian contemporaries, and his private correspondence reveals a delicious touch of unabashed whimsy.

Eve might shock the sensibilities of many who found the Slave quite as much as their moral feelings could bear, for Eve is quite "naked," and she does not appear in the least "ashamed." It was very wrong to make her so, but it is now too late to correct an error which Eve herself discovered in the season of fig leaves and managed to set all right where all was wrong before. I forgot to do so until too late in the season to get any, and so I had to send her off naked as she came from the chisel of her maker. I trust she will not corrupt the morals of her more perfect and less sinful descendants. She is an old-fashioned body, and not near

so well formed and attractive in her person as are her grand-daughters, at least some of them.[13]

Powers surely enjoyed the appeal of youthful female beauty as much as Hearn and Eakins, and he wrote about the episode with his tongue very much in cheek. Meanwhile *Eve Tempted* underwent a series of mishaps in shipping, indecision among purchasers, relocations across the Atlantic, and eventual resale. It remained in private hands throughout the nineteenth century and disappeared at the beginning of the twentieth. All that survives is a plaster model at the Smithsonian and a marble replica carved after Powers's death in 1873. In this case, no public visibility meant no controversy.[14]

In 1841, while waiting for *Eve Tempted* to be transposed from plaster to marble, Powers envisioned another full-length nude female: a Circassian maiden being sold into slavery by Turks in Istanbul during the war for Greek independence almost two decades earlier. (The remote and exotic Circassian tribe lived in the Caucasus. Their relation to Greek independence is a bit murky.) It is clear from surviving correspondence that Powers rather liked the process of creating these undressed females. Some thirty different models posed for *Eve*, and quite a few—always chaperoned—for what came to be known in various marble versions as *The Greek Slave*. Powers was sufficiently savvy to recognize that he needed altruistic symbolism in order to display such statuary at that time, and a rationale was readily at hand. American enthusiasm for the Greek cause had been avid; and adding a cross dangling from the girl's wrist (thereby helping to obscure her pubic area) called attention to the need for Christian liberation from the infidel. In addition, Powers's antislavery sentiments would help to make this work the most visible emblem of abolitionist advocacy prior to the appearance of *Uncle Tom's Cabin*. Finally, he made sure that the girl appeared young, chaste, and demure rather than voluptuous and brazen.[15]

The work was completed in plaster during an eight-month span in 1842, and a marble version was commissioned a year later by a wealthy English officer who collected contemporary art. After this first rendition was exhibited in London, Edward Everett wrote to Powers about concerns being expressed in London and warned his friend to prepare very carefully for the less "sophisticated" audience in the United States. In 1844, however, there seemed to be a good omen. The Reverend Orville Dewey, Unitarian pastor of the Church of the Messiah in

New York, had seen the *Slave* in Florence, did not find her nudity inde-
cent, and felt inspired by her religious aura. Upon his return to New
York, Dewey praised the work from his pulpit and published an article
in its defense, thereby bestowing the kind of respectability needed so
that Americans would line up and pay twenty-five cents admission to
see it. That is exactly what happened when the piece arrived in New
York and was displayed at the National Academy of Design. Even so,
there were sputterings from scandalized individuals, and private hours
were established for women visitors. Powers's agent, a painter-friend,
wrote to explain that he had been "defending your reputation against
the slime that has been scattered here for some time."[16]

The principal line of defense on both sides of the Atlantic required
widespread distribution of pamphlets proclaiming the work's artistic
integrity and spirituality. Moreover, English encomia and admiring
notices from the exhibition there in 1845 were publicized. Carriages in
London lined up for blocks while the social elite waited their turn to
see this new aesthetic phenomenon. Elizabeth Barrett Browning felt
moved to compose a sonnet to the *Slave*. Many men who were not pro-
fessional writers dashed off tributes such as the following.

> Naked, yet clothed with chastity She stands
> And as a shield throws back the sun's hot rays,
> Her modest mien repels each vulgar gaze.[17]

In 1848 *The Greek Slave* was moved to Washington for display, and
after that to Baltimore, Philadelphia, and even Boston, where the abo-
litionist connection helped to mollify some cynics. During 1848–49
Powers's American friends used an array of public relations strategies
to protect the artist as well as his work from accusations of indecency
and prurience. For some members of the public, the *Slave*'s link to
antislavery made her a symbolic figure of American freedom. Critical
statements made publicly by clerics whose views concerning decency
deviated from Dewey's only seemed to whet the public's appetite to
see *The Greek Slave*. Although it made a second successful tour in
1850–52 — being shown in special tents, exhibition galleries, mer-
chants' exchanges, and rotundas — intense interest began to wane and
quite soon the nation was fully distracted by other, more pressing
political issues.[18]

In the 1860s critical responses became increasingly common,
though often for reasons other than nudity. An 1868 essay in *The*

Atlantic Monthly described the *Slave* as meaningless to the United States because it was a foreign subject made by an expatriate artist. The author also lamented the lack of realistic training on the part of a neo-classical sculptor. As with several of our best-known public memorials, the *Slave* seemed caught in a perpetual conflict between idealists and realists, as well as partisans of native versus foreign influence. Following the Civil War, however, miniature versions of the statue made of biscuit and plaster (called Parian ware) became popular in the United States and even more so in England. In some homes the reason might have been relief at the abolition of American slavery, but in many others it may simply have been a way of indicating aesthetic tolerance if not open-mindedness.[19]

In any case, *The Greek Slave* often came close to prompting a major controversy and certainly made a great many people uneasy. Its widespread acceptance within a generation ultimately serves as testimony to the adroitness of Powers and his admirers in anticipating just what needed to be done in order to defuse the societal reaction that seemed virtually inevitable at the time. This statue was viewed by more people than any other work of art in nineteenth-century America. In addition to the six full-length, full-size versions, Powers made three that were half-size and at least seventy-one busts. Reproductions and copies were made by other artists.[20] A century later many an artist hoping to win acceptance for work potentially deemed indecent might very well have profited from Powers's legacy and the lessons of his experience. Looking to the past for tactical guidance and prudent morality tales, however, turned out to be an uncommon phenomenon.

Acceptance of *The Greek Slave* certainly did not mean that guardians of public taste and probity at the turn of the century would be remotely ready for expanded tolerance in the realm of decency. A group responsible for presenting art at the World's Columbian Exposition in 1893 invited Auguste Rodin, by then widely recognized as one of the foremost modern sculptors, to send several works to Chicago. As it happens, he sent two different manifestations of a motif originally intended for one of his masterworks, *The Gates of Hell*. The design involves the story of Paolo and Francesca, who yield to one impassioned kiss, forbidden because it betrays Paolo's brother, to whom Francesca is betrothed. In Dante's *Inferno* Paolo and Francesca are for-

ever bound together to repeat the single kiss that caused their downfall. In both works by Rodin the couple is entirely nude.[21]

In the less familiar version (1887–89 and later enlarged), the two are joined but fumbling in their eternal futility. In the larger and more famous work, simply known as *The Kiss* and often reproduced more than life size, the woman appears to be the aggressor and quite ardent, with both of her arms draped around his neck. The man might well be perceived as surprised by her ardor (fig. 25). The Chicago fair authorities rejected both works for prominent display and relegated *The Kiss* to an inner chamber with admission permitted by personal application only. It did not matter that the French government had already purchased the work for twenty thousand francs. To rub salt in the wounds of such protective arbiters of art, an American collector living in England ordered a copy of *The Kiss* in Pentelic marble for £1,000, and specified through his agent that he wanted his copy to be as explicit as

25. Auguste Rodin, *Le Baiser (The Kiss)*, (1886).
Courtesy of the Musée Rodin, Paris.
Photo by Erik and Petra Hesmerg.

possible: "*l'organe génital de l'homme doit être complet.*" American prudery prompted international bemusement.[22]

As one art historian has observed, what bothered Americans above all in the indeterminate realm of decency and indecency was not nudity per se, or even passion and voluptuousness (though those conditions could certainly prove problematic), but "conscious sensuality"; and that is exactly what Rodin had offered the Chicago exhibition: two variants of conscious sensuality. In the 1890s that was clearly unacceptable in the United States. Within a few years constraints tightened. In 1899 all the nude statues at the Art Institute of Chicago (mainly from antiquity) were moved or dismantled in response to public pressure. The nineteenth century was not ending on an auspicious note for artistic freedom.[23]

Early in 1906 *The American Student of Art* began to appear—a monthly magazine published by the Art Students League in New York. Its purpose was to make available a pictorial volume for the use of serious students. An editorial in the first issue explained that "the pictures which are contributed by distinguished *American* artists will, however, be accompanied by short, instructive articles concerning their manner of working, their methods of teaching and their aims in order to make the studies which we are enabled to reproduce as intelligible as possible to our readers. It must be understood that the paper will be devoted entirely to the discussion and reproduction of the work of American rather [than] to that of foreign artists."[24] This emphasis dovetailed closely with a similar orientation on the part of "The Eight," whose highly vocal pronouncements emerged eighteen months later. National pride in the abilities and motifs of American artists would crest visibly at several venues early in the twentieth century.

Anthony Comstock, the pious engine constantly pumping the New York Society for the Suppression of Vice, had kept a close eye on activities at the league for several years. In the summer of 1906, accompanied by two policemen, he appeared at the office and confiscated the July issue of the *Student* because it reproduced drawings of undraped nudes made by students there. The monthly was being mailed, according to Comstock's early biographer, "apparently to people of all sorts, whether known to be lovers of art or not." Investigation revealed that "girls and unmarried women" were on the recipient list. Because the society sought to protect young women from offensive material—the

26. A women's life drawing class at the Art Students League (ca. 1905).
From Marchal E. Landgren, *Years of Art: The Story of the Art Students League of New York* (New York: Robert M. McBride & Co., 1940), 85.

most widely reproduced photograph showed a women's life class of about a dozen intent students with a male model posed and wearing the equivalent of a jock strap (fig. 26)—an effort was made to find a man connected with the publication because of the social stigma associated with arresting women; when none could be identified, Miss Robinson, the nineteen-year-old bookkeeper, was arrested and taken into custody for distributing the magazine.[25]

Because Comstock and his society wished to avoid the appearance of harassing a young woman, they offered concessions. She could be spared the disgrace of being listed under her own name, a plea of guilty might be entered in court without the young woman appearing, and the society would thereupon agree to a suspended sentence. The offending magazine would then be legally condemned and destroyed. Miss Robinson did appear, however, but became so hysterical that a doctor had to be called in. The next morning reporters awaited Com-

stock at his office: "The role of ogre to a frail and innocent girl did not please him." According to an account in Joseph Pulitzer's *New York World*, Comstock complained: "I'd like to know who gave that out to the papers. I thought it was going to be kept quiet."[26]

The Art Students League felt that it had nothing to lose from widespread media attention. For years it had been distributing pamphlets and catalogs similar to the ones seized by the society, and it insisted that they were sent through the mails with the knowledge and consent of postal authorities. League defenders regarded the raid as the opening wedge of an attack upon art schools in general, so they threatened Comstock and his society with revocation of its charter and Comstock with the loss of his commission as Post Office inspector. Sculptor Gutzon Borglum declared that Comstock "is the one who is lewd" and asked with rhetorical flourish why he did not confiscate Boccaccio, Rabelais, and Balzac. Comstock, of course, had been unsuccessfully trying to repress spicy literary classics for years. The art students sought revenge with malicious caricatures of their nemesis. The press savored this opportunity to increase sales, of course, and on August 4, 1906, the *World* carried on its front page a full-length photograph of the "vice chaser" flanked by equally large images of the Venus de Milo and the Apollo Belvedere, along with the suggestion that Comstock might very well arrest them if they appeared out of doors.[27]

The league formally protested: that "a school of this character should be subjected to this sensational attack by Mr. Comstock is outrageous. The League had not the slightest intimation that its publications could be considered in the slightest degree objectionable until Comstock's sudden arrest of an entirely innocent and unprotected girl employee." In late December the case was withdrawn from the Court of Special Sessions. The district attorney told the court that there could be no question that the promoters of the magazine had acted in good faith, and that their only motive was to illustrate the quality of the artwork being done by the students. "Even if it could be assumed," he argued, "that the pictures in question are contrary to the legal standard, it is clear that their publication was done with honorable intent and involves no such moral obliquity as is deserving of punishment by law." Comstock backed off with this message to the DA: "Since there is nothing which in any way impeaches the integrity of Miss Robinson, I shall be most happy to extend to her a Christmas greeting by the dismissal of any further proceedings against her."[28]

Reverberations from the case lingered throughout the following

year, and Comstock's stature as the paramount guardian of public morals began to suffer. At a burlesque exhibition held at the league in April 1907, a student dressed as Comstock "stamped" around the gallery pretending to regard the pictures displayed there with horror and shame. On April 18, the evening of the students' annual auction, an Anthony impersonator strode up the center aisle when the auctioneer offered a pink plaster nymph to potential buyers. Taking the gavel from the hand of the auctioneer, he declaimed:

> Friends we have had differences. It was not long ago that I invaded these precincts and took away your catalogues, and the result was a little newspaper notoriety, which you may remember. But I have undergone a complete change of heart. I have gained a broader vision of art, beauty and morality. Let us call bygones bygones. For forty years I have battled for righteousness, and you will, I am sure, pardon me if accidentally I revert to my old ways.

The impersonator then proceeded to take over as auctioneer. The audience delighted in making Comstock a laughingstock.[29]

Publication of the league's catalog for the winter session of 1907–08 was clearly perceived by the press as a deliberate act of defiance of the Society for the Suppression of Vice. Quite a few undraped nudes drawn by students appeared, along with photographs of classrooms with nude men posing before a men's life class but also a women's modeling class. Despite the nationwide publicity that the catalog received, no effort was made to suppress it. *The American Student of Art* was not revived, however. It was supplanted by a bulletin titled *The League*, which appeared three times a year but was not a picture book—somewhat curious for a publication by an artists' organization. It mainly consisted of articles by instructors and artists on their methods and concerning the relationship of the artist to society. This brouhaha ended with both sides backing off, but in different ways and to different degrees. Indeed, in 1907, Comstock did lose his Post Office commission. When his dismissal from government service was announced in the press, the art students claimed victory because members of the league had visited Washington to complain that Comstock had long since abused and overstepped his prerogatives.[30]

Comstock's influence and impact on issues of "decency," too broadly defined and misunderstood, had been considerable for a quar-

62 VISUAL SHOCK

ter of a century. His role in relation to art and sexuality anticipated in certain respects the determined leadership of Donald Wildmon from the 1980s onward as head of the American Family Association, based in Tupelo, Mississippi. Wildmon's crusades targeted sexuality in film, fine art, and photographic exhibitions, especially. His political clout increased dramatically during the Reagan-Bush years, particularly because of support from conservative political figures like North Carolina senator Jesse Helms.[31] Although Comstock is not well remembered today and is never cited as a precedent by groups like Wildmon's, it is instructive to recall how effective Comstock was for a considerable period, as well as his decline when he overreached himself and art groups spoke out against excessive censorship and intolerance of diverse views concerning artistic expression.

By the second decade of the twentieth century, when nudity in art appeared as a serious public issue, it was more likely to happen in the Midwest or South than on the two coasts. In 1913 Chicago became the site of three separate episodes that happened to converge and swiftly exacerbate one another. They are notable not so much because they aroused intense conflicts but because they were prompted by instances of relatively innocuous female nudity, as opposed to nakedness that appeared to be explicitly erotic or notably sensuous. In a very real sense, these episodes seem more like a postscript to the nineteenth century than a preview of the twentieth, when the bar for provocative arousal would be gradually lowered. They are significant nonetheless because they help us to understand why antimodernism and the Sanity in Art movement would have Chicago as its home base in the mid-1930s, and why Chicago art circles would resist Abstract Expressionism long after it gained aspects of acceptance in the northeastern United States.

Early in the spring of 1913, when the Armory Show of international modern (Post-Impressionist) art moved from New York to Chicago, it included a very bold work by Henri Matisse titled *Blue Nude: Memory of Biskra* (1907), in which a fully naked woman is lying on her side with her torso turned frontally, exposing accentuated breasts, hips, and buttocks, while her face is depersonalized (fig. 27). As one scholar has observed, "the representation flies in the face of bourgeois definitions of femininity, the sanctified ideal of the married woman in the domestic sphere." That picture along with several others

27. Henri Matisse, *Blue Nude: Memory of Biskra* (1907).
The Baltimore Museum of Art. The Cone Collection, formed by
Dr. Claribel Cone and Miss Etta Cone of Baltimore, Maryland. BMA 1950.228.
© 2007 Succession H. Matisse, Paris/Artists Rights Society (ARS), New York.

by Matisse were burned in effigy by students at the Art Institute's School, where the artist, "Henry Hair Mattress," was impersonated by one of the students and made to stand trial for his sins against art. The indictment read as follows: "You are charged with artistic murder, pictorial arson, artistic rapine, total degeneracy of color, criminal misuse of line, general aesthetic aberration, and contumacious abuse of title." The students' greatest concern was Matisse's degradation of the female form. Their exaggerations for the sake of ridicule supplied the incident with a certain notoriety.[32]

The second episode involved Lorado Taft, leader of the sculpture community in Chicago, who had received an important commission in 1906 to create a major work of public art to be called *Fountain of the Great Lakes*, positioned along the south wall of the Art Institute close to Lake Michigan (fig. 28). In designing the fountain, Taft invited five well-proportioned young women from the Kendall College of Physical Education to pose for him at their summer camp, each one lightly wrapped in gauzy fabrics and very carefully positioned in an elaborate pyramid configuration. Based upon their stylized positions and gestures, he created a major work in which the women, each one holding a large seashell, are emptying water from higher to lower levels, just as the lakes empty their waters sequentially from Superior in the west to

28. Lorado Taft, *Fountain of the Great Lakes* (1913).
Art Institute of Chicago. Photo by Samuel Gilbert.

Ontario in the east. The sculpture can be perceived as a bit corny, but basically it works. It is like no other fountain monument, and it is conceptually appropriate.[33]

When the model for this statue was displayed in 1907, the response was generally favorable, as it continued to be at the time of the dedication in 1913. Yet there were dissenters who were either too literal minded or else remained as prudish as many nineteenth-century forebears had been in response to the work of Powers and others. Three of the five female figures were bare-breasted and were perceived as perhaps too muscular at a time when the slender Gibson Girl ideal reigned supreme. Some observers made reference to "packing house ladies," which is not a compliment in Chicago. Taft joked openly about the matter and told an audience that the light tone of a spoof in the *Tribune* "only demonstrated that the subject of nudity in public art was

so thoroughly exhausted that it required eye-catching presentation to attract any attention at all."[34] Be that as it may, some took the matter quite seriously, and for reasons raised by the third heated issue of the day.

Three months prior to the fountain's dedication, a Wabash Avenue art gallery in downtown Chicago placed in the window a reproduction of *September Morn*, a recent painting of a graceful but fully nude young woman by a French academic artist of no particular distinction named Paul Chabas. Almost immediately the police confiscated the picture as "lewd and indecent." A lively court case ensued with conflicting testimony given by a local school superintendent, a priest, several critics, art dealers, and even collectors. When the jury determined that the girl's nudity did not render the picture indecent, such an outcry arose that the mayor went to the city council with a proposal to amend the municipal obscenity law, expanding the existing ban on the sale of indecent materials in order to prevent future displays "in any place where the same can be seen from the public highway or in a public place frequented by children which is not connected with any art or educational exhibition, any picture representing a person in a nude state." The amendment passed unanimously because it met with broad social and political approval.[35]

The furor touched off by *September Morn* did nothing to ease or facilitate the feelings of traditionalists about Taft's seemingly harmless figures. But Taft had other challenges to reckon with, most of them silly to our minds yet seriously intended. Some people demanded to know which lady represented which lake, even though it seemed spatially self-evident. Others wanted the physical proximity of each figure to be proportional to the actual distance from one lake to the next. Still others took exception to Taft's belief in the necessarily static character of monumental art. Hence there was much rumbling in the press that the work seemed too serene for such large and often stormy lakes. Where, they asked, was the dynamism and the drama of Lake Michigan?[36]

Despite these concerns, *Fountain of the Great Lakes* met with more approval than disapproval and meant that Taft would become the doyen of Chicago sculptors. For a while he enjoyed the leadership of a substantial following among younger artists. He swiftly began angling for and then received the commission for a massive public sculpture along the Midway near the University of Chicago. This time he succumbed to that persistent temptation, gigantism, which was then

aggravated by conceptual diffuseness. He envisioned a *Fountain of Time* that would be 110 feet long with the statue of Time itself reaching twenty feet, making it "the largest undertaking ever attempted in sculpture." When a one-third scale model appeared, charges of excessive size were explicitly leveled. Beyond that, the proposed parade of famous figures from the arts and philosophy in Europe prompted people to ask what all of these time- and place-bound people had to do with Chicago. When the concrete work was finally complete and dedicated in 1922, disappointment and disdain were the dominant verdicts. It quickly came to be known as one of the "pet atrocities" of Chicago.[37] Essentially, Taft's ideas had been overtaken by time and by the new ideas of younger sculptors working in a less classical and less allegorical mode. The generation of Jacob Epstein and Jacques Lipchitz was emerging and experimenting with modernism and modified cubism, building on the precedent set by Raymond Duchamp-Villon at the Armory Show in 1913.

One other Chicago episode brought back memories of intense issues raised by the use of nude models in drawing classes. In 1938, *Life* magazine published a two-page photo-feature devoted to the School of the Art Institute. Two of the pictures showed nuns wearing their full habits hard at work in drawing classes intently sketching a muscular man wearing only the skimpiest sort of covering (fig. 29). As a result, the nuns were nearly forced to withdraw from the school, and only after the dean wrote a letter of apology to Cardinal Mundelein of Chicago were they permitted to stay. I suspect that much of the country enjoyed a good chuckle; but once again many midwesterners and certainly some Catholics felt scandalized.[38]

Lorado Taft's fate would also befall Frederick MacMonnies when he finally completed his major public sculpture called *Civic Virtue* for City Hall Park in New York in 1922. MacMonnies had been one of the most admired American sculptors of the late Victorian period. His exuberant *Columbian Fountain* featuring the *Barge of State*, created for the World's Columbian Exposition at Chicago in 1893, had been a great success: Columbia seated on a triumphal barge rowed by Art, Science, Industry, Agriculture, and Commerce, guided by Time, and heralded by Fame. Copies of his *Nathan Hale* (1893) were very much in demand and spoke to ideals of patriotism and self-sacrifice. These two

29. Nun in a life drawing class at the School of the
Art Institute of Chicago (1938).
Time & Life Pictures/Getty Images.

projects made MacMonnies nationally famous as one of the country's major artists and most gifted sculptors.[39]

Civic Virtue, however, was ill conceived from the outset and remained too long in gestation. Once again the times changed and the sculptor did not. MacMonnies first envisioned such a work in 1891 but received the commission for it only in 1909. The result was a piece of public art that was comparable in concept to a Florentine work like Michelangelo's *David* but did not comport well with a "colonial style" city hall. Clearly this was not a judicious juxtaposition. The basic scheme called for a heroic male (Virtue) to be trampling two female figures representing Vice. Between 1914 and 1919 the New

30. Frederick MacMonnies, *Civic Virtue* (1922), New York City.

York City Art Commission repeatedly disapproved of MacMonnies's designs. A great many women, quite predictably, were highly offended. The artist insisted that Vice was represented by sirens (sea creatures), not by women, but few accepted that explanation. Large numbers of people perceived a more topical meaning in the work, which MacMonnies most likely had *not* intended: namely, the battle of the sexes and the oppression of women (fig. 30). The dedication of this work in 1922 brought overt hostility followed by residual bitterness. In 1941 Robert Moses had the fountain removed from Man-

hattan and relegated to Queens, where it stands today next to the Borough Hall.[40]

In 1909, the same year MacMonnies finally received his commission, Robert Henri painted two fairly similar versions of *Salome*, each one depicting an exuberant dancer wearing a Near Eastern costume that exposed much of her middle as well as all of her shapely legs. The one exhibited achieved considerable popularity despite seeming sensuous and semiscandalous to some (see fig. 31). But why did that image appear at that particular time? In 1907 an aspiring group that was pro-

31. Robert Henri, *Salome* (1909).
Courtesy of the Mead Art Museum,
Amherst College. Acc. No.: 1973.68.

MAUD ALLAN LA SYLPHE OLIVE FREMSTADT GERTRUDE HOFFMANN JULIA MARLOWE

All Sorts and Kinds of Salomes

S ALOMANIA is not a new craze. Mary Garden, who is now impersonating the Daughter of Herodias in Strauss' vivid music drama at the Manhattan Opera House, is only the descendant of a long line of scantily-clad Salomes that have cropped up from time to time during the last two thousand years.

Medieval legend depicts Salome blown upon by the Mighty Breath for having caused the Prophet's death by her dancing, and by way of punishment being whirled into space, where she is doomed to dance and whirl forever. Thus Salome joined the "furious host," a roaming band of banished spirits which haunted medieval Europe with their restlessness. Berchard of Worms reports with twelfth century gravity that fully one-third of the whole world worshipped her. We still seek her shrine, but we do not always worship.

Salome, as we know her to-day, has evolved gradually from the brief accounts given of her in the Bible, and she has inspired poets, painters, dancers, dramatists and composers. The subject "Salome Dancing" has appealed particularly to artists of all ages, from the fourteenth

century manuscript which reveals her "vaulting before Herod" on her hands, to several pictures by the old masters.

The numerous versions of the story are conflicting. Some, based upon the meager Biblical account, are historical, while others follow the Oscar Wilde dramatic poem, vivid in the color of its word-painting and unpleasantly morbid in its imagination. Historically Salome was a "korasian," which in the Hebrew means "damsel," innocent of evil motive, but the victim of her wicked mother's revenge. She is terror-stricken at the sight of the head of John the Baptist, and remorseful. Renan in his "Life of Jesus" suggests the interpolated love of Salome for the Prophet, and in Flaubert's "Herodias" the motive is further emphasized. Sudermann's "Johannes" deals with this theme more gently, while in Wilde's version Salome is imbued with a revoltingly morbid motive for her crime — sexual passion for John the Baptist.

Some fifteen years ago, Sarah Bernhardt presented the Wilde drama at the Palace Theatre in London, but the censor prohibited it after the first performance. Oscar Wilde later tried to sell her the drama, which she refused.

EVA TANGUAY LAURA GUERITE LOTTA FAUST

32. "All Sorts and Kinds of Salomes," *Theatre* 9 (Apr. 1909), 130.

gramming the Metropolitan Opera sought to bring to New York a production of Richard Strauss's recent *Salome*, which included not only the Dance of the Seven Veils but a suggestion of incest in the plot, and the severed head of John the Baptist cradled by Salome in a state of frenzied lust. J. P. Morgan's daughter happened to catch the dress rehearsal and reported the reprehensible and immoral theme and dance to him. As a dominant figure on the board, he succeeded in closing the show after its opening night. Oscar Hammerstein successfully produced it just two years later at a separate venue, however, and the whole episode seems to have hit the art world like an electrical charge. Paintings of Salome suddenly appeared hither and yon, and critics complained of a "Salome epidemic." Social dancing inspired by the Salome sensation became a brief but intense craze (fig. 32).[41]

The National Academy of Design rejected Henri's painting because the jury in 1909 recalled his leadership of The Eight the year before and felt obliged to prevent the entertainment fad of "Salomania" from spreading like a contagion into the world of fine art. By choosing to paint Mlle. Voclezce in provocative garb, Henri immersed himself in an ongoing debate over the regulation of sensuality, entertainment, and art. Censorship of the arts emerged as a prominent public issue. When the painting finally went on public view in the Independent Artists' Exhibition of 1910, its frankness and suggestiveness startled people. The very subject challenged traditional definitions of the proper subject matter for fine art. Although the Salome sensation soon waned, it signified that semiclothed sensuousness could provoke controversy just as readily, if not more so, than chaste nudity had in the nineteenth century.[42]

By the 1920s two iconoclastic sculptors, who quite literally worked on the cutting edge, chose to advance their art in impassioned and unexpected ways that proved shockingly unacceptable to many yet were admired by a growing coterie of devoted followers. Although these artists crossed the Atlantic in opposite directions, there are some striking parallels between the kinds of work they created and the responses of critics and the public. Gaston Lachaise was born in France and in 1902 met a married French-Canadian/American woman ten years his senior in Paris, where they fell madly in love and fled to Boston in 1906, eventually marrying in 1917. Lachaise not only remained devoted to her until his death in 1935, but she became his muse and the

inspiration for some of the most voluptuous statuary ever seen in the Western world, certainly in the United States. Isabel Dutaud Nagle was a woman with generous proportions ("full blown figure" was the phrase frequently used by those who knew her). She stood less than five foot three, weighed about 110 pounds, and carried herself proudly. She often served as his studio model, though the increasingly exaggerated results could not have been considered flattering.[43]

With primitive art and erotic Indian stone sculpture in mind, Lachaise sought to depict a kind of earth mother or fertility goddess, perhaps suggesting some sort of a cult figure. Beginning with his widely praised project called *Elevation* (1912–27), his women have melon breasts, roundly full stomachs, prominent nipples, deeply arched backs, broad hips, and delicate, graceful feet. In his later work the breasts became huge, even pendulous, as with *Striding Woman* (1928–31). Critics eventually referred to these figures as grotesquely malproportioned, yet statues like *Standing Nude* (1927) would increasingly be acquired by the Metropolitan and other major museums. Although his work achieved some cachet from institutional legitimacy, during the later 1980s and 1990s radical feminist groups like the Guerrilla Girls would bitterly protest what they perceived as its gross sexism.[44]

Lachaise owed considerable inspiration as well as a sense of legitimacy to the art of Auguste Rodin, which was equally bold and contemptuous of contemporary social conventions. For Lachaise, Rodin's authority helped him feel comfortable accentuating and even exaggerating strategic parts of the female body in order to achieve dramatic and symbolic effects. A reviewer of an extensive Lachaise retrospective in 1992 commented upon the inner tension involved in assessing these distinctive sculptures: "It is possible to be so caught up in the sexual charge in Lachaise's work as not to be able to see what remarkable formal inventions some of them are: bizarre exclamation marks at the end of a long tradition of human icons. Then again, dwelling on the strong formal character of Lachaise's sculpture can be a way of repressing attention to its libidinous, if not lubricious, impact."

During the last twenty years of his life Lachaise produced a new and more radical figure of a nude woman annually. As his friend and fan Gilbert Seldes remarked in a *New Yorker* profile, "each year the people who were terrified by the fatness or the largeness of the old figure look at the new one and say that the old one was monumental and perfectly proportioned and beautiful, but that the new one is excessive

and 'indecently fat.' "[45] Lachaise understood full well just how radical and potentially offensive his later work was. He showed only some of it, and many pieces would still have abrasive impact more than half a century after his death when finally displayed. He supported himself by creating sensitive and prized portrait busts that do not engage in distortion at all.

In 1933 he completed the work that connects him most closely with the American-born Jacob Epstein. Called *Dynamo Mother*, it represents a woman on her back, legs akimbo and spread awkwardly, giving birth. Presumably because her milk is coming in, her nipples radiate upward and outward, like male sex organs. There is something almost violent about the figure—the act of parturition has sent a vast shudder through her body. Given the heftiness of all his figures, we might legitimately assume that the hostile response to them surely owed something to the residual impact of the Gibson Girl ideal of feminine beauty. As Seldes wrote in 1931, "the cult of slenderness of 1918 found Lachaise a sort of public enemy of its thin and athletic idea." Although his work has long since won acceptance as serious art, it still can raise eyebrows, especially among those encountering it for the first time. The misshapen women are perceived as too naked, revealing, and grotesque, despite their undeniable power.[46]

Jacob Epstein left the United States and studied in Paris from 1902 until 1905, when he moved to London. In 1907 he received his first major commission: eighteen figures for the exterior walls of the new home of the British Medical Association on The Strand in London. Because Epstein also admired the roughness of certain forms of archaic and primitive sculpture, his work seemed not just starkly modern but brutal and yet, to some critics, both "archaic" and "reverent." His human figures were also nude, which evoked harsh criticism despite the fact that they rested forty feet above street level. Pedestrians did not exactly stroll at eye level with genitalia. Letters to the editor ardently defended Epstein from "the most prurient of impropriety hunters and sensational journalists."[47] The net result was early prominence and even fame. He continued to receive desirable commissions, such as *Maternity* (1910) in Leeds City and the design for Oscar Wilde's tomb in Paris's Père Lachaise Cemetery (1912), with its flying demon-angel.

In 1913 Epstein completed an especially minatory work titled *The Rock Drill*. He mounted a demonic figure, half human and half automaton, on a real drill. It appeared as much animal and sexual as it did

industrial, seeming to equate mechanical power and action with human energy. When it was exhibited in 1915, it caused a predictable stir, both because the figure was so intense and because Epstein had incorporated into a work of art an actual mechanical device. A year later, perhaps because of World War I and the great loss of life that ensued, he discarded the bottom of *The Rock Drill* and amputated part of the arms. An aggressive image became a casualty of war and eventually entered the collection of the Tate Gallery, the major museum of "modern" British art.[48]

In 1931 Epstein completed his birth sculpture, a swollen pregnant woman comparable to Lachaise's *Dynamo Mother*, just in time for his February show at the Leicester Galleries. Called *Genesis*, he first conceived the work in 1926 though it developed themes that had preoccupied him since the start of his career. He wrote in retrospect that "I felt the necessity for giving expression to the profoundly elemental in motherhood, the deep down instinctive female, without the trappings and charm of what is known as feminine; *my* feminine would be the eternal primeval feminine, the mother of the race." He explained these points at length in his autobiography, partially in self-defense because the piece caused the critics and public to howl in protest.

> The figure from the base upward, beginning just under the knees, seems to rise from the earth itself. From that, the broad thighs and buttocks ascend, the base solid and permanent for her who is the bearer of man. She feels within herself the child moving, her hand instinctively and soothingly placed where it can feel this enclosed new life so closely bound with herself. The expression of the head is one of calm, mindless wonder. . . . she is serene and majestic, an elemental force of nature. How a figure like this contrasts with our coquetries and fanciful erotic nudes of modern sculpture. At one blow, whole generations of sculptors and sculpture are shattered and sent flying into the limbo of triviality, and my *Genesis*, with her fruitful womb, confronts our enfeebled generation.[49]

Even before the exhibition commenced, people suggested that the gallery director should withdraw the work. When the show did open, *Genesis* took fusillades of hostile fire. Given his fairly arrogant assumptions about its excellence, Epstein was shocked, or at least seemed so

and said so. Typical headlines ran "Mongolian Moron That Is Obscene" in the *Daily Express*, and "Mr. Epstein's Latest—and His Worst" in the *Daily Telegraph*. Meanwhile, apparently timed to coincide with the opening, genuine shots were fired at some of Epstein's public sculptures elsewhere in the city.[50]

Nevertheless, the statue actually sold! (Recall the American purchase offer for Rodin's *The Kiss*.) A member of Parliament who also happened to be an architect bought it and then offered it on loan to the Tate, but the museum's trustees rejected it on the grounds that it had caused a "sensation." That annoyed the MP so much that he sent it on tour to raise money for charities. In Manchester more than forty thousand people paid to see it. In the face of such disdain Epstein was fairly thick-skinned and shrugged off a good deal of criticism. When it became vicious, his response grew more volatile. His harshest and cleverest critic, Paul Nash, writing in the *Weekend Review* several months after the fact, consigned Epstein to the level of the "man-in-the-street" who enjoys cheap entertainment—a canard that continued long after Epstein's death in 1959. Partial truth slipped over into outright unfairness.

> More to the point is that Epstein is the only artist among us who *wants* to shock. His work is definitely épatant. The principal subjects of his exhibitions are invariably controversial. But it is seldom aesthetic controversy which they excite. Faced with such a creation as *Genesis*, critics and purists are apt to stand a little to one side, if they are not to be positively elbowed out of the way or trodden under foot.[51]

Epstein responded in a remarkably temperate manner, and a few detached critics managed to make sound observations that mediated between savage attacks and adoring apologias. A writer for the *Observer* made the unexceptionable comment, "No other sculptor in England to-day could have produced this *Genesis*, because no other is mentally so removed from everyday life as to be able to arrive at this primeval conception, and to rest upon it as sufficient." A Belgian critic writing in *Neptune* argued that Epstein had "the fierce and inflexible will of those men of primitive times to whom his *Genesis* takes us back. Is it not true that he is related, across the millenniums, to those sculptors in ivory who chiseled that famous and astonishing figure of fecun-

dity, called the Venus of Brassempuy?" But whereas that primitive artist had been guided solely by instinct, Epstein "is guided uniquely by reason."[52]

The responses of women to the work are interesting because they were divided in an uneven way. A positive view, very much in the minority, was conveyed by a woman who felt that "he has captured the feelings of a pregnant woman in a way that no person could ever have imagined." Epstein himself, however, summed up the dominant view.

Women complained I had insulted their sex; there is something in this complaint. Missing in this statue all the usual appealing, so-called "feminine" graces, they would see in it an attempt to undermine their attractiveness, their desire to please and seduce. This is where "the insult" to womanhood came in. They were more alarmed at the symbolic truth of this statue than at the many cruel caricatures perpetrated by a Daumier, a Toulouse-Lautrec, or a Grosz, whereas my work is a hymn of praise and rejoicing. The misunderstanding of my motives and the perverse construction placed upon my aims always astonishes me. This statue, when offered on loan to the Tate Gallery, was refused on the grounds that it had caused a "sensation" and, therefore, was unsuitable for the solemn halls of the Gallery. . . . It is imagined that I do my work in a storm of controversy, somewhat like the atmosphere of a boxing ring, with adherents and enemies shouting encouragement and abuse to each other. The reality is that for long periods, thank God, I work quietly and give no heed to anything else.[53]

The concluding controversies in Epstein's career involved destruction of the earliest work that had made him famous. When the government of Southern Rhodesia purchased the British Medical Association building in 1935, it announced that the statues would be removed because they were "not perhaps within the austerity usually appertaining to Government buildings." Epstein replied that his statues "were intended to have a universal appeal and were built into the fabric," but the new owner responded that they were inappropriate because they did not indicate the produce of Southern Rhodesia! A letter to the *Times* of London signed by leaders of the art world forestalled destruction, but two years later when decorations were being added to the fig-

ures for the coronation of George VI, one section of a statue crashed to the pavement. The Rhodesian high commissioner prevailed upon the London County Council to issue an injunction requiring the owner of the building to render it safe for pedestrians. Despite a second press campaign by prominent art authorities, workers hacked away pieces of the carvings with hammers and chisels, leaving most of the statues mutilated.[54]

When Epstein's angel for Oscar Wilde's tomb was sent to France in 1913, the keeper of Père Lachaise Cemetery considered the work indecent because of the size of the angel's testicles. He first had them "swaddled" in plaster. Then the prefect of the Seine and the keeper of the École des Beaux-Arts decided that Epstein must either castrate the angel or else supply a large fig leaf for it, and a Comité d'Esthétique had the tomb covered with a huge tarpaulin. The executor of Wilde's estate had a bronze plaque provisionally attached to the censored area so that the tomb could eventually be unveiled in August 1914. For decades thereafter the pendulous testicles became increasingly shiny because the shrine served as a place of pilgrimage for homosexuals. Rubbing the genitals was apparently an act of homage, or else might bring good fortune. So the situation remained until 1961, when the testicles were anonymously hacked off. According to one source this was actually done by two indignant English ladies, and the broken pieces were brought to the keeper of the cemetery, who used them for some time as paperweights.[55]

Although Epstein died rich with honors—a retrospective at the Tate Gallery in 1952 was followed by an honorary doctorate from Oxford in 1953 and knighthood by the queen a year later—he will nevertheless be remembered as a willful Anglo-American troublemaker, more than a bit arrogant and always glad to be "disturbational" while acting upon his visceral instincts. I have no doubt that he preferred it that way.

If issues involving nudity and decency have been with us and contested for quite some while, then we confront the inevitable question: What is new or different in our own time, when some feel that there is a surfeit of overt sexuality and indecency? How can historical perspective clarify our understanding of the recent past as it morphs into the present? Most basically, perhaps, the difference between erotic art and

overt obscenity has acquired heightened significance. Recognition has gradually increased that sexuality can be aesthetic, indeed beautiful, and that a reasonable distinction can be made between such appeal and merely prurient titillation. Not that the authorities always made the most prudent choices. In 1934 Assistant Secretary of the Navy Henry L. Roosevelt became distressed over a notorious depiction of licentious military personnel enjoying shore leave, straight and gay, and had Paul Cadmus's amusingly bawdy picture, *The Fleet's In*, removed from the walls of the Corcoran Gallery in Washington. He claimed that it defamed American sailors. The national press delightedly seized upon the incident and reproduced the picture all across the country. Consequently far more people saw it than would otherwise have been the case. That superbly crafted painting would not be publicly displayed again for another forty-five years.[56]

By 1990 an important new dimension of this issue had emerged and gained visible prominence, sometimes in improbable places. Nudity that was quite deliberately raised to the point of indecency became commonplace, while implicit sexuality was displayed in spaces, such as public murals and billboards. That pattern had few precedents in the earlier period, and it became an issue in various locations across the United States. Needless to say, what seemed indecent and unacceptable to some turned out to be nonproblematic for others. A poll taken in March 1990 asked for responses to the statement, "Sexual poses in art are pornographic." Eighteen percent strongly agreed, and another 18 percent agreed somewhat. But 32 percent disagreed somewhat, 29 percent strongly disagreed, and 3 percent didn't know.[57]

In a society becoming ever more heterogeneous, achieving a consensus about decency, not to mention obscenity, became ever more difficult. One of the most striking aspects of the notorious exhibition of photographs by Robert Mapplethorpe, "The Perfect Moment" (1989–90), is that it aroused no significant public protest in three venues before it reached Washington, D.C., in 1990. Then the director of the Corcoran canceled the show because she feared congressional wrath. Later the same year at the Contemporary Arts Center in Cincinnati the show was closed by the police, and the director of the Museum of Contemporary Art was put on trial for "pandering obscenity." Acceptability turns out to be increasingly situational.[58]

Several of Mapplethorpe's "X Portfolio" photographs, situated in a section with a special warning to alert those who might be offended,

show naked children, including a little girl clothed but without panties and her legs open. Despite the outraged cries of "kiddie porn," it remains unclear whether Mapplethorpe actually meant these images to be voyeuristic and shocking, or a whimsical spoof of the intensely commercial market for illicit "kiddie porn" being sold by mail.[59]

In any case, the contrast between what looked like "kiddie porn" in the 1830s and the 1980s and 1990s is worth pursuing. In 1829 James Fenimore Cooper visited Horatio Greenough in Florence and commissioned him to sculpt a pair of children based upon two putti in Raphael's *Madonna del Baldacchino*, located in the Pitti Palace. Greenough did so the following year and designed for the naked boys two alabaster fig leaves that could be attached by ribbons if necessary, though apparently he never executed them. As for models, he used the children of a local servant to an elite family but reproduced the faces of Cooper's little boys.[60]

It mattered greatly to the young sculptor that the *Chanting Cherubs*, as they were known, be exhibited in the United States in order to generate some income for him; and Cooper, as his principal patron, consented. They envisioned a tour of more than half a dozen cities that might raise as much as $2,000. Following a favorable reception in Italy, the cherubs reached Boston in April 1831 and went on display with a young man stationed to rotate the work by hand in order to maximize its three-dimensional grace. At least half a dozen newspapers and two magazines carried notices that were largely positive. Naked children with all parts accounted for had never before been displayed in the United States, and initially they seemed innocent enough. Greenough's piece was also the very first work of sculpture by an American artist commissioned by an American. Its exhibition might have been a triumphal moment for the arts in the United States.[61]

Some literalists objected, however, because the cherubs did not actually sing! "Well what are they good for then?" By the third week others objected so stridently against the full nudity that little aprons had to be tied around the waists of the lads. That in turn touched off a genuine flap. One writer in the *Courier* denounced this addition as "deforming" the work "by a vile covering" and declared that any lady who feared seeing something improper had "corruption eating at her." A correspondent of the *New York Evening Post* suggested that the aprons be left behind when the work was brought to New York in order to furnish Bostonians with night caps. They were indeed

removed, and one New York editor declared, "We are happy to hear that the *gentlemen nurses* who have the care of Mr. Greenough's Chanting Cherubs intend to 'change *the diaper*' of the group in a few days."[62]

Greenough actually felt surprised and chagrined by the controversy. Unlike Hiram Powers a decade later, he had not anticipated it. When the news reached him in Florence in the fall of 1831, he wrote to his friend, the Boston painter Washington Allston. "I had thought the country beyond that," he explained. "There is a nudity which is not impure—there is an impurity which pierces the most cumbrous costume." In a more lighthearted mood, probably at this time, he sketched a very sober-faced cherub holding a very large square cloth quite decorously in front of him. What happened during the rest of the tour was even sadder than scandal, however: basic indifference. At most venues the exhibition closed early following a mild combination of mixed reactions. Either American audiences were not prepared to appreciate allegorical-religious sculpture in 1831–32, or they were not at all ready for naked little boys—perhaps both.[63]

Beginning in the mid-1980s Sally Mann, a Virginia-based photographer who lived on a four-hundred-acre farm near Lexington with her husband and children, began to exhibit and eventually publish photographs of her three youngsters in a variety of situations and poses indicative of what uninhibited youngsters might do, especially when raised on a farm in a benign climate that facilitates comfortable nudity for many months of the year. This time the controversy that erupted involved a double scandal: not only were the children often naked and sometimes defiantly or oddly posturing as miniature adults, but they were her very own kids. How could she possibly violate their privacy? Moreover, still other photos by Mann featured neighboring girls in late adolescence or their early teen years, clothed but provocatively posed.[64]

Groups such as the American Family Association felt scandalized, but so did ordinary, even quite liberal adults who wondered how such images could advance the cause of art—or anything else for that matter. What was Mann advocating or trying to say? Speculation ran the gamut, and it became extensive, often within a larger framework in which the negatives of "kiddie porn" were weighed against the positives of freedom of expression and parental rights to both freedom and decision-making about privacy. Many would claim, of course, that any-

one who displays photographs of her own children naked is guilty of exploitation and may very well have forfeited her claim to a right of privacy.[65]

Mann was obliged to defend her work on various occasions, both in interviews as well as in the texts that accompanied her published collections. She did so in various ways. To begin with, she said, she wanted to be with her children while they were growing up but still be able to pursue her career as a professional art photographer. Hence they became her subjects. She also wanted to be able to record their growth and development prior to puberty. Having been raised in an unusually uninhibited farm family, she did not feel a conventional middle-class sense of shame about nudity. Hence this passage in her text for *Immediate Family* in 1992: "When the good pictures come, we hope they tell truths, but truths told 'slant,' just as Emily Dickinson commanded. We are spinning a story of what it is to grow up. It is a complicated story and sometimes we try to take on the grand themes: anger, love, death, sensuality, and beauty. But we tell it all without fear and without shame."[66]

Even so, she conceded that "seeing these images is as if I were re-reading old love letters. They bring on a curious surge of embarrassment, elation and shamefaced longing," perhaps for the innocence of her own youth, but even more because that of her children seemed largely gone. Looking back, she matter-of-factly explained that "I have always been interested in taking the everyday slice of life and making art out of it. That's particularly true with the pictures of the children. I was just another mother with three children under foot." These remarks seem more than a bit disingenuous because the pictures go beyond the highly unusual. While a few are candid, most were very carefully posed and composed, often requiring as long as an hour to shoot.[67]

The response to Mann's images varied greatly. Following each exhibition, local newspapers received large numbers of negative letters, and organizations attempted to have the most "offensive" photographs removed entirely. Some proposed taking legal action against Mann for pandering obscenity and kiddie porn, yet her books sold extremely well, and the prices for individual prints rose dramatically. In commercial terms, Mann became exceedingly successful. And she developed a devoted following among critics and reviewers who praised her deep understanding of childhood ambiguities about sexuality, sibling rivalry, and the scrapes and bruises of roughhouse play in a

natural setting. They also sought to situate her work in the history of photography and provide a nuanced reading of its complexity. As one essayist wrote:

> Mann's photographs acknowledge nineteenth-century traditions of childhood symbolism. However she brings to this arcadian vision the chanciness and edginess of American photojournalists like Weegee and Diane Arbus. Of course it is precisely this stylistic hybridity that has confused the viewer: quite literally we are not sure how to read Mann's work in relation to the "real" world.[68]

One critic offered a pithy response, early on, that remains representative of those who have defended her focus: Mann's images "capture the often incongruous process of growing up. But, more than that, Mann has accomplished an amazing feat of revealing the darker thoughts that parents almost never articulate."[69]

By the mid-1990s, as the two girls and a boy moved toward puberty and beyond, Mann shifted her subject matter to landscape and other sorts of images. Although even some of these exhibitions and pictures proved controversial as well, Mann remains best known for the children's pictures, which continue to charm or fascinate some people yet outrage many others. She has managed to avoid being taken to court and has become one of the celebrated photographers of our time.[70] With Greenough's *Chanting Cherubs* the most basic issue was simple decency but not sexuality. Those who objected believed that if innocent little angels actually had private parts, they should remain well covered. With Mann's youngsters, not only does the question of sexuality move front and center, so does the very notion of childhood innocence itself, which Mann is clearly challenging, and that may very well be the most threatening aspect of all for people upset by the images.

As it turns out, we need a typology in order to understand causes more than outcomes because in recent years, however different the kinds of controversies and their causes, the ultimate result has usually been acceptance if not affirmation of provocative art. Even in conservative Cincinnati the jury acquitted the director of the Contemporary Arts Center in the Mapplethorpe case. The same has happened, more often

than not, with full nudity in public art. In 1991 a field officer of the General Services Administration (GSA) ordered a nine-by-five-foot painting titled *Madonna* to be draped in black plastic. Created by Dayton Claudio in 1985, it was displayed in the federal building at Sacramento, California, as part of the General Services Administration's Living Buildings program. Employees who worked there submitted a complaint stating that nudity was inappropriate for the workplace. When the GSA field office manager ordered the painting to be covered or removed, the artist refused to comply, declaring that "it celebrates the beauty of the human form. It is not political, sexist or erotic." After one week a higher GSA official reversed the order, acknowledging that there had been "some complaints by some of the tenants of the building, but you're going to find complaints on virtually any artwork you put up."[71] Diversity of opinion was thereby acknowledged, the issue dimmed, and similar denouements emerged across the United States at the close of the twentieth century.

In 1990 twelve hundred American adults were asked to respond to the statement "Nudity in art is usually pornographic." Eight percent strongly agreed, 10 percent agreed somewhat, 30 percent disagreed somewhat, and 50 percent strongly disagreed. (Two percent didn't know.) They were then asked to respond to a follow-up statement: "People have different views on what is obscene in art and what is not." Seventy-five percent strongly agreed, 21 percent agreed somewhat, 1 percent disagreed somewhat, and 2 percent strongly disagreed.[72]

In 1991, three thousand miles away, quite a different situation and dynamic achieved an outcome similar to the one at the federal building in Sacramento. The Addison Gallery of American Art at Phillips Academy in Andover, Massachusetts, organized an exhibition titled "Motion and Document/Sequence and Time: Eadweard Muybridge and Contemporary American Photography." It included a work by the highly respected artist Sol LeWitt in which a series of ten photographs of a fully nude woman advance toward the viewer, who sees her through a series of circular apertures. When it came time for this show to open at the National Museum of American Art (NMAA) in Washington, director Elizabeth Broun ordered the LeWitt piece to be excluded because "peering through successive peep-holes and focusing increasingly on the pubic region invokes unequivocal references to a degrading pornographic experience."[73]

Jock Reynolds, director of the Addison, had been director of the

Washington Project for the Arts when it took on the Mapplethorpe show after the Corcoran canceled it in 1990. Declaring his dismay that Broun was shocked, Reynolds and others pressured her by indicating that they would withdraw the *entire* exhibition if it did not include the conceptual work by LeWitt. Artists threatened to boycott the NMAA. Broun then backed down, explaining that the affair had been a case of private curatorial disagreement and discussion that had unfortunately gone public. As she put it in a prudent attempt to save face: "If the debate is to be public, it's essential that the art be on public view." It seems a fair indication of where mainstream America stood when *Time* magazine ran a dismissive item about the flap with the headline "Eek! A Naked Lady."[74]

Simultaneously, just when peep shows and nonerotic nudity achieved validation in public buildings and museums, some of the most explicit sexuality imaginable, produced by well-known American artists, appeared in public places *outside* the United States but was reproduced photographically in *Vogue* and elsewhere. An exhibition by Jeff Koons titled "Made in Heaven" had its debut at the Venice Biennale in 1990 and then traveled to venues in Cologne and London. Koons had met and married the Italian pornographic film star and member of Parliament known as Cicciolina.[75] His show consisted of vastly enlarged color photographs (redone in oil on canvas and then clear-varnished) of the two making love in different positions amid studio settings with props, mostly faux pastoral. In addition to Karl Lagerfeld's fantasy images in *Vogue*, the display was widely reviewed in the art press, *The New Republic, The New Yorker,* and elsewhere—mostly by writers who were nonplussed but not very enthusiastic either. The images certainly raised eyebrows but caused no great stir—just *tut-tut, what poor taste.* When a TV reporter asked Koons, "Are you Romeo and Juliet?" he curtly quipped: "We are the contemporary Adam and Eve."[76]

By the mid- to late 1990s the kinds of cases most likely to make headlines, or be written up at all, were those at the extreme poles of provocation and conservatism. In 1993, for example, former porn star and prostitute Annie Sprinkle opened her revised performance art show (in Fort Mason, California, as part of the Solo Mio Festival) in which she strips to her corset, masturbates, performs her "Bosom Ballet," invites audience members to pose for Polaroids with her very ample breasts framing their heads, and finally asks people to inspect

her cervix through a speculum. When interviewed, Sprinkle (born Ellen Steinberg to Jewish parents turned Unitarian) demurely says that her "Post-Porn Modernist" performance is an extended ritual covering her complete life story. "It happens to include masturbation, but placing it out of context, which most reporters do, is inaccurate. . . . The whole idea is to take these taboo, shocking things and make them normal and natural and playful."[77]

Sprinkle had been one of the subjects of congressional attack in 1990 as an "obscene" example of misspent tax dollars. In fact, she had never received support from the National Endowment for the Arts; although The Kitchen, a Manhattan performance space where she appeared, did. A close friend explains, as others do, that "it's not 'Mary Poppins.' But she does [her stage show] with such humor and love and honesty. She wants people to integrate their sexuality with the rest of their lives, which is what she's done." Sprinkle wrote an enthusiastic essay about the Jeff Koons photographs for an art journal, presumably by invitation, though she has also published in many and quite varied magazines.[78] For the most part, the art world neither admired nor liked her—indeed, she became an embarrassment to most, and best ignored—but her zany exhibitionism helped make other kinds of "sexy" art seem tame by comparison! Similarly, each time Gaston Lachaise created an even more grotesquely misshapen woman with exaggerated parts, observers found nice things to say about the previous ones, which had seemed outrageous at the time.

At the other extreme we have an intriguing episode from 1997 at Brigham Young University (BYU) in Provo, Utah, which is administered by the Church of Jesus Christ of Latter-day Saints. A touring exhibition of some fifty works by Rodin, scheduled to be shown there, included one of his most famous, *The Kiss* (fig. 25), along with *Saint John the Baptist Preaching, The Prodigal Son,* and *Monument to Balzac.* All four works were nude or seminude to some degree. The director of the BYU Museum of Art would not uncrate them and excluded them from the display. He insisted that censorship had not occurred. "In fact, it's the opposite," he claimed. "It's a method of insuring and respecting the basic integrity of the exhibit."[79]

Rachel Blackburn, the woman who curated and prepared the traveling exhibit, acknowledged that Mormon officials were troubled by both the poses and the presentations, but she added that "Rodin's subject matter is the nude, so you can't really not have nudes if you want to

have a Rodin show." Among the large number of letters to the editor
published in Salt Lake City, pro and con, was one from a Mormon who
took issue with the *Salt Lake Tribune*'s critical stance.

The public display of nudity is not essential to teaching or learn-
ing about art. Why can't we leave such displays in their proper
places, such as classes on human anatomy? Why does *The Trib-
une* find it so surprising that BYU would reflect the teachings of
the religion that sponsors it? The only controversy surrounding
this incident has been created by the media and will be quickly
forgotten when the media moves on to create the next "flavor of
the day" controversy.[80]

Even at the close of the millennium, then, issues that had been
commonplace a century before survived in small pockets of the popu-
lation. But by and large, not much remained off limits in most of the
country. Words like *decency, obscenity, lewd,* and *offensive* seemed more
difficult than ever to define and increasingly remote from public con-
sensus. In June 2003 a new sculptured mural appeared on a building in
downtown Helena, Montana, intended to depict historical figures in
the city's history. It includes a naked bordello dancer, who many feel
bears a striking resemblance to then Republican governor Judy Martz,
kicking up her heels with two other unclothed women. Another female
figure is definitely modeled on Josephine Helmsley, a whorehouse
madam from Montana's early history, and the short hair and glasses of
a third woman match the visage of the state's first woman governor.[81]
 The Seattle-based artist Kristine Veith insists that the apparent
likeness is purely accidental—that the dancer's features were modeled
after an aunt. When outraged citizens registered protests, the devel-
oper of the Great Northern Town Center, where the clay mural was
dedicated in June, denied that anything intentional had been planned.
It was purely a coincidence and problematic only in the eye of the
beholder. A director at the local art foundation, which also received
many complaints, could not say how the "coincidence" had happened.
After viewing the mural for the first time, the unhappy governor
mused that "I'm a very modest person. No one would ever see me like
that. My husband doesn't ever see me like that." Martz then deperson-
alized the issue by observing that it was "ridiculous to have naked
women up there. There are no naked men up there. It's just another
prejudice against women. The naked women don't fit." The artist

defended her work, declaring that she had spent four and a half months doing research on local history. The nude women are intended to represent the brothels that once were an important part of Helena society that attracted money and created wealthy women. The developer rejected criticism from the governor and others, and the mural will apparently remain unchanged. Needless to say, it has become a major tourist attraction and brings added visitors to that part of town.[82]

Once upon a time, back in the days of Powers and Greenough, nudity *might* have been accepted if it were validated as genuinely beautiful and totally natural. It also helped significantly if the nudity had either a religious justification, a political one, or both, as in the case of *The Greek Slave*. During the generation of Jacob Epstein and Gaston Lachaise, exaggerating or distorting female anatomy, especially in ways suggesting brutal primitivism, stirred serious social concern. By the 1960s, with Tom Wesselmann's *Great American Nude* series well under way, ninety-nine variations by 1968—inspired by the Kinsey Reports, *Playboy*, and First Amendment cases involving freedom of expression—mythic birth mothers seemed like fairly tame stuff.[83] A full generation later overt sexuality in art would simply reflect an unleashed obsession with sexuality in the society at large, though more often than not the former ran a few steps ahead of the latter. Controversies had by no means ceased in the 1990s, but the requisite degree of outrageousness for provocations had definitely been raised.

Coming to Terms with Modernism

It should come as no surprise that modernism has been one of the most frequent causes of art-related controversies in the United States. Less familiar, perhaps, at least to nonspecialists, is that modernism was far more provocative during the first half of the twentieth century and much less so after the 1950s, when other kinds of issues appeared more prominent. Quite often, when those who opposed or disliked modernism felt compelled to explain why, they equated modernism with disorder, a source of uncertainty and hence bewilderment. They believed that art not only should provide "beauty" (endlessly invoked) but also could promote a harmonious sense of society and nature. Any form of artistic expression that signified or suggested disorder was certain to be frowned upon by traditionalists.

Defining modernism is not easy because it has meant many different things to different people at different times. Its usage seems best understood situationally; but we can begin with a working definition that might enjoy fairly wide acceptance, certainly among those who have felt skeptical about modernism. Writing in 1984, MIT-based architect William Hubbard offered this generalization.

Like architecture, art before modernism spoke of human affairs. When one encountered a work of art, one would encounter (in addition to the play of shape and light) some puzzle of human conduct: What is happening in that scene? What would I do and think and feel if I were there? And what does that say about the way I live in the here and now?

But moderns set themselves a different task. They wanted artworks that would not be *about* things in the world but would themselves *be* things in the world. They did not want to create scenes and shapes that reminded us of places and things we had previously encountered in the world; they wanted to present us with scenes and shapes wholly unlike any we had ever encountered, so that we could contemplate the invented qualities of those new works—shapes never before experienced, configurations of color and light never before seen.[1]

We can envision variations and exceptions to that assertion, of course, but it suggests a stark contrast between modernism and what preceded it, and also the view, shared by many who dislike or mistrust modernism, that it is somehow antithetical to humanism and historical experience. For them, modernism does not correlate very well with the realities of recognizable human events but instead connotes intensities of form and color detached from our perceived realms, known and remembered. To put the matter much too simply, in the eyes of its critics modernism is about art for art's sake and not for our own. Its purpose is not to inform or uplift us. Its existence is autonomous, often enigmatic, or else remote from our own lives—and surely from the world as we would like it to be.

Although a group of late-nineteenth-century American artists admired the Impressionists and were deeply influenced by them, many others were appalled by their innovative techniques. Frederick Bridgman, for example, published an impassioned diatribe in 1898 called *Anarchy in Art.* (The word *anarchy* would become a great favorite among antimodernists.) "Most of the horrors from the point of view of subject, color, and form, which are being hung on the walls of our recent expositions," he wrote, "are the products of brain diseases, of envious men thirsty for fame, of new art and seeming uniquely to preoccupy oneself with the desire to give an illusion of the vibration of light."[2] It has also been observed that modernists rejected a fixed and absolute system of morality. They assumed that moral values necessarily remain in flux, adapting continuously to changing circumstances. To the extent that antimodernists heard or perceived that point of view, it reinforced their determined opposition.[3]

A majority of Americans, even while embracing *modernity* because it is equated with progress and thereby improves the quality of life, have acknowledged disliking or feeling uncertain about modern art.

Modernity did not connect well with modernism, and there was nothing paradoxical about that. As late as July 1955 a Gallup poll asked fifteen hundred people the simple question, "Do you like modern art?" Interviewees were invited to define *modern* however they wished. The response? Twenty-five percent said yes, 54 percent said no, and 22 percent responded "don't know."⁴

During the four decades following 1913, the proportion of people hostile to modern art would have been considerably higher, but it gradually began to decline after 1955. Art-related values have changed more swiftly since the 1960s because of a growing recognition that social values generally have changed. Ironically, modernism gradually became more widely accepted just when it began to wane as a driving force in the world of art. "Construed as an agenda of progressive divestiture," Arthur Danto observed, "modernism petered out sometime in the early 1970s. Its demise accounts in part for the fuddled state of art criticism since that time, for with each purification, a platform was established for criticism of everything else on grounds of esthetic bulimia."⁵

It is also important to note that Europeans tended to be more accepting of modern art than Americans were. The Old World embraced it earlier, especially during the middle decades of the twentieth century. One obvious reason was ideological. Neither fascism nor Communism approved of modernism, considering it degenerate. Therefore those who suffered under those two types of political regime were often disposed to approve of modernism, almost by default. The enemy of my enemy.... In the United States, serious concern about Hitler's condemnation of modern art seems to have been limited to a small group of avant-garde artists, like Stuart Davis, Mark Rothko, and Adolph Gottlieb, who were internationalist in outlook and strongly leftist in their politics.⁶

When the famous Armory Show brought European Post-Impressionism to America for the first time in 1913, some critics were shocked, others were puzzled, and many lay observers felt utterly bewildered. Marcel Duchamp's *Nude Descending a Staircase* created a scandalous sensation, and that was only the most notorious example of an apparently bizarre trend, though endlessly cited. Duchamp's work became a critical focal point of the exhibition, the butt of many jokes, a puzzle to be deciphered. *American Art News* offered a ten-dollar prize for the best solution to the enigma of this semi-Cubist work. The winning entry was a bit of doggerel titled "It's Only a Man."

> You've tried to find her,
> And you've looked in vain
> Up the picture and down again,
> You've tried to fashion her of broken bits
> And you've worked yourself into seventeen fits;
> The reason you've failed to tell you I can,
> It isn't a lady but only a man.[7]

Naming and explaining this painting got to be a giddy parlor game. It was described as "an assortment of half-made leather saddles," an "elevated railroad stairway in ruins after an earthquake," a "dynamited suit of Japanese armor," an "orderly heap of broken violins," or an "academic painting of an artichoke." The quip mostly widely bandied about, "an explosion in a shingle factory," appeared in *Everybody's,* and the sculptor Gutzon Borglum contemptuously renamed the work "a staircase descending a nude."[8]

It should be kept in mind that the leading American art critics during the first third of the twentieth century—Kenyon Cox, Royal Cortissoz, and Frank Jewett Mather—were decidedly conservative. Cortissoz, who served as art critic for the *New York Tribune* from 1891 until 1941, commented, "I have been a traditionalist, steadfastly opposed to the inadequacies and bizarre eccentricities of modernism." In 1920 he offered his basic aesthetic critique: "I disbelieve in modernism because it seems to me to flout fundamental laws and to repudiate what I take to be the function of art, the creation of beauty." Mather invariably attacked modernism in articles that he wrote for *The Nation* and other journals, though he often did so with thoughtful regard for its relationship with earlier traditions in art and important social changes.[9]

Strident concerns became common during the second decade of the twentieth century. Antimodernists expressed their fear that these new developments seriously disrupted the capacity of art to provide society with a model of harmonious order. Between 1917 and 1920, with the advent of Bolshevism, critics worried that modernism was part of a larger effort to undermine "law and order," threatening the "Revolutionary destruction of our entire social system." A 1921 piece in *Current Opinion* titled "Modern Art as a Form of Dementia Praecox" suggested that "the new art is but a reflection of the subconscious of the age," one characterized by disillusionment and grief. In 1930 a reviewer declared that modern painting increased the American sense

of confusion. After "being hit in the eye" by a modern painting, "many a well meaning inquirer feels bewildered, dizzy, he doesn't know what the world is coming to." The menace of modernism was repeatedly tied to threats of "social chaos" and even Communism.[10]

The first highly visible American art controversy of the twentieth century involved modernism but in a triangulated way. In 1907 painter Robert Henri led a revolt against the conservative National Academy of Design (NAD), which dominated art juries and therefore exhibitions. The charismatic Henri led a group of younger urban realists who preferred to use freer brushstrokes in depicting the ordinary street life of bars, tenement neighborhoods, fight clubs, and street waifs. Their radicalism and hence their modernism lay more in content than in technique. They were as much in revolt against European dominance in subject matter as they were against the stylistic norms of the NAD. Their 1908 exhibition at the Macbeth Galleries in New York as "The Eight" (only later were they retrospectively designated as the Ashcan School) achieved considerable media attention and made the public highly aware of an intergenerational rift among American artists.[11]

At almost the same time, however, Alfred Stieglitz opened his Little Galleries of the Photo-Secession at 291 Fifth Avenue and began to show the work of modernist innovators like Cézanne, Fauvists like Matisse, Cubists like Picasso, and Surrealists like de Chirico—work that was more avant-garde in form than The Eight and quite comfortable acknowledging the leadership of European pioneers. Rodin had his first American show in 1908 at the 291. At that time there was considerable tension between Stieglitz and his close ally Edward Steichen, on one side, and The Eight on the other. But with age and the passage of time, Stieglitz (a significant patron and promoter of others) became increasingly sympathetic to American artists and, perhaps a greater surprise, antimodern in one sense because of his hostility to technology (such as the automobile). By the mid-1920s, when Stieglitz's American Place Gallery achieved its peak influence, it certainly continued to display modernist work, but that which was less radically avant-garde than a decade earlier and far more American in its authorship and emphases.[12]

One might have expected that a meeting of the minds would have occurred during the 1920s between the Henri and Stieglitz circles. The latter, however, was as tightly exclusive and patriarchal as the former was open, accessible, and egalitarian. Sparks flew from time to

time based upon rivalries and slights, real and imagined. Although they shared a desire to promote the prospects for American artists, long-standing personality conflicts and Stieglitz's patronage of favorites perpetuated the distances between them. Moreover, the kind of art that achieved sudden visibility and notoriety at the Armory Show in 1913 made Henri and The Eight seem rather tame, almost conventional.[13]

The International Exhibition of Modern Art, sponsored by an ad hoc group called the Association of American Painters and Sculptors, took place at the Sixty-ninth Infantry Regiment Armory in New York City between February 15 and March 15, 1913. It represented an astonishing achievement organized by artists Walt Kuhn and Walter Pach, who selected much of the new work in western Europe (especially France), and Arthur Bowen Davies, who did a remarkable job of fund-raising. More than thirteen hundred paintings were hung in a matter of days, and an array of sculpture carefully mounted. The Armory itself had to be physically converted from a hall where troops drilled to a series of sectioned galleries with sufficient wall space to display so much art. The whole affair represented a triumph of whirlwind energy expended efficiently by a small but determined group.[14]

What made the exhibition so significant and such a revelation was the simple fact that most American critics, never mind the general population, had not yet seen work by Braque, Matisse, Dufy, Maillol, Brancusi, Archipenko, Cézanne, Gauguin, and hundreds of others working in various modes that seemed far more radical than anything the Impressionists had done. Although work by quite a few American artists was shown, the European section drew much the larger crowds and caused most of the excitement. Kuhn and Davies had hoped to inform and educate American taste to what was happening at the forefront of contemporary art. In one sense they succeeded because large numbers of ordinary folks saw the show in New York and subsequently in Chicago and Boston, and many came away feeling excited or energized if not always enthusiastic.[15]

What made this event such a contested landmark, however, is that quite a few influential critics did not like it, condemned it, and provided justification for the general public's disdain of modernism for almost two full generations. Because tradition-oriented artists and social tastemakers felt vindicated, modernism became a notable target for denunciation and debate. Older artists whose careers had begun in the 1860s and 1870s might be ridiculed or found wanting; but the younger ones who had emerged since the turn of the century received

an unprecedented amount of vituperation. Everything from their sincerity to their sanity was called into question. Many suggested that their work might actually be a hoax, and surely they were guilty of moral depravity. An article spoofing the Armory Show in the *New York Evening Sun* ended with the observation that for modernists to display their paintings in frames (as they all did in 1913) "is as when a man having voluntarily sacrificed his lower members [legs] should cling importunately to the wearing of fashionably cut trousers."[16]

Certain influential art critics pulled out all the stops in terms of shrill remarks ranging from the political to the aesthetic. When Kenyon Cox called the modernists "artistic anarchists," he revealed the pervasive fear of disorder aroused by modernism. His anxiety about subjectivism in art would linger in many minds for half a century. Describing the Post-Impressionists as a group, he worried that "it is not knowledge of form alone that is unnecessary, but knowledge of any kind. The artist is no longer to occupy himself with the problem of how things look—he is interested only in how he feels about things." In a frequently quoted sentence, Cox mourned, "Now all discipline has disappeared, all training is proclaimed useless, and individualism has reached the pitch of sheer insanity or triumphant charlatanism."[17]

To compound the uproar, public figures like Teddy Roosevelt who did not customarily comment on artistic issues connected works in the Armory Show with retrogressive change. This new art suggested the prospect not only of cultural collapse but of social chaos as well. An editorial in the *New York Times* warned that "this movement is surely part of the general movement discernible all over the world, to disrupt and degrade, if not to destroy, not only art, but literature and society too."[18]

Much of the anxiety generated by this episode was exacerbated by the fear that art was just the tip of the iceberg, and that the artists had taken tendencies already present and carried them to madcap extremes. Hence Frank Jewett Mather's conclusion to his lengthy essay-review: "And here, perhaps, lies the fallacy of the whole recent movement—so far as it is at all sincere. In the desperate research of novelty, themes that might serve a minor purpose in literature are promoted to major use in the art of painting. An exact description of a distorted and toadlike nude by Matisse would perhaps not offend the mind; the picture does offend the eye."[19]

The varied concerns expressed by those who felt so vexed in 1913 are fairly familiar because this contretemps has been exceedingly well

documented. Barely remembered is a secondary level of frustration experienced by those American nationalists who affirmed modernism but resented that a disproportionate amount of attention at the Armory Show was given to work by Europeans. Consequently, three years later a two-week exhibition, the Forum Exhibition, comprised exclusively of work by native artists was mounted at the Anderson Galleries in New York. As the catalog's preface explained,

> The object of the present exhibition is to put before the American public in a large and complete manner the very best examples of the more modern American art; to stimulate interest in the really good native work of this movement; to present for the first time a comprehensive, critical selection of the serious painting now being shown in isolated groups; to turn public attention for the moment away from European art and concentrate it on the excellent work being done in America; and to bring serious, deserving painters in direct contact with the public without a commercial intermediary.[20]

Once again strong feelings of national chauvinism complicated the advent and the controversial character of modernism. (Significantly, both Robert Henri *and* Alfred Stieglitz were among prominent figures in the art world who organized the Forum Exhibition in 1916.) As late as the 1950s, one "saving grace" of Abstract Expressionism in the United States was the recognition it gradually received as the most influential avant-garde development in the world. National pride could make *some* folks feel better about modernism, even when they didn't much like the pictures.[21]

The catalog for the 1916 Forum show included an explanatory essay, "What Is Modern Painting?", an individual foreword by each of the six committee members, and sixteen explanatory notes in which each artist could unwrap his intentions. (Marguerite Zorach, the only female participant, was not included.) If the purpose of the catalog was to disarm criticism, it had just the opposite effect. Negative responses treated not only the art itself but the catalog's extensive justifications in the realm of theory. What is most curious about the content of the catalog, however, is the way several of the most articulate artists insisted that what mattered most to them, realism and order, were *exactly* the qualities that critics found most wanting in modernism for decades to come. As Arthur Dove, an early exponent of abstraction, wrote, "I

should like to . . . give back in my means of expression all that [life] gives to me . . . the reality of sensation." Charles Sheeler explicitly equated reality with sensory response and order: "I venture to define art as the perception through our sensibilities, more or less guided by intellect, of universal order and its expression in terms more directly appealing to particular phases of our sensibilities."[22]

Five years later the Metropolitan Museum of Art held its first, and for many years its *only*, exhibition of modern painting (May to September 1921), including Impressionists, Post-Impressionists, and pre-Cubist works by Picasso—all borrowed from twenty-five lenders. Although this exhibition helped to make modernism socially acceptable in elite circles, it also prompted a torrent of criticism. The greatest stir was aroused by twenty-eight pictures loaned by lawyer John Quinn, the single most important purchaser at the Armory Show. Two elegant ladies were overheard complaining: "Well, I was up there and invariably the awfullest pictures belonged to John Quinn." *American Art News* safely predicted, "It is sure to arouse bitterness and enthusiasm." The bitterness received far more press coverage.[23]

Four months after the show opened, a four-page flyer was mailed to many people in the New York City area, warning that "this 'Modernistic' degenerate cult is simply the Bolshevic philosophy applied to art." Those responsible for the mailing aimed special contempt at the dealers "who are trying to unload on the American dumping ground more of the degenerate art-trash now in this exhibition." Robert Henri's swift response is notable: "The protest of the writers of the circular seems to be in keeping with the modern idea of prohibiting. Good heavens! We can't drink any more; surely we ought to be allowed to ruin ourselves looking at pictures."[24]

One of the works that caused particular consternation at the Armory Show was a Cubist bust by Constantin Brancusi titled *Mademoiselle Pogany*, referred to as a "magnificent grotesque" because the woman's features were so simplified: eyes greatly enlarged, mouth tiny, nose long and angular, the overall head egg-shaped. In 1926 a single work by the Romanian-born, Paris-based Brancusi sparked a two-year court battle that achieved much notoriety at the time and that illuminates several aspects of the misunderstanding over modernism. Edward Steichen purchased in Paris a tall, graceful sculpture by Brancusi titled *Bird in Space* (fig. 33). Two conservative curators at the Metropolitan Museum tipped off a customs inspector that this work and seven others would arrive at the Port of New York. An official there

33. Constantin Brancusi,
Bird in Space (1926), Bronze.
© 2007 Artists Rights Society (ARS), New
York/ADAGP, Paris. The Museum of Modern Art.

ruled in turn that *Bird* could not be admitted duty free as a work of art. Rather he considered it merely a manufactured piece of metal and dutiable at 40 percent of its value—paradoxically, not its value in bronze but rather its value as sculpture, even though the inspector ruled that it could not be sculpture because it did not look like a bird![25]

Steichen and Brancusi took the case to court, and the trial opened in October 1927. It became one of the earliest trials in which the expert testimony of artists and critics carried the day, but only gradually and with considerable suspense. Thus began what came to be known as the Brancusi Brawl. Progressive leaders in the art world considered the case quite serious because it loomed as a threat to modern art in general. The press had a field day, designating *Bird in Space* as "a folded umbrella," "a pale and lean banana," and a "white panatela cigar." The case hinged upon whether the object qualified as sculpture, and the Treasury's 1916 invocation of a dictionary definition declared that sculpture was "that branch of the fine arts . . . which chisels or carves or models . . . imitations of natural objects, chiefly the human form, and represents such objects in their true proportions of length, breadth, and thickness."[26]

During 1927, as the trial proceeded very slowly, Brancusi's work was exhibited publicly at the Wildenstein and Brummer galleries. It received mixed responses even within the so-called arts community, which is hardly surprising. Most interesting perhaps is that the specter of American gigantism even made an appearance. One enthusiastic reviewer remarked that "simplicity is complexity itself," then added that he would like to see *Bird in Space* placed in a city square or a harbor "enlarged to a height of many hundred feet to be visible many miles distant."[27]

Interrogation of witnesses by the three judges produced many humorous moments, but Frank Crowninshield, the editor of *Vanity Fair*, produced the most eloquent testimony: "It has the suggestion of flight, it suggests grace, aspiration, vigor coupled with speed, in the spirit of strength, potency, beauty, just as a bird does." Other witnesses agreed in defining art as something that gave pleasure and possessed or instilled a sense of beauty. But they made no attempt to define these qualities with precision because they could not. Late in 1928, when Justice Waite rendered his decision, he surprised many by acknowledging that conceptions of what is art and what is beautiful are not static. They change with time. He then conceded that "there has been developing a so-called new school of art, whose exponents attempt to

portray abstract ideas rather than to imitate natural objects. Whether or not we are in sympathy with these newer ideas and the schools which represent them, we think the facts of their existence and their influence upon the art world . . . must be considered."[28]

He then defended Brancusi's bronze, a work the sculptor subsequently modeled in other media, such as wood and marble. "It is beautiful and symmetrical in outline," he explained, "and while some difficulty might be encountered in associating it with a bird, it is nevertheless pleasing to look at and highly ornamental, and as we hold under the evidence that it is the original production of a professional sculptor and is in fact a piece of sculpture and a work of art according to the authorities . . . we sustain the protest and find that it is entitled to free entry."[29] Although this decision marked a major breakthrough for abstract art and set an important precedent for court testimony by art experts, the general public remained unpersuaded. A physician viewing the work in 1935 quipped: "a bird or a suppository?"[30] Yet another major legal challenge involving the importation of contemporary sculpture lay less than a decade ahead.

The Museum of Modern Art, which opened in Manhattan in 1929, mounted its first controversial exhibition in 1932. "Modern Architecture: International Exhibition," including work by more than fifty architects, was not well attended. It did receive considerable press coverage, however, and a typical response took the form of a rhetorical question. "Do you call this architecture? This utilitarian, unornamented, beautiless, so-called 'functional' building?" Four years later the first director, Alfred H. Barr Jr., became considerably bolder and sparked two major conflicts within the span of a year. Up until that time he had shied away from contemporary American abstraction, which prompted the formation of a group (more than fifty) calling themselves American Abstract Artists, who challenged Barr and the Modern to be more inclusive in defining modern art. This was only the first in an intermittent series of conflicts between MoMA and younger generations of artists hungering for recognition.[31]

In March 1936, when MoMA opened an exceedingly ambitious and comprehensive exhibition, "Cubism and Abstract Art," the critics proceeded to have a field day. Writing in the *Times*, Edward Alden Jewell called it "the most elaborate, complex, and in a sense at least, the most bewildering exhibition arranged thus far in the career of the

MoMA." Midway through, however, he added: "On the other hand, that it succeeds in fitting together, all in all, a most scintillant and informative jig-saw puzzle, few, perhaps, will care to deny. Accept or reject it, the modern movement—with the redoubtable, revolutionizing, creative impetus for which it stands—here receives a magnificent demonstration." The show actually offered what became some of the most famous icons of modernism, including Brancusi's *Bird in Space*, Picasso's *Three Musicians*, Dalí's *Persistence of Memory*, and works by Braque, Gris, Lipchitz, and others.[32]

In a long featured review, Charles G. Poore lamented that "artists of the Paris School continue to paint clinical dreams in the cults of obscurity. . . . Facing life as it is, they paint life as it isn't." Designating the show as "singularly uneaseful" while scorning "weird cubism," Poore spoke for the overwhelming majority of Americans by declaring that "the most famous thing about abstract modern art is its unintelligibility. A round billion words have been uttered by eminent authorities, all impelled to tell you what the pictures are about, why they were painted that way, what they mean. And still the world looks at the pictures and still the world can't understand them."[33] Letters to the editor used even stronger language to express agreement. One writer cited "these recent evidences of psychoses among so-called artists." Referring explicitly to the horrors of modernism, he added: "I have come to look upon these morbid manifestations in this field as emotional manifestations of a widespread loss of stability in all human cerebral functions during the last twenty-odd years."[34]

The show involved yet another dimension of conflict that harkened back to the Brancusi Brawl a decade earlier. When nineteen works of abstract sculpture by such figures as Giacometti, Arp, Duchamp-Villon, Miró, and Henry Moore arrived at customs, puzzled officials decided that they were not art (once again holding sculpture to a higher standard of representation than painting) and required MoMA to post bond before these works could enter the country. Conger Goodyear, president of MoMA, swiftly sent a letter to some one hundred museums in the United States, seeking their support in amending the customs laws to allow museums rather than customs officers to decide what is art and what is not. The principal issue, he explained, "is whether the government is to determine by law what is art."[35] Within two months forty museums had agreed to cooperate with MoMA in obtaining an amendment to the tariff laws that would place abstract

sculpture on the same footing as abstract painting. It took three years, but they succeeded.

The following winter MoMA's exhibition of "Fantastic Art, Dada, Surrealism" became, quite possibly, the most controversial museum show of the decade. *Time* magazine scrolled its droll sarcasm in describing some of the highlights.

Oblong slabs of glass painted with black stripes revolved steadily under a six foot pair of red lips painted by artist Man Ray. In other galleries throughout the building were a black felt head with necklace of cinema film and zippers for eyes; a stuffed parrot on a hollow log containing a doll's leg; a teacup, plate and spoon covered entirely with fur; a picture painted on the back of a door from which dangled a dollar watch, a plaster crab and a huge board to which were tacked a mousetrap, a pair of baby shoes, a rubber sponge, clothespins, a stiff collar, pearl necklace, a child's umbrella, a braid of auburn hair and a number of hairpins twisted to form a human face.[36]

Surrealists believed that incongruity could prompt great leaps in human understanding. Not many visitors to this display felt persuaded, not even in New York City and much less so in Hartford, Connecticut, where the Wadsworth Atheneum also attempted to introduce its members to the trendiest modes of modernism in Europe since the 1920s. The flamboyant young director, A. Everett Austin, had mounted a daring and pioneering exhibition of the "Newer Super-Realism" (referring to Surrealism) in 1931, a Picasso show in 1934, and still others in subsequent years until his trustees basically drove him away, whereupon he became director of the resuscitated John and Mable [sic] Ringling Museum of Art in Sarasota, Florida, which owned a notable collection of early modern works from Europe. Although the Wadsworth trustees found Austin's Atheneum shows absurd and the local elite felt more baffled than boffo, the shows attracted greater interest and drew larger crowds than any previous exhibits held in Hartford. Not everyone liked these challenging works, but they certainly discussed and debated them. The local press made a valiant effort to understand what it was all about, aided by "Chick" Austin's disarming interviews designed to make it all entertaining at the very least.[37]

People in Hartford, Boston, and Philadelphia were notably resistant to modernism. The word most frequently invoked to justify the fear of modernism was, predictably, *disorder*, and the standard justification for that fear was that modernism signified a disordered world. In 1928 Boston became the scene of an uproar when the venerable Boston Art Club decided to show some drawings by Picasso along with other works of contemporary European art. Opponents began calling for "sanity in art," which quite soon became a catchphrase all across the country. The club quickly issued a statement declaring that it had "purged itself of modernism."[38]

Antimodernism surfaced in Chicago in a notably virulent way. In 1936 the Art Institute of Chicago decided to remove from display one of its most beloved paintings, *The Song of the Lark* by Jules Breton, a rather conventional picture from the turn of the century that enjoyed a certain sentimental appeal. It had been featured at the Century of Progress exhibition in 1933, where it placed first in a ballot for the most popular painting in the entire collection. Meanwhile a highly vocal and conservative art critic who wrote for the *Chicago Tribune*, Eleanor Jewett, intensified her crusade against "unnatural modernism." In 1935 she and others were furious when the Art Institute presented its annual awards to paintings they considered "atrocities." In April 1936, following the outrage prompted by removal of *Song of the Lark*, Jewett joined forces with a new organization called Sanity in Art formed by Mrs. Josephine Hancock Logan. Its sole purpose was to make a strong, organized stand against "modernistic, moronic grotesqueries that today masquerade as art."[39]

The group's basic crusade sought the Death of Modernism, a slogan first voiced in Chicago in 1933, and its influence would soon be felt nationally. Its leaders promoted "rationally beautiful" pictures. Logan mobilized so much support in the Midwest that she eventually established offices in New England, Pittsburgh, Kansas City, and California, and by the eve of the war even a branch in Paris. Nevertheless, Edward Alden Jewell, a moderately conservative art critic, regarded the Sanity movement as ridiculously reactionary, calling it "the most militant anti-modernism pro-conservatism movement in recent art history."[40] By 1940 members of Sanity in Art seem to have joined forces with the isolationist America First movement. The chairman of the Los Angeles branch declared, "We all know too well the type of art Europe foisted upon us since the last war and called it 'modern.' We now can also see clearly where it has led them."[41] Even though the

movement persists to this day under another name, it gradually faded from prominence following World War II because its taste for the banal happened to coincide with the kind of art approved in Nazi Germany, and by 1950 modernism began to achieve at least a modicum of acceptance in the United States.[42]

In 1936 Edward C. Bruce, chief of the Treasury Department's Section of Fine Arts and founder of the Works Progress Administration's Treasury Relief Art Project, proposed a museum in Washington "dedicated to living artists." He envisioned it as complementary to the National Gallery of Art then under construction on the Mall, John Russell Pope's "mausoleum for dead masters." Bruce gained a few key supporters and suffered some setbacks, but a bill passed by Congress in 1938 provided $40,000 for a national design competition. Advocates openly wanted a "modern" plan, a "flexible" solution that would not necessarily require a balanced relationship with neighboring structures. The jury selected was carefully weighted in favor of a modernist outcome. In a two-stage competition the Saarinen firm won first prize for an aggressively contemporary design with rectangular blocks having different functions.[43] As Richard Guy Wilson has described it, "large walls of glass, horizontal strip windows, and flat, blank, and 'weightless' marble surfaces pervaded the major elevations." Although modernist architectural critics strenuously promoted the design for a number of years, "it never stood a chance of being erected." Members of the Fine Arts Commission were unalterably opposed. As the chairman noted in 1940, "The sketch for the proposed Smithsonian Gallery of Art is frankly radical, conspicuously defiant of the existing patterns of Washington. If executed, it doubtless would set a fashion for further adventures in a futuristic direction." Funding from private sources never materialized.[44]

During the 1950s the political climate in Washington remained overtly hostile toward modernism. Representative George A. Dondero of Michigan served as chairman of the House Committee on Public Buildings. His 1952 talk "Communist Conspiracy in Art Threatens Public Buildings" epitomized his outspoken stance throughout the decade. "So-called modern or contemporary art in our own beloved country contained all the 'isms' of depravity and destruction."[45] A museum for contemporary American art, designed in a starkly modern style, was not going to be built on the Mall, at least not yet. And when

such a structure was proposed with presidential support in 1966, the Hirshhorn Museum and Sculpture Garden, it touched off an eight-year battle with Congress and the critics.

Meanwhile, in 1946 a few young staff members at the State Department decided that an exhibition of contemporary American art selected for travel overseas could win goodwill for the United States and demonstrate its commitment to freedom. The department took the unprecedented step of purchasing seventy-nine recent oil paintings and seventy-three watercolors. Dealers and artists were so delighted that they provided the works at less than market value. Even so, the government's investment exceeded $49,000, a substantial amount for current work at that time. Two tours titled "Advancing American Art" were envisioned: one in Europe beginning in Prague (not yet behind the Iron Curtain) and another south of the border that would open in Port-au-Prince, Haiti.[46]

The conservative Hearst papers got hold of information about the exhibits and published pictures of some of the paintings. By February 1947 they appeared in the press hither and yon, including a scornful spread in *Look* magazine that attracted wide notice and derision. The bold headline read "Your Money Bought These Pictures." Perhaps the most frequently reproduced painting was *Circus Girl Resting* by the Japanese-American artist Yasuo Kuniyoshi (fig. 34). Because she appeared to be a big and muscular woman, one congressman objected to the inference that "the typical American girl is better equipped to move a piano than play one." Another politician compared the figure to a "Chicago Bears tackle taking it easy during a time out."[47]

At congressional hearings Undersecretary of State William Benton (later a senator from Connecticut and an art enthusiast who had approved the purchases) underwent a humiliating interrogation about particular pictures that seemed to convey an unflattering vision of life in the United States. In the transcript of those hearings the congressmen come across as crude, bullying philistines, and Benton seems to stonewall as a nonplussed know-nothing about art or how the whole fiasco could conceivably have happened. Representative Karl Stefan of Nebraska (R) led the tough interrogation.

> STEFAN: Look at that Mr. Secretary. Those are supposed to be human beings in a discussion on a street in the United States somewhere. Aren't you horrified yourself?
> BENTON: I would not use the word "horrified."

34. Yasuo Kuniyoshi, *Circus Girl Resting* (1925).
Courtesy of Auburn University and Art © Estate of Yasuo
Kuniyoshi/Licensed by VAGA, New York, N.Y.

STEFAN: Well, you are shocked arcn't you?
BENTON: No, I wouldn't say I was shocked.
STEFAN: Well, what would you say?
BENTON: I would say "art."[48]

The lengthy dialogue was frequently interrupted by derisive laughter. Although Benton was actually well qualified to explain modern (and even abstract) art, he prudently chose to remain low-key and bland yet hold his ground. Lecturing or hectoring the committee would have been counterproductive.

The embarrassed Benton received two stiff letters from the president that Truman himself did not make public; but someone in the

White House leaked copies to Drew Pearson, the nationally syndi-
cated columnist, who published them in full. Benton promptly ordered
the exhibits withdrawn from Prague and Haiti, which of course out-
raged American artists, who denounced him at mass meetings held in
New York.[49] Only some years later did he reveal the most basic reason
for his swift retreat: "I discovered that a very big percentage of the
artists who had painted the pictures were on the Attorney General's list
of Communists." Although he felt certain that many did not belong
on that list, citing the case of his good friend Reginald Marsh, he
described his vision of a worst-case scenario.

> I had a report that the most important cultural attaché in Prague
> was the man who represented the Soviet Union. His home was
> one of the most important salons in Prague. Thus I had a men-
> tal picture of the Soviet ambassador to Prague going down to
> visit the American art collection. I could imagine his saying, "I
> am glad to discover that so many of the great artists of the
> United States, as judged by the State Department itself, are fel-
> low comrades of the great soviet party." Or words to this effect.
> I had the mental picture of the impact of this on the Congress.
> This was a final argument to cause me to order the collection
> back from Prague.[50]

Secretary of State George C. Marshall repudiated the exhibition,
and Congress slashed the State Department's budget request for cul-
tural initiatives to much less than half of what had been sought. That
would become a precedent for actions threatened and taken half a cen-
tury later at the federal and local levels. The art collection itself was
sold at public auction for $5,544 to the University of Oklahoma and
Auburn University. Many of the remarks made in Congress and the
media revealed a mood that was not merely antimodern but anti-
intellectual, anti-elitist, and especially anti-eastern.

What is most intriguing, yet little noticed, is that the works causing
this contretemps were actually one of *two* American collections gath-
ered by the State Department for display overseas. The other one
(quite forgotten historically) stretched back to the early nineteenth
century to take a more comprehensive look at national art and was bor-
rowed from the collection formed by Thomas J. Watson for IBM.
After "Advancing American Art" was shown at the Metropolitan
Museum in October 1946, prior to being sent abroad, Watson's collec-

tion went up the following month at the Grand Central Terminal Galleries, was well received by the critics, and headed for Egypt, where it received a warm welcome from King Farouk, and then to Europe in 1947 without fanfare or complaint. Moreover it traveled under the explicit title "American Industry Sponsors Art." Media coverage or its absence made all the difference. Support from corporate capitalism certainly did not hurt either.[51]

Even some of the more progressive critics did not have kind words for the genesis and early growth of modernism in the United States. In 1946 the Whitney Museum of American Art put together a thoughtful show specifically dedicated to reassessing the new work that had developed in American art following the Armory Show. After noting that the Armory Show had received a very negative response from academic artists and critics, then from regionalists and their supporters during the 1930s, Alfred M. Frankfurter minimized the work of the first generation of American modernists because they had been inspired by the Post-Impressionists but lacked their deep heritage. He remarked that the Europeans had been iconoclasts who nonetheless could draw selectively on the grand context of Renaissance and early modern art. Lacking that rich context, the American work was derivative and lacked any sort of cohesion as a movement. The real fault, Frankfurter explained, "was that a way of art was assimilated without understanding it and, still more, without having, in the fullest sense, experienced it." He lamented that it was impossible to define American modernism by scrutinizing the supposedly seminal 1916 show.[52]

Beginning in 1943 but intensifying between 1947 and 1950, a series of related issues kept American art and museums very much in the news as institutional relationships and questions of cooperation played themselves out. Complaints that American art was severely underrepresented at the Metropolitan Museum caused concern on all sides and prompted serious consideration of a merger between the Whitney and the Met. After ruminating for several years on whether to combine its collections with the Met, the Whitney decided in September 1948 that its liberal tradition of support for contemporary art would not be perpetuated there and withdrew from the proposed engagement. There would be no Whitney Wing. As a result the Met promptly announced that it would take a more active role in collecting and showing modern American art, thereby making it a competitor of the Whitney but with far greater resources at its disposal.[53]

At the end of 1949 the Met announced that it would sponsor a

nationwide competition for American painters, culminating in an exhi-
bition one year later of several hundred works that impressed regional
juries. It also planned a large retrospective show of "contemporary"
American paintings during the summer of 1950, but then selected
"classics" by already-familiar artists that appeared on the walls without
any fanfare. Meanwhile the Museum of Modern Art, which had always
been more partial to European work, made a commitment to be more
supportive of American art. All of this may very well have been a
response to Cold War patriotism. It certainly reflected an effort to put
the best possible face on the breakdown in collaborative negotiations
among the three museums.[54]

If the Met hoped to garner positive publicity from its new plans,
it achieved very mixed results. In May 1950 eighteen well-known
"advanced" painters (including Motherwell, Hofmann, Pollock,
Rothko, de Kooning, Pousette-Dart, and Reinhardt) issued a mani-
festo declaring that they would not participate in the national compe-
tition and exhibition planned for December, "American Painting
Today—1950," because the award juries were "notoriously hostile to
advanced art." Yet one prominent member of that jury, Yasuo
Kuniyoshi, had been responsible for *Circus Girl Resting*, the painting
that had sparked such derision just three years earlier. *Life* magazine
even ran a feature story about the show when it opened, preceded by a
posed group portrait of the eighteen "irascible" rebels with a surly
Jackson Pollock at the center (fig. 35). Members of the recently formed
Artists Equity Association promptly released a letter to the president
of the Met commending the museum's "present attitude toward con-
temporary artists." On July 4 a larger group of seventy-five prominent
painters added their defense of the Met, arguing that it was premature
to condemn the juries before their verdicts were even known.[55] As
usual, the art world was a house divided.

While these tensions were rife among institutions as well as artists,
and both were very much in the public eye at midcentury, the Met's
exhibition of "major tendencies" in American art since 1900 opened in
mid-June. It received praise for including photography, a bold step for
such a tradition-oriented museum, though work by Stieglitz, Steichen,
Ansel Adams, and other major figures do not exactly seem in retro-
spect to have been risky choices. Still, a new generation of photogra-
phers interested in documentary work and aspects of everyday life was
not included. In general the show was well received, and responses
even included a mild reproach to those intolerant of modernism and

35. "The Irascibles": Willem de Kooning, Jackson Pollock,
Adolph Gottlieb, Ad Reinhardt, Robert Motherwell,
Clyfford Still, Barnett Newman, Mark Rothko,
Hedda Sterne, and others (1950).
Nina Leen/*Time & Life* Pictures/Getty Images.

abstraction. One reviewer suggested that "a glance at the Ryder 'Moonlight Marine' in the book and then at the Baziotes 'Dragon' should convince the observer that abstraction is neither new nor arbitrary and that it is present in the use of essential forms in the painting of our great romantic realist as much as in that of our poetic abstractionist of today." The times *appeared* to be changing, but as we shall see in Chapter 5, modernism still faced an ideological firing squad during the 1950s.[56]

The exhibition of contemporary American art that opened at the Met on December 8 had a new and different dynamic because more

than 6,200 artists had responded and entered the competition. Of that number 728 made it to the final judging, from which 307 were selected. A strong note of national pride was sounded by the associate curator of American art, Robert Beverly Hale. "I am convinced," he announced, "that in many respects their work surpasses that being done in any other country." A parallel tone appeared in a *Times* editorial that praised the political importance of the show. Its very inclusiveness, "from old-fashioned realism to completely non-objective painting," warranted warm praise. "The Metropolitan's gesture at this time, in a confused and heartsick world, is in itself an affirmation of belief in the importance of culture and a further affirmation of democratic principles at a time when faith is sorely needed."[57]

Media coverage suggested that the Met was reclaiming from the Whitney a serious role in the presentation of American art, but that judgment proved to have been rather premature. The reviews stressed repeatedly and affirmatively that a dominant motif would be found in "the artist reacting emotionally to our age. Abstraction, in some degree, is almost everywhere evident." Even the photography of Edward Weston was singled out for praise because his close-up of a green pepper resembled a nude woman's slightly turned back. "Photography, which first stressed utter realism and subject matter, is helping to train the public eye to surrealism and abstraction." Ironically, of course, almost all of the leading Abstract Expressionists, the group that would give American art its international dominance for the next quarter-century, were absent because they assumed that the selection process would be hostile to them.[58] Their boycott provided a preview of numerous museum exhibitions during the next two decades where discontented and vocal artists protested the exclusion of whatever they happened to be most enthusiastic about.

The rapidly shifting reputation of Abstract Expressionism at midcentury reveals a time of artistic experimentation and flux. Even before the end of World War II this development in the so-called New York School began to be touted by certain collectors and art critics, most notably Clement Greenberg and Peggy Guggenheim, and yet was scorned by others. At midcentury the mass media, such as *Time* and *Life*, began to tout the reputations of certain artists without actually endorsing them. Most notably in 1949, *Life* titled an essay "Jackson Pollock, Is He the Greatest Living Painter in the United States?" What emerged from the piece, at once celebratory and skeptical, was quite typical. The press found much to like but also much to mock,

calling Pollock's technique "dribbling" and later designating him "Jack the Dripper." Sarcasm abounded in much of the coverage.[59]

Nevertheless, the very nature of Abstract Expressionism made it seem simultaneously apolitical (especially compared with the content-laden, left-oriented social realism that immediately preceded it during the 1930s and early 1940s) and a powerful symbol of American individualism and freedom of expression that could be favorably contrasted with the Stalinist constraints of socialist realism. Observers asserted that the modern artist "is preserving something that is in great danger—namely, our ability to remain individuals." *Life* magazine summed up a round-table discussion that it sponsored by declaring that the work of the new avant-garde "is at bottom the struggle for freedom."

> As several at the Table pointed out, the temptation in authoritarian societies is to settle the problem of modern art by fiat. Both Hitler and Stalin have actually done so—and in both cases the artists were ordered to return to representational painting. . . . In light of it the layman who might otherwise be disposed to throw all modern art in the ashcan, may think twice—and may on second thought reconsider.[60]

That round-table discussion is symptomatic in several respects. First, even the experts could not agree on the significance of Picasso's *Girl Before a Mirror,* now considered a masterpiece. So what could be expected of laypersons? At midcentury the latter were clearly at least agog over modern art, and trying to figure out what it was all about, but still found it difficult to appreciate, never mind understand. Robert Motherwell may very well have been the most articulate of all the American abstract artists, and this is his summation late in 1950:

> The process of painting then is conceived of as an adventure, without preconceived ideas on the part of persons of intelligence, sensibility, and passion. Fidelity to what occurs between oneself and the canvas, no matter how unexpected, becomes central. . . . The major decisions in the process of painting are on the grounds of truth, not taste. . . . No artist ends up with the style he expected to have when he began. . . . It is only by giving oneself up completely to the painting medium that one finds oneself and one's own style.[61]

If subjectivity and spontaneity were so central and so crucial to this new and influential development, is it any wonder that the public at large found it very difficult to grasp, never mind view the "product" as appealing? As Donald Kuspit has observed, modernism in art was very much about anxiety, rebellion, and destructiveness on the part of practitioners, and those impulses, in turn, prompted "aggression, desire and a power to negate." That is not simply a perspective from hindsight. Here is Motherwell's answer in 1951 to the question, what does abstract art mean to you? As a response to the conditions of modern life, he asserted that it was "rebellious, individualistic, unconventional, sensitive, irritable . . . this attitude arose from being ill at ease in the universe." Those are not qualities that most Americans were accustomed to expect, let alone welcome, in art prior to the 1960s.[62]

If the mass media sent mixed signals by continuing to notice yet lampoon modernism in various ways throughout the 1950s, the general public pretty clearly resonated to the humor more than it did to the ideological hype about American freedom and individualism. After *Life* ran its major and highly ambivalent assessment of Pollock in 1949, the 532 people who wrote letters to the editor mostly joined in the fun, mocking Pollock's technique, his skill, and even his sanity. He remained a highly visible joke, at least for a while.[63]

Because of pressure from Alfred H. Barr, "A Statement on Modern Art" was produced in March 1950 and signed by the directors of MoMA, the Whitney Museum, and the Institute of Contemporary Art. Its most important tenets included a rejection of narrow nationalism in the arts, a defense of modern art's hermetic qualities as "an inevitable result of its exploration," and an underscored belief in "the humanistic value of modern art even though it may not adhere to academic humanism with its insistence on the human figure as the central element." The text did, however, include an important hedge, a paragraph devoted to the importance of the artist communicating intelligibly with the public and a reaffirmation of the "validity of conservative and retrospective tendencies." The museums hoped, if possible, to avoid alienating anyone.[64]

What might be called the art establishment, however, warmed rather swiftly to the Abstract Expressionists during the 1950s. Their work soon dominated commercial galleries and then institutions like the Museum of Modern Art, so much so that by 1953–54 a distinguished group of realists and representational painters organized to produce a publication protesting their virtual exclusion from places of

visibility in the art world. When it came to selecting artists and their works for prestigious international exhibitions such as the Venice Biennale, Abstract Expressionism went from being reasonably well represented in 1954 to a position of dominance at the privately funded American pavilion in 1956. The CIA even provided covert support to ensure that American-made abstract art enjoyed pride of place because of its stark contrast with the art being done behind the Iron Curtain. Hence the huge irony that U.S. government agencies and elite art institutions did their very best to promote a type of art not well regarded by the lay public at home.[65]

By the later 1950s the triumph of Abstract Expressionism was virtually complete within the art world, even though derisive comments continued to appear in the popular press. Modernism seems to have achieved a level of professional acceptance utterly inconceivable one or two decades earlier. Prices for work by the Expressionists soared in the 1960s, even as people still joked about paintings by Pollock and others that hung upside down without anyone seeming to know the difference.[66] It is believed that the longest period of time for which a painting was so displayed in a public gallery was forty-seven days. That occurred between October 18 and December 4, 1961, at the Museum of Modern Art. The picture was *Le Bateau* by Matisse, a sailboat and clouds with their complete reflection inverted directly below the water line. Judging by the size of screw holes on the back of the frame, it may have been hung right side up only once in its ten-year existence.[67]

Although highbrow institutions, affluent collectors, some government agencies, and worldly exhibition audiences were now warming to modernism for reasons that varied from national chauvinism to sheer investment value, the American heartland still was not altogether ready in the 1950s. Take, for example, the 1954 commission awarded to Kenneth Evett to paint three major murals for the rotunda of the state capitol in Lincoln, Nebraska. It is a remarkably modern building (decidedly not neoclassical) begun in the mid-1920s with many design features, including friezes and murals, that perpetuated nineteenth-century aesthetic values. Those elements gradually emerged over several decades as budgetary considerations permitted. Evett's fifteen-by-twenty-four-foot rotunda murals would essentially complete the structure as an artistic ensemble, and they would be especially visible to visitors passing through.[68]

Evett, a native of Colorado who had done post office murals for the Treasury Department Section of Fine Arts during the late 1930s in Kansas, Colorado, and Nebraska, was a forty-one-year-old assistant professor of art at Cornell University in 1954 when he won a competition for which careful designs had to be submitted. A major requirement stated that the murals must harmonize with the angular and quite vertical architecture of the building. Its massive tower conveys a sense of dignity and power and can be seen for miles. The motifs assigned for the murals were Labors of the Head (mainly scientific pursuits), Labors of the Heart (honoring the arts), and Labors of the Hand (the manual labor of builders and miners, but especially cattlemen and farmers). The public, and particularly members of the state legislature, wanted illustrative ("pictorial") art that had some narrative content, perhaps similar in style to the murals done by Thomas Hart Benton for the Missouri State Capitol in 1936. (Those had actually caused a heated controversy because of their content, as we shall see in the next chapter.)[69]

Evett did not feel enthusiastic about the required subjects, having done that sort of thing to satisfy small-town citizens fifteen years earlier. In June 1954 a Lincoln newspaper interviewed nine people from Pawnee City, Nebraska, to report their reactions to Evett's mural called *Country Auction*, done for the post office there late in the 1930s. Most of them offered grudging approval but felt that his style would be inappropriate for the state capitol. A clergyman called it "good but not . . . typically Western. . . . I hope the picture he paints for the Capitol Building is more in the Nebraska tradition." Another explained that it was "definitely 'impressionistic' and the 'impressionistic' school is completely foreign to our midwestern thought and even 'faddish.' " A physician who said that he liked the mural nevertheless expressed hope that the new work would be "more along Nebraska lines." One man who chose to remain anonymous exclaimed: "It ought to be thrown in a trash can. I think it stinks."[70]

By 1954 Evett had become a committed modernist though he preferred to call himself a "modern classicist" because of his deep concern for form, definition, and clarity. His work for the capitol turned out to be representational but symbolic rather than realistic. His style was a deliberately flat, crisply outlined geometric schematization that offered a kind of modified, Americanized Cubism. When his *Labors of the Hand* was dedicated in November 1954, bitter complaints were directed especially at what viewers designated the "square bull." All of

the figures were shown frontally, and this bull (standing beside a farmer) loomed with massive-shouldered solidity that would have pleased a meat market but not this midwestern audience. They knew a bull when they saw one, and Evett's did not look the part. One state senator felt that the figures "appear to have been drawn with a T-square." By February the state legislature was in an uproar over this initial installment. The *Lincoln Journal and Star* teemed with feature stories, cartoons, and letters calling Evett's work "putrid" and "primitive," "distorted," and, the most damning epithet of all, "modernistic." It received warm praise from many art critics, however, and an encomium from the director of the Joslyn Art Museum in Omaha.[71]

Evett was permitted to continue, even though one state senator wanted the panel removed and the entire contract disallowed. The artist completed the other two murals during a sabbatical year in Rome. When news of that "un-American" arrangement reached the press, the public's response was predictable. Evett received an affable letter from Harry F. Cunningham, professional adviser to the selection commission who had been his advocate from the outset.

Will you give me a brief explanation as to why you want to do your work in Rome. This for the reason that several persons of better than average intelligence have asked me, "why does he want to work in Rome; is it that he wants classical or Renaissance inspiration?" I answer that it is because you can get a fine studio there, probably at the American Academy; that the peace and quiet of such a setting as the Academy will be helpful to creative work; etc. But I cannot seem to satisfy the funny notions that feel that America is a good enough place to do anything. Such notions are particularly prevalent in this mid-West. If you will give me a "good line" I shall see that it gets in the newspapers and people will be satisfied.[72]

When the completed murals (mainly using a handsome combination of browns, red, and buff) were installed in 1956, there was no formal unveiling, in order to minimize media coverage and public consternation. But the complaints continued. One statehouse employee remarked: "I feel that the mural in the Capitol is grotesque and ugly. Why don't we have a prairie scene such as Miss [Elizabeth] Dolan painted, or a prairie scene with Indians? But, for heaven's sake, let's get rid of that seventh grade art class stuff." Another visitor con-

ceded that "I know little about art, but I know what I like and enjoy and to me modernistic art is putrid. . . . You do not have to be an artist, an art critic, or a patron of the arts to enable you to enjoy it. A great majority of the people who do enjoy art in its many forms are not experts. The murals in the Capitol should appeal to a majority of the people, not to the few who for some unexplainable reason, want to look at something that is supposed to look like something that has been distorted and crucified beyond recognition."[73]

The heartland was clearly not ready for modernism in the mid-1950s, at least not the ordinary citizen sufficiently articulate to voice an opinion but not well versed in current trends. It evidently did not help to salve the wounded pride of Cornhuskers that Evett was not a native Nebraskan, and, to make matters worse, was identified with New York and preferred to paint in Europe. There were almost as many complaints about his geographical affiliations as there were about his stylistic inclinations. Significantly, Henry Luce's *Time* and *Life* had expressed strong support for American regionalism in art during the later 1930s and 1940s. Only in the 1950s had such publications begun to come around to explaining and supporting Abstract Expressionism because it suited the Cold War emphasis upon American individualism, personal creativity, and freedom of expression.[74]

Although those magazines and others like them were being read in mid-America, the "plain folks" there still wanted a bull to look very much like a bull rather than a geometrical simulation. It is tempting to recall that Robert Henri had been born in Nebraska and to speculate that perhaps he prudently left for Philadelphia because he aspired to a career as an innovative artist. As it happened, however, his father fled from the Platte River area after he killed a workman and decided that the better part of valor would be to vanish and relocate in Atlantic City, New Jersey.

With the bold emergence of Pop Art in 1962 and then Minimalism, swiftly followed by a series of other, overlapping "isms," modernism began to seem familiar, "old hat," even if not entirely tame or comprehensible. Large numbers of Americans still did not care for abstract art any more than before; but it clearly was going to endure, valued by many who paid substantial prices for it; and people also became aware that it somehow added to America's cultural preeminence. During the

1950s that meant a great deal. If modern art enhanced an ideological edge in a polarized world, it must not be all bad.

As late as the close of the twentieth century, however, the media could still find fodder for public interest by taking on and tweaking American modernism. In 1993 the CBS newsmagazine *60 Minutes* featured a segment titled "Yes . . . But Is It Art?" that questioned the very premises of abstract art. Host Morley Safer began by quoting P. T. Barnum's legendary quip about a sucker being born every minute. Safer proceeded to scorn most contemporary art as "worthless junk," given value only by the "hype" of critics, auction houses, and dealers committed to misleading the public. A predictable furor promptly developed in exactly those circles as collectors joined the fray and scrambled to obtain a tape of the show. A typical response came from color-field artist Ellsworth Kelly, who expressed disappointment "that a group of people like *60 Minutes* who are generally respected have slipped up so completely that none of them are more sophisticated about the arts." The owner of the prestigious Pace Gallery declared that the televised segment "stank of anti-intellectualism."[75]

When describing a painting from the 1950s by the American artist Cy Twombly that had sold at Sotheby's the previous year, Safer observed that "this one, a canvas of scrawls done with the wrong end of a paintbrush, bears the imaginative title of *Untitled*. It is by Cy Twombly and was sold for $2,145,000. And that's dollars, not Twomblys." Safer seemed astonished that urinal sculptures by the artist Robert Gober could possibly be considered art, but he never mentioned that Marcel Duchamp had entered an actual urinal titled *Fountain* (and signed "R. Mutt") in an important American exhibition in 1917, which became the genesis of a swelling trend: ready-made and found objects as art.[76]

Using clips from a film of Sotheby's major auction of modern art in November 1992, one segment of the *60 Minutes* program showed the auctioneer correcting an error in the catalog. "Lot 242, the Gerhard Richter," she warned: "Please note that the measurements for this work are reversed. It's actually a horizontal painting; I'm sorry, it's actually a vertical painting, seventy-eight by fifty-nine." The camera then zoomed in on a close-up of the painting as if to underscore the bewildering nature of abstract art. Safer interviewed two prominent conservative critics to reinforce his point of view. He also spoke with a New York collector who owned one of Gober's urinal sculptures.

When he described a "white rectangle" by the artist Robert Ryman, the collector explained that the artist "had reduced painting to its very essence, and a lot of people don't understand that but—" whereupon Safer interrupted to assert, "I confess I'm one of them."[77]

The president of the Museum of Modern Art, where a Ryman retrospective just happened to be under way, declared the CBS show entirely negative and lacking in balance. Larry Gagosian, a prominent Manhattan gallery owner, agreed and explained that he wasn't surprised. "They stacked the deck," he noted, "but it's the nature of the way media and society deal with radical or new art; they devour their newborns. It was a pretty cheap shot." When told of Gagosian's views, Safer responded caustically: "I resent people saying the show was a cheap shot. If you want to look at a cheap shot, look at Mr. Koons's or Mr. Gober's art. By no definition is it art." A week later Safer responded in the *New York Times* to concerns that he had questioned "the very premises of abstract art." "If you genuinely believe that the derivative pissoirs, infantile scrawls, and gibberish uttered by painters on canvas and critics in journals raise the spirit and tease the imagination, then I apologize to our viewers and your readers. If, on the other hand, you were simply doing your civic duty by supporting a sagging local industry, I understand."[78]

One might have thought that by the 1990s the battle over modernism had finally and mercifully run its course, with grave markers carefully arrayed for the casualties. In many ways it actually had done so, and new issues had come to the fore. But disputes did linger over the legacies of modernism (fairly numerous), and they involved critics and museum officials as well as the public on both sides of any given dialogue. Modernism may be finished in some technical or historical sense, but it does have an afterlife in which consensus is as rare (or thick) as the air one might expect to breathe in places associated with the afterlife.[79] Cultural change is commonly destabilizing, yet failure to change is invariably stultifying. People do tend to channel artistic change *and* stasis with other changes or stasis in society.

Troubles with Murals

Our focus here will mainly be the lost lessons of the 1930s and 1940s. Lessons *ignored* might actually be closer to the mark than *lost*. They are surely an important instance of historical amnesia inducing disregard for latter-day policy implications. During the 1960s and 1970s, when the federal government began to provide funding for public art by way of the General Services Administration and the National Endowment for the Arts, controversial episodes emerged swiftly, though we are more likely to recall works that caused intense, ongoing disapproval rather than those that received calm acceptance. What we barely remember at all, however, is that public art (most often in the form of murals for post offices and courthouses) became a frequent source of social friction during the 1930s and 1940s. One reason those conflicts are so unfamiliar to us today is because they were rarely referred to (let alone carefully scrutinized) during the public art battles of the later twentieth century, despite the fact that there were important procedural lessons to be learned from some of the unfortunate conflicts that occurred during the New Deal era. Most important, perhaps, is the lesson that public art cannot simply provide a willful ego trip for a determined artist. If the community or audience for such work is unhappy with the outcome, trouble is bound to bubble up.

There are, to be sure, some very significant differences between aesthetic issues that arose during the 1930s and those in more recent times. A preponderant majority of all of the murals back then were fully representational, whereas much of contemporary public sculpture is abstract and its meaning therefore obscure—when it is actually

intended to have "meaning" at all rather than just form. Also, even though many murals could be fairly large, their size did not usually become offensive or overwhelming in the way that gigantic three-dimensional abstract works do. Minimalism on a massive scale makes for a curious combination: it is not only big and "in your face," it may also be in your way. On the other hand, contemporary public art does not usually contain ideological content or political messages, explicit or implicit, whereas the 1930s murals quite often did. And because New Deal artists tended to be more politically radical than their audiences, those messages had the potential to spark conflict.[1]

Even though historical awareness and greater sensitivity might have averted or minimized at least some of the clashes that occurred during the 1970s and 1980s, differences between the circumstances of these two generations are striking and significant. Public art in our own time is meant to be "site specific" in a newly defined way. It is not only created with a very particular place in mind but frequently requires collaboration or consultation between the artist and an architectural firm.[2] By contrast, during the 1930s the vast majority of artists had no personal relationship with the community for which they were commissioned to paint a mural, and ordinarily there were no funds to send them there in order to consult and become informed about the aspirations and mores of the locale. Moreover, many of the artists seem to have been remarkably oblivious to the historical nature and needs of their designated communities.

To make matters worse, administrators in Washington often arbitrarily reassigned schemes and sketches prepared by artists with one venue in mind to a different location with an entirely different history and economy. In 1939 the Treasury Department Section of Fine Arts of the Public Works Agency created a huge nationwide contest called the 48 States Competition. It attracted the largest number of entries of any competition in that decade: 972 artists submitted 1,477 designs. The plan somehow managed to be simultaneously simple and yet complicated. At least one ordinary post office in every state would receive a mural for the end wall above the postmaster's door. Because a certain amount of generic planning by the artists became necessary, the Section offered some rough guidelines: categories of subjects for consideration, such as the postal system, local history, local industries, flora and fauna, popular recreational activities, agricultural developments, or area landscapes. The Washington office did, at least, offer this commonsense (indeed, rather obvious) advice, even though it would not be

easy for most low-budget aspirants to act upon it: "Experience has indicated that subject matter, based upon knowledge of the particular locality, frequently aids the artist in his desire to achieve vitality."[3]

Painters often imagined what might be most suitable for a given venue without doing adequate research, and consequently they highlighted the wrong crops or an inappropriate topography. After New York–based painter Joe Jones received a commission to paint a mural for the Seneca, Kansas, post office, he sent off a color sketch, *Men and Wheat*, showing two farmers at work on a tractor and a combine in the midst of a Kansas wheat field. When photographs of the sketch were published in Seneca, the town's postmaster wrote Jones explaining that his scene did not reflect the geography, the architecture, or the predominant crop of northeastern Kansas. Jones initially resisted making changes, insisting to the Section authorities in Washington that "postmasters are never typical in their community." He stubbornly charged that the proposed modifications amounted to "a near destruction of content." Eventually, however, he altered the mural background and crop to make it a scene more typical of the region. That tale is representative of conflicts that eventually achieved a reasonably satisfactory resolution.[4]

On other occasions the artist's quest for realism ran counter to a community's pride, idealism, or prudent wish to avoid witnessing on a daily basis some depressing reminder of dangers faced in pursuit of the principal local livelihood. When Fletcher Martin won the competition for a post office mural in Kellogg, Idaho, a mining community, he designed, prepared sketches, and painted in tempera on panel a work titled *Mine Rescue* in which two grim miners carry a third (who may be dead or injured) on a stretcher from the interior of a claustrophobic mine shaft. The citizenry of Kellogg protested to authorities in Washington that the subject was unsuitable because it would offend local families who had lost loved ones in mining accidents. Because the Section leadership in Washington happened to admire this painting, however, it initially resisted and tried to persuade Kellogg to accept the work just because it was "good art." When the protest persisted, however, the administrators backed down and insisted that Martin choose a different motif. His alternative mural of two enthusiastic early prospectors at the very moment when they strike ore comes off as conventional if not downright corny. But Kellogg felt vindicated and satisfied.[5]

The men who ran the program in Washington, Edward Rowan and

Edward Bruce, had fairly keen eyes for quality art yet genuinely wanted to please their communities. Conflicts and controversies were not exactly desirable, and when the vision of an artist ran counter to the self-image of a locality, the latter usually won out, though not always. On some occasions, when Rowan and Bruce were especially partial to a particular design, they might delay taking action adverse to the painter in hopes that the conflict would somehow subside or spontaneously go away. Usually it did not, with the result that the issue dragged on and left a very bitter aftertaste.

That is exactly what happened in Aiken, South Carolina, in an unusually protracted and bitter dispute involving an image of Justice commissioned for a federal courthouse. The New York–based artist Stefan Hirsch had never been to South Carolina and could not afford the trip until his mural was ready for installation. His style was flat Cubism, for which Aiken was not exactly ready in 1938. His female figure of Justice had dark skin and facial features suggesting to locals that she might be a mulatto, which did not sit well in South Carolina at the time either. The side panels, devoted to symbolic Protectors and Avengers, featured robberies, beatings, and a prisoner who might have been entering or leaving prison—it was unclear which. The presiding judge did battle with Washington for several years. Unsuccessful in getting the despised mural removed, he had it covered with a curtain, which at least concealed the painting whenever court was in session. That only occurred for a few days each year, which exacerbated anti-Washington antagonism because locals felt that money spent on building the courthouse could have been used productively in ways more beneficial to the residents of Aiken.[6]

A different kind of war was waged in 1938–39 between artist Marion Gilmore and the Section over her commission to paint an evening band concert for Corning, Iowa. In this instance the authorities leaned heavily on the artist to eliminate from her design any objects and scenery not actually found in Corning, thereby insisting upon authenticity and deferring to the wishes of the community. Gilmore had placed a memorial obelisk and a cannon alongside the bandstand because such things often appeared that way in other Iowa towns, and she wanted her picture to be representative—a generic midwestern community, as it were. Rowan insisted that the obelisk and cannon had to go, so Gilmore obliged but somehow managed to insert some attractive landscaping rather than reveal the unappealing "downtown" that ordinarily could be viewed behind the bandstand. The ultimate

image conveyed the warm bucolic glow of a summer evening in a town where nature took priority over vernacular architecture. It *appeared* realistic even though it sentimentally flouted matters of documentary detail. When it was installed in 1941, the community seems to have been quite pleased. The local paper even reproduced the unrevised, inauthentic original sketch with cannon, thereby putting the contretemps behind them.[7]

If designated artists too often preferred their personal notion of what might be appropriate over that of the locals, Section administrators could be equally opinionated and obtuse. In 1936 Georgina Klitgaard won the competition for a post office mural in Goshen, New York. Urged to learn about the town's history and enthusiasms, she gladly complied because Goshen was accessible, unlike Seneca, Kansas, or Aiken, South Carolina. Following her personal visit she reported that "there remained no doubt as to what the subject matter . . . should be. The whole-hearted pride and interest of the town— the business too—concerns horseracing, the 'harness horse,' preparing for and bringing off the summer Hambletonian, a racing meet which has taken place since before the Civil War." Harness racing was not merely the local passion, it remained a major source of tourist income and shaped the very identity of Goshen.[8]

Ed Rowan was appalled, however, because horse racing seemed to him a totally inappropriate subject for a public building. Only after the Goshen postmaster personally appealed to Washington was approval forthcoming in favor of the horses. In this instance the artist and the community cooperated closely. The assistant postmaster had been "following the races for years," and the manager of the Good Time Track, a collector of equestrian paintings, provided Klitgaard with photographs and design criticism. The Section chiefs, however, kept carping about details. When the artist put her color sketch on display in the post office, locals approved heartily. Nevertheless the Section heads withheld Klitgaard's commission and continued to quibble about quirky particulars. The racecourse looked crooked, the hindquarters of the trotters seemed too small, and their flying tails were "offensive" to good taste. As the artist ruefully remarked, "What they said in Goshen doesn't matter much."[9]

The Running of the Hambletonian Stake was finally approved and put up, "offensive tails and all," and much to the astonishment of the Section, letters of appreciation began to flow in. A ranking postal official who stopped there for a visit in 1938 reported that the mural looked

"splendid" and even touched off a local campaign to have Klitgaard compose a second panel for the opposite side of the lobby! It never happened because the artist had sacrificed considerable income while engaged in her struggle with Washington for earnings of less than thirty dollars per month. She couldn't afford to continue painting in Goshen. A sympathetic informant in Washington advised Klitgaard and her husband that Rowan and his associates, however well-meaning, were nicknamed "little schoolmarm Hitlers."[10]

Although that barb seems harsh, the program was undoubtedly administered in an arbitrary manner. Admittedly, each case had to be considered on its own merits, but no clear pattern or rationale existed for Washington's support for the community on some occasions, for the artist on others, and sometimes for neither because the Section believed that it knew best. When Kenneth Evett received a commission for the post office mural in Caldwell, Kansas, he sketched a livestock shipping scene, something quite basic to that railhead community. The local postmaster, however, envisioned a romanticization of the Old Chisholm Trail, because its creation in 1867 had caused the emergence of Caldwell as the transfer point where cattle began their trip by rail to eastern markets. The postmaster told Evett: "My idea of the mural would be a herd of cattle on the plains with cowboys driving them along a trail."[11]

Evett did not care for the idea and sent Rowan another sketch of a contemporary scene accompanied by this explanation:

> The subject matter of the sketch, as you see, doesn't correspond with the suggestions offered by the Caldwell postmaster. I don't want to be uncooperative but must we do historical murals indefinitely? The concept of cowboys herding cattle is especially unexciting to me. Yet here is this postmaster with his heart set on cowboys herding cattle. Since I'm much more interested in the mural material offered by the barn forms, the animals, machinery, plants, and simple human situations . . . I make so bold as to do the sketch about these things.

In 1941 the postmaster got exactly what he wanted, *Cowboys Driving Cattle* along the Old Chisholm Trail. Rowan intervened in this instance and leaned very hard on Evett, not because he felt nostalgia for the historic cattle drives but because he did not want to reject local preferences categorically when there seemed to be no aesthetic or

political reason to do so. As he told Evett, "We are very anxious whenever possible to give the public what they want."[12]

Evett's lament about the surfeit of historical murals gets to the heart of the matter during the 1930s. Times were tough, so painting a contemporary scene could be awkward at best and downright grim if candor prevailed. Consequently historical murals provided a safe and sound alternative. Best of all were moments of genesis, images that vivified the mythic moment when a consensual community came into being. These have been labeled "foundation pictures" by Karal Ann Marling and others. The formula explains the remarkable success of works like *First Pulpit in Granville* by Wendell Jones, a mural that described the way settlers cut down a tree in order to facilitate worship upon reaching their new home in Ohio.[13] That icon clearly indicated the path to success in New Deal image-making. Go back to roots, highlight the creation of community, and keep in mind that a touch of piety doesn't hurt either.

Historically descriptive murals in the southern states presented special problems because too often the commissioned artists turned out to be northerners who simply did not understand the regional readings of history that were distinctive to the South. Moreover, Section officials had neither the time nor the inclination to double-check both the actual events and southern preferences or versions of them. Consequently the citizens of Radford, Virginia, rejected a sketch for *The Return of Mary Ingles* (an Indian captive from 1755) and requested instead something that would "do justice to the natural beauty of this section of the country." In Petersburg, Virginia, local media spurred on by the Sons and Daughters of the Confederacy found intolerable a mural of J.E.B. Stuart's cavalrymen swimming the Chickahominy River, especially considering that Jared French's initial version had them unclothed. In Paducah, Kentucky, some citizens seemed satisfied with a depiction of the city as it looked a century earlier, but many could never accept the fact that their mural did not depict General George Rogers Clark's contribution to the development of the nation. History was not a matter of options and choices. It had to be tailored to suit local priorities.[14]

The same problem caused even more controversies concerning the particulars of southern agriculture, perhaps the single most common motif in regional post office murals. A New Jersey artist named Lee Gatch sought to portray different phases of tobacco curing as a kind of horizontal narrative. What he learned from a helpful librarian did not

match the actual nature of the process in Mullins, South Carolina, and locals had a field day with all the flaws in his design: wooden floors in a tobacco patch, plowing at harvest time, sorting prior to curing, driving narrow-gauge carts into the tobacco, and juxtaposing racial types that would not have worked side by side. Although asked to redesign the project, he stubbornly made few changes. The mural went up anyway, and the local paper (and postmaster) registered their bitter disappointment.[15]

Similarly Philip Evergood, one of the leading social realists, did his research in the New York Public Library for a mural devoted to *Cotton—From Field to Mill* for Jackson, Georgia. He failed to submit a design to the locals for their approval and managed to get the basic procedures wrong. The weighing of cotton takes place in the field, not in front of a mill. The scale of Evergood's mill, the gin, and the train are bizarre; but worst of all, the figures are misshapen and racially mixed. As Sue Beckham puts it, the artist "seems to have included the whole ill-fed, ill-housed, and ill-clothed third of the nation. People are everywhere, and all of them are lumpy." Moreover, whites and blacks, males and females work together doing precisely the same tasks, which is not the way white majorities idealized southern life in 1940. After the mural was installed, Washington officials learned that "comments have been unfavorable and critical." After Rowan received the fourth attempt at a design, he had actually warned Evergood: "Care should be used to avoid carrying the tones of the negroes too low in value as this is a sensitive point"; and Evergood was also advised to add a colonial mansion in the background so that viewers would not assume that all southerners were cotton workers. The mansion Evergood inserted is so small that it is barely visible.[16]

One of the most egregious episodes of outsider insensitivity involved a New York City artist named Harold Egan, who disliked historical and documentary painting and determined to make strikingly modern works for Okolona, Mississippi, and Wake Forest, North Carolina. He did not consult either the locals or their traditions, and his *Richness of the Soil* for Okolona (1938) featured a horizontal, semimythical female apparently lying on a riverbed with an indescribable agrarian water sprite pointing a forefinger at her misplaced left breast. Three years later he did a variation on the same motif for Wake Forest, this time with gigantic stylized farmers (thereby creating problems of scale once again) and a baffling landscape. In the central background

there is a significant body of water, perhaps the ocean, with a major vessel crossing it. But the ship seems to sail from a landlocked factory and heads for a landlocked warehouse of some sort. A farmer covers the ground with tobacco leaves while magnolia blossoms sprout straight out of the soil. The mural never received final approval, and a disgruntled resident of Wake Forest who spoke for many "has yet to find anyone who admires [the mural], in my opinion it is terrible."[17]

In May 1932 the Detroit Arts Commission, with support from Edsel Ford and initiative from the director of the Detroit Institute of Arts, commissioned the Mexican muralist Diego Rivera to undertake major murals for the institute's baroque-trimmed central court. Rivera's work had been receiving both international acclaim and notable appeal in the United States—he had just enjoyed a successful exhibition in San Francisco—and the Detroit commission was especially receptive to the narrative elements in Rivera's work. He eagerly accepted and, almost anticipating the content preferred by the U.S. Treasury Section a few years later, chose to ignore the Depression, which had hit the automobile industry especially hard. Instead he wanted to illustrate the awesome capacity of production-line manufacturing and spent several months sketching at the River Rouge and Dearborn plants of the Ford Motor Company as well as other factories and laboratories in the area. He was intrigued by ultramodern mechanization and the effects of its environment on workers. As a sometime member of the Communist Party, ideology was not absent from his concerns, but it did not dominate excessively on this project. As he wrote,

> The frescoes were inspired by a belief in things even broader than Communism. They were inspired by a belief in the worker. I am a worker myself. I know the worker. And I have painted him as I know him and see him. I understand the struggle of the worker. And I have tried to put in these frescoes that struggle as I understand it.[18]

At the official opening of the murals on March 19, 1933, however, angry protests did occur. Some referred to alleged Communist imagery and religious disrespect but above all, perhaps, objected to the unsuitability of these intensely busy, crowded paintings for such a

serene and highly traditional architectural setting. Some called for parts or all of the mural to be whitewashed, and the editor of Detroit's *Free Press* injected a note of fierce nativism that was typical of the time: "An art director is brought from Germany [William Valentiner, a Rivera enthusiast] to commission a Mexican artist to interpret the spirit of an American city. Why not hire a French director to find us a Japanese muralist to tell us what he thinks we look like?"

At times such sardonic objections from detractors verged upon physical confrontation with museum staff and those who liked what Rivera had done. The curators published promotional materials to explain the paintings and organized the People's Museum Association to help mollify hostile public feelings. Valentiner declared that "in their gigantic conception the murals would seem to be the most important addition in the field of modern art that has been made at the museum since its opening." With continuing support from Edsel Ford, the arts commission decided to "leave the final decision to coming generations." The risk of removal had been quite genuine, however.[19]

The outcome of Rivera's next controversy would be less fortunate, and the artist bears a major burden of responsibility. He had met Nelson Rockefeller late in 1931 after an exhibition at the Museum of Modern Art opened. The following year, with Nelson's enthusiastic approval, the development manager for Rockefeller Center in Manhattan, then under construction, invited Rivera to paint murals that would occupy the most desirable location in the entire complex, the large principal wall on the ground floor of the RCA Building. Countless workers and visitors would view it daily as they waited for elevators. The motif would be "New Frontiers," and it would establish the fundamental theme for many other artworks commissioned for the center's buildings. It has been said that Rivera typically signed the contract (elaborately specific as to content) in November 1932 without ever reading it.[20]

Rivera's detailed description of the design and rationale he had in mind should have made it quite clear that a confrontation would surely be inevitable: "my panel will show the Workers arriving at a true understanding of their rights regarding the means of production, which has resulted in the planning of the liquidation of Tyranny. Personified by a crumbling statue of Caesar, whose head has fallen to the ground, it will also show the Workers of the cities and the country inheriting the Earth."[21] Given a go-ahead despite his radical candor,

Rivera began work in March 1933 and hoped to finish within six weeks, an astonishing expectation even for a man who was capable of working for prodigious periods of time. Soon after starting, he indicated that he fully expected negative criticism of the sociopolitical content he had in mind. He called his ambitious and complex design *Man at the Crossroads Looking with Hope and High Vision to the Choosing of a New and Better Future.*[22]

For one part of the panel Rivera used his sketchbooks from a May Day celebration that he had observed in Moscow in 1927. Apparently Mrs. John D. Rockefeller Jr. rather liked the sketches. During April 1933 his rendering of an anonymous "labor leader" wearing a worker's cap had grown increasingly to resemble V. I. Lenin, revolutionary founder of the USSR. Soon the cap gave way to the familiar bald head. And by the end of April the visage became unmistakably Lenin's, quite lifelike and dominant, the strongest face in the entire fresco in fact (fig. 36).

Predictably, perhaps, trouble started with the media. On April 24 a

36. Diego Rivera's unfinished mural,
*Man at the Crossroads Looking with Hope and High Vision
to the Choosing of a New and Better Future* (1933).
Photo by Lucienne Bloch. Bloch took one of the few pictures of the work
just before it was destroyed. Courtesy of Old Stage Studios, Gualala, California.

reporter for the *World-Telegram* who had been closely observing progress on the project ran a story with this headline:

Rivera Paints Scenes of Communist Activity
and John D. Jr. Foots Bill

Rivera correctly noted that the mural would be "likely to provoke the greatest sensation" of his career. This bombshell account only aggravated the mounting complaints from observers that the design was too realistic and the colors too vivid. Public interest and concomitant tension mounted. A wayward Communist needing to reestablish his bona fides with the party was bearding the most eminent embodiments of capitalism in their own den.[23]

On May 4 Nelson Rockefeller sent a polite letter requesting that Lenin's image revert to that of a generic labor leader. Rivera refused but offered to offset Lenin with a portrait of Lincoln on the opposite side.

> I could change the sector which shows society people playing bridge and dancing, and put in its place in perfect balance with the Lenin portion, a figure of some great American historical leader, such as Lincoln, who symbolizes the unification of the country and the abolition of slavery, surrounded by John Brown, Nat Turner, William Lloyd Garrison or Wendell Phillips and Harriet Beecher Stowe, and perhaps some scientific figure like McCormick, inventor of the McCormick reaper, which aided in the victory of the anti-slavery forces by providing sufficient wheat to sustain the Northern armies.

On May 9 Rivera was ordered to stop work and leave the building with his assistants. He was not permitted to take photographs of his nearly completed mural, and the contractor's uniformed guards swiftly covered the entire project with heavy canvas.[24]

The whole affair became a genuine cause célèbre, and coast-to-coast reporting proved disastrous for Rivera's career in North America. Demonstrators on his behalf repeatedly picketed Radio City demanding that the mural be uncovered and Rivera allowed to finish. Simultaneously, however, the Rockefellers received a steady flow of sympathetic messages. Progressive members of the art world from all across the country wired their support to Rivera, but matching protests

against the mural came from the tradition-oriented National Academy of Design, the National Alliance of Art and Industry, and the National Commission to Advance American Art, an ad hoc group of conservative painters formed solely in response to this crisis.

Keep in mind that the year was 1933 in the depths of the Great Depression. Sympathy for mighty capitalists was not exactly strong. Hostility to the Rockefeller interests ran so high that Nelson pledged to the public that "the uncompleted fresco of Diego Rivera will not be destroyed, nor in any way mutilated, but . . . will be covered to remain hidden for an indefinite time." Nine months later, however, beginning at midnight on Saturday, February 10–11, 1934, Rivera's mural was removed from that interior wall by being smashed into small pieces and powder. Experts had explained how it could be removed without damaging either the wall or the fresco, and interested parties had even offered to pay the cost of removal and preservation. That did not happen.[25]

Because Rivera had almost $7,000 left from his $21,500 commission (after paying for materials and assistants), he decided to create a new mural, a Marxist interpretation of the entire sweep of American history, on walls located somewhere in New York City. He disliked all those offered and chose instead to paint it in an old building located on West Fourteenth Street, the home of the New Workers' School. His team constructed movable walls and produced twenty-one frescoes, packed with portraits and episodes covering seven hundred square feet of wall space. Each sectional panel was framed in wood, fastened at the corners with metal cleats, and backed by wooden crosspieces. The project was done so skillfully that the paintings were moved with the school in 1936 to Twenty-third Street without suffering a crack or a scratch. Eventually, when the New Workers' School was dissolved, it donated the paintings to the International Ladies' Garment Workers' Union. They had to be moved once again to the dining hall of the union's recreation center in Forest Park, Pennsylvania (Camp Unity). This time, however, Rivera was censored by labor. Three of the panels were deemed too overtly Communistic and ended up in a private collection! All the rest were destroyed by fire in 1969.[26]

Meanwhile, on his return to Mexico, Rivera sought permission to re-create a somewhat smaller version of the Rockefeller Center mural. The government gave him a wall of the National Palace of Fine Arts in Mexico City. Lenin's portrait remains in this second version, of course, but the mural also has some additions, such as a portrait of John D.

Rockefeller located in close proximity to venereal microbes. Rivera had visited laboratories in New York City and featured an array of microbes as part of his microcosm/macrocosm design scheme. The latter would be represented by two large television screens, complete with cathode tubes in front. Rivera was avant-garde in more ways than one. He eagerly incorporated his vision of what technology could contribute.[27]

In 1932 Mrs. Christine Sterling, a socially prominent member of the Los Angeles elite and owner of the Plaza Art Center in that city's Olvera Street "Mexican community," commissioned another prominent Mexican muralist, David Alfaro Siqueiros, to paint a joyful, lush tropical paradise with fruits, exotic plants, and colorful women. The designated site was the second story of an Italian hall, a broad surface that could be seen from Olvera but also by those outside the Mexican barrio on Main Street. Siqueiros, who was far more radical than Rivera, obliged her with lush foliage but highlighted powerful symbols of the oppression brought to Latin America by U.S. imperialism and capitalist exploitation.

In the very center of the mural titled by the artist *América tropical* or *Tropical Paradise* (fresco on cement, thirty feet long and six feet high) is a crucified young Indian martyr, his hands and feet tied to a double cross. He is suffering rather than dead. Directly above the cross the American eagle is perched with its wings spread. (The eagle might also represent the resilient presence of ancient Mexico.) On the extreme right sniper guns of Mexican and Peruvian revolutionaries protrude from the tropical jungle.[28]

At the dedication on October 9, 1932, Siqueiros announced in his newly acquired English that "the buildings of the future will be covered with these dynamic paintings, the special product of communism in art created by groups of artists who work together with the same desire." According to an account in the Los Angeles press two days later:

The artist Siqueiros, whom the federal authorities seem so anxious to deport, is without doubt a dangerous type; dangerous for all the snarling and pusillanimous speculators and retailers in art and life. The federal agents justly claim that art is propaganda, for when the youth confront this gigantic dynamo that pounds in the night under the rain, or clamors boldly when the brilliant

sun of midday shines in the plaza, they will possibly find in it the inspiration to rise in rebellion in future revolution, in art and in life, exclaiming: "Off the road, conservatives and old ones, here comes the future."

That is exactly what the artist had in mind, of course, deeply concerned at the time by the mass deportation of Mexican nationals and the wretched conditions of migratory workers; but sun and weather caused rapid deterioration. Worse still, much of the mural was sufficiently vulnerable that political vandals could apply plentiful coats of whitewash, thereby making restoration virtually impossible. Siqueiros's radical views were unacceptable in Los Angeles. The immigration authorities refused to renew his six-month visa, and he was forced to return to Mexico.[29]

José Clemente Orozco, yet another prominent Mexican muralist, had a very similar outlook and temperament, but his American project fared better, though not without tumult. Also more radical (and consistent) in his politics than Rivera, he did not share the latter's optimism about the prospects for human civilization made possible by science and technology. Orozco's reputation for powerful narrative art on an epic scale was equally strong, however, and in 1932 the art faculty at Dartmouth College felt eager to invite him as a resident artist to fill the expansive walls of the new Baker Library with murals. His *Prometheus* sequence at Pomona College (1930) and his allegories of ideal human orders at the New School for Social Research in New York (1930–31) had achieved considerable visibility and acclaim. The sheer power of his images more than compensated for a certain steely grimness and geometric precision quite unlike the exuberant, fluid, and colorful styles of Rivera and Siqueiros.

Despite deep reservations by some at Dartmouth, the commission came through, thanks once again to Rockefeller largesse. (Nelson was an alumnus.) Although Orozco chose as his motif a developmental vision of civilization in the New World (taking *both* Americas into account), his theme would be one of decline, a markedly pessimistic one. He explained that he hoped to symbolize the recovery of the integrity of the human soul, which seemed to be in danger of becoming "lost in the confused welter of modern mechanized existence." In fourteen pictures that each measured approximately ten by thirteen feet and in ten smaller ones, he intended to depict his conception of

the development and current state of civilization in *America, the "New World."* He envisioned a series of symbolic, iconic statements rather than a conventional historical narrative.[30]

The sequence of dramatic scenes selected by Orozco can be diagrammed as a kind of rise and fall schematization, with a downward turn directly following the European conquest. Hence his positive imagery with *Aztec Warriors, The Coming of Quetzalcoatl,* a *Pre-Conquest Golden Age,* and *The Departure of Quetzalcoatl,* followed by grim visions of *Europe, Cortés, Modern Machine Age, Anglo-American Society, Hispano-American Society,* and finally *Stillborn Education*—not exactly an inspirational trajectory for an American liberal arts college. The final panel depicted a skeleton being delivered of a dead fetus, with five cadaverous academics standing above wearing ghastly masks, and an array of tumbling vials and books below: the ceremonial birth of dead wisdom. The four side panels rather moodily treated ancient and modern human sacrifice, then ancient human migration versus *Modern Migration of the Spirit.*[31]

The college administration fully expected "vitriolic comment," and President Ernest M. Hopkins bravely defended the murals on educational grounds. "That the Orozco murals should arouse controversy was anticipated and desired," he declared. "Passive acceptance has no legitimate place in the educational process, and the double-edged incisiveness of controversy is one of the major educational values to be derived from work as positive and vital as Orozco's." Opposition, especially from alumni, arose in response to the painter's Mexican nationality and leftist politics, both objections entirely predictable. What many perceived as figural distortions only added fuel to the fire. Hostile observers referred to a "deformed" or "grotesque" modernism. The incongruity of such a style inside a neo-Georgian library seemed especially irksome to many.

The very fact that any supporter of modernism lauds these things should be sufficient reason to bar them from the building they occupy. The idea of fitness to purpose in art and design is axiomatic. How then reconcile the measured dignity, simple and refined, of Baker Library with the strident, jarring, jumbled masses of these decorations?[32]

The business and professional community in Boston, which included many Dartmouth alumni, raised its voice in concern. At the

national level the conservative National Commission to Advance American Art, formed not long before to protest the selection of Rivera to paint the major mural at Rockefeller Center, "indicted" Dartmouth College on grounds of preferring foreign art and therefore placed the school on its "regret list" in order to "call attention to inconsiderate blows being dealt American artists by important national institutions." President Hopkins boldly weathered this potent critical storm during 1934–36 by insisting once again upon the educational value of controversy.

> My own sentiments in regard to the whole matter are that I would bring in anybody to espouse any project that would be as intellectually stimulating to the undergraduate body as these murals have proved to be. The very fact that opinion is so definitely divided among the students is in itself, I think, a far better effect than could be accomplished by something in which everyone was agreed.[33]

Student responses did, indeed, range from deep antagonism to apathy to strongly supportive positions, typified by Budd Schulberg who argued that Orozco "was painting a view of history that we felt was urgently needed." Liberal writers across the country weighed in supportively. Lewis Mumford saw in Orozco's work—"probably the most impressive mural in North America"—"the realities of human mind and passion, the realities of the world in which we live and dream and plan and act." By 1940 the murals had become an energizing force behind a burgeoning art program at Dartmouth; and the following year, with the advent of U.S. involvement in World War II, people felt a sense in which history had caught up with the murals. "What Orozco depicted in 1932 seems no more brutal nor horrifying than many of the cartoons or photographs to which we are subjected in the news today."[34] The murals survive in superb condition, and they continue to resonate with the challenging circumstances of our own time.

If many traditionalists resented having American history and politics depicted by foreigners, being a native son certainly did not ensure acceptance of one's work. Not even if one was a Regionalist working in the 1930s, which supposedly was their heyday. By 1935, when Thomas Hart Benton received a commission to decorate the walls of the House

lounge of the Missouri State Capitol in Jefferson City, he had completed major murals during the previous five years for the New School in New York and for the Whitney Museum of American Art, as well as a vivid social history of Indiana for the Chicago World's Fair in 1933. He cut his teeth as a muralist during the 1920s with an ambitious undertaking titled *The American Historical Epic*, a project that never reached completion. Each of his three projects from the early 1930s aroused some predictable criticisms concerning color, form, and especially their topical subject matter. Benton prided himself on being a populist. He had a proclivity for irreverence and for incorporating popular culture at a time when such matters did not seem suitable for "fine art." But none of those projects had sparked a major scandal (well, except perhaps for the Whitney Museum murals in 1932), all of them had many appreciative admirers, and each one had led swiftly to new commissions. By 1935 Benton had become the best-known American muralist, and the busiest.[35]

He devoted eighteen months to planning his *Social History of the State of Missouri*, traveled extensively throughout the state seeking different types of citizens, sketching, and making notes. He witnessed numerous courtroom scenes because he believed that legal cases were highly representative of behavior and sentiments in the state. His twelve-foot-long clay model (four feet deep), designed to help him with distances and proportions, required two months to build. He took the assignment very seriously, and when the murals were finished in December 1936, he considered them his best work. Benton was not a modest man, and at this point in his career he felt a surge of self-confidence. When two lawyers came to observe him at work, they took liberties in handling his paints. Benton climbed down from the scaffold, walked over to them, and scribbled a note: "God damn it, keep your fucking hands off my stuff." He handed it to them without saying a word and climbed back up his scaffold to resume painting.[36]

The murals provide a riot of color, history, folklore (Frankie shooting Johnny), literature (Huck Finn and Jim), politics (Boss Tom Pendergast of Kansas City), crime (Jesse James), farming, electioneering, and much, much more. When the legislature reconvened in January 1937, the completed work upset a great many politicos because it seemed too bright and busy for a lounge, even an ample lounge. According to one representative, "They'd go swell in a lot of Kansas City barrooms." The state engineer told a reporter: "I wouldn't hang a

Benton on my shithouse wall."[37] An editorial in the *Kansas City Star* exclaimed, "Our first impulse was to duck. The great scale on which the pictures are made, together with the apparent smallness of the room and the vividness of the colorings, the impression of distorted proportions in some of the larger figures, sort of combine to make the spectator feel he is about to be overwhelmed and crushed, perhaps, in an avalanche that somehow seems very threatening and imminent." Quite a few legislators called for removal of the murals, but the governor (who did not have to live with them) liked them. And they had other defenders as well.[38]

In one scene a mother changes an infant's diaper in a public place. At a gathering of politicians a scantily clad dancer entertains them. (Benton insisted that she wore more clothing than such women usually did.) Moonshiners appear prominently. A selection of critical comments can convey some sense of the affronts and the tumult: "Benton's shown Missouri as nothing but honky-tonk, hillbillies, and robbers. We're more than a 'coon dog state." "Not a brush mark indicates cultural, moral, or spiritual institutions in the state." "Whitewash the murals! They're vulgar! Look at those half-naked dancers!" On January 8 the *Kansas City Journal-Post* reported that among the people polled there was no middle ground. "You either like 'em or you want the wall painted a deep black."[39]

The earliest newspaper reviews were actually positive more often than not. Then the tide turned, and the consensus seemed to be that the murals were in bad taste. The *Independence Examiner* took a typical stand: "The whole thing is sordid and rather disgusting and it's more like a cartoon which picks out and emphasizes the weaknesses and extravagance of early Missouri life and leaves out the mighty purposes, the strong characters, the ideals of men and women who built Missouri." According to the *Tulsa Tribune*, "Mr. Benton has lied about Missouri. He has desecrated its capitol walls declaring that Missouri's social history is one of utter depravity. That is a lie—Missouri's social history is a story of growing refinement and nobility." *Art Digest* carried the headline: "Thomas H. Benton Paints the History of Missouri—Starts a Civil War." *Life* magazine sent its prize photographer and three staff members to snap the murals and then visit the Ozarks to get some "original Benton types."[40] Even when the press didn't *initiate* a controversy, it commonly exacerbated one.

In mid-January Benton decided to go on the offensive and began holding a series of public forums at which he aggressively answered

questions, explained why he depicted certain vignettes as he had, and countered criticisms. On March 8 he went to St. Louis to defend his work before the Junior League. "I've been called many things by many people," he commented, which was true. "Good Communists say I'm a Fascist and conservatives say I'm a 'damn Red.' But I'm trying to make an objective picture of American society. I know, of course, I bring an attitude to my work. But I am not using my stuff as propaganda for a predetermined conception of what society ought to be." By late spring Benton was winning the battle of public opinion, though a handful of intransigent legislators kept trying for an entire decade to have the image of Boss Pendergast excised from the mural. Some folks would never accept this emblematic presentation of the state's past, but the turmoil subsided more quickly than one might have expected, and the murals endure.[41]

Directly on the heels of that episode, a comparable one raged between 1937 and 1941 while John Steuart Curry worked on his murals commissioned for the Kansas State Capitol in Topeka, a project that became so mired in bitterness that Curry never completed it. The initiative began with a group of newspaper editors in June 1937, who proposed that the state commission the best-known artist who was also a native son, and that meant Curry. The public liked the idea but promptly divided into two camps with conflicting visions. One faction wanted an idealized, highly upbeat set of pictures: waving wheat fields, sunflowers, and scenes of productive industry. The opposition was more historical and political: it wanted Kansas "raw, rough, and true." They were closer to Curry's thinking in wanting him to depict pioneers, abolitionists, Wild Bill Hickok, Bat Masterson, Carry Nation, and the Populists.[42]

The *Kansas City Times* noted from the outset that it was going to be as difficult to please everyone in Kansas as it had been to please everyone in Missouri. Benton had demanded and received artistic freedom. It remained to be seen whether Curry would get the same. The paper tried to face up to reality.

> It is always difficult to reconcile the artist's viewpoint with that of the general public. . . . Some Kansans are sensitive concerning any mention of the dust bowl tragedy [of 1936–37]. Yet it is a part of the state's background and history. If nothing but the beautiful and good should be portrayed, a saccharine, untruthful picture of the state would be left for future generations.[43]

By the spring of 1939 Curry had prepared sketches aimed at satisfying both agendas, but a storm broke when they became available for viewing. His Hereford bull was deemed too red and not "natural-like." The legs on his cows looked too long. His farm mother was unacceptable because her skirt was too short. It stopped at her knees, and she looked taller than her farmhouse. The proportions were unacceptable. The tails on his pigs were too curly, and that became a major issue. According to one critic, pigs' tails don't curl when they eat.[44]

The greatest hullabaloo of all concerned Curry's mural of John Brown rising up in wrath, with a terrifying tornado looming behind him. Giving such prominence to an insurgent lawbreaker was bad enough, but the long "snout" of the tornado looked like an elephant's trunk, at least in the eyes of Curry's embittered critics. Perhaps they were Democrats. Wishful Republicans viewed the elephant's trunk as an omen that the GOP might soon return to power, with New Dealers disappearing in a cloud of dust at the foot of a hill. "Why call attention to storms, dust, and soil erosion?" the critics wondered. And the blood visible on John Brown's hands only called needless attention to his criminality. Why not Kansas's finest rather than her worst? As one observer has written, viewed in retrospect the controversy "has serio-comic overtones. But it was a tempest in Kansas art—and politics—though the paintings themselves—giant murals in the areas off the Capitol rotunda—seem almost prosaic today."[45]

The offensive image of "The Kansas Mother" is actually part of a group called *Kansas Pastoral*. The historical ones were known as *Tragic Prelude*, and there were many others intended to show the state's important agricultural crops that Curry never finished. He requested that some marble panels be removed from the rotunda to create the space he needed for the pastoral portion of his three-part design plan. When people decided the marble was potentially more valuable than his murals and chose to retain them, he quit and refused to sign the murals that he had completed. "These works stand as disjointed and disunited fragments," he explained. By that time the national media had picked up the story. The ending was abrupt and bitter. Years later folks in Kansas were still debating the merits and the uncompromised imagery in Curry's paintings.[46]

The next major mural controversy lingered even longer and shared in common with the Hirsch, Rivera, Siqueiros, Orozco, and Benton bat-

tles many resounding demands that the murals be destroyed. Like the latter two, those painted by Anton Refregier at the Rincon Annex Post Office in San Francisco would miraculously survive. Once again they are historical, seeking to be sympathetic to labor. They also happen to be among the very last Treasury Section murals to be commissioned, though the controversy they generated reached a boiling point on two separate occasions and lasted well into the 1950s. For that reason they form a bridge between the distinctive conflicts of the New Deal era and the ideological partisanship of the early Cold War. That Refregier happened to have been born in Moscow complicated matters, though he actually came to this competition, the winner among eighty-two entries, from the famous artists' colony in Woodstock, New York, where he knew Kenneth Evett and many other American painters with modernist and leftist inclinations.

Although Refregier won the unusually lucrative $26,000 commission in 1940 to paint the history of San Francisco in twenty-seven panels, the war intervened, and he did not return until 1946 to take up the assignment. By then the Section had been phased out, and its uncompleted projects had been passed on to supervision by the Public Buildings Administration (PBA). Refregier had initially intended to begin with a California Indian creating a work of primitive art, then proceed through a series of conflicts in local history, culminating in the 1939 Golden Gate International Exposition celebrating peace in the Pacific. Following the surrenders in 1945 he decided to alter the final panel to include a three-part composition representing the war, Franklin D. Roosevelt and the Four Freedoms, and the founding of the United Nations in San Francisco, a momentous event that Refregier had covered as an artist for *Fortune* magazine. For highly partisan reasons, he was not permitted to include FDR in this postwar panel, even though doing so seemed utterly logical.[47]

Hostility emerged before the paintings were ever completed. When the Catholic Church complained that a friar preaching to Indians at Mission Dolores was too fat, Refregier reduced his bulk. In 1947 the PBA ordered the artist to remove Roosevelt. Early in 1948 the Veterans of Foreign Wars (VFW) protested Refregier's depiction of a bloody waterfront strike that had occurred in 1934, in which workers had been killed not far from the site of the murals. According to the VFW, the strike leader who was rallying workers in the murals appeared to be the labor leader and suspected Communist Harry Bridges. Because the Hearst press ran such negative stories about the

murals, Refregier later wrote that gangs of hoodlums "were constantly under my scaffolding and I no longer worked after the sun set." Once again the media played an incendiary role.[48]

Refregier had devoted considerable effort in 1940–41 to learning as much as possible about the history of the Bay Area. One of the panels depicted an early demonstration on Market Street demanding the eight-hour day. That seemed appropriate because San Francisco had long been a strong "labor town"; but the PBA ordered the artist to remove all the written matter because "this material is considered controversial." Refregier explained to a friend that if he omitted "signs carried by the figures, the whole point of the panel will be lost." He then added, perhaps innocently: "Personally, I can not conceive of an historical fact being considered controversial."[49] According to his undated narrative of the Rincon project, Refregier learned privately that "any reference to Labor was considered undesirable. This incident accured [sic] at the time Congress was passing the Taft-Hartley law." In June 1948 he informed the PBA that he would make the required changes because "I have no time to indulge in a prolonged controversy." Unlike Rivera, discretion seemed the better part of valor if he hoped to complete the murals and have them survive.[50]

Refregier did receive strong support from the Congress of Industrial Organizations, the National Maritime Union, and the International Longshoremen's and Warehousemen's Union, which denounced the "Hearst-inspired attempt to suppress the work of art." During the next six years, the most intensely fought phase when the very survival of the murals seemed in doubt, the artist also won encomia from art critics like Alfred Frankenstein and from the leading local art associations and museums and their boards of directors. The heads of all three major art museums in San Francisco defended the project; their support would be desperately needed in May 1953 when the House Committee on Public Works chaired by Representative George Dondero convened in Washington to debate destruction of the murals. Vice President Richard Nixon encouraged these hearings—as a congressman in 1949 he had written that "some very objectionable art, of a subversive nature, has been allowed to go into Federal buildings in many parts of the country"—and consequently the murals became the first artworks in the United States to be tried for themes "inconsistent with American ideals and principles."[51]

The California State Senate voted to urge Congress to destroy the murals. Dondero's avid anti-Communism actually needed no encour-

agement. Since 1949 he had been the most vocal congressional opponent of modern art because it was un-American and suspiciously tainted by Marxist values. (He seemed blithely unaware of Stalin's hostility to modern art.) One critic warned that the head of the family in Refregier's *The Four Freedoms* wore a red tie and that the boy in the picture held a red-covered book. Attorney Waldo Postel warned that "these murals are definitely subversive and designed to spread communistic propaganda." Others objected that the disastrous 1906 earthquake was made to appear even more horrific in its effects than it actually was—not easily done. Whereas the California Indians were depicted as vigorous and strong, the Spanish and English explorers appeared warlike and conquering. The monks building Mission Dolores looked scrawny in one panel but potbellied in the next while their Indian wards seemed to be starving. The pioneers on *The Overland Trail* also looked "cadaverous and soulless." In the panel showing construction of the transcontinental railroad, Chinese laborers appeared to have done most of the work—which, in fact, was true![52]

Compared with all of these politically tainted sins, matters of style should have been less problematic, yet they, too, generated criticism despite the murals being vividly representational. Critics found Refregier's figures too lanky and angular; and ultimately, when style and substance were taken together, enemies of the murals became convinced that they promoted class warfare. That turned out to be the basic link between the labor-related objections in 1947–48 and the intensely McCarthyite charges of 1953. When the Artists Equity Association wrote to Dondero's committee in support of the murals, Congressman Herbert B. Scudder read into the *Congressional Record* a statement exposing the "communist inclinations" of Equity's founders.[53]

Be that as it may, the committee ultimately did not support the motion and the murals survived. Sadly, however, some who had followed the whole bitter fight observed that eventually very few of the many hundreds of people who used this post office daily paid the slightest attention to the murals, and not many could even identify any of the important or incendiary events that Refregier had depicted. Nevertheless in 1979, when the postal service abandoned the Rincon Annex, artists and preservationists managed to save it. The lobby subsequently became a designated city landmark, serving as the foyer for an upscale mixed-use office complex called the Rincon Center.

. . .

Although nudity did not arise as an issue very often during this period, it did on occasion, though in inconsistent ways and often as part of some larger problem. Bruce and Rowan had sent out a general directive warning that nudity of any sort should be avoided in post office murals, and their admonition went largely heeded. The biggest exceptions occurred in scenes involving Native Americans, mostly in the colonial period, which provided artists who had taken the usual classes in life drawing an opportunity to display their skills at depicting human anatomy, most often muscular male Indians shown from the backside. When Lorin Thompson received approval for his *Legend of the Singing River* for Pascagoula, Mississippi, which involved a considerable number of Indians performing ceremonial ablutions in the river, the Section made just one admonition based upon the sketches he submitted: not to "overemphasize the nudes in the further progress of the work as you realize that certain citizens might find such treatment objectionable."[54]

The most notorious example, perhaps predictably, turned out to be *Pocahontas Saving the Life of Captain John Smith* (1939) by Paul Cadmus for the Parcel Post Building in Richmond, Virginia, in which a group of able-bodied braves wearing leggings and loincloths are being staved off by a nubile maiden who has one breast fully exposed. In that case a fox head dangling downward just where a warrior's genitals would have been diverted attention from the maiden. Cadmus remained incorrigible because of his delight in coy naughtiness, which had caused such a ruckus five years earlier with his randy painting titled *The Fleet's In.*[55]

Perhaps the liveliest (and silliest) controversy had more to do with what might be termed decency than with nudity, but also with local pride and rivalry. In 1941 artist Elizabeth Tracy received a commission from the Section to paint a mural for Kennebunkport, Maine, and chose a "bathing beach scene." Trouble arose for two reasons. The rival community of Kennebunk was actually the beach community, while Kennebunkport was a fairly sedate writers' colony and magnet for socialites. When Tracy proceeded to paint her bathers anyway, the five women appeared hefty rather than svelte. They certainly were more "full-bodied" than prevailing norms of attractiveness at the time. One letter's lament typified the outraged local hurt.

> In this town of great historical interest from the earliest days, throughout the war of 1812, Indian fighting, great shipping interests, ship building, etc., etc. and not merely a summer

resort it seems to us that a picture of bathers of beefy forms and ugly faces [is] quite out of place. It might do for Coney Island, but here it is an offense.[56]

Although Rowan responded to Tracy's design sketch with guarded encouragement—"you have handled the scene in a way that I should regard as above reproach"—all hell broke loose when a local sent a letter to Frederic A. Delano, an uncle of the president, revealing the artist's willful disregard of local interests and sensibilities.

> The artist arrived one afternoon with her husband, also a painter. I asked her what she was going to do and she replied that she would not do anything historical or about shipbuilding—that Kennebunkport was a summer resort, and she was going to do a beach scene. She had never been to Kennebunkport before, and her design had already been accepted by the Treasury Department. (She had been awarded the mural and it was not a competition.) I asked her if anyone had told her the beach was in Kennebunk . . . and that our coast is rocky. Since this town has been feuding with Kennebunk since before the Revolution I pointed out it was going to be just too bad if we got the wrong mural. . . . She immediately said that it did not make any difference to her, that it did not matter what the people here thought, and when I said that they might refuse to have it, and I thought she ought to be warned, her husband said, "Never mind! The Treasury will have to pay for it."

When Tracy sketched in the figures initially, they lacked bathing suits entirely (like Felix de Weldon's marines), enraging the locals and summer visitors even more. They also disliked the overly bright colors once attire was added, began writing letters to the Treasury Department and members of Congress, and circulated a petition. Acoustics in the post office were remarkably good, so that "every breath of criticism was heard by the unhappy artist and she would get so mad she would cry with rage."[57]

Although the mural somehow got approved and was installed, tradition-oriented novelists Booth Tarkington and Kenneth Roberts, both summer residents of the enraged community, organized a determined campaign to reverse the situation by writing letters to Congress conveying the impression that the women in Elizabeth Tracy's not-so-

soft porn scene were quite naked and were carrying on with naked men in "ultra modern" Commie fashion. Newspapers all across the country picked up this titillating tale of "fat hussies" and "shameless maids." The episode became a national amusement or embarrassment, depending upon one's perspective. The Senate gladly deferred to a bill introduced by one of their own from Maine, and the mural was removed in 1945.[58]

Given the impact of tattling to the president's uncle, there is some irony in remarks that FDR happened to express on the radio in dedicating the new home of the Museum of Modern Art on May 10, 1939. Following a few platitudes about the importance of preserving individualism in art and society, the president declared that "art in America has always belonged to the people and has never been the property of an academy or a class," which unfortunately was not exactly true. He then proclaimed that "the WPA artist exemplifies with great force the essential place which the arts have in a democratic society such as ours." FDR then concluded that American artists can "express themselves with complete freedom from the strictures of dead artistic tradition or political ideology."[59] No one seemed to remember those words when Anton Refregier's murals were being attacked by the House Un-American Activities Committee in 1953.

Nudity, decency, and sexuality would become far more common as causes of art-related controversies after the 1960s, but one of the most engaging cases involving murals in official places dates from 1980 and illuminates the mixed pattern of continuity and change that epitomizes our narrative. The story is largely unknown beyond the state of Washington, where the House of Representatives decided to commission an ambitious set of murals that came to be titled *The Twelve Labors of Hercules*. Michael Spafford won the $92,000 commission, and his eleven-by-forty-six-foot mural sequence was unveiled in Olympia in 1981. When asked to explain the motif he chose, Spafford claimed that he saw Hercules's labors as a metaphor for the staggering effort of getting legislation passed. People promptly took exception to his work for a variety of reasons, mainly having to do with suggestive sexuality in the murals. A conservative legislator deemed them pornographic and mobilized support to prevent installation of the final panels.[60]

In some of the images an apparently nude man is capturing or slaying a beast. Their physical intimacy *might* have been suggestive to

some observers as excessive. In another he vanquishes the nine-headed hydra, some of whose tentacles appear to be groping his private parts. Cleaning the dung-heaped Augean stables is vile business. Stealing the jewel-encrusted belt from Hippolyte, queen of the Amazons, resembles a rape scene; and crushing the immortal giant Antaeus might be construed as homoerotic wrestling. Most critics would have preferred a more traditional art form than these stark, modernistic silhouettes. Others felt that the bleak black-and-white murals did not fit well with the House chamber's classical marbled architecture. Rural Washingtonians were told by the press that the murals represented "elitist" city-slicker art being foisted upon an unsuspecting populace.[61]

Within a year of their unveiling the murals were covered with draperies over plywood, unveiled for a few months in 1989, then removed and stored despite the artist's objections. Although Spafford insisted that he would prefer to destroy them himself, a judge ruled that the murals had a right to exist independent of the artist's desires. In 2003 Centralia College, located twenty-five miles from Olympia, paid $75,000 to move the state-owned murals, unwrap them from their protective film, and install them in the college's 506-seat theater. They were displayed for the public once again on October 11, 2003, following a symposium devoted to the legal, ethical, and emotional issues surrounding their journey from the House chambers to the theater's walls. Spafford's work thereby joined another set of murals at Centralia, painted by abstract modernist Alden Mason, that had been removed from the Senate chamber.[62]

The episodic narrative of public murals in the United States since the early 1930s has involved intermittent censorship of history, ideology, nudity, and sexuality—but the first two with much greater frequency than the latter. The fundamental line of continuity throughout, however, has been profound disagreement over closely related fundamental issues: What is art? And what kind of art is suitable for public spaces? The most notable change, perhaps, is that murals since the 1970s have been somewhat less likely to prompt political conflict than they did a generation earlier. Other forms of art assumed that intensely divisive role, as we shall see, ranging from public sculpture and performance art to photography as well as museums themselves.[63]

What is clear from relatively recent experience, primarily since the 1980s, is that when artists involve themselves deeply with the commu-

nities for which they have been commissioned—exploring in depth the history and ethnic diversity of the locale—they can achieve an outcome that is satisfactory to all concerned. We have the splendid examples of Judy Baca painting *The Great Wall* in Los Angeles (1976–83), a "monumentally scaled history painting depicting the panorama of events that contributed to Los Angeles' distinctive profile," very much a collective project; and her remarkable success in Guadalupe, California, with a mural portraying the lives of farm workers living there (1988–89). These achievements reveal how personal engagement and sensitivity can enhance artistic skill in realizing goals that are consciousness-raising as well as aesthetically pleasing.[64]

Which is not to say that the era of contested murals is over and gone—not by any means. Still, the nature and meaning of what constitutes a "mural" may be changing. In 1999 the city of Richmond, Virginia, decided to decorate its new Canal Walk with a floodwall gallery on which pictures of famous residents and historic events would appear. These murals are not painted—they are enlarged images derived from the local Valentine Museum, the Library of Congress, and New York's Schomburg Center for Research in Black Culture, mounted on canvaslike mats and tied to the wall. The so-called outdoor museum was designed by Ralph Appelbaum of New York. The twenty-nine images, selected in secret and put up in May 1999, included Edgar Allan Poe, black community leader Maggie Walker, Indian chief Powhatan, Thomas Jefferson, slave revolt leader Gabriel Prosser, Patrick Henry, entertainer Bill "Bojangles" Robinson, and black soldiers from World War I—but in the most prominent position of all, Robert E. Lee wearing his Confederate uniform.[65]

A photographer for the *Richmond Times-Dispatch* was present on opening day, and his image of Lee made for rather splashy front-page news the next day. The rest of the media swiftly followed suit, and for the next three months all the city newspapers were bombarded by letters to the editor, pro and con. Members of both races called for a boycott of the Canal Walk, which had been designed to enhance tourism in downtown Richmond.[66]

On June 2, 1999, an angry black member of the city council demanded that the portrait of Lee be removed because he had defended slavery. That touched off a bitter dispute within the city that activated all sorts of pro-Confederate organizations and elicited protests from a biracial citizens' committee. Members of the African-American community and leaders of the NAACP insisted that they

were sick and tired of seeing the Confederacy glorified; but several distinguished black scholars declared that Lee was a prominent part of Richmond's history and could not simply be excised. By mid-June a panel sought some way to arbitrate the ruckus, and on July 1 it urged that Lee's portrait be restored, but this time an image of Lee at his house on Franklin Street following the war rather than the familiar picture of General Lee, Commander of the Army of the Potomac, wearing that offensive uniform.[67]

In mid-July a poll of 551 area residents recommended the restoration of the Franklin Street portrait of Lee, with support coming from a majority of both races. In late July, following a heated debate, the city council voted six to three to restore Lee to the floodwall gallery. When the originator of the anti-Lee protest proposed to remove *all* the pictures, the entire mural, he lost by eight to one. On January 17, 2000, however, an arsonist burned Lee's portrait on the Martin Luther King Jr. holiday; even the agitated councilman who had initiated the bitter fracas condemned the burning as "outlawish thuggery."[68]

Perhaps that sort of outrageous behavior was needed to calm tempers and restore a sense of balance. The number of images along the floodwall has become even more inclusive, and Robert E. Lee remains there, larger than life. As we shall see, racial differences would become a prominent source of art-related controversy during the closing decades of the twentieth century.

Art Politicized: Ideological Issues

Although art became politicized in numerous ways during the nineteenth and early twentieth centuries, it did not get deeply entangled with *ideological* issues such as patriotism and partisan politics until the years following World War II—at least not often, and not pervasively so. Discussions of art's proper role in a democratic society have occurred intermittently ever since the 1840s, but they did not become commonplace and persistent until more than a century later, when two disparate developments arose and converged in time—war in Southeast Asia and the emergence of publicly funded art as part of systematic government programs (as opposed to monuments and memorials that appeared on an occasional basis). We can certainly trace rhetorical flourishes concerning the democratization of art all the way back to the early republic, at least sporadically, but significant numbers of people were not engaged by such discourse because it basically did not affect them. Access to art was not a burning issue for the populace at large, and neither was the very nature of art in American society. Art definitely mattered and it generated some intense disagreements, but they took place, for the most part, within elite circles.[1]

One of the earliest examples of partisan conflict involves the statue that stands on top of the United States Capitol building in Washington, D.C., known in recent times as the *Statue of Freedom* but originally called *Armed Liberty* for highly political and revealing reasons (fig. 37). In 1855, as the Capitol neared completion, sculptor Thomas Crawford was invited by Montgomery Meigs, an army engineer commissioned in 1853 to construct new wings for the Capitol, to create a striking figure that would be suitable as the crowning symbol on the great dome.

37. Thomas Crawford, *Freedom* (1863),
U.S. Capitol, Washington, D.C.
Division of Prints and Photographs, Library of Congress.

The designs envisioned by Crawford underwent a series of alterations fraught with tension. The concept he first proposed, "Freedom Triumphant in Peace and War," would have presented a female figure holding an olive branch with one hand and the other resting on a sword sustaining the shield of the United States. He thereby merged Peace with Victory and America as Liberty in a triple fusion of stock allegorical imagery that then underwent additional changes based upon requests from Jefferson Davis, the secretary of war who exercised final control over the project.[2]

Four months later Crawford submitted an altered design in which he minimized the peace aspect in favor of greater emphasis upon a female representation of Libertas standing on a globe surrounded by

wreaths placed beneath emblems of justice. He then added three motifs: a circlet of stars around the Revolutionary liberty cap (adapted from the Roman pileus), the shield of the United States, and a sword held in America's right hand, "ready for use whenever required." Davis would not approve of including the pileus, an ideological symbol of long standing, on the grounds that "its history renders it inappropriate to a people who were born free and would not be enslaved"—quite a self-serving assertion from a Mississippi slaveholder soon to become president of the Confederacy. His racism seems to have been so deeply internalized that he could not acknowledge that so many thousands of slaves in the South were not born free. He suggested that "armed Liberty" should wear a helmet instead of the classical liberty cap since "her conflict [is] over, her cause triumphant." Crawford obliged him and substituted "a Helmet the crest [of] which is composed of an Eagles head and a bold arrangement of feathers suggested by the costume of our Indian tribes."[3]

Quite clearly, at a time when slavery was the most divisive political issue in the land, when the cause of abolitionism was gaining ground in the United States, and when many others at least preferred to stop the expansion of slavery, Jefferson Davis felt determined to avoid any symbols that might provide moral support for his Northern opponents. Crawford's third and final version of the dome statue retained a figure of Freedom but bore clear trappings of Minerva (the Roman goddess of war) on her head, thereby creating an odd fusion of iconic forms that did not fit well together: a warrior nation identified with freedom, though not freedom for all. The compromised image would not be completed until 1863, by which time the polarized sections had gone to war over the slavery question and Davis had long since become chief of the secessionist states. Although he had relocated to Richmond, his views had prevailed, and the most potent legislative body in the world is *still* overseen by this odd amalgam. An important work of art, meant to be meaningful to the entire nation, had been compromised by the exigencies of ideological politics. Its empyrean motif and accoutrements remain a mystery to most contemporary viewers.[4]

In 1870 the first major art museums were created in the United States in New York, Boston, and Washington. Their charters and dedicatory speeches invariably heralded a wide-ranging rhetoric of educational mission. In principle, at least, art would be gathered and displayed for

the benefit and uplift of the American people. That same purpose would be articulated when other public buildings of a cultural nature were created at the turn of the century, such as the landmark Boston Public Library. Nevertheless, most of these institutions were largely administered in an elitist manner until the mid-twentieth century. The art museums initially would not open on weekends or evenings in order to keep out the working classes and even substantial segments of the middle class, for that matter. Some bitter struggles occurred over precisely this issue, and many decades would pass before museum directors and their boards became eager to welcome the cleansed populace at large, never mind the "great unwashed."⁵

In 1913 a discriminating collector of contemporary art and literature, New York attorney John Quinn, appeared before a congressional committee with an appeal that the duties on imported art be lowered so that Everyman could afford to collect beautiful and interesting objects. "This committee should bring within the means and within the power of the man of moderate means—yes, even of the poor man—to acquire works of contemporary art before they become 20 years of age and appreciate in value and then fall into the hands of dealers and then become merely the hobby or exclusive possession of the rich."⁶ How interested the poor and middling folk really were in collecting foreign art remains murky; but for this democratizing impulse to be voiced at all in 1913 seems remarkable, especially by a man of considerable personal wealth.

Following the war, Congress considered reverting to an array of new and higher tariffs on art, so Quinn remained continuously engaged in what he called "the art fight." In May 1921 he spent the better part of two weeks in Washington appearing before various committees. He got the sales tax on art reduced from 10 to 5 percent, and the House Tariff Bill reluctantly kept imported art on the affordable list. But Quinn still had to battle against efforts by the Ways and Means Committee to restore the customs duty on incoming art.⁷

Meanwhile, even as collectors and museums continued to prize and seek European art, many artists repeatedly sang a particular refrain: the need for an authentically *American* art. Quite often one key implication of that desire was an art more keenly in touch with and responsive to the American people. The Ashcan group urged this starting in 1908. The aging Thomas Eakins did so in 1914. "If America is to produce great painters," he wrote, "and if young art students wish to assume a place in the history of the art of their country, their first

desire should be to remain in America to peer deeper into the heart of American life." Even the devotees of modernism wanted to develop their own domestic variants. Paul Rosenfeld, an important member of Alfred Stieglitz's avant-garde circle, made this observation in 1924: "We have been sponging on Europe for direction instead of developing our own." Those were exactly the sentiments and motives of Gertrude Vanderbilt Whitney when she established her Museum of American Art in 1931. In 1958 Lloyd Goodrich, the director of that museum, answered the question "What Is American in American Art?" with boilerplate gusto: it is pluralistic and individualistic, the fitting expressions of a democratic society.[8]

During the 1930s, as we have seen, a considerable number of American artists and writers had strong leftist sympathies. They formed various associations whose objectives were not merely a more egalitarian art world but the democratization of American society as well. Quite a few of the social realists were activists. They formed artists' unions and, in 1936, the American Artists' Congress, with branch groups in several major cities and worldwide affiliation with kindred organizations. Its objective was to fight censorship of the sort that befell Diego Rivera and to repel other violations of civil liberties. A fair number joined the Communist Party USA or at least attended its meetings and discussion groups. If they signed petitions or other documents that got published in the *Daily Worker,* they frequently found themselves under FBI surveillance. There would not be a comparable period of truly sustained political activism on the part of artists until 1966–70.[9]

We have already seen what happened when Rivera rashly attempted to include a portrait of Lenin in a major mural for the RCA Building at Rockefeller Center. That conflict of stubborn wills was actually untypical of the 1930s because not many artists pushed quite so far beyond the acceptable limits of a society in which the dominant groups still maintained a stronger faith in free enterprise than freedom of expression. Yet the taint of Communism would, in fact, exclude the work of some significant and prominent artists from venues where they wanted their work displayed. In 1936, for example, Alfred Barr deliberately omitted from the major Surrealism show photomontages made by the German Marxist John Heartfield in order to avoid compromising MoMA's putative political neutrality.[10]

Immediately following World War II conflicts involving murals

sympathetic to the labor movement, such as Anton Refregier's in San Francisco, would bring accusations of Communist sympathies. Early in 1949 Congressman Richard M. Nixon wrote a letter to an officer of a San Francisco American Legion post on the subject of "objectionable art." (Although he tried to keep it out of the press, it first appeared in *The Nation* in 1953.) "At such time as we may have a change in the Administration," he averred, "I believe a committee of Congress should make a thorough investigation of this type of art with a view to obtaining removal of all that is . . . inconsistent with American ideals and principles."[11]

On March 11, 1949, Representative George A. Dondero of Michigan, whom we have previously encountered in connection with modernism and the Refregier murals, gave the first in a sequence of nine speeches to the House denouncing modern art in general and its close association with Communism in particular. He would insist until his retirement in 1957 that modern art essentially began with the Bolshevik Revolution in 1917, that all of the heinous "isms" were foreign in origin, and that modern art was antithetical to the great beauty of traditional American art and values. It was a "weapon of communism," he contended, and the modern artist was a "soldier of the revolution." Dondero used militant and militaristic language quite effectively in this early phase of the Cold War.

> It is my firm conviction that the time has come when the loyal, patriotic, clean-minded, right-thinking artists of this country must rouse themselves, band together, and purge their establishment of this social disease. . . . It would indeed be an admission of transcendent weakness and feeble manhood if such powerful and healthy organizations as the National Academy of Design, the American Artists Professional League, the Allied Artists of America, the Illustrators Society, and the American Watercolor Society were unwilling, or reluctant, now to gird themselves for battle in a common cause, and throw the Marxists out.[12]

Dondero chaired the House Public Works Committee and became the dominant voice condemning modern art in ideological terms for nearly a decade. His words were echoed in many quarters and provided support and legitimacy for antimodernists in a number of confrontational situations. He actually knew very little about art, and his

charges invariably remained rather general. Where did he get his basic information, the particular exhibitions and programs he targeted, and the language of his accusations? Partially from reports by the House Un-American Activities Committee but especially from conservative art organizations like the ones he listed in the strident statement cited above. He used tactics quite similar to those associated with Senator Joseph R. McCarthy, pointing to supposed parallels between Communist-front groups and modern art organizations. They operated in comparable ways: "A disguised structure is built up and when its true purpose is disclosed to the public, it fades from view—to be followed by an organization with a new name, but controlled by the same Marxist individuals."[13]

In 1949 and again in 1956, Dondero called upon Congress to conduct a full-scale investigation of modern art in the United States. Although quite a few colleagues shared his views, Congress had more pressing matters to attend to, and no formal investigation ever took place. Two members of the House offered rebuttals, Jacob Javits of New York and Eugene R. McCarthy of Minnesota, the latter in the very first year of his first term in Congress. He had just come from teaching a variety of subjects at a small Catholic college and provided a response to Dondero that was as courageous for a freshman as it was judicious. He asked rhetorically whether people should reject all of modern art simply because it required them to think.

Are we to shut our eyes to the follies of mankind and reject an art form simply because it uses, perhaps in extreme, a critical device which is almost as old as the arts? Are we to reject abstractionism because it calls on the artist as well as the student of art to go beyond the obvious and the superficial in order to arrive at meaning . . . ? Is surrealism to be outlawed because it asserts and attempts to show graphically that many of the actions of modern men are unreasonable?[14]

McCarthy then added that a society should not reject an artist's work just because it borrows conceptually from sources elsewhere. After all, "progress in art and culture generally is the result not only of internal growth but of accretion from other cultures." Speaking knowledgeably, he observed that an Italian artist who adapted techniques from a Flemish artist was no less Italian for doing so. Rejecting Dondero's sweeping condemnations, he concluded: "We cannot reject

every modern art form because it is different from that with which we are familiar. We cannot reject every work of art which expresses social protest. We cannot reject the works of artists simply because we do not share their political, philosophical, or religious beliefs."[15]

Dondero had also accused art critics sympathetic to modernism of being soft on Communism, and the most vocal critic to rebut him was Emily Genauer, art critic for the *New York Herald Tribune*. After noting his admission that he rarely visited museums and was not very knowledgeable about art, she pointed out that Dondero's principal support in the art world came from the American Artists Professional League, which she described as "the most reactionary wing of art." She scoffed at his simplistic explanation of modern art and ridiculed him for doubting that artists involved with a museum-on-wheels program at a naval hospital could conceivably have been "trying to do something pleasant for the veterans" rather than indoctrinating them.[16] If modern art was a "weapon of communism," Dondero turned out to be a loose cannon in the armory of the most traditional art organizations.

One of the major art journals pointed to the irony of two political systems that seemed to function in paradoxical ways. "Only a great, generous, muddling democracy like ours," wrote Peyton Boswell, "could afford the simultaneous paradox of a Congressman who tries to attack Communism by demanding the very rules which Communists enforce where they are in power, and a handful of artists who enroll idealistically in movements sympathetic to Soviet Russia while they go on painting pictures that would land them in jail under a Communist government."[17]

Another courageous rebuttal came late in 1952 from Alfred H. Barr of MoMA. His essay titled "Is Modern Art Communistic?" appeared in *The New York Times Sunday Magazine*. Barr elaborated upon the remarks once made at MoMA's dedication by Franklin Roosevelt, observing that no Western government would want to impose its taste upon its citizens or interfere with their creative freedom as the totalitarian dictators of Germany and Russia had done. The modern artist's individualism and nonconformity could not be tolerated within a monolithic tyranny, and modern art is useless for a dictator's propaganda because being modern, "it has little popular appeal." He concluded by taking aim directly at Dondero and his allies but without naming names: "To call modern art communistic is bizarre as well as very damaging to modern artists, yet it is an accusation frequently made. . . . This is a point of view which is encouraged by the more

reckless and resentful academic artists and their political mouthpieces in Congress and elsewhere."[18]

Just the kind of people Barr had in mind, though about as obscure and provincial as they could possibly be, managed to precipitate a four-year donnybrook in Dallas involving modern art, one that eventually involved Dondero in an important way and led to the cancellation of an exhibition of art in American sport that had been destined for the 1956 Olympics in Sydney, Australia. On March 15, 1955, the Public Affairs Luncheon Club, a genteel but political group of Dallas ladies, issued a statement to the press declaring that the Dallas Museum of Fine Arts was "over-emphasizing all phases of futuristic, modernistic, and non-objective painting and statuary." They then leveled a more serious charge at the museum, especially in the immediate wake of McCarthyism (Joe, not Gene), for "promoting the work of artists who have known Communist affiliations to the neglect of . . . many ortho-dox artists, some of them Texans, whose patriotism . . . has never been questioned." The group offered a public resolution demand-ing that the museum "correct their policy of sponsoring the work of Communists."[19]

It did not take long for an array of organizations, including the American Legion, to chime in and protest the alleged misuse of the museum's public financial base and to harass the director for being supportive of modern art. The groups soon formed an umbrella orga-nization, the Dallas County Patriotic Council. The museum stood accused of displaying artworks by "reds" or "pinko" artists; and of course the local media followed the fracas with frenzied inten-sity. Dallas newspapers were packed with letters warning people to be alert for Communist infiltration, denouncing modernism and demanding patriotism. For foes of Communism in art, censorship was an acceptable option. As one letter to the editor proclaimed: "I happen to love America far more than I love art." Financial backing and logis-tical support by way of supposedly fact-finding publications came from H. L. Hunt, an exceedingly wealthy Dallas oil man whose wife served on the luncheon club's board of directors. Eventually this intense struggle would receive attention from *Time* magazine and national newspapers.[20]

Where did the ladies of the luncheon club get their reactionary ideas and information? They based their charges against the museum on material disseminated in Hunt's pamphlet called *Facts Forum News* and on George Dondero's conspiracy-fearing speeches, boldly citing

one of his most frequently uttered lines: "Communist art, aided and abetted by misguided Americans, is stabbing our glorious American art in the back with murderous intent." On March 17, 1952, he had given one of his most widely noticed speeches in the House, titled "Communist Conspiracy in Art Threatens American Museums." His primary goal was "to expose Red infiltration and control in certain artists' organizations," and he vowed to show that "many great museums are being used by these organizations, and that the critical appraisal of art by some papers and magazines often aids this Marxist cultural conspiracy."[21]

Based upon lists of artists with suspect political leanings tracked by Dondero and Hunt, the ladies' club examined catalogs of the holdings of the Dallas Museum and checked off a roster of the "most objectionable" artists, including Chaim Gross, George Grosz, Jo Davidson, Picasso, Rivera, Max Weber, and Joseph Hirsch. The club then published an information bulletin titled "Is There a Communist Conspiracy in the World of Art?" for distribution to members and the museum board. Its answer to the question was a resounding yes, of course. Quoting liberally from two of Dondero's speeches, the pamphlet proclaimed that abstraction was a form of subversion. Stanley Marcus, director of Neiman-Marcus and president of the Dallas Art Association, which governed the museum, consulted with the director and appointed a committee of trustees to study the charges. It determined that the accusations were unfounded and declared that the issue was "a matter of taste, and neither communism or patriotism is involved."[22]

An exhibition called "Sport in Art," organized by the tradition-oriented American Federation of Arts, was scheduled to appear at the Dallas Museum from March 25 through April 20, 1956. It had already been exhibited without incident at Boston's Museum of Fine Arts, at the Corcoran in Washington, and at the Speed Art Museum in Louisville. After Dallas it was destined for Denver, Los Angeles, and San Francisco, then would end its tour in Australia at the Olympic games. The Patriotic Council, which had been expanded by all sorts of freshly politicized groups, demanded that work by four artists be eliminated from the show: Ben Shahn (*National Pastime* [1955]), Yasuo Kuniyoshi (*Skaters* [1933]), William Zorach (*Fisherman* [1927]), and Leon Kroll (*The Park* [1933]). The director and trustees resisted, issued statements in defense of diversity and artistic freedom, and refused to remove the pictures. Although the issue of public tax dollars for the museum arose once again, no punitive action was taken. The

beleaguered board and director would eventually be remembered for their courage.[23]

They could and did invoke one unexpected authority on behalf of their cause. In 1954 President Dwight D. Eisenhower served as the principal speaker at the twenty-fifth anniversary celebration of the Museum of Modern Art. At the heart of his remarks was a ringing declaration that "Freedom of the Arts is a basic freedom, one of the pillars of liberty in our land. . . . As long as artists are at liberty to feel with high personal intensity, as long as our artists are free to create with sincerity and conviction, there will be healthy controversy and progress in art." The notion of *healthy controversy* could not have come at a more salutary time, and this quotation would often be mobilized and cited during the politicized art conflicts of the McCarthy era.[24]

Most of the national news coverage sided with the museum board and frequently cited Eisenhower's statement. It happened to echo very clearly the remarks that Franklin Roosevelt had made in his radio address when MoMA dedicated its new building on Fifty-third Street in 1939: "Only when men are free can the arts flourish and the civilization of national culture reach full flower. The arts cannot thrive except where men are free to be themselves and to be in charge of the discipline of their own energies and ardors. The conditions for democracy and for art are one and the same."[25] So if modern art was a manifestation of individual freedom, how could it possibly be part of a Communist conspiracy? *Time* magazine, not exactly a radical rag, mocked the Dallas Patriotic Council.

But Time Inc. and *Sports Illustrated* along with the American Federation of Arts had actually sponsored "Sport in Art," so they had a vested interest. The U.S. Information Agency (USIA) was physically and politically responsible for touring the exhibition overseas, and in May, after the show had closed in Dallas, the USIA decided to abandon its scheduled display in Australia. The official reason given, as usual, was "over-all budgetary considerations," but widespread charges of "subversion" aimed at some of the artists had unquestionably taken a toll and made the exhibit too hot to handle at a most volatile time in the Cold War and amid anti-Communist fervor. George Dondero felt delighted by the cancellation, of course, and a speech that he gave in the House on June 14, 1956, included a complete narrative of what had happened at Dallas from his perspective.[26]

Canceled exhibitions became a common casualty of politicized antimodernism in these years and more particularly an effective way to

combat the perceived link between abstraction and Communism. In 1956 the USIA asked the American Federation of Arts to organize an exhibit of one hundred works by contemporary American artists that would tour Europe. Called "Twentieth Century American Painters," it was shut down at the last minute amid a storm of controversy. Because of accusations by Dondero, ten of the artworks were deemed "social hazards," and no fewer than forty of the artists represented in the show were declared to have an affiliation with the Communist Party (which was notably weak and quite modest in membership just then).[27]

Yet another exhibition organized at that time for the USIA by the College Art Association, showing works by leading contemporary European artists, was scheduled to tour internationally as part of America's cultural exchange program. That one, too, was canceled because of political pressure. Anti-Communist hysteria seemed ubiquitous, and the disgrace of Senator Joe McCarthy in 1954 did nothing to reduce pressure from the Right to disassociate the United States from modern art. While indomitable figures like Dondero and a considerable range of patriotic organizations mobilized, avocational painting gained immensely in popularity during the 1950s, and most of those amiable amateurs neither liked nor understood modern art. The Dallas Museum actually worked out a compromise whereby local artists could exercise total control over one museum gallery, displaying their own work or anything else of their choice. That did not serve to appease them sufficiently or reduce their impassioned feelings and mistrust. American art had never before been so divisively politicized.[28]

In 1957 some bold and articulate artists began to fight back in public. Ben Shahn, for example, published a broad statement about the necessity for nonconformity in art, arguing that it leads to important shifts in creative trends. Near the end of his essay Shahn addressed the political pressures for conformity in his own time and specifically the now-notorious "congressional scourge," Congressman Dondero.

> In the shelter of his congressional privilege he has recorded a list of artists whom he has designated as "international art thugs," "art vermin," "subversives of art," and so on. To museums and museum directors—that is, those interested in contemporary art—he has attributed reprehensible motives and practices. He regards the modern forms as a disguised plot to undermine our

morals and our "glorious American Art." Such are the bludgeons of conformity.

Referring to the recent "commotion" in Texas, he lamented that "in such a climate all art becomes suspect. . . . Today's conformity is more than anything else the retreat from controversiality. Tomorrow's art, if it is to be at all stirring, will no doubt be performed upon today's forbidden territory."[29]

In 1957 the intensity of feeling had not waned in Dallas, but press coverage had. Each side could claim some sort of victory, and perhaps more than one on the Right. Antimodernist patriots enjoyed the satisfaction of having canceled shows. They had achieved a degree of intimidation and demoralization at the museum and had captured space there that they could fully control. The museum, however, emerged with national recognition as a champion of artistic freedom. It had removed none of the artists who were singled out as subversive. The director was commended by a resolution at the annual meeting of the American Association of Art Museum Directors. *Life* included Jerry Bywaters in a feature article devoted to museum directors, and *American Artist* congratulated him as a "progressive director who has worked hard at building a first-rate institution."[30]

The forward movement of history is frequently fraught with anomalies, so we must pause briefly to acknowledge a curious juxtaposition especially notable to readers who have recollections of the 1950s. Who emerged as the most popular American artist of that decade and beyond? Andrew Wyeth, of course, with his meticulously painted representational works like *Christina's World* (1948) and *Young America* (1950), the latter showing a young man riding his bicycle ever so freely through wide open countryside, a red, white, and blue faux-fox tail flowing back from a tall "antenna" extending vertically and high from the bike's handlebars. Individualism rampant in a land of adventuresome opportunity. It was not exactly subtle, but it was beloved nonetheless.[31]

In stark contrast to Wyeth's widely appreciated work, however, what emerged in elite circles by 1956 as the influential new "school" of American art? Abstract Expressionism. That is what the organizers of the U.S. contribution to the prestigious Venice Biennale in 1956,

covertly supported by the CIA, chose to feature in the American Pavilion there. That is what American museums and commercial galleries would be displaying in overwhelming numbers until well into the 1960s. Was America out of sync with itself? Was Wyeth's accessible realism utterly distant from Jungian-inflected abstractions? If we mean a clear disconnect between what the demos liked and what the curators and critics preferred, the answer has to be categorically yes.[32]

If Communism became the principal anxiety and political hot spot in the art world during the 1950s, it would soon be supplanted by democracy during the 1960s. The emergence of Pop Art was central to that development. Looking back from the summer of 1969, English-born critic John Russell asserted that Pop Art had "a democratic, in fact egalitarian source," which he felt made it "a distinctively American activity. . . . It stands, in other words, for a largeness of embrace, a breadth of acceptance, an openhandedness which have been bred out of European art."[33] All participants in the art world did not exactly join a consensus linking the latest trend with social inclusiveness at that time, but a good deal of basic evidence in the Pop Art movement sustains Russell's claim. Andy Warhol could be maddeningly disingenuous, yet after a while his words seemed to convey oracular wisdom. So he proclaimed that "Pop art is for everyone. I don't think art should be only for the select few, I think it should be for the mass of American people and they usually accept art anyway." He was taken at his word, and his telling "truths" were constantly quoted.[34]

Pop Art and the warm reception it received deserves to be considered a pivotal moment in the democratization of American art, despite abundant ambiguities when we look closely at the tongue-in-cheek views of many of its devotees. Pop artists certainly did seek to create "fine art" based upon mundane objects of daily living, such as comic strips, soup cans, and Brillo boxes. They also did more than merely acknowledge the rapidly expanding consumer culture. They sanctified it when they were not spoofing it, and therein lies some of the ambiguity. If Warhol tends to come to mind first and foremost, it is useful to balance his opaquely calculated pronouncements with consideration of the soft sculptures by Claes Oldenburg from the early and mid-1960s. Oldenburg's objective was the droll idealization of ordinary objects, spaces, and experiences. One sentence can epitomize his efforts: "I am for an art that embroils itself with the everyday crap & still comes out

on top." If his work seemed whimsical, which it certainly was, the pub-
lic most certainly could connect with it and smile.[35]

As for the radical discontinuity between Abstract Expressionism
and Pop, there are at least two contrasting ways to perceive their
sequential relationship. Writing from a formalist point of view,
emphasizing similarities of technique rather than content, Robert
Rosenblum observed in 1965 that the gulf "is far from unbridge-
able. . . . The most inventive pop artists share with their abstract con-
temporaries a sensibility to bold magnifications of simple, regularized
forms . . . to taut brushless surfaces that often reject traditional oil
techniques in favor of new industrial media of metallic, plastic, enamel
quality; to expansive areas of flat, unmodulated color." John Russell
then added, however, a cautionary contrast in terms of content:
namely, that Pop Art really did intend to answer critically the aesthetic
assumptions of Abstract Expressionism. Wayne Thiebaud's rows and
rows of high caloric cakes and pies spoke to the daily experience if not
the very existence of sugar-fixed ordinary Americans. His art might
be banal, but it offered instant access and visual validation for the
commonplace.[36]

By 1969–70 the trend to democratize the content of art, already
well under way, was compounded by the desire to radicalize art politi-
cally in response to the war in Vietnam and the civil rights struggle at
home. Those latter issues, raising and compounding the stakes for art
as social criticism, took many forms and used various media. The anti-
Communist attacks so virulent only a decade earlier seemed remote, a
position utterly missing, even by allusion, from the various art world
symposia springing up by the start of the 1970s. The pendulum of
opinion swerved notably left of center even where no consensus
existed. There were as many different takes on how, why, and where art
should be politicized as there were artists and critics. Agreement did
not even exist on the extent to which the audience for public art should
be consulted about the designs that ordinary folk would have to view
on a daily basis in or near their workplace. Some (considered elitists)
felt that populist input into the selection of artists for commissions
might very well compromise the quest for quality and excellence. Oth-
ers insisted that it did not matter—only that the vox populi did.[37]

A neglected episode that erupted in 1969–70 raised complex emo-
tional issues (and hackles) involving impassioned patriotism in conflict
with historical revisionism. In 1968 the National Park Service (NPS)
decided to issue a new, modern guidebook to the Custer Battlefield

National Monument in Montana, which it hoped would eventually be renamed the Battlefield of the Little Bighorn, thereby lowering Custer's high-pedestal stature as an American martyr. He had been a mythic folk hero ever since his death during the bloody fight in June 1876, and revisionism would not go over well with the public, especially among whites in the Great Plains and Rocky Mountain West. The extra funding required to pay for the new guidebook had actually been raised by a Custer Battlefield association based in Billings, Montana. The NPS commissioned a distinguished (though sometimes contentious) artist, Leonard Baskin, to prepare fifteen sheets of original drawings of the Indians and Custer to appear in the guidebook, whose extensive text was prepared by Robert Utley, a prominent historian who specialized in the military and Indian relations.[38]

Baskin's distinctive drawings of various Indians and chiefs, including Sitting Bull, appeared in the new volume. His depiction of Custer seated and in uniform rendered him rather shaggy and with an apparently glazed look, yet the NPS also intended to use it on a very large poster (fig. 38). This image was certain to stir controversy, especially given Baskin's forthright feelings about the man. "I was fascinated by his sense of posturing," he said, "his sense of dressing up and by his incredible mania about himself." Baskin also depicted the dead Custer naked, which is how the Indians had actually left his body (fig. 39). Utley's text, which preceded Baskin's vertical drawing of the nude corpse by one page, read: "Custer's body lay just below the crest at the north end of the ridge. It had been stripped but neither scalped nor mutilated. One bullet had lodged in the left breast, another in the left temple." Baskin's brief comment in an interview: "The Indians took him—that's all. And somehow one is glad. He would have made a terrible President."[39]

When the new guidebook reached the park for distribution in 1970, Custer partisans became extraordinarily angry and embittered. Utley had told the NPS chief of publications, who had commissioned Baskin, that he was "appalled by the artwork" and would not permit his name to be associated with the book in any way if Baskin's art appeared in it. His rendering of the dead Custer was "terribly disrespectful." In his autobiography Utley repeatedly refers to Baskin's style as "impressionistic," which it is not, and to the dead Custer as "mutilated," which he is not. But Utley faced a fait accompli as well as a great embarrassment when meeting old friends who remained devoted to Custer's memory.[40]

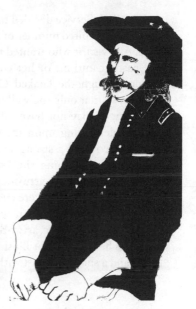

38. Leonard Baskin, *George Armstrong Custer* (1969). Courtesy of the National Park Service and Lisa Unger Baskin.

39. Leonard Baskin, *George Armstrong Custer* (1969). Courtesy of the National Park Service and Lisa Unger Baskin.

The Park Service decided to resolve the issue by printing the guide-book with a limited number of Baskin's Indians and with a totally blank page. Any visitor who wanted to buy Baskin's dead Custer could do so and paste it into his or her copy. But nothing was posted about that option, though the "naked Custer" was kept available at the sales counter, so that only the well informed knew to ask for it. Rangers on duty may or may not have called the option to the attention of pur-chasers, depending upon their feelings about Custer. Many visitors simply discovered a strangely blank page when they returned home. Utley's text describing the "stripped" Custer remained unchanged. Subsequently Baskin's artwork appeared intact in a second edition—no blank page. The times were changing and tempers cooled—somewhat. In 1988 yet another edition appeared with less Baskin and more pho-tographs and "historic artwork." The pictorial format of subsequent printings has more color illustrations added, but they are highly tradi-tional and a sharp contrast with Baskin's stark depictions.[41]

The emergence of large-scale public art in highly visible spaces near the end of the 1960s would swiftly open a nexus of politically volatile issues involving how choices would be made and whether taxpayer monies should be spent for works that many found incomprehensible, offensive, or both. The famous *Chicago Picasso*, a very large work erected in 1967 at the Civic Center in the heart of downtown, was not selected by means of a competition—neither for artist nor for the motif. In 1963 the architects of the Civic Center decided that they needed a work of monumental sculpture to enhance their large but severely modern structure. Along with all-powerful Mayor Richard Daley, they were determined to get a work by Picasso for their city, but the only way that opinionated artist, who could pick and choose his commissions, would make a commitment was if he received carte blanche. Ultimately he not only agreed but waived his fee, thereby making the unnamed, rust-colored work his gift to the city of Chicago. Others in the private sector picked up the construction costs, so that the public paid nothing for it. Even so, citizens had no role in deter-mining whether there should be a work of art on that plaza, who should design it, or what it might look like. All decisions were made at the top, which prompted resentment.

When the work was ceremoniously unveiled on August 15, 1967, large crowds gathered and most viewers found it baffling, and not

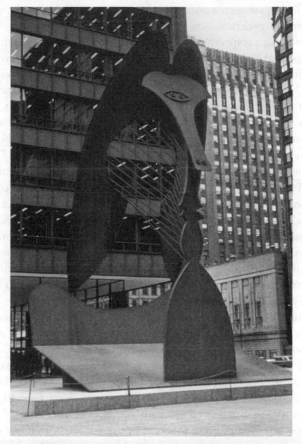

40. Pablo Picasso, the *Chicago Picasso* (1967).
© 2007 Estate of Pablo Picasso/Artists Rights Society (ARS), New York.

just because of the astonishing size (fig. 40). Was it meant to resemble the head of Picasso's beloved Afghan hound? Or perhaps a gigantic baboon? When Picasso was asked about the "subject" of his work, he is said to have blithely replied, "It's my wife," or words to that effect—perhaps. By and large the press did not respond well to this highly enigmatic situation and made frequent reference to the artist's erstwhile membership in the Communist Party and his many "mistresses." As the *Chicago Tribune* put it, "This man so full of contradictions—the innovator who conserves much of the past, the Communist who insists on living in a free country"—had created for a

city he had never seen a civic monument that might become a subject of dispute for generations.[42]

A different perspective at the dedication, and a description much closer to what actually developed, came from the lieutenant governor (filling in for Governor Otto Kerner, who had been called to Washington), who found it "wonderful to witness the healthy controversy which a work of art can generate." (Note the echo of President Eisenhower's emphasis upon "healthy controversy.") On that first day, in fact, a large group became engaged in a "floating argument" about the meaning of the sculpture "and such topics as war and politics." More than one person wished that it had been a statue of Ernie Banks, the beloved first baseman for the Chicago Cubs. An opinionated colonel, upon first confronting the *Chicago Picasso* (the artist refused to give it a title, and it remains so designated), archly declared that "if it is a bird or an animal they ought to put it in the zoo. If it is art, they ought to put it in the Art Institute." The core response and message was that "unfamiliar art doesn't belong here in this public space. It belongs in a place that clearly identifies its objects as art so you only have to look at them if you want to."[43]

While Chicago's aldermen viscerally disliked it, art critics were impressed and called attention to the city's historic tradition of accepting advanced architecture but not avant-garde art. John Canaday pointed out that Picasso's politics and his private life "have been thrashed over once more as if they have any connection with the merits or demerits of his sculpture." It puzzled him that so many Chicagoans felt bewildered or irate about this "not very advanced sculpture—this sculpture in what has become a classical, if not quite a conservative, 20th century style," and then expressed the only objection that seemed valid to him: "rather than not looking enough like something, it looks too much like something. Simply as an object, 'a thing all by itself,' the sculpture is a handsome design, an ingenious contrivance at huge scale, a satisfyingly firm piece of engineering that harmonizes in its structure and its material with the new Civic Center building that dominates the plaza.

> In the openness of its forms it at once occupies a great volume of space—which it has to do in order to hold its own in the large plaza—and yet displaces no space, obstructs no view, in that rarest of treasures, an airy spot in a big city. Because we look not only at but through the sculpture, it takes on an unusual variety

of aspects according to our angle of vision. Regarded as a huge abstract stabile (borrowing Calder's term), the Picasso is a brilliant success in situ.

Canaday concluded, however, that because Picasso refused to comment upon or explain his design, "the sculpture is reduced to a game of charades."[44]

Taking a longer view, more often than not the initial response to such works is not the enduring one. Outrage or puzzlement at the outset usually gives way to acceptance, sometimes reluctant but often even affectionate. That is exactly what happened to the *Chicago Picasso* within a brief span. As one observer remarked: "The longer you look, the more you see. That's art." What also helped considerably in this case, reminiscent of Hiram Powers's *The Greek Slave* in the later 1840s, was a well-managed public relations campaign choreographed by Mayor Daley's office. For several years following its installation, birthday celebrations were held in the plaza, complete with cakes provided by a local advertising agency. When Daley died in 1976, one cartoonist portrayed the sculpture shedding a tear. The *Chicago Picasso* had won acceptance.[45]

We will return in depth to controversies provoked by government-sponsored public sculpture in Chapter 7, because that is a post-1960s narrative. What must concern us here is just one pertinent piece of that story: what it revealed about the relationship between art and democracy and, more specifically, changing perceptions of their interconnections. In 1974, the year when Alexander Calder's stabile called *Flamingo* was dedicated in Chicago, an artist and critic named Douglas Davis expressed concern about undermining the quality of public art because of too much meddling by the public and elected officials. "What disturbs me," he wrote, "is the spreading belief that art should compromise everything—including its personal independence—on behalf of a larger public function, democratically defined."[46]

Although Davis actually supported taxpayer funding for art, he worried about the "danger" that "the independence of art itself will be affected (however subtly) by political pressures." His views may have been both overly altruistic as well as excessively anxious, but they were widely shared within artistic communities. "Art begins in the self," he wrote, "which is the final and incorruptible source of our culture. The

true end of public funding is the support and encouragement of that self, not its diffusion." Davis may or may not have been undemocratic, but he believed in complete artistic control, even with publicly funded art projects. Forget about consultation with the people. That cavalier view would not turn out to be a recipe for success, and at crucial times it cooked up some disasters.[47]

By the beginning of the 1980s similar skepticism about the democratization of art museums would be voiced cautiously and judiciously because such a position had become unfashionable and seemingly out of touch with the times. Nonetheless, it, too, became evident in certain circles. One critic, Gifford Phillips, began with a historical approach, noting that populist pressures to democratize art museums had emerged from the political protests of the 1960s, and one major consequence was a change in the "profiles of many of our major cultural institutions—and not necessarily for the better." He acknowledged that "museum managers today consider it economically disastrous to disregard public taste" and that for better or for worse, "crowds have come to be the measure of an art museum's success."[48]

Phillips lamented the tendency for museum directors to dissociate themselves from the idea of the museum as a highbrow institution, especially because "recent moves to democratize museums have been aimed primarily at weakening elitist control of them." The National Endowment for the Arts' (NEA's) primary objective, "to bring more art to more people," served as a very clear signal to art institutions that they must do everything possible to broaden their clientele by popularizing their exhibits and programs. His response? "Whether popularizing museum exhibitions really means democratizing them is debatable. Pandering to popular taste and promoting heavily to stimulate curiosity can both produce crowds. But is there any evidence that esthetic experience is thus enriched, or that the number of such experiences has been increased?" He concluded that "art's effectiveness resides in its mystery, its 'otherness,' its supracultural quality. These are precisely the values which the highbrow museum has always sought to preserve and protect." So yet another ballot was cast against the excessive democratization of art. This view was no longer widely shared yet remained highly visible.[49]

Later in 1981 Donald Kuspit, a prominent art critic, sought to look back on two decades of changing taste and place them in perspective by schematizing a typical trajectory. "On the whole," he observed, "for

an art to endure it must first be popularly received, then critically rejected, and finally ideologically acclaimed. This seemed particularly the case in the modern period." In sum, it must begin with "democratic appeal," then undergo "aristocratic rejection," and eventually reevaluation by an "intellectual aristocracy." In Kuspit's view, "It seems a pity that almost no new art that emerges these days is seriously regarded as arbitrary, for it is denied the period of heroic suffering and scandalous exile necessary to make it successful in the long run." He closed by regretting the apparently inevitable dominance exercised by the media over experienced critical judgment. The "democratic" power of manipulated public opinion invariably trumped expertise. As the authority of critics waned, things were not as they should be.[50]

During the mid- and later 1980s a surge of highly politicized art events occurred in certain venues but did not receive wide notice until the Serrano-Mapplethorpe-Finley controversies burst on the scene so explosively in 1989–90. Prior to that, for example, the work of Sue Coe fiercely attacked the Reagan and Thatcher administrations, most notably with her "Police State" exhibition (1986–87), which toured seven cities but created only a mild stir, in part, perhaps, because the media did not make a fuss even though the art was quite graphic in depicting various forms of violence.[51] Hans Haacke's installations tended to be more sharply satirical and semihumorous even while earnestly attacking misguided state and corporate support for the arts (meaning *control* in Haacke's view). His fundamental goal was to reveal how capital affected art and museums from the inside because so many museum trustees came from the realm of corporate America and corporations were competitive collectors. His first major retrospective opened at the New Museum of Contemporary Art in New York late in 1986 and then traveled to seven other American cities, once again without notable incident.[52]

By the mid-1990s, however, the visualization of American history from any perspective other than a fervently patriotic (or else blandly neutral) one became problematic in the extreme. In 1977 one of the leading American "primitive" artists, Ralph Fasanella, painted a large, five-by-ten-foot work called *Lawrence 1912: The Bread and Roses Strike*, commemorating a major episode of labor unrest and protest against impossible wages and working conditions. Fasanella, a self-taught

artist of great charm and power, had been a labor organizer and one-time member of the antifascist Abraham Lincoln Brigade which fought against Franco in Spain during the later 1930s.[53]

Fasanella painted this panoramic work during a residency in Lowell in the mid-1970s. A group of unions purchased it and donated it to Congress expressly to be hung in the meeting room of the House Committee on Education and Labor. The old mill buildings seen clustered together convey a sense of authenticity and intimacy. The viewer becomes an eyewitness to a dramatic moment in American history. In 1995, after the Republican Party gained control of the House of Representatives, the painting was removed from its wall in that committee room and finally found a home at the Labor Museum and Learning Center in Flint, Michigan. Meanwhile the Republicans renamed what had been the venerable Labor Committee the Committee on Economic and Educational Opportunities. Its Subcommittee on Labor and Management was redesignated Employer-Employee Relations. Labor and its history had been rusticated.[54]

Another prime cause of ideological and patriotic conflict right through 1996 arose from a variety of flag-desecration cases that achieved renewed notoriety between 1966 and 1974 with marine veteran Marc Morrel's soft sculptures (described in the next chapter). It may be useful to recall that not only was this a rather old issue, it had long remained ill defined nationally. At the Chicago World's Columbian Exposition in August 1893, for example, a delegation from California held a festive reception for military cadets at the fairgrounds. For purposes of patriotic decoration, they believed, the delegation carpeted the steps leading to the reception with a forty-foot American flag. A Daughters of the American Revolution (DAR) member walking up to the event became dismayed by the sight of the flag on the steps and rolled it up in righteous anger. Thereupon one of the Californians insisted upon replacing it. When two cadets approached the stairs, they stopped abruptly upon seeing the flag. "We were taught by this government to keep the flag afloat, not under foot," said one. The other agreed, and both young men left the reception.[55]

The story of this incident circulated widely among the Sons and Daughters of the American Revolution, provoking considerable outrage. The San Francisco chapter of the DAR felt honor-bound to respond and passed a resolution of censure aimed at the Californians hosting the affair. Local papers published accounts, and *The American Monthly* printed an article entitled "Respect the Flag" and circulated an

extensive account of the incident. Clearly, appropriate treatment of the American flag remained somewhat variable at the close of the nineteenth century.[56]

By 1988 several major court cases involving flag desecration (though not directly linked to art) became visible in litigation well covered by the media. In the presidential campaign that year George H.W. Bush mocked Governor Michael Dukakis for vetoing legislation in 1977 that would have required public school teachers to lead daily recitals of the Pledge of Allegiance. Bush suggested that his opponent's stand reflected poorly on his patriotism and asked rhetorically, "What is it about the American flag that upsets this man so much?"[57] That highly charged context may very well have inspired a twenty-four-year-old student at the School of the Art Institute in Chicago, Scott Tyler (known as "Dread Scott"), to develop an installation sculpture that he called *What Is the Proper Way to Display the American Flag?* (1988).

The work featured a wall montage of photographs of flag burnings and flag-draped coffins placed above an open book with blank pages resting on a shelf. In order to inscribe an answer in the book, a person would be obliged to walk on an American flag placed strategically on the floor directly in front of the ledger. After the piece received jury approval for the school's minority students' show, administrators asked Tyler to withdraw it, but he declined. It went up as part of an exhibit scheduled to run from February 17 until March 18, 1989. Word of this provocative piece spread quickly, and large numbers of protestors gathered and marched in front of the school. Veterans' organizations mobilized and multiple times each day picked up the flag and folded it properly, whereupon Tyler's fellow students unfolded it and replaced it on the floor. After the media came in with cameras and the controversy gained national notoriety, bomb threats began to be phoned in, but the school had already heightened its security force, and nothing more explosive than shouting and coarse insults occurred.[58]

A coalition of military veterans took their case to the Cook County Circuit Court on March 1 and asked that the piece be removed from the exhibition. One day later a judge denied the request, ruling that "placing a flag on the floor is not mutilating, defacing or trampling it," which were the terms of the Illinois state flag-desecration law. On March 16 the U.S. Senate voted unanimously, by 97 to 0, to amend the federal flag law by making it a crime to display the flag on the floor or ground. By then, of course, the show was coming to a close. The vari-

ability of comments that visitors wrote in the ledger is striking—and equally impassioned on both sides. A construction worker sympathetic to Tyler remarked, "It is easy for white people to say this is our flag, protect it. The same flag was there in numerous courtrooms where lynching mobs were set free." Politicians sought to make hay from the conflict, of course, and called for boycotts of all companies that contributed to the Art Institute. Tyler received death threats but blithely ignored them.[59]

One visitor to the exhibit asked, "Why don't we have a Scott Tyler flag and put it on the floor where dogs can crap on it?" Protests occurred all over Chicago, and not just at the School and the Art Institute. A junior high school teacher, deeply offended by Tyler's outrage, created a protest exhibit featuring a life-size sketch of Tyler drawn on cloth in the manner of a police outline of a homicide victim. While that cloth lay on the floor, an American flag hung above it on a wall in a small North Side museum. Viewers were encouraged to step on the sketch of Tyler's face while they wrote their comments concerning "How to display 'Dread' Scott Tyler."[60]

Tyler's piece reappeared elsewhere sooner than anyone might have imagined, given all the trouble it caused in Chicago. Perhaps what is most interesting about its "revival" is the variability of the response to it, depending upon the venue—a significant pattern that we have already noted. In 1994 the Cleveland Center for Contemporary Art mounted an ambitious and striking exhibition titled "Old Glory: The American Flag in Contemporary Art." Chief curator David Rubin organized the show and made it sufficiently comprehensive that it reached back to the 1950s. With seventy-five works by fifty-nine artists, it included a fair number of innocuous objects that could not have upset anyone; but in addition to Scott Tyler's *What Is the Proper Way* it also re-created Kate Millett's *The American Dream Goes to Pot*, which had caused such a ruckus at the highly political Judson Church show in November 1970 (fig. 3). There were other iconoclastic items as well.[61]

The show received a positive and calm reception not only in Cleveland but after that in Colorado Springs as well, long known to be a very tradition-oriented town. One Cleveland reviewer deemed the exhibit highly engaging and observed that "from beginning to end, there are virtually no weak spots, no lulls in the excitement. Just about every group of artworks in the show carries a strong punch." He went on to acknowledge, "To be sure, there are works that will anger people

determined to be angered, including a flag made from leathery scraps of human skin, (obtained legally) by artist Andrew Krasnow. . . . But such works are treated seriously, not milked for shock value." He described the mood at the exhibition as "an offbeat holiday atmosphere." Curator Rubin then moved on to the Phoenix Art Museum, where he brought the exhibition in 1996. That turned out to be quite a different and highly agitated scenario.[62]

In Phoenix the Millett and Tyler pieces, in particular, sparked outrage from American Legion members, elderly ladies, and lots of patriotic folks in between. As one reporter wrote, the exhibit "sets those obvious patriot-baiting works in a context that is lost to the TV audiences watching American Legionnaires tussling over the flag. And unfortunately, the context was also lost to state and city officials who are seriously considering ways to censor the show and censure the museum for daring to show it." Rubin acknowledged that in assembling the project he had been inspired by the Mapplethorpe and Tyler episodes in 1989, both of which attracted an immense amount of national publicity. "I feel very strongly," Rubin declared in 1994, that "the show should look at risk-taking art, art that has caused uproar."[63]

He succeeded in Phoenix beyond his wildest dreams. Attendance topped anything the museum had seen in years. On the other hand, on more than one occasion Rubin had to flee from an angry mob of protestors outside the museum. State legislators called for an investigation, and the city council tried to figure out how to close the exhibition, but to no avail. The principal comment by the vice mayor of Phoenix acknowledged a censorship problem and explained why that obstacle needed to be overcome.

> There's such a thing as art, and such a thing as being vulgar. This is definitely into the vulgar category. Seeing as the City of Phoenix is the museum's landlord, we have a responsibility, and that's why the city attorney is looking into our contract agreement. We're looking at what we as a city council can do to make them realize that while we're totally 100 percent behind the First Amendment and the right to protest, when it borders on decency, then we need to look at it and say is this what we're going to allow?[64]

Although the mayor stood willing to permit public hearings, as several council members requested, when asked for particulars on how to pro-

ceed the mayor responded with more caution than most, recognizing that hearings would only inflame the public and attract more visitors who would not ordinarily set foot in an art museum. "If you want a hearing," he replied, "have it. If you don't, then don't. I think this nation, and the flag that symbolizes it, will withstand in either case. They are miraculously strong."

By late April the story had made national news. The *New York Times* reported that some 2,500 angry demonstrators gathered outside the museum demanding removal of the show. Senator Bob Dole and Speaker Newt Gingrich offered their criticisms, and Dole declared that First Amendment freedoms "do not excuse such a disgusting display of contempt for the people and the ideals of this nation." The Citizens Flag Alliance also entered the breach, a national coalition of more than one hundred organizations working to pass a constitutional amendment to protect the flag from physical desecration. Although the museum lost numerous sources of funding, ranging from foundations to private donors, it stood firm and the show ran its full course, with veterans carefully folding up Tyler's flag once again, and the curators putting it right back in place. In this testy standoff between freedom of expression and patriotism, the former won. If the demographics matter, however, one might have to concede that "democracy" lost. Majority will was flouted.[65]

One of the most dramatic moments during the entire run occurred when a cluster of veterans contemplated dismantling Kate Millett's *American Dream*, with Old Glory half-stuffed into a porcelain commode, which was being "protected" by staunch feminists. Here is the account recorded by an observer.

The vet was venting when I wandered in.

"I'm not going in there," he said, indicating the rooms with the flag exhibit.

Referring to the flag stuffed in the loo, he explained, "If I go in there, I know I'm going to pull it out."

Two seconds later, he marched up to the Kate Millett piece.

He read the sign describing Millett and learned she was a feminist. "Didn't that just figure?" he said out loud.

After a pause, he asked his sidekick, "Are you ready to go to jail?"

"It wouldn't be the first time," came the reply, and I thought, "Oh boy, here come the salty road-dog stories."

Instead, the first vet reached between the cell bars of Millett's piece and extracted the flag, which he folded smartly and stored on the top of the artist's display. Laura Mumby, probably a feminist, reached up, unfolded the flag and jammed it back into Millett's toilet. People cheered.[66]

A standoff at the O.K. Corral.

By the later 1980s and early 1990s, the peak period of what came to be known as the "culture wars," there were angry people at both ends of the spectrum, but very few were any angrier than those afflicted with HIV/AIDS who felt that the American government was not taking the epidemic seriously and was falling woefully short in terms of funding for research. One of the leading activists in the art world was a gay man named David Wojnarowicz, who had suffered an abusive childhood, lived on the streets from the age of sixteen, became a self-taught artist, and settled in New York's East Village in 1978. Because his "real world" experience had been so gritty and adverse, he despised what got glorified as the history of a "democratic society" in the United States and sought to compose his own history using photographs, recordings, images, and objects that would contradict "state-supported forms of 'history.' " His *Sounds in the Distance* (1982) was a collection of monologues from "people who lived and worked in the streets," and *The Weight of the Earth, Part I & II* (1988) became an arrangement of black and white photographs taken during his travels and life in New York. He repeatedly returned to the personal voices of people stigmatized by society.[67]

Wojnarowicz had his work included in the 1985 Whitney Biennial. After being diagnosed with AIDS late in the 1980s, his art took on a more sharply political edge, and he soon became deeply involved in public debates about medical research and funding, morality and censorship in the arts, and the legal rights of artists. He brought a lawsuit against Donald Wildmon and the American Family Association, which he accused of misrepresenting his art by cropping it and reproducing it selectively, thereby damaging his reputation. The suit also charged libel owing to Wildmon's alleged intent to strip the work and the artist of political and artistic significance. Wojnarowicz won. His work became increasingly ideological, individualist, antistatist, and global (or universalist) in scope: "His aim is to affect the world at large; he

attempts to create imaginary weapons to resist established powers."
One of his major works, entitled *Tongues of Flame* (1990), dealt with
AIDS by attacking prominent religious and political figures indifferent
to suffering caused by the disease, which eventually killed him in
1993.[68]

Perhaps the most infamous politically motivated protest against
insensitivity to AIDS occurred at the Walker Art Center in Minneapo-
lis. Ron Athey was an HIV-positive performance artist who pierced
himself with needles and carved designs into the flesh of an assistant.
In March 1994, with an audience of about one hundred in attendance,
he cut a design into the back of another man, blotted the blood with
paper towels, and then hoisted the bloodied towels on a clothesline
above the audience. Accounts differ about the extent of the panic.
Some say that people knocked over chairs while fleeing from beneath
the dripping towels. Officials of the Walker Center, which had given
Athey about $150 of its annual NEA grant in excess of $100,000,
insisted that there was no panic and that most people remained in the
auditorium.[69]

By June the incident had come to the attention of the U.S. Senate,
where leaders of both parties condemned the Walker Center for mis-
using NEA funds and indicated that the agency's funding would be in
"serious jeopardy" for 1995 if efforts were not made to prevent "such
grossly improper activities." Senators Byrd and Nickles added that
"the public should be able to expect to attend a publicly funded perfor-
mance without being exposed to HIV-infected blood." The Walker
Center insisted that the man whose back had been cut was not infected
with the AIDS virus and that local health officials confirmed that the
audience had never been at risk. Unfortunately, when Athey was asked
about what he had done, his mild-mannered response came across as
disingenuous at best. He expressed surprise and dismay at the tempest
he had caused and resented the way his "work" was being used as a
political weapon by conservative politicians. "Politics just gets dragged
into it," he declared, "because of my working with the body." Accord-
ing to a feature writer for the *Los Angeles Times*, "The politics have
indeed eclipsed any discussion of the work's content—which includes
symbolic and allegorical responses to his ultra-Fundamentalist up-
bringing. His works rely heavily on references to martyr symbols and
archetypes as well as stigmata."[70]

Athey's performance contributed significantly to the growing
demonization of the NEA and to budget cuts that agency would suf-

fer in 1994 and 1995. In July 1994 the Senate engaged in an extensive but predictably fruitless debate over where artistic expression ends and pornography begins. Punitive legislation introduced by Senator Jesse Helms, accompanied by a picture of the heavily tattooed Athey as well as photographs of earlier NEA "sins," was defeated by a vote of 49 to 42 but left the majority, seeking to prevent outright censorship, in a very awkward position. As Senator Jim Jeffords of Vermont remarked, "You go back home and try to defend voting against an amendment that would keep people from cutting up one another." Not easy.[71]

As new "categories" of art achieved the kind of legitimacy that would make them eligible for public funding, beginning most notably in the 1970s with conceptual art, installation art, performance art, and even photography in certain traditional institutions, the range of potential sources for political provocation grew dramatically. Unprecedented kinds of controversies occurred—ones that would have been inconceivable just a few decades earlier. Carol Becker is the dean of faculty and a professor at the School of the Art Institute of Chicago. In the wake of that wildly explosive exhibition called "Sensation" at the Brooklyn Museum of Art in 1999, she called for a wide-ranging discussion of how "art becomes a magnet for the issues and politics of its times and how even democratic societies expose their fear of the human imagination when they act out the desire to repress and punish it simply because some feel it has gone too far."[72]

That discussion is still ongoing. But a comparison of similar polls taken between 1990 and 2003 is instructive and somewhat surprising. In March 1990 a survey conducted by People for the American Way Action Fund posed this statement to twelve hundred adults nationally: "Freedom of expression is essential to artists and the arts." Sixty-six percent strongly agreed, 27 percent agreed somewhat, 4 percent disagreed somewhat, 2 percent strongly disagreed, and 1 percent had no response.[73]

In April 2000, following a decade filled with numerous controversies like the one caused by Ron Athey, a survey conducted by the Freedom Forum on the state of the First Amendment achieved a rather different result. The statement posed to 1,015 adults read as follows: "People should be allowed to display in a public place art that has content that might be offensive to others." In response, 22 percent strongly agreed, 24 percent mildly agreed, 17 percent mildly disagreed, 34 percent strongly disagreed, and 4 percent didn't know. In June 2002

the same statement was presented to a national adult sample of one thousand, with very little change in the responses.[74]

In June 2003 the same issue was offered once again to an adult sample of one thousand, and the results changed only slightly: 22 percent and 22 percent agreed, while 20 percent mildly disagreed and 35 percent strongly disagreed. Only 1 percent had no answer. It would appear from the most recent poll that a shift toward restraint is evident, with those supporting restraint in a somewhat stronger majority of 55 percent to 44 percent who favor a more permissive reading of the First Amendment.[75] Americans remain deeply divided on such matters. We must also recognize in these polls, of course, that the manner in which questions are posed has a profound effect upon the answers given.

The Pivotal 1960s

Many of the familiar issues that spark art controversies have obviously been around for quite some time, even if they have acquired significantly new or different manifestations in recent years. Our emphasis thus far has been upon the persistence of these varied phenomena. Unquestionably, there have been quantitative as well as qualitative changes just during the past generation. Art-related conflicts have not only become more common and even more widely publicized but also more diverse and quite often more intense than ever before. When and why did this intensification occur? What changed, and perhaps more to the point, what prompted change? What happened to make art not only more controversial than ever but in new ways? Crucial answers to those questions are found quite strikingly in the decade of the 1960s, which appears to me the most pivotal period or "moment" in our story.

By the early 1960s modernism had reached a degree of abstraction that made it virtually inaccessible and meaningless to all but a relatively modest number of insiders who had acquired the visual vocabulary and acuity to appreciate where the advanced phase of Abstract Expressionism had gone.[1] Artist Ad Reinhardt, for example, wanted to expunge from his painting all ideas, all emotions, and all values so that his art would have no subject matter and no social or practical value. (Curiously, he happens to have been a very committed leftist and activist.) He painted black on black, using multiple degrees of blackness that were quite difficult to differentiate. Color field painting, meanwhile, certainly lacked popular pizzazz. Representational art was *bound* to make a comeback, but to do so it would need to take new

forms. Beginning with Pop Art, those forms often turned out to be radically different and consequently disturbing to many, both within the "art world" and beyond.[2]

Critic Arthur C. Danto has proposed the very handy phrase "disturbatory art" as a way of describing some of the major developments that began in the 1960s. "Disturbational objects are intended to bruise sensibilities," he observes, "to offend good taste, to jeer and sneer and trash the consciousness of viewers formed by the very values disturbation regards as oppressive." And later he added:

> This is art that does not just have disturbing contents, for a lot of traditional . . . art and even some of its masterpieces are filled with disturbing content. . . . Disturbatory art is intended, rather, to modify, through experiencing it, the mentality of those who do experience it. This is not art one is intended to view across an aesthetic distance that serves as an insulating barrier . . . but art intended instead to modify the consciousness and even change the lives of its "viewers."[3]

The new art often drew upon or made reference to mass culture— hence the designation Pop Art—and it achieved a much broader, indeed a more popular appeal than preceding movements had. Art in general enjoyed commercial success in the 1960s. New art sold surprisingly well, though the prices realized for Abstract Expressionism also rose. In 1966 a public relations man "invented" the idea of Art Indexes as a means of tracking prices and hence the value of art as an investment.[4] It helped at this time that large corporations began buying art to enhance their offices and plazas, thereby expanding not only the market and art's visibility but also the number of aspiring artists. A dramatic increase began to take place in the number of individuals attending and graduating from art schools, knowing at the same time that to achieve success they needed to come up with something strikingly different. Without some idiosyncratic breakthrough in style or content, not to mention a modicum of iconoclasm, an artist was unlikely to "make it."[5]

Despite the growing commodification of art, an increasing number of altruistic artists felt fairly ambivalent about making art as an overtly commercial product and therefore turned deliberately to modes of creation that were ephemeral rather than permanent, unlikely to

appear in commercial galleries, and in many instances could not even be sold. They subsisted by selling sketches, prints, or photographs and from foundation grants. Christo is merely the most famous example of this trend. Artists who turned to nature for their materials and constructions, for example, altered the way their vocation would be defined in the future. Andy Warhol might proclaim that making money from art was just fine, and he did so increasingly in pursuit of fame as well as fortune, but others sought to create art that might only endure, for example, in the form of documentary images. Art for art's sake thereby acquired fresh meaning.[6]

As new modes of making art emerged, with what came to be known as "art off the easel"—installation art, conceptual art, performance art, video art, body art—the meaning of "art" became democratized but in the process it also became more protean. As growing numbers of artists felt engaged by technology, for instance, and wanted to make it integral to their work, the public had increasing cause to be unsure just what qualified as art, and why.[7] Its parameters became looser, vaguer, and more elusive, which had both positive as well as negative consequences. Some influential critics began to refer repeatedly to the "death of art," which did not usually mean the absolute *end* of art, only the end of art as it had been understood for several hundred years. Other observers vigorously disputed that view, however, and their dialogue has persisted. Here are two exemplary, oppositional statements by eminent critics:

The Age of Manifestos, as I see it, came to an end when philosophy was separated from style because the true form of the question "What is art?" emerged. That took place roughly around 1964. Once it was determined that a philosophical definition of art entails no stylistic imperative whatever, so that anything can be a work of art, we enter what I am terming the post-historical period. [Arthur C. Danto][8]

Easel painting lives! Knocked by kineticists, laughed at by light artists, humbugged by happeners and maligned by multimediaries, good old-fashioned painting, the kind that's done with brush and canvas (and traditionally on an easel) is doing very nicely, thank you. And reports of its demise have been greatly exaggerated. [Grace Glueck][9]

When the war in Vietnam escalated in 1965–66, increasing numbers of artists became politically and socially alienated. Quite a few felt an obligation to use their work to protest the war—prime examples would be Mark di Suvero's *Tower of Peace* (1966) and Edward Kienholz's intensely sardonic installation piece titled *The Portable War Memorial* (1968)—and many more decided to add "social critic" to their vocational mission and identity. Artists like Claes Oldenburg and Richard Serra turned away from the museum as a suitable setting for their work. The 1960s phenomenon known as Happenings also developed as a protest against what Susan Sontag called the "museum conception of art." That attitude was not entirely new, of course, but it achieved a depth of commitment that seemed almost unprecedented.[10]

Meanwhile American art museums actually sought to transform themselves by democratizing and expanding their social role. Their departments of education, previously not a primary agency or function, swiftly became a high priority and received far more attention and resources from administrators. Two major questions remained unclear, however: what new kinds of exhibitions should be mounted to suit the increased attendance that was envisioned, and what sorts of things actually belonged in a proper art museum? Photography? Sculpture "off the pedestal"? Electronic installations? Artifacts generated by fashion or popular culture? Those issues would generate considerable debate and dispute during the 1960s and on into the 1970s.[11]

What about objects created by serious artists who offered them as art but whose primary purpose was clearly social criticism and political change? In 1971, for instance, the Solomon Guggenheim Museum in New York refused to exhibit a work by Hans Haacke titled *Shapolsky et al. Manhattan Real Estate Holdings, a Real-Time Social System, as of May 1, 1971*, a devastating critique of New York area slumlords. In 1961 the Guggenheim's director, Thomas Messer, had published an article with the rhetorical title "What Should a Museum Be?" Museums, he explained,

> contemporary museums in particular—are battlefields where forms are the weapons and the spoils—the means and the end. Forms, within one's own time, become carriers of ideas, and of ideologies. The particular form makes common cause with its closest kin and asserts itself more powerfully as idiom or style. Museums today are caught in the thick of battle and, for better or for worse, have some influence upon the outcome.[12]

That almost sounds as though Messer felt that contestation in the art world was inevitable and perhaps even instructive as well: part of a democratic process in which the museum as an institution serves a didactic function. On March 19, 1971, however, Messer wrote the following to Haacke.

> The trustees have established policies that exclude active engagement toward social and political ends. It is well understood, in this connection, that art may have social and political *consequences* but these, we believe, are furthered by indirection and by the generalized, exemplary force that works of art may exert upon the environment, not, as you propose, by using political means to achieve political ends, no matter how desirable these may appear to be in themselves.

Following this cancellation, Haacke used the media to publicize the museum's censorship of his work. Messer then issued a statement: "I did explain that by trustee directive the museum was not to engage in extra-artistic activities or sponsor social or political causes but was to accept the limitations inherent in the nature of an art museum."[13] Haacke, of course, did not exactly regard what he had done as "extra-artistic." Nor did many high-profile critics. That gap served as a preview of coming distractions.

Another new development during the later 1960s would prompt an entire spate of contretemps that became notably problematic for the next quarter-century concerning works of public sculpture commissioned by the General Services Administration and the National Endowment for the Arts. Many of these works turned out to be startling because of their abstraction, their unavoidable in-your-faceness (office workers were obliged to view them daily), and their size. Gigantism became not merely feasible and surprisingly affordable but often a mark of prestige, frequently for the artist and sometimes for the sponsoring agency. Art critic Barbara Rose wrote the following in 1968 when the problem was just beginning to become apparent.

> Certainly one of the factors that has contributed to making large scale [work] endemic in new sculpture is the demand on the part of American institutions ... for impressive, monumental objects to decorate their premises and enhance their images. But it would surely be naïve to see these many new outlets for sculp-

tural decoration as expressive solely of a hunger for beauty on
the part of American civilization in general. . . . The pervasive
and, I would argue, pernicious notion of scale as content is
undoubtedly the most unfortunate side effect of the present
American sculptural explosion.[14]

Although the problem of American gigantism would be most
notably evident in public sculpture—made possible by the develop-
ment of new supersize cranes and fabrication techniques starting in the
mid-1960s—sculpture also took a cue from recent trends in painting.
Consider an especially extravagant example, *F-111*, a vast painting
made in 1964–65 by the Pop artist James Rosenquist that is ten feet
high and eighty-six feet long (longer than the actual war plane it repre-
sents). Created when the artist was only thirty-one years old, it swiftly
achieved notoriety when collector Robert Scull proclaimed it "the
most important statement made in art in the last 50 years" and pur-
chased it for $60,000. Named for a controversial fighter-bomber and
covered with commonplace motifs from consumer advertising and
photojournalism, it seemed to be a satirically political commentary on
the aggrandized power of the military-industrial complex. Because his
studio was small, the artist actually painted it on fifty-seven panels and
then assembled them in Leo Castelli's gallery, where the work received
immense hype and close attention from critics and the press. As one
headline cleverly asked: "To What Lengths Can Art Go?"[15]

Because Scull had no place to put such a vast work, it went on inter-
national tour from 1965 until 1968, when Scull loaned it to the Metro-
politan Museum of Art, which made the rather curious decision to
display it with three famous works in a show titled "History Painting—
Various Aspects." Its iconic companions for this display were *The Rape
of the Sabine Women* by Poussin, *The Death of Socrates* by David, and
George Washington Crossing the Delaware by Leutze. Quite predictably,
the critics became incensed and blamed the Met as much for poor
judgment as it did Rosenquist for his grandiosity and startling colors.
Hilton Kramer weighed in for the *New York Times* in no uncertain
terms.

A slick, cheerful, overblown piece of work that is, expressively,
on a level with the commercial art from which its visual materi-
als are drawn. Far from prompting any deep emotions about the
fate of civilization, this is the kind of visual spectacle—gay,

extrovert, technically adept, but irredeemably superficial—that leaves the spectator feeling as if he ought to be sucking on a popsicle.

As for the Met, "the notion of employing Poussin and David as some sort of support for the Rosenquist work is itself an idea of stunning vulgarity and insensitivity."[16]

Kramer's senior colleague, John Canaday, was no kinder. "Pretentious and juvenile in conception," he wrote, the work "is not too bad when it is taken as an entry in the vaudeville sweepstakes of the international exhibitions where it has been prominently exhibited. At the Metropolitan, on the other hand, where our standards are lifted the moment we enter the doors, '*F-111*' becomes an embarrassing exposure." Canaday could not decide whether *F-111* came off worse than the museum. He then passed sentence on the movement that gave Rosenquist his vocational perch. "Pop art in '*F-111*' takes up where Salon art died a well-deserved death almost a hundred years ago." But who had the last laugh? By 1987 the value of *F-111* had appreciated to $2.09 million.[17]

In a very real sense, art became both more and less democratic during the 1960s. On the one hand, the New Realism (as it was briefly called before critic Lawrence Alloway effectively labeled it Pop) seemed so much easier to comprehend than a great deal of modernism and especially Abstract Expressionism. Ordinary folks could "get it," even when its meaning was deliberately ambiguous or else designed as a satire of the superficiality of consumer society. At least it related to everyday life, albeit in banal ways. (The apotheosis of Warhol's Brillo boxes and Campbell Soup cans remains a mystery to me, despite Arthur Danto's delightful effusions about the Brillo boxes.)[18]

But Pop Art also dominated the scene and thereby squeezed out other forms of representational imagery; and because it made such a hit so fast, it swiftly came to serve as a status symbol for new and affluent collectors. If Andy Warhol got rich making lurid, limited-edition screenprints of celebrities, who would want cheap copies of weirdly colored knock-offs? Warhol often spoke of democratizing art, insisting that it ought to be for Everyman. He talked the talk, but he really didn't walk the walk. "Being good in business," he wrote, "is the most fascinating kind of art . . . making money is art and working is art and good business is the best art."[19] For several generations, modernism had connoted the "flaunting of outrageous behavior to shock the bour-

geoisie." So what happens when the consumer class not only ceases to be shocked by the avant-garde but eagerly seeks its output because it has become chic?

Nineteen sixty-two was the breakthrough year for Pop Art, and it culminated in a splashy exhibition mounted by the prestigious dealer Sidney Janis in November (so big that the show required two galleries). Janis's imposing reputation helped immensely to attract attention and get viewers to take this strange new stuff seriously. The work sold, and the Pop movement took off like a rocket. Or at least like an F-111. In December, just after the Janis exhibition closed, the Museum of Modern Art organized a symposium devoted to the subject of Pop. Rarely has any new fad or trend in American art achieved such visibility so fast. But at what cost in terms of controversy? First, although some critics liked it, or at least tried to, a number of very established and well-respected reviewers did not: people like Dore Ashton, Hilton Kramer, Irving Sandler, and Thomas Hess. Second, Janis had been representing some of the most prominent Abstract Expressionists. When he continued to take on and handle more Pop artists, his customary painters held a protest meeting and decided to go elsewhere. Robert Motherwell, Philip Guston, Adolph Gottlieb, and Mark Rothko all left the gallery. Only de Kooning remained from that circle.[20]

By 1965 the emergence of Op Art (for optical) and various forms of "Cool Art" left observers wondering what to take seriously and what might possibly have staying power. As Irving Sandler asked: "Is this art the product of a nihilistic generation or are positive values being discovered in impassiveness and boredom [a dart aimed directly at Warhol]?" He dismissed Pop for being "so dead-pan, so devoid of signs of emotion." In 1968 the Museum of Modern Art's "Art of the Real" exhibition seemed to validate the acceptance of factory-finished Minimal Art. That trend evoked a kind of psychic reminder of the incomprehensibility of Abstract Expressionism for viewers who were not insiders. A candid observer like Octavio Paz could declare, "I am not saying that we are living the end of art: we are living the end of the *idea of modern art.*"[21]

Amid this dramatic sense of transition and transformation there nonetheless remained an intriguing element of continuity, an almost perverse relationship with predecessors and previous developments in art. Danto has called it "master-baiting" from observing the manner in which so many artists starting in the 1960s created pieces that refer

in one way or another to classic works in the history of art. Sometimes their intention has been to spoof, or to update in conjunction with new circumstances; but they could also serve to pay homage and to acknowledge a source of inspiration. Among the favorite masters whose styles and subjects were most frequently alluded to are Manet, Goya, Michelangelo, Leonardo, Rembrandt, Vermeer, Van Gogh, and even Emanuel Leutze.[22]

More often than not, that sort of experiment occurred rather early in an artist's career as part of the process of developing a distinctive style and identity directly following in-depth exposure to classic works. In 1961 critic Emily Genauer asked what the primary function of art had become, especially for the newly expanding class of consumers. Her suggested answer, above all, was *sensation*. Art is not just about beauty and order, she argued; rather, it had become exuberantly spontaneous and very much about chaos. She acknowledged that "defiant individual expression" at that time was "not necessarily aesthetic." She turned out to be more than prophetic.[23]

The 1960s became notable not merely for the appearance of "art off the easel" but also for the growing emergence of art on the floor, or on the ground, assembled and installed, or on the screen in a dark room. Younger artists increasingly felt that they needed to find or contrive new modes of expression by which they could *incorporate* technology and not just *depict* it, as Charles Sheeler and Fernand Léger had done a full generation earlier. By the 1960s it seemed to some participant-observers as though science and technology had rapidly advanced very far ahead of art. Quite a few new artists felt deeply disturbed that art had fallen so far behind. The principal organizer of "Harlem on My Mind," the controversial exhibition at the Metropolitan in 1969, explained that his concept for the show was a form of "electronic theater" where more traditional media would be outmoded and out of place. He had come to believe that "paintings are from another world. They've stopped being a vehicle for valid expression in the 20th century. I believe in art as process, not as artifacts." As we shall see, the audience for that particular show had not yet found that same wavelength.[24]

In 1964 Edward Kienholz, a provocative assemblage artist from the Pacific Northwest working in Los Angeles, became the prototypical exemplar of Emily Genauer's prescience. Alienated, angry, and caustic,

Kienholz anticipated the sort of socially antagonistic art that would become commonplace during the later 1960s. His *Back Seat Dodge '38* (1964), displayed as part of a midcareer retrospective at the Los Angeles County Museum of Art (LACMA) in 1966, caused one of the greatest uproars in his entire career and foreshadowed many that would follow during the 1970s and 1980s. Considered pornographic and obscene, it appeared just when the Supreme Court was struggling to define obscenity, a quest that lasted for more than a decade and ended rather inconclusively. This piece made starkly palpable what people had only been reading in the likes of runaway best-seller *Peyton Place* during the later 1950s: young people making love in the backseat of a car.[25]

The work consisted of a shortened 1938 Dodge with its front seat removed, thereby making the vehicle a veritable "bedroom-on-wheels," reminding viewers of John Steinbeck's frequently quoted remark in *Cannery Row* (1944): "Most of the babies of the period were conceived in Model T Fords and not a few were born in them." The copulating "couple" consists of a chicken-wire male and a plaster female sharing a single, faceless head that contains a photograph of a salacious scene. By lining the windows of the car with mirrors, Kienholz not only denies the covert pleasure of voyeurism but confronts the complicit spectator with himself trying to peer inside. Kienholz seems to have been indicting members of an older cohort who criticized the sexual mores of the 1960s generation. Gerald Silk has pointed out that a hypothetical child conceived in the Dodge when new in 1938, say, would have been in his or her mid-twenties when the composition was completed.[26]

Quite a few of the forty-seven Kienholz works displayed at LACMA had the capacity to antagonize, though for varied reasons. *George Warshington* [sic] *in Drag* (1957) seemed gratuitously unpatriotic (the mother of our country?). *It Takes Two to Integrate, Cha Cha Cha* (1961) called attention to the nation's racial turmoil at a time of intense resistance to integration. Sexual violence and capital punishment were satirized in *The Psycho-Vendetta Case* (1960), abortion in *The Illegal Operation* (1962), and *Roxy's* (1961–62) re-created the salon of a capacious bordello and made prostitution seem the casual, everyday affair that it is.

On March 15, 1965, two members of the Los Angeles County Board of Supervisors, including Warren Dorn, who planned to run for

governor, toured the exhibition and several days later sent a letter to the president of LACMA's board of trustees indicating that the show left them "sick and saddened." Singling out *Back Seat Dodge '38* and *Roxy's* as the most objectionable, they made clear a view that would be widely shared by other supervisors and by many in the general population.

> I am most vehemently opposed to having this kind of expression shown by a public institution to the public at large. Certain of the objects or creations are most revolting, and I feel, pornographic in nature. In particular, I found the scene in the automobile and the House of Prostitution repugnant . . . and not art in any sense.[27]

The board of supervisors met on March 22 and, based on the opinion of the only two members of the five-person board who had actually seen the show, unanimously condemned the two most offensive works and demanded that they be removed. Within a day the museum board responded by declaring its full support for the exhibition, calling it "an honest statement by a serious artist." That same day Dorn announced his candidacy for governor in the Republican primary—eventually won by Ronald Reagan. Predictable charges and countercharges flew back and forth, with the supervisors announcing that they were obliged to intervene—threatening the museum with a loss of funds—because the trustees had abdicated their responsibility as moral arbiters. The museum issued testimonials by leading art experts concerning the significance of Kienholz's art.[28]

During a seven-hour closed-door meeting held just one day before the exhibit was to open, a fairly bizarre compromise was reached involving token modification of the two most controversial pieces, and the supervisors voted to permit the show to proceed. *Five Dollar Billie*, one of the prostitute figures from *Roxy's*, was raised on a higher plinth, making its offensive elements ostensibly more difficult to see. The door to the backseat of the Dodge would be open only during four daily museum tours, and the entire exhibition would be off limits to those under the age of eighteen unless accompanied by a parent or teacher. Because of all the media hype, the show opened to record-breaking attendance. Nonetheless Dorn remained dissatisfied since two swear words were still visible on *Five Dollar Billie*, and because dis-

playing *The Nativity* during Easter week seemed sacrilegious. At this point, even some of Dorn's supporters grew tired of his pious grandstanding.[29]

Although the furor gradually began to subside, the *Los Angeles Times* ran daily articles about the conflict while expressing opposition to censoring the show. The newspaper seems to have been predisposed to that view because following the very first day the paper began its story with a vindicating headline: "No Giggles in the Gallery; Public Sees Exhibition; Consensus: Not Pornographic." Paul Conrad's newspaper cartoons, which began appearing a week before the show even opened, spoofed the supervisors as prudish troglodytes. Kienholz's explanation from the outset held that his work had been "designed to show life stripped of its sham and hypocrisy." Throughout the press coverage, that became the most frequently invoked characterization of what motivated the artist.[30]

Kienholz claimed that he did not appreciate all the ruckus his retrospective had caused and wondered whether the intense media attention might cause people to come view his work for the wrong reasons. Even allowing for a certain degree of disingenuousness, he clearly understood that "captivation is a prerequisite for communication," and the media circus generated by this show certainly became a form of frenzied captivation. All of the publicity, which appeared nationwide, including *Time* magazine, served as a major boost to the artist's reputation and placed his work at the forefront of two major developments in the 1960s: the enthusiasm for assemblage and created social environments, and the production of willfully provocative works at a time of intensified social and political divisiveness. This would not be the last controversy Kienholz sparked, but it surely was his most outrageous, and it made him a prominent figure in the art world until his death in 1994.[31]

By 1966 antiwar demonstrations and protests began taking fresh and varied forms, and many artists became increasingly politicized. Pop artists like Andy Warhol, however, remained assiduously apolitical about anything and everything. Others, like Jasper Johns, created work that seemed deliberately ambiguous and thereby raised eyebrows without prompting major controversies. Beginning in 1955, for example, Johns painted the American flag in many different formats, some of

them in startling, inexplicable colors such as orange and green. As one critic asked when the first of these flag pieces was displayed at the Leo Castelli Gallery in 1957: "Is it blasphemous or respectful, simple-minded or recondite?" The very brilliance of such work seemed to rest in the questions it raised in the viewer's mind. In 1958 the director of the Museum of Modern Art visited Johns's first solo show and bought *Flag*, thereby validating it as an original work of art and one worthy of inclusion in the world's leading collection of modern art. Johns produced variations on this motif for more than a decade without prompting charges of disrespect or desecration.[32]

In April 1966 José Rodriguez-Soltero, an artist and filmmaker, electrified an audience at the Bridge Theatre on St. Mark's Place in Greenwich Village by setting fire to an American flag with accompaniment from the number one pop music hit of the day, "Ballad of the Green Beret." This was one segment in a "Live-Multi-Screen-Scrambled-Love-Hate-Paradox USA" titled *LBJ*. What is most significant, considering the venue, is the very mixed audience reaction. Some approved, but many were shocked, even horrified, and only in part because the display was staged rather clumsily. Abusing the American flag to protest the war was still quite novel at that time. One guest wearing a dinner jacket shouted "Pinko . . . fag!" A writer for the *New York Post* felt "physically, spiritually, morally, and aesthetically oppressed" and promptly left. Although flag burning was not a federal offense, it did violate New York State law, and the department of licenses attempted to close the theater.[33] It did not ultimately succeed, but the episode set the stage for a series of intense conflicts involving the flag as an artist's emblem of political protest.

In December of that year a more complex episode began to unfold that became noteworthy for multiple reasons. Litigation involving the defendant persisted for almost eight years; the media covered the story intensively; and vicious hate mail generated from different segments of society echoed the anti-Communist and homophobic barbs heard at the Bridge Theatre, along with anti-Semitic remarks. Marc Morrel, a twenty-nine-year-old marine veteran, worked in soft sculpture to create an array of antiwar pieces, many of which used the American flag. The most highly publicized was a kind of body bag made from a stuffed flag hanging from a yellow rope noose that could clearly be seen in the display window of Stephen Radich's commercial art gallery on upper Madison Avenue in New York City (fig. 41). Other pieces in

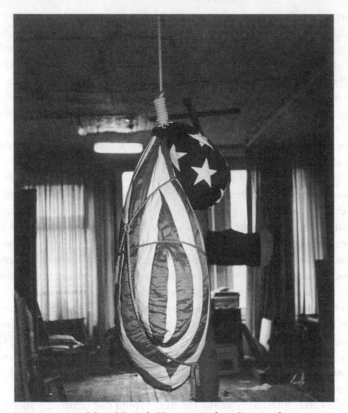

41. Marc Morrel, *Hanging* (soft sculpture of
body bag with American flag, 1966).
Courtesy of Stephen P. Radich.

the show included a large cruciform object decorated with ecclesiasti-
cal prints and having an erect phallus tidily wrapped in an American
flag: a kind of unpatriotic condom.[34]

After someone notified a policeman about the hanging flag-sack, a
complaint was filed against Radich on December 28, 1966, under New
York's flag-desecration law, and he was arrested in connection with the
display in his gallery of sixteen works by Morrel. (No legal action was
ever brought against the artist.) Radich received rather limited sup-
port from major art institutions and organizations. A representative
response came from the director of the Art Institute of Chicago. "I can
only say that it seems to me that the matter is one of a legal technical-

ity rather than one of the artist's right to choose his own materials. Frankly, however, I do not believe that the American flag, or the flag of any nation for that matter, should be desecrated."[35]

The American Civil Liberties Union defended Radich and declared, "What is at stake is the right of artists to freely express themselves and to use all the materials available to them." The head of the United States Flag Association filed a separate civil suit against Radich, asserting that "you can't use the flag as a protest. It's just like you wouldn't murder your grandmother. The American flag is so high above everything—it's on a pedestal—that nothing should touch it."[36]

Radich's trial took place on March 29, 1967, before a three-judge panel in New York City Criminal Court. Aside from violating state law, the prosecution claimed, the visibility of Morrel's sculptures could arouse the public "to the point where there would be possible riot and strife." Art seemed a potent source of civil disorder. When the defense pointed out that the law explicitly excluded ornamental pictures, which should also cover sculpture, the district attorney insisted that three-dimensional objects were more likely than pictures to provoke hostilities. "A photograph in a book is not an animated object and cannot be touched," whereas a sculpture "can be touched, it can be seen and it is an object more likely to arouse the public wrath." The prosecution seemed to fear that people might want to touch the body bag or the cross or even its flagged phallus, and that they would become agitated as a result. *New York Times* art critic Hilton Kramer testified in support of Radich, contending that although the works were "rather feeble," they nonetheless qualified as serious works of "protest art."[37]

Radich was found guilty and sentenced to a $500 fine or sixty days in jail by a 2–1 vote delivered on May 5. The majority determined that Radich had contemptuously displayed the flag, that the state's flag law was not constitutionally vague, and that its "ornamental pictures" exclusion did not cover Morrel's sculptures or invalidate the law on grounds of arbitrary classification because "any contemptuous use of the flag comes within the purview of the statute, whether two-dimensional or three-dimensional." They also held that the First Amendment guarantee of freedom of speech did not cover "license to desecrate the flag." The lone dissenter argued that New York's flag law *was* unconstitutionally vague. He also sustained Radich's free speech contentions, stating that although "we may quarrel with his theme, disagree with his method, [and] condemn his goal," the sculptures were clearly expressions of political protest, which Radich viewed as

"not showing contempt for the flag" but instead as attempting to show that American foreign policy violated such ideals as liberty and equality, for which the flag was supposed to stand. Judge Amos Basel took a position very close to Hilton Kramer's.

I agree with defendant's art expert that the artist's talent is limited, his symbolism obvious, clichéd and lacking in imagination. I acknowledge he has chosen a means of expression in extreme poor taste and shabby in form. But is he to be punished for his lack of manners and his vulgarity when his intention is a serious condemnation of our present foreign policy?[38]

Between the trial and the verdict in the spring of 1967, hate mail began arriving at Radich's gallery, and it proliferated for several years. One of the earliest to arrive, just a few days following the trial with its intense media coverage, would turn out to be typical.

JEW BASTARD
You wonder why Jews are hated[.] we have had enough of
your type this is the end. [Radich was not Jewish. His parents
were immigrants from Yugoslavia.] Both you and Morrel will
have bombs tied to your cocks and set off, after that your bodies
will be burned in the ovens.
This is not just a crank letter this is it, too bad we can't tell
you the time & place. You are being watched and checked every
day by 50 Stars and 50 Stripes[,] a group you never heard of or
from, now you did, and oh how you will.
Signed
(100) Patriotic Americans & Christians
GOD BLESS AMERICA

And then this one from the Bronx, dated March 30, 1967.

Bagel Eater:
Like most Jews of your type [you] would look great hanging
from a Lamp Post in Times Square with your wee wee organ in
a Pigs mouth. You are done and don't forget it—if it takes yrs. So
is the Bum Green [the ACLU attorney] defending you who is
another lousy Jew.
Auxiliary Amer. Legion. We get Action—you Jew Bum.
Your face is for a latrine.

The vicar of St. Paul's Chapel in Trinity Parish, near Wall Street, wrote in a very different vein, which surely must have been comforting even though the death threats continued:

> As a person who has a small collection of contemporary art and a much larger interest in it, I felt that this was a defeat for those who believe in freedom of expression. I came to see the show of Mr. Marc Morrel, whose work I am sure you believe shows talent and integrity, several times and I think what he was trying to express—thoughts and apprehensions felt by many of us—was not intended to be disrespectful to a nation's symbol, but rather the reverse. I took it as a protest against false patriotism and against a growing sense of national infallibility. . . . I hope this verdict will not discourage you from exhibiting the works of artists, whose work you believe show promise and sincerity of purpose.[39]

The number of negative letters outnumbered the positive ones by far, however, and the class differences are obvious. When Radich initially received the summons in December, he circulated a petition throughout the art world, inviting recipients "to sign this statement in support of the artist's right to express himself as he wishes, his right to select and use whatever materials he chooses, and the liberty to have his work exhibited and viewed by the public in galleries and museums." Some distinguished figures did sign, including critic Clement Greenberg and the directors of Harvard's and Yale's art museums. But the number who declined to sign or did not respond at all was considerably greater. The Art Dealers' Association of America (Radich was not a member, although he had been a Manhattan art dealer for fifteen years) turned down a request to submit a brief as a friend of the court because its members "had strong views on both sides of the question and did not feel it should take a position." Most of those opposed seem to have felt that Morrel had shown bad taste, and consequently the case did not offer a strong First Amendment issue.[40]

Although Radich appealed, his conviction was upheld in 1968 by a unanimous vote of a three-judge appeals panel of the New York Supreme Court, and once again in 1970 by a 5–2 vote of New York's highest criminal court, the Court of Appeals. After the *New York Times* story about that ruling appeared with a photograph of Radich standing next to Morrel's hanging noose, people clipped the article and mailed

it to Radich with vicious comments attached. In one instance the word *Kike* was carefully typed across Radich's forehead, and above the photo this message: "When the Commies take over, the first ones they will kill will be the likes of you, on the theory that once a traitor, always a traitor."[41]

The U.S. Supreme Court agreed to examine the case but upheld the previous verdicts in 1971 by splitting 4–4 without any written opinion. (Justice William O. Douglas, already threatened with impeachment by Representative Gerald Ford, strangely recused himself.) The Court of Appeals majority stressed that placement of the flag-noose sculpture "in a street display window" could threaten "preservation of the public peace" because a "reasonable" man might find this and other flag sculptures an act of "dishonor." In 1972, however, the U.S. Court of Appeals for the Second Circuit held that because the Supreme Court had not actually handed down an opinion, Radich had not yet been given his right in federal court to seek one substantive adjudication of a claim to violation of constitutional rights.[42]

While waiting for the appeal to proceed yet again, Radich gave an unpublished interview to Paul Cummings for the Archives of American Art. He explained how Morrel had brought photographs of his work to Radich's gallery, and how he became more intrigued by the content than by the quality of the art.

> All this using the flag or parts of the flag. There was one of the UN flag with pins stuck in it. So it looked to me like it might make a very good show. I didn't think in some ways the protest was strong enough but I liked the idea and I felt that certainly this was the time for this kind of exhibition to be staged. My feelings about our involvement in the Viet Nam War were very strong and I was violently opposed to it and I liked the idea of showing an artist that had the same feeling.[43]

On November 7, 1974, the most litigated flag-desecration case in American history finally ended after eight years when a federal district court judge handed down an extraordinarily long, well-researched, and carefully argued opinion. It held that the New York flag-desecration law had been unconstitutionally applied to Radich in violation of his free speech rights. Judge John Cannella determined that the Morrel sculptures had clearly involved a form of symbolic speech raising important First Amendment concerns. Morrel had not permanently

destroyed or damaged a flag, as in the flag-burning episodes then current. Rather, he had harnessed the flag's symbolic power "in all of its communicative majesty, unalloyed and undiminished," to transmit political views by transferring "the symbol from traditional surroundings to the realm of protest and dissent."[44]

A disillusioned Morrel had left the United States for London in 1967, where he tried to make films and struggled to make ends meet as an artist. In 1972 the expatriate settled in Amsterdam. When he learned of Radich's vindication two years later, he wrote the following to him:

> It's difficult to put into words how I feel. I am happy that the years of pain and frustration are over. I guess the guilt feelings over the war have also come to an end, what with the "Watergate" and other truths coming to light. For myself, I feel my eight long years of political exile have given me the chance to see how much people all over the world are alike. Politics is a wordgame-of-fools, in which no one ever wins. We were trapped into playing because we could not live with what we knew.[45]

In 1970, even while the Radich conviction was moving through the appeals process, increasing numbers of artists decided to use the flag in various ways to protest the war in Southeast Asia. A group organized "The People's Flag Show," a one-week exhibition of flag works designed to test the legality of flag-desecration laws, which had actually proliferated since 1966. Objects included flag miniskirts, flag cookies, a flag penis (labeled "Yankee Doodle Keep It Up"), and Kate Millett's notorious flag covering a toilet bowl (*The American Dream Goes to Pot*).[46]

The show opened on November 9, 1970, at the Judson Memorial Church on Washington Square South in Manhattan, and it closed a day earlier than planned when the organizers were arrested and the district attorney's office threatened more arrests, this time of the artists. On December 3 the Art Workers Coalition organized a well-attended panel discussion of the "Judson Three" and larger issues involving freedom of artistic expression.[47] In many ways, these well-publicized events marked a critical moment not only in the struggle between artists and the law but in an equally bitter battle within the art world between contemporary and "modern" art that by 1969–70 was becoming fiercely acrimonious.

The conflict gained initial momentum in 1967 with New York's Angry Arts Week and its Collage of Indignation, an artist-organized protest that prompted similar demonstrations in Philadelphia, Boston, and elsewhere. Anger arose because of the difficulty artists were experiencing in achieving recognition from what seemed to them the "hegemonic" world of galleries, museums, and critics—what they called "the system" and how it controlled the art market. The Art Workers Coalition, formed in 1969, brought together radicalized artists—antiwar and antiauthoritarian—with numerous grievances directed especially against the Museum of Modern Art, the Metropolitan, and the Whitney. They resented MoMA's partiality toward Abstract Expressionism and comparative neglect of new art being produced in the 1960s. But the issues were more numerous and ran deeper than that.[48]

The Art Workers contended that because of MoMA's devotion to the development of modern art in Europe and America since the late nineteenth century, starting essentially with Cézanne, it had become an "art-historical mausoleum" that ignored contemporary work, which actually was the new, truly "modern" art. The coalition wanted MoMA to deaccession its "classical" collection, perhaps selling pieces to the Met and using the money to acquire large amounts of recent work, but also to decentralize its holdings into neighborhood communities rather than building a palatial new structure in midtown Manhattan. Democratization became the underlying goal of many demands: direct participation by artists in determining which works are acquired by museums; control by artists over their own work even after it belongs to private individuals or museums (e.g., the right to alter or even to destroy their own art); greater control by artists over when and how their work would be shown; greater attention to work by African-American and women artists; and a commitment that museums not charge any admission fees.[49]

Although the Art Workers Coalition remained active until 1974, it achieved very few of its demands and continued to feel powerless and resentful; but its energies moved increasingly toward a more generalized protest against the war. On May 19, 1970, for example, following the tragic news from Kent State and Cambodia, a huge gathering of artists, dealers, even some museum officials, and other members of the art community came together at New York University for an unprecedented joint political action meeting. Feeling that antiwar protest superseded their own vocational concerns, they decided to do what

they could as artists to advance the peace movement: close museums and galleries for one day as a symbolic statement, with "optional continuance for two weeks"; take over the ground floors of galleries and museums to help politicize visitors; set aside 10 percent from the sale of every work of art, to be placed in a fund for peace-related activities; and so forth.[50]

Their goals were more idealistic than realistic, perhaps, yet were highly symptomatic of the way art had become so fully politicized by 1970. In June an artists' strike in New York called "Pause for Peace" opposed racism, the war, and "repression" of artists. To protest a big exhibition at the Met devoted to nineteenth-century art, a large banner appeared: "I invite you to join the 20th century." A proliferation of groups with more particular aims emerged. On July 6, for example, a newly formed student organization—Women Students and Artists for Black Art Liberation (WSABAL)—held a gathering at the School of Visual Arts to protest the Venice Biennale because of the show's neglect of women and blacks. According to their broadside announcing the action, "The government sponsored Venice Biennale was forced to close in Venice in 1968 because students there protested the show's lack of relevance to the horrors taking place in the world then. WSABAL can see no improvement in the world situation since that time and thus no improvement in moving this show of ART FOR RICH PEOPLE from Venice to New York."[51]

By the close of 1970 some of the anti-institutional anger had been deflected by sympathetic and conciliatory responses made by John B. Hightower, director of the Museum of Modern Art. Some extracts from his message in the members newsletter for November are revealing.

> An issue that has become of particular concern this year is the willingness as well as the appropriateness for the Museum to become politically involved. Aside from some fairly explicit language on the subject by the Internal Revenue Service, the question is no longer easily dismissed, largely due to the fact that the work of artists is increasingly oriented to political issues. . . .
>
> Artists have traditionally been the most conscientious and, at times, the most provocative critics of society, and our obligation, as a museum, is to reflect the concern and work of the artist. As a modern museum, our responsibility is more complicated, for we must reflect most importantly the work and con-

cerns of the artists of the present day, who feel that their work cannot be divorced from the humanism that provokes it.

This concern was most particularly raised by the recent exhibition *Information*, in which many of the artists represented had strong feelings regarding many political issues, especially the Indochina War. The reasoning behind the artists' concern over such a political issue is both complicated and profound. . . .

I think the *Information* show, brilliantly assembled by Kynaston McShine, Associate Curator of Painting and Sculpture, over a period of many months, was a benchmark exhibition for the Museum. The palette of this part of the 20th Century is technology, and the artist is experimenting with this palette. Were we, as the Museum of Modern Art, to wait fifty years from now to reflect on what was artistically valid in terms of this work, we would cease to be a museum of modern art. At the same time artists are saying, through some of the technological media, that art is not property; it is not solely an adornment; it is not an object either to be revered like an icon or traded like a commodity. In many ways, though, this is what art has become, and the Museum has played a role in its treatment as such. Both art and man are diminished.[52]

As MoMA gradually maneuvered a truce with its angry antagonists in 1969–70, the Metropolitan Museum of Art made a very serious blunder in planning an exhibition that managed to alienate blacks and Jews while reaping a whirlwind of negative publicity. The photographic exhibition titled "Harlem on My Mind," which opened on January 18, 1969, added yet another dimension to the litany of new and unprecedented kinds of art-related controversies during a contentious decade. In this instance, certain larger issues became inescapable: What should be the character of a major, world-class art museum? What are its responsibilities to the more immediate communities it serves (or neglects)? What kind of political savvy is required to operate a successful museum in swiftly changing and politically charged times?

When Thomas Hoving became director of the Met in 1967, he determined to make a splash in as many different ways as he could—and in the process dramatically increase the museum's visitation figures. One of the very first shows that he decided upon was meant to reach out to a neighboring community customarily ignored by the

Met and most other museums. He approved an exhibition that used enlarged photographs, photomurals, slide and film projections, videotapes, and recordings of Harlem sounds and voices in order to document Harlem's history from 1900 through the 1960s. The purpose, according to the exhibit's director, Allon Schoener, was "to prove that the black community in Harlem is a major cultural environment with enormous strength and potential." Schoener proposed the idea to Hoving because he had done a similar multimedia exhibition devoted to Jewish life and culture at the Jewish Museum in 1966 — "The Lower East Side: Portal to American Life"—which had been well received.[53]

Although "Harlem on My Mind" drew huge crowds, albeit mainly curiosity-seekers wanting to learn what all the fuss was about, nearly everything that could go wrong did. To begin, the critics strongly disapproved and said so before the show even opened. John Canaday titled his preview piece "Getting Harlem Off My Mind" and asserted that this kind of exhibition simply did not belong at the Met. Grace Glueck wrote that the show "panders to our penchant for instant history, packaged culture, the kind of photojournalistic 'experience' that puts us at a distance from the experience itself. Instead of the full, rich, Harlem brew, it presents a freeze-dried Harlem that does not even hint at flavor." One of the kinder reviews in the Sunday *Times* explained that "mere gigantism vies with inventiveness and imagination in displays that involve the viewer emotionally while providing a pictorial record of cultural development in Harlem's continuing history." After a careful description of what to look for, Jacob Deschin warned of a "succession of galleries that one penetrates as in almost a maze to find some in which pictures are displayed on structural squares that vary in height to maximum elevations that often reach close to the ceiling. In one, depicting the Thirties, the display structures are so close together that one maneuvers about in an atmosphere seemingly tense and constrained." He concluded, however, by noting "occasional surprises and visual rewards. The visitor has to work to take it all in . . . but the effort is well worth while."[54]

On the evening of the press preview, fifteen black and white demonstrators picketed the museum with signs reading "That's White of Hoving" and "Tricky Tom at it Again." Composed mostly of artists and their friends, the group distributed leaflets headed by the line "Soul's Been Sold Again!!!" and charged that the exhibition had been developed "by whites who do not begin to know the black experience." This protest was organized by a group calling itself The Black Emer-

gency Cultural Coalition. Subsequently a number of prominent black artists, including Jacob Lawrence and Romare Bearden, protested because their depictions of Harlem had not even been considered for inclusion. That seemed particularly strange because the show made such a point of calling attention to black poets and writers. Why would a serious art museum not include *paintings* devoted to aspects of the community's social history? Why had the artists not even been consulted? They repeatedly voiced their bafflement and anger.[55]

The next evening about thirty-five protestors, mostly black, picketed the high-tone preview, a black-tie cocktail and dinner affair for trustees and friends. The following day, sometime around noon, ten paintings in adjoining rooms, including a Rembrandt, were defaced at the Met in an apparent protest against the exhibition. Small *H*s were scratched into the varnish covering the paintings and in one case into the pigments. None actually cut through the canvas. The *H* scratched into Rembrandt's *Christ with a Pilgrim's Staff* was five inches high. The vandals were not caught, and the group that had been picketing disassociated themselves from the illegal acts.[56]

Meanwhile the 255-page exhibition catalog published by Random House offered as an introduction an essay written as a term paper two years earlier by a sixteen-year-old high school senior in the Bronx. The most troublesome of several statements, and the one most frequently quoted, declared, "Behind every hurdle that the Afro-American has yet to jump stands the Jew who has already cleared it. Jewish shopkeepers are the only remaining 'survivors' in the expanding black ghettos. . . . The lack of competition in this area allows the already exploited black to be further exploited by Jews. Another major area of contact involves the Jewish landlord and the black tenant."[57]

Criticisms flew thick and fast from the city's Special Committee on Racial and Religious Prejudice and from the Anti-Defamation League of B'nai B'rith. Mayor John V. Lindsay denounced sections of the introduction as racist and anti-Semitic, demanded that the catalog be withdrawn until the offensive passages were deleted, and pressured the Met to insert a disclaimer by the young author in the catalog. Mrs. Elinor C. Guggenheimer, a former member of the City Planning Commission, promptly denounced Lindsay for his "ineptness" in handling racial tensions between Negroes and Jews in New York. A day later Hoving, who had been taking quite a lot of heat for "Harlem," publicly apologized to "all persons who have been offended" by the misbegotten catalog. Hoving acknowledged that when he approved the intro-

duction "many months ago I wholly failed to sense the racial under-
tones that might be read into portions of it." One has to wonder
whether he had actually bothered to read it at all. Random House
issued its own apology and promised to insert printed versions of both
statements in all copies of the catalog, hardcover and soft.[58]

On January 30, however, Hoving and the museum bowed to pres-
sure from Lindsay, other politicians, and Jewish organizations by
withdrawing the catalog entirely. Nevertheless the *New York Times*
denounced this "half-baked solution to a second-rate show and a third-
rate catalogue." Neither the museum nor Random House had "exer-
cised any discernible editorial judgment in the project," but it would
violate the concept of a free press to suppress the volume. "That would
be book burning without the flames, an even greater offense to Amer-
ican traditions than anything in the book." Meanwhile Governor
Nelson Rockefeller ordered the broadening of a state inquiry into
anti-Semitism in the city. Ten days after the exhibit opened a freshman
Democratic assemblyman from Brooklyn introduced a resolution in
Albany calling for the withdrawal of public funds "from any institu-
tion" that in any way promoted or aroused racial antagonism. Sidney
Lichtman accused Hoving of "callous insensitivity and flagrantly poor
judgment."[59] Nothing came of this initiative, but it echoed punitive
responses that we have encountered previously in Washington, and it
anticipated more problematic ones that would arise in the 1980s and
1990s, in Washington, Brooklyn, and elsewhere.

Letters to the editor were predictably polarized. On the one hand,
a critic wrote that he objected to "the politicalization of museums of
art. Aside from that, I object to the involvement of an art museum in
controversies which, if not deemed political, are not esthetic in con-
tent. I object to the debasement of the Metropolitan by the display of
material which is not even art . . . and to the gutter fascism of the
brochure circulated in connection with this exhibition." On the other
side, the most commonly heard objection was that the exhibit was not
truly representative of the black community. The editor of *The Black
Power Revolt* suggested, "Since Harlem is just up the road, some of the
time and money spent on encapsulating the black experience could
have been used for chartering two buses which would depart hourly in
that direction. . . . Or is the actual fact of Harlem too real?"[60]

For weeks the crowds seeking admission to the museum were so
large that Sunday lines had to be cut off at three-thirty, ninety minutes
prior to closing. Museum officials estimated that six or seven times

more than the average number of African Americans who attend museum exhibitions were seeing the Harlem show. Three days before "Harlem on My Mind" opened, however, the Met also launched "Young Harlem Creates" (on the birthday of Martin Luther King Jr.), thirty-nine paintings and drawings by Harlem and East Harlem schoolchildren, ages five through fourteen. Installed in the Junior Museum, it achieved a modest audience of children, parents, and teachers. It caused no stir.[61]

As the Met returned to its customary exhibitions during 1969–70, the controversy calmed down and Hoving even received acclaim for some of his other shows and major new acquisitions. Being regarded as a flamboyant carnival barker cut both ways, and he certainly attracted people to the Met who would not otherwise have entered. But the residual damage to his reputation in the art world would be significant. Hilton Kramer, then the principal art critic for the *New York Times*, wrote a lengthy farrago, from which an extract makes some of the complexities clear, at least from the perspective of a traditionalist. He found the show "lamentable in so many fundamental ways—in its conception, in its execution, and in its general ideological assumptions—that at times it hardly seems a proper subject for criticism at all."

Mr. Hoving complains that "For too long museums have drifted passively away from the center of things, out to the periphery where they play an often brilliant but usually tangential role in the multiple lives of the nation." This is not my reading of the recent history of museums. On the contrary, there has probably never been a time when the public, albeit only certain segments of the public, has been so responsive to what our museums have to offer. But I suppose the museum—and art itself—is always vulnerable to charges of passivity and irrelevance. Genuine works of art rarely pretend to offer us either solutions to social problems or—what the "Harlem on My Mind" exhibition provides in abundance—the illusion that we are experiencing such problems at first-hand. Art speaks to us in a language of feeling, and its generative effect on our lives is as slow and mysterious and socially incommensurable as the force of love, which art very much resembles in its delicate equations of the spiritual and the material.

To politicize this subtle transaction of the mind and the emotions is, inevitably, to damage it, perhaps in the end to

destroy it, and to declare that politics must have priority over every sphere of the human sensibility. . . .

We have a right to know, I think, exactly how far Mr. Hoving intends to carry this process, and how large a part of the museum—and of our artistic heritage—he intends to sweep in the path of historical relevance.[62]

Although the Metropolitan reestablished its reputation, its apparent arrogance would be remembered in certain quarters. More important, the issues raised in 1969 about what did or did not belong in an art museum—such as history, photographs, music, literary texts, and how they should be configured—not only lingered, they were already front and center with the protracted dispute over the Hirshhorn Museum and Sculpture Garden in Washington, D.C. (1966–74), as they would be once again when the National Gallery of Art displayed Andrew Wyeth's *Helga* pictures in 1987. Those were just two of the major flaps that followed in the wake of "Harlem on My Mind." Not just the responsibilities but the definitional parameters of the American art museum have now been contested and constantly reassessed over the past thirty-five years.[63]

One other major source of conflict that we most often identify with the 1970s and 1980s had its roots firmly planted in the 1960s: the nature, selection, and placement of public art. In 1962 the General Services Administration (GSA) unveiled its Art in Architecture Program whereby 1 percent of the cost of any federally funded building would be set aside for a major work of public art. (That would be reduced to half of 1 percent in 1972 and fluctuate at low levels after that.) In 1967 the National Endowment for the Arts established its own program called Art in Public Places. (It subsequently morphed into three related programs administered differently according to need and financial scale.) Its essential purpose was to inspire municipal backing for public art projects and to support artists with an administrative agenda through which matching funds could be raised for a work agreed upon by the artist in conjunction with a proactive community.[64]

Although quite a few of these commissions enjoyed success, or at least passive acceptance, many that did not provided occasions for some of the most heated art controversies of the later twentieth century. The first one is notable not only because its intensity matched its

brevity but because the press irresponsibly provided fuel for its igni-
tion, a pattern that we have seen already and that would become ever
more common in the decades that followed. The media increasingly
sensed that the public savored a juicy imbroglio involving art. The
politicization of art invariably coincided with or converged upon other
sensitive issues, and the result was mutual exacerbation and heightened
antagonisms.

In 1965 Robert Motherwell, a prominent spokesman for Abstract
Expressionism, received a $25,000 commission from the GSA to paint
a large mural (thirteen by fifteen feet) well above the glass corridor
entrance to the new John Fitzgerald Kennedy Federal Building
designed by Walter Gropius in downtown Boston; Gropius was a lead-
ing exponent of the Bauhaus School and its international style.
Although the mural was meant to be a memorial to Kennedy, Mother-
well wanted to avoid anything decorative and worked abstractly and
metaphorically, as he had in his extended *Elegy to the Spanish Republic*
series (1949–90). He also had in mind the recent, violent death in a
vehicular crash of his close friend, the innovative American sculptor
David Smith. Motherwell wanted his design to be an "aggressive coun-
terpoint to the geometric abstraction of the architecture," and he
intended to use an ink-bleeding technique he had devised for his *Lyric
Suite* (1965). Somehow, without meaning to, the black shapes he cre-
ated took on a harsher, more brutal quality as opposed to the blurring
and softening of edges that characterized *Lyric Suite*.[65]

To counteract the brutality and soften the impact of this image,
Motherwell added a thin colored strip between the two main black
areas. He subsequently regretted that decision but could not modify it
because the painting had become government property. So the final-
ized work, *New England Elegy*, would be dominated by stark, irregular
black and white sections with a sky-blue border and a yellow line tra-
versing a white center section (fig. 42). One week after the mural was
unveiled on August 6, 1966, a "sensation-seeking" sports reporter from
the *Boston Herald*, the more conservative local paper, asked a woman
for her reaction to what he irresponsibly described as a depiction of
JFK's assassination. "It's an outrage" was her prompt response. After
sharing that information with an unwary assistant curator at the
Museum of Fine Arts and suggesting a false assassination title for
the painting, the *Herald* proceeded to run a trumped-up story with the
headline, "Boston Outraged." Wire services soon flashed it across the

42. Robert Motherwell, *New England Elegy* (1966),
John F. Kennedy Federal Building, Boston, Massachusetts.
Art © Dedalus Foundation, Inc./Licensed by VAGA, New York, N.Y.

country. Because of the tabloid piece, people suddenly flocked to downtown Boston to view the mural.[66]

The more liberal *Boston Globe* followed up on August 12 with a feature titled "Abstract Painting of JFK Death Scene Stirs Furor." The article quoted the curator's interpretation of the abstraction: "one black blotch may represent the profile of the President's head, a very direct and specific depiction of the most brutal moment of the tragedy when Kennedy was struck by the bullet." The lines radiating near the profile might be intended to represent "either bullets or splatters of

blood." As for the painting in general, the curator declared that "it is hideous in one sense because . . . it emphasizes as powerfully as possible the brutality of the moment." The *Globe* added brief reactions solicited from people in the crowd. According to a woman who refused to give her name, "The consensus is we think it's a horror," and more than one person suggested that the small pieces of paint near the imagined "head" were bits of the president's splattering brain. Margaret Finn was quoted as saying, "I like it, but I think I'm the only one who does."[67]

All that and more appeared in the morning edition. In the evening edition on the same day, however, Motherwell was given an opportunity to explain what he had envisioned. He declared that the mural "has nothing to do with the assassination. It is a representation of an emotion of grief . . . not a picture of his death scene." He went on to describe an elegy as "an expression of grief for someone dead, like a requiem Mass." Still other observers were quoted with more negative reactions, however. "There is no configuration, no beauty," said one; "it looks like an unfinished item. The taxpayers have a right to complain." And another, finding particularity in abstraction, declared that Kennedy's "profile was large in proportion to the street because of the telescopic view Oswald had of Kennedy, which brought the President into large perspective."[68] People could somehow see a street, a limousine, a battered head, and mortal remains in midair—mostly owing to the power of suggestion. When I interviewed indifferent visitors in 2004, none of the above entered their ken. Locals and tourists had no idea what the mural represented, either literally or metaphorically. The predominant response: indifference to a pure abstraction.

Another feature in the same edition of the *Globe*, but buried inside, sought to put the controversy in perspective. Most art experts affirm the worth of Abstract Expressionism, it explained. Motherwell, as a leading exponent of that approach, was acknowledged as one of the country's most respected artists. In matters of new artistic endeavors, the general public tends to be fairly conservative. And whatever the government paid for the mural, it was a bargain because it could be sold for double the price to "any number of museums or collectors." Apparently the paper hoped to calm a needless storm and divert negative perceptions of Boston as a provincial place.[69]

The very next day the *Globe* published an article that almost amounted to a retraction. A spokesman for the Museum of Fine Arts explained that the museum had been given a "false impression of the

painting because the title was incorrectly represented to its curator as *The Tragedy of the Death of President Kennedy.* Therefore the Museum assumed it depicted a specific event and was open to a specific interpretation." After noting the correct title, the statement added, "nor was it the artist's intention to represent any specific event or moment. The painting is completely abstract; it is a painting of a mood, not a scene, and cannot be given a literal interpretation." Moreover, Motherwell's agent added that "the artist completely rejects any literal interpretation of the mural."[70]

Although the controversy gradually began to recede, both local papers continued to publish irate letters to the editor from people who persisted in accepting the initial misunderstanding. Several weeks later the *Globe* did print a thoughtful communication from an art instructor at Wellesley Junior High School describing his frustration with the media's handling of the whole affair. "Surely the press could offer more constructive assistance than they have in this case," he wrote. "The public could have been introduced to this memorial in a way that would have enlightened them. Publicizing the negative comments of so many self-confessed 'Know Nothings' creates a hostile atmosphere of which too many people are eager to take advantage."[71]

Press coverage of the dedication of the John F. Kennedy Building on September 9, 1966, pretty much ended the public discussion yet managed to leave an unpleasant aura. In describing events of the day, the *Globe* offered brief mention of *New England Elegy* and managed to imply that Motherwell feared even more vilification. The account related that the master of ceremonies introduced Motherwell, "whose controversial abstract impressionist painting, 'New England Elegy' hangs in the building lobby, and drew a scattering of boos from the audience. Boland [the M.C.] then turned around and found Motherwell was not there." The *Globe* also failed to report any reactions to the painting from the Kennedy family, which meant either that the press had not asked, which seems unlikely, or else that the family had no objections, which the *Globe* preferred not to admit.[72]

In mid-August the acting commissioner of the GSA's Public Buildings Service "suspended" the Art in Architecture Program for reasons of "rising costs of construction" due to inflation. According to a different GSA official, however, the real reason for the suspension was concern over "public reaction to certain works, particularly a Robert Motherwell mural that was installed in the John F. Kennedy Federal Building in Boston."[73] The program would be revived six years later in

1972 but with more careful safeguards to avoid the kind of contretemps we have just traced. Greater scrutiny would be given to the design phase, though that would not prevent some of the most virulent controversies that erupted during the 1970s and 1980s, ones that would linger considerably longer and involve extended court litigation. The Boston episode in 1966 was a comparatively mild harbinger of coming dissension.[74]

By the close of the 1960s a swiftly changing set of circumstances had established a new mood—troublesome to many, portentous but exciting to others. In the spring of 1969 the journal *Art in America* devoted a special issue to the topic "Impossible Art—Why It Is." Thomas M. Messer, director of the Guggenheim Museum, offered this answer: "Impossible for collectors to collect, for museums to show, for dealers to handle, for critics to appraise, the latest art may seem the ultimate frivolity, but it must be recognized as the expression of a radical disenchantment with the present role of art in society." David L. Shirley devoted his contribution to gigantism: earthworks, waterworks, skyworks, thinkworks, nihilworks, and archiworks! Art, he concluded, "has become an impossible term for the 'artist' who sees *everything* as a work of art, ridiculing the shrines of the masterpiece."[75]

One other major development during the 1960s, print coverage, would not only help to transform and expand the visibility of art in the United States but generate more attention for any untoward episode that occurred. The journals *Art in America*, *ARTNews*, *Arts*, and, after 1967, *Artforum* were all published in New York City. Although printed in Switzerland, *Art International* included copious American coverage. Moreover, collections of essays by critics appeared constantly, starting with Clement Greenberg's widely read *Art and Culture* in 1961, Dore Ashton's *The Unknown Shore* in 1962, Harold Rosenberg's *The Anxious Object* in 1964, Michael Kirby's *Happenings* in 1965, and many others during the second half of the decade. As Lawrence Alloway has observed, for the first time a substantial body of occasional art writings was readily available outside their scattered appearances in the multi-author format of art magazines. When controversies occurred, therefore, they would get more visible and varied coverage than ever before.[76]

The Dimensions and Dilemmas of Public Sculpture

We have already noted the potential for public art to generate controversy in twentieth-century America, from murals by Diego Rivera and Thomas Hart Benton to an array of Treasury Section civic projects commissioned by art-sponsoring agencies created under New Deal auspices. Although a pattern of public sculpture as we now perceive that concept did not begin to develop until the late 1960s, we can certainly point to a variety of provocative works, each one long in gestation, that appeared on occasion, such as Frederick MacMonnies's *Civic Virtue* for New York City and Lorado Taft's *Fountain of Time* for Chicago, both completed in 1922. Although both received very hostile reactions and are remembered negatively (when they are remembered at all), each one was representational and meant to convey an allegorical and idealistic message. In terms of understanding a major change in the nature of public sculpture in the United States, it should be noted that neither of those earlier instances emerged from a systematic, government-sponsored program—a development that emerged only in the later 1960s and then by fits and starts.

But why then? What explains the timing? Very large public structures were being commissioned and built but usually in styles best called austere if not severe. They needed a "touch" of something to soften or humanize them. The same was true of large civic spaces like the Vandenberg Plaza in downtown Grand Rapids. It was a time of comparative affluence, and government spending on "art" and culture had been legitimized by Congress in 1965 with its creation of the National Foundation for the Arts and Humanities. Each and every cit-

izen did not become a believer, of course, but along with the Historic
Sites Act of 1966, the floodgates really opened and all sorts of innova-
tions ensued in terms of publicly funded art. There was also some
residual Cold War chauvinism at work, to be sure. One often heard
such phrases as "A great nation deserves great art," and a major mea-
sure of greatness for many was sheer size, just as social status in the
United States has for so long been achieved through great wealth. So
"gigantism" reappeared—often with a vengeance.[1]

When the General Services Administration began its Art in Archi-
tecture Program during 1962–66 and the National Endowment for the
Arts launched Art in Public Places in 1968–69, a good deal of careful
planning went into both. Even so, the guidelines and implementation
procedures necessarily underwent revisions and evolved for various
reasons, mostly prudent: histrionic reactions to inflammatory works
like Robert Motherwell's *New England Elegy* in Boston (1966); the
logic of having an actual competition among three to five qualified
finalists chosen by an expert panel; and the need for broader commu-
nity participation in the ultimate review process. Although a fair
amount has been written about these new federal programs, little
attention has been paid to what might be called the "lessons of the
past," that is, how misjudgments (and controversies) might have been
avoided by taking note of approaches and procedures that had been
successful or not at earlier times.[2]

Failure to consult with host communities in a serious and sustained
manner, mostly about subject matter, had been the single most serious
difficulty with the New Deal post office and courthouse murals; but
those stories stayed buried in scattered archives, and public memories
of such episodes have a way of fading from blurred to dim. Or else they
become part of local lore but in warped versions that grow less reliable
and coherent as time passes. With some highly significant exceptions
here and there, most public art projects are not only accepted after a
few years but come to be taken for granted when they are not simply
ignored. Within less than a generation, many people barely recall that
there had ever been a controversy, never mind why. Yes, a few "old-
timers" and art critics could recollect notably nasty episodes; but
memories turn fuzzy and elusive in a society that lives so blithely in
the present, and most folks simply go about their business with
more pressing matters on their minds. What's done is done, and we
move on.

What might the most obvious lessons of the past have been? That

elites cannot determine, without careful and sustained community input, what kind of art project, motif, and style is most likely to succeed or fail. A community with little or no previous exposure to modernism, for example, and especially to abstract art, is going to require a considerable amount of preparation if not indoctrination. The ethnicity and regional identity of the designated artist matters, especially if that person has no prior relationship with the place that will be the recipient of a new work. Outsiders tend to be mistrusted, even when they have strong professional credentials.[3]

People concerned about such matters tend to make a sharp distinction between two excessively broad categories: elites and everyone else ("the people"), then blame the unpopular decisions of the former on their failure to take into account the feelings of the latter. But that broad distinction is simplistic. When it comes to the creation of public art, there are at least three sorts of elites: first, artists, critics, and art administrators; second, political people at several levels, from federal to local; and third, the business and corporate community, especially bankers and industrialists from whom financial support is sought. Sometimes these groups are coordinated and cooperate, while at others they work at cross-purposes because they have quite different concerns and agendas.

Similarly, when we turn to the grass roots, especially since the 1970s, often some well-situated or prominent citizens have been consulted—but not key local organizations, or the groups most directly affected by the particular venue (in cases of urban revitalization, for example), or the workers actually employed at a particular office building who must unavoidably stare at an unsettling work many times each day. Sometimes "vertical" alliances cut through the hierarchical lines and pit segments of the elite and some community members against politicos, businessmen, and ordinary folks who simply cannot abide anything deemed too bizarre, unbeautiful, or "futuristic." The configurations of taste-preference are constantly in flux. And they can cut both ways, affirmative or negative.[4]

We must also keep in mind that within just a few decades following 1968 almost a thousand projects came into being under GSA and NEA auspices, and the preponderant majority did not create very much of a stir. Many were warmly welcomed, sometimes under quite difficult circumstances. In 1977, for instance, the Youngstown Area Arts Council in Ohio received from the NEA a grant of $27,500 to commission sculptor George Segal to create a major piece of civic art. Just as the

requisite matching funds were being raised, however, a severe economic crisis began afflicting the area. Most of the major steel mills, the primary employer there, were shut down with scant prospect of reopening. The project director advised the coordinator of NEA's Art in Public Places about this dire situation: "doors closed, and it was difficult to talk about a sculpture for Federal Plaza."[5]

Quite amazingly, completion of the project became a matter of civic pride in Youngstown, and an array of local businesses, foundations, and councils contributed the necessary money. When Segal explained the highly representational subject he had chosen—two steelworkers at an open-hearth furnace—the Jones and Laughlin Steel Corporation responded by donating a large unused furnace. The crucial turning point occurred, however, when the Building Trades Unions joined the cause with genuine commitment and pledged in-kind contributions of assistance in fabricating and installing the work. They disassembled, transported, and rebuilt the furnace on the designated site and helped to install Segal's bronze figures. All sorts of fund-raising parties took place, and the completed project (1979), initially intended to honor the local steel industry, became a poignant requiem for it but also a tribute to the community's pride and resilient determination in the face of harsh economic adversity.[6]

If there have been so many successful public sculpture projects, and quite a few of them despite notable adversity, why should we focus on the failures, on works perceived at the time as disasters? There are many sound reasons.

- To achieve historical perspective by comparing contemporary public sculpture with earlier versions, noting especially, for example, the supplanting of historical and moralistic motifs by vaguely symbolic, abstract, or oftentimes whimsical ones.
- To understand what particular modes of modernism have been most readily acceptable, even warmly appreciated, such as Louise Nevelson's ninety-foot-long *Bicentennial Dawn* in Philadelphia (1976) and Claes Oldenburg's *Batcolumn* in Chicago (1977), both brilliant achievements and well received— save for Senator William Proxmire's Golden Fleece Award in the latter case, denoting a notable waste of taxpayer money.[7]
- To notice the variability by venue of which kinds of motifs seem to work well and which do not, depending upon the "fit" between artist, architecture, site, and audience. Region-

alism matters, and sometimes in surprising ways. Local jour-
nalists, moreover, have been a frequent source of uninformed
and inflammatory comments.

- To appreciate the role played by artistic temperaments,
 because they have ranged from arrogant to conciliatory, from
 egotistical and self-serving to sensitive and adaptive. When
 he was negotiating with City of Miami officials in 1980,
 Isamu Noguchi told them that an artist had to be a "dictator."
 He refused to discuss his designs with the people of the city.
 The most successful projects have so often required compro-
 mise. As Luis Jiminez astutely remarked in the later 1970s, "I
 don't want to sound like a commercial artist, but [making art]
 is entirely different when you're working with a community.
 The work belongs to the people. It has to come from the
 artist, but the people have to be able to identify with it."[8]
- To recognize the opinionated, often stubborn, or fiercely
 determined roles played by art administrators and federal
 judges in precipitating or perpetuating some controversies.
 The cases of *Baltimore Federal* by George Sugarman (1976–
 78) and *Tilted Arc* in lower Manhattan by Richard Serra
 (1981–89) come quickly to mind.
- To grasp the ways in which situations can whirl out of control
 when an artist exceeds the bounds of propriety or indulges in
 excessive flamboyance—usually not in his own eyes, yet so
 readily giving offense to others. Robert Arneson's ceramic
 sculpture in memory of San Francisco's slain Mayor George
 Moscone provides a prime example (1980–81).

We might well begin with a glance back at a barely remembered
public sculpture from the 1930s that can serve as a useful bridge
between the work of MacMonnies and Taft and the striking innova-
tions of the later 1960s and beyond. Because of a 1923 bond program
in St. Louis, a plaza located near Union Station became the site for a
1931 commission to a Swedish-born sculptor named Carl Milles who
had recently come to the United States to teach at the influential
Cranbrook Academy in Bloomfield Hills, Michigan. He had already
achieved prominence for civic art boldly designed for specific sites.
The challenge for Milles in planning a major fountain was to provide a
sound but engaging counterbalance to the massive Romanesque rail-
road terminal with its 230-foot clock tower. This was not an ideal set-

43a and 43b. Carl Milles, *The Meeting of the Waters* (1939–40), St. Louis.
Photo by Michael P. S. Brick.

ting for a sculptor who liked to achieve the sparkle of sunshine on water spray. So Milles prepared models of sportive tritons, mermaids, and leaping fish; but the principal and central images would be a male Mississippi River figure and a female Missouri River figure, both naked, advancing toward each other. Thinking literally and figuratively, Milles called it *The Marriage of the Waters* (figs. 43a and 43b).[9]

Two members of the Municipal Art Commission objected strenuously to the bride and groom appearing in the altogether, so a heated debate spread swiftly through letters in the newspapers, editorial cartoons mocking the prudish objections, concerns about traumatic effects on children, and the prospect of automobile collisions by distracted drivers. Even an apparent tulip that the male Mississippi held out to the female Missouri prompted anxious inferences. One member of the Art Commission swiftly proposed an entirely different design as an alternative: a panorama of transportation from the pony express to the airplane, exactly the kind of tableau art then popular for bank and post office murals.

Following extensive debate, the Art Commission traveled to Detroit to view full-scale models and then voted with two dissents to approve Milles's concept. Eventually completed in 1939, the ensemble consisted of nineteen figures, nine more than Milles's contract required. Water outlets were designed to activate the entire basin area with configurations of jets and spray that became an important aspect of the sculpture. A one-word revision of the title seemed to calm local apprehensions, and the work was unveiled in 1940 as *The Meeting of the Waters*. In the absence of marital prospects, sexual innuendo seemed to wane. (Notably, however, all of the lesser figures behind the male are males, and only females follow the lead female. Groomsmen and bridesmaids?) With time, it would simply be called the Milles Fountain.[10]

Although the traditionally representational mermaids appeared demurely topless, the customary charge of indecency did not become a serious issue, and the fountain plaza was basically exempt from heavy-handed allegory and invidious moralism. Its notable size and weight also pointed ahead to the huge works that would become so characteristic of GSA and NEA commissions in the 1970s and 1980s. No lack of resistance to abstraction would intervene during the 1950s, however. In 1959 the czar of New York City's roads and related structures, Robert Moses, fought bitterly to defend Park Avenue against an intrusive invasion of contemporary art. "We are," he proclaimed, "in mat-

ters of public outdoor art, conservative and will not approve any abstractions."[11]

New York's Fine Arts Commission also made its position very clear when the issue arose in 1960 over what kind of American art should be exhibited at the 1964 World's Fair. "We have a responsibility to keep public outdoor art in New York City at a comprehensible level. This, so far as we are concerned, rules out the abstractionists and the non-objective art." So even *The Bather* by Jacques Lipchitz (1923–25), which is modern and Cubist but discernibly representational, became unacceptable to the guardians of taste who felt it their firm duty to keep outdoor sculpture "readily understandable by the general public."[12]

In 1967, however, a New York group called the Park Place Artists became responsible for organizing the first exhibition of radically contemporary public art in the United States, called "Art for the City" and held in Philadelphia. Within a few years a program intended to liberate art from museums, designated "Sculpture in the City," started to take off.[13] The dam of resistance had begun to break. In 1967 the *Chicago Picasso* would be dedicated. When the National Endowment for the Arts created its Art in Public Places program at just the same time, it negotiated a cooperative funding relationship with Grand Rapids, Michigan, for its maiden effort. Alexander Calder was invited to create what became a gigantic stabile titled *La Grande Vitesse* (1969). Once again there was no open competition. The NEA and the local authorities candidly wanted Calder, just as Daley had wanted Picasso in particular; but many locals wondered why an artist who seemed more at home in France had been chosen rather than someone local or at least someone from the Midwest. That turned out to be just the tip of the initial controversy because many felt that this huge stabile was not only too big, too costly, and too giddily red (no political connotations, so far as I know) but also detracted from the honor bestowed upon Michigan senator Arthur Vandenberg, for whom the new urban renewal venue had been named. Moreover, excavation had already begun for an expensive fountain on that very site, which Calder's work would displace, so residents grumbled about money being wasted (fig. 44).[14]

If we think back to the Brancusi controversy in the later 1920s and then to MoMA's battle a decade later to import European sculpture duty free, it seems especially noteworthy that the Federal Maritime

44. Alexander Calder, *La Grande Vitesse* (1969), Grand Rapids, Michigan.
© 2007 Estate of Alexander Calder/Artists Rights Society (ARS), New York.

Commission passed a special resolution to allow *Grand Vitesse* to be imported duty free from France, where it had been fabricated in steel near Calder's home in Sache. Governmental doors were opening in unprecedented ways to accommodate the complexities of custom-designed, oversize art.[15]

Gradually, as with the *Chicago Picasso*, though even more swiftly, public opinion about the Calder swung away from negative jokes and newspaper cartoons. Simultaneously, all the publicity, positive as well as negative, attracted curious crowds from out of town to see a rather stunning and unprecedented project. The realization gradually dawned that this unique construction might actually sustain a serious boost for tourism in Grand Rapids, not previously known as a magnet for visitation, and that helped to push public opinion in its favor. Congressman Gerald Ford, the representative from that district, eventually decided he liked the piece, and that would gradually lead him to approve of increased appropriations for NEA in the future. Within a short time Calder's *Grande Vitesse* became the municipal logo, appearing on everything from city stationery to the sides of trash-collection trucks.[16]

Today the piece is truly beloved and has become the stimulus for

everything from festivals to children's design contests. Controversy gave way to an era of good feelings, at least in this instance. In 1974 Calder's $325,000 stabile known as *Flamingo* would be erected at the Federal Center Plaza in Chicago as a GSA commission for its reestablished Art in Architecture Program, the other major source of public art in the United States. Gerald Ford had become president by 1974, and he proclaimed *Flamingo* "a conspicuous milestone in the federal government's effort to create a better environment."[17]

In 1974 two signal developments in public art programs emerged. First Brian O'Doherty, who had supervised the NEA's program since its inception, wrote the initial account of its accomplishments, a "progress report" that came across as judiciously upbeat, just as one might expect. Along with a report written for the NEA the previous year by art critic and historian Irving Sandler, it enthusiastically declared the times propitious for government support of public art. As O'Doherty put it, hopefully but rather vaguely, "Those of us who have accepted the premise that artists should have a public arena for their art, if they so desire it, have become aware of a new theme—that the insertion of advanced art into the social matrix alters both in ways we have hardly begun to understand."[18]

The second development would make the mid-1970s a tumultuous though ultimately a positive period for the two programs. New commissions proliferated, though some of the most prominent ones met with stiff opposition. In July 1974 a panel appointed by the NEA met in Seattle to choose an artist to enhance a new federal building there. The members swiftly agreed on Isamu Noguchi, who proceeded to design a work based upon a configuration of five carved natural granite boulders covering an area thirty by fifty feet and ranging in height from one foot six inches to eight feet three inches. In April 1975 he transmitted photographs of the work as it appeared in his studio garden on the island of Shikoku, Japan. His accompanying letter explained that "the composition is predicated on the particular site, on the location of the trees and the old arch, the direction of traffic toward and from the entrance, from the street and up the steps . . . and the view from all these points. The composition in a sense will be completed by all the factors of use over the years."[19]

At the dedication of *Landscape of Time* on September 9, 1975, as Noguchi supervised the final installation and grouting, a full rainbow filled the sky above, as though consecrating both the moment and the

monument. The GSA immediately came under fire, however, for "wasting tax dollars on that junk you call art." One writer in the *Seattle Times* headlined his piece "A Work of Art No One Will Take for Granite." He ended by declaring, "We must have rocks in our head."[20]

By the early months of 1976 this mockery had spread to national media, including the tabloids. One U.S. congressman wrote an angry piece for the *National Enquirer* linking Noguchi's work to "a pet rock craze sweeping the country." At that point negative letters began pouring into GSA headquarters, but the administrators' confidence never wavered and Vice President Nelson Rockefeller publicly lauded the work. Gradually the hostile locals tired of the fight, and the national ruckus died down. It did not hurt that the NEA's second commission, closely following the Calder for Grand Rapids, had been Noguchi's massive granite *Black Sun* (1969), strikingly carved and overlooking Seattle from Volunteer Park near the former Seattle Art Museum.[21]

One month following Noguchi's Seattle commission in 1974, the GSA chose a respected sculptor, George Sugarman, from a group of NEA nominees to design a major work in leafy aluminum for the new federal courthouse in Baltimore. One year later he presented a maquette of his proposal, which sparked one of the bitterest and more prolonged fights caused by any of these commissions. After a diverse panel reviewed Sugarman's concept with enthusiasm, the chief judge of the U.S. District Court of Maryland sent a vigorous protest on behalf of his colleagues on the bench to the GSA with copies to twelve VIPs, including Maryland's entire congressional delegation. The essence of the judges' complaint? They were unanimously outspoken in feeling that "the contours of the structure itself present a danger both as to possible injury to individuals moving around it, as well as a potential shelter for persons bent on mischief or assault on the public." They anxiously added that terrorists might use the sprawling work as a hiding place for nefarious plots, but they may also have been miffed at not being consulted about either the choice of the artist or his design (fig. 45). Although some members of the general public also raised voices in opposition, embittered criticism came primarily from the judges, who threatened to condemn and remove the work if it were completed.[22]

This time the press was largely supportive of the project, and gradually the media turned negative sentiments and uncertain public opinion in its favor. The *Baltimore Sun* and *Washington Post* enjoyed

45. George Sugarman, *Baltimore Federal* (1978), Baltimore, Maryland.

mocking the judges' anxieties about security and their evident distaste for advanced art. An editorial in the *Sun* on August 13, 1976, reminded readers that

> Nothing in the federal arts program gives members of the federal bench the authority to exercise a veto over public art, in front of a courthouse or anywhere else. . . . The judges' injudicial intrusion is not silly but shameful and should be viewed as such by the public, which may not know much about art but has more respect than the judges have for those who do.[23]

In addition, a large number of arts organizations from the area mobilized in support of Sugarman's design and offered overwhelming testimony on its behalf at a major public hearing called by the GSA during September. Within weeks some members of Congress and a senator began to relent, and the following month the GSA announced its determination to proceed with the fifty-foot-long sculpture. Although the chief judge continued to threaten "the removal of structures which would create security problems," he eventually backed

down, the project proceeded, and *Baltimore Federal* was finally dedicated on May Day 1978. (Was it pure coincidence that May 1 is traditionally a leftist holiday?) The elected politicos appear to have drifted away from the judges when it became clear that opposition from the lay public seemed modest. Successful completion and countless editorials and magazine stories meant a major boost for Sugarman's career. The GSA staff felt quite proud for holding firm and facing down a determined and seemingly powerful opposition.[24]

Other crises occurred simultaneously, though with reverse twists. In 1974–75 George Segal was selected to create a sculpture for the Federal Building Plaza in Buffalo, New York; but unlike his work for Youngstown, this project ran into its stiffest opposition from, of all sources, GSA administrators, but also from some citizens and baffled critics. Segal named his work *Restaurant* and called it a "slice of life," which it clearly was; but the design appeared to Ford administration officials to be too provocative, perhaps even "pornographic." A life-size older man is walking past the front of a restaurant, about to pass a shapely younger woman who might possibly feel threatened by him. Behind a plate-glass window, seated hopefully yet alone at a table, there is a second woman of mature age (though younger than the man) whom he is ignoring. The dynamics among the three figures are simultaneously enigmatic but with implied possibilities and suggestive of anxiety, at least to some viewers. Segal's tantalizing explanation: "There's a long list of buried details in that work that are there for you to observe—that will unfold over a period of time."[25]

The local press in Buffalo responded with reasonable enthusiasm, and at the dedication in June 1976, Senator Jacob Javits of New York not only praised the work as "extraordinary" but added that for the GSA to "actually commission and pay for such an adventurous work of art as this one marks the real maturity of our country." It was premature praise, perhaps. The entire dedication had to be planned through private initiative because the GSA had decided not to participate in it at all. Here is Segal's response to the agency's hope that he would just vanish and that perhaps his sculpture might somehow disappear with him.

> At the point of my completing the bronze and installing the piece, I was aware of the uproar and the protest about the Sugarman in Baltimore. . . . And my feeling was that if there's

an uproar—a groundswell of protest from whatever source, whether it's from the citizens of the town or the judges—and these people are convinced that this artwork is of terrible quality, and if I disagree and think this work is of excellent quality, then politeness should stop and there should be a standing of ground. I was annoyed, frankly, that the GSA—after its history of being impeccable—turned cowardly in the face of criticism.

Ultimately, however, Segal would praise the two programs that had brought his first work in bronze, "about people not getting together," into public view. An ironic touch, as meaningful for the commissioners as it was for the installation itself.[26]

Issues that involve deciding on the appropriate character of public art in a democratic society arose in yet another and closely connected but problematic way: that is, defining procedures that would not be so bureaucratic and cumbersome that they could stifle the selection process or result in mediocrity rather than something innovative and excellent, however startling. Early on, from the late 1960s through the mid-1970s, approval of artist and design was almost entirely in the hands of professionals: artists, architects, arts administrators, and a few local leaders. The general public was not consulted and had virtually no input at any stage. Following some episodes involving communities unhappy with what had been handed to them, procedures were redesigned with a mandatory sequence of stages so that greater public input could be achieved. By 1977 the modestly reconceived procedures raised a serious issue in the minds of some interested observers: when the U.S. government wants an artist to create a sculpture or mural or tapestry for a building with public funds, they wondered, have the hurdles and hoops become so complicated that it's problematic whether government patronage of the arts can effectively survive in a democracy? Architect Philip Johnson had actually raised exactly that issue way back in 1961, but his was a lonely voice that predated the GSA and NEA programs. By the later 1970s this question had achieved a certain urgency. The frequently required input from various sorts of fine arts commissions and local arts-related agencies complicated matters even more.[27]

Initially the NEA panels that advised the GSA Art in Architecture Program were chosen solely on the basis of expertise, and consultation with community leaders was not even a firm requirement. In 1972–73 the GSA revised its procedures in an effort to obtain the best art possi-

ble while pursuing a more inclusive process. Each architect of a new federal building would be told that art could be incorporated into the design process and that half of one percent of the construction cost would be set aside to pay for the art. (The percentage actually fluctuated and gradually diminished, particularly following the Sugarman fracas.) If the architect chose to commission some art, the GSA was required to ask the NEA to appoint a nominating panel of qualified experts to meet at the site with the architect and submit the names of three to five artists they considered suitably qualified to carry out the proposed commission. The names of artists suggested by the panel were then submitted to an in-house design review panel, with the administrator of the GSA responsible for the final decision.[28]

Even more bureaucratic wrinkles would soon be added, but that was the essence of the process. Outcomes were inevitably complicated, especially when an architect's top choices turned out to be unavailable. The earlier procedures might have been less inclusive, but they were also more efficient and often achieved distinguished results. Critics of the elaborately revised rules complained about the rules' complexity, the cost to taxpayers, and the prolongation of the process, but above all they believed that despite so many circuitous consultations, the ultimate pieces of art were thrust upon a public that *still* found them bewildering. Democratic procedures did not achieve better results, it was argued, only more convoluted, costly, and capricious ones.[29]

On the other hand, on some occasions, most notably in the mid-1970s and 1980s, grassroots democracy worked rather well on behalf of public sculpture. It seems to have helped if a community had some prior experience with such projects and consequently had an understanding of the process by which they are created and of the "period of adjustment" needed to come to terms with a new work. Initial reactions are frequently precipitous and not usually generous. In 1974 the sculptor Mark di Suvero received a GSA commission to create a work that would be situated close to Calder's *Grand Vitesse* in Grand Rapids. After it was finished, the GSA informed di Suvero that his project was unacceptable because it was totally unlike the maquette that he had originally submitted.[30]

Called *Moto Viget*, it consisted of a tripod made of three Cor-Ten steel beams from which a hard rubber gondola was suspended in which several children could swing and play (figs. 46a and 46b). The GSA had very strict guidelines about fidelity to design and consistency in this process. When the people of Grand Rapids saw the piece, how-

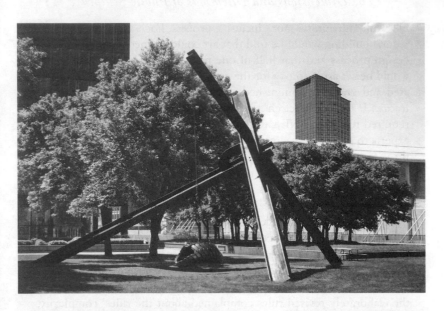

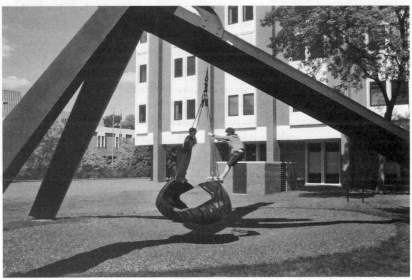

46a and 46b. Mark di Suvero, *Moto Viget* (1974–75),
Grand Rapids, Michigan.
Photos by Mitch Kachun.

ever, their response was highly enthusiastic, and many art experts actually found it quite superior to the original maquette. After receiving four hundred letters and a petition with six hundred signatures, GSA commissioner Nicholas Panuzio backed down. "It is clear," he acknowledged, "that the people want the sculpture." And they got it. Di Suvero felt deeply grateful to this enlightened community. "It gladdened me to see these people unite for art," he wrote in 1978. They "took me into their homes, gave me help, faith in the work, love—and when the government said *no* to the sculpture they acted democratically, and the art community united practically unanimously."[31]

As Michael North has observed, the gap between art and audience can be closed "by bringing the audience into the art, by making spatial experience the very subject of the art."[32]

By the later 1970s the NEA Art in Public Places program had revised its funding procedures in order to make local groups exclusively responsible for selecting artists. So power devolved. And by this time, having had more than a decade of intermittently tumultuous experience, virtually no one was surprised when highly particular local controversies occurred. They had now been factored in as an almost normal part of the process. As one long-suffering committee member patiently put it, "We expect an adverse reaction for a time, but after a while the outcry dies down."[33]

At just this moment the national media began to recognize and explain to the public what the art world had been increasingly aware of for well over a decade: namely, that modern art, but particularly postmodern sculpture, had moved away from and quite often entirely beyond the museum. That meant more than simply exposing larger numbers of people to modern art. Museums confer a kind of legitimacy or validation upon art they choose to obtain or exhibit, even when the viewer is unimpressed or actively dislikes what is on display. When public art is not associated with a museum and lacks an institutional imprimatur, people are more likely to voice criticism because it is "my art," the public's, and not "theirs." If it is simply sitting "out there," and especially if tax dollars helped to pay for it, then public opinion really matters. A new movement known as Artpark helped to add and define still another dimension to public art: site-specific sculpture designed to be *impermanent* yet enhance leisure-time activities and social capital.[34]

In describing these developments, however, the media did not necessarily bless them, and in fact during the years between 1980 and 1982 the most intense debates concerning the relative merits of public

sculpture took place. In August 1980, for example, *Newsweek* published a substantial retrospect called "Sculpture Out in the Open" and did not conclude its summary with a positive assessment.

The simple fact is that most modern art is not well suited to serve a public purpose. For the most part, abstract art was made to be seen in a private room or in the neutral space of a museum. It does not celebrate common cultural aspirations or fix any hierarchy of social values, which was a traditional function of public art. There is no iconography which people without esthetic know-how can interpret; if public sculpture commemorates anything . . . it is the artist himself.[35]

Not all responses were as negative or, in key respects, as misleading as that one. But such essays sent a very clear signal that yet another decade of misperception and controversy lay ahead.

Writing an assessment of this "widening debate" in 1982, art critic Grace Glueck came across as more sympathetically insightful, yet she echoed some of the key concerns of those less judicious than herself. The rationale for public art, she observed, "is the notion that art benefits the community, but unlike the old-style commemorative works, they tend to be abstract, and to celebrate the creative process of a particular artist, rather than a person or event." Despite this recurring concern about gratifying the egos and reputations of ambitious artists, expansive news coverage about a movement whose time had come could only please or placate citizens who felt that America's urban spaces needed some sprightly attention-grabbers. Glueck noted that more than sixty-five state and local governments had adopted legislation providing "percent for art" programs as part of their urban renewal efforts, thereby adding not merely an important complement to the GSA and NEA programs but yet another way to enhance city vistas and culture. That is how Philadelphia got Claes Oldenburg's gigantic, whimsical clothespin, a monumental steel piece located in Central Square and now an accepted landmark.[36]

A few months earlier an intense debate about the merits and problematic limitations of public sculpture appeared in the policy-oriented publication *The Public Interest*. Two conservative philosophers argued that "much public sculpture, and public art generally as it is created nowadays in the United States, provides at best trivial benefits to the public, but does provide substantial and identifiable harm." They

asserted that most pieces are not enjoyed by the public, so that the "aesthetic benefits are few and thin." Often such work causes genuine offense and intrudes into people's normal living routines. The authors insisted that by doing so the sculptures raised moral issues that even transcended questions of public funding for works that most people either disliked or remained utterly indifferent to.[37]

They objected in no uncertain terms against "having to finance an object from which no benefit is derived, and the special exquisiteness of having to finance one's own humiliation." These authors concluded that "big time art is an industry that has moved out of the cottage, an industry that has an articulate and influential lobby at many levels of government." They insisted that the large sums being spent on public sculpture could so much more fruitfully be devoted to playgrounds or fountains or parks or monuments. Ultimately, they argued, "Philistines are people too, and, whether or not one shares their tastes, the moral point of view requires that their interests be considered."[38]

Five specialists from different segments of the art world responded along as many lines, arguing that an advanced democracy cannot function without expertise, which inevitably included the realm of art. Another added that art has the capacity to say different things to different people, and that ambiguity in art is equally predictable and a healthy quality for a democratic society. John Beardsley, the author of a then-recent survey of NEA projects up to 1980, observed that occasional failures and more recent successes would eventually lead to the emergence of useful criteria for incorporating art fortuitously into public buildings, parks, and plazas in noncontroversial ways. The moralistic authors who generated this discussion, he argued, were calling for elimination of programs *just* as they were achieving the goals for which they had been created. Although this debate remained unresolved, it certainly made apparent many of the conflicting perspectives that would be heard for a decade to come.[39]

During the later 1970s and early 1980s contestation continued to agitate people and make news concerning GSA and NEA commissions, and no state seemed more vexed than Ohio. In 1977 Akron actively sought a project for its new federal building, and the following year a commission materialized for sculptor William King, who created a work called *Caritas* (Caring) in which a very tall stick figure standing upright extends a helping hand to an equally gigantic one on bended knee. Because nothing remotely like it had ever been seen in Akron, and because it looked a bit too cartoonlike, negative letters

flowed to the local press and congressman, lamenting the waste of precious tax dollars. Fear of the unfamiliar seemed to be a prime mover alongside anxiety at the prospect of being embarrassed at having one's most visible civic artwork considered silly or oafish by outsiders.[40]

The arts community came to the rescue by informing Akronites of the interesting change of heart almost a decade earlier in Grand Rapids and by mounting an exhibition of King's work and drawings in the local art museum. The community gradually came around, and Hilton Kramer had kind words when the project was completed in 1979. King's sculpture of comic gesture, he wrote, "is sculpture that choreographs a scenario of sociability, of conscious affections and unavowed pretensions, transforming the world of observed manners and unacknowledged motives into mimelike structures of comic revelation. . . . It is sculpture that draws from the vast repertory of socialized human gesture a very personal vocabulary of contemporary sculptural forms."[41]

The other Ohio contretemps did not achieve a successful reversal of sentiment. In 1978 Kent State University commissioned George Segal to create a memorial sculpture dedicated to the four students killed by the National Guard in Kent, Ohio, on May 4, 1970. The students had been engaged in a protest against illicit U.S. military encroachment in Cambodia. This time Segal chose an allegorical motif: Abraham's commanded sacrifice of his beloved son Isaac. Because God was testing Abraham's obedience but ultimately allowed the son to be spared, the piece seemed to be sending highly ambiguous and confusing signals, and it felt utterly inappropriate for a constituency that sought memorialization and consolation rather than obscure meanings that seemed to offer the prospect of intergenerational violence rather than reconciliation (fig. 47). Kent State rejected the work outright, but Princeton University accepted it without a murmur in 1979—made possible, perhaps, because the sculpture there could be seen in purely aesthetic terms rather than evoking vexed memories of a local tragedy.

Another horrific episode that took place far across the country precipitated quite a different controversy involving public sculpture as memorial art. On November 27, 1978, an aggrieved former city supervisor named Dan White entered City Hall in San Francisco and assassinated Mayor George Moscone and Supervisor Harvey Milk, the first openly gay person to serve on the city's governing body. The motive for killing both men arose from working-class resentment at urban

47. George Segal, *In Memory of May 4, 1970,*
Kent State: Abraham and Isaac (1978).

The John B. Putnam Memorial Collection, Princeton University. Art © The George
Segal and Helen Segal Foundation/Licensed by VAGA, New York, N.Y.

renewal efforts that were displacing blue-collar residents from their traditional homes and neighborhoods and into housing projects along the city's southern rim. Following the assassination, the next mayor, Dianne Feinstein, decided that a new convention center then under construction should be named for Moscone, and an art commission was designated to acquire art for the center, above all a piece that would commemorate Moscone himself.[42]

In April 1981 a Bay Area ceramicist with a national reputation for satire and whimsicality, Robert Arneson, submitted a sketch showing a head smiling cheerfully, mounted on a plain white pedestal above a

three-tiered base. The word *polychrome* on the drawing referred to multicolored dabs of glaze that would add texture and color to the bust. Following due deliberation, the San Francisco Art Commission selected Arneson's proposal out of the twenty submissions, though members complained privately that some leading artists had either chosen not to compete or else submitted inadequate designs. From their perspective, Arneson's proposal was the best they had seen, but they were disappointed by the number and quality of the proposals.[43]

After Arneson won the competition, he acknowledged to a local interviewer that "I like to keep the art on the cutting edge, so people can ask questions, stimulate the mind a bit." As it turned out, a misunderstanding existed from the outset. While the commission expected a statue bust exactly like Arneson's sketch, with no deviations or elaborations, he assumed that it was merely a starting point from which he could extemporize as he developed the concept in his mind. The original drawing had been no more than a suggestive proposal. To complicate matters a bit more, Arneson was never told that his project would stand in the place of honor at the Moscone Center. He claims to have been surprised when he brought the work for installation.

One month prior to completion Arneson invited Gina Moscone, the mayor's widow, to view the work at his studio. According to the artist, "She patted it and said, 'That's George.' It was very touching. We had a wonderful, creative, upbeat afternoon." When Arneson invited the Moscone Center Joint Commission to view the sculpture, only one member appeared, the others explaining after the fact that they served without pay and were busy people. On November 30, 1981, two days before the opening, Arneson delivered the sculpture to the joint commission at the convention hall. It was almost eight feet tall and weighed a thousand pounds. A three-foot bust of the mayor rested upon a three-tiered, four-foot pedestal (fig. 48). The handsome face of the mayor had a cheerful, toothy grin. It certainly qualified as a very good likeness. But the pedestal, hitherto undecorated, now contained a history of Moscone's life, including sketches, biographical notes, and some of his favorite sayings, including "Is Everybody Having Fun?" Interspersed were references to the assassination, including spatters of red paint suggesting drops of blood, bullet holes, and the profile of a .38 caliber pistol (the murder weapon). Adding insult to injury, there was an outline of Moscone's body along with the words "bang, bang, bang."[44]

48. Robert Arneson,
Portrait of George (1981).
Glazed ceramic (private collection). Art © Estate
of Robert Arneson/licensed by VAGA, New York,
N.Y. Photo by Lee Fatherree. Image courtesy
of George Adams Gallery, New York.

Hostile reactions surfaced immediately. The Art Commission questioned the wisdom of using the work as the artistic centerpiece for the convention center and proposed covering the pedestal with a red silk shroud for the dedication ceremony. Arneson protested that doing so would only prompt curiosity and either create an issue or else intensify one. He asked the widow to have a look at his piece and perhaps just play it cool at the opening. If she did not react negatively, he thought that no one else would. She went, looked at the statue, nearly

fainted, said that she did not want her children to see it, and requested that Arneson take it back. He refused but agreed to keep the pedestal covered with only the bust showing during the dedication.[45]

Some twenty thousand people attended the ceremony, but very few had any idea of the potential controversy. The following day, December 3, leading city officials agreed that secrecy was not wise and that modification should be requested because artists are expected to deliver "what was ordered." As soon as the local press gained access and printed columns of reportage with detailed photographs, serious agitation understandably began. In an exclusive interview Arneson defended his work as "beautiful" and "a piece for the people." When asked why a Twinkie had been painted so prominently on the pedestal, he replied, "The ladies always thought that [Moscone] had a twinkle in his eye."[46] More likely, it referred to what became known as the "Twinkie defense," in which Dan White's attorneys argued that the normally health-conscious White's increased consumption of junk food was evidence that he suffered from depression when he committed the crime.

While Mayor Feinstein insisted that Arneson had not produced what he promised and Mrs. Moscone declared that she did not want her husband remembered in such a manner, the Bay Area art community closed ranks in support of Arneson. The *Chronicle*'s leading critic insisted that "the pedestal is actually a powerful piece of social commentary that, rather than deifying Moscone, tells the truth about his life and death. But isn't that the purpose of modern art?" The associate director of the San Francisco Museum of Modern Art defended the work on different grounds. "An artist has to be trusted once a commission is granted," he argued. "There was no mystery about what an established artist such as Arneson would create. His work has always had a cutting edge. The controversy will go away if you leave the work alone and let it be shown . . . it will have a different meaning 50 years from now."[47]

The very next day civic leaders began to attack the piece in earnest and demanded its immediate removal. A series of public meetings and private discussions resolved nothing because each side dug in its heels. When Arneson left to attend the opening of his new show in New York, he declared that "I am not making the piece for Gina Moscone; I'm making it for the people of San Francisco." Meanwhile, the public could not see the work because the center had been closed, allowing the initial press coverage to very quickly inflame the situation, which it

did. An editorial in the opinion section of the *Examiner* argued that the work reflected an elitist notion of art by subscribing to the view that iconoclasm somehow served a higher calling, then offered a drastic solution: "the commission should get the statuary out of the center as quickly as possible and deposit it somewhere out of public view— perhaps in the Bay, at the deepest place. . . . Censorship is not the term we had in mind; demolition is more in order."[48]

Over the weekend of December 5–6 the convention center opened, ostensibly only to a gathering of dermatologists; but many members of the general public streamed in, and the inevitable outcome was a fiercely divided city. One man said that he had seen "better graffiti on a New York subway," but a local woman wrote that she liked it because "it really represents the times." On Monday the seventh, well before the Art Commission was scheduled to meet to render its final decision, the piece was covertly removed at seven A.M. and placed in a locked room at the Museum of Modern Art, ostensibly to protect it from threats of vandalism. When the Art Commission held its hearing at an altered location, it received primarily positive comments about the statue but voted 7–3 to reject it. That simply intensified the ferocity of letters pouring in to the press, pro and con, with no holds barred. The "conversation" got coarse.[49]

The *San Francisco Chronicle* decided to open its phone lines for twenty-four hours for a poll on whether people approved of the work. A total of 22,314 people voted. Sixty-one percent indicated that they did not like it, while 31 percent did. Following that decisive vote, interest began to wane, Arneson reconsidered his threat to keep his $18,500 advance (half of his full commission) and indicated his willingness to sell the work on the open market. In April 1982, after it had been exhibited at the San Francisco Museum of Modern Art, he sold it to the Grant Avenue Gallery for $50,000.[50]

Curiously, as agitated as residents of the Bay Area had become, this particular controversy did not cause a major splash in the national press. Perhaps San Francisco and its distinctive political dynamics seemed too remote or too complex. Perhaps Moscone had not emerged as a figure of sufficient national importance. Locally, the Art Commission's failure to view the work in Arneson's studio and ask basic questions contributed to the brouhaha; but so did Arneson's irrepressible, impish impulses. He had long thumbed his nose at audiences of every kind, and here was the grandest opportunity of all. Mayor Feinstein took a principled stand but not a conciliatory one. Her insis-

tence upon conforming to the original sketch brings to mind the di Suvero episode in Grand Rapids six years earlier, except that in that case the public generally liked the work, while the populace in San Francisco was quite bitterly divided. It's probable that the incorrigible Arneson achieved his goals and had no regrets. He gained considerable notoriety, which is always good for sales. And a different sculpture on the wall of his studio bears the motto: "Judgements and opinions in the area of art are doubtful murmurs in mental mud."[51]

The journal *ARTNews* at least sought a broader and more upbeat perspective. "If nothing else," it observed in an editorial, "at a time when most public art is . . . unremittingly bland and decorative, the Moscone bust proved a striking exception. It was a work that actually prompted a broad segment of the public to think and debate, as distinct from the mildly approving but basically indifferent reaction to the more innocuous sort of embellishments generally found in public edifices."[52]

The palm for the single most notorious and persistent controversy in the history of public sculpture in modern times surely belongs to Richard Serra's *Tilted Arc*, once located at Foley Plaza in lower Manhattan in front of the Javits Federal Building and the U.S. Court of International Trade. Those structures had actually stood there for well over a decade, awaiting some sort of major project; but public art emerges with unusual deliberation in New York, perhaps because there are so many more conflicting and vocal points of view than elsewhere. Navigating the cross-currents of opinionated criticism can be quite treacherous. Whatever the reason, in 1979 the GSA offered the commission to Serra, who was then forty, a sculptor who had already achieved considerable prominence and several major successes during the previous decade.[53]

The son of a steelworker who had grown up in San Francisco, Serra worked almost exclusively with large rusted plates of Cor-Ten steel in a minimalist style deliberately envisioned as both anti-art and anti-environmental in the sense of being counterintuitive to its context. Serra's customary goal was to redefine a space rather than to complement it or set it off in an aesthetically pleasing way. His own highly articulate statements of purpose identified him as anti-institutional and a radical leftist but not exactly a populist. Referring to locations where a sculpture might conceivably be accommodating, he declared

that "it is necessary to work in opposition to the constraints of the context, so that the work cannot be read as an affirmation of questionable ideologies and political power." Regarding this commission in particular, he made no secret of his contempt for the site and its adjacent structures. Hence his determination to "dislocate or alter [its] decorative function," affirming that "after the piece is created, the space will be understood primarily as a function of the sculpture." Artists and critics sympathetic to his cause supported the use of sculpture "to hold its site hostage."[54]

After he spent nearly two years considering how he wished to fulfill this highly visible opportunity, Serra's work was installed during the summer of 1981. He had created a slightly curved, 73-ton wall of self-oxidizing steel (the color of brown rust) that ran 120 feet long, 12 feet high, and 2½ inches thick. It bisected the plaza in an aggressive way that blocked vistas and required employees who worked in the buildings to reorient their customary walking paths and, even more grievous, gaze continuously at an overpowering object that seemed menacing and created a source of disequilibrium for some viewers (see fig. 2).

No measures whatever had been taken to prepare and facilitate the local reception of *Tilted Arc*. That omission was mainly a lapse on the part of the GSA, whose policies at the time required no consultation, but also owed much to Serra's elitism. As he explained on numerous occasions over the next eight years: "When I conceive a structure for a public space, a space that people walk through, I consider the traffic flow, but I do not necessarily worry about the indigenous community. I am not going to concern myself with what 'they' consider to be adequate, appropriate solutions." Serra's self-assurance supplied a certain formula for public art insensitive to civic needs and wishes.[55]

Within months thirteen hundred office workers had signed petitions demanding the removal of *Tilted Arc*; equally ominous for the project's long-term future, while it received praise from some art critics, it got very negative notices from the likes of Grace Glueck in the *New York Times* and Peter Schjeldahl in *The Village Voice*. Letters to the editor that flowed in to various newspapers from people other than local employees were evenly divided and equally strident. An extensive yet intermittent battle had begun. Judge Edward D. Re of the Court of International Trade protested the work's "stark ugliness" to the GSA, and his hostility would remain constant throughout the struggle. Although criticism calmed down for a few years, Judge Re reactivated

it late in 1984 with a bitter complaint to Ray Kline, the new acting administrator for the GSA who was a Reagan appointee and sympathetic to the plight of those distressed by this "ugly, rusted, steel wall" that evoked frequent analogies to the Berlin Wall. Kline agreed to hold a public hearing the following March, and then William J. Diamond, the new regional administrator for the GSA, made it very clear that he favored relocation of *Tilted Arc* because "it has made it impossible for the public and the Federal community to use the plaza."[56]

Public hearings held on March 6–8, 1985, the most widely noticed among all debates concerning public sculpture, are instructive because Serra, his supportive wife Clara Weyergraf-Serra, and their attorneys were able to turn out an impressive number of art authorities who testified in support of retaining *Tilted Arc* in situ despite the fact that quite a few of them personally had grave reservations about it. They quite logically feared the precedent for themselves and other artists if a government agency could censor and remove an object that enjoyed something less than consensual support. The so-called art world really did circle its wagons on this occasion, but as one scholar has observed, "a rhetoric of democracy pervaded the debate, demonstrating the degree to which public art discourse had become a site of struggle over the meaning of democracy."[57]

Calvin Tomkins summed up the complex dynamics two months later in a lengthy assessment of the proceedings. "Some of Serra's most fervent supporters actually dislike the piece, and feel considerable sympathy for the office workers who have to look at it every day. They argued as they did because of the larger issues that seemed to be involved—issues of artistic freedom and the government's role in support of the arts."[58]

Alvin S. Lane, a lawyer active in quite a few arts organizations, raised the most searching questions of anyone who spoke at the hearing. Although he was negative rather than neutral about the work, he came across as very thoughtful and well spoken so that he seemed to foreshadow the inevitable outcome of a case that pitted two positive goods against each other: pleasing the people and avoiding censorship of iconoclastic art. Lane effectively raised a series of the most pertinent questions. Is the purpose of the Art in Architecture program to benefit the artist or the community? Should an artist have the right to impose his values and taste on a public that now rejects his taste and values? And finally, "in the selection of art, even the greatest experts will make mistakes from time to time. If it is a private matter, the mistake can be

rectified by not showing the work of art. Where it is a public matter, should there be a different standard?"[59]

Calvin Tomkins himself came across as equally balanced in setting a framework for those who would count votes in a literal-minded manner. "Art cannot be determined by voice votes, majority rule or democratic dialogues. By its very nature," he reasoned, "the selection of art is subjective—and for better or worse elitist." If that seemed to lean toward support for Serra, his weighing of all the factors in play did not. "I think it is perfectly legitimate," he wrote, "to question whether public spaces and public funds are the right context for work that appeals to so few people—no matter how far it advances the concept of sculpture." His final analysis would prove to be prophetic: "In its rough, confrontational way, [the fight over *Tilted Arc*] has pushed the whole notion of public art—what it is, what it could or should be—into clearer focus for a great many people. It is already a landmark, and it will continue to be one for years to come, even if it goes away."[60] Exactly right.

The whole issue managed to hang fire for yet another three years, with feature stories, symposia, and letters to the editor keeping all of the principal issues front and center while similar (albeit less inflammatory) episodes took place all across the country in Cincinnati, Los Angeles, and Concord, California, to name just a few that generated considerable media attention.[61] Some of these contemporary conflicts had satisfactory outcomes because the principal artists involved were willing to listen carefully to community wishes or, at the very least, bow to inevitable pressure rather than have no visible work to show when all was said and done. The central problem that Tomkins and many others identified in the mid-1980s could be succinctly summarized: "today there is no general agreement or understanding about art's social function."[62]

Ultimately, Serra's candidly undemocratic utterances cost him dearly in this particular ordeal, though his career would continue to flourish in the United States, and the considerable appeal of his distinctive style in Europe barely wavered. During the early years of the controversy Serra repeatedly questioned the "weird notion that sculpture should somehow serve what are being called 'human needs.' " In the 1985 hearing his defenders repeatedly distinguished between those who were competent to judge *Tilted Arc* and those who were not—an elitist perspective even when presented in the most reasonable way. As Donald Thalacker of the GSA told a reporter: "You go to a medical

expert for medical advice; you go to a legal expert for advice about the law. We go to experts for real estate and gardening. Yet when it comes to art, it seems they want the local gas station attendant in on things." And throughout the hearing, virtually all of Serra's defenders and apologists "openly ridiculed the idea of a public art rooted in democratic processes."[63]

Following the hearing, a panel voted four to one that *Tilted Arc* should be relocated. Serra soon filed a lawsuit to have that decision overturned. In 1987 his suit was dismissed, and the next year he filed an unsuccessful appeal. Under cover of night on March 15, 1989, the U.S. government rationalized its ownership of the work, for which it had paid $175,000, to completely dismantle and store *Tilted Arc* at a motor vehicle compound in Brooklyn. GSA regional boss William Diamond achieved what he had been hoping to do for four years. Ceaseless condemnations of an "iron curtain" and anxieties about a terrorist bomb bouncing off it, when viewed in conjunction with Serra's complete recalcitrance and his insistence that the work was "site specific" (meaning that to relocate it would be to destroy it), enabled large numbers of people, including art critics and arts administrators, to feel that justice had been served and a horrendous problem solved.[64]

Traditionalists among the populace at large as well as conservative art critics felt not merely pleased and relieved but vindicated by the removal set in motion by the hearings. During this very period Hilton Kramer had moved from the *New York Times* to his own freshly established journal called *The New Criterion*. He remarked that "the element of provocation is an integral part of Mr. Serra's artistic program. It would therefore be absurd to ignore it." He then used the fairly unrepresentative ruckus raised by *Tilted Arc* to support a much larger agenda in a fairly cavalier manner.

> Nor was I persuaded that the decision to order its removal from the Javits plaza constituted a crime against art, society, or anything else. On the contrary, it seems to me that there are legitimate reasons for objecting to the work and that the entire controversy has done much to illuminate the deeply problematic nature of the project which has come to be called public art—a vast and expensive program upon which the government embarked with a great deal of naïveté and a woeful paucity of

serious thought about its implications or indeed its essential purposes.[65]

By March 1989, of course, major disputes were also raging over the photography of Robert Mapplethorpe and Andres Serrano, over performance art by Karen Finley and others whose litigation against the NEA would persist from 1990 until the Supreme Court provided a final resolution against them in 1998. The end of the 1980s was a propitious time for censorship of art that appeared radically offensive. Government agencies with any sort of responsibility for art projects were hoping to avoid the wrath of Jesse Helms and his censorious colleagues in the Congress, and therefore radical or advanced art had reached one of its most vulnerable moments in all of American history. The convergence of indecency, religious offense, AIDS research advocacy, and sheer incomprehensibility paved the way for cancellations, restrictive legislation, and outright demolition.

It is surely ironic that in 1981–82, just when Serra had finished his work on *Tilted Arc* with limited consultation and review, the GSA's Art in Architecture Program decided to make its commissioning procedures more inclusive in order to establish contact with a broader cross-section of people working in the designated localities. In 1981 the GSA halted twenty-five projects pending the formulation of new procedures that would increase community participation in the nomination and selection process. In 1982 it adopted something called the Community Outreach Concept in which a cross-section of ordinary citizens and building occupants from any proposed site would henceforth be involved in the selection process from the earliest stages. Unfortunately, the concept was never formally adopted or made a standard part of all GSA contracts, though it would be implemented on an ad hoc and partial basis.[67]

Meanwhile, in 1985–87, yet another of Serra's American commissions reached crisis proportions. His supposedly parklike installation near the St. Louis Gateway Mall, titled *Twain*, made of eight rust-patinated Cor-Ten steel rectangles forty feet in length and as high as ten feet each, almost triangulated a city block in a fortresslike manner, except that there were thirty-inch spaces left between each plate and a fifty-foot slab at one end. A person could be enclosed and yet still see beyond the "corral," and one could be positioned inside the enclosure and see through it if the angles were well aligned. Beyond its extremi-

ties space had been left for grass and trees. The work became hotly contested on grounds of sheer ugliness and, once again, that sense of menace. Quite a few members of the board of aldermen wanted it removed, and the issue hung fire for a prolonged period.[68]

In August 1986 one of the board's twenty-eight members sponsored a bill calling for a public referendum on whether to excise the sculpture, thereby avoiding an arbitrary decision that would reflect only the taste of board members. The bill died after a period of weeks because a committee of the board refused to refer it to a popular vote—seemingly because members of the art community in St. Louis declared that the public needed still more time to contemplate the work and recognize its artistic merit. The author of the bill, obviously an opponent, explained that he wanted to bring it to the ballot "because people keep telling me it was ugly and an embarrassment and it offended them." In response to the delaying tactics of those who hoped to save *Twain*, this alderman insisted that "I saw an elitism in the committee meetings that prevented the public from having a voice. A certain few people have put themselves above the will of the public and I am offended by that. It's gone from the problem of the artwork itself, to the issue of how we form public policy. It's much more symbolic for me now as an issue for the people, for a democratic participation."[69]

Twain survived, and most observers seem to have agreed in retrospect that it should have. A 1986 work of environmental art by Alan Sonfist, however, intended as a kind of civic monument to St. Louis's natural history—native Missouri trees atop a shaped mound of earth surrounded by a formal French garden—was leveled by bulldozers in October 1987 just seventeen months after its dedication, when a new head of the city parks department unilaterally declared *Time Landscape of St. Louis* a public eyesore.[70]

What ensued in St. Louis for almost a decade following these two episodes were extensive discussions of how to involve the public in choosing and approving public art—essentially, how to open the process to majority rule and not have the fate of works be determined by a small group of experts or else by civil servants perceived as being out of touch with the populace at large. Meanwhile during 1986–87 the NEA developed and published a handbook intended to help artists and communities arrive at a flexible model for dealing with disputes over public art. More particularly, the guidelines would assist public officials and artists in drawing up careful contracts and providing an

acceptable review process for the placement (and removal, if necessary) of controversial works.[71]

Does it sound familiar? It was one more reprise in an ongoing saga, and a decade later public art persisted as a major provocation for municipal politics in St. Louis. Because *Twain* remained controversial, city officers dithered endlessly over the most effective means of enhancing the city's public art without risking yet another donnybrook. It bothered many residents that Seattle, among other cities, had successfully used funds from its percent-for-art program to acquire more than a thousand pieces of public art, which did much to create a buzz about its beauty and attract tourists there.[72] By 1998, estimates indicated that between two hundred and three hundred municipal governments across the country had some sort of percent-for-art policy, with the number increasing steadily. Even as wisecracks about *Twain* continued to be heard, Richard Serra received more and more plum commissions yet *still* complained that in the United States "any sculpture commissioned by the Government that isn't an expression of America's ideals is going to be suppressed or censored."[73]

Turning to the last decade of the twentieth century, we find quite a few familiar figures receiving commissions for public sculpture, artists who had been the young lions of the early 1970s but were now well established and yet were *still* able to generate controversy for various reasons, even in cities fairly tolerant of postmodernism and well accustomed to the multiphased process that has become ubiquitous as each participant seeks to maximize control—ranging from the artist to the administrator to spokespersons for "the people." Let's look at three instances that occurred in San Francisco between 1994 and 2002. The players and the issues are known quantities by now, never mind the chronic anxiety of those who call the shots in avoiding what one critic gave the pejorative label "Plop art," meaning "sculptural monoliths placed in front of buildings with no thought to the relationship between the two or their impact on the public."[74]

In 1994 the Fine Arts Museums of San Francisco commissioned Serra to create an outdoor piece for the Palace of the Legion of Honor as part of a remodeling project for that museum's site. The *San Francisco Chronicle* published a misleading photograph of Serra's proposed model for seven very tall plates of Cor-Ten steel to be propped up

against one another. (They would have been 48 feet high and weighed 140 tons, a somewhat more elaborate version of *Carnegie*, Serra's 1985 commission for the Carnegie Museum of Art in Pittsburgh.) Unfortunately the angle of the photograph distorted the relationship between the museum structure and the art, making the latter seem far too large and brutal in relation to the graceful building.[75]

The photo sparked an uproar among the public because newspaper columnists and talk-show hosts attacked the proposal savagely. The popular writer Herb Caen suggested that the sculpture "could be useful downtown as a large public sanitary facility." Meanwhile Serra learned that his piece would be implemented on land owned by the parks department rather than by the museum, and the parks department had a policy that permitted it to move sculpture wherever it saw fit. Given Serra's belief that his work was always site specific, and his previous experience with *Tilted Arc*, he insisted that a contract specify that his works must remain in place until twenty-one years after his death. When the park's policy would not permit that, Serra withdrew his proposal. Still more critical comments surfaced, but the project was dead.[76]

When that prospect evaporated, the museum authorities still wished to fill the envisioned space that separated the building from its parking lot, so they purchased Mark di Suvero's *Pax Jerusalem*, a configuration of cadmium-red bent I-beams made, of course, of steel. The parking lot site remained exactly the same, but advocates could claim that it enjoyed sweeping views of the city, including the Golden Gate Bridge. Newspaper coverage began casually, but letters to the editor weighed more heavily on the negative side than the positive. Nevertheless, in 1998 di Suvero's constructivism supplanted Serra's putative minimalism.

Meanwhile, Claes Oldenburg and his wife Coosje van Bruggen received a commission to create a work in the vein of Pop Art for a new Rincon park along the Embarcadero. Called *Cupid's Span*, their work consisted of a very large inverted bow and arrow, the shaft of which was being shot into the ground at the heart of grassy open space. It suggested love as a driving force unleashed from heaven—not merely the feeling but the weapon as well. The site for this work, implemented in 2002, provided a fine view of the Bay Bridge to Oakland and vistas across the bay. People could walk along the water with the city skyline as a backdrop, and sidewalks were also accessible on the opposite side of the sculpture on the street level. *Cupid's Span* was surely the

most amusing and least threatening of the three initiatives. It appeared as graceful as it was coy.[77]

So two of the projects were conceived as abstract, while the third was unequivocally representational. We tend to assume that laypersons are more likely to respond ambivalently or negatively to the absence of clear meaning in art. But as it happens, based upon interviews, letters, and articles, one investigator found that people seem to have been more confused or perplexed about the meaning of a bow and arrow than they were by bent steel I-beams or stacked slabs of steel, which is not at all the outcome one might casually have predicted. Even so, Serra's work had the highest percentage of negative evaluations (85.2 percent) whereas Oldenburg's had the highest proportion of positive responses (51.2 percent). The di Suvero had the most ambivalent evaluations, perhaps predictably so, but they were usually qualified rather than absolute—such as "I don't like the sculpture here, it doesn't fit, but I can see how it balances the museum and the city."[78]

What we learn from this survey, perhaps not too surprisingly, is that in an enlightened environment, contingency really counts. People do make an effort to come to terms with something unfamiliar if it is not too shocking or off-putting, and the location of a work matters to people and affects their reactions at least as much as purely aesthetic considerations. With public sculpture, being handsome or engaging may not be enough if the site seems wrong; and being peculiar or startling in appearance may not be insuperable if the object seems to be strategically situated and thereby serves a function that enhances vistas or visual equilibrium.

Turning to the varied assessments of Serra's project, virtually no one had anything positive to say about it on aesthetic grounds. His defenders simply suggested that having a work by Serra would help San Franciscans overcome their provincial attitude toward modern art. By accepting Serra, they argued, the city might achieve a more cosmopolitan reputation in relation to public sculpture. Serra's principal strength in this "competition" was his fame (or notoriety, if you prefer).[79]

The author of this inquiry found that many nuanced variables affected the responses of viewers to these three proposals for public sculpture. Aesthetic qualities turned out to be the "trickiest" because most people do not expect to "understand" abstract art, and therefore they respond to it by using other criteria, such as shape, color, configuration, amusement, frequency of viewing, and so forth. By contrast, it

is easy to recognize an arrow shot into the ground, though what that is supposed to mean might be much less clear. (When a bow appeared in the sky in seventeenth-century New England, the Puritans perceived it as a divine omen—perhaps a warning of impending Indian conflict.)[80] Consequently context or setting turns out to be a crucial factor in determining acceptance. Here are two highly symptomatic reactions, equally negative, first to the Serra concept from 1992, and then to di Suvero's from 2000.

> Say it ain't so! Don't tell me there's going to be a 48-foot-tall Richard Serra steel sculpture in front of the Palace of the Legion of Honor! That would be like putting a huge Andy Warhol painting of Marilyn Monroe in the middle of the Sistine Chapel. The Palace of the Legion of Honor is surrounded by statues and gardens that take us back to another time and give us feelings of noble grandeur. Mr. Serra's piece will deprive us of that privilege.

> During our recent visit to the Palace of the Legion of Honor with relatives from Ohio, we were all astonished to see this hideous sculpture in the front plaza. It looks like a discarded heap of scrap metal with no relation to the elegant building itself or the works of art housed within. The color is garish and the form unintelligible. . . . To think that this monstrosity might be a permanent part of the Palace's gorgeous landscape is indeed depressing.[81]

By the close of the twentieth century, public sculpture in the United States had actually achieved remarkable diversity, and the responses it elicited were appropriately varied. While we must never forget that a high percentage of the work was readily accepted, and sooner rather than later, intense controversy most certainly persisted, though rarely resulting in outright removal or destruction of the sort that we witnessed with Serra's *Tilted Arc* and Sonfist's environmental work in St. Louis. The passage of time has not healed all wounds, but it does seem to have subdued a good many strident conflicts, either because people became accustomed to an object or else because their concerns were diverted elsewhere. More often than not, the American attention span is finite.

With the passage of years, moreover, increasing numbers of works became time-specific and hence not permanent eyesores, sometimes because they did not arise from governmental commissions, were not meant to be permanently situated, and appeared under gallery auspices, such as Barbara Kruger's exuberant, vaudevillelike *Family* (1997), a satirical white-fiberglass modeling of John F. Kennedy and Robert Kennedy kneeling with a joyous Marilyn Monroe, legs spread, astride their shoulders. Kruger is a modern master of the enigmatic utterance. Here is one comment by her from an interview concerning two of her recent installations: "I should say that I feel uncomfortable with the term public art, because I'm not sure what it means. If it means what I think it does, then I don't do it."[82]

A public art has emerged that is not only impermanent but radically antiheroic, like Kruger's *Family*. One may scorn it with impunity, knowing full well that it will not remain an eyesore for very long. Sculptures by Nancy Rubins provide a prime example. Although she works on a very large scale, primarily with junked appliances attached to steel armatures, she deliberately challenges the very notion of elegant or celebratory public sculpture. Her first major commission, *Big Bil-Bored* (1980), consisted of a massive wall of toasters and other discarded consumer goods. It prompted community protest in Chicago, and a poll taken by radio voted it the "Ugliest Sculpture in Chicago." One mayoral candidate proposed that it be condemned by the city health department.[83]

Rubins's next project, called *World's Apart* (1982), provoked even greater outrage. Consisting of electrical household appliances welded together in the shape of a mushroom cloud (forty-five by forty by forty feet), it was installed along the heavily traveled Whitehurst Freeway near the Watergate complex in Washington, D.C. (fig. 49). Ridiculed by the *CBS Evening News*, the *National Enquirer*, and others, it prompted the inevitable cry about wasted taxpayer dollars by the Washington Project for the Arts. Residents of the Foggy Bottom neighborhood and many others petitioned against this "unsafe, illegal pile of garbage." It was dismantled just as soon as its five-month display permit expired. A last-minute purchase offer might have prevented its complete demolition, but the offer never materialized, and the disassembled pieces were shipped to California, where Rubins attempted to reconstruct *World's Apart*.[84]

Rubins explained in an interview that it was not unusual to demol-

49. Nancy Rubins, *World's Apart* (1982), Washington, D.C.
(since removed).

ish such large projects if they could not be sold or permanently placed. She declared that she often created and destroyed works of art. "But I [want to] have control over it. When somebody else wants to knock it down for stinking reasons, for negative reasons, it's bad," making her all the more determined to persevere and sell the work. Her most charitable art critic had this to say: "Rubins's sculptures achieve their immediate impact through a self-consciously vulgar excess, a daring splendor that seems similarly Baroque in spirit. With her explosive embellishments, she aims to reinvigorate a stultified genre: monumental modernist sculpture."[85]

At the time there seems to have been something infectious about this trend toward eyesore public art pieced together from the detritus of our disposable society. In 1982 a work by Arman called *Chariot's Tro-*

phy appeared in the Laumeier Sculpture Park in St. Louis. Twenty-eight feet high, it consisted of several hundred metal shopping carts welded together into a kind of prison-cell tower, perhaps to entrap unwary squirrels.[86]

The most symptomatic conflict over this kind of construction, however, occurred in September 1993 when a work by painter-sculptor Frank Stella was installed near the main entrance of the Metcalfe Federal Building in Chicago—this piece being a partially painted, jagged steel and aluminum scrap metal construction for a GSA project costing $450,000. Titled *The Town-Ho's Story* (from the name of a chapter in Melville's *Moby-Dick*), it weighed nine tons and stood twenty-two feet high. It had received approval from a thirteen-member panel (art professionals and local politicians), but no input at all had been sought from people who worked in the building. Within weeks 625 federal office workers signed a petition labeling the piece an "alien presence" that should be banished. Described as a "dozen craggy metallic blasts in one," for months it was reported to have "stopped folks in mid-stride and left them goggle-eyed." Its defenders came from predictable places. A curator at the Museum of Contemporary Art called it "a whale of a piece, swelling with fire in the guts."[87]

Stella explained that in his view it was "an industrial piece for an industrial city whose art sprouts from the pavement in the name of architecture. . . . I consider it to be a colorful piece because of the way light hits it." (The aluminum enhanced this effect.) Stella took more than two years to create *Town-Ho* at a foundry in Beacon, New York, and insisted that he conceived it in relation to the urban industrial environment—"that is what this part of the world [meaning Chicago] is about." A woman who worked in the building had a different take, and one fairly typical of her fellow workers.

> For nearly an hour I tried to "read" that story. I tried to allow all that chaotic tonnage to speak to me. I watched and watched . . . but nothing doing. Once, I almost thought I was getting something. The piece seemed to be telling the story of a painful gall bladder surgery suffered by someone's Aunt Gladys until I realized it wasn't the sculpture talking but a heavy-set woman standing behind me. After a while I threw up my hands in frustration. Only an FAA disaster specialist could make any sense out of it, I concluded. I suppose I'm just not ready for

modern art. My tastes are still more couch-potato than vichysoisse. I like my art quaintly representational, preferably emblazoned on a McDonald's collector's cup.[88]

Nothing whatever seems to have been learned from the still insufficiently inclusive procedures of the 1970s and 1980s, despite several efforts at reforming those procedures. Not only do we ignore lessons of the past, we don't even do very well with lessons of the present.

The Environmental Protection Agency staff member who organized the petition drive observed that 80 percent of his colleagues objected to the "pile of junk," but because Stella's contract contained a proviso that it could not be removed for five years, it stayed put, the commotion died down, and within less than a decade few people in the building even seemed to notice it. Neither the offensiveness of miscellaneous scrap metal nor the steep price tag of taxpayer money seems to have had much staying power as an issue. A guard who monitored one of the security points nearby declared in 2004 that he had not heard anyone mention *Town-Ho*, pro or con. Time certainly seems to heal many wounds, even when they come from public sculpture made from explosively discarded metal.[89]

Given the history of WPA and Treasury Section murals sponsored by New Deal agencies during the 1930s, and then the various art projects advocated during the Cold War, such as "Advancing American Art" and works sent to the Venice Biennale and other international exhibitions, what was actually new about the GSA and NEA programs designed to allocate federal funds for art in public places? Unlike earlier initiatives, the GSA and NEA projects placed aesthetic concerns first and foremost, even though many contemporaries might not have agreed. Although they sometimes became politicized, as did many previous efforts, their purpose was not to employ starving artists or improve America's cultural image abroad. Nor were their creators notably interested in national identity or commemoration. As two authorities have written, "whereas previous public art was intended to be instructive and socially cohesive, modern public art has most often been experimental, individualistic and thus potentially divisive. In these ways, recent public art commissions have tended to be radically different in their artistic substance from preceding commissions. Con-

comitantly, the historical procedural lessons, perhaps thought to have been outlived, have evidently been ignored, in large measure."[90]

Administrators who have been directly involved with new developments from the 1970s and 1980s are inclined to see clear demarcations between the two major programs, but perhaps overly so. John Beardsley, for example, who created the first inventory of the NEA Art in Public Places program, has insisted upon

> a significant distinction between federally sponsored artworks, such as those commissioned by the General Services Administration, and those that are sponsored at the community level and merely supported by the government. The NEA . . . program operates on the latter model; it supports projects in which both site and artist are selected on the local level. These are not artworks that are unthinkingly imposed on their host communities. Between 1967 and 1980, the Endowment supported 312 projects in 46 of the 50 states.[91]

Readers should recall that Beardsley's claims on behalf of choices made from the bottom up emerged only gradually, after an extended trial-and-error process. Although the mechanisms for funding the two programs definitely differed in certain respects, and the GSA relied upon guidance from NEA rather than vice versa, their outcomes were remarkably similar and so were many of the controversies they spawned. I doubt whether many people who were not insiders had much if any awareness of which program facilitated which sculpture. Calder's *Grande Vitesse* grew from an NEA initiative, while his *Flamingo* came to Chicago courtesy of the GSA. Who today can recall which one had which sponsor, and besides, who cares? What matters is that between the two of them, enhanced by a proliferation of municipal percent-for-art programs, committing art in public made a whole new beginning in 1969.

CHAPTER 8

The Art Museum Transformed

In 1961 the journal *Art in America* organized a timely symposium addressing the question "What Should a Museum Be?" Responses appeared from John Canaday, the prominent critic; Thomas Messer, new director of the Guggenheim Museum; and Robert Motherwell, a major and voluble Abstract Expressionist. Their replies shared no common theme, not because their vocations varied but because the American art museum was just entering a significant period of transformation that would continue for a full generation. Museums had long been perceived as temples of art, often referred to as "morgues for masterpieces" and even less formally as "warehouses for the protection of art objects." In 1991, following several decades of expansion, redefined missions, and intensive commercialization in the art world, the museum was increasingly referred to as an "emporium."[1]

Its transformation from a warehouse for preservation to an emporium for commodification was not, like a butterfly's metamorphosis, a natural and predictable process. A striking number of unprecedented controversies marked these decades of transition in which art institutions became commercialized and politicized in ways previously unimagined. We have already encountered two major examples: the exhibition of works by Edward Kienholz at the Los Angeles County Museum of Art in 1966 and "Harlem on My Mind" at the Met in 1969. At one point during a symposium held in 2001 concerning the changing nature of American museums, David Ross, then director of the Whitney Museum of American Art, declared that such institutions "cannot" be devoted "only to art and its preservation." Later in the dis-

cussion he took a still more strident stand: "museums sometimes should be the armchair [i.e., comfortable], but not always. Sometimes they should just be like being in a fistfight, or being mugged somewhere. You should leave a museum reeling and thinking."[2]

It might be useful at the outset to note the range of responses to the 1961 symposium question. Thomas Messer began and ended by declaring that "a museum today is many things; among others, it is treasure house, school, church, and battlefield." John Canaday called it a "house of preservation" in which the objects "are worth going out of your way to see." Given that qualitative emphasis, he felt "not at all sympathetic to the idea that every community must have its art museum." Those in small cities contained mediocre stuff, and consequently the "innocents" gaze "with glum reverence at objects not even worth looking at with respect." So much for art in the heartland or at the grassroots level.[3]

Robert Motherwell went out of his way to attack the Whitney Museum because its "rationale seems to be democratic, to give a fair sampling from hundreds of artists of what is going on in America at any given moment." His preference would have been to place all the works by great artists in individualized museums, so that one went to San Francisco for Matisse, to Chicago for Goya, to New York for Rembrandt, to Philadelphia for Cubism, and to "any small town for all of a minor artist, say, Boudin or Marin or Guardi. . . . And how incredibly less dull would travel be in America if, say, in Falmouth one could see all of Homer's watercolors; in Cicero, Sullivan's architectural renderings; in Gettysburg the Matthew Bradys," and so forth. It was rather idiosyncratic thinking, even for those visitors with unlimited budgets and time for travel; but by the early 1960s eccentricity was not only in the air, it was becoming infectious.[4]

Considerable apprehension was also evident, and for a variety of reasons. Pop Art had just begun to emerge and was receiving supportive attention from influential gallery owners like Leo Castelli and Sidney Janis, which unnerved quite a few of the Abstract Expressionists. More to the point, perhaps, the Solomon R. Guggenheim Museum in Manhattan, designed by Frank Lloyd Wright in his "search for a new monumentality," finally achieved completion in 1959, six months following his death (fig. 50). Although it elicited gasps of awe for its architectural bravura and uniqueness—the art critic for the *New York Herald Tribune* called it "the most beautiful building in America"— many other critics and artists did not like it because they believed that

50. Frank Lloyd Wright, Baroness Hilla Rebay, and
Solomon R. Guggenheim with the model for the
Solomon R. Guggenheim Museum (1947).

Division of Prints and Photographs, Library of Congress.
© 2007 Donald Greenhaus/Artists Rights Society (ARS), New York.

its spiral ramp posed insuperable problems for the proper display of contemporary art.[5]

The notably influential but cantankerous Canaday wrote that "Mr. Wright was not too fond of painting, believing that its only legitimate function was that of an adjunct to architecture. If he had deliberately designed an interior to annihilate painting as an expressive art, and to reduce it to an architectural accessory, he could not have done much better." Canaday complained that the pictures seemed to hang askew, and that seen from across the atrium looking up or down, they were bisected horizontally with only a top or a bottom visible. Unfortunately, he concluded, "the pictures disfigure the building and the building disfigures the pictures, and in honesty, for this writer at any rate, there is no point in pretending anything else." The doyenne of architectural critics, Ada Louise Huxtable, did her best to offer a balanced assessment. She assumed that the building would attract curiosity-seekers who might end up feeling some interest in

art—perhaps even a bit of appreciation. "But is it a museum?" she wondered.

> It is too soon to say, even though one visitor [herself] is tempted to put in a resounding negative. A museum's purpose is primarily to be a background; it is a setting created to serve other forms of art. In spite of Wright's repeated picturesque statements that man and his needs were at the center of all that he did, one has the persistent impression that human and practical considerations were always subordinated to his personal work of art.[6]

No art museum in American history had ever generated such a varied and intense response to its structure and design. An editorial in the *New York Times* suggested that the building resembled "an indigestible hot cross bun." A group of twenty-one prominent artists signed a petition condemning Wright's plan to hang paintings along the spiral ramp. The art world was agog with questions concerning how pictures should best be shown, and whether innovative architecture now threatened to overshadow and undermine the art it was intended to display. But heated controversy only heightened the public's curiosity about the Guggenheim. Crowds gathered to get in from the very outset, and thousands had to be turned away each day, especially on weekends. The vast majority, not sharing the artists' concerns about ideal conditions for viewing, felt exhilarated by the soaring open space of the interior. Three-quarters of a million visitors passed through the museum during its first nine months, and it remained an extremely popular tourist attraction.[7]

The museum world was also beginning a major transition at just that time because the Cleveland Museum of Art had made an innovative decision to emphasize the importance of art education, a movement that would catch on in the following decade and become pervasive by the 1970s. This trend was certainly driven in part by altruism: a genuine commitment to democratization, especially through increased visitation by school groups, but also by means of lectures, symposia, publications, and regularly scheduled guided tours that would highlight masterpieces of the permanent collection or notable features of a special installation.[8] Beyond that commendable idealism, however, enterprising directors hoped to enhance

their attendance figures, both for prestige but also because more bodies passing through the turnstiles meant added income for the museum at a time of rising costs. Hence the advent of the "block-buster" exhibition during the 1970s and intense competition for corporate sponsors to facilitate these large and expensive shows. In the 1990s maximizing attendance would become an obsession for most directors.[9]

Controversial exhibitions at museums as well as the wish to enhance visitation was hardly a new phenomenon in the 1960s, though the frequency and intensity of such trends *would* be. In May 1932, for example, the very new Museum of Modern Art mounted a show of freshly executed murals by contemporary American artists. Among the reasons for selecting that particular emphasis at the time was an advocacy tactic: Rockefeller Center was on the verge of selecting muralists to decorate the RCA skyscraper then under construction, the centerpiece of this new entrepreneurial extravaganza. Wouldn't it be nice to give some native artists timely visibility for possible commissions, especially in the eyes of young Nelson Rockefeller, who had a significant stake in both projects?[10]

The critics, however, hated MoMA's murals. Edward Alden Jewell called the art "pretty terrible" and added that the exhibition as a whole "is so bad as to give American art something to think about, very gravely, for a long time." To make matters worse, a number of radical artists had submitted work sufficiently iconoclastic that painter Hugo Gellert would proclaim in *The New Masses*, "We Capture the Walls." He made it sound like the successful siege of a medieval fortress.[11]

Gellert's own painting, *Us Fellas Gotta Stick Together—Al Capone*, linked the notorious gangster with John D. Rockefeller, J. P. Morgan, Henry Ford, and President Herbert Hoover. That mural, along with Ben Shahn's *The Passion of Sacco and Vanzetti* (1931) and one by the leftist William Gropper, were on principle rejected for display. When all the other artists threatened to withdraw their work, leaving MoMA with no show and poor publicity for a fledgling institution, its most powerful trustees relented and included the radical trio but refused to reproduce murals in the catalog. The media received word of this, and a day before the exhibition opened New York's *Daily World Telegram* announced in bold type:

**Insurgent Art Stirs Up Storm Among Society.
Murals for Modern Museum Rejected as Offensive,
Then Accepted. Linked Hoover to Al Capone**[12]

Alfred H. Barr, the young director, survived that minor fiasco intact, but he had a major crisis of quite a different nature looming immediately. He needed to raise $1 million in order to comply with the very generous Lillie Bliss bequest of works that comprised the very core of MoMA's budding collection. Barr's attendance needed a serious boost, not only for the revenue but to demonstrate to wealthy trustees who were delinquent in making good on their pledges that the museum really did have a future. Barr succeeded, after lengthy and difficult negotiations, in persuading the Louvre to lend James McNeill Whistler's *Arrangement in Grey and Black* (1871), better known as *Whistler's Mother*. Cartoons had appeared when it was first shown in 1872, and journalists as well as caricaturists treated it with contempt following its display at the Paris Salon of 1883. Over the years, however, it nonetheless achieved a certain iconic cachet in the United States, where it had been known only from photographs and descriptions. Barr's brilliant hunch was that a showing at MoMA might have considerable impact on the public, and his board actually underestimated the extraordinary power of an emblematic painting at a time when motherhood was passing through a distinctive phase of American veneration.[13]

The picture went on exhibit to the public at the end of October 1932 as part of an all-American show. Every review singled it out as the central work in the exhibition, and MoMA received 102,000 visitors during the next three months, a record number. That achieved Barr's purposes locally, and he boldly succeeded in persuading the Louvre to extend the loan for two full years, which made it possible for the painting to be displayed for five months at Chicago's "Century of Progress" exhibition in 1933 and then to tour through twelve other American cities, where it was seen by more than two million people. Although the press was inconsistent in its coverage of the tour, invoking cynical headlines like "Over-Excited Public" yet stressing the picture's moral and artistic qualities, national enthusiasm exceeded all expectations. The painting's estimated commercial value doubled from $500,000 to $1 million, and the U.S. Postal Service featured it on a Mother's Day stamp in May 1933, one that upset purists both because the image was cropped for the stamp and because a vase of flowers was added at the

elderly woman's feet, a sentimental touch not found in the original yet quite pleasing to the current cult of motherhood. To the extent that this episode involved controversy, it mainly hinged upon a battle between MoMA and Chicago for kudos earned in bringing the work to Whistler's native land. But MoMA's future had suddenly been assured (and surprisingly so to many). Barr had truly scored a coup.[14]

More often than not major art museums recover fairly swiftly from crises and negative public opinion. The unfortunate exhibition at the Met called "Harlem on My Mind," for example, did not harm that museum very much or for very long in 1969–70. Similarly, the collapsed negotiations between the Met, MoMA, and the Whitney Museum of American Art in the period 1948–50 caused no permanent harm and in the long run may very well have been a blessing for the institutions individually and for the art-viewing public in terms of maintaining diverse acquisition policies and upholding curatorial criteria. Emphases and modes of spectatorship vary from one venue to the next, and that is appropriate for a diversified art world in a heterogeneous society.

Albert C. Barnes, a rich, opinionated, and eccentric Philadelphian, assembled an astonishing private collection of works by French Impressionists, Post-Impressionists, some Old Masters, and various others at his home in the suburb of Merion during the first half of the twentieth century. He maintained it at first in a semiclosed fashion, allowing only certain individuals to view it, including the philosopher John Dewey, from whom he had taken courses at Columbia. In 1923 the Pennsylvania Academy of the Fine Arts, the oldest institution of its kind in the country, displayed Barnes's recent acquisition of works by young Parisian artists such as Modigliani and Soutine. (Barnes had a brilliant eye for undiscovered talent and future "stars," though he also received wise advice from the Philadelphia painter William Glackens.) When the press reaction to the show turned out to be harshly negative, he became outraged, and as a result very few professional art critics would gain admission to his galleries at the Barnes Foundation, which became a combination school and museum. The Philadelphia "art crowd" was notoriously conservative at the time, so Barnes really should not have been shocked when works obtained at miserly rates from artists younger than thirty-five set people's teeth on edge; but they did, and the result was an enduring battle aligning Barnes

51. Albert G. Barnes (right) and John Dewey (1930s).
Special Collections/Morris Library, Southern Illinois University, Carbondale.

and his few allies (such as Dewey for a while), against everyone else (fig. 51).[15]

In 1931 Barnes cynically managed to maneuver away from the Philadelphia Museum of Art (PMA) an important painting by Matisse, *The Three Sisters*, for his own collection. A PMA trustee had recruited Barnes to help obtain it for the museum, and his presumed greed in deceiving colleagues resulted in a legacy of ill-feeling that made cooperation between the two institutions impossible, despite various efforts by the esteemed though feisty Fiske Kimball, director of the PMA.[16]

Bad blood spilled quite openly in 1937, when the PMA opened an exhibition titled "Forms of Art" with a catalog explaining its underlying aesthetic. Barnes believed that his ideas had been crassly plagiarized because the philosophy taught at his school, based upon his own book, *The Art in Painting* (1925), deemphasized the biographical. The exhibition catalog insisted that what an artist is trying to say, and how he says it, is more important than when and where he says it. Historical facts fail to reveal very much "about the one thing in a work of art that is essential to appreciation—and that is why and how it functions

as a work of art; and why artists of all ages ... have been moved to express themselves in much the same way." So the works shown were arranged by "unanimity of purpose" rather than by period or medium. Barnes became infuriated because the ideas expressed were borrowed from his own but, he believed, were misunderstood and strangely distorted. John Dewey actually took time out from his hectic schedule to visit Philadelphia and endorse Barnes's critique of the show. Henceforth Barnes proclaimed the rapidly growing PMA a "house of artistic and intellectual prostitution."[17]

Following Barnes's death in a bizarre automobile collision with a truck in 1951, one of his bitterest foes, Walter Annenberg's *Philadelphia Inquirer*, launched a campaign to force the foundation to open its galleries to the public, but especially to art experts and scholars, particularly because it was a tax-exempt institution. The lower court's decision upheld the sanctity of Barnes's will and the bylaws of the foundation, but following several appeals the Supreme Court of Pennsylvania ruled that the school and the viewing galleries were separate and it therefore required the museum to open its doors to four hundred people each week, in compliance with the original charter. The school continued under the supervision of a devoted disciple (rumored to have been Barnes's lover), Violette de Mazia, and according to the terms of Barnes's will, no object could be moved from the precise place where he had chosen to hang it. That and many other provisions of Barnes's will became involved in a sequence of convoluted lawsuits ever since.[18]

In 2002 the trustees filed a petition in court seeking to relocate the museum to downtown Philadelphia because the foundation was on the verge of bankruptcy and could be saved only by the paid admissions of many more people than had been willing to trek out to the inconvenient location in Merion. Arguments pro and con filled the press for several years, and the issue was finally resolved by a court ruling in favor of the trustees late in 2004. Relocation will have Barnes spinning in his grave, but it appears to be the only way to save a collection that he gathered with a keen eye and loved above all else. As one among many embattled partisans has written, "current law permits donor restrictions to run in perpetuity. Yet every museum confronts increasing costs, changing public demands and new approaches to the presentation of collections."[19]

. . .

The next wealthy collector who wished to leave a splendid legacy but with personalized constraints, and thereby provoked multiple controversies, would be Joseph Hirshhorn, a uranium and mining magnate who also had a keen eye for contemporary art and very strong views about where and how his collection might be displayed. By the mid-1960s his inventory of modern painting and sculpture from both sides of the Atlantic was immense and impressive. As the largest such collection in private hands, it was coveted by several major American museums as well as by the British and Canadian governments. Hirshhorn was ardently wooed by numerous suitors.[20]

In 1964 S. Dillon Ripley, the secretary (i.e., director) of the Smithsonian Institution, contacted Hirshhorn and began suggestive discussions whereby the magnate would bequeath his collection to the people of the United States and the grateful nation would erect a museum to contain it in a place of particular honor in Washington, where it would become a part of the Smithsonian. Ripley convinced Lady Bird Johnson that this would mark a wonderful coup for the United States and its foremost museum complex. She in turn persuaded the president, who accepted the donor's gift with reassurances and sent a bill to Congress in 1966 that included all of Hirshhorn's self-aggrandizing terms: a museum bearing his name to be built on the Mall at public expense. He could also hand-pick as the first director his longtime assistant, Abram Lerner.[21]

As soon as the bill reached Congress and entered the legislative process with no lack of sponsors, criticism rained down on every aspect of the project. The site (displacing the Army Medical Museum on the south side of the Mall) and the name were contested, and Hirshhorn himself was disparaged in ways revealing nativist and anti-Semitic bigotry. One senator insisted that the museum be named in honor of Franklin D. Roosevelt, who still lacked a memorial in Washington. Another pointed out that Andrew Mellon had not required that his name appear on the National Gallery of Art, his generous gift to the nation. (No one ever seems to have mentioned Andrew Carnegie's insistence that every institution he endowed should bear his name.)[22]

Sherman E. Lee, the widely respected director of the Cleveland Museum of Art, addressed a letter to Mrs. Johnson objecting to the whole plan, and his views represented those of many in the art world.

> The recent action seems to me ill-advised and inimical to the national interest in the fine arts. . . . Its acceptance [by LBJ] ill

accords with current standards of wisdom and professional knowledge in the arts. It is a mistake to accept a collection of contemporary art formed by one man. . . . One presumes that the proposed monument will be designed to display the Hirshhorn collection in its entirety or nearly so. Anyone who knows the contents of the collection [almost no one did because it was so large] knows of its personal and quixotic nature and of its considerable variation in quality. . . . I feel that a truly National Museum of Contemporary Art should be founded on a carefully developed program employing the best available professional advice and that it should bear the name of the nation.[23]

House and Senate committees listened to a long queue of opponents who elaborated Lee's perspective, and from others in the medical community who objected to disrupting the Army Medical Museum's scientific functioning (actually minimal at that time) and the loss of a historic landmark. Still others feared the appearance of an ultramodern structure on the Mall (fig. 52). The minister of All Souls Unitarian Church was quoted as saying that it would be tragic. "We should then view the Capitol from the Washington Monument and the Washington Monument from the Capitol as if through a modernistic cemetery." Antimodernism was alive and well in 1966. But Lyndon Johnson still had political wiles as well as the clout to prevail, and he used both to get the bills out of committee, approved, and on to himself for signing in November.[24]

52. Model of the Hirshhorn Museum.
Division of Prints and Photographs, Library of Congress.

The public response to this swift fait accompli turned out to be very mixed. The *New York Times* observed that the act represented Johnson's "boldest stroke as a patron of the arts, a personal triumph, a national victory over foreign bidders, and an inestimable enrichment of Washington's cultural resources." Aline Saarinen, who earlier had praised Hirshhorn in her book *The Proud Possessors,* echoed Sherman Lee and with unrestrained anger at the done deal. She blamed Ripley for hyping the collection excessively to the Johnsons instead of bargaining astutely and persuading Hirshhorn to give only his finest pieces to form the core of a National Collection of Modern Art. (Saarinen conveniently overlooked the fact that Hirshhorn had other options and never would have consented to such a deal.) She condemned public payment for a building named in Hirshhorn's honor and also criticized his indirect dominance of the museum through his demand to select its initial director.[25]

The fray remained comparatively quiet while the appropriation and design stages occurred. But in 1969 when a model of the building was displayed and after groundbreaking the next year, all hell broke loose, with such heat that Hirshhorn more than once contemplated withdrawing from the arrangement. He was taken aback because the art world that had so lionized and courted him only a few years earlier now seemed to express nothing but contempt for not only the deal he had struck but the new home for the collection as well. Reporters outdid one another in making fun of the circular design by Skidmore, Owings, and Merrill. They likened it to a "gargantuan bagel . . . the Pentagon with the corners knocked off" and "the biggest tomb since the Pyramids."[26]

Ada Louise Huxtable, the most vocal and widely read architecture critic of the day, savaged the design as "the biggest marble doughnut in the world." She warned that the new structure "will line up solidly and formidably with the crushing phalanx of marble mausoleums devoted to the endless aspects of American art, culture, history and technology shepherded along both sides of the Mall by the Smithsonian. . . . The scale is megalomaniac and the style is colossal funerary." Landscape architect Gordon Bunshaft responded that "she doesn't like Washington; she doesn't like the Mall; she doesn't like poor men getting rich." He later observed that monumental buildings were very out of fashion at the close of the 1960s—a cyclical phenomenon; and that hence Huxtable tore the design to pieces.[27]

As construction proceeded during the early 1970s, so did open war-

fare concerning the project, conducted mainly in the press by way of features, interviews, and letters to the editor. It did not help that Bunshaft's plan for an extensive sculpture garden would have bisected the Mall from north to south, serving as a kind of perpendicular appendage to the doughnut (fig. 53). The Fine Arts Commission drew the line at that point, perceiving the Mall's central corridor as sacred space. Bunshaft was forced to compromise so that the garden parallels the Mall directly in front of the museum. He had given critical landscape architects something to second-guess, along with government workers and citizens devoted to the status quo.[28]

Ongoing efforts persisted to get Hirshhorn's name off the building, and a Government Accounting Office inquiry was launched to determine whether there had been "various questionable policies and practices in Smithsonian financial management." The board of regents expressed its confidence in Ripley, who continued to placate Hirsh-

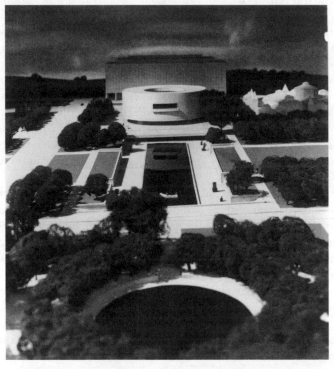

53. Design for the Hirshhorn Museum, Washington, D.C.
Division of Prints and Photographs, Library of Congress.

horn and plead for patience during years of harrowing attack. When the museum finally opened in October 1974, a year behind schedule, the art critics were very divided in their views, some quite positive about the collection and exhibition but others scornful. More often than not, however, they were mean-spirited.[29]

Having been so fiercely critical of the structure in 1970, Huxtable sounded surprisingly upbeat about the interior. "The generous galleries," she declared, "display painting and small sculpture well and work pleasantly for the visitor. There is no sense of being thrown off balance as at the Guggenheim." But Lawrence Alloway, the distinguished British critic, countered in *The Nation* that "one of the merits of the Guggenheim spiral is that it is finite. Visitors always know their location; you see clearly where you are, and how much farther you have to go." That obviously was not the case with the Hirshhorn.[30]

A writer for the *Washington Star-News* joined his colleague at the *Washington Post* in writing a judicious response to the broad range of reactions, pro and con.

> The Museum has taken eight years to get here. It may take another decade or so before we know precisely what we've been given. It is the powerful gestalt of the exterior . . . that has created enemies of the building. Nevertheless, there seem to be excellent reasons for both the shape and its concentrated mass. . . . The whole question of what the Hirshhorn will become is promisingly open-ended. How the question is answered depends on the wisdom and energy of the Museum's trustees and staff, and in part, I suppose, on us.[31]

Joseph Hirshhorn had given an estimated $50 million worth of art and $1 million in cash to help establish a national museum of modern art. He endured the heated congressional hearings, personal harassment, and a great deal of negative coverage by the press, especially from art and architecture critics. It required fifty-five trucks plus large helicopters to move the two thousand sculptures and more than three thousand paintings to the completed building. When the museum opened to the public in October 1974, the seventy-five-year-old collector arrived chirping: "Look at the lights! I'm getting excited. I'm getting delighted. I'm in love!" Surely that love involved an element of narcissism (fig. 54), but the general public voted with its feet. From the moment it opened, the newest national museum became a roaring suc-

54. Joseph Hirshhorn and the model
for his museum (late 1960s).
Division of Prints and Photographs, Library of Congress.

cess, at least if measured by attendance. Crowds poured in and within two years it pulled ahead of the Museum of Modern Art, logging 1.5 million visitors per year to become the fourth most popular art museum in America.[32]

As the novelty and curiosity factors gradually waned, so did visitation, which remains perfectly respectable but no longer so notable. The Hirshhorn does not seek to mount the kinds of special exhibits with blockbuster appeal that is one of MoMA's trademarks. It tends to be more avant-garde, with an emphatically international emphasis. But it no longer attracts sarcastic scorn because of its shape; its name and location are simply accepted; and few visitors have any idea that it stirred eight years of bitter controversy. As for the fear that the donor

would maintain some sort of dictatorial control, once the museum was finished he did not even serve as an initial trustee, though his longtime curator did serve as the first director, which clearly displeased most members of the art world even though Lerner knew the collection better than anyone else. Hirshhorn was finally elected to the board late in 1977 and died less than four years later at the age of eighty-two.[33]

It is worth pausing to note some similarities between initial reactions to the Lincoln Memorial and the Hirshhorn Museum. Both elicited strong protests concerning their proposed sites on the Mall. When designs for the two structures became public, they drew more negative responses and calls for revisions. And when each was completed, it received a very mixed response from architectural critics. Both remained controversial for a relatively brief period but then won more than mere acceptance. The Lincoln Memorial became iconic, and the Hirshhorn seemed to many a breath of fresh air, a deviation from all that horizontality lining the highly linear Mall.

Early in 1868, just days following a fire that destroyed P. T. Barnum's American Museum, the *New York Times* ran an editorial about exhibitions in the city. It began with a rhetorical question. "Why cannot we now have a great popular Museum in New York, without any 'humbug' about it?" The word *humbug* enjoyed popular usage in nineteenth-century America, but it had many nuanced meanings, ranging from phony to inauthentic to inappropriate.[34] Concerns about authenticity and appropriateness, such as what sorts of things genuinely belong in a great museum, have persisted with varying degrees of intensity. They became increasingly prevalent and problematic during the 1970s, and they provide a highly symptomatic aspect of the transformation of American museums during this period.

The National Museum of American History (NMAH), yet another component of the Smithsonian that stolidly anchors the Mall, has vast and diverse collections that range from musical instruments to various types of machinery. It's all very respectable stuff and fits well with traditional criteria for what belongs in a history museum that is pleasing to visit. Many of the objects even qualify as examples of "popular culture" if we take that phrase to mean, quite innocently, objects used over time by ordinary people. "Vernacular culture" might serve a bit better to convey the acceptability of what was displayed following a revision of the museum's identity and mission during the 1970s. The

special exhibition mounted in 1976 for the Bicentennial of Indepen-
dence, for example, "A Nation of Nations," highlighted America's her-
itage as a notable land of immigrants. In 1978 it installed and met the
fresh challenge of interpreting the humble, rural home of a black ten-
ant farmer's family.[35] Democratization was in the air.

But innovative curators also decided that *mass* culture had long
since begun to play a significant role in American history and therefore
should also be represented in the collections and display cases at their
museum. Acquisitions had already been made, ranging from pop music
albums to sporting goods that had been used by some of the nation's
most famous athletes. In 1978 the museum announced that it would
place on permanent display the easy chairs used by Edith and Archie
Bunker in the immensely popular television sitcom *All in the Family*
(1971–79). Large numbers of people protested, but for diverse reasons.
Some simply did not like that particular series because it included a
good deal of bigotry spewed forth by Archie and tolerated by Edith. As
one woman wrote, "*All in the Family* is an offensive, degenerative
show." Others, holding more traditional views of what belongs in a
museum purporting to be a serious cultural institution, felt scandalized
that furniture from a TV sitcom could possibly receive consideration
for inclusion, even though positioned within an exhibition concerning
ethnicity in America.[36]

This innovation received a considerable amount of media cover-
age from coast to coast, and the proliferation of opinions reached
remarkable proportions. S. Dillon Ripley, the Smithsonian's secretary
who was also a distinguished ornithologist and devotee of high cul-
ture, once again put his prestige and influence on the line, presiding
exuberantly at the opening of the Bunker display. A mix of famous
entertainers, including Hollywood stars like Bette Davis, participated
in the occasion and probably helped to lend some legitimacy to the
innovation, at least among those whose minds had not already been
made up. But as one principal curator has observed in a persuasive
essay:

> A particularly interesting aspect of these letters is that protests
> rarely came from people who visited the *All in the Family* exhibit
> in person, only from those responding to media coverage. Gen-
> erally complainants fell into three categories: those who looked
> down on television as trivial, considering it inappropriate for
> inclusion in a national shrine; those who did not like the *All in*

the Family series specifically; and those who were either puzzled or amused.

Let one typical response suffice: "This morning I learned via the radio news that Archie Bunker's chair was now ensconced in the Smithsonian Institution, near George Washington's effects. How silly can you get? No wonder you are always having to ask Congress for money . . . if the Smithsonian is going to be cluttered up with junk like this."[37]

Those who approved of the innovation were much less inclined to write letters (yet those who did are actually very amusing precisely *because* of their righteous indignation); but within a short time it became clear that one of the first things that visitors wanted to see upon entering this vast building were the Bunker chairs. Soon, of course, other items comparable in nature or category were placed on display: Charlie McCarthy, the dummy of ventriloquist Edgar Bergen (1978); Dorothy's ruby slippers from *The Wizard of Oz* (1979); "Black Baseball: Life in the Negro Leagues" (1981); a studio set from *M*A*S*H* (1983); "Hollywood: Legend and Reality" (1986); "*Sesame Street:* The First Twenty Years" (1989); and eventually Fonzie's jacket from the sitcom *Happy Days* (1974–84), to name just a few. Within a decade, as more and more mass culture icons were acquired and rotation became necessary in order to exhibit new pieces, bitter protests arose from people who had come fully expecting to see certain items they had heard about from friends or remembered from TV and recalled from press clippings indicating that they had been acquisitioned. The museum's situation went from damned if you do to damned if you don't.[38]

In 1985 the Smithsonian's new secretary, a distinguished archaeologist, sought to stem this inundation that seemed to be tainting the high-toned reputation of the entire institution. Writing an editorial in the *Smithsonian* magazine, he first offered a defensive response: "For all its popularity, the museum's TV trivia collection is small and selective and is being allowed to grow only slowly." He did acknowledge that the museum had an obligation to the diversity of its audiences, "including those for whom some tangible vestige of familiar TV imagery is clearly a pleasurable part of a trip to Washington." But he insisted that the media attention lavished upon such items was disproportionate to their numbers and importance. He concluded with an attempt to regain respectability by sounding gently judicious and high-minded.

So why is the whole matter still somewhat troubling? Most people, I believe, come to the Smithsonian and other museums as places to view treasured achievements that are tangible as well as enduring. But if the relics of TV are accepted as additions to the permanent collections of museums, with accompanying fanfare, is there not some danger that we will contribute to the ongoing erosion of vital standards of judgment and performance in the society at large?[39]

We encounter echoes of that concern from art critics right into the 1990s. But that particular secretary is now gone, and the popular culture collection has grown exponentially in the past twenty years. During the summer of 2004 Ellen Hughes, the same veteran curator from the Bunker brouhaha in 1978—now wearing the title of Cultural Historian for Sport, Leisure and Popular Culture—was boasting in *Sports Illustrated* about the acquisition of Abraham Lincoln's handball, physical fitness trainer Jack LaLanne's jumpsuit, Sonja Henie's figure skates, Carl Yastrzemski's batting helmet, and Superman's red trunks from the popular TV series. Mass culture has "made it" big to the nation's most eminent museum of Americana. Controversy over. Case closed.[40]

Flash-point incidents and serious issues would arise for other units of the Smithsonian during the 1990s, as we shall see shortly, but in between more than one would erupt at the neighboring National Gallery of Art (NGA). In 1974 Hilton Kramer devoted a major essay to the challenging transformation that art museums in general were undergoing at the time. Here is how he began.

Of all the institutions that currently preside over the conduct of our cultural affairs, none confronts more vexing problems than our major art museums. In little more than a generation—or what used to be counted a generation—the art museum has moved from something close to the margin of our cultural life to the very center. In the process, it has acquired responsibilities unknown to museums in former times. A vastly larger public of very mixed background presses a wide variety of claims on staffs and facilities originally intended to minister to smaller and more specialized interests. The museological arena is no longer neatly divided—as, to a large extent, it once was—between the casual

tourist and the entrenched connoisseur. Others less easily cate-
gorized by anything but their steadily increasing number now
look to the museum for pleasure, enlightenment, information,
and spiritual solace, and in responding to this appeal, the
museum has been obliged to modify a good deal more than its
budget or its physical premises. It has been obliged to redefine
the very basis of its existence.[41]

After reviewing recent developments, Kramer ended on a highly opti-
mistic note, concluding that a "new conception of service to the public
and a heightened commitment to intellectual excellence—are given
equal emphasis and importance in what amounts to a new institution."
The age of the blockbuster exhibition was just getting under way,
which meant achieving common ground comprehensible and pleasing
to many but also establishing at the elegant new East Wing designed
by I. M. Pei, a Center for Advanced Study in the Visual Arts that would
foster serious scholarship that might eventually be communicated in
somewhat diluted form to the expanded audience now attending
museums.

For more than a decade the NGA achieved that balance rather well.
Its visitation figures accelerated upward along with some extraordinary
accessions and stunning exhibitions that proved to be enormous crowd
pleasers, such as the "Treasures of Tutankhamen" (1976) and the very
different "Treasure Houses of Britain: Five Hundred Years of Private
Patronage and Art Collecting" (1985), for which "houses" should
really have read "mansions." In 1986, however, the NGA made a deci-
sion that stirred a huge pot of controversy centering on the same old
question: what is it appropriate for a major art museum to do, include,
and promote?

During the second week of August a revelation occurred that
seemed potentially scandalous for several reasons. The public learned
that the most popular American artist, Andrew Wyeth, had been
secretly painting a neighboring farmer's wife and mother of four chil-
dren at all seasons, clothed and unclothed, for fifteen years. Helga
Testorf was a handsome blond and full-bodied woman who had the
stolid patience to pose for Wyeth during very arduous sessions (often
lasting four hours). The result was a collection of some 247 works in
watercolor, tempera, and drawings—a stunning body of distinctive
pictures that clearly had been a clandestine labor of love for Wyeth and
perhaps for Helga Testorf as well. Whether the painter's wife knew

anything about this project seemed doubtful at first, but then became increasingly confusing. (She had always been his business manager.) What mattered more, in the long term, was that *Time* and *Newsweek* vied with each other to hype the story with bold cover stories and attendant speculation. After all, there wasn't much to spark media sales during the dull month of August, and the *Helga* pictures and the rumors behind their creation made great copy.[42]

What swiftly intensified speculation and a sense of scandal was the news that a publishing entrepreneur and amateur art collector named Leonard E. B. Andrews had bought not merely the entire collection for "many millions of dollars" but also their copyrights. That meant he would receive royalties from reproduction of the images in various forms, from posters to books, potentially even T-shirts. He planned to send the pictures on an international tour of museums starting at the National Gallery of Art in May of the following year. Had all the hype been some kind of double promotion, to benefit both Mr. Wyeth commercially and Mr. Andrews as well? Had the tantalizing hints of sexual infidelity along with all those voluptuous nude pictures been largely a tease in order to maximize publicity and hence readership of the sumptuous catalog produced for the exhibition—not to mention all the ancillary "stuff" that now appears in every museum shop on the occasion of a crowd-pleasing show?[43]

The catalog became the first art book ever chosen by the Book-of-the-Month Club as a main selection. Although the formal publication date was set for May 19, by the twenty-fourth it was already in its third printing. People who did not ordinarily buy exhibition catalogs couldn't wait to see it. The introductory text is not long, and it is restrained or tame, depending on your point of view. It provided no new revelations about Wyeth's relationship with Helga. The book contains 294 illustrations (ninety-six in color), and it sold for $40 in cloth. The paperback edition, available only at participating museums, cost $20. E. I. du Pont de Nemours & Co. sponsored the accompanying show and made a contribution of $250,000 to the National Gallery. A spokesman for the company explained that Du Pont had been founded in 1802 on the banks of the Brandywine River, not far from Wyeth's home at Chadds Ford, Pennsylvania, and it had bought its first Wyeth painting forty years earlier. By 1987 it owned seventeen pictures by N. C. Wyeth, his son Andrew, and Andrew's son Jamie. It was a most logical collaboration all around.[44]

Criticism rained down upon the National Gallery for multiple rea-

sons. Art critics and historians had not had anything positive to say about Wyeth's work for decades because he seemed too traditional and "sentimental," a narrative artist, a mere "illustrator"—though perhaps his most serious sin was being too well liked by the American public. Was it appropriate for the National Gallery to honor a living artist with an unprecedented one-man exhibition, especially one so doggedly devoted to a single subject? After all, this was not exactly a lifelong retrospective. As one major critic lamented, "The Helga Pictures are not what they seem. They involve meticulous observation, but they are not observant. They are obsessed with detail, but they are not curious. They preach pragmatism, self-reliance, and forthrightness, but they are anything but resolved and whole. What is more disturbing than the work is the amount of attention this hymn to provincial life has received and the degree to which the public continues to be captivated by its song."[45] That's a rather polite and subdued version of where most professional critics came out.

The National Gallery vigorously defended its decision, of course. "Along with Hopper, he's one of the two greatest American realists in the twentieth century," declared John Wilmerding, a distinguished art historian and deputy director of the NGA, who wrote the text for the catalog. "I think these paintings are among the most powerful images of the human figure in the history of 20th-century American painting." The influential director, J. Carter Brown, also weighed in: "It is an extraordinary opportunity to see a body of material that all relates to one subject and documents the creative process." And from the publisher of the catalog: "It's unusual in that it's such a complete picture of an evolutionary process. It's also very unusual to see a subject dealt with over a period of time like that, to see an evolution in technique—also the change in the subject herself." Helga had been thirty-nine when the series began in 1970.[46]

But how could all this publicity have been cooked up with such incredible speed? Just in case anyone didn't know, insiders informed the public that major exhibitions were planned years in advance, not months. (Actually, both the book and the exhibit were already being arranged well before public frenzy over the "secret" Helga series occurred in August.) And wasn't the whole scheme, from Andrews's purchase to the touring exhibition, mainly going to escalate the already-high prices for any piece of work by Wyeth? In short, wasn't the entire enterprise exactly that—a crass example of entrepreneurship involving collusion between the artist, the buyer, the Book-of-the-

Month Club, and the National Gallery? It soon transpired that a forty-minute, full-color videotape about the paintings and their genesis, narrated by Charlton Heston, would be available in museum retail shops for $39.95. (A laser videodisk cost $59.95.)⁴⁷

The sheer visibility achieved by Wyeth in 1986–87 was virtually unprecedented. On November 24, 1986, WNET-TV in New York broadcast on public television a one-hour feature devoted to *The Wyeths: A Family Portrait*, as a segment of *Smithsonian World*. In March 1986 an unrelated three-generation exhibition of works by N. C. Wyeth, Andrew, and Jamie, sponsored by A.T.&T., opened in the Soviet Union as part of a tour lasting almost two years that included Tokyo, Milan, Cambridge (England), Washington, Dallas, Chicago, and finally Chadds Ford. When this exhibition came to the Corcoran Gallery in Washington, it would actually coincide with the summer-long show at the National Gallery of Art, leaving the nation's capital completely awash in Wyeth's art.⁴⁸

Meanwhile, the national tour of the *Helga* pictures managed to be both impressive and prickly. From Washington it went to the Museum of Fine Arts in Boston and then to Houston, Los Angeles, and San Francisco, and it eventually terminated in Detroit early in 1989. But other possible venues had spurned invitations to participate in what looked like the greatest public relations campaign ever mounted on behalf of one body of work by an American artist. The director of the Kimbell Art Museum in Fort Worth explained that Wyeth was "not a good draftsman, and he's a sentimental artist. His paintings tell stories. They're anecdotal, not profound; backward-looking and not forward-looking." That judgment sounded both formulaic and gratuitous because the Kimbell, although a quality museum, did not even display American art.⁴⁹

The Metropolitan Museum of Art, which had mounted a Wyeth retrospective in 1976 to very mixed reviews, was notably disdainful. Philippe de Montebello, the Met's director, issued a statement on which he declined to elaborate: "We had an opportunity to show the Helga series. We quite pointedly and as a conscious decision declined to do so." Ever since the rise of the big blockbuster shows more than fifteen years earlier, the NGA and the Met had become exceedingly competitive. They did not often cooperate and frequently tried to trump each other. According to Michael Brenson, a widely respected critic, "what is particularly troubling is not so much that American museums are eager to jump on the bandwagon and take a show that

will keep their turnstiles pumping, but that there appears to be an abnegation of curatorial responsibility. The National Gallery is making the case for the work, but is not confronting the hard issues it raises."[50]

In October 1987, a month after the show left Washington for Boston, Leonard Andrews sought to refute the charges that commercial motives had driven all the ballyhoo. He insisted in an interview that financial gain had not been a factor. "I've turned down T-shirt requests, and balloons, and a plate-maker. The main reason I bought the Helga series was to show it to the American public, because if it went to a dealer, it would be sold and scattered around the world." He then explained that all the royalties from *Helga* would be used to pay for the National Arts Program, a project he initiated in 1985 to sponsor art fairs in major cities around the country. In 1987 these art fairs were held at fourteen venues and were open to the public without charge, the judging done by art professionals and offering art scholarships to the winners.[51]

The yearlong controversy gradually waned with Andrews emerging as a philanthropic benefactor of traditional art, and Wyeth's reputation just about where it was when the whole fracas first surfaced in August 1986. The National Gallery certainly had some egg on its face, at least in the view of professional critics, but no permanent harm had been done. It had produced a highly visible and popular summer blockbuster and quickly returned to business as usual, its reputation basically unsullied.

The next major controversies involving American museums arose in 1989–90, which turned out to be a profoundly pivotal moment in the intense politicization of art in the United States. Episodes that come to mind most promptly involve the large and luminous photograph by Andres Serrano called *Piss Christ*, the exhibition of photographs by Robert Mapplethorpe known as "The Perfect Moment" (which included homoerotic and so-called kiddie porn images), and the denial of NEA grants to performance artist Karen Finley and three others on grounds that they violated basic standards of public decency. All of these contretemps have been written about extensively and have already been mentioned; the case of the NEA Four will be discussed in the next chapter. The principal reason that they generated such heated controversy is because directly or indirectly each one had received

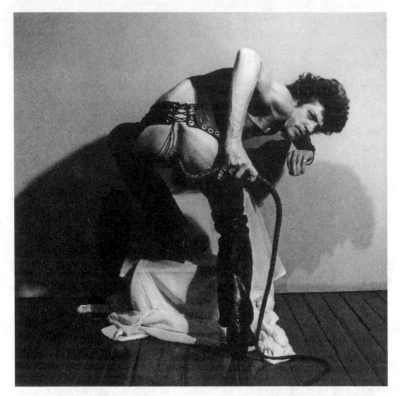

55. Robert Mapplethorpe, *Self-Portrait* (1978).
© The Robert Mapplethorpe Foundation. Courtesy Art + Commerce Anthology.

financial support from the NEA, meaning taxpayer dollars, and because their content was deemed either indecent or religiously offensive (fig. 55). Many members of Congress, prodded by outraged citizens and such organizations as the American Family Association, wanted the NEA to be punished if not abolished.[52]

Because these episodes are so familiar by now, and demonstrate the changing nature of the museum as a locus of controversy in rather tangential ways, discussion of them here can be cursory. In the case of Mapplethorpe's "Perfect Moment" (displayed between 1989 and 1991), what seems most noteworthy is that it was shown at institutions in Boston, Philadelphia, and elsewhere without provoking protest. When it was due to open at the Corcoran Gallery in Washington in 1990, however, the director decided to cancel the show rather than risk

congressional criticism. Christina Orr-Cahall miscalculated the equilibrium of her constituencies and aroused the wrath of a national coalition of activist artists who organized to project the images against the exterior walls of the Corcoran in a boldly spectacular light show at night. Another local museum then mounted the pictures instead (without incident), and the Corcoran director was obliged to resign for fecklessly self-censoring her own museum.[53]

Only in Cincinnati, a venue well known for its conservatism in artistic matters, was the director of the Contemporary Arts Center placed on trial for pandering obscenity, but he was acquitted late in 1990 by a jury that somehow felt persuaded by a parade of art experts that Mapplethorpe's work qualified as serious art even though some of its content could be offensive to viewers and inappropriate for nonadults. Needless to say, media attention lavished on these seemingly lurid matters only piqued the public's curiosity and attracted many more visitors than would have been the case without heavy-handed intervention by the authorities. And of course the fame and commercial value of work by Serrano and Mapplethorpe enjoyed a major boost.[54]

Notably, the convergence of art-related crises during the decade preceding 1989–90 brought explicit recognition that the time-honored concept of "quality" in art had become highly divisive. That concept remained meaningful and acceptable to formalists and traditionalists who felt contempt for so much overrated recent work that seemed mediocre and worthless. As one widely read editorial titled "Controversy vs. Quality" put the matter, "the problem isn't obscenity. The problem is mediocrity."[55]

For many others, however, invocations of "quality" in assessing art seemed politically incorrect or simply old-fashioned and snobbish because they tended to privilege form over content. As Michael Brenson viewed the matter in his influential essay, "the art that has generated the most debate about quality in recent months is partly defined by a tense, unstable relationship between content and form. In Robert Mapplethorpe's photographs of extreme sexual acts, and in Andres Serrano's photograph of a crucifix in a Plexiglas tank filled with urine, it is impossible to ignore or defuse content."[56]

Hence formalists like the critic Clement Greenberg and the painter Helen Frankenthaler (once his companion) felt no awkwardness about using the ever-more-elusive notion of "quality" as a legitimate measuring rod in making judgments (in the artist's case as an outspoken mem-

ber of the NEA council), while opponents insisted that content had *always* been more meaningful than form as the driving force in significant art. As Brenson observed, "From the Parthenon to Poussin to Manet to Mondrian, content, not form, has guided European art. The idea of the primacy of content over form is itself part of the European tradition." Placing these issues in the context of rapid social change, Brenson acknowledged that prejudice against new artistic media constituted part of the problem, and he asserted repeatedly that "some people in the art world claim that the word [quality] is simply a pretext for preserving the authority of the heterosexual white male."[57]

Brenson, a widely respected critic, concluded as always by trying to strike a judicious balance in this enduring but notably symptomatic debate. "We could do worse," he wrote, "than look at the history of Western art and listen to contemporary artists [i.e., perceive continuities and have it both ways]. Greek art learned from Egypt. Christian art was shaped not only by Greece but by the East. Modernism would not have flourished—would not even have been modernism—without a willingness to listen to the voices of African, Chinese, Egyptian and Mexican art. All over America you will find artists responding to almost every conceivable visual source and tradition. The number of sources and traditions is growing. Judgment [meaning quality and perhaps form] always matters, but this may be a time when curiosity [about innovative content *and* form] matters more."[58] This tension between the partisans of form and content persists, of course.

What seems especially germane to our focus here may be the changing role, reluctant acceptance, and gradually enhanced status of photography as a legitimate endeavor deserving serious attention in art museums. The process had been lengthy and slow, dating back to the later nineteenth century. As Susan Sontag noted, "The earliest controversies center on the question whether photography's fidelity to appearances and dependence on a machine did not prevent it from being a fine art—as distinct from a merely practical art, an arm of science, and a trade. . . . Against the charge that photography was a soulless, mechanical copying of reality, photographers asserted that it was a vanguard revolt against ordinary standards of seeing, no less worthy an art than painting."[59]

The Museum of Fine Arts (MFA) in Boston, one of the earliest major museums to collect photographs, began to do so in 1924 but

only when Alfred Stieglitz donated some of his work, followed by a gift from his widow, Georgia O'Keeffe, in 1950. The first actual *purchase* of a photograph by the MFA did not occur until 1967 (a series of works by Edward Weston). The Alfred Stieglitz collection at the Met got started in 1933. The National Gallery of Art began its photo collection with O'Keeffe's donation of work by Stieglitz in 1949, but the department of prints, drawings, and photographs did not actively undergo expansion into photographic images until the 1980s. The photography department at the Los Angeles County Museum of Art was founded only in 1984, and the Guggenheim Museum finally established a permanent photography collection in 1993.[60]

Understandably, the Museum of Modern Art took the new technology quite seriously, almost from the outset. It hosted the first major exhibition devoted to the history of photography in 1937, when Beaumont Newhall took over the entire museum and mobilized almost eight hundred examples. That show circulated throughout the United States, and Newhall would eventually be responsible for planning thirty photographic exhibitions. His successor as director of the photography department (1947–62), Edward Steichen, undertook the organization and supervision of more than forty-five shows, including the most famous of all, "The Family of Man" in 1955, which toured internationally. Although that acclaimed exhibition has subsequently been critiqued and become somewhat controversial as sentimentally simplistic, it may very well mark the beginning of broad-gauge "legitimacy" for photography as a widely accepted art form.[61]

By the mid- and late 1950s professional enthusiasts for photography were divided into two opposing camps: those committed to social realism, narrative clarity, and a documentary approach on the one hand (perceived as traditionalists), and those with a more aesthetic emphasis upon personal visions, multiple perspectives, and viewer response to ambiguity on the other (perceived as the avant-garde and best represented by the work of Swiss-born Robert Frank). MoMA's best-known curator of photography in modern times, John Szarkowski, would embrace both (reconciliation between them really being impossible) and lend much respectability to museum acquisitions and display with his many notable publications from the 1970s on through the 1990s.[62]

Photographic provocation was very much in the air at the close of the 1980s and involved many more instances than the well-remembered headline-grabbers. In 1991 New York's International

Center of Photography, in conjunction with the National Portrait Gallery in Washington (part of the Smithsonian), mounted the first museum exhibition of Annie Leibovitz's work from 1970 through 1990. Those who made their way to this relatively neglected museum were fairly self-selecting and appreciative, but the critics responded with much less enthusiasm. As one typical review explained, "Where other practitioners of the form such as Irving Penn and, to some extent, Richard Avedon managed to get behind the mask, Ms. Leibovitz has been content to leave it in place. More often than not, she has even helped her subjects adjust to it."[63]

As Leibovitz is a celebrity photographer, her work had been featured for two decades in *Vanity Fair* and *Rolling Stone* magazines and in an American Express "Portraits" advertising campaign. (Recall Whoopi Goldberg in a bathtub full of milk?) Her images were unabashedly promotional and commercial and had not previously been deemed worthy of a museum retrospective. Because of her ability to persuade subjects to try unusual poses in untraditional settings, however, her work ranged from startling to compelling. One of the most famous was her photo of the fully nude John Lennon folded up in a fetal position next to Yoko Ono, who chose not to remove her clothes despite Leibovitz's request. The result is undoubtedly more striking because of Ono's unwillingness to comply. (That image happens to have been taken just a few hours before Lennon was murdered.) It is difficult to imagine such images being presented in a mainstream museum a generation before and perhaps not even a decade earlier.[64]

Innovation and revisionism were very much in the air at that point—most often self-consciously but sometimes innocently, or at least with an admixture of political naïveté. In 1991 a major exhibition at the National Museum of American Art, yet another part of the Smithsonian Institution, sowed and reaped a political whirlwind by offering a sharply revisionist look at nineteenth-century landscapes, battles, genre scenes, photographs, and paintings of Native Americans in relation to westward expansion and its justifying rationale, Manifest Destiny. The exhibition was titled "The West as America: Reinterpreting Images of the Frontier, 1820–1920." The curatorial team, hard at work on serious research during the late 1980s, called interpretive attention to imperialism, racism, and genocide as engines and consequences of aggressive national growth. Explorers, conquistadores, military men,

and their trusty scouts were treated in the wall texts as rapacious and villainous figures, occasionally explained by curious neo-Freudian interpretations that compounded the offense of sounding more than a bit un-American here and there. From a leftist perspective the exhibit seemed valid and refreshing, especially because it borrowed heavily from the so-called New Western History pioneered by Yale's Howard Lamar (and his distinguished former Ph.D. students), who wrote in the exhibition catalog that the West had always been "a place to project wishes and dreams" and that in doing so, Americans "reveal themselves and their own ideologies."[65]

Because the show posed fundamental challenges to traditional, rarely questioned views of historically based nationalism, it came across as didactic (which it was) and unpatriotic (which it really was not meant to be). The intense controversy that it sparked can be followed at three levels, with the third being the most overtly—one might even say outrageously—political. Most critics did not like the show, finding it moralistic, oblivious to ambiguities inherent in many of the images, and excessively PC. ("Politically correct" became a common charge.) Reviews in the *New York Times*, *Washington Post*, and *New Republic* were fairly devastating. As Michael Kimmelman wrote in the *Times*, "The show preaches to visitors in wall texts laden with forced analyses and inflammatory observations." Charles Krauthammer may have been the most severe, condemning "a crude half-baked Marxist meanness" and suggesting that it could have appeared in Moscow, courtesy of the Soviets, at the height of the Cold War thirty years earlier![66]

The second level involved visitors to the show who inscribed their reactions in a book conveniently provided for comments. A preponderant majority were unfavorable, and some verged upon being overtly nasty. One of the longer entries concluded, "I didn't need to be told that these pictures were propaganda. Fooey! I'm happy with the myth. I cried like a baby at *Dances with Wolves*. I know the scholars and curators would have poo-poohed my red eyes. My great-grandfather was a sheriff in Kansas in 1874." Historian Simon Schama called it "a relentless sermon of condescension." An atypical entry in the comment book read: "Where are the 'Buffalo Soldiers'? Again blacks have been left out."[67] Was the show politically correct or a call for affirmative action?

The third and most problematic aspect involved heavy-handed politicians, who had a chilling effect. Daniel Boorstin, a distinguished and conservative historian who had served as librarian of Congress and before that as director of the National Museum of American History,

alerted members of Congress. Senators Ted Stevens of Alaska and
Slade Gorton of Washington, both Republicans, condemned the exhi-
bition without having seen it and threatened to slash the Smithsonian's
budget even though the $500,000 cost of the show had come from
endowed and private funds rather than federal appropriations. That
cut did not occur, but the consequences of congressional harassment
were significant: some of the wall texts were quickly muted, and the
national tour that would have taken the exhibit to St. Louis and Den-
ver was canceled, with those museums pleading a shortage of funds to
mount the show. The real reason was obvious. "The West as America"
was politically explosive. The episode left Smithsonian staff demoral-
ized and set a precedent for intimidation that would be well remem-
bered four years later when "The Last Act," an exhibition at the
National Air and Space Museum, devoted to the end of World War II
in the Pacific, touched off an even noisier brouhaha.[68]

The narrative of that nasty controversy has been rehearsed and
reckoned with by partisans from all sides and by scholars seeking to
understand the views of various stakeholders. Because the central
issue was not art but the appropriateness of a revisionist exhibition at
a patriotic moment, what primarily concerns us here is its impact on
the Smithsonian Institution in general and art museums more partic-
ularly. During the later 1980s the National Air and Space Museum
(NASM), a component of the Smithsonian and for a time the most
frequently visited museum in the world, began planning an exhibi-
tion to commemorate the end of World War II in the Pacific. That
meant telling the story of the *Enola Gay* dropping the first atomic
bomb, its social as well as political consequences, and Japan's surren-
der to General Douglas MacArthur. The rehabilitated bomber had to
be the centerpiece, inevitably, but curatorial attention would also be
devoted to the long-debated question of whether it was really neces-
sary to drop the bomb in order to prevent further loss of American
lives and to expedite the Japanese surrender. Sympathetic attention
would be paid to the amount of human suffering caused by the
unleashing of atomic power. Moreover, even if one bomb had been
necessary in order to demonstrate what might follow, did the United
States really need to detonate a second one? Wasn't that quite liter-
ally overkill?[69]

The curators working at the NASM who prepared multiple ver-
sions of the script for this 1995 show were also revisionist historians

who felt that sufficient evidence had emerged to indicate that the Japanese were so close to surrender during the summer of 1945 that dropping the world's most devastating weapon had not been necessary. Japan's capacity and will to fight was virtually exhausted. Various veterans' organizations felt otherwise, and they did a sufficiently skillful job through publications, the media, and political allies in Congress that the Smithsonian secretary felt compelled to curtail the exhibition as planned and present a highly sanitized, literally truncated, and blandly depoliticized show. Martin Harwit, the director of the NASM, was a distinguished astronomer and an army veteran who lacked the political savvy and clout to resist emasculation of his museum's exhibit. There is a consensus that the show as planned might have been viable at a different moment in time but not on the fiftieth anniversary of the end of World War II, the "good war" that had been fought by the "greatest generation" at considerable sacrifice of American lives. Sound history cannot compete with well-hyped patriotism.[70]

Michael Heyman, quite recently arrived from the University of California as newly appointed secretary of the Smithsonian, had much to lose and little to gain by defending his museum and its staff against political censorship. Academic freedom was not considered an issue because the Smithsonian is not a university even though it supports original research and scholarship. It is a public institution located in the nation's capital, subject to the political whims and wiles of Congress. Had Heyman held firm, his board of regents most likely would not have backed him. If he had not compromised the exhibition as planned, the budget for his entire "empire" would have received punitive cuts, and it would have jeopardized several other potentially controversial exhibitions that were nearly ready to open, such as "Science in American Life," long planned for the National Museum of American History with increasingly reluctant funding from the American Chemical Society. The humiliating outcome, at least for the museum world, was summarized by Harwit at the end of his book.

A Smithsonian secretary, barely four months in office, released a series of statements in which he concluded that the museum had made a basic error in attempting to couple a historical treatment of the use of atomic weapons with the 50th anniversary commemoration of the end of the war; that veterans and their families were not looking for analysis in this commemorative year;

that we needed to distinguish between opinion and fact; and
that we needed to contribute to light rather than heat.[71]

Aside from the wasted years of research and planning, the
inevitable capitulation to political forces too powerful to withstand,
and the negative wave of public opinion that were far stronger than
protests on behalf of the NASM emanating from academe, the most
serious damage to the Smithsonian as a system of museums, five of
which feature art, was a devastating loss of morale by the professional
staff. They became exceedingly cautious in the following years in plan-
ning *any* exhibition that might prove remotely controversial. They
heard rumors that conservative superpatriots in Congress sent anony-
mous staff members to inspect Smithsonian exhibitions, looking for
"un-American" displays or wall texts. For a while all exhibition scripts
had to be vetted and approved by "the Castle," meaning the central
administration. For a period of time following "The West as America"
and "The Last Act," the scholarly work (or responsibility) of interpre-
tation was virtually abandoned, and wall texts became basically
descriptive. By 1995 the Smithsonian had been politically sanitized
and, from the perspective of insiders who had labored long and hard as
highly professional public servants, emasculated.[72]

Somehow, by dint of finesse, in April 1998 a modest exhibit
appeared at the NMAH devoted to the history of American sweat-
shops, and more particularly one where workers were treated like pris-
oners and exploited. An actual sweatshop from El Monte, California,
along with much of its original context and equipment, had been
donated, and only very delicate negotiations managed to avoid a crisis
with the California Fashion Association, which made serious legal
threats against the Smithsonian. "We cannot stand idly by," its
spokesperson warned. "We want to turn this exhibit plan into another
Enola Gay." The curators avoided disaster by making sure that voices
from both sides, labor and management, were clearly heard. But in the
wake of museum turmoil in 1995–96, that kind of success would be the
exception rather than the rule.[73]

In May 2003 a photographic exhibit of the Arctic National Wildlife
Refuge finally opened at the American Museum of Natural History
following many months of controversy over whether it would call
excessive attention to environmental battles over oil drilling in the
region and consequent threats to the natural habitats of various

species. The caption for a buff-breasted sandpiper was supposed to describe the bird's migration patterns and the risks posed by habitat destruction. When the show opened, the caption merely identified the bird and gave its location.[74]

A photographer named Subhankar Banerjee from Calcutta had spent fourteen months in the far northeastern corner of Alaska taking the pictures that also appeared in a beautiful, large-format book in which Banerjee stated that oil development "would forever unravel the delicate pattern of nature found here." When Democratic senator Barbara Boxer praised (and displayed) the book in the Senate in a March 19 hearing on the Bush administration's plan to open that area for drilling, the controversy flared and Smithsonian authorities swiftly excised any "editorial" content from the captions, all the while protesting that they had not succumbed to political pressure. Senator Ted Stevens, already the bête noire of "The West as America" in 1991, offered to take senators to see what was being discussed. "It's frozen tundra," he barked. According to Secretary of the Interior Gale Norton, the area was barren and inhospitable. "Flat, white, nothingness," she declared.[75]

The exhibit had originally been scheduled for a prime spot near the museum's main hall and rotunda, but the photographs were ultimately relegated to a lower level space that is more of a hallway than a proper gallery. The photos were actually hard to find because they were obscured by an escalator. Robert Sullivan, the museum's associate director for public programs, had initially selected Banerjee's photos and explained that it had always been his intention to display them as "fine art." The captions that Banerjee proposed, taken largely from his book, seemed almost "sentimental," according to Sullivan. Hence the need for editorial control. "I wanted a really lean script and to let the pictures speak for themselves."[76]

As closure settled on the twentieth century in 1998–99, two quite different episodes highlighted (but also darkened) new and important issues that had been on the horizon for several seasons without quite causing a truly great stir. The first problematic question concerned commercialization and inappropriate influence through corporate sponsorship of exhibitions at art museums. The second involved unusually flamboyant museum directors and the startling lengths to

which they might go in order to escalate attendance. A third issue was not exactly unprecedented but was new enough in its latest manifestations to make a major splash in the media: what sorts of things properly belong in a serious museum of art?[77]

The year 1998 happened to mark the fiftieth anniversary of Honda motorcycles, the seventy-fifth anniversary of BMW motorcycles, and the ninety-fifth anniversary of Harley-Davidson. So fifty-four museums and private collections around the world contributed 114 machines for display on the pristine spiral ramp of the Guggenheim Museum, whose atrium was fully lined with stainless steel by architect Frank Gehry, who designed the spectacular installation (fig. 56). Following a summer run from late June through late September, the show would proceed to the Field Museum in Chicago and then to Gehry's flashy titanium-clad Guggenheim in Bilbao, Spain. Needless to say, the media loved it because this was "art" with outreach as well as the potential for swift conflict. More than one feature story asked the now-familiar question: "But is it art?"[78]

The bikes ranged from an 1868 French velocipede with a steam engine jammed in between the wheels to a 1998 Italian model, the very latest in fashion and power. It could exceed 170 miles per hour, whereas the French prototype might hope to reach 19. In between there were machines from half a dozen countries ranging from huge to sleek. Every famous model ever built and familiar to cognoscenti was represented. If anyone made too much of the coinciding anniversaries, director Thomas Krens could explain at press conferences and interviews that the idea had been in gestation for a decade. And if anyone made too much of BMW's sponsorship of the show—and critics did—Krens could point out that only six BMW models were included compared with ten Harleys and nine Hondas. Favoritism? No. Visibility? Lots.[79]

So how was such a radical departure from museum norms received? By the general public, exceedingly well. Krens, very much a showman in the mold of Thomas Hoving, wanted to break all records for attendance at the Guggenheim, and he more than succeeded. The show had remarkable appeal and drew huge crowds at a rate 45 percent higher than normal. "The Art of the Motorcycle" became the best attended show in the museum's history. The massive catalog with its gorgeous photographs ($85 for cloth and $45 for the paperback) became the biggest-selling catalog in the entire history of museum exhibitions. Large numbers of people came who had never before been to an art

museum, never mind to the Guggenheim, often wearing jeans, black T-shirts, and flashy tattoos. They loved Gehry's uncluttered display, with identification texts for the bikes on the floor adjacent but historical/contextual material set apart on the railing overlooking the atrium. People had come to gawk at the machines, not get lost in historical data.

And the critics? More often than not they gushed. Sometimes they

56. "The Art of the Motorcycle," Guggenheim Museum (1998).

needed to invoke Krens's notion that the motorcycle served as a metaphor for the twentieth century—although just how or why was never explicitly spelled out. Quite often the arts of design were invoked, the crucial point being that art museums had long been interested in design, so why not technological design? "Objects of industrial design" became a frequent phrase in reviews. Robert Hughes of *Time* magazine loved the show because he had once owned two bikes until he nearly died totaling a Kawasaki in southern California in a crash some years earlier. "I am reminded of a Japanese saying," he wrote, "about the poisonous fugu blowfish, which, when prepared under license, becomes a gastronomic delicacy: 'I want to eat fugu, but I want to live.' "[80]

Other prominent critics, such as Michael Kimmelman writing for the *New York Times* and Peter Plagens for *Newsweek*, were quite positive despite very different degrees of personal relationship to "hogs"; and the challenge of writing a review that managed to be both sympathetic and wry made for an unusual lilt in their writing. Here is Plagens, for example.

> Had Krens stuffed the Guggenheim with bad objects of consumer culture, the naysayers might have a case. But these motorcycles happen to be gorgeous. Just as aerodynamic airplanes are simple and streamlined, a motorcycle—which manages to balance an engine and a seat between two wheels—has a mechanical integrity, with intertwining pipes, chains and springs, that is fascinating to behold. At the Guggenheim, you're presented with a sequence of masterpiece bikes whose technological and esthetic developments remind you of, say, Brancusi's paring down his sculpture until he arrived at the purest form possible.[81]

Those critics who did *not* approve, however, expressed themselves with venom. Hilton Kramer was coldly dismissive: "As between the noisy, nasty nuisance of motorcycles on the road and the noxious designs of Frank Gehry, it would be hard to say which I find more unappealing." That came across as pure snobbery. Others, however, questioned whether Krens was just looking for outlandish novelties in order to attract greater publicity and crowds. He was ever ready with a defense against such charges. "We can't focus on Monet and minimalism too much," he replied. "We have to keep the intellectual vitality of

the institution sharp, and I think the bikes do that. They vary the rhythm of the museum and pique your curiosity about what the next show might be. This show isn't meant to be a thumb of the nose at art." He acknowledged the felt need for showmanship, but it served a cultural purpose, a point that quite a few critics echoed.[82]

Jed Perl, however, writing for *The New Republic*, offered the most hostile criticism. He accused Krens of simply seeking "media buzz" and added that "as a museum concept, 'The Art of the Motorcycle' is bottom feeding for the fashion-conscious. . . . Listening to Krens at the press preview—he arrived on a chopper, along with other bike aficionados who had come up from the midtown showroom of BMW, the exhibit's corporate sponsor—I knew that I was witnessing a dark day in the history of American museums. There has never been a more pathological display of institutional least-common denominator braggadocio. This is the last word in late-'90s gonzo hedonism." Just in case the reader hadn't been paying close attention, he later added that the museum "has been lobotomized. . . . There does come a time when the slippery slope gives way to the bottom of the barrel."[83]

Still others, such as regular *Times* critic Roberta Smith, would call the show "dazzling" but not "real art." The most serious and relentless objections, however, dealt with corporate sponsorship of their own product and the tacky array of objects being offered in the gift shop. According to *The Economist*, even the exhibition catalog "looks like a company annual report, as if to flag the double origin of good design in art and commerce." The sales shop offered, in addition to the lavish catalog, an array of motorcycle books, T-shirts, beach blankets, posters, postcards, a Ducati windbreaker, a child's red plastic BMW motorcycle ($120), a full set of bright red or yellow Ducati leather jumpsuits ($1,595), and *The Henna Body Art Kit: Everything You Need to Create Stunning Temporary Tattoos* ($29.95).[84]

The most strident charges of commercial sellout actually came late in the following year when the Guggenheim announced that its fall show in 2000 would pay homage to the Italian fashion designer Giorgio Armani with a major retrospective of his work. The museum planned to turn its rotunda over to his ballgowns and pantsuits and tuxedos, "providing a breathtaking backdrop for an opening soiree and adding even more luster, if such a thing is possible, to the fashion designer's name." What the museum did not acknowledge was that eight months earlier Armani had become a very sizable benefactor of the Guggenheim. The amount of the contribution was unknown, but

insiders suggested that it would eventually reach $15 million. When asked about the gift, museum officials explained that it was part of a "global partner sponsorship," gifts that can go to Guggenheim projects anywhere in the world, and denied that it was a quid pro quo for the Armani show.[85]

That incident reminded readers that the motorcycle exhibition had already intensified a growing debate about the ethics of museum fundraising and the increasing links between financial support and exhibitions. The Association of Art Museum Directors, which represents 170 museums in the United States, Canada, and Mexico, was just then beginning a review of its professional practice guidelines on finances, a process undertaken every ten years. This time, however, it took on new urgency: a recent show at the Brooklyn Museum of Art had just caused one of the most explosive and overtly political art museum controversies of the century because it provided so many different kinds of provocation.[86]

Called "Sensation: Young British Artists from the Saatchi Collection," this exhibition was made possible by money from several different sources that had a commercial stake in the artists whose work was being shown. They included Charles Saatchi, the biggest British advertising mogul and owner of the artworks; Christie's auction house; and dealers who represented some of the young artists. Critics argued that the exhibit would increase the value of the works shown, which meant that Saatchi, who runs his own gallery in London and is England's largest single buyer and seller of contemporary art, stood to profit financially. The Brooklyn Museum did not initially disclose Saatchi's contribution of $160,000 to the show, and that would later compromise its case. Christie's gave $50,000. Several others gave $25,000 each.[87]

Perhaps it is only fitting that the last major art museum controversy of the twentieth century became a kind of frenzied finale that incorporated many familiar issues as well as some newer ones, such as flagrant funding that certainly appeared to violate ethical norms. The fracas involved an aggressive new director (as of 1997) who needed not only to increase attendance but to complete a massive capital campaign that would give the aging structure a $120 million "face-lift," to which the city was supposed to make a major contribution. The issue would not have aroused animosities to anything like the degree it did if the media had not been determined to set it ablaze. It also might not have been politicized so intensively had Mayor Rudolph Giuliani not been con-

templating a campaign for the U.S. Senate against Hillary Rodham Clinton in 2000. Last but not least, the Brooklyn Museum received support amounting to $7.2 million each year from the City of New York, and its building is owned by the city. So yet another familiar issue arose: should offensive art be displayed at taxpayer expense, and can the city legally punish a willfully "disobedient" tenant? That in turn raised First Amendment issues involving freedom of expression. This episode had everything.[88]

The Royal Academy of Arts had organized the exhibition in conjunction with Saatchi, and it drew large crowds in the fall of 1997 when shown in London. Protests there mainly concentrated on a large image called *Myra* (1995), made up of many tiny handprints of children configured to depict the face of a notorious child-killer, Myra Hindley, one of the so-called Moor Murderers. Because that case was unknown in the United States, the picture caused no offense here. Following a visit to Berlin in 1998, the exhibition was scheduled to open at the Brooklyn Museum on October 2, 1999. Other novelties in this show included Damien Hirst's dead sharks and also pigs suspended in glass cases filled with formaldehyde solution; Jake and Dinos Chapman's mixed media "sculpture" of many naked girls with pig snouts and penises protruding from their faces; a version of the Last Supper by Sam Taylor-Wood with a topless woman standing in the place of Jesus; the bust of a man made entirely from his own frozen blood; an open cow's head on which freshly introduced maggots fed daily; and Jenny Savile's huge female nudes with vast virtuoso surfaces. All told, there were close to one hundred works by forty-two artists. Death, sexuality, and the body were frequent motifs. Did it resemble a freak show? It came close.[89]

Back in July officials from the museum who met with staff members at City Hall to review the exhibition actually warned them that there might be some controversy and even showed them slides of selected images, though not the one that caused the greatest stir of all. Chris Ofili's *The Holy Virgin Mary* (1996) is a colorfully garbed image of a black Madonna with shellacked elephant dung on her breasts and small cutouts from girlie magazines of women's genitalia—especially buttocks because baby butts are so prominent in Renaissance depictions of the Virgin and child, often accompanied by angelic cherubs. City Hall had a complete illustrated catalog of the entire assemblage as early as 1998. Officials just hadn't bothered to look at it attentively.

On September 16, two weeks prior to the opening, the New York *Daily News* ran a story with the headline

Brooklyn Gallery of Horror:
Gruesome Museum Show Stirs Controversy

It enumerated the offensive items and noted that Director Arnold Lehman was warning the public that the exhibit might cause nausea, vomiting, and other forms of personal discomfort—hype virtually certain to attract people eager to test their own tolerance for terrible and disgusting sights. Other media quickly picked up the exciting news—the *New York Post* kept referring to "leftist loonies" and ran a ceaseless sequence of dung-related jokes. Within five days Mayor Giuliani, without seeing the installation for himself, declared it "sick stuff" and threatened to close the museum and cancel its annual appropriation as well as its lease unless the offensive items were removed. One of the largest and finest art collections in the United States might very well become homeless in a matter of weeks. The museum's board voted unanimously to reject Giuliani's ultimatum and brought a federal court suit against the mayor and the city on grounds that its First Amendment rights had been squelched. The city's countersuit contended that the museum had violated its charter in various ways, including charging a special fee of $9.50 (above and beyond general admission) in order to see "Sensation."[90]

Despite the array of potentially offensive objects in this show, Giuliani and the press concentrated most of their fire on *The Holy Virgin Mary* as a blasphemous work offensive to Roman Catholics in particular. Cardinal John J. O'Connor of New York as well as several area archbishops joined the attack, so that a typical headline in the *Post* read:

O'Connor Joins the Holy War—
Says Mary Painting Is Anti-Catholic

The recently formed Catholic League led by William Donohue also mobilized and organized protests at the museum. Yet influential Catholic art critics took a more temperate view.[91]

Lehman pointed out that Ofili was an observant Catholic and that elephant dung had sacred uses in his native Nigeria. (The *Post* called that the "Holy Sh*t Defense.") Lehman even introduced a tactical per-

spective on cultural relativism. He had heard from a group of nuns associated with a nursing order in Malawi that they customarily used a poultice incorporating dung in order to treat women suffering from inflammation of their breasts after childbirth. The poultice reduced the swelling and allowed the women to breast-feed successfully.[92]

Lehman also had to contend with protests from People for the Ethical Treatment of Animals; his major allies were to be found in the liberal press and the ACLU but initially not in the art world. The directors of the Met and MoMA clearly took a very dim view of the exhibition and would not weigh in on behalf of freedom of expression (which might conceivably affect them on some future occasion) until they were called to testify as expert witnesses at the hearing in federal court. Public opinion polls, however, showed that New Yorkers supported the museum by a two-to-one margin over Giuliani. In September 1999, even before the exhibition had opened but while the press was filled with vivid descriptions of the objects and conflicting views, people were asked by the Controversial Arts Funding Survey: "Regardless of how you feel about the art exhibit itself . . . banning art in public places is something that violates Americans' right of free expression." Fifty-one percent strongly agreed, 22 percent mildly agreed, 9 percent mildly disagreed, 14 percent strongly disagreed, and 5 percent didn't know.[93]

On November 1 Judge Nina Gerson delivered a ruling that rebuked Mayor Giuliani and offered a ringing affirmation of First Amendment rights. "There is no federal constitutional issue more grave," she declared, "than the effort by government officials to censor works of expression and to threaten the vitality of a major cultural institution as punishment for failing to abide by governmental demands for orthodoxy." She then ordered the mayor to resume city subsidies to the museum and abandon his campaign to evict the museum from city land and fire its board of trustees. As Michael Kimmelman wrote in the *New York Times* two days later, "Even those museum officials (and there are plenty of them around the country) who privately disliked 'Sensation' and the way it was handled by the Brooklyn Museum couldn't help feeling that their own fates were on the line, too."[94]

Although Giuliani was wisely advised not to appeal, he proceeded to do so, this time putting the emphasis of his prosecutorial case on the financing of the exhibition rather than the sacrilegious art. Learning

that this approach had no more likelihood of success, he settled out of court at the end of the month, but because the museum had not actually won the case, it remained saddled with $1 million in legal fees. It had, however, won a major political victory and would soon gain considerable sympathy when a devout Roman Catholic named Dennis Heiner slipped behind the Plexiglas screen protecting Ofili's *Holy Virgin Mary* and squeezed tubes of white paint on it in an effort to "cleanse" the blasphemous work (fig. 57). The seventy-two-year-old man called his action "veiling" or "effacement," a gesture of protection and modesty for the Virgin. Following his arrest and release pending charges, he became a hero to the Catholic League and the conservative press, but he made the opposition to "Sensation" as a show appear to consist of unscrupulous vandals who took the law into their own hands. Although Heiner insisted that he had not told anyone of his plans, how did it happen that a photographer just happened to be present to record his moment of protest?[95]

The consequences and legacies of this complex episode are manifold. Lehman most certainly achieved the accelerated attendance that he had hoped for: daily crowds and a total visitation of around 190,000 by the closing on January 12, despite Lehman's requirement that anyone under the age of seventeen had to be accompanied by an adult. Although Giuliani had lost the legal battle, he emerged with at least the appearance of being less hostile to cultural institutions than he seemed prior to September. (His senatorial campaign still appeared to be viable early in 2000.) Even so, the battle and its cost in money, morale, and media frenzy had a very chilling effect on other museums, in New York and elsewhere. The Brooklyn Museum continued to receive fairly harsh criticism from sources one might have expected to be more sympathetic. *New York Times* roving columnist Frank Rich, for example, had actually wanted Giuliani to succeed. His reasons, if not his wish for the outcome, were widely shared.

> The Brooklyn Museum, for its part, is not anyone's ideal martyr to the mayor's wrath. "Sensation" was assembled by a private collector, the British advertising tycoon Charles Saatchi, and much of it is kitsch. The museum's own cynicism is evident in its vulgar marketing campaign (almost nostalgically reminiscent of those at the dawn of X-rated movies), its abdication of any curatorial input and even its camp audio tour narrated by David Bowie. . . . In an era of empty blockbuster repackagings of

57. Dennis Heiner putting white paint on *The Holy Virgin Mary*,
Brooklyn Museum of Art (1999).
P. J. Griffiths/Magnum Photos.

impressionists and a Guggenheim Museum homage to the sculptural finesse of Harley-Davidson motorcycles, the best to be said in the Brooklyn Museum's defense is that its craven embrace of showmanship is far from an anomaly.[96]

Ethical issues remained front and center because donors and those who made the show possible, once again as in the *Helga* episode, stood to gain financially from its notoriety as well as its visitation success. In 2000 the American Association of Museums opened a sustained re-assessment of funding practices and procedures, with new guidelines the following year for the display of work borrowed from private collections. Art historian and theorist W.J.T. Mitchell of the University of Chicago put it plainly: "One thing I liked about the show is that it burst open the relationship between art and commerce. . . . The role of big capital in the art world was made visible." Glenn Lowry, the director of MoMA, observed in an interview that the battle "did not help the cause of contemporary art; it did not help the cause of museums. Any time museums come under the kind of scrutiny that occurred in Brooklyn, it inevitably frays the public trust that museums enjoy. This has consequences for all museums."[97]

By the time Michael Kimmelman wrote the first of many opinion pieces pertaining to "Sensation," eleven days before the show even opened, his first words were, "So the culture wars continue unabated, tragedy long ago having turned to farce." After touching upon most of the nasty threats and counterthreats, he closed by suggesting, "Maybe we should all lighten up."[98] Well, except for the *New York Post* finding new and better ways to make puns with dung, that never happened. One might say that the situation got "seriouser and seriouser."

A lengthy essay that appeared early in 2000 in *Art in America* managed to reflect many of the tensions that had arisen during the preceding decade and anticipated unsettled times ahead. "The costs of the conflict could go far beyond the financial outlays," an astute observer indicated. "Just when the 'culture wars' seemed to be subsiding, contemporary art has once again been loudly excoriated as offensive, obscene and blasphemous. Both houses of Congress have passed nonbinding resolutions calling for an end to federal funding for the Brooklyn Museum, renewing broader threats of cuts for cutting-edge art."[99]

So intimidation and caution were very much in the air at the turn of the millennium. In November 1999 the new director of the Detroit

Institute of Arts postponed indefinitely an exhibit that had been two years in the planning because it included potentially offensive pieces, such as a vial of urine from Serrano's highly publicized *Piss Christ* and a work called *Bathtub Jesus* featuring a doll wearing a condom. Also cause for concern: a pile of human excrement and a brazil nut labeled with a racial epithet. The very first installation, called *Van Gogh's Ear*, actually contained specific references to previous art world controversies. The principal artist affected, Jef Bourgeau, exclaimed to the *Detroit News* that "the '90s is about shock." Hadn't the world heard?[100]

On March 17, 2002, an exhibition opened at the Jewish Museum in New York titled "Mirroring Evil: Nazi Imagery/Recent Art." It contained eighteen pieces by thirteen younger artists from eight countries, four of them Jewish. Virtually all had been born well after 1945, so that the Holocaust was a historical event they had read about rather than experienced. Holocaust survivors who attended or only read about the show were horrified, as were a great many Jews who had not been directly affected by the Holocaust, as were non-Jews as well. As one survivor put it: "I was there. I testify: Genocide is not art." Museum officials disingenuously explained that the exhibit was not about the Holocaust at all. "It is about the way some younger artists are commenting on today's society, using images taken from the Nazi era."[101]

The museum staff was wise enough, however, to provide a large warning sign preceding a special exit from the gallery for visitors who did not want to proceed or even have to retrace their steps. They would thereby be able to avoid a "Lego Concentration Camp Set" and an image called "It's the Real Thing," which is viewed on a computer screen and shows a portrait of the artist holding a can of Diet Coke superimposed onto a photograph of inmates at the Buchenwald concentration camp. Is that conceivably defensible, or nothing more than a juxtaposition in very poor taste? According to Norman Kleeblatt, curator of fine arts at the museum, a meaningful explanation is at hand if the viewer has sufficient context, because the artist lost relatives in the Holocaust. "That photograph of the liberation is part of his history. He wanted to see what it would be like to be in that space. He is collapsing historical distance." As one writer inquired, however: should a museum build a show that requires so much personal context and explanation?[102]

Kleeblatt observed that with the passage of time, increasing numbers of people glean their information about the Holocaust from pop-

ular culture. The younger generation, he argues, did not learn about the Holocaust in school or from their parents. Rather, they learned about it from films and cartoons. So these artists are "vigilant about popular culture and how we encounter imagery." They are interested in representations of reality and want to know, for example, why the Nazis in movies look so glamorous. When Michael Kimmelman interviewed the director of the museum, he got a different kind of response. According to Joan Rosenbaum, "This is art with a message, political art, so we're not talking about aesthetic issues, by and large. It's art that provokes discussion. We're reporting on this trend, we're interpreting the work."103

Almost every exhibit that was completed or canceled in the wake of "Sensation" made inevitable references to it. Were those responsible simply seeking to spike their attendance figures? Had the paramount lesson learned been that controversy accounts for cash if not converts at the turnstiles? As still another preopening feature story about "Mirroring Evil" observed, "warning signs have become an increasingly common solution in cases like this. Exhibitions with sexually explicit works routinely carry them, and even 'Sensation,' the Brooklyn Museum show with the Madonna, carried a large warning sign, though that seemed intended to pique curiosity more than anything." "Mirroring Evil," aimed at the Jewish Museum's clientele, certainly *needed* warning signs as well as contextualization. One of the "art objects" beyond the admonitory sign was called *Giftgas Giftset* by Tom Sachs. It featured colorful poison gas canisters with Tiffany, Chanel, and Prada logos. Welcome to the twenty-first century and postmodern art—not for the faint of heart.104

Between 2001 and 2003 the cluster of innovative and distinguished museums in Santa Fe, New Mexico, tiptoed around a variety of problematic works of art and exhibitions in order to avoid stirring up trouble in an area where ethnic and religious sensibilities are strong and can be readily politicized. For more than two years the state-run Museum of International Folk Art did its best to obscure—without totally concealing—Alma Lopez's image of the Virgin of Guadalupe posing in a retro, rose-covered bikini. Tom Wilson, who served as director during the community rift that occurred over that collage, has no doubt that he lost his job because he refused to remove the offending work of art. (He did close the entire exhibition a few months early.) Ever since 2001 the curatorial staff there has trod very warily, and sev-

eral works that they feared would spark controversy were excluded from exhibits.[105]

In 1991 a handsome new book appeared bearing the title *The Museum Transformed*. It provided an opportunistic springboard for the veteran critic Hilton Kramer to write an expansive essay. His opening description of the transformation of museums is so succinctly astute that it bears repetition. Where I part company with Kramer is in his assessment of the negative consequences of these changes. More on that in a moment. Here is how he begins.

> Of all the institutions of high culture that have undergone significant change in recent decades, none has been more radically transformed than the art museum. In every aspect of its function, its atmosphere, and its scale of operations, in the character and number of the events that it encompasses, in the nature and size of the public it attracts, and in the role it plays in codifying . . . our ideas about what art is, the museum has been so dramatically altered in our lifetime that in many important respects it can no longer be said to be the same institution we came to in our youth. And of all the changes that have overtaken the art museum in our time, the most crucial has been the elevation of change itself to the status of a dynamic principle.[106]

Kramer expressed a poignant feeling of loss for what the museum once was and represented: the place accorded to high art in our culture; a sense of hierarchy and the importance of distinctions in quality; a site of stability and continuity in a culture characterized by rapid change; the commercialization and consumerization of museums; the fact that so many nonart activities take place there, like eating and listening to concerts; and a loss of confidence on the part of museum professionals in art itself! He felt nostalgic because he convinced himself that museum-going is now entirely separated from a genuine interest in art for its own sake.[107]

Some of Kramer's particular concerns remain valid. Because of the trend toward highly creative, one might even say "flashy" new museum designs, architecture is now ever more likely to compete with the art and in some instances even overwhelm it. The Guggenheim museums

in New York and Bilbao come quickly to mind, as does the spectacular new Milwaukee Art Museum designed by Santiago Calatrava. Kramer worried about what he called "technocratic populism"; but without the new gadgetry that parallels all of the other gadgets in our lives, the museum might be a less informative place than it has become. Kramer's claim that museums have become dynamic rather than "stable" is indisputable, but I regard that as a positive rather than a negative. Attendance at American art museums has skyrocketed in recent decades, and it has done so at an even more rapid rate than in Europe. There are many plausible reasons why this has occurred.[108]

Museums have become more diverse, accessible, informative, and user friendly. If the new architecture has occasionally become more flamboyant than stolid, it is also exciting. (Yes, there have been endless debates among art critics about the relative value of irregular internal configurations as opposed to a neat series of rectangular rooms that lead the viewer inexorably from one period or style to the next.)[109] As for the dread of technocratic populism, acousti-guides are invariably educational and immensely informative. They are also optional and can be used selectively. We are not their captives. Are computer terminals in set-aside rooms a bother? No one is *obliged* to take advantage of the cyberspace links between specific objects or entire collections. And the browsing rooms with catalogs and ancillary materials are not only a place to rest weary legs but an opportunity to absorb and integrate what might otherwise become a large dose of information overload. If guided tours by museum staff or well-trained docents have increased, so has the educational outreach of art museums, which are now coming much closer to achieving those lofty democratic goals declared in the earliest charters back in the 1870s. Museums have become more interactive facilities than the passive sites they once were. Blockbuster exhibitions and controversies have certainly contributed, but there are many other reasons why museum attendance has soared in recent decades.[110]

Traditionalists like Kramer have argued that museums should really be all about an ineffable "aura" of aesthetic contemplation and, in addition, about the comforts of continuity and eternal verities in times of stress. During the days directly following the catastrophe on September 11, 2001, Michael Kimmelman spent time at the Met just to see who was there and why. On the day it reopened, September 13, 8,200 visitors showed up on a very busy day in the "real world" and with no major exhibition to see. Here are some of his conclusions fol-

lowing that experience of sharing art with others in the confines of a place dedicated to the blending of beauty with serenity.

> While everything in the world has changed, museums are about continuity. And about excellence, by the way. Now is a good time to remind ourselves why quality matters. . . . Looking at [art] doesn't make you a better person. Making it isn't a virtue, either. People aren't back in the Met and the Whitney because they need artists to tell them the difference between good and evil, and artists can't mitigate the inequities of society. Art that has tried to do so is mostly cheap and tedious as well as ineffectual, although all thinking artists, like all thinking people, are affected when the world changes, and their work changes in turn, consciously or otherwise. So good art is insignificant but indispensable.

And as one visitor from Seattle told him, "It's definitely about beauty."[111]

As though the planets seemed to be moving into an intermittent alignment, the University of Texas held a conference early in 1992 so that a diverse group from the arts could address the question: "What ever happened to beauty?" Many answers were offered, and Arthur Danto's prescient response only occurred to him after he had returned home. The heart of it provides helpful illumination on the concerns Hilton Kramer had expressed a year earlier. Danto is referring to the intense politicization of art ever since the 1960s.

> I don't think the opposition between aesthetics and politics, if there is one, quite accounts for beauty's predicament. What accounts for it instead is a kind of cultural convulsion we have been living through, in which beauty seems all at once irrelevant to the aims of art rather than antithetical to the aims of politics. It is a convulsion in what one might term the deep structure of cultural history, of which the bickering between conservatives and radicals is at best a surface manifestation.[112]

Once again, the issue here is not new so much as intensified. Marcel Duchamp and his followers had categorically rejected "beauty" as a consideration in art; and Huntington Hartford had asked in 1964, "In the busy world of contemporary art, what has happened to the old-

fashioned belief in the existence of beauty? To Pablo Picasso it is a word devoid of meaning."[113]

In one key respect, namely the quest for beauty by means of art and its repositories, what Kimmelman found in 2001 reaffirmed what Kramer was saying a decade earlier in 1991. But unusual and stressful times provide only one reason among many to explain why people visit museums and what they seek there when they go. Given the diversity of our population and our lives, there inevitably must be *many* reasons, including the very nature of art as it has changed so swiftly and starkly since the 1960s. Hence the compelling validity of a different observation made by Danto in 1991: "What we see today is an art which seeks a more immediate contact with people than the museum makes possible . . . and the museum in turn is striving to accommodate the immense pressures that are imposed upon it from within art and from outside art. So we are witnessing, as I see it, a triple transformation in the making of art, in the institutions of art, in the audience for art."[114]

There has been a phenomenal and quantifiable boom in Americans' interest in art since 1962. The population of the art world and its active participants expanded enormously during the 1970s and 1980s. Attendance at art museums rose from 22 million per year in 1962 to well over 100 million in 2000. More than half of all the art museums in the United States were founded after 1969.[115] Since then new and different assumptions about cultural institutions have developed alongside a much greater diversity in modes of spectatorship—swift and slow, informed and ill informed, mediated and unmediated—and in which items happen to be the objects of desire and admiration at any given time, or, of course, objects of disinterest and disgust. Those are some of the primary contextual conditions for controversy in the ever-changing realm of art.

Issues of Diversity
and Inclusion

In 1997 a group of congressmen began a quiet campaign to correct what they perceived as a long-standing injustice: there were too few images of women and members of minority groups displayed in the U.S. Capitol, one of the nation's most-visited buildings. Leading the charge was Senator Christopher J. Dodd of Connecticut, senior Democrat on the Senate Rules Committee, a position that gave him a seat on the Senate Commission on Art. Although there were more than eight hundred works in the Capitol's collection at that time, only twenty-one depicted African Americans, and women fared only slightly better with twenty-eight, including no fewer than three featuring Pocahontas.

Predictably, commentators exhibited no consensus over the desirability of bringing about change. Some said that this initiative was simply an overdue outcome of the feminist and civil rights agenda to rewrite history so that marginal people who had been excluded—such as Blanche Kelso Bruce, a black senator from Mississippi during the later nineteenth century—might now be represented. Others, like Roger Kimball, managing editor of *The New Criterion* magazine, denounced such actions because they "let political correctness triumph over accurate history. The truth of the matter is that with very few exceptions the people who framed the political documents that founded this country were white men. That's just historical fact."[1]

This difference of opinion is symptomatic of a significant issue and shift that has occurred in the art world, most notably since the mid-1970s: when and how are situations and people other than white males going to be remembered and presented for visual recognition? As the

validation of multiculturalism became increasingly pervasive, imperatives of diversity and inclusion required attention; and that often meant expressions of assertiveness if not protest, such as "Black is beautiful," "A woman's place is in the Senate," and "We're here and we're queer." In order to achieve recognition, artists have frequently found it necessary to become what is called "essentialist" by emphasizing or calling attention to what is indisputably different or distinctive about the subject in question: gender, color, ethnicity, and sometimes religion.

Not surprisingly, some of the most heated controversies have occurred *within* groups because of strongly felt differences over the most appropriate ways each segment might be represented and interpreted. Group members have had understandable shades of opinion concerning how one's "outsiderness" can most effectively be demonstrated: in blatantly didactic ways or in subtle or even satirical ways. The ardent feminist Judy Chicago explicitly depicted the actual process of birth in her multipart work *The Birth Project* (1982), whereas Jenny Holzer prefers to use challenging words rather than schematic images: "A man can't know what it's like to be a mother" (later 1970s) is actually one of her *least* enigmatic sayings.[2]

Quite often works of art have been very deliberately intended to be provocative and have succeeded. We have no lack of "disturbatory" art involving ethnicity, race, and gender. At other times, however, provocation has either been inadvertent or else very much in the eye of the beholder and an unintended surprise to the person giving offense. More often than not, the objective has been to raise consciousness rather than simply to shock—though it turns out that consciousness-raising can all too easily have alarming consequences. Most of these controversies, as it happens, have occurred during the past quarter of a century and consequently have involved art "off the easel" because so much of contemporary art has been either three-dimensional or else performance art.

We have already encountered examples of offensive sexuality or perceived indecency in the art of Lorado Taft, Gaston Lachaise, Sally Mann, and Robert Mapplethorpe. Curiously, many of the most familiar provocations of this sort have come from people raised as Roman Catholics, including Robert Mapplethorpe, Andres Serrano, Karen Finley, David Wojnarowicz, Robert Gober, and Chris Ofili, among others. As Eleanor Heartney, a Catholic writer herself, has asked: "Is there something about the Catholic perspective that pushes certain

artists toward the corporeal and the transgressive? And if so, does that fact cast a different light on the culture wars?" She notes the blending of sacred and profane in their work and the likelihood that it may appear as blasphemy or sacrilege to fundamentalist believers. Heartney has suggested that acknowledgment of "the religious roots of various controversial works of art might help us challenge the reductive tendencies of fundamentalist morality. By the same token, an awareness of the influence which religion has had on certain highly visible artists might explode the myth of the necessary hostility between religion and contemporary art."[3]

Certain instances of religious offense in art, long since lapsed from public memory, date back more than a century in the United States. In 1893 John Singer Sargent, one of the greatest American painters of his generation, signed a contract to create an elaborate and major mural sequence for the third-floor hallway of the newly constructed Boston Public Library in Copley Square. *Triumph of Religion* (which perhaps more accurately should have been called the triumph of Christianity), nearly completed between 1919 and 1924, stirred an extended controversy because of a strange interpretive imbalance and religious implication found in the central triptych.[4]

The major panel planned (but never finished) by Sargent, *Sermon on the Mount*, would have posed no problems; nor did one of its side panels simply titled *Church*. A fresh and forward-looking work, it contrasted sharply with its counterpart on the opposite side, however, titled *Synagogue*, which showed a decrepit and broken old woman. From the moment these pendants were unveiled in 1919, critics anticipated controversy, and it came swiftly. Leo M. Franklin, president of Reform Judaism's Central Conference of American Rabbis, concluded his lengthy assessment with a strong judgment: "this presentation of Judaism as a broken faith, as a faith without a future, is untrue to fact and on this ground, rather than in contempt for the mind that conceived it, I maintain that this picture must not find a place in a public institution devoted to the spread of knowledge and to the dissemination of truth. Anti-Semitism has found many a cruel weapon with which to fight its unholy battle, but surely the time has not come in America when even art may be prostituted to so base a purpose."[5]

A local petition drive to remove the *Synagogue* panel became an effort taken up by Jews all across the country. Refuting the historicity of Sargent's images, critics rejected the medieval belief that with the rise of Christianity, Judaism went into decline. Painter and sculptor

Rose Kohler produced a very large bas-relief medallion (forty-two inches in diameter) devoted to Sargent's subject but from an opposing point of view. As she explained, her treatment "is from the Jewish standpoint; the crown is firmly placed on the head of the allegorical central figure [a vigorous young woman], whose sceptre is unbroken and whose eyes look into the future as she holds aloft the Scroll of the Law [the Torah]." In 1922 the National Council of Jewish Women published a substantial essay by Kohler that she had presented numerous times as an illustrated lecture. She emphasized a humanistic universalism in Jewish scripture and tradition as a counterpoint to what seemed to many, including non-Jews, as a bigoted and degrading interpretation of the historical trajectory of Judaism.[6]

For four years bills were introduced into the legislature of the Commonwealth to have the painting removed, and in April 1924 the *Synagogue* bill finally passed, but with an interesting substitution. The word *religion* was replaced by *race and class*, so that the final phrasing read: "It is the sense of the general court that works of art which by their nature and character reflect upon any race or class within our commonwealth should not be placed in public buildings." Two months before the bill passed, an unidentified vandal splattered Sargent's *Synagogue* with ink, despite the presence of a guard. One had been stationed by the painting ever since 1919 because it generated so much "bitter feeling."[7]

Sargent professed utter bewilderment at all the fuss, but he had long loathed both public speaking and being questioned about controversial topics, and consequently he rejected all attempts at interviews. It is unclear how widely known was his immense admiration for Wagner's music and social views. It is clear, however, that the mural sequence was the overall artistic project by which Sargent most wished to be remembered. Nevertheless, he refused to paint the most important panel, the grand finale as it were, *Sermon on the Mount*, thereby leaving two segments of a seventeen-part mural program undone.[8]

The most plausible explanation is that like Frederick MacMonnies's monument to *Civic Virtue* in New York (1922), "broad changes in stylistic climate may have figured in Sargent's hesitation: the first concerns expectations regarding mural painting in the United States; the second concerns the course of modernism; and the third concerns the visual representation of Jesus." In a sense, the American mural movement simply outpaced Sargent. He had begun *Triumph* before any

clear consensus about suitable stylistic approaches for public murals had been reached; but he painted *Synagogue* and *Church* well after opinion had jelled. By 1906 or so, according to art historian Sally Promey, American patrons and publics "no longer wanted complex narrative schemes that required extensive guidebooks." So the two parallel panels he had completed struck many as overly intellectualized and abstruse. By contrast, his successful murals for Boston's Museum of Fine Arts were decorative rather than dependent upon an interpretive historical narrative.[9]

This kind of religious controversy would not become common and truly virulent until late in the twentieth century, and by then Hollywood films were far more likely to provide the source of offense than were painting or sculpture. Late in the summer of 1988, when Universal Pictures announced the release of Martin Scorsese's *Last Temptation of Christ*, based upon the 1951 novel by Nikos Kazantzakis, a storm of protest arose because the film depicted Jesus as a man who might have been susceptible to the foibles and pleasurable feelings of ordinary mortals, such as the desire for marriage and a family. Fundamentalists and others denounced Universal on grounds that the film was blasphemous. Anti-Semitism was sparked because Lew R. Wasserman, the chairman of MCA (Universal's parent company), was Jewish. Fierce attacks came from many people who had not even seen the movie, such as Franco Zeffirelli, the famous Italian director, who called the picture "truly horrible and completely deranged." In a typical radio statement the film was designated a product of "that Jewish cultural scum of Los Angeles which is always spoiling for a chance to attack the Christian world."[10]

Predictably, attendance at the movie became unusually avid precisely because of all the negative publicity. Some people who stood in the very long lines to get in were there just because they were Scorsese fans, having seen *Taxi Driver* and *Raging Bull*. Some said that the intense conflict had made them curious. Still others declared that they intended their presence in line to be a gesture of opposition to censorship. According to the editor of a Hollywood newsletter, "There is no doubt this film would have done modest business without the controversy," but "the controversy fired people up. I talked to people in line the first day who said, 'They told me I couldn't see it, so I came.'" Christian groups organized boycotts that achieved limited success, but the security problem became Universal's greatest nemesis. The film

could not play in any of the new ten-to-eighteen-screen multiplex the-aters because it would be too difficult to provide adequate security. For the most part it ran in upscale neighborhoods, which are easier to guard and where a long run might be possible.[11]

Adding an element of curious complexity to this saga, a number of influential Catholics defended the film, though in different ways. In July Archbishop Roger M. Mahoney of Los Angeles criticized what he termed the "anti-Semitic implications" in the attacks being made on the film by Protestant fundamentalists. The Reverend Andrew Gree-ley argued that if Christians truly understood their own tradition, they would not argue with Scorsese's presentation of Jesus as attracted to the prospect of marriage. "They will argue rather that such an attrac-tion is not a temptation at all." Anna Quindlen, an Irish Catholic and at the time a featured editorial writer for the *New York Times*, insisted that people who seek to suppress it "say that they object to the film's portrayal of Jesus' humanity. But what really frightens, I suspect, is our own humanity. Their credo is that, left to our own devices, we will always make wrong choices." After condemning those who proclaimed it a mortal sin to see the movie, Quindlen concluded in a judicious manner.

> I have seen "The Last Temptation of Christ." Some of it was unbearably moving, and a great deal of it did not correspond to the portrait of Jesus Christ I have built over the years from reading the Gospels and having discussions and making judg-ments. That's not what's important. What's important is that the movie made me think again about what I really think. And thinking about what you really think is the greatest part of our humanity.[12]

Meanwhile the film critics did not seem notably impressed, though that caused no deficit at the box office. Janet Maslin felt that the movie wandered from its central thread and that the lengthy main sec-tion failed to be emotionally compelling as various miracles were reenacted. "This part of the film, working as a kind of greatest hits sequence in which Jesus heals the sick, turns water to wine and raises a handsome young Lazarus from the grave, functions as pageantry with-out much passion. A lot of the film has this stilted, showy quality, since it's often more apt to announce its ideas than to illustrate them." Despite these lukewarm-to-negative reviews, *Last Temptation* broke

box-office records in Los Angeles and failed to do so in New York only because the 160-minute length of the movie limited it to four shows a day rather than the usual five. The chairman of one large chain reported that after studying audiences carefully for three days, "we're getting many, many people who never go to the movies," with ticket buyers ranging from eighteen to seventy.[13]

The responses of fundamentalists and evangelicals ranged from harsh fulminations by Pat Robertson and Donald Wildmon of the American Family Association to this letter to the editor of the *Times*: "As a member of a Bible-believing, evangelical church, I thought that to join the chorus of protest against Martin Scorsese's 'Last Tempta-tion of Christ' without seeing it would be an error. Having now seen it, I consider the hysterical outcry against it a great evangelical misunder-standing." Former president Jimmy Carter eventually weighed in once he had left office. "Although most of us were willing to honor First Amendment rights and let the fantasy be shown," he wrote, "the sacri-legious scenes were still distressing to me and many others who share my faith. There is little doubt that the movie producers and Scorsese, a professed Christian, anticipated adverse public relations and capital-ized on them."[14]

As so often happens, this film did far better at the box office than it would have without all the negative publicity. That pattern repeated itself early in 2004 when Mel Gibson's film *The Passion of the Christ*—regarded by most critics as the goriest movie they had ever seen, and condemned as anti-Semitic because of its explicit emphasis upon the Jews as Christ-killers—racked up record sales with group promotions by churches so that by midsummer many were buying the newly released DVD version in wholesale lots. A critic writing for *Newsweek* commented that Gibson's love of Jesus was clearly equaled by his fond-ness for "the cinematic depiction of flayed, severed, swollen, scarred flesh and rivulets of spilled blood, the crack of bashed bones and the groans of someone enduring the ultimate physical agony." An unusu-ally long review in the *New York Times* concluded that the film "never provides a clear sense of what all this bloodshed was for," and it singled out "inconclusiveness" as Gibson's most serious artistic failure. With the opening carefully timed to coincide with Ash Wednesday, many viewers on that day went directly to the movies from hearing Mass and with ashes still on their foreheads. Despite all of the negative public-ity—or perhaps precisely *because* of it—the film has broken movie attendance records.[15]

The advent of aggressively feminist art that deliberately uses the exposed body as a site for display began with much less fanfare or even controversy because during the 1960s and into the 1970s it could happen only in small venues for largely self-selecting audiences. Carolee Schneemann, trained as a painter, became one of the seminal figures in the development of performance and body art. *Eye Body: 36 Transformative Actions* (1963) and *Meat Joy* (1964), for example, would be landmarks in the history of works dedicated to sexual freedom informed by a knowledge of ancient rites for which the nude body is marked with pigments in ritualized ways and snakes are used as body "ornaments." In *Eye Body*, for example, Schneemann transformed her naked body "as an extension of the painting/constructions. I produced a photographic series with the body painted, covered with string that was greased, oiled, and dusted."[16]

These early ventures were unlikely to spark widespread public controversy because it took Schneemann eighteen years to find a dealer/gallery, and by 1993, even though she had achieved a certain degree of notoriety, no museum possessed any of her work. Looking back at the 1960s from the perspective of the 1990s, she lamented that she had been too far ahead of her time and was now being imitated yet also criticized by a younger generation that could not appreciate what she had gone through in order to pursue her vocation. "Young feminist artists and art historians are using my early work—which they never saw—to club me over the head and define it as essentialist and naive, as being less significant in comparison to a whole list of other women whose work they now want to put forward."[17]

Schneemann achieved her greatest "fame" (or notoriety) for a performance piece titled *Interior Scroll* (1975). It is particularly well known because of photographs taken of her at the crucial moment when, painted with lines of mud and standing totally naked, she gradually pulled a long, narrow, accordion-pleated scroll—inscribed with her own poem "I met a happy man"—from her vagina and then read the poem to the audience (fig. 58). The point of this act, apparently, was that the female body would be giving birth, in the most literal sense, to the fully created artwork. The idea of "interior knowledge" seemed to Schneemann "to have to do with the power and possession of naming—the movement from interior thought to external signification, and the reference to an uncoiling serpent, to actual information (like a

58. Carolee Schneemann, *Interior Scroll* (1975).
Photo by Anthony McCall. Courtesy of Carolee Schneemann.

ticker tape, torah in the ark, chalice, choir loft, plumb line, bell tower, the umbilicus and tongue)." Her work was about the body becoming the source of self-knowledge and truth.[18]

Schneemann has said on several occasions that she trusts her body, that she follows her body because it never leads her astray. When asked in 1993 whether this is "close to intuition," she responded by saying:

> It's physiology more than anything else. It is really paying atten-
> tion to how the sexual body is ecstatic and connects to the
> erotic, which is in itself something that is split and fragmented
> with two thousand years of Judeo-Christian prohibitions. I trust
> the body in terms of tactility, as a painter—painting comes out
> of the whole organism, it comes out of having to use the whole

arm, letting the whole body be the "eye," so it does not get strat-
ified or constrained or constricted.[19]

If that sounds somewhat mystical or even nonsensical, there can be
no doubt that Schneemann's philosophy of performance art had con-
siderable impact on the following generation of feminist performers,
women such as Karen Finley, who is best known for covering her nude
body with chocolate syrup while screaming at her audience about the
indecent abuses heaped upon women, minorities, and people infected
with the AIDS virus. Finley began performing early in the 1980s, but
her act achieved particular notoriety and controversy in 1990 when it
came to the attention of Senator Jesse Helms and others that she had
received grants from the National Endowment for the Arts in 1984,
1987, and 1989 for her feminist activities in the name of art. The cru-
cial difference between Schneemann and Finley, aside from the latter
receiving grants from the NEA, is that Finley articulates her political
activism in the most unambiguous terms. One reporter remarked that
her performances are "nearly always shocking and invariably—some
would say relentlessly—political." As she wrote in a letter published in
the *Washington Post* on May 19, 1990, "My work is against violence,
against rape and degradation of women, incest and homophobia.
When I smear chocolate on my body it is a symbol of women being
treated like dirt."[20]

Finley's performance art toured the country in 1990 and was fea-
tured at such venues as the Walker Art Center in Minneapolis and the
Serious Fun Festival at Lincoln Center in New York. Her act at that
time was called *We Keep Our Victims Ready*. When the conservative
columnists Rowland Evans and Robert Novak learned about it, they
called attention to Finley's "art" as a prime example of the kind of
thing that built deep resentment against the NEA and that by 1990 had
many politicians as well as citizens calling for its abolition. Shortly
after the Evans and Novak column appeared on May 11, the NEA
decided to defer approval of all performance grants, and in July it
reversed its confirmation of awards to Finley and three others, two
men and a woman, all equally political as well as sexually explicit in
their acts. That fall Finley began the most extensive tour of her career,
and the NEA Four, as they came to be known, filed a lawsuit against
the NEA for breach of promise and violation of their First Amend-
ment right to freedom of expression.[21]

The performances and legal battles of the NEA Four are significant

in the history of art controversies for several reasons. First, the division between their enthusiasts and their critics was not the usual one. Although Finley, for example, has many avid supporters in the "arts community," she also has had strident detractors on the left, like reviewers for the *Village Voice* newspaper and members of such political groups as Women Against Pornography and the Women's Caucus for Art. One writer for the *Voice* called her "a misplaced prima donna" whose national tour included stops in "white liberal intellectual temples of art." Conversely, the *Voice* theater critic praised Finley as "the cleanest artist in America" and called her anger "the justification of her art." Martha Wilson, founder and director of New York's Franklin Furnace, an avant-garde gallery-theater where Finley first performed in 1983 and where many similar artists have performed, explained that "the goals of performance art are not the same as for theater, which involves a suspension of belief. Karen uses both techniques in her works, and because she often takes on the persona of the victimizer— the rapist, the abusive father—people get confused. But I have seen Karen make whole rooms of people cry."[22]

A second reason why the case of the NEA Four is important and unusual in the history of American art controversies involves its sheer notoriety and the public visibility it gave to issues involving homosexuality in public entertainment. Finley was married to her male manager, but John Fleck, Holly Hughes, and Tim Miller are gay and made gay rights central to their acts. Fleck and Miller began as Los Angeles–area performing artists, while Finley and Hughes developed their careers in New York (although Finley was raised in a large Catholic family near Chicago). Because the U.S. Congress responded to the Evans and Novak column by enacting a decency clause in 1990 that required NEA applicants to be in compliance, the suit brought by the NEA Four challenged the law of the land. During the week of August 6, 1990, Garry Trudeau devoted his widely syndicated *Doonesbury* comic strip to a send-up of the self-censorship problem raised by the new NEA requirement (fig. 59).

A third reason for the significance of this episode is that it took eight years to work its way through multiple levels of the judicial system. In June 1992 a federal panel of judges ruled 2 to 1 on behalf of the NEA Four, declaring the decency clause for NEA grants unconstitutional because it was too vague and restricted artists' freedom of speech. The suit had also asked for $50,000 in damages to Finley, whose privacy rights had been violated by an alleged NEA leak to

Evans and Novak about her confidential application to the NEA. The NEA appealed this verdict, and four years later the Court of Appeals for the Ninth Circuit (California) upheld the lower court's decision. Whereupon the NEA appealed once again to the Supreme Court, and this time, on June 25, 1998, it got a reversal by an eight-to-one margin. Writing for the majority, Associate Justice Sandra Day O'Connor declared that the amending clause passed by Congress in 1990 "merely adds some imprecise considerations to an already subjective selection process. It does not, on its face, impermissibly infringe on First or Fifth Amendment rights."[23]

Associate Justice David Souter, the lone dissenter, wrote that "the decency and respect proviso mandates viewpoint-based decisions in

59. Garry Trudeau, *Doonesbury* cartoon, week of August 6, 1990.

the disbursement of Government subsidies, and the Government has wholly failed to explain why the statute should be afforded an exemption from the fundamental rule of the First Amendment that viewpoint discrimination in the exercise of public authority over expressive activity is unconstitutional. The Court's conclusions that the proviso is not viewpoint based, that it is not a regulation, and that the NEA may permissibly engage in viewpoint-based discrimination, are all patently mistaken."[24]

Nevertheless, an overwhelming majority of the justices interpreted the 1990 law as containing only "advisory language" that did not actually prohibit federal subsidies for indecent art. Moreover, the Court even suggested that if the law were invoked to impose "a penalty on disfavored viewpoints," it would violate the First Amendment. So the NEA Four lost their case against the 1990 law, but they had already been allowed to keep their grants; and the door was left open for discretionary awards by the NEA on the merits of individual applications. The 1990 law was deemed "advisory" but not an absolute litmus.[25]

Judy Chicago (born Judith Sylvia Cohen) is undoubtedly the most famous figure among feminist artists active since the 1970s. Her career actually began in Los Angeles during the 1960s where she encountered constant rebuffs from a male-dominated art world and changed her name from Judy Gerowitz in 1969. (She had been married for less than two years.) She could not get her work treated with respect, and that set her on an aggressive path not only to define a feminist mode of expression for herself but to explore the history of women and their mistreatment, starting with antiquity. During the mid-1970s she conceived an ambitious installation piece that not only would celebrate the historic roles of some 1,038 women in Western civilization but would also utilize many of the handicraft skills traditionally associated with women, such as needlework, ceramics, painting china, and figuratively speaking, even food. More than four hundred women and men, mostly volunteers, worked on fulfilling her project, which she called *The Dinner Party*—a feminist remembrance of the Passover seder. Recognizing that its complexity would require thousands of hours of handwork, she enlisted scores of assistants who shared her perspective and who generously volunteered their efforts on the project from 1976 until its completion in 1979. The finished work cost $200,000 and left the artist $20,000 in debt.[26]

It made its widely noticed debut in April at the San Francisco Museum of Modern Art, and as one prescient reporter wrote, *The Dinner Party* "will be wonderfully controversial on all counts: as art, as message, and for combining the two." The design is an equilateral triangle (one of the earliest symbols for the female of our species) that is forty-eight feet long on each side (fig. 60). It has thirty-nine place settings, thirteen per side, and each setting has an elaborately embroidered runner displaying the identity of a famous woman, ranging from antique mythology to recent literary and political history, and a ceramic plate whose design is in some way symbolically appropriate for the particular woman being honored. Most of the plates have painted on them, in suggestive but aesthetically stylized fashion, female genitalia as the icons for different women. (Chicago insists that the imagery is actually symbolic of liberation and resurrection.) Whereas Emily Dickinson's design is dainty and lacy (fig. 61), Margaret Sanger's is bright red (suggesting bloodiness?) because of her role as progenitor of the birth control movement and the eventual legalization of abortion (fig. 62). Georgia O'Keeffe, who was still alive at the time, is the thirty-ninth honoree at the table, and given her allusive paintings of flowers, it should come as no surprise that the decoration on her dinner plate is totally vulvar. (Judy Chicago's preferred word is *vulval*.)[27]

Each place setting has flatware and a chalice. The runners identifying individual guests are readily visible from the outside as well as the inside of the table, so that when seated all of the guests would have been able to identify one another. Within the triangular open space and placed on the floor, there are 999 ceramic tiles bearing the names of many other women whose contributions to society and the arts should be duly noted. Interviewed prior to the opening, Chicago explained that "the piece works on all kinds of levels. For example, the images on the plates are variously flat and three-dimensional to symbolize the rise and fall of women's freedom and possibility in history." Place settings often suggest the amount of freedom given to women over time—one reason for the seder motif: God had spared the firstborn among the Israelites. The runner for the English feminist Mary Wollstonecraft, which shows her death in childbirth, is done in stump work, a form of needlepoint popular during the nineteenth century. (Her child, Mary Shelley, survived.) Many techniques of needlework that had become virtually extinct were revived to lend variety as well as appropriateness to each place setting.[28]

The critical response was curiously mixed from the outset. One

60. Judy Chicago, *The Dinner Party* (1979).
Collection of the Brooklyn Museum of Art, gift of the
Elizabeth A. Sackler Foundation. © 2007 Judy Chicago/Artists Rights
Society (ARS), New York. Photo: © Donald Woodman.

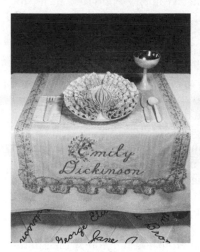

61. Judy Chicago, place setting for
Emily Dickinson (1979).

Collection of the Brooklyn Museum of Art,
gift of the Elizabeth A. Sackler Foundation.
© 2007 Judy Chicago/Artists Rights Society
(ARS), New York.
Photo: © Donald Woodman.

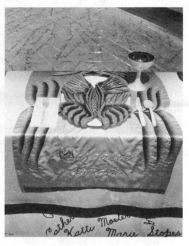

62. Judy Chicago, place setting for
Margaret Sanger (1979).

Collection of the Brooklyn Museum of Art,
gift of the Elizabeth A. Sackler Foundation.
© 2007 Judy Chicago/Artists Rights Society
(ARS), New York.
Photo: © Donald Woodman.

observer wrote that "the parts are greater than the whole," but another exclaimed that the visitor is "both dazzled and awed at its total grandeur." Still another admired much but concluded that "many of her plates don't work. In the flowers of O'Keeffe the vaginal imagery is muted. In Chicago's plates, it often seems forced. Chicago says she was after a certain rawness of look, but in art the raw must, in some way, be transfigured. With some exceptions, the plates don't bear sustained looking: you don't see more the more you look." To many, however, that critique seemed unjustified. Although the installation was scheduled to travel to museums in Seattle and Rochester after its showing in San Francisco, both venues canceled, giving lame excuses but clearly fearing negative public relations because *The Dinner Party* was so utterly unprecedented, but more particularly because of all the vaginal imagery. Quite a few feminists were also angry, resenting the work for being "essentialist" and rejecting the implication that somehow biology is destiny, which Chicago herself clearly does not believe.[29]

In retrospect, Seattle and Rochester seem to have been precipitous in expecting unedifying contestation. There surely would have been some, but *The Dinner Party* drew 100,000 visitors during its initial three-month display, and the crowds were intrigued and largely enthusiastic. The director of the National Women's Political Caucus, for which Chicago completed a limited edition serigraph in August 1979, declared that "museums are outraged by the female sexual imagery in her work. But the use of male sexual imagery in art has been constant through history and no one's offended." For the next two decades *The Dinner Party* was in and out of storage at considerable expense to the artist, languishing between trips to various art museums in the United States and Europe, where it always drew very substantial crowds and the usual mix of skeptics and enthusiasts.[30]

The latter increasingly outnumbered the former, however, and Chicago became a celebrity in feminist circles. Her 1979 book narrating the story of how the work came to be made sold reasonably well; the following year Anchor Press/Doubleday also published a book devoted entirely to the needlework, which also had reasonable sales, especially during Chicago's speaking tour and subsequent displays of *The Dinner Party*.[31] When she lectured in Washington at the Smithsonian in August 1980, the performance sold out and 150 people had to be turned away. She pulled no punches when interviewed by a reporter. When asked her opinion of the East Building recently added to the National Gallery, designed by I. M. Pei and lavishly praised by

critics, Chicago replied that "it's just another monument to the male ego and it's not a good place for art." Some critics have gradually come closer to the latter point of view and moved away from the initial wave of enthusiasm for the addition.[32]

In 1980 the Brooklyn Museum gave *The Dinner Party* an exhibition that provided an opportunity for East Coast residents to see the work. Then, when prospects looked bleak, independent groups of women across the country began raising money, and ten different cities staged *The Dinner Party* across North America (1981–83), drawing more than half a million visitors. Once again the responses were very mixed, but far more were positive than negative. Encouraged by that success, Chicago launched into *The Birth Project*, involving many different pieces of needlework and painting in several media designed to illustrate and illuminate what she regarded as one of the great neglected themes in Western art. Her hope this time was not for a single, unified installation like *The Dinner Party* but for clusters of work that would travel to different venues. The executive director of the Southeast Arkansas Arts and Sciences Center in Pine Bluff, Arkansas, for example, reported that the exhibit of five pieces there early in 1983 "was received very well. It did attract controversy, but we would have been disappointed if it hadn't. Some people said it is not a fit subject for a museum. We felt that it was, especially because of the quality of the work."[33]

When selections from *The Birth Project* were installed at UCLA in 1985, it received a savage review from Suzanne Muchnic in the *Los Angeles Times*, and the situation felt like 1979 all over again. She referred to *The Dinner Party* as "a feminist triumph and an aesthetic disaster that bludgeoned its way into the national consciousness with all the grace of a sledgehammer. Now Chicago has switched from gynecology to obstetrics, with a predictable lack of subtlety." Muchnic concluded that *The Birth Project* probably wouldn't create as big a fuss as its predecessor because it didn't involve as many people "and because the emotional fervor that once engulfed feminism's devotees and detractors has fizzled. The spectacle is over; what remains is hard work in every aspect of life that discounts women's contributions. It is doubtful that one artist's attempts to promote herself as a guru of birth will have much impact on that serious effort." Whew! Judy Chicago had a way of eliciting hyperbolic responses, pro and con.[34]

In 1990 Chicago experienced a heartbreaking false start in finding a permanent home for *The Dinner Party*. The University of the District

of Columbia (UDC) was prepared to accept it until the conservative *Washington Times* tipped off Congress, and some conservative members took turns on C-SPAN denouncing the work and the gift. That intensely negative publicity, in turn, mobilized some of the more radical black students at UDC, who challenged the logic of a grandiose work by a white artist largely about women in Western civilization being installed at a predominantly black university. The trustees were reminded that Alice Walker and others had complained that the place setting for abolitionist Sojourner Truth did not display genitalia, so they wondered whether Judy Chicago did not understand that black women have the same physiology as white women (fig. 63). Walker's words are sharp and memorable.

> The Sojourner Truth plate is the only one in the collection that shows—instead of a vagina—a face. In fact, *three* faces. One, weeping (a truly cliché tear), which "personifies" the black woman's "oppression," and another, screaming (a no less cliché scream), with little ugly pointed teeth, "her heroism," and a third, in gimcracky "African" design, smiling; as if the African woman, pre-American slavery, or even today, had no woes. There is of course a case to be made for being personified by a face rather than a vagina, but that is not what this show is about. It occurred to me that perhaps white women feminists, no less than white women generally, cannot imagine black women have vaginas. Or if they can, where imagination leads them is too far to go.[35]

The trustees canceled the invitation to house the project.[36]

In 1996 UCLA built an exhibition of feminist art around *The Dinner Party*, and the professor of art history who organized it declared that "the idea of high art being a separate reality from the popular, the social or the political never existed until modernism." In 2002 the saga finally achieved a satisfactory ending. Arnold Lehman had fully recovered from the "Sensation" debacle and remained eager to keep the Brooklyn Museum of Art highly visible and newsworthy. He was delighted to accept Elizabeth A. Sackler's gift of *The Dinner Party*, now valued at $2 million, and provide it with a permanent home. Sackler also endowed a center at the museum for the study of feminist art. She happened to own a few pieces of work by Judy Chicago but had never seen *The Dinner Party* in person—only through photographs. "This

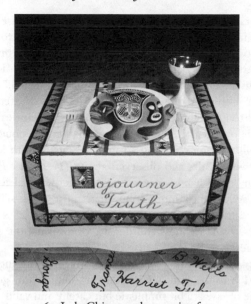

63. Judy Chicago, place setting for
Sojourner Truth (1979).
Collection of the Brooklyn Museum of Art,
gift of the Elizabeth A. Sackler Foundation.
© 2007 Judy Chicago/Artists Rights Society (ARS), New York.
Photo: © Donald Woodman.

represents a very important moment in time," Lehman declared grate-
fully, "and continues to tell an extraordinary story about women. It will
be the centerpiece around which we will be able to look at other social
issues."[37]

Talk about happy outcomes! *The Dinner Party* was displayed at the
Brooklyn Museum for five months beginning in September 2002, then
went into conservation; it is scheduled to reopen on permanent view in
2007. On October 11, 2002, a major retrospective of Judy Chicago's
work opened in Washington at the National Museum of Women in
the Arts. In addition to *The Birth Project* (1982–85), Chicago had fol-
lowed that ambitious undertaking with several others: one concerning
masculinity called *Powerplay* (1983–87), and another called *The Holo-
caust Project: From Darkness into Light* (1985–93), which includes
mural-sized mixed-media pieces on which she collaborated with her
photographer husband.[38]

All this high visibility prompted reassessments of the artist's entire

career. Overall she received consistently warmer praise than ever before, yet invariably many earlier moments of controversy were reprised, above all initial reactions to *The Dinner Party* from the art world. Robert Hughes had labeled it "agitprop," Hilton Kramer had called it "kitsch," and Kay Larson had found it "banal." When the work was reinstalled at the Brooklyn Museum in September 2002, however, the tough-minded Roberta Smith asked rhetorically whether it is "good art or bad art? So far, it's more than good enough, and getting better all the time." Taking an unusual tack, Smith looked back more than two decades and observed about *The Dinner Party* that it presented an "early hands-on example of international festivalism—feminist in style, much more solid than most. It is self-conscious spectacle, meant to impress a large audience with its scale, labor-intensiveness, visual richness and density of information. All festivalism should be so good."[39]

Contemplating the imminent retrospective in Washington, Smith called attention to the shift in Chicago's aesthetic from "geometric to organic" (the phrase is a bit simplistic but catchy and valid) and lauded "the force of personality that enabled something as extraordinary as *The Dinner Party* to be made in the first place. An upside is her generally strong sense of color, in all tones and hues, that provides the work's greatest unifying force."[40] Following years of barely being able to make ends meet, Judy Chicago is now comfortably ensconced at her studio in Belen, New Mexico (population 8,300); her nonprofit organization called Through the Flower advocates and sponsors an array of feminist educational projects; and her influence can be seen in the new wave of art by women that displays women's bodies quite seriously and sensuously—sometimes alone but more often in relationships with men and other women. Miriam Schapiro observed that Chicago had made her way through the "exclusionary imperatives of postwar art history," found her own vision with aggressively feminist work, and declared on the occasion of a collaborative exhibition in 1989 that "feminism taught me not to worry about what I was 'allowed' or 'not allowed' to do as a serious artist."[41]

More than twenty-five years later, Judy Chicago's visual projects do not seem as startling or provocative as they did in 1979. Arnold Lehman has remarked that several decades ago the word *vagina* was mainly used in clinical settings. Thanks to theater pieces like Eve Ensler's *Vagina Monologues*, that has changed, and Lehman anticipated appreciation rather than controversy associated with permanent instal-

lation of *The Dinner Party* at the Brooklyn Museum. "It's the definitive work of feminist art," he says. It may or may not be definitive, but it certainly is the best-known radical work of its generation.[42]

In 1989 the Pennsylvania Academy of the Fine Arts mounted an exhibition titled "Making Their Mark: Women Artists Move into the Mainstream, 1970–1985." Reviewing it, Arthur Danto found "a greater degree of diversity among women artists and at the same time an almost insistent feminist edge to women's art."[43] We are only just beginning to appreciate fully the impact of work by women on art more generally beginning in the later 1970s.

In 1985 a group of activist women calling themselves the Guerrilla Girls started showing up at museums and exhibitions that neglected women artists to protest their historic and ongoing exclusion. They wear gorilla masks for anonymity, often combined with unusual outfits and lace stockings. Calling themselves the "conscience of the art world," they perform street theater, create challenging posters, distribute leaflets, and disrupt events in order to protest sexism and racism. They have appeared and now perform by invitation at museums, theaters, and colleges across the country. They felt prompted to take action early in 1985 by the International Survey of Contemporary Painting and Sculpture, an enormous exhibition at MoMA in which women constituted less than ten percent of the 169 artists represented. Aiming to "make feminism fashionable again," the Guerrilla Girls initiated a hit-and-run poster campaign, keeping their identity and base of operations totally mysterious. Today there are more than twenty different groups called Guerrilla Girls on Tour. They have blanketed the country, especially college campuses, and done much to encourage women artists, especially aspiring younger ones.[44]

The Guerrilla Girls would have found it difficult, if not impossible, to perform when the next major issue involving aspects of feminism and art occurred, because it happened at the U.S. Capitol. In 1920 Alice Paul, the leader of the movement for women's suffrage, wished to commemorate the great constitutional victory that year and commissioned an American sculptor named Adelaide Johnson to create a statue honoring the prime movers of the women's rights movement: Elizabeth Cady Stanton, Susan B. Anthony, and Lucretia Mott. Johnson did so in classic marble, leaving an unfinished area on the block, where a fourth figure might well have gone, as a way of saying that the work of this movement was not yet finished and that there would be future heroines, as yet unknown (fig. 64). Titled *The Portrait Monu-*

64. Adelaide Johnson, *The Portrait Monument* (1921), later
known as *The Woman Monument*, U.S. Capitol,
Washington, D.C.
Division of Prints and Photographs, Library of Congress.

ment and weighing 14,500 pounds, it was formally presented to Congress by the National Women's Party on February 15, 1921.[45]

Most of the male-dominated Congress who bothered to look did not like *The Portrait Monument*, which has also been known as *The Woman Monument*. After being displayed in the Rotunda for two days, it was removed to a broom closet in the basement, but eventually in 1963 it was moved to the Capitol crypt (where George Washington would have been reburied in 1832 if the preventive lawsuit brought by his collateral descendants had gone the other way). In 1995, the seventy-fifth anniversary of the women's suffrage amendment, the Senate unanimously passed a resolution to move the work back up to

the Rotunda. All sorts of objections were raised, from many different perspectives. A two-year battle began. Some Republicans, led by Representative Sue Myrick of North Carolina, objected to spending the estimated $75,000 merely to move the seven-ton object. One suspects that fear of a revived push for the defunct Equal Rights Amendment may also have motivated the same opponents.[46]

Others disliked the sculpture for aesthetic reasons, calling the women's faces homely and objecting to the way they were positioned together from just below the bustline upward, looking like a trio of "biddies in a bathtub," which became a favorite and pejorative way of referring to the work. Still others, led by C. Delores Tucker, chairwoman of the National Political Caucus of Black Women, objected to the absence of a black female in the monument and insisted that no action be taken until Sojourner Truth was added to the group, either by being carved into the unfinished section of marble or else by authorizing an entirely new work. During Black History Month Tucker vowed that "never again will black women allow themselves to be written out of history." The conflicting views of pro-life and pro-choice groups complicated matters even more, and Newt Gingrich, newly powerful as Speaker of the House, seemed unsympathetic about relocating the ladies.[47]

Representative Louise M. Slaughter, a Democrat from Rochester, New York, who would have been Anthony's representative in Congress, had still another perspective shared by quite a few others. "As a work of art, that statue's never done much for me," she declared. "While we need something in the Rotunda, and while Sojourner Truth is also an important part of that fight, if I had my druthers, I'd see something else commissioned. . . . My bottom line is, these people deserve a better piece of work. . . . They all look dead. There is no sense at all of the energy, humor and everything else they gave." Senator John H. Chafee of Rhode Island feared that the statue of Roger Williams might be moved to an obscure location in order to make room in the Rotunda for *The Portrait Monument.* Baptists were very upset when they learned of this because they regard Williams as a founder of the first Baptist church in the United States and a prominent advocate of religious freedom as well. Chafee called the removal of Williams a "Capitol offense."[48]

Despite this two-year flurry of identity politics, in 1996 the House voted its approval of bringing the ladies up from the basement on condition that the $75,000 moving cost come from private sources rather

than taxpayer money and that Roger Williams be suitably relocated to make room. (By the time they got around to it, the cost had escalated to $80,000, but the funds had already been raised.) On May 12, 1997, the statue moved back to its original place of honor, and a month later it was rededicated, but with the understanding that it would be displayed for only one year. Well, once something is done in the Capitol, it is exceedingly difficult to undo it, and the statue remains in its honored place.[49]

When *The Portrait Monument* finally made it back to the Rotunda after seventy-five years of basement banishment, what did the public think? By and large they gave it a positive reception mingled with some puzzlement because of the work's unfinished appearance. Very few visitors could identify who the three ladies were without the help of an explanatory sign. Yet many *had* read enough about the controversy in the national media that they knew *what* it was and *why* it was there. A husband and wife from Indianapolis explained that they had "kept up with [the statue-moving debate] because of the fuss it caused. It seemed so ridiculous." A woman from California looked around the Rotunda and replied to a reporter: "There are a lot of men in here for just three women." When told that the statue was slated to leave the Rotunda a year later, another woman objected: "Well, I protest that. Why not have women up here on a full-time basis." But one from Nebraska remarked that the art simply did not look heroic enough. She felt that it "doesn't quite fit with the grandeur of the men. . . . They almost look tired and beaten. I would have preferred something with a little more presence."[50]

Did the new venue and overall satisfaction expressed by the public put an end to the squabble? Not exactly. First the Capitol staff underwent the kind of demoralizing censorship that the Smithsonian staff had experienced ever since 1991. In September 1997 all Capitol staff, and especially tour guides, received a memorandum instructing them not to discuss the two-year dispute. Even historical interpretation was discouraged. The lofty and inspirational sign must speak for itself.[51]

Early in 1999, Representative Marcy Kaptur of Ohio, the same person who had led the charge in 1987 for a World War II memorial on the Mall, complained about sexism on the walls of the Capitol's corridors. "It's been bothering me ever since I got here," she said. "The only hung portrait of a woman political leader is Sen. Hattie Caraway," the first woman elected to the Senate after being appointed to serve the unexpired term of her late husband. She represented Arkansas

from 1931 until 1945. The architect of the Capitol's office actually counted twelve portraits or statues of women among 451 works of art then on display. Many of the females who appeared in allegorical art at the Capitol were either ancient goddesses or mythological nymphs. Although Kaptur convinced forty-four House colleagues to sign a letter to Speaker Dennis Hastert about adding new works, she received no response.[52]

In 2001 the call for diversity expanded when the long-awaited House Resolution 169, "To Construct a Monument to Commemorate Minority Women," called for a statue honoring black and other women of color in the Rotunda. The proposal sought to improve American understanding of the "major sacrifice of women for the achievement of women's suffrage, but also of the enrichment of our history and our country by Native American, Latina, Asian-Pacific, Jewish and Black women." No action has been taken yet, but as we have seen in so many instances, in a democratic polity these initiatives move with the speed of a glacier rather than an avalanche. Resistance combined with sheer inertia make for an all-too-familiar story.[53]

African Americans had actually appeared in American art in various ways ever since the eighteenth century but most often in supporting roles as servants, maids, and soldiers, sometimes as fugitive slaves or field hands, and just occasionally in portraits of blacks who had been financially successful and enjoyed an unusual degree of social status. Very little of this art aroused controversy when it was created, though some has done so more recently, most notably the statues of grateful and obedient freedmen who appear to have been the beneficiaries of politically motivated largesse from Abraham Lincoln and other whites. The extent to which bondsmen played a meaningful role in their own liberation has been relatively neglected in art, and that has caused a stir, at least within academe and the African-American community (fig. 65).[54]

In 1990 a major exhibition opened at the Corcoran Gallery in Washington titled "Facing History: The Black Image in American Art, 1710–1940." Organized and curated by Guy McElroy, it included more than one hundred works of art created by seventy-seven artists; the fairly striking show subsequently traveled to the Brooklyn Museum of Art. In both venues it attracted an unusual number of visitors, drawn by the quality of the artists represented, by the presumed

cohesion of the ensemble, and by the publicity generated by McElroy's organizing "thesis," namely that blacks had long and too casually been represented in racist ways, even by northern artists assumed to have liberal views about racial issues, such as Eakins and Homer. McElroy, actually a doctoral candidate in the history of art at the University of Maryland, also wrote the catalog's introduction, which highlighted his emphasis upon racial stereotyping.[55]

Reviews were generally mixed. Some praised the show as a notable historical achievement while others found it disappointing or insufficiently comprehensive. The principal question that generated controversy among critics, and even the general public to some degree, was whether McElroy was judging the artists by the standards of their own time or by those of the later twentieth century. He first became interested in the topic in 1985, for example, by looking closely at William Sidney Mount's depiction of black entertainers, especially musicians, and blacks who appeared in lesser roles within genre scenes, especially

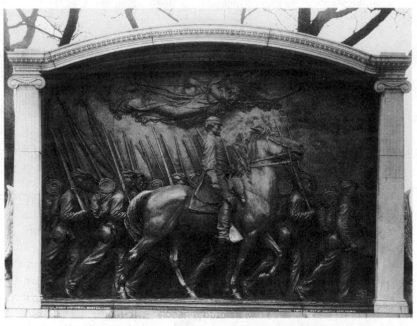

65. Augustus Saint-Gaudens and Charles F. McKim,
The Shaw Memorial (1897), Boston Common.
Division of Prints and Photographs, Library of Congress.

where music was being played. McElroy decided that even though Mount portrayed blacks in a natural and sympathetic manner, his images "didn't break from the idea of blacks as minstrels, servants, entertainers, members of the slave class." In sum, they became stereotyped visions of black identity and limited possibilities.[56]

Quite a few critics complained that the quality of the art included in "Facing History" was very uneven, and that the least accomplished art in qualitative terms was most likely to be racist whereas the best, by figures like Homer and Eakins, were most likely to be reaching for "a sense of shared humanity and common decency." Others followed the same emphasis, lamenting that those of low quality seem to have been included "primarily for their sociological interest," and adding that those artists who were most likely to present stereotyped blacks were equally likely to do the same for whites! McElroy made this response in an interview: "I take exception to the idea that all these images were negative. The negative images should not, of course, be ignored just because they are not pleasant to look at. These images were selected because they say something about how people were looking at African Americans at a certain time."[57]

Michael Kimmelman's review for the *New York Times* was gentler in its criticism yet more wide-ranging, especially in terms of what McElroy and contributors to the catalog had failed to address. Kimmelman also felt that too many minor artists were included, which seems somewhat unfair because the exhibition's explicit agenda was as much social/historical as it was aesthetic. McElroy never said "I will show you the best," only "I will show you a long-standing pattern." Kimmelman also felt that the show included few surprises while neglecting important patterns of patronage and provenance. The viewer needed to know more about the circumstances that led to the creation of any given work in order to make an informed judgment about the nature and degree of racism involved. Finally, Kimmelman lamented the absence of popular images that, in one way or another, had been sources of inspiration for so many paintings in the show. "Seeing in depth how painters and sculptors transformed the banalities of printmakers and cartoonists would arguably have been a more valuable contribution by Mr. McElroy than the overview of 230 years of artistic activity he provides."[58]

In addition to critics who felt that McElroy seemed determined to find racism virtually everywhere, even when the evidence was questionable, others voiced dissent because so few black artists were

included—only eight out of seventy-seven. There was no work by Henry Ossawa Tanner, for example, in part because Hampton University refused to lend one that it owned on grounds that it did not fit any of McElroy's five overdetermined categories for analysis. Michael Brenson, on the other hand, rather liked the show for its basically compensatory contribution. "Few [blacks] are perceived by artists as players in rather than pawns of history." He built upon McElroy's thesis by insisting that these images were so important precisely because "stereotyping is a form of control and power."[59]

Guy McElroy strongly believed, and declared more than once, that "all art is by nature a political statement." It seems apparent that he entered the process of selecting images and writing his catalog text with what might be called a selective filter that predetermined what his emphases would be. The fact that his exhibition did not become any more politicized than it did, however, is notable. It surely helped that it followed so swiftly on the heels of the Corcoran's decision to cancel Mapplethorpe's "Perfect Moment." The art community, especially in Washington, wanted to de-escalate the intensity of antagonism. The battle over NEA funding and Jesse Helms's "decency" amendment was heating up. And other race-related episodes had very recently occurred in the art world. McElroy's untimely death on May 31, just two months after his exhibit closed at the Corcoran, also meant that critics would be less disposed to attack it during its time at the Brooklyn Museum. Relative calm prevailed, and the catalog remains the best broad overview of race in American art. It has a self-evident point of view; but so do most engaging art exhibits.[60]

In May 1988 a student exhibition at the School of the Art Institute of Chicago included a satirical painting of the late Harold Washington, the first black mayor of that city. He happened to have been unmarried, and there had been occasional speculation about his sexual orientation. The painting by David Nelson, titled *Mirth & Girth*, rather crudely depicted Washington wearing women's lingerie, including a lacy garter belt holding up what looked more like ski socks than stockings. The image had not been preapproved by School authorities, and staff members quickly brought it to the attention of the administration. There were calls for its removal, and reporters accompanied by photographers descended the very next day to make the most of what would clearly have been a tense situation in any case. A group of black aldermen arrived, accompanied by three uniformed police officers, and tried unsuccessfully to remove the painting. They met in the

office of the School's president, bringing the painting, which by then had suffered a six-inch gash. After yet another meeting with higher-ranking police officers, the aldermen persuaded the police to "arrest" the painting and remove it from the (nonpublic) part of the building where it had been hung. The aldermen had no doubt that the work was so inflammatory that it could have incited a riot.[61]

This episode dominated the media and public discussion for weeks thereafter and commanded a good deal of national attention as well. In response to intense criticism and pressure, the School issued a public apology through Chicago newspapers and agreed to intensify its quest for more minority faculty members. The city council then dropped its threat to withhold public funds from the School or the Art Institute. The painting was returned to Nelson, who had managed to disappear during the height of the crisis, and the ACLU took on the case as a violation of his First, Fourth, and Fourteenth Amendment rights. When asked why he had created such an outrageous caricature, Nelson responded that in Chicago "it's almost like there's certain icons, like Washington is a deity and you can't touch him. It wasn't Washington I wanted to poke a hole in. It was the deity aspect." Four years later a judge ruled that the aldermen had violated Nelson's First Amendment rights and recommended very high punitive damages.[62]

In 1994–95 the Library of Congress in Washington worked closely with John Michael Vlach, a distinguished scholar in the field of African-American history, especially material culture and architecture, to prepare a photographic exhibition about slavery and plantation life titled "Back of the Big House: The Cultural Landscape of the Plantation." The exhibit drew upon Vlach's scholarly book of the same title, which was based upon twenty thousand pages of interviews that had been made with former slaves along with photos and drawings from the library's Historic American Buildings Survey. The show dealt with the cruelties of plantation life but also with the skills and crafts of those held in bondage. A high percentage of the staff members and employees at the library are black and took quick offense at the exhibit, whereupon it was taken down in its entirety the day after it appeared. Vlach and various black legislators and professionals in the art world generally were utterly astonished.[63]

Word of the angry dispute spread quickly, not only nationally but internationally as well: it was reported in London and Paris, and in papers in South Africa and Australia. The Martin Luther King Jr. Public Library in Washington, located little more than a mile from the

Library of Congress, swiftly offered to host the exhibition, so it was transferred and viewed there for much of 1996 without the slightest incident. What explains the apparent overreaction at the Library of Congress on both sides? Long-standing, unresolved tensions between staff and administration there had resulted in a 1982 class-action suit alleging that the library discriminated against its black and female employees. The suit had only recently been settled for $8 million, but two thousand employees had received no money because some of the issues were still pending on appeal. Too many of the images were also positioned in such a way that they literally confronted persons leaving an elevator with scenes of degradation. Many black staff members had apparently been accustomed for years to calling the library "the big house," as though they were field hands working on a plantation.[64]

One month prior to its self-censorship of "Back of the Big House," the library had been forced to postpone the opening of an ambitious interpretive exhibition based upon the life and work of Sigmund Freud. The reason was a bitter conflict that simmered between two rival schools of Freudians who might be called, for the sake of reductive simplicity, admiring disciples and skeptical revisionists. Although the library's official explanation for the postponement was a $352,000 shortfall in funding support, a variety of manifestos made it clear that twenty years of criticism hostile to Freudian theory had taken a very high toll. Although the advisory board for the exhibition consisted mainly of Freudian scholars and "believers," much anger emerged because the views of critics seemed to be largely ignored. The most fiercely determined critic declared that "the Freudians charge us with trying to pull a condom over their dildo of an exhibition." And as one historian of science observed at this initial stage of the conflict, the exhibition as scripted seemed to look at Freud through rose-colored glasses. A much revised and compromised show finally opened in October 1998.[65]

During the mid- and late 1970s administrative authorities at Colonial Williamsburg took steps to recognize publicly the historical reality of slavery in eighteenth-century life. They not only replaced the docents' euphemism "servant" with the actuality of "slave" but hired blacks to participate in educational programs, both within museum buildings and on the streets. In the 1990s that approach began to seem rather tame, so bolder efforts were initiated; several became controversial in

different ways and for varied reasons. When the authorities announced that in October 1994 a slave auction would be reenacted, many African Americans, ranging from the NAACP to black clergy and ordinary citizens, were angered and protested. Colonial Williamsburg chose to proceed with the auction anyway, and it attracted a great deal of media attention. Black leaders were invited to witness the forty-five-minute event, quite a few did, and they went away deeply moved by the experience. The result was a public relations "plus" for Colonial Williamsburg, though it did not plan to repeat the experience with any regularity. Perhaps the greatest benefit simply came from letting the public know that the organization had actually created an African-American department fully staffed by blacks to develop educational programs of this sort—historically accurate, carefully planned, and useful in sensitizing members of the public who had never learned about such experiences in their schools.[66]

In 1999 a new program at Colonial Williamsburg did not receive such negative publicity in advance, but neither did it unfold as positively as the auction. A gripping street drama unveiled in the spring was called "Enslaving Virginia." A major part of the program involved escaped slaves and white slave patrols in costume, portrayed by actors who were intensely earnest in their performances. At times the drama became so tense (and apparently authentic in feeling) that some audience members lost sight of the reenactment aspect and tried to physically attack the slave patrol actors. On one occasion a visitor spontaneously attempted to lead his own revolt against the slave handlers. "There are only three of them and a hundred of us!" he yelled. The actors had to step out of character to restrain him. Visitors now have an opportunity to learn about the religious lives of slaves in this "urban" environment, and black parents find it richly educational for their children. As one mother remarked: "I used to think, 'Why go to Williamsburg? There's nothing there about us.' Now there is, even if it's not something I'm happy about or comfortable with. These kids need to know about this side of history."[67]

Meanwhile not far away, sentiment developed to honor the African-American tennis great Arthur Ashe—who had died of AIDS in 1993 because of a botched blood transfusion—with a monument in his native Richmond. Because the population of the city of Richmond itself (excluding the suburbs) has a black majority, this proposition was irresistible—except that its advocates wanted the statue to be placed on Monument Avenue, the broad boulevard with an alignment of eques-

66. Paul Di Pasquale, *The Arthur Ashe Monument* (1996),
Richmond, Virginia.

trian generals elevated on high pedestals, starting with Robert E. Lee,
who had defended the Confederacy. The fight over where in Rich-
mond to place the monument to Ashe became deeply embittered and
prompted the strongest parti pris by the United Sons and Daughters of
the Confederacy to put it *anywhere* but Monument Avenue. Wiser
heads prevailed, a sculptor named Paul Di Pasquale was commissioned
in 1994, and after two acrimonious years the statue was dedicated on
Monument Avenue on Ashe's birthday in July 1996 (fig. 66). There
stands the elegant athlete, with one upraised arm holding a tennis

racket and the other holding books as a lesson in useful learning for the children facing him, also part of this poignant and highly effective memorial.[68]

On August 28, 2000, a fourteen-foot bronze statue of Ashe was unveiled at the Ashe Commemorative Garden at Forest Hills, New York, where the U.S. Open is played. Many in the crowd were perplexed and some visibly shaken because the rough-hewn statue created by Eric Fischl, though not intended as a likeness, was nude. The man holds only the grip of a tennis racket, the hitting end torn off to suggest a baton that could be passed from generation to generation. Whereas Ashe had a lean and lithe build, the statue is stocky and not well proportioned. The genitals are depicted "in an abstract form." According to the president of the U.S. Tennis Association (USTA), the work is "meant to represent all people from all races and backgrounds, Arthur's full range of impact."[69]

Reactions varied widely, but they were mostly negative. Some people requested that it be removed, others only that it be clothed. A Floridian responded, "People have to get with it. I like it. It's modern." The editorial board of *Black Tennis* magazine found it offensive. "This is tennis, not track," ran an editorial. "The next generation will ask, 'How did Ashe hit a tennis ball without a racquet, assuming he was allowed to play tennis in the nude?' This statue is a travesty. It is both degrading and disrespectful." Fischl explained that he meant to create work within the tradition of "heroic sculpture," and that he "wanted it to be uplifting, to give the figure a soaring and transcendent feeling. I believe it had to be nude to give these values a timeless quality."[70]

The essay in *Black Tennis* wondered: "What lawyer wrote that message for him?" Early in 2004, the issue still very much alive, the USTA's director of marketing and communications claimed that before the statue was unveiled in 2000, it was approved by Ashe's widow. It is unclear from the statement whether she had any choice because she may very well have been presented with a fait accompli.[71]

In the summer of 2002, following a decade of legislative setbacks, Congress finally passed legislation that will result in the first national museum devoted to the history and culture of African Americans. Its proponents, led by Representative John Lewis of Georgia, lobbied long and hard to have it located on the Mall; but space there being very

tight, an extended debate persisted until early 2006, when approval was achieved for a site near the Washington Monument. The bill also created a presidential commission to determine the cost of such a museum, as well as the effect that it might have on regional African-American museums. Similar legislation calling for the National Museum of the American Indian was signed into law swiftly in 1989. The building finally opened in September 2004 on the autumnal equinox. These two successful efforts, however slow their progress, have encouraged the Congressional Hispanic Caucus to strengthen its efforts to establish a Hispanic museum.[72]

Museum controversies arising from issues of ethnicity had not been common until late in the twentieth century, and when they did occur, they might involve grievances about exclusion, as we have seen, but also very strong differences of opinion *within* a group over matters of interpretation or, even more fundamentally, over who was going to exercise basic control over an exhibition: the selection of materials, the manner of presentation, and above all, perhaps, the basic narrative. That is exactly what happened during the mid-1990s when the Museum of the City of New York sought to mount a presentation of Irish-American history in New York. An archivist and doctoral student at New York University named Marion Casey undertook important initiatives, wrote successful grant applications, and did much of the preliminary planning under contract with the museum.[73]

There is intensely strong disagreement over how and why a falling out occurred, but at some point the talented Casey seems to have become rather possessive about "her" show; and when the museum sought to negotiate a new contract, it would not agree to her insistence that she should have final say over many matters involving display and interpretation. Casey contended that she merely asked to share the show's copyright, which had been a condition in the original contract. Robert R. Macdonald, the museum's director, felt that he and his staff should retain ultimate control over the exhibit and offered Casey a lesser role than that of guest curator. In May 1995 she was dismissed from the team preparing the show. (Macdonald claims that she quit.) Clearly there had been a clash of temperaments as well as a power struggle. But a great deal was at stake, making the dispute symptomatic of what can happen when an American subculture is divided over how best to interpret its heritage.[74]

Both Casey and Macdonald had staunch allies within the Irish-American community, which turns out to have been less than mono-

lithic. Casey and her ardent supporters insisted that the latest, revisionist scholarship was being neglected or insufficiently attended to by the museum staff, who knew about mounting exhibits but had little expertise in Irish-American history or the comparative perspective needed to understand the Irish-American experience in the light of other ethnic groups that had settled in New York. Casey insisted that traditional Irish-American historiography was time-bound to the nineteenth century. "My point was to break down the old impressions of the Irish as having only arrived during the Famine and living in the Five Points. Slums, Tammany Hall, political corruption, you can almost predict what they will have. What I wanted to do was move the history into the twentieth century."[75]

Others attacked Macdonald's fund-raising efforts as inadequate and an insult to one of the city's oldest ethnic minorities. They raised as much of a public relations fuss as they could muster through the media by arguing that the show would be characterized by stereotypes and caricatures that had been disproved by recent scholarly work. In January 1996 the dispute became so heated that an ad hoc coalition of Irish-American writers, labor organizers, and historians gathered at the Fitzpatrick Manhattan Hotel and voted to demand that the exhibition be canceled pending "some meaningful outreach" from the museum to the community.[76]

Macdonald responded that the exhibit, "Gaelic Gotham," would open on schedule on March 13, 1996 (which required considerable last-minute scrambling by his small staff), and he stated that the quality of the exhibit would speak for itself. "We will not be intimidated. No one can claim they own the history of the Irish in New York, and we'll stand by the scholarship of this show." Brendan Fay, an Irish-American educator and gay rights advocate who helped organize the community meetings, insisted that greater inclusiveness and input were imperative. "The telling of the story is very important and very sacred," he declared, "because often the storytellers, whether they're from Hollywood or Madison Avenue, their telling often collapses the richness and all the different shades of a people's lives into simplicity. We rarely get the chance to tell our own story and in such a public way. Maybe that's why it's so important."[77]

Although expectations had been very high for an exhibition due to open just before St. Patrick's Day, casualties of the conflict began taking a toll. Three academics who had been acting as consultants withdrew. Several Irish folklorists and musicians declined to appear.

Prominent Irish-American organizations reneged on their commit-
ment to lend artifacts and documents. Inevitably the defections over
this fracas got entangled with the six-year dispute created by homosex-
uals who wanted to participate in the traditional St. Patrick's Day
parade down Fifth Avenue but had been excluded. The Hibernians did
not welcome the gays and lesbians yet excoriated the museum for
spurning input from major stakeholders in the Irish-American com-
munity. Macdonald continued to insist that this exhibition was not
being mounted for the chauvinistic benefit of outspoken members of
that community. It needed to be balanced because it was intended for
all the citizens of New York. As he put it, " 'Gaelic Gotham' is not for
the Irish, but about the Irish. . . . Let the people judge."[78]

First, of course, the *critics* did so, and they were not especially kind.
Writing for the *New York Times*, Paul Goldberger acknowledged that
the presentation was chronologically comprehensive, with coverage
reaching to the very present. Although he found the show pleasant and
consistently engaging, "it never quite delivers on its promise. Chock
full of artifacts of every which kind, it feels as much like the hold of a
vast ship as a museum gallery," yet it was diminished nonetheless
because lenders had withdrawn promised objects and participants in
ancillary programs had also stepped aside. After rehashing the contro-
versy, Goldberger wondered why it had become so heated because
"the exhibition is broad-minded, and presents the Irish in a positive
but generally nonjudgmental way. . . . Most visitors will come away
from this exhibition seeing it more as a great Irish attic than as the pre-
sentation of a particular point of view, however. It is really a parade of
artifacts as much as anything else."[79]

Writing for the *Wall Street Journal*, John McGinnis emerged as a
complete Casey partisan and savaged the museum's "cavalier disregard
for the diversity and authority of academic scholarship." He found the
exhibit lacking in ambition and scope, with too much of it relegated
to the museum's basement hallways. He accused Macdonald of not
making available to the public the exhibition's script (which Gold-
berger felt certain would not have caused the kind of intense conflict
prompted by the *Enola Gay* script) and noted that Macdonald was
accusing his enemies of conducting a McCarthyite "disinformation
campaign." He concluded that New York's Irish population, and
indeed the entire city, were poorly served by the exhibition. Louis
Auchincloss, chairman of the board, responded along with the presi-

dent of the museum by calling this review unbalanced and inaccurate; he defended the breadth and depth of the show and noted that more than 480 paintings, prints, photographs, pieces of sculpture, and other objects and artifacts had been gathered from eighty-eight public and private collections. He also noted with pride that "it is a testament to the richness of the museum's own holdings that 65% of the materials are drawn from the museum's collections," which had been donated by New Yorkers during the preceding seventy-two years.[80]

Two months following the opening the city-based *Irish Times* weighed in by acknowledging that "there's no such thing as bad publicity" because attendance was up for the show, but it went on to excoriate it as a "timid, unimaginative, dull exhibition, thoroughly unworthy of its subject. . . . Domestic life is virtually invisible and despite some high falutin' social history lingo, Gaelic Gotham takes an essentially passive view of the people it portrays. . . . Such coherence as there is narrates the too familiar drama of assimilation versus identity. Some of the 'facts' trotted out to support the narrative are dubious." The bitter piece had been written by a committed partisan of the Casey cause.[81]

Curiously and somewhat unusually, for well over a year after the initial reviews appeared, the entire controversy continued to be rehashed in the press, most of all in the *Irish Times*. The rehashing was encouraged perhaps by the release in late May 1997 of a 177-page document called *The Gaelic Gotham Report*, drafted by critics who refused to let the dust settle and who revived all the charges and countercharges between the two sides. A lengthy assessment in July 1996 acknowledged that "the organisers were to a large extent in a 'no win' situation."[82]

As late as mid-August the *New York Times* received a detailed letter from Phoenix, Arizona, lamenting the omission of the Mahan family, "who contributed to the building and defense of America": most notably, Dennis Mahan had been the dean of faculty at West Point from 1838 until 1871 and his son, Alfred Thayer Mahan, became one of the country's most influential historians. This omission seemed strange and sad to the writer, "especially given all the space devoted to boxers, bars, politicians, churches and parades. It misses the immigrants like the Mahans looking out upon a new country, not just a city, that they would embrace and shape beyond their wildest dreams." The author closed with a cheap shot at those who would let gays and lesbians march in the St. Patrick's Day parade. All in all, this exhibition

elicited the most intense partisanship imaginable, and some of it was clearly due to the politicization of the parade, which started half a dozen years earlier—exactly when planning for the show itself had begun.[83]

Delayed reactions often occurred when sharp differences and contestation resulted from feelings rooted in religion and ethnicity. Most of the stridently adverse reactions to Serrano's *Piss Christ* were not registered until after its tour was completed. It had already been displayed in Los Angeles and Pittsburgh, then closed in Richmond on January 29, 1989, but much of the intense criticism emerged during the Easter season that year. George Segal's public sculpture *The Holocaust* (1982–83), created in two versions—one for the interior of a museum in Israel, which gained acceptance, but the other for the very beautiful setting of Lincoln Park in San Francisco—became controversial in the latter venue for a variety of reasons having to do with conflicting views over how best to represent such a catastrophe and whether it could be physically represented at all, especially by bleached figures of corpses prone on the ground and exposed to blazing sun and the elements. San Francisco discovered how many conflicted and contested assumptions there could be concerning "public memory" in relation to the tragic history of particular ethnic groups and political figures.[84]

The narrative of planning and developing the Holocaust Museum in Washington, now so widely regarded as a wholly successful installation, was fraught with fierce conflicts among competing stakeholders with divergent interests: Jewish Holocaust survivors (who usually won these battles because they seemed to occupy a kind of moral high ground), representatives of non-Jewish groups who had endured Nazi persecution—Armenians who had suffered genocide earlier in the century, gays, Gypsies—professional museum staff, and various advisers and consultants, usually Holocaust historians. In 1981 an intense struggle took place between Jews who felt that their Holocaust experience had been unique and the Polish-American Congress who believed there should be exhibition space for the story of Hitler's Polish Catholic victims. Then strong disagreement among Jews persisted over how a tour of the museum ought to end: Elie Wiesel, the most influential (and temperamental) spokesperson of all, objected to any sort of "triumphal, redemptive ending, arguing that the ending could

reflect both the continuation of life and the sober realization that the 'predicament of aftermath' would remain."[85]

The very first Days of Remembrance ceremony was held in the U.S. Capitol Rotunda on April 24, 1979, which ironically coincided with the occasion for commemorative ceremonies within the Armenian community, which soon lost its claim for inclusion in the museum. The years 1982–85 turned out to manifest the greatest amount of tension over questions of inclusion, and animosities would linger long after critics proclaimed the museum a remarkable achievement when it opened in 1993. Compromises were negotiated as non-Jewish victims were excluded from the museum but included in educational programs administered by it. Some advocates point to the high percentage of visitors who are not Jewish as a measure of the museum's success — 62 percent by the fall of 1993 — but ill feelings among stakeholders remain to this day, even though one reads or hears very little about them.[86]

The final decade of the twentieth century seems in retrospect to have produced a record number (and diversity) of museum-related controversies, large and small, local and national. In 1992 the Museum of Contemporary Art in Los Angeles used its warehouse annex, known as the "Temporary Contemporary," to mount a huge exhibition titled "Helter-Skelter: L.A. Art in the 1990s." Crammed with tasteless objects, more often than not vulgar, it managed to be offensive to just about everyone. It felt like the legacy of Edward Kienholz running amok, if that is conceivable. Michael Kimmelman commented that "it sometimes seems that for art to attract attention nowadays it must take place at one extreme or the other." He then added:

> The disappointment of the exhibition is less its attention-grabbing sensationalism than the pretense that this sensationalism amounts to something substantial and challenging. At a time when the art world, always desperate for the latest trend, can cling to no dominant movement, the show eagerly celebrates one in Los Angeles. Unfortunately, the movement turns out to be good old adolescent nihilism.[87]

Paul Richard called it an "exhibit with a difference. It's got Charley Manson and the Beatles humming in its title. It's got bare-butt bimbo bikers, copulating robots, comic strips and gall. It's a nightmare in

Nirvana. . . . Much newish New York art seems designed to baffle viewers. This exhibit isn't like that; it's right up in your face. It sticks it to the prudes, the developers, the pols . . . much in 'Helter Skelter' is fiercely impolite." One of his prime examples of impoliteness was Paul McCarthy's installation innocently titled *The Garden.*

> Its plastic bushes fool you and its trees are life size. Two dull-faced male mannequins, both plastic-skinned and motorized, with their pants around their ankles, are busy in the garden, methodically, mechanically doing, well, the dirty deed—one with the dark soil, the other with a tree. Sure, the rape of Mother Earth. Where but in L.A. would one bother to devote such ferocious ingenuity, and so many plastic leaves, to a political cartoon?[88]

During the fall of 1997 the Geffen Gallery at the Museum of Contemporary Art in Los Angeles provided the next major art controversy in that city, but this time the primary issue had a much clearer focus: a perceived offense to traditional Roman Catholics. Robert Gober, who was raised Catholic and is an openly gay artist, wanted to make a major statement about the terrible melancholy affecting the gay community because of devastation caused by AIDS. His ambiguous but startling installation featured the Virgin Mary with a five-foot-long bronze culvert pipe impaled directly through her middle. Eleanor Heartney, the liberal Catholic art critic, considered the work "a complex meditation on the realms of spirit, matter, life, death, and grace." Although art critics in general responded sympathetically, outraged citizens wrote angry letters to the *Los Angeles Times,* and the Catholic League for Religious and Civil Rights, based in New York, condemned the work and declared that anyone who identified with its message was, like the artist, a bigot.[89]

Offended correspondents called Gober's work a "twisted misrepresentation of art" and denounced him as one who "bastardizes artistic freedom to licentiousness and sacrilege." Another letter writer wished that the *Times* would feature some artist depicting Gober being burned at the stake for blasphemy.[90] Yet what seemed most striking about this episode was the critics' empathy. Gober had invited viewers to construct their own meanings from what they saw, and critics generally acknowledged that his ambiguous project was indeed open to multiple interpretations. Hence this sort of frequent emphasis upon a phallic

symbol placed within a womb: "she gave over her womb in order to bear Jesus for the world. This also meant she would ultimately be torn open as she witnessed the persecution and death of her son. Therefore, Mary is a figure very much pierced through and opened, gaining for the church a certain access to God."[91]

It certainly helped those inclined to find positive meaning in the work that it involved other sorts of contextual symbolism even more open to highly personal understanding. The piece is lit in order to produce cruciform shadows, thereby suggesting not merely crucifixion but also a mother losing her son. Behind the white figure of Mary water pours down a stairway into a depression in the floor, and the figure is also flanked by two open suitcases with grates built into the bottom of each. Beneath the grates there is a subterranean tidepool. Peering through the grates, the viewer can see rocks, sea life, coins, and the legs of a man and a baby.

So one serious reviewer concluded that "while the piece should be about Catholicism, it is not, precisely because of that layering of images." But then, returning to religious imagery, she declared that the work is actually about transformation and change. "About how we are transfigured by the journey that is life. About how the slow drip of water wears down everything in the end. About the mystery of the Eucharist." Clearly, this installation with enormous potential to shock and offend certainly did so, yet it also lent itself to redemptive interpretations as well.[92]

In marked contrast, the 1993 Biennial Exhibition of contemporary work hosted by the Whitney Museum of American Art hit rock bottom in terms of negative reactions from critics and much of the public. Neither complexity nor even ambiguity could be discerned. Why? Most reviewers accused the museum of carrying political correctness to excess and the artists of straining outlandishly for novelty. The eighty-two artists selected by a curatorial team represented the diversity of America unless, as one wag put it, "you happen to be a white male or a painter." The artists tended to be even younger than usual and heavily invested in such issues as race, class, gender, and sexuality. But as one disenchanted observer put it, "Too much of the work veers between bludgeoning with the agenda or being so abstruse that only art-world initiates can get it. There's a lot of sound and fury and elaborate installations, but in the end it seems more like a form of therapy than good political art, which above all, needs to persuade and communicate."[93]

Ordinarily judicious and fair, Michael Kimmelman declared flat out: "I hate the show. . . . I imagine that many have left the Biennial, as I have, feeling battered by condescension. The show implies that anyone who disagrees with what is on view is morally suspect." Critic Eric Gibson observed that the only PC group not represented were animal rights activists. How did the Whitney defend itself against this wave of rejection? According to curator Lisa Phillips, "At any one moment, there are certain concerns that artists share, and the Biennial has traditionally sought to identify them. Today everybody's talking about gender, identity, and power the way they talked about the grid in the late 1960s and early 1970s. The issues of context and presentation are paramount, and formal invention has taken a backseat to the interpretive function of art and the priorities of content." How persuasive was she? The *Christian Science Monitor* echoed Kimmelman with what clearly became the consensual judgment: "One emerges from the Biennial feeling battered, harangued, and badgered by voices usually considered out of the mainstream." In the art of the 1990s, the Biennial catalog claims, "The margins have become dominant."94

During the 1990s "outsider art," or work by imaginative and creative nonprofessionals, began to achieve recognition and even gallery exhibitions; but those were not the "margins" the catalog was referring to. Work displayed at the Whitney was simply too crude, personal, and angry. In the decade that followed the Whitney lightened up. It continued to present what might be called cutting-edge work by mostly younger artists, but with much less of a political agenda—partially in response to the abuse it received in 1993 but also because by 1995 the very existence of the NEA, and a major source of support for aspiring artists, seemed threatened. The art community could be stubborn, but it was not suicidal.

In the early years of the twenty-first century, some familiar artists who had initially stirred controversies two decades before once again became both provocative and determined in resisting censorship of work that was quite deliberately cause-based. In 2003, for example, several artists created conflict once more at New Mexico's Museum of Fine Arts in Santa Fe and had their work rejected but would not capitulate. The basic issue involved what might be socially acceptable in a forthcoming exhibit provisionally titled "So Que" (later changed to SoQ ["So What?"]), intended as a showcase for work by living artists in southern New Mexico and scheduled for early in 2004.

For several years painter Delmas Howe, a resident of Truth or

Consequences, New Mexico, had been addressing the spread of AIDS among gay men and especially the insensitivity of the Catholic Church to their plight. His paintings contain frontal male nudity and are staged within what Howe called a "gay S & M theater." He was notified by the independent curator of "So Que" that the museum had a new administration and its staff had become rather wary about showing work that might cause religious or sexual offense. His project called *Stations: A Gay Passion* was rejected but with the hope that he might submit something less provocative. Howe complied by adapting a work-in-progress, inspired by Jean Genet's novel *Miracle of the Rose*, that contained no male nudity or religious references and ended up with an acceptable semiautobiographical work about transformation and transcendence.[95]

Meanwhile Judy Chicago, by then the most acclaimed female artist living in the United States, proposed as her installation for "So Que" a project that she organized at the request of the Chinese government. She had invited women artists from across China to create work that responded to the challenging hypothetical "If Women Ruled the World" and to share their work at a gathering on Lugu Lake near the Tibetan border. That area was selected because it is home to an unusual matriarchal society. The art that Chicago offered to the New Mexico museum consisted of several tapestries, documentary photographs, and texts that emerged from her project in China. On one of the banners she proposed a small twelve-by-nineteen-inch panel with an outline of an ancient mother-goddess-type figure with the vulva exposed and the words *Would God Be Female?* written beneath it. A preliminary sketch of this panel had already been shown to curators at the museum. When they expressed objections and asked her to design a different panel, Chicago decided to withdraw from the show and seek other venues for her China project.[96]

Marsha Bol, director of the Museum of Fine Arts, acknowledged in an interview that political pressure not to offend museum visitors had become very strong, especially since the controversy involving Alma Lopez's *Virgin of Guadalupe* in 2001–02. But she also acknowledged that potentially explosive content had been a major concern, particularly the rhetorical question *Would God Be Female?* Her cautious response was representative of many museum directors during the early years of the twenty-first century, especially those who worked at public museums whose offerings are monitored and whose budgets are controlled by the legislature. Ever since the *Virgin* episode a sensitive

materials committee had become responsible for guarding against possibly controversial artwork. The group met quarterly, and any staff member could bring an issue before the committee at any time, from the planning stage of an exhibit to its opening.[97]

As Bol acknowledged, "What we most want is not to get blindsided." Judy Chicago's perception of this intense scrutiny and selection mechanism came through a telephone interview: She felt that the censorship was actually self-imposed by the museum. "A fear response. It's a frightening thought, because the art world has always been a place for alternative voices to be heard." Well, perhaps, but as Chicago knew as well as anyone, the art world has not *always* been such a place, nor with complete success. In May 2003 the principal curator at the museum was asked whether the public might see any "edgy" work in the "So Que" show. She answered: "I just want to have a nice show and not cause problems for the museum." When the director of the Albuquerque Museum of Art and History was asked for his view of what was happening, his politically timid response was symptomatic. It is easier for museums to assess community values and respond to them when the communities are homogeneous. But in a highly diversified community like Santa Fe, there is simply no consensus about what is "offensive." He ended by agreeing that censorship was not a good thing. Hence it is better to be highly preselective rather than be forced to remove something that is deemed offensive after it has been displayed. *Caution* had become the potent watchword.[98]

The self-protective diffidence displayed by these museum professionals might appear anomalous at first because recent polling data seemed to suggest that a majority of the American people supported freedom of expression. For example, late in September 1999 a poll conducted by the Center for Survey Research and Analysis asked 502 adults nationwide whether the Brooklyn Museum of Art should have the right to show "Sensation" ("which includes material some people have said is offensive"). The response configuration included 33 percent who strongly agreed, 24 percent who mildly agreed, 8 percent who mildly disagreed, 31 percent who strongly disagreed, and 5 percent who didn't know or refused to answer. That's a 57 percent majority in favor of freedom of expression in an art museum. The margin is not overwhelming but fairly impressive nonetheless.[99]

Phrasing, of course, can be a subtle and crucial determinant in these polls, so let's look at the very next question, which asked: "Regardless of how I feel about the art exhibit itself . . . banning art in public

places is something that violates Americans' right of free expression." This time 51 percent strongly agreed, 22 percent mildly agreed, 9 percent mildly disagreed, 14 percent strongly disagreed, and again 5 percent didn't know or would not answer. That's 73 percent opposed to censorship—even more impressive.[100]

Now let's check out two questions from the same 1999 poll that pertain directly to the kinds of groups we have examined in this chapter: women and those with strong religious views. We can assume that the respondents would have similar or possibly stronger reactions concerning offenses to ethnic and racial minorities. They were asked to respond to this assertion: "People should be allowed to display in a public place art that has content that might be offensive to religious groups." Only 15 percent strongly agreed, 24 percent mildly agreed, 15 percent mildly disagreed, 43 percent strongly disagreed, and 2 percent were agnostics.[101] So 58 percent would have been opposed, in theory, to displaying Chris Ofili's *Holy Virgin Mary*—except that we do not know that *all* Christians found it offensive, or might have. We only have Rudolph Giuliani's say-so.

Then the respondents were also offered this statement: "People should be allowed to display in a public place art that has content that might be offensive to women." To that 14 percent strongly agreed, 20 percent mildly agreed, 20 percent mildly disagreed, and 44 percent strongly disagreed, with 2 percent once again agnostic. The proportions are quite close to those concerning religion, differing only somewhat in the "mild" categories.[102]

Problems arise, of course, when we try to reconcile these reactions with majoritarian support for artists and museums enjoying freedom of expression. For example, the very same group was also presented with this statement: "Government should be able to cut funding to museums that display exhibits which are offensive to others." With that assertion, when the offensive exhibits or groups offended are not actually specified, 21 percent strongly agree, 15 percent mildly agree, 23 percent mildly disagree, 38 percent strongly disagree, and 4 percent didn't know or could not answer.[103]

So it would appear that a majority of the American public does not want to offend specific subgroups within the society; but we may infer, in the absence of data to the contrary, that art that might be offensive in a general way, such as vulgarity or indecency, but that is not directed at particular categories or "identity groups," should be not only considered for government support but protected from censorship

because freedom of expression is a prized American value. We are not entirely consistent, but at least there appears to be a pattern. Artwork may be offensive in general but not in particular: that seems to be where we came out at the close of the twentieth century.

One last piece of information is worth mentioning in order to be realistic about the actual audience we are discussing, because all the issues cited above were presented to a general sample rather than to an audience of dedicated museum-goers—or even *undedicated* museum-goers. The same poll also asked: "Have you visited an art museum within the past 12 months?" Thirty-one percent said yes, 68 percent said no, and 1 percent either didn't know or refused to answer.[104] Similarly, an exit poll taken at random among 860 visitors to "Sensation" at the Brooklyn Museum in the fall of 1999 revealed that more than half were making their very first visit to the museum. They had simply been drawn by curiosity and all the media hype. As we have also noted, the huge crowds that showed up at the Guggenheim in the summer of 1998 to see the motorcycle show included large numbers of people who had never before entered an art museum.[105]

So now we may add one more anomaly. As we shall see in the final chapter, attendance at art museums has reached an all-time high, and Americans strongly affirm the value of art education in their communities—not in order to proliferate more Wyeths, Warhols, and Wesselmanns but merely because they believe that interest in the arts is somehow a life-enhancing experience.

Comparisons and Closure

By the end of the millennium it had become clear that visitation at American art museums was scaling upward, even more markedly than in Europe and Australia. *The Art Newspaper*, a London-based international monthly, first reported that comparative trend in 1997. A year later it announced that "the keenest exhibition visitors" in 1998 were "the Americans by far." The single most popular show that year was "Monet in the 20th Century" at the Museum of Fine Arts in Boston, which counted 565,992 visitors during a three-month run, followed by "The Private Collection of Edgar Degas" (which included works by Ingres, Cézanne, Manet, and others) at the Met, drawing 528,267, followed by "Van Gogh's Van Goghs" at the National Gallery of Art, which drew the highest average number of daily visitors: 5,339 per day (versus 5,290 for Monet) and a cumulative total of 480,496. Overall, twenty-one exhibitions in the United States attracted more than 200,000 visitors each, including ones in Minneapolis, Brooklyn, St. Louis, and Philadelphia.[1]

In 1999 the figures rose even higher, perhaps because the media seemed so replete with stories about controversial shows like "Sensation" and "The Art of the Motorcycle"; yet the most magnetic attractions of 1998 were not contested shows, just big-name artists in displays that were extremely well publicized and positively reviewed. By comparison, only seven 1998 shows in Europe exceeded 200,000 viewers each. Aside from a special ongoing exhibition at Mount Athos in Greece, the top draws were a Gauguin show in Matigny, Switzerland (379,260) and a Magritte exhibition in Brussels (302,204). The editor of *The Art Newspaper*, Anna Somers Cocks, noted that the

numerical gap between American museum-goers and their counter-
parts in other countries seemed to be steadily widening. "The museum
plays an incredible role in American cities," she believes. "It's a focal
point, a place for entertainment, for shopping. I don't think any Euro-
pean museum has that same presence."[2] (Surely the Louvre and the
Pompidou Center in Paris should qualify, and reports indicate that
major museums in Madrid, Berlin, Florence, and elsewhere are
expanding in order to follow the commercialized American "model,"
intending to be ready for larger crowds by 2007 or 2008.)[3]

It is tricky to assess the role of curiosity about controversies in
explaining the increase in American museum attendance. Population
and demographics clearly matter, but the intensity of American mar-
keting may be even more important. As the British-born director of
the Museum of Fine Arts (MFA) in Boston put it, "American museums
are better at getting their message out." But advertising is only part of
the story. It has become standard practice for American museums to
arrange discount packages with hotels and to plan related musical and
other performing-arts events in connection with specially timed tick-
ets to ensure minimal waiting in line. The MFA even arranged for
three buses to be wrapped in a blow-up of Monet's *Waterlilies* (1907)
and offered free shuttle service from the downtown and Back Bay sec-
tions of the city to the museum. More than 100,000 people took
advantage of that service.[4] It also matters that art museums have made
themselves less passive and offer more interactive experiences.

As we noted at the outset, controversial art is a familiar story in
Europe, almost as old as the first public museums themselves during
the early nineteenth century. Conflicts in Europe have unquestionably
piqued curiosity and enhanced attendance in recent years, but we need
to look in greater depth and more widely to appreciate differences (as
well as some growing similarities) between the art worlds on opposite
sides of the Atlantic, especially during the past century. From the nine-
teenth century onward Americans undoubtedly looked to Europe for
leadership in the arts, but when we reach the first half of the twentieth
century we also notice that resistance to Old World primacy increases
in certain areas, and that enhances our understanding of quite a few of
the controversies that have been discussed.

Acceptance of modernism in the United States, for example, lagged
more than a full generation behind its engaged reception in Europe. To
begin with, modernism emerged and developed under very different
circumstances on opposite sides of the water. And then for ideological

reasons the Nazi attack on "degenerate art" made "lost modernism" seem especially appealing in postwar Europe, whereas Americans knew little of Hitler's vicious 1937 attack in Munich and elsewhere on modernism. In Europe the erasure of modernism when it became so politicized during the 1930s would be virtually equated with a loss of cultural identity. By contrast, American enthusiasm for regionalism and homegrown art during the 1930s meant *both* an enhancement of provincial identity and additional reasons to find modernism incomprehensible, ugly, and apparently un-American. Similarly, *pervasive* American interest in primitivism in art also lagged almost a generation behind Europe—the approximate points of genuine absorption being 1910 and the 1930s respectively.[5]

Between 1939 and the end of World War II it *appeared* as though American art still remained deferential to European and more particularly to the impact of significant émigrés who had fled to the United States for refuge from fascism—figures like Piet Mondrian, Fernand Léger, Marc Chagall, Hans Hofmann, and Josef Albers. But as we now know so well, by 1947 a radical ferment among younger artists soon to be called Abstract Expressionists would become the single most influential movement at midcentury, and the capital of the art world, so goes the conventional wisdom, shifted from Paris to New York.[6]

American discontent with patterns of European influence in the realms of art and architecture dates back, selectively to be sure, to the nineteenth century. Theodore Dreiser, for example, became greatly distressed in 1895 when he went to the Metropolitan Museum of Art and observed "young men and women laboriously engaged in copying reproductions of exhumed Grecian marbles of heroes and Goddesses, when American heroes and Goddesses are thronging Broadway, and not maintaining unnatural poses either."[7] This xenophobic response became notably manifest at the time of the Armory Show in 1913, and when the Mexican muralists received commissions ranging from New Hampshire to California in 1931–34, and then when the Francophile Calder was invited to create a giant stabile for Grand Rapids in 1968. Aesthetic nativism has been a key component of the national narrative. Even when the foreign artists themselves were not deemed too radical, what they created appeared to be.

In 1955 the first "Documenta" exhibition held at Kassel, West Germany, helped to canonize European modernism and especially German Expressionism from the first half of the twentieth century. The 1981 exhibition titled "Westkunst" (West art), held at Cologne, how-

ever, integrated European modernism with newer developments in American art. What had been referred to for quite some time as "internationalism" now genuinely deserved the name. Moreover, scholarship and criticism in the history of art had been taken over from the stellar émigré generation by a younger group of American authorities. The United States had seemingly "caught up" with, if it had not actually surpassed, the Old World in these respects.[8]

When we turn more particularly to the politicization of art and artists, however, the trajectory of dependence, interdependence, and leadership becomes more complex than it first appears. In terms of long-standing transatlantic differences, the United States remained squeamish about nudity and "decency" in art (and in art classes) long after they came to be taken for granted in Europe. Our monuments and memorials remained highly derivative from classical models, more often than not, though we at least tended to keep designs somewhat simpler than their antique prototypes and *sometimes* scaled down in size because of cost and the constraints of particular venues. Even so, charges of "gigantism" remained constant for public monuments and sculpture throughout the national narrative.

The insistent rhetoric that we should demand art and architecture well suited to the values of a democratic society also persisted, though its spokespersons did not always win when push came to shove. Nevertheless, the recurrence of that rhetoric distinguished American discourse about art from its European counterpart for many generations.[9] And the appeal of narrative murals here also seems distinctive, a function in part of governmental walls to be filled, artists needing employment during the 1930s, and a popular enthusiasm for pictorial storytelling, especially at the state and local levels. Murals in Europe have been somewhat more likely to provide reminders of political conflicts won and lost, whereas in the United States following that lead was almost invariably a recipe for trouble.[10]

When a big retrospective covering Georges Braque's work between 1917 and 1947 was held at the Galerie Maeght in Paris and then moved to Curt Valentin's gallery in New York (1948), Braque's most memorable epigram, "*L'art est fait pour troubler,*" was translated as "Art is meant to disturb."[11] Variants of that view would be echoed as a virtual motto by many American artists, but especially starting in the 1960s as an interesting indication of the complex, constantly changing relationship between the avant-garde and the lay public. Hence Robert Rauschenberg's familiar maxim from the emergence of provocative

Pop Art: "If the painting doesn't upset you, it probably wasn't a good painting to begin with." An ad for a Richard Serra exhibition in 1989 listed eight demands, including "Support indecent and uncivil art." Norman Rosenthal's introduction to the catalog for "Sensation" insisted that "the chief task of new art is to disturb [the viewer's] sense of comfort." And David Halle argues that " 'Sensation' was an exhibition in search of controversy, a search that is a valid goal of contemporary art."[12]

If judged primarily by the desire to be genuinely provocative, American artists *began* "catching up" with Courbet and Manet just about half a century ago. By the 1980s one might almost suggest that they were leading the way. Vito Acconci's work called *Gang-Bang* was banned from the Spoleto festival in 1980. It consisted of ten self-erecting anatomical appendages to be installed on the cars of people who lived in the city. A roof-rack with a windscoop was part of each appendage, and the inflatable object would be activated as the vehicle accelerated. Nine of the objects were penises, and the tenth was a breast made of pink parachute material; each one was nine feet high when fully inflated. In October 1989 Seattle gallery owner Greg Kucera opened his exhibition called "Taboo," declaring that without the right to examine controversial and sometimes disturbing works of art, "we would be fascists."[13]

But not so fast. What quite a few American artists clearly *had* learned by the mid-1960s was that provocation helped to build reputations, and the more unusual if not outrageous the art, the better. But *political* activism was quite another matter, and in 1965–66, when some American artists, but by no means all, became distressed by the U.S. military engagement in Southeast Asia, they looked to European modes of protest for models and perspectives. So initially they took heed of protests mounted by French intellectuals a decade earlier and studied what figures like Sartre and Camus had done. Still, collective action among artists for any purpose lacked clear precedents in the United States except for brief moments during the 1930s. Therese Schwartz has written:

> Artists in Europe rarely lock themselves into a one-gallery contract unless the arrangement is very favorable. They know how to place their work in several galleries, and they are much more accustomed to selling from their studios. For Americans a logical development from anti-war activity could be an artists' coop-

erative action. But an artists' cooperative for exhibiting purposes would not appear a very radical act to Europeans.[14]

When the student revolt against universities began in France in May 1968, many artists there joined in. Visual artists, actors, filmmakers, and writers all put themselves, and not just their names, on the line in support of social and political change. On May 31, as the uprising spread across the continent, Milan became a venue because the Triennale, a smaller version of the Venice Biennale, was about to open. Even as paintings were being put up, one hundred angry artists demanded to see the director. When he refused, they entered the building and declared it occupied. They then proceeded to demand control of the exhibition and then of *all* exhibitions in all museums. Declaring themselves unequivocally against "any exhibition which is organized from above," they threatened to subvert all such shows in the future; and indeed in June they also forced the Venice Biennale to close.[15]

A total of twenty-three European artists refused to show their work at the Biennale, but no American artists protested or left the U.S. Pavilion, and the work displayed there was labeled "reactionary" by European artists. Similarly "Documenta IV" was scheduled for Kassel in July 1968. The organizers had selected 150 artists from seventeen countries, including 57 Americans—a dominant number proportional to the prestige that American art enjoyed at the time. When radical artists such as Jean Dubuffet, Victor Vasarely, Vassilakis Takis, and others saw the composition of the show, they protested that "Documenta" was U.S.-dominated and represented an "imperialist takeover." The dispute did not involve artistic merit so much as it did the art market; visibility at an international show like "Documenta" enhanced value, so American artists stood to gain more than those from any other country. The exhibition was greeted with disgust and scorn.[16]

European artists took the lead when it came to the politicization of art shows during the later 1960s. In New York the Art Workers Coalition was just getting started. It would never enjoy the consensual unanimity and clout of its European counterparts, and the alliance fell apart just a few years later. Takis, a Greek sculptor and one of the earliest art-and-technology artists, had been involved in 1968 protests at Paris, Venice, and Kassel. Early in 1969, following his appointment as a fellow at the MIT Center for Advanced Visual Studies, he played a major role in the highly publicized action of removing one of his works

from the Museum of Modern Art because it was an early and minor piece rather than the recent one he had been promised would be displayed. So a European led the way in resisting arbitrary control by administrators over artists' work in American museums. Takis extracted from Bates Lowry, the director of MoMA, a verbal agreement that his "immature" work would not be returned to the show and that Lowry would seriously consider holding a public hearing concerning artists' rights of intellectual property.[17]

Just as germane and important for our purposes as European primacy with respect to modernism and politicization, however, are some striking similarities between the appearance of all manner of offensive art in England and the United States beginning in the mid-1960s. Specific cases most certainly vary, but not the overall patterns and parallels. In 1966, for example, Gustav Metzer organized a "Destruction in Art" symposium in London. For one of the twenty-a Viennese artist named Hermann Nitsch strung up the carcass of a dead lamb in front of a white canvas and eviscerated it while a film showing male genitalia being manipulated by strings and immersed in liquids was projected over it. Loud sounds made by rattles, whistles, and other instruments accompanied the gory display. (An echo of charivari perhaps?) Meanwhile a young man stuffed the animal's lungs into his trousers (substituting symbolically for missing genitals?), and then a raffle was held for the carcass. The police charged Metzer, the organizer, with "indecent exhibition" at his trial in 1967, which lasted several days at the Old Bailey—an interesting parallel to the 1966 Radich-Morrel flag episode in New York in which Radich, the gallery owner, stood trial but no charges were brought against Morrel, the artist who actually created the offensive objects.[18]

In 1972 an abstract sculpture by Barry Flanagan called *Vertical Judicial Grouping* consisted of four fiberglass pillars surrounding a metal goalpost for soccer. Flanagan made enthusiastic predictions about the shadows that would be cast by his work during the summer, located on Laundress Green in Cambridge, England, because "the shadows' abstraction upon the meadow carries some mathematical sense." Residents and students apparently did not achieve that "sense" because they attacked the sculpture so often that it had to be removed by city council workers. All of which seems to anticipate the removal of Serra's *Titled Arc* from lower Manhattan.[19]

Ironically, with some notable exceptions, Serra's work has received a rather warm reception in most of Europe, especially in France and Scotland. A work called *Clara-Clara* (honoring his wife) was commissioned for the Forum of the Pompidou Center on the occasion of a Serra retrospective there late in 1983. It consists of two identical, irregularly inclined, curved steel bands, each one 120 feet long and 10 feet high. Placed on their sides, the bands curve away from each other at the ends and stand almost touching in the middle, but with a 6-foot passageway between them at the nearest point, through which people could move. According to Michael Brenson, the work seemed "both to open like magical doors and to squeeze inward like a trap, both to expose itself like a flower hungry for the sun and to curl up like a sunflower at dusk." It is considered "unusually sexual and anthropomorphic," at least by the French.[20]

Concern about the burden of its immense weight on the museum floor led to its relocation to the Jardin des Tuileries, where it remained during the exhibition and for some months after that. The City of Paris eventually acquired *Clara-Clara* permanently and, in consultation with the artist, found a permanent site for it in the Thirteenth Arrondissement in the Place de Choisy, a small, stately park. Another work, titled *Slat*, consists of five steel plates, four trapezoidal and one rectangular, each one twelve feet wide by forty feet tall, composed into a construction resembling a stable house of cards. It is situated in the town of Puteaux, a suburb just west of Paris. The actual site is a path alongside a main road near the important traffic intersection of La Défense. According to Brenson, once more, "Both sculptures are rich and complex. Like many of Serra's other works, they are direct and elusive, bristling and calm, effusive and suspicious."[21]

While these two works were being formally dedicated in 1985, Serra also accepted a commission to create a sculpture for the sixteenth-century cloister of a Benedictine monastery in Bourg-en-Bresse, in eastern France, between Macon and Geneva. The monastery is a historic site. Serra chose the cloister "because of the rigor and history of the architectural convention—it is a square within a square—and because I think it is a hallowed space." He enjoyed the hospitality of François Mitterand's government, which was eager to identify itself with cultural innovation and was open to foreign artists and experimentation. Dominique Bozo, director of the Pompidou, was very likely the most powerful figure in the French art world and happened to be a fan of Serra's work. How ordinary citizens responded is

less clear, but bear in mind that they once got used to the Eiffel Tower—after a time.[22]

On the other hand, a work by Serra rather similar to *Tilted Arc* but called *Berlin Junction*, installed early in 1988 at Wittenbergplatz, not far from the Berlin Wall and the Brandenburg Gate, was considerably less well received. Among the many inscriptions written on its surface is this one, and quite representative: "560,000 [marks] for this shit." It is gratefully used today as a half-pipe for skateboarding.[23]

And a work titled *Terminal* (1977) erected in the very center of Bochum, at the central hub of commuter traffic, aroused a furor: "The streetcars miss it by a foot and a half." *Terminal* is a construction of four identical trapezoidal plates of Cor-Ten steel, forty-one feet high. Serra had intended this commission for that particular site because he wanted it to be situated in the literal heart of a steel-producing district where his kind of plates were manufactured. That seemed more appropriate to him, however, than it did to those who needed to negotiate traffic in downtown Bochum. The conservative Christian Democrats opposed the work with highly visible press releases, while supporters of the work saw great symbolic value for the Ruhr district generally and for Bochum in particular as the German home for coal and steel.[24]

Although the volatile sculptor and conceptual artist Joseph Beuys (1921–86) preferred to work with materials like fat, felt, and found objects—a far cry from Serra's oxidized steel—he became equally controversial, perhaps even more so, and was often involved in legal proceedings that brought him notoriety along with numerous disciples. Beuys became a dominant figure in the German art scene during the 1960s and 1970s, one of the first members of the international Fluxus movement. His ongoing dispute with the Düsseldorf Academy from 1968 to 1972 over the admission of students—Beuys wanted open admissions—ended with his being dismissed from his professorship and abruptly removed from the building, his puckish smile blazoned by the media as the police led him out. He received his first museum exhibition in the United States at the Guggenheim in January 1980, leaving many viewers somewhat baffled by his "Nordic spiritualism." As critic Donald Kuspit wrote in response to the show, "Beuys restores the anti-materialistic, visionary core of avant-garde art, continuing the idealistic tradition. . . . He means to articulate the very substance of 'modern,' the belief in advance [progress], whether by means of revolution or evolution, or, as Beuys puts it, by revolutionary evolution and evolutionary revolution."[25]

If Beuys's name is linked with that of any American artist, however, it is with Andy Warhol. In 1972 a West German museum in Wuppertal organized an exhibition titled "Reality—Realism—Reality" which subsequently toured for fourteen months. Based upon works by Duchamp, Warhol, and Beuys, it attempted to show, according to the catalog, "the change of this radical reality-relatedness into magic-emotional incantation rites and a relic-like object-art." The connection became more vivid when the two had a famous encounter in 1980 at a gallery in Munich where Warhol was exhibiting his serigraphed portraits of Beuys—the American celebrity artist immortalizing a German counterpart![26]

They were, arguably, the most notorious artists in their respective countries at the time, and Beuys had recently been hailed at the Guggenheim as a European prophet of new art. Politically, of course, they could not have been more different. Beuys had passionately sided with the radical student movement in the late 1960s, whereas Warhol had always remained utterly detached from politics. More than apolitical, he literally disdained civic engagement. Although both men enjoyed iconic status and had become famous, at least in part, because of their epigrammatic iconoclasm, they seemed to function within remotely distant spheres. Hans Belting, a distinguished art historian with one foot figuratively in each sphere, has summed up the disconnect that disappointed expectations in Munich.

Warhol, the virtuoso oracle of American society, at first was rebuffed by Beuys' cult of nature. It may be that each was acting out the role of a protagonist who would speak for his own culture. It may also be that they stylized their art for or against the mass media in an opposite sense. Nevertheless, they offered the spectacle, not of a merely personal encounter, but of one between two hemispheres that, with its illusions, were as much connected as they remained separate.[27]

The much-anticipated encounter turned out to be a rather bland nonevent, albeit memorable nonetheless. Although it was nonconfrontational, in fact amiable, it highlighted in the minds of people curious enough to care certain differences between postmodern styles and values in their respective cultures. Warhol sought to be affectless, yet he exerted enormous influence. Beuys was perceived by his critics as

being affected to the point of self-dramatization. Each man projected a self-created persona that critics were invariably eager to expose.[28]

Ultimately, however, Warhol not only approved the values of a crassly commercial, celebrity-oriented society, he embodied those values and incorporated them into his art. He affirmed the social and economic status quo and achieved wealth along with notoriety by pictorializing it. Beuys rejected the status quo in every way and created enigmatic installations that required careful contemplation if their elusive meaning was to be grasped. Unlike Warhol, he offered repeated warnings about the danger of blurring the lines between culture and commerce, yet he eventually did so himself. If their messages clearly separated them, their mutual desire to reach a mass public served as one common denominator. What Kuspit has written of Beuys was true of both men: "he is trying to address an audience that art as such has rarely addressed, that great indeterminate mass audience that Plato scornfully called the beast that swallowed everything."[29]

The other German artist who has enjoyed even greater transatlantic notoriety, involved in notable controversies on both sides of the ocean, is Hans Haacke. We have already encountered the conflict he created at the Guggenheim in 1971, when he sought to expose the real estate holdings of New York's worst slumlords, resulting in the cancellation of his exhibition. Three years later he made a parallel effort at the Wallraf-Richartz Museum in Cologne by creating a comparably researched work based upon Manet's painting *Still Life with Asparagus* (1880). Haacke asked museum officials whether he might re-create the provenance for this important painting that had been donated to the museum by a very wealthy man named Hermann J. Abs. When museum officials asked just what Haacke planned to do with the Manet, Haacke replied that he simply wanted to trace the genealogy of its ownership, from Manet's daughter down to Abs. The officials said, "That's fine." They should have known better.[30]

Museum authorities first saw the wall text for the painting the day before the opening of the show. When the text got to Abs, it gave this identification: "1930–1938 [head of some major bank in Berlin]," then "1938–1945, Vice Chancellor of the Reich Bank," and then "1945–1950, Vice Chancellor of the Recovery Bank." Abs had simply remained in his position of considerable power throughout the Nazi period and beyond. So without ever calling him a Nazi or even an evil person, Haacke supplied his less-than-impeccable political lineage and

ownership, ending with "Donated by Hermann Abs." The next day museum administrators decided that this work could not be shown and demanded that Haacke remove it. He replied, "Okay, I'll take it down, as long as you give me a letter that I will then post stating why you wanted me to take it down. I'll even put up another work." The museum answered with "No letter, nothing—you're just out."[31]

On opening day, right next to where the Manet text was supposed to be, there was a work by Daniel Buren, an environmental piece of his striped wallpaper. During the middle of the ceremonial opening, as an improvised performance Buren and twelve friends, including Haacke, put a photostat of the original Haacke piece directly over Buren's so that the provenance of Manet's still life was revealed. The next day, when the general public was admitted, perfectly cut pieces of white paper exactly covered Haacke's work, neatly pasted into place. It became a notable moment in the history of state censorship by an art museum, and many of the artists participating in that show promptly removed their works or, if they were video installations, turned them off and fled, feeling, "This is it. We've now encountered Nazism ourselves. It was a scary feeling."[32] Cologne, where the Ludwig Museum is also located and which owns the virulently antiwar *Portable War Memorial* (1968) by Edward Kienholz, had censored Hans Haacke just as resolutely as the Guggenheim had done three years earlier. History repeated itself, this time as farce, and once again the art world was roiled by a droll but divisive controversy. I suspect that Hans Haacke felt quite pleased with himself.

One might very well wonder at this point whether Haacke ever achieved the unobstructed realization of a project. Despite his willingness to take risks and suffer the consequences, and despite his apparent affection for causing contretemps, he has, in fact, had challenging schemes succeed. My favorite occurred in Graz, Austria, a very conservative city. Every fall starting in 1968 it has held a cultural festival jointly financed by the city, by the province of Styria, and by the Austrian government. For the twentieth anniversary of the festival in 1988, the organizers decided to solemnly mark a different anniversary, Hitler's annexation of Austria fifty years earlier. Sixteen artists were invited to produce works for temporary installation in public places that had played some sort of significant role under the Nazi regime. The curator of the municipal museum for modern art in Graz explained his vision for the project, called "Points of Reference": it would aim "to challenge artists to confront history, politics and society,

and thus regain intellectual territory which has been surrendered to everyday indifference in a tactical retreat that has been continual, unconscious and manipulated."[33]

Haacke's proposal was as daring as it was ingenious—but was quite likely to be foiled, once again. He wanted to "conceal" the base of a very tall historic monument in the center of Graz, dedicated to the Virgin Mary, using a wooden obelisk as cover bearing a modified Nazi insignia (as the Nazis had done in 1938) but adding an account of those who had died under their regime in Styria. The notion of naming names of the dead supplies a reminder of Maya Lin's successful concept at the Vietnam Veterans Memorial. What ensued is best told by Haacke.

> When I presented the proposal, I was absolutely convinced it would not be possible to realize it. However, I did not want to participate in the exhibition except with this project. The people in charge could easily have rejected it by reasoning that its realization would exceed the limits of the budget. In light of the region's still sizable number of Nazi sympathizers, they could have rejected it also for reasons of public safety. They could even have said that it should not be done out of respect for the Virgin, as a newspaper argued after my memorial to the victims of Nazism had been firebombed. In spite of all these possible arguments and obstacles, the project was carried out. The city under Social-Democratic leadership and the Conservative provincial government collaborated. As I hoped, among the people of Graz the memorial served as a catalyst for historical awareness. It is always assumed that censorship and self-censorship exist wherever one turns—and, of course, they do. However, if one tests the limits, sometimes one discovers that there are holes in the wall, that one can get through, and that things can be done which appeared to be impossible.[34]

During the night of November 2, one week before the end of the special exhibition, this memorial to Nazi victims in Styria was firebombed. Even though firemen arrived promptly, much of the fabric and the top of the obelisk burned, and the statue of the Virgin Mary was severely damaged. The Austrian and German press reported the incident in detail, condemning the arson and its presumed motivation. An exception was the largest and most conservative Austrian daily

tabloid, which attacked leaders of the Catholic Church for having permitted the encasement of the *Marien-Säule* and also the politicians for wasting taxpayer monies on such a shameful project. For days following the incident leftist politicians, artists, students, and other citizens placed flowers and lit candles by night at the foot of the burned obelisk.[35]

Two people had seen the arsonist from afar, so thanks to a police sketch he was spotted and arrested among a crowd of bystanders lining the streets of Graz during the silent march commemorating Kristallnacht. He turned out to be an unemployed thirty-six-year-old man who moved in neo-Nazi circles. The instigator of the firebombing was also apprehended and arrested: a well-known sixty-seven-year-old Nazi. Both men were sentenced to prison terms.[36] When I visited the memorial on April 27, 2005, no physical trace remained of Haacke's "intervention," and the locals gathered around on a sunny spring day (fig. 67), enjoying the exuberant flowerbeds below the monument, seemed oblivious to the uproar that had occurred there almost two decades earlier.

A German-American scholar who has studied Haacke's work closely provides us with an implicit contrast between the meaning of *site-specific* for Haacke and Serra. For the latter that phrase means that his sculpture is intended for a particular site and most often will actually *redefine* it. In contrast, according to Benjamin Buchloh, Haacke makes every effort in his installation work to reconstitute *all* of the contextual aspects of the objects he uses.

> Just as he insists on the site- and context-specificity of his various interventions in the institutional framework, he also insists on the object-specificity of the elements operating in that intervention. Thus, when Haacke investigates the interrelationships between the cultural and the political activities of an individual or a corporation, he deploys the very objects of their productive enterprise within the aesthetic construct itself.[37]

More recently Austria made at least a partial recovery from a longstanding embarrassment: the absence of any Holocaust memorial. One was finally unveiled in October 2000 in Vienna before a group that included the president of Austria, the city's mayor, its chief rabbi, and its Roman Catholic archbishop. The memorial is a large concrete box located in the middle of the Judenplatz, a small baroque square where

67. *Marien-Säule* (St. Mary's Column), (1666–70).
Gilded statue on a stone base. Iron Gate Square, Graz, Austria.

a synagogue was burned during a medieval pogrom. On the one hand, such a memorial had been long delayed, and on the other it had been opposed not only by Jorg Haider's far-right Freedom Party but also by many Jewish leaders in Vienna. All the more surprising, therefore, that the new monument has been acclaimed by most of its former opponents.[38]

The project was even expanded to include a museum to display newly excavated remains of the ancient synagogue and the renovation

of an Orthodox Jewish Center in the square. The most acclaimed achievement, however, is the actual monument designed by Rachel Whiteread, one of the young British artists made notorious in the public relations fiasco caused by "Sensation." Whiteread won an international competition sponsored by the City of Vienna in 1996, and she seemed astonished that after so much opposition and so many delays, her work was actually completed just as she originally intended it. According to Michael Kimmelman, "It is a major new example of public commemorative art, a rarity in the proliferating industry of Holocaust memorialization. Its fundamental success is that it creates a rude interruption in a gingerbread square and in a picturesque, tradition-bound capital. It is a thing that now can't be ignored."[39]

The memorial is meant to resemble a library turned inside out (fig. 68). Its exterior is incised to simulate rows of identical books on shelves, spines facing inward. The names of Nazi camps are inscribed

68. Rachel Whiteread, The Holocaust Memorial (2000),
Judenplatz, Vienna, Austria.

around the base. Kimmelman notes that the symbolism is clear. "The room cannot be entered. We will never know what is in the books or their names. They are forever lost to us. It is also a sculpture about public conscience flipped on its head: about making public what some Austrians wanted to shutter away, to keep behind closed doors."[40]

The furor over the exhibition installed at the Jewish Museum in New York, "Mirroring Evil: Nazi Imagery/Recent Art," was anticipated in Germany and Austria by an equally intense controversy in 1996–99 by a display of nearly one thousand photographs called "War of Annihilation: Crimes of the Wehrmacht, 1941–1944." It was visually provocative because Germans had cherished a myth of the heroic and "clean" Wehrmacht (unlike the notorious SS) fighting valiantly against the Russians on the Eastern Front. Although the photos showed graphic scenes of torture and execution, conservatives and apologists condemned the exhibit for errors of interpretation and presentation. The exhibit was eventually seen by more than 800,000 visitors in every major German city and some smaller ones. Essentially it aroused fierce conflict because of the rise of nationalistic solidarity in the newly unified Germany. Its itinerary was suspended in November 1999, but not before it renewed bitter feelings about the ways in which the German army had conducted warfare during those years.[41]

The art exhibition called "Sensation" that evoked such intense political passion at the Brooklyn Museum in 1999 was almost as provocative elsewhere in the English-speaking world, both for being launched in London in the fall of 1997 and for *not* being shown in Australia during 2000 as scheduled. In London its venue was actually the Royal Academy, a venerable but cash-strapped institution founded in 1768. Critics accused it of trading on its distinguished past and good name to rake in some quick profits because of all the media hype preceding and then surrounding the show. Contestation arose over the potential enrichment of Charles Saatchi but also because so many of the pieces seemed grotesquely intended to frighten, repel, or offend people for an entire panoply of reasons, ranging from animal rights activists to those who found various works truly vulgar, such as the Chapman brothers' naked and disfigured girls, weirdly titled *Zygotic acceleration, biogenetic desublimated libidinal model* (1995).[42]

The single most upsetting work and response in London, however,

was the huge (13-by-10½-foot) portrait of child murderer Myra Hindley, which the *Independent* described on opening day, September 19, 1997.

> We had shattered glass, megaphones, placards, images of media manipulation, tears, confusion and bewilderment. And that was just in the courtyard. Inside the Royal Academy there was a genuine sensation. A man was apprehended after two canisters of ink were thrown at the much publicised painting of Moors murderer Myra Hindley, made from the casts of children's handprints. Minutes later an egg was thrown. . . . It started at 4 am when a rock was hurled through a window in Piccadilly next to the Royal Academy banner proclaiming the show.[43]

According to a "Report from London" published in the United States eighteen months before the exhibit ever reached Brooklyn, it "turned into a sort of Punch and Judy show, its supposedly 'controversial' works first attacked with gusto in the press then stoutly defended by Royal Academy spokespersons." One newspaper was so eager to raise the level of hysteria that it paid for the mother of one of the murdered children to come to London to express her grief and outrage as patrons lined up to be searched by security teams prior to being admitted.[44]

The Royal Academy refused to bow to pressure to remove the grisaille portrait, citing as its grounds freedom of expression. An official candidly acknowledged that it was "literally a certain sort of sensationalism in the artists' approach to their work—in subject matter, materials, or even the amount of press response it had evoked—which was the decisive factor in the final [curatorial] choice." By the time "Sensation" closed on December 28, 1997, it had tallied 284,734 visitors, a daily average of 2,800, making it one of the academy's best attended shows of the decade. The institution had surely achieved its economic objective and in the long run suffered no ill effects. Where people experience excitement, they are likely to return—many of them at least.[45]

Because of the furor touched off by this show at the Brooklyn Museum, however, the National Gallery of Australia, located in Canberra, announced late in November 1999 that it was canceling the opening there that had been scheduled for June 2000. According to the museum's director, the decision stemmed from ethical issues that had been raised about the financing of the exhibition. "We as a public insti-

tution can't take it," he explained. "We cannot ignore what's happened in Brooklyn; we're not disconnected from the art world." He also acknowledged, however, receiving hundreds of letters from Australians who had read about the disturbing exhibits of a dead shark floating in a tank of formaldehyde and the bust of a man made from his own frozen blood. The National Gallery is a public museum. People associated with it said that a public outcry there could well lead to criticism from its government-appointed eleven-member council. Meanwhile, "Sensation" was still scheduled to open in March at the Municipal Museum of Art in Toyota, northwest of Nagoya, Japan.[46]

In the spring of 2004 a massive fire at a warehouse in East London consumed much of Charles Saatchi's art collection, including works by many of the artists represented in "Sensation." The financial loss to Saatchi and the artists was immense, of course, but a vocal segment of the British public felt that some sort of poetic justice had occurred. A sarcastic commentary in the *Guardian* captured much of the feeling that somehow stuff called "art" that did not deserve to be so categorized had been given its comeuppance. "If anyone was in any doubt that Britart was over, they couldn't have had a less subtle sign from God. Some unkind Internet wags have already suggested it was Saatchi himself who orchestrated the whole thing as an insurance job. Once upon a time in art circles, the names God and Saatchi were interchangeable, so I think that between them, we've definitely got our man."[47]

The destructive fire provided large numbers of people with an opportunity to express their disgust with contemporary British art. Some offered to place anything that had survived the fire on their weekend barbecue. Artists who had lost their work were said to be taking the tragedy with philosophical stoicism, which led to larger conclusions about the national character, such as: "In many ways, the response to the fire has been very British. If it happened in France, there'd be a day of mourning and intellectuals would at this moment be penning thousand-page tomes on the death of death." Meanwhile the art season did not seem to lose a beat. Even if trendy "Britart" had been burned, the Tate could still show "The Pre-Raphaelite Vision," El Greco could draw large crowds at the National Gallery, and the Science Museum could continue "Sensation" in a new vein with an exhibition devoted to a creative history of torture.[48]

Once again the requisite stance for the media seemed to be snide cultural criticism. According to the *Observer*, "Each exhibition has

been cleverly marketed, enjoys strong brand sponsorship, and will generate impressive visitor numbers. But is that the true purpose of a museum or art gallery?" There seemed to exist a growing disquiet within the curatorial world that in the process of launching ever more high-profile temporary shows, "part of the deeper function of the museum—as a place of reflection free from the everyday maelstrom; as a public sphere with a different ethos to the marketplace—is being lost." The journalist Tristram Hunt then heaped scorn on Thomas Krens, director of the Guggenheim in New York, as the prototypical museum entrepreneur of the twenty-first century, whose formula for a successful gallery experience

> demands "great collections, great architecture, a great special exhibition, a great second exhibition, two shopping opportunities, a high-tech interface via the internet and economies of scale via a global network." . . . Krens suggests galleries should be run as components of the entertainment industry. The Guggenheim, like Disney or Time-Warner, is becoming just another global multi-national with powerful brand value.[49]

Hunt went on to critique the superficiality of blockbuster exhibitions that attract large crowds of people who cannot appreciate the art because of jammed rooms and the imperative to keep moving. "The chance for personal engagement with individual paintings, for reflection and contemplation, remains slim as the distractions of headphone commentaries, mobile phones and sheer numbers undermine attention. The sense of museums as somewhere more demanding and more stimulating than the sensory entertainment of cinema or television can be jettisoned with it." If all that sounds like so much nostalgic elitism, the final paragraphs come as quite a surprise.

The essay ends by praising the government's "laudable decision to end museum charging" for admission and notes with approval the dramatic increase in museum visitation. Annual attendance at the Victoria and Albert, for example, leaped from 900,000 to more than 2 million in 2003. "The extraordinary growth in visitor numbers to museums and galleries over the past decade has constituted a remarkable cultural renaissance." Even so, a still, small voice yearned for "the opportunity just to muse a little." That ambivalent sentiment—sincere celebration of cultural democracy in the abstract fused with wistful longing for the good old days of highbrow intimacy with quality art—

was fairly widely shared by 2004. If the meanings of great art are supposed to be enigmatic and require real contemplation, yearnings for optimal, uncongested ways of experiencing art were becoming equally compromised.[50]

Writing in 1995 about *The Art of Today*, Brandon Taylor looked at both sides of the Atlantic but from a British perspective. Although he saw comparable trends in the Anglo-American art worlds since the 1970s, he felt that the pattern of influence was clearly flowing from west to east. While Taylor acknowledged that some of the *most* outrageous artists were British, and that citizens in both countries could get very upset by the art their tax dollars were supporting, there were no voices in Parliament comparable to those of Jesse Helms and Newt Gingrich in calling the arts funding agencies to account for the quality and seriousness of their work.[51]

Writing at the very end of the century, another British art historian helped us notice some similarities but even more differences. Much British art of the 1980s and 1990s was clearly *designed* to stir public debate, usually by means of allusions to or depictions of death, sexuality, or drug use. Julian Stallabrass found that "Britart" had been Americanized by using the Union Jack as an antinationalist symbol to flog British culture and on those grounds seemed belatedly derivative. On the other hand, this critic *also* noticed that what he called "high art lite" in England took the mass media as its arena and used the tabloids (rather than vice versa) as a source of notoriety to a degree unknown in the United States. Since the 1980s the art world in the U.K. had been operating very much like any other business, manipulating the media as a mode of hype and presenting art like any other consumer product.[52]

All across Canada during the years between 1984 and 1996 a series of tense controversies took place over the use of public funds to support sexually suggestive or explicit art in publicly supported museums. The episodes ranged in venue from the Vancouver Art Gallery in 1984 to the Mendel Art Gallery in Saskatoon, Saskatchewan, in 1989, to the Musée du Québec in 1991, to the National Gallery of Canada in Ottawa in 1988–89, and to the Banff Centre for the Arts in Alberta in 1992–93. Clusters of shared themes and issues were common to all of these and other disputes. First, video as an art form became a major medium of choice. Second, the varied nature of sexuality became a

subject of choice. Third, depicting the pleasures and anxieties of gay and lesbian sex became such a prominent motif that accusations frequently arose that what was being shown at these galleries and media centers was pure pornography rather than art.[53]

The artists, gallery directors, and curators were, in fact, deeply engaged by what they called "erotics in the arts," and they failed to recognize that the population at large was not quite as "liberated" as themselves in terms of feeling comfortable with sex acts being shown on screen, not only to mixed audiences but especially to ones likely to include children and adolescents. Museum officials even tended to resist requests that they at least install signs warning parents that some of the material might be offensive to adults or inappropriate for youngsters. Battles over signage became common: whether it was needed at all, and if so, how strongly worded the warnings should be. In several instances gallery directors lost their nerve at the very last minute and canceled the showing of videos most likely to elicit protest, cause controversy, and possibly jeopardize either financial support or the continuing participation of recently joined members.[54]

In every instance where a video was canceled, directors and staff members had screened and approved the film, which meant that a breach of contract occurred. Sometimes gallery directors only made matters worse by changing their minds in response to ardent protests by artists and their friends. Invariably, by the time a change of heart occurred on the part of an indecisive director, the maker of the challenged video had withdrawn it from the exhibition, and quite often other artists had pulled their works as well, as a sign of solidarity. Most of the artists had very strong credentials and had received numerous awards for previous work. The media, of course, enjoyed a field day with all of this, and accusations of censorship and homophobia became frequent and bitterly contested.[55]

Censorship by Canadian government authorities, however, was rarely an issue. Rather, the recurring crises involved self-censorship by directors fearful of alienating a significant part of the expanded public they had worked so hard to recruit as ongoing members and regular attenders at museum events. Moreover, despite lurid feature stories that the more exploitative papers liked to run, the editorial pages of responsible newspapers revealed a notable degree of tolerance for, and even advocacy of freedom of expression. Both the *Vancouver Sun* and the *Province* (another British Columbia paper), for example, were firmly committed to the idea that a "good museum could and, in fact,

should take on controversy whether it wins the ensuing battle of popular opinion or not."[56]

In 1988 the *Ottawa Citizen* published a remarkably judicious editorial that affirmed the National Gallery's responsibilities.

> Predictably, one outraged viewer said taxpayers' money shouldn't be used to purchase this kind of material for the National Gallery. It can be argued that some of the Gallery's contemporary art deserves to be laughed out of the Gallery. But none of it—neither the "obscene" nor the absurd—should be hounded out. If curators caved in to fear, as opposed to ridicule, they could eventually give us an "uncontroversial" Gallery. Inoffensive because it would be empty.[57]

The frequency with which these videos were described as sensitive accounts of gay desire and "the elusive nature of love" suggests that Canada was several decades ahead of the United States in public tolerance for homosexuality. More often than not, charges of pornography, indecency, or reckless disregard for the morals of children came from small numbers of individuals but nonetheless sparked considerable anxiety on the part of museum staffs. The closest organizations to Donald Wildmon's American Family Association to emerge in these accounts were, first, the Society of Christian Counselling Services, which played a role at Saskatoon in requesting that warning signs be posted at the Mendel Art Gallery and that children be prohibited entirely from viewing the videos by Evergon, a renowned Canadian photographer; and second, an antiabortion group called Human Life International.[58]

Flora MacDonald served as minister of communications at that time, which meant that she had responsibility for all Canadian public galleries and museums. In 1988 she became the target of a well-organized letter-writing campaign, protesting videos that showed explicit sexuality. Her standard form-letter response provides striking testimony to the significance attached to a federal policy of hands off: "Although Miss MacDonald is the minister responsible for museums and galleries she is prevented by long-standing convention and the firm commitment of this government to the arm's-length principle from becoming involved in curatorial or artistic decisions made by cultural agencies in her portfolio." And that was that.[59]

In 1990, at the height of controversy in the United States generated

by the works of Mapplethorpe, Serrano, Finley, and others, conservative congressman Henry J. Hyde of Illinois wrote an essay for *The National Review* that epitomized the sentiments of many Americans—most likely a solid majority, in fact—when he observed that "public funds in a democracy are to be spent for public purposes, not for the satisfaction of individuals' aesthetic impulses. And if the impulse in question produces a work which is palpably offensive to the sensibilities of a significant proportion of the public, then that work ought not to be supported by public funds."[60] Hyde's outlook had less support in Canada but more in the U.K. One major difference between the United States and the U.K., however, is that "offensive" here was *somewhat* more likely to involve sex or sexuality, whereas in Britain it was more likely to involve insensitivity (to cruelty and death) or sheer ugliness.

During the final decade of the twentieth century a new genre of museum experience began to appear in the largest and most cosmopolitan cities of the Western world: the sex museum. The earliest appeared in Amsterdam in 1985. Copenhagen followed in 1993, and Barcelona three years later. Meanwhile Hamburg opened its Erotic Art Museum on the notorious Reeperbahn; and in Paris a museum in Pigalle (1997), with seven floor levels, caused nary a buzz and is quietly visited by couples (rather than being primarily a male-only affair). It displays all sorts of objects and photographs from around the world of interest to people regardless of sexual orientation. In Berlin a highly successful entrepreneur (who retails sex manuals throughout the country) opened a "vast museum of erotica" in 1996. On its first weekend lines of visitors snaked around the block and the elevators were so overworked that one of them stalled, trapping two couples for nearly an hour. The museum is located on a prime piece of downtown real estate, fills three floors, and contains more than three thousand items. Like its counterpart in Paris, it is entirely a private-sector operation.[61]

When Daniel Gluck announced in May 2002 his intention to open an exhibition devoted to the sexual history of New York City as a "trial run" for a full-scale sex museum in the city, the press took notice to a much greater degree than had been the case in Europe. There was considerable speculation about its social and civic acceptability. Topics at the museum would be explored primarily through photographs and texts, but there would also be some stag films from the earlier twenti-

eth century, graphic French postcards, and some leatherware in the fetish display. Admission was set at seventeen dollars (making it the most expensive museum in the city at that time), and visitors would have to be eighteen or older. Gluck had originally hoped that the Museum of Sex would be a nonprofit institution chartered by the state, but cultural foundations were not interested, and the New York State Board of Regents, which oversees nonprofit cultural institutions, would not accept the name "Museum of Sex," advising that the word *museum* could not be used in any way that might demean the term, whatever that meant.[62]

MoSex, as it came to be called, opened in September 2002 in a former retail space (once upon a time, reputedly, a brothel) located at the corner of Fifth Avenue and 27th Street. Operating by default as a for-profit corporation, its bylaws rule out financial backing from anyone in "the adult entertainment industry." It is necessarily located at least five hundred feet away from any church or school but quickly drew condemnation from the Catholic League for Religious and Civil Rights. According to the executive curator, however, the mission of the first installation, controversial before it even opened, would be exploration of "the sexual subcultures of the city and how they influenced the mainstream." Its preparation did involve scholars in the planning phase, and much of the museum's material and themes were available on its Web site prior to opening (www.museumofsex.com) and are depicted in a boldly illustrated catalog prepared to accompany its first show. Daniel Gluck and his two cofounders indicated that their museum would be patterned after similar institutions in Europe, "but more serious."[63]

More than a year after its opening, attendance turned out to be far less than expected, with fewer than 100,000 visitors. The press reported that it "seems to be suffering from that dreaded condition, public unawareness." Perhaps because tourism was generally down in New York during 2002–03, Gluck complained that "most people don't know we're here," but he planned to extend the opening show devoted to the sexual history of New York City, then shift to a new exhibition, a two-thousand-year overview of Chinese erotica, followed by a blockbuster show alluded to only as "the King Tut of sex," referring to a wildly popular exhibit on Tutankhamen during the 1970s. Australia also opened a National Museum of Erotica in 2002, cheekily located close to the National Museum and aiming to show the "erotic roots of Australians." How successful it will be remains uncertain, but Euro-

pean sex museums, prudently located close to legalized red-light districts, clearly do better than these two newest ones in Anglo cities that are situated more respectably and therefore are less likely to attract folks who happen to be passing by for other reasons.[64]

If a sex museum takes longer to gain acceptance and attract tourists in the United States, and evokes more titillation and anxiety upon opening, than its European counterparts, Martin Scorsese's film *The Last Temptation of Christ* (1988) provoked hostility all across Europe, and not simply because Jesus imagines having sex with Mary Magdalene and contemplates what it would be like to marry and have a family. Viewed by many as sacrilegious, even in secular Europe where the rate of church attendance is so much lower than in the United States, the film drew overt protests on more general grounds of bad taste. It received poor reviews in London and was banned from advertising in the London subway system, presumably to avoid incidents of vandalism that might make travel in the "tubes" unsafe. The movie's distributors, United International Pictures (UIP), declared in a statement that the decision amounted to censorship. London Transport Advertising responded that "our job is to protect our passengers." The British Board of Film Classification ruled that admission could be permitted only to persons over the age of eighteen.[65]

In France the film was attacked in Paris, Lyon, Nice, Grenoble, and several other cities, usually by individuals throwing teargas or stink bombs in theaters but occasionally even by clubbing moviegoers as they were attempting to enter or leave the cinema. An apparent arson attack against a Paris movie house showing the film received condemnation from the government, film directors, and even religious leaders. Although the work had opened in fifty theaters outside Paris, by late October 1988 it was playing in fewer than twenty. Several ultraconservative religious groups had repeatedly threatened to prevent the movie from being shown, and a representative of UIP conceded that "opponents of the film have largely won" by intimidating the public. UIP had expected a two- to three-month run attracting half a million viewers but estimated that 170,000 would be the maximum they could hope for.[66]

In Italy protests began when a Milanese lawyer asked Venetian courts to ban the film from a Scorsese film festival there. Organizers of the festival held their breath until magistrates let the suit die because of a legal technicality. Roman Catholic leaders then joined in a chorus of condemnation that reached its peak when the Italian Bishops' Con-

ference labeled the movie "unacceptable and morally offensive." Instead of encouraging activists to protest, however, they called upon Catholics to simply ignore it. "The film is not worth seeing," they advised. "It deserves only the silence reserved for the mediocre."[67]

Scorsese himself responded to critics, including Franco Zeffirelli (whose own new film, *The Young Toscanini*, was not well received by Italian critics and audiences either). At a stormy news conference in Venice, Scorsese defended his film as "an act of faith" and as an attempt to portray Christ as "fully divine, fully human in one entity." He then added that far from being blasphemous, "We take Him seriously and we take His message seriously, which is loving." That actually triggered a burst of spontaneous applause from many reporters covering the conference. Overall, the Italian reaction to *Last Temptation* was surprisingly more moderate and involved less overt censorship than in Britain and France, partially, perhaps, because other movies released at the same time, including at least one other concerning Judas as a man who loved Jesus but felt predestined to betray him, were deemed even worse.[68]

There does not appear to be any clear or consistent pattern to what is acceptable in Europe but not in the United States. In February 2003 Gucci created an ad showing a twenty-four-year-old Estonian model, Carmen Kass, pulling down her panty far enough to reveal that her pubic hair had been tidily shaved into a capital G, for Gucci. A second person, a fully clothed male, is standing very close, one hand on her right thigh, closely examining the "G-spot," as it had facetiously come to be known (fig. 69). The two-page ad appeared in the British and Italian editions of *Vogue*, once considered a byword for elegance and style, but now hoping to add an eye-catching element of sexual chic.[69]

In Britain the Advertising Standards Authority (ASA), which has sufficient power to ban offensive material, said that it was investigating the ad after receiving a number of complaints. ASA rules had been modified in 1998 to ensure that "particular care should be taken to avoid causing offence on the grounds of race, religion, sex, sexual orientation or disability." The image, created for the Italian fashion house by celebrity photographer Mario Testino, was called "vile, coarse and degrading to women." A representative of the Family Education Trust declared that "it is hugely disappointing that a magazine like *Vogue* should be displaying images like this." A Gucci spokesman refused to comment and *Vogue* remained defiant, defending its decision to publish the photograph, which it described (tongue-in-cheek?) as "cutting

69. Gucci advertisement (January 2003).

edge." It would only say that the ad was running in every fashion mag-
azine in Europe and Asia.[70]

Although this ad did not appear in the U.S. edition of *Vogue*, under-
graduates made it clear to me that the Internet makes such material
readily available to Americans. I find the reaction of one of my Cornell
students worthy of note. She happens to be a very thoughtful young
woman from an old New England family who majored in the history
of art and closely follows trends in women's fashions. "I think although
perhaps 'tasteless,' " she wrote, "it's really not that offensive and was a
very smart move. If you want to be known for cutting edge clothes, you
need cutting edge advertising. In an industry that is so alert to acts of
'copying' you are vying to be the FIRST. Gucci has in a sense copy-
righted the pubic hair gimmick. Anyone who does it now will just be

copy cats. Obviously, the point of advertising is to get attention and most likely the kind of people in the market for Gucci products wouldn't be offended by the advertisement (essentially what Britain's ASA ruled)."[71]

And one really wonders whether the bar for decorum in Europe is significantly any higher or lower than in the United States. Think of the ads for Calvin Klein underwear that have raised many eyebrows, and consider the exhibition titled "Bad Girls" at Manhattan's New Museum in the spring of 1994, its counterpart in California called "Bad Girls West," shown simultaneously at UCLA, and "Black Male," which opened in the fall of 1994 at the Whitney Museum of American Art. Even *USA Today* ran an editorial in March 1994 with the headline

Provocative Art Deserves Debate, Not Censorship

By the mid-1990s we were getting fairly close to the point where one might say "anything goes."[72]

The aftermath of unimaginable catastrophe on September 11, 2001, brought to light the desire by many to find solace, serenity, and beauty in art museums, parks with works of public sculpture to contemplate, and concerts. People old enough to remember living through the blitz in London during World War II will never forget the piano concerts given in the National Gallery by Dame Myra Hess. Because she felt that people needed the reassurance that artistic expression can provide, she went to Sir Kenneth Clark, director of the National Gallery, who persuaded the Home Office to relax its wartime ban on crowds in public buildings. The line for tickets became so long that it crossed Trafalgar Square and disappeared around a corner. As Michael Kimmelman has observed, the Hess concerts were not the only cultural events that received encouragement in war-weary Britain. Painters and sculptors were commissioned to draw and paint pictures of bombed buildings or portraits of Londoners forced to sleep in the subways for safety. These were not major or great works of art, but they showed people coping with stressful conditions. In Germany the Berlin Philharmonic also played on, and for similar reasons: "not because art and music could change the world but because without them the world would have been changed."[73]

The impulse to memorialize the victims of September 11 has been

strong but predictably controversial at times, not just in touching the major competitions to erect a formal memorial at the site of the Twin Towers, for example, but in all sorts of ways, large and small, that arose in the weeks and months following the tragedy. Within one week a sizable and spontaneous memorial site had emerged at the southern end of Union Square Park close to Fourteenth Street, where makeshift shrines appeared near the base of the equestrian statue of George Washington. Someone colored Washington's boots pink and covered his horse with antiwar graffiti. On Friday the fourteenth, the country's official Day of Remembrance, candles covered the square, "melting and mixing during the next few days with wilted flowers to make a huge waxy carpet on the plaza below the statue." As Kimmelman has observed, "The essence of the modern memorial is its social energy."[74]

He also made the astute observation, contemplating all the conflict provoked by modified designs for the World War II Memorial then in progress, that "the public's heart now seems to be more in participatory shrines . . . wherein everybody gets to contribute something to its construction. The graffiti and amateur murals painted in East Los Angeles or the South Bronx have their natural progeny in these vernacular outpourings of popular sentiment." He found that street theater in the broadest and rather informal sense was emerging as the most authentic memorial and the best evidence of the city's continuing vitality and culture. As people began to speculate about the most appropriate form for a permanent memorial at the World Trade Center site, it became clear that Minimalism had already become the "unofficial language" of memorial art. Maya Lin's great success in 1982 had achieved that, even though it took nearly a decade for any sort of consensus to emerge.[75]

Failures, rejections, and serious controversies were certain to follow in the wake of 9/11 because with the passage of time populist and improvisational efforts at memorialization gave way to planned and official ones that required approval from organizations and authorities that were bound to have conflicting views. As one account put it, "professional memorialization" had inevitably kicked into gear. Within months the city disassembled the makeshift memorials that had sprung up so swiftly in sites like Union Square. The design for a bronze memorial to be erected in Brooklyn, honoring firemen, was based on a photograph that had been taken of three firemen raising an American flag above the ashes and rubble of the Twin Towers. Unfortunately, the photo was politically incorrect because all three were white. The

design was altered to depict one black man, one white, and one Hispanic.[76]

In September 2002 people became distressed when a bronze statue by Eric Fischl titled *Tumbling Woman* was placed on display at Rockefeller Center depicting a woman upside down seeming to land on her head, shoulders, and upper back. The purpose of this work was to memorialize those who jumped or fell to their deaths from the towers on September 11. Because of angry protests at the grotesquely distorted body, the statue was covered with a cloth and surrounded by a curtained wall one week after it first went on view in the center's lower complex. A spokeswoman apologized to anyone distressed by the work and announced that it would be removed entirely that evening. Most of the complainants found the statue excessively and disturbingly graphic. With the passage of time striking the right note became ever more difficult; but it did become increasingly clear that abstraction was more likely to succeed than explicitly representational art.[77]

If postmodernism, minimalism, and multiculturalism were the most logical and persuasive modes for the start of the twenty-first century, then visual culture in the United States had clearly undergone a vast sea change—and most of that transformation occurred during the full generation since the 1960s. Dore Ashton, an astute observer of modern art, remarked in 1962 that "a 'fresh beginning' has been the recurrent cry of the embattled American artist."[78]

What that has repeatedly meant, of course, is a fresh beginning that would be distinctively American. So Thomas Cole, although born in England, would insist during the first half of the nineteenth century that "I am an American discovering America . . . and for the American the reality of his own America as Landscape." During the latter half of that century painter Worthington Whittredge would offer this representative declaration: "We are looking and hoping for something distinctive in the art of our country, something . . . to enable us to pronounce without shame the oft-repeated phrase, 'American art.' "[79]

When the Ashcan group of urban realists emerged as the rebellious Eight in 1908, their manifesto rang out: "We want true American art." In 1933 Holger Cahill organized an exhibition at MoMA titled "American Sources of Modern Art." Even when Abstract Expressionists gathered at places like the Cedar Bar in Greenwich Village, their favorite discussions often centered upon establishing distinctions between European and American art. At the famous Studio 35 conference held in 1950, that issue became a principal topic. Participants sought to

define the "American" characteristics of their work and then be able to assert its independence and importance in contrast with European precedents. That may seem ironic now that we regard the Abstract Expressionists as the vanguard of a transnational movement, but national autonomy and distinctiveness remained a strong concern during their formative years at midcentury. As late as 1987 a pioneering Pop artist like Robert Rauschenberg could declare that "the great thing about American art *is* that it's different. It has a natural energy without history."[80]

Needless to say, the criteria for being distinctively American varied from one artist to the next, even from one phase of each new movement to the next. But high on any composite list that we might make would be the democratization of art in the broadest sense: subject matter, accessibility by individual artists to galleries and museums, and increased access for the American public to view their work. Second, the list would have to include a radical breakdown of conventional distinctions between high art ("serious") and popular art derived from vernacular culture. Moreover, there must be acceptance of the trend toward fusion of taste levels and then actually creating such blends for museums as well as for public places, ranging from permanent installations in parks and plazas to ephemeral art that could be altered over time by natural forces, or else walls with murals that can be replaced with new motifs as the times and moods changed.[81]

A third criterion for the list, dating with remarkable specificity to the mid-1960s, involved the imperative to be provocative, indeed, for many artists to actually shock. The "disturbational" aspect of American art during the past forty years has been increasingly prominent, clearly encouraged by dealers, galleries, museum directors, and especially the media. The press just loves juicy controversies, especially when they involve religion, sexuality, gigantism, or sheer incomprehension: "What is it?" and "But is it art?" were questions heard with growing frequency since the 1960s.[82]

In 1989, the year when a notable number of heated art controversies seemed to converge, thereby achieving a high degree of public awareness and political conflict, Judge Richard Posner examined the larger ramifications of these bitter disagreements from the perspective of law and society, conflict resolution, and the elusiveness of art's multiple meanings in a diverse society when the very nature of art itself seemed to be undergoing rapid change. Posner concluded that "nowadays there is no objective method of determining what is art or what is

offensive, and to consider whether, if this is right, it implies that offensive art should get a lot, or a little—or even no—protection from governmental interference, however that interference should be defined in this setting."[83]

Consequently, complex questions of censorship versus the protection of free expression have been pervasive, vexing, and remain unresolved in many respects. Entire exhibitions continue to be canceled, and individual works removed from shows, often by administrators but sometimes by the artists themselves. Nonetheless battles on behalf of works that range from politically dissenting to personally disgusting have been won, and the wholesale wave of censorship (and self-censorship) episodes that occurred between 1988 and 1996 has perhaps lessened *somewhat*, though not entirely. In poll after poll Americans have increasingly expressed their disapproval of censorship, especially when it occurs at the behest of government. People are now more likely to say, "If I don't think I'd like it, I don't have to go." And warning signage has become increasingly normative to prevent children from accidentally seeing things that would require awkward explanations.[84]

Let's look one last time at latter-day public opinion. In 1990 Research & Forecasts conducted a national telephone survey of twelve hundred adults for the People for the American Way Action Fund. Asked to respond to this statement, "The Congress should prevent funding of any controversial art projects or shows," 13 percent strongly agreed and 18 percent agreed somewhat, but 30 percent disagreed somewhat, and 35 percent strongly disagreed. (Four percent didn't know.) So a very strong majority, 65 percent of those polled at a time of maximum contentiousness, nevertheless supported freedom of expression.[85]

National values, by which I mean values that fundamentally define and self-consciously concern the nation itself, change rather slowly, perhaps because in principle they are not *meant* to be very malleable. A prime example would be the difficulty encountered when attempting to alter or amend the U.S. Constitution. Yet cultural (or societal) values *do* change, though gradually, as a rule; and even then the changes invariably meet with resistance. That has been especially true of art in America, and it has sparked some of our most fractious controversies.

Aesthetic values certainly can alter from one generation to the next. They did so with increasing speed in the years after World War II and even more rapidly since the mid-1960s. The nature and underlying

assumptions about art have been *driven* to change at an accelerated pace by entrepreneurial people who have a personal or financial stake in novelty, but also by visionaries who keep their eyes wide open on the past through a rearview mirror, yet remain intensely forward-looking, as though peering through a telescopic lens in search of new stars.

Visionary innovation in the arts is virtually certain to provoke resistance and controversy, at least initially. When unprecedented aesthetic possibilities conflict with national values (pertaining to the American flag, for instance), or with traditional social values (pertaining to nudity or explicit sexuality), contestation is likely to occur. Whether or not it takes place within the bounds of civility and efforts at mutual understanding depends not only upon contextual circumstances but also what role the media choose to play—one of education and clarification or one of sensationalism and obfuscation. It does seem certain, however, that a society increasingly attracted to cultural change and trendiness, and one that places a premium upon both, is going to remain a prime candidate for art-related controversies.

NOTES

ABBREVIATIONS

AAA — Archives of American Art, Washington, D.C.
Ex. cat. — Exhibition catalog
MoMA — Museum of Modern Art, New York
NPS — National Park Service
NYT — *New York Times*
RCPOR — Roper Center for Public Opinion Research, University of Connecticut, Storrs, Conn.
WP — *Washington Post*

Introduction

1. See Robert Atkins, "A Censorship Time Line," *Art Journal* 50 (Fall 1991), 33–37.

2. See Leo Steinberg, "Contemporary Art and the Plight of Its Public," in Steinberg, *Other Criteria: Confrontation with Twentieth-Century Art* (New York, 1972), 1–16; Arthur C. Danto, "The Art World," *Journal of Philosophy* 61 (Oct. 1964), 571–84.

3. See Michael L. Krenn, *Fall-Out Shelters for the Human Spirit: American Art and the Cold War* (Chapel Hill, N.C., 2005); *AIDS: Cultural Analysis/Cultural Activism*, ed. Douglas Crimp (Cambridge, Mass., 1988); Douglas Crimp with Adam Rolston, *AIDS Demo Graphics* (Seattle, 1990).

4. Cassandra Burrell, "Attacks on Artistic Freedom Increasing in U.S., Report Says," *Chicago Sun-Times*, Mar. 28, 1994, p. 20; "Controversial Art Continues to Draw Protests, Study Says," *Atlanta Journal and Constitution*, March 29, 1994, sec. D, p. 6.

5. Kirk Savage, "The Self-Made Monument: George Washington and the Fight to Erect a National Memorial," in *Critical Issues in Public Art: Content, Context, and Controversy*, ed. Harriett F. Senie and Sally Webster (Washington, D.C., 1992), 5–32; *NYT*, July 17, 2000, p. E6; *NYT*, Oct. 8, 2000, sec. 5, p. 3; Nicolaus Mills, *Their Last Battle: The Fight for the National World War II Memorial* (New York, 2004).

6. Gordon Hendricks, "Thomas Eakins' *Gross Clinic*," *Art Bulletin* 51 (Mar. 1969), 57–64; *NYT*, Apr. 30, 1979, sec. 4, p. 10; *WP*, Aug. 9, 1979, p. D18.

7. Dore Ashton, "Response to Crisis in American Art," *Art in America* 57 (Jan. 1969), 24–35.

8. Douglas Crimp, *On the Museum's Ruins* (Cambridge, Mass., 1993), 25.

9. Rosalind Krauss, "Postmodernism's Museum Without Walls," in *Thinking About Exhibitions*, ed. Reesa Greenberg et al. (New York, 1996), 342–46, at 346.

10. Dorothy Johnson, *Jacques-Louis David: Art in Metamorphosis* (Princeton, N.J., 1993), 100–09; Simon Lee, *David* (London, 1999), 168, 317.

11. See Anthony Julius, *Transgressions: The Offences of Art* (Chicago, 2002),

chap. 2. Courbet's erotically scandalous painting *The Origin of the World* (1866), long believed to be lost, can be viewed via Google by entering "Courbet Origin of the World 1866." For a provocative analysis of the work, see Michael Fried, *Courbet's Realism* (Chicago, 1990), 209–13, 220–22.

12. Julius, *Transgressions*, 225; Vlaminck quoted in Bruce Altshuler, *The Avant-Garde in Exhibition: New Art in the Twentieth Century* (New York, 1994), 19. Ensor's painting hangs at the J. Paul Getty Museum in Los Angeles.

13. See Elizabeth Milroy, *Painters of a New Century: The Eight and American Art* (Milwaukee, 1991), 44.

14. Pierre Bourdieu and Hans Haacke, *Free Exchange* (Cambridge, Eng., 1995), 23.

15. Barbara Haskell, *The American Century: Art & Culture, 1900–1950* (New York, 1999), 91.

16. For hostile critics, *bewilder* emerged as a word of choice. When the Museum of Modern Art displayed a pioneering show of "Cubism and Abstract Art" in 1936, critic Edward A. Jewell called it "the most elaborate, complex, and in a sense at least, the most bewildering exhibition arranged thus far in the career of the MoMA." *NYT,* March 3, 1936, p. 19; Russell Lynes, *Good Old Modern: An Intimate Portrait of the Museum of Modern Art* (New York, 1973), 137–47.

17. George H. Roeder Jr., *Forum of Uncertainty: Confrontations with Modern Painting in Twentieth-Century American Thought* (Ann Arbor, Mich., 1980), 158; Krenn, *Fall-Out Shelters*, chap. 1; Taylor Littleton and Maltby Sykes, *Advancing American Art: Painting, Politics, and Cultural Confrontation at Mid-Century* (Ex. cat.: Tuscaloosa, Ala., 1989), 58; "Are These Men the Best Painters in America Today?" *Look,* Feb. 18, 1947, pp. 44ff.

18. See Peter Schjeldahl, "Welcome to Helgaland," *Art in America* 74 (Oct. 1986), 11, 13.

19. Judy Chicago, *Beyond the Flower: The Autobiography of a Feminist Artist* (New York, 1996), 218–30; Lucy Lippard, "Uninvited Guests: How Washington Lost the Dinner Party," *Art in America* 79 (Dec. 1991), 39–49; Teri J. Edelstein, "Sensational or Status Quo: Museums and Public Perception," in *Unsettling "Sensation": Arts-Policy Lessons from the Brooklyn Museum of Art Controversy,* ed. Lawrence Rothfield (New Brunswick, N.J., 2001), 104–14.

20. See Stanley Cohen, *Folk Devils and Moral Panics: The Creation of the Mods and the Rockers* (New York, 1980), 16–17; Steven C. Dubin, *Arresting Images: Impolitic Art and Uncivil Actions* (New York, 1992), *passim* for Wildmon.

21. Nancy Einreinhofer, *The American Art Museum: Elitism and Democracy* (London, 1997); Diana Crane, *The Transformation of the Avant-Garde: The New York Art World, 1940–1985* (Chicago, 1987), 128.

22. André Gschaedler, *True Light on the Statue of Liberty and Its Creator* (Narberth, Pa., 1966), 134; Marvin Trachtenberg, "The Statue of Liberty: Transparent Banality or Avant-Garde Conundrum?" *Art in America* 62 (May 1974), 36–43.

23. Jo Ann Lewis, "A Modern Medici for Public Art," *ARTNews* 76 (Apr. 1977), 37–41.

24. Salley Promey, "Sargent's Truncated 'Triumph': Art and Religion at the Boston Public Library, 1890–1925," *Art Bulletin* 79 (June 1997), 217–50.

25. Phillips is quoted in Michael Brenson, *Visionaries and Outcasts: The NEA, Congress, and the Place of the Visual Artist in America* (New York, 2001), 7–8; Kimmelman in *NYT,* Mar. 4, 2001, sec. 4, p. 5.

26. Adolph Gottlieb, "Artists' Sessions at Studio 35," in *Modern Artists in Amer-*

ica, ed. Robert Goodenough (New York, 1951), 18; Max Kozloff, "The Critical Reception of Abstract Expressionism," *Arts Magazine* 40 (Dec. 1965), 28; Robert Hughes, *American Visions: The Epic History of Art in America* (New York, 1997), 513.

27. Kimmelman, *NYT*, Mar. 4, 2001, sec. 4, p. 5; Ronald Lee Fleming, "The Meaning of Place," *Public Interest* 66 (Winter 1982), 28.

28. Serrano is quoted in *Interventions and Provocations: Conversations on Art, Culture, and Resistance*, ed. Glenn Harper (Albany, N.Y., 1998), 116; Serra in *Art in the Public Interest*, ed. Arlene Raven (New York, 1985), 274.

29. Serra is quoted in *Against the Grain: The New Criterion on Art and Intellect at the End of the Twentieth Century*, ed. Hilton Kramer and Roger Kimball (Chicago, 1995), 166; interview with Larry Rivers in *Art Chronicles, 1954–1966*, ed. Frank O'Hara (New York, 1975), 112. Italics in the original.

30. Lichtenstein is quoted in Hans Haacke, "Museums, Managers of Consciousness," in *Hans Haacke: Unfinished Business*, ed. Brian Wallis (Cambridge, Mass., 1986), 8; Sugarman is quoted in Don Hawthorne, "Does the Public Want Public Sculpture?" *ARTNews* 81 (May 1982), 61; Finley is quoted in *Los Angeles Times*, Oct. 21, 1990, Calendar sec., pp. 3–4; Mann is quoted in *NYT*, Oct. 30, 2002, p. 2.

31. Milroy, *Painters of a New Century*, 37; Henri is quoted in Annie Cohen-Solal, *Painting American: The Rise of American Artists, Paris 1867–New York 1948* (New York, 2001), 175, and 229 for the Armory Show; Stephen Gardiner, *Epstein: Artist Against the Establishment* (London, 1992), 320; Henry Adams, *Thomas Hart Benton: An American Original* (New York, 1989), 187, 267.

32. Julius, *Transgressions*, 97, 138.

33. *Phoenix New Times*, June 6, 1996.

34. Lynes, *Good Old Modern*, 126.

35. "Opinion on the Arts: Educate, Don't Gag," *Columbus Dispatch*, Sept. 24, 1989, pp. G1–2; Judith A. Russo, "Gallery Owner Opens 'Taboo' Exhibit," Associated Press, Oct. 7, 1989, online at http://web.lexis-nexis.com/universe/print/doc.

36. Donald Kuspit, "Art, Criticism, and Ideology," *Art in America* 69 (Summer 1981), 96.

37. Claes Oldenburg, *Store Days* (New York, 1967), 39.

Chapter 1: Monuments, Memorials, and Americanism

1. Elizabeth Hess, "A Tale of Two Memorials," *Art in America* 71 (April 1983), 120–27.

2. Ibid., 123–24. Hart is quoted in Daniel Abramson, "Maya Lin and the 1960s: Monuments, Time Lines, and Minimalism," *Critical Inquiry* 22 (Summer 1996), 679–709.

3. Nicolaus Mills, *Their Last Battle: The Fight for the National World War II Memorial* (New York, 2004).

4. See Siegfried Giedion et al., in Giedion, *Architecture, You and Me: The Diary of a Development* (Cambridge, Mass., 1958), 48–51; Andreas Huyssen, "Monumental Seduction," in *Acts of Memory: Cultural Recall in the Present*, ed. Mieke Bal, Jonathan Crewe, and Leo Spitzer (Hanover, N.H., 1997), 204–05.

5. Garry Wills, "Washington's Citizen Virtue: Greenough and Houdon," *Critical Inquiry* 10 (March 1984), 420–41.

6. Sylvia E. Crane, *White Silence: Greenough, Powers, and Crawford: American Sculptors in Nineteenth-Century Italy* (Coral Gables, Fla., 1972), 69.

7. Ibid., 74–75, 77, 79; Christopher A. Thomas, *The Lincoln Memorial & Ameri-*

can Life (Princeton, N.J., 2002), 96–97; and Lois Craig et al., *The Federal Presence: Architecture, Politics, and Symbols in United States Government Building* (Cambridge, Mass., 1978), 508–09. See Katharine Kuh, "Must Monuments Be Monumental?" *Saturday Review*, Sept. 2, 1961, 26–27, for a contemporary response to the initial design for the FDR Memorial.

8. Wills, "Washington's Citizen Virtue," 431.

9. Nathalia Wright, *Horatio Greenough: The First American Sculptor* (Philadelphia, 1963), 142–53.

10. Crane, *White Silence*, 83; Wright, *Greenough*, 147. Hawthorne is quoted in Vivien Green Fryd, *Art & Empire: The Politics of Ethnicity in the United States Capitol, 1815–1860* (Athens, Ohio, 2001), 76.

11. Wright, *Greenough*, 151–153, quotation on 152.

12. Ibid., 156–57.

13. Rhodri Windsor Liscombe, *Altogether American: Robert Mills, Architect and Engineer, 1781–1855* (New York, 1994), 170–71.

14. Ibid., 261–62.

15. H.M. Pierce Gallagher, *Robert Mills: Architect of the Washington Monument, 1781–1855* (New York, 1935), 118–19.

16. Kirk Savage, "The Self-made Monument: George Washington and the Fight to Erect a National Memorial," in *Critical Issues in Public Art: Content, Context, and Controversy*, ed. Harriet F. Senie and Sally Webster (Washington, D.C., 1992), 5–19.

17. Louis LeGrand Noble, *The Life and Works of Thomas Cole*, ed. Elliot S. Vesell (Cambridge, Mass., 1964), 152–53.

18. Gallagher, *Robert Mills*, 104–10.

19. "National Washington Monument," *Crayon* 1 (Mar. 21, 1855), 187.

20. Charles Eliot Norton, "Something About Monuments," *Nation* 1 (Aug. 3, 1865), 154–56.

21. Craig, *Federal Presence*, 151.

22. Ibid., 19–24. Italics in the original.

23. Ibid., 25–27.

24. Clarence King, "Style and the Monument," *North American Review* 141 (Nov. 1885), 453.

25. Christopher A. Thomas, *The Lincoln Memorial and American Life* (Princeton, N.J., 2002), 26.

26. Ibid., 81–82.

27. Ibid., 31, 33, 50–52, 81–82, 94, 96–98.

28. Albert Boime, *The Unveiling of the National Icons: A Plea for Patriotic Iconoclasm in a Nationalist Era* (New York, 1998), 261, 265, 269.

29. Thomas, *Lincoln Memorial*, 104, 110, 123.

30. Ibid., 140–41.

31. Ibid., 141–43.

32. Barry Schwartz, *Abraham Lincoln and the Forge of National Memory* (Chicago, 2000), 270–72.

33. Ibid., 273–75; Boime, *Unveiling National Icons*, 269–73.

34. Schwartz, *Lincoln and the Forge*, 278–80; F.W. Ruckstull, "A Mistake in Bronze," *Art World* 2 (June 1917), 211, 213, 220.

35. Schwartz, *Lincoln and the Forge*, 275–76. In May 2004 a pastor in Illinois proposed construction of a 305-foot statue of Lincoln in Lincoln, Illinois. (The one by Daniel Chester French is nineteen feet high.) The new statue would be based upon a drawing by the late artist Lloyd Ostendorf, showing Lincoln spilling a tin of watermelon juice on the ground.

36. Richard Guy Wilson, "High Noon on the Mall: Modernism versus Traditionalism, 1910–1970," in *The Mall in Washington, 1791–1991*, ed. Richard Longstreth (Washington, D.C., 2002), 152–53.

37. Merrill Peterson, *The Jefferson Image in the American Mind* (New York, 1960), 424–25; Marquis W. Childs, "Mr. Pope's Memorial," *Magazine of Art* 30 (April 1937), 200–02.

38. Peterson, *Jefferson Image*, 426; Wright's letter is in *Magazine of Art* 31 (June 1938), 368.

39. Peterson, *Jefferson Image*, 428; Kimball wrote eloquently on behalf of the commission, first in a letter to the *New York Times* and then in an expanded version in the *Magazine of Art* 31 (May 1938), 315–16, 318.

40. Peterson, *Jefferson Image*, 427–29.

41. Ibid., 429–30.

42. Boime, *Unveiling National Icons*, 180–84, 205–07.

43. Karal Ann Marling and John Wetenhall, *Iwo Jima: Monuments, Memories, and the American Hero* (Cambridge, Mass., 1991), 154–60.

44. Boime, *Unveiling National Icons*, 180–81.

45. Ibid., 209–11.

46. Marling and Wetenhall, *Iwo Jima*, 161–69.

47. William Hubbard, "A Meaning for Monuments," in *The Public Face of Architecture: Civic Culture and Public Spaces*, ed. Nathan Glazer and Mark Lilla (New York, 1987), 138–41; Abramson, "Maya Lin and the 1960s."

48. Robin Wagner-Pacifici and Barry Schwartz, "The Vietnam Veterans Memorial: Commemorating a Difficult Past," *American Journal of Sociology* 97 (Sept. 1991), 392.

49. Ibid., 394–95; Karal Ann Marling and John Wetenhall, "The Sexual Politics of Memory: The Vietnam Women's Memorial Project and 'The Wall,'" *Prospects* 14 (1989), 341–72.

50. *Austin American-Statesman* (Knight-Ridder Tribune News Service), Oct. 25, 1990, p. A22.

51. Kristin Huckshorn, "Monuments: Cornerstones of Controversy," *USA Today*, Nov. 6, 1990, p. O3A.

52. Ibid.

53. Barbara Gamarekian, "Panel Turns Down Plan for Korean War Shrine," *NYT*, Jan. 19, 1991, p. 20.

54. Sarah Booth Conroy, "Arts Panel Approves Korean War Memorial; Long Fight Over Design Reaches Negotiated Peace," *WP*, Jan. 17, 1992, p. C1; Charles Krauthammer, "The Cold War Memorials," *WP*, Aug. 4, 1995, p. A23.

55. James Reston Jr., "The Monument Glut," *NYT*, Sept. 10, 1995, sec. 6, p. 48.

56. Ibid.; Deborah K. Dietsch, "Compromised Commemoration," *Architecture*, Sept. 1995, p. 15.

57. Kuh, "Must Monuments Be Monumental?" 26–27.

58. Craig, *Federal Presence*, 507–09.

59. Wolf von Eckardt, "The Malignant Objectors," *Public Interest* 66 (Winter 1982), p. 23.

60. Meghan Mutchler, "Roosevelt Disability an Issue at Memorial," *NYT*, Apr. 10, 1995, p. A10; Mills, *Their Last Battle*, 74–75.

61. Mills, *Their Last Battle*, chap. 4.

62. Ibid., 131–33.

63. Ibid., chaps. 6–7; Irvin Molotsky, "Design for World War II Memorial Awaits Review, with Detractors Vocal," *NYT*, July 17, 2000, p. E6.

64. *NYT*, Sept. 24, sec. 1, p. 30; *NYT*, Oct. 8, sec. 5, p. 3; and *NYT*, Nov. 12, 2000, sec. 1, p. 21.

65. Letter from James L. Joseph of Poughkeepsie, N.Y., *NYT*, May 8, 2001, sec. A, p. 26.

66. Elaine Sciolino, "War Memorial Builder Has Link to Nazi Era," *NYT*, June 13, 2001, p. A31.

67. *NYT*, Apr. 30, 2004, p. A14; *Ithaca Journal*, Apr. 30, 2004, p. 2A.

68. *NYT*, Mar. 4, 2001, sec. 4, p. 5.

69. Monte Reel, "Washington Monument Design Dispute Resurfaces," *Ithaca Journal*, Aug. 9, 2003, p. 11A.

70. Ibid.

71. "In Richmond, Lincoln Statue Is Greeted by Protests," *NYT*, Apr. 6, 2003, p. A26; NPS briefing statement, "Donation of Lincoln Statue," Mar. 21, 2003, courtesy of NPS.

72. Michael D. Shear, "Lincoln Statue Heightens Old Pains," *WP*, Apr. 6, 2003, p. C06.

73. Ronald C. White Jr., "Lincoln in Richmond: Worth Setting in Stone," *WP*, Mar. 30, 2003, p. B05.

74. A. Barton Hinkle, "Year That Gets Reviewed in Versed Way," *Richmond Times Dispatch*, Dec. 30, 2003.

Chapter 2: *Nudity, Decency, and Morality*

1. Henry Adams, *Eakins Revealed: The Secret Life of an American Artist* (New York, 2005), esp. chaps. 3 and 15; Gordon Hendricks, *The Life and Works of Thomas Eakins* (New York, 1974), 141–43.

2. Quoted in Lloyd Goodrich, *Thomas Eakins* (Cambridge, Mass., 1982), 282–83. See also Eleanor Tufts, "An American Victorian Dilemma, 1875: Should a Woman Be Allowed to Sculpt a Man?" *Art Journal* 51 (Spring 1992), 51–56.

3. *Eakins and the Photograph: Works by Thomas Eakins and His Circle in the Collection of the Pennsylvania Academy of the Fine Arts*, ed. Susan Danly and Cheryl Leibold (Washington, D.C., 1994), esp. 65–93; Kathleen Foster et al., *Thomas Eakins Rediscovered* (New Haven, Conn., 1997), 111–12, 118.

4. Elizabeth Johns, "An Avowal of Artistic Community: Nudity and Fantasy in Thomas Eakins's Photographs," in Danly and Leibold, *Eakins and the Photograph*, 89.

5. Foster, "Eakins and the Academy," in *Thomas Eakins Rediscovered*, 105; Hendricks, *Life and Works of Eakins*, 144–45.

6. Darrel Sewell, *Thomas Eakins: Artist of Philadelphia* (Philadelphia, 1982), 103; Goodrich, *Thomas Eakins*, 285. For a judicious assessment of Eakins's enigmatic fascination with nudity, see Sarah Burns, "Ordering the Artist's Body: Thomas Eakins's Acts of Self-Portrayal," *American Art* 19 (Spring 2005), esp. 92–95. For the most recent and most critical assessment, see Adams, *Eakins Revealed*, chap. 7.

7. Foster, "Eakins and the Academy," 105. Elizabeth Johns emphasizes Eakins's desire to create an intimate sense of community and fantasy, but also to re-create for his own time some of the classic poses of antiquity without simply drawing from statues or casts. Johns, "Avowal of Artistic Community," 84–86. See Adams, *Eakins Revealed*, chap. 16 and p. 465.

8. Deborah Davis, *Strapless: John Singer Sargent and the Fall of Madame X* (New York, 2003), 155–86; Trevor Fairbrother, *John Singer Sargent: The Sensualist* (New Haven, Conn., 2000), 72–75, 81.

9. Edward Larocque Tinker, *Lafcadio Hearn's American Days* (New York, 1924), 22–23; Beongcheon Yu, *An Ape of Gods: The Art and Thought of Lafcadio Hearn* (Detroit, 1964), 206–07; Jonathan Cott, *The Odyssey of Lafcadio Hearn: Wandering Ghost* (New York, 1991), 81.

10. See Joy S. Kasson, *Marble Queens and Captives: Women in Nineteenth Century American Sculpture* (New Haven, Conn., 1990), chap. 3.

11. David M. Lubin, *Picturing a Nation: Art and Social Change in Nineteenth-Century America* (New Haven, Conn., 1994), chap. 1; Salvatore Mondello, *The Private Papers of John Vanderlyn (1775–1852): American Portrait Painter* (Lewiston, N.Y., 1990), 47, 56–58, 61, 71.

12. Lubin, *Picturing a Nation*, 15–17; Marius Schoonmaker, *John Vanderlyn, Artist, 1775–1852* (Kingston, N.Y., 1950), 25–27, 36–37, 56–57.

13. Robert P. Wunder, *Hiram Powers: Vermont Sculptor, 1805–1873* (Newark, Del., 1991), 1:187.

14. Ibid., 139–42, 305, 340.

15. Ibid., 207–08.

16. Ibid., 219, 221, 223.

17. Margaret Farrand Thorp, "Rediscovery: A Lost Chapter in the History of 19th-century Taste: The Nudo and the Greek Slave," *Art in America*, 49, no. 2 (1961), 46–47.

18. William H. Gerdts and Samuel A. Roberson, "'The Greek Slave," *Museum* [Newark], n.s., 17 (Winter–Spring 1965), 1–30; Vivien M. Green, "Hiram Powers' *Greek Slave*: Emblem of American Freedom," *American Art Journal* 14 (Autumn 1982), 31–39.

19. Wunder, *Hiram Powers*, 233, 248, 252; Linda Hyman, "*The Greek Slave* by Hiram Powers: High Art as Popular Culture," *Art Journal* 35 (Spring 1976), 216–23.

20. William H. Gerdts, "Marble and Nudity," *Art in America* 59 (May 1971), 62.

21. Mary L. Levkoff, *Rodin in His Time* (New York, 1994), 86–87. Rodin's work also became controversial at the St. Louis World's Fair in 1904. See George McCue, *Sculpture City: St. Louis* (New York, 1988), 68–70.

22. William Harlan Hall, *The World of Rodin, 1840–1917* (New York, 1969), 14; Frederick Lawton, *The Life and Work of Auguste Rodin* (New York, 1907), 109–10. In 1881 Rodin modeled *Eternal Springtime*, which anticipates *The Kiss*. Here the woman does not seem to be the more aggressive partner, but she has certainly given herself with abandon. Museum of Fine Arts, Boston.

23. Gerdts, "Marble and Nudity," 60–67, at 60; Steven C. Dubin, *Arresting Images: Impolitic Art and Uncivil Actions* (New York, 1992), 30. For anxiety in 1913 about a nude female statue honoring German-Americans in St. Louis, see McCue, *Sculpture City: St. Louis*, 77–78.

24. Marchal E. Landgren, *Years of Art: The Story of the Art Students League of New York* (New York, 1940), 85–86.

25. Heywood Broun and Margaret Leech, *Anthony Comstock: Roundsman of the Lord* (New York, 1927), 216.

26. Ibid., 217.

27. Ibid., 218.

28. Landgren, *Years of Art*, 88–89.

29. Ibid., 89.

30. Ibid.; Broun and Leech, *Anthony Comstock*, 219. For a photograph of a nude modeling for a women's life class at that time, see *New York by Artists of the Art Students League of New York in Celebration of the Centennial Year. . . .* (New York, 1975), 6.

31. See http://www.cd.sc.ehu.es/FileRoom/documents/Cases/12filmFest91.html, and other File Room cases involving Wildmon, 1991–93; Lucy R. Lippard, "Out of the Safety Zone," *Art in America* 78 (Dec. 1990), 130–39, 182, 186.

32. John O'Brian, *Ruthless Hedonism: The American Reception of Matisse* (Chicago, 1999), 17–18; Hilary Spurling, *Matisse the Master. A Life of Henri Matisse: The Conquest of Colour, 1909–1954* (London, 2005), 136; see Milton W. Brown, *The Story of the Armory Show* (New York, 1963), 178–79. When the painting appeared in Chicago, it received the title *The Blue Woman*. Using the word *nude* seemed to go too far, even though the woman is obviously *quite* nude!

33. Timothy J. Garvey, *Public Sculptor: Lorado Taft and the Beautification of Chicago* (Urbana, Ill., 1988), frontispiece and 157.

34. Ibid., 158–59.

35. Ibid., 157–58. The original painting was sold to a Russian, hidden during the Bolshevik Revolution, and rediscovered in 1935 in a private collection in Paris. It is now owned by the Metropolitan Museum of Art.

36. Ibid., 150–51, 154–55.

37. Ibid., 163–68, 173; *Chicago Tribune*, Jan. 6, 1926.

38. "Chicago Art Institute," *Life*, May 23, 1938, pp. 40–41; Norman L. Rice to Cardinal Mundelein, Aug. 23, 1938, in *New World*, Sept. 2, 1938, p. 5; *Over a Century: A History of the School of the Art Institute of Chicago, 1866–1981*, ed. Roger Gilmore (Chicago, 1982), 91.

39. Michele H. Bogart, *Public Sculpture and the Civic Ideal in New York City, 1890–1930* (Chicago, 1989), 33, 40–41.

40. Ibid., 259–69.

41. Theresa M. Collins, *Otto Kahn: Art, Money, and Modern Time* (Chapel Hill, N.C., 2002), 75–77. For version number two, see Robert Hughes, *American Visions: The Epic History of Art in America* (New York, 1997), 324.

42. Rebecca Zurier and others, *Metropolitan Lives: The Ashcan Artists and Their New York* (Washington, D.C., 1995), 19–20; Susan A. Glenn, *Female Spectacle: The Theatrical Roots of Modern Feminism* (Cambridge, Mass., 2000), chap. 4.

43. Gerald Nordland, *Gaston Lachaise: The Man and His Work* (New York, 1974), 9.

44. Sam Hunter, *Lachaise* (New York, 1993), 1–4. For an affirmative response to Lachaise's work and to *Elevation* in particular from a contemporary critic, see Henry McBride, *The Flow of Art: Essays and Criticisms*, ed. Daniel Catton Rich (New Haven, Conn., 1997), 150–51.

45. *San Francisco Chronicle*, Dec. 20, 1992, Sunday Datebook, p. 46.

46. Gilbert Seldes, "Hewer of Stone," *New Yorker*, April 4, 1931, 28.

47. Hunter, *Lachaise*, 5–9; Seldes, "Hewer of Stone," 28–29.

48. Jacob Epstein, "The Artist's Description of His Work," *British Medical Journal* 2 (July 4, 1908), 40–43; "The Scribe and the Sculptor," *British Medical Journal* (July 11, 1908), 101–02.

49. T. E. Hulme, "Mr. Epstein and the Critics," *New Age*, Dec. 25, 1913, pp. 251–53.

50. Quoted in Stephen Gardiner, *Epstein: Artist Against the Establishment* (London, 1992), 317–18.

51. Ibid., 318–19.

52. Ibid., 319–20.

53. Ibid., 320–21.

54. Jacob Epstein, *An Autobiography* (London, 1963), 140.

55. Dario Gamboni, *The Destruction of Art: Iconoclasm and Vandalism Since the*

French Revolution (London, 1997), 152–54. For a droll account of "Epstein's Monument to Oscar Wilde," see McBride, *Flow of Art*, 44–46.

56. Lynda Nead, *The Female Nude: Art, Obscenity and Sexuality* (London, 1992); Lincoln Kirstein, *Paul Cadmus* (San Francisco, 1992), 23–25.

57. Carole S. Vance, "The War on Culture," *Art in America* 77 (Sept. 1989), 39–43; Survey by People for the American Way Action Fund, March 14–26, 1990 (USRF.90ART.R14B.), RCPOR.

58. Dubin, *Arresting Images*, 170–91; Graham Beal, "But Is It Art?" *Apollo* 132 (Nov. 1990), 317–21.

59. Jayne Merkel, "Art on Trial," *Art in America* 78 (Dec. 1990), 41–51; Arthur C. Danto, *Playing with the Edge: The Photographic Achievement of Robert Mapplethorpe* (Berkeley, Calif., 1996).

60. Nathalia Wright, *Horatio Greenough: The First American Sculptor* (Philadelphia, 1963), 67–70.

61. Ibid., 70–72.

62. Ibid., 71–72. For a promotional brochure to see the chanting cherubs at the American Academy of Fine Arts in New York in 1831, see the American Antiquarian Society, Pams. G815, Gree 1831.

63. Wright, *Horatio Greenough*, 72–74; Thorp, "Rediscovery," 46–47.

64. See Sally Mann, *At Twelve: Portraits of Young Women* (New York, 1988); and Mann, *Immediate Family* (New York, 1992), n.p.

65. Reynolds Price, "Neighbors and Kin: Four Southern Photographers," *Aperture* 115 (Summer 1989), 32–39; Anna Douglas, "Childhood: A Molotov Cocktail for Our Time," *Women's Art Magazine* 59 (1994), 14–18; *Newsweek*, Mar. 9, 1998, p. 58.

66. Mann, *Immediate Family*, n.p.

67. Associated Press file, Dec. 18, 1992, Entertainment News, http://web .lexis.com/universe/printdoc; *Richmond Times Dispatch*, Apr. 16, 2000, p. H1.

68. Douglas, "Childhood," 17.

69. *Los Angeles Times*, Mar. 24, 1989, Calendar, part 6, p. 1.

70. "Mann Handled," *Art on Paper* 4 (July/Aug., 2000), 16; Sally Mann, "Correspondence with Melissa Harris," *Aperture* 138 (Winter 1995), 24–35.

71. http://www.cd.sc.eh.es/FileRoom/documents/Cases/08claudioPain.html. For controversies in southern California involving a nude self-portrait by a male artist in 1961–63, see Gerald Nordland, "The Suppression of Art," *Artforum* 2 (Nov. 1963), 25–26.

72. Survey by People for the American Way Action Fund, Mar. 14–26, 1990 (USRF.90ART.R14A and R14F), RCPOR.

73. *Boston Globe*, July 16, 1991, Arts and Film, p. 51.

74. Ibid.; Brian Wallis, "Peeping Sol," *Art in America* 79 (Sept. 1991), 29.

75. Judd Tilly, "Jeff Koons's Raw Talent," *WP*, Dec. 15, 1991, p. G1.

76. Jeff Koons and Thomas Kellein, *Jeff Koons: Pictures, 1980–2002* (New York, 2002), 59–63.

77. Edward Guthmann, "All But Kitchen Sink for Queen of Kink: Ex-porn Star Annie Sprinkle in Controversial One-Woman Show," *San Francisco Chronicle*, Sept. 26, 1993, Sunday Datebook, p. 29.

78. Ibid; Annie Sprinkle, "Hard-Core Heaven," *Arts Magazine* 66 (Mar. 1992), 46–48.

79. *Salt Lake Tribune*, Oct. 27, 1997, p. D1; *Salt Lake Tribune*, Oct. 28, 1997, p. B1; editorial in *Salt Lake Tribune*, Oct. 31, 1997, p. A18; *Deseret News*, Oct. 27–28, 1997, p. B3.

80. "The Public Forum," *Salt Lake Tribune*, Oct. 30, 1997, p. A10; *Salt Lake Tribune*, Nov. 4, 1997, p. A8; *Salt Lake Tribune*, Nov. 7, 1997, p. A34.

81. http://www.cnn.com/2003/US/Central/09/04/offbeat.nude.mural.governor.ap/index.html.

82. http://www.missoulian.com/articles/2003/09/05/news/mtregional/new06.prt.

83. Sam Hunter, *Tom Wesselmann* (New York, 1994). The first one appeared in 1961.

Chapter 3: Coming to Terms with Modernism

1. William Hubbard, "A Meaning for Monuments," in *The Public Face of Architecture: Civic Culture and Public Spaces* (New York, 1987), 132–33.

2. Quoted in Annie Cohen-Solal, *Painting American: The Rise of American Artists, Paris 1867–New York 1948* (New York, 2001), 134–35. For comparable views as late as 1964 see Huntington Hartford, *Art or Anarchy? How the Extremists and Exploiters Have Reduced the Fine Arts to Chaos and Commercialism* (Garden City, N.Y., 1964).

3. Daniel J. Singal, "Toward a Definition of American Modernism," *American Quarterly* 39 (Spring 1987), 15.

4. USGallup.55-0550.QK019A, RCPOR.

5. Arthur C. Danto, *The State of the Art* (New York, 1987), 160. See also Benjamin H.D. Buchloh, *Neo-Avant-garde and Culture Industry: Essays on European and American Art from 1955 to 1975* (Cambridge, Mass., 2000), 465.

6. Cécile Whiting, *Antifascism in American Art* (New Haven, Conn., 1989), 75–77, 99, 131–32, 195.

7. Milton W. Brown, *The Story of the Armory Show* (New York, 1963), 109–10. For a revisionist perspective arguing that most critics were more receptive to the Armory Show than hitherto assumed, see J. M. Mancini, " 'One Term Is as Fatuous as Another': Responses to the Armory Show Reconsidered," *American Quarterly* 51 (Dec. 1999), 833–70.

8. Brown, *Story of the Armory Show*, 110. See also Jerrold Seigel, *The Private Worlds of Marcel Duchamp* (Berkeley, Calif., 1995), 1–11.

9. H. Wayne Morgan, *Keepers of Culture: The Art-Thought of Kenyon Cox, Royal Cortissoz, and Frank Jewett Mather, Jr.* (Kent, Ohio, 1989), esp. 82, 99. For the broader cultural context of American antimodernism, see T. J. Jackson Lears, *No Place of Grace: Antimodernism and the Transformation of American Culture, 1880–1920* (New York, 1981).

10. George H. Roeder Jr., *Forum of Uncertainty: Confrontations with Modern Painting in Twentieth-Century American Thought* (Ann Arbor, Mich., 1980), 38, 58–59, 115–17, 123. For a prime example of modernism being equated with disorder in 1932 (Thomas Hart Benton's murals for the new Whitney Museum), see Henry McBride, *The Flow of Art: Essays and Criticisms*, ed. Daniel Catton Rich (New Haven, 1997), 295–96. "There is no order whatever in Mr. Benton's America."

11. Elizabeth Milroy, *Painters of a New Century: The Eight and American Art* (Ex. cat.: Milwaukee, 1991), 21–60; Garnett McCoy, "Reaction and Revolution, 1900–1930," *Art in America* 53 (Aug. 1965), 68–87.

12. Cohen-Solal, *Painting American*, 204–11; Wanda Corn, *The Great American Thing: Modern Art and National Identity, 1915–1935* (Berkeley, Calif., 1999), 16–20.

13. Brown, *Story of the Armory Show*, 194–95.

14. *The Armory Show International Exhibition of Modern Art 1913* (New York, 1972).

15. JoAnne Mancini, *Pre-Modernism: Art World Change and American Culture from the Civil War to the Armory Show* (Princeton, N.J., 2005).

16. Brown, *Story of the Armory Show*, 134–40; Roeder, *Forum of Uncertainty*, 39.

17. Cox, "The 'Modern' Spirit in Art," *Harper's Weekly*, Mar. 15, 1913, p. 10.

18. Roeder, *Forum of Uncertainty*, 10–11, 15; *NYT*, Mar. 16, 1913, sec. 4, p. 6.

19. Mather, "Newest Tendencies in Art," *Independent* 74 (Mar. 6, 1913), 512. For the wildly hostile response to Matisse in Chicago in 1913, see *Over a Century: A History of the School of the Art Institute of Chicago, 1866–1981*, ed. Roger Gilmore (Chicago, 1982), 79.

20. Christopher Knight, "On Native Ground: U.S. Modern," *Art in America* 71 (Oct. 1983), 168.

21. Jane DeHart Mathews, "Art and Politics in Cold War America," *American Historical Review* 81 (Oct. 1976), 762–87.

22. Knight, "On Native Ground," 169; Karen Lucic, *Charles Sheeler and the Cult of the Machine* (Cambridge, Mass., 1991).

23. B. L. Reid, *The Man from New York: John Quinn and His Friends* (New York, 1968), 498–99.

24. Russell Lynes, *Good Old Modern: An Intimate Portrait of the Museum of Modern Art* (New York, 1973), 40–41, 43–45.

25. Sanda [sic] Miller, *Constantin Brancusi: A Survey of His Work* (Oxford, 1995), 156; Aline B. Saarinen, "The Strange Story of Brancusi," *NYT Sunday Magazine*, Oct. 23, 1955, pp. 26–27, 38, 42.

26. Ibid., 28.

27. D. Dudley, "Brancusi," *Dial* 82 (Feb. 1927), 129.

28. Saarinen, "Strange Story of Brancusi," 38–42.

29. Ibid., 42. For Steichen's recollection of the affair, see "Brancusi vs. United States," *Art in America* 1 (1962), 56–57.

30. Cohen-Solal, *Painting American*, 288, 290–91.

31. Lynes, *Good Old Modern*, 86–88; Cohen-Solal, *Painting American*, 323.

32. Edward Alden Jewell, "Cubist Show Opens with Private View," *NYT*, Mar. 3, 1936, p. 19. See Alfred H. Barr Jr., *Cubism and Abstract Art* (Ex. cat.: New York, 1936), a valuable exhibition catalog.

33. Charles G. Poore, "Furiously They Ask Once More: But Is It Art?" *NYT*, Mar. 8, 1936, sec. 7, pp. 14–15.

34. *NYT*, Mar. 17, 1936, p. 20.

35. "Cubist Art Fails to Pass Customs," *NYT*, Feb. 22, 1936, p. 17.

36. Roeder, *Forum of Uncertainty*, 151–53.

37. Eugene R. Gaddis, *Magician of the Modern: Chick Austin and the Transformation of the Arts in America* (New York, 2000), 149–67, 225–29, 238–41.

38. Nicholas Fox Weber, *Patron Saints: Five Rebels Who Opened America to a New Art, 1928–1943* (New York, 1992), 3.

39. "Sanity in Art," *Art Digest* 10 (Apr. 1, 1936), 12.

40. "Josephine Logan, Militant Leader of the Right, Presents 'Sane' Art," *Art Digest* 13 (Oct. 1, 1938), 7.

41. "Sanity in Art," 18.

42. For Eleanor Jewett's fierce disapproval of annual student exhibitions at the School of the Art Institute during the late 1940s, see Gilmore, *Over a Century*, 92–93.

43. Wilson, "High Noon on the Mall: Modernism versus Traditionalism, 1910–1970," in *The Mall in Washington, 1791–1991*, ed. Richard Longstreth (Wash-

ington, D.C., 2002), 158; Travis C. McDonald, "Smithsonian Institution, Competition for a Gallery of Art, January 1939–June 1939," in *Modernism in America, 1937–1941* (Ex. cat.: Williamsburg, Va., 1985), 197–201.

44. Wilson, "High Noon on the Mall," 144.

45. Ibid., 159; Karl E. Meyer, *The Art Museum: Power, Money, Ethics* (New York, 1979), 49.

46. Taylor D. Littleton and Maltby Sykes, *Advancing American Art: Painting, Politics, and Cultural Confrontation at Mid-Century* (Ex. cat.: Tuscaloosa, Ala., 1989). For a re-creation of the collection, see Margaret Lynne Ausfeld and Virginia M. Mecklenburg, *Advancing American Art: Politics and Aesthetics in the State Department Exhibition, 1946–1948* (Ex. cat.: Montgomery, Ala., 1984).

47. *Look*, Feb. 18, 1947, pp. 80–81.

48. Sidney Hyman, *The Lives of William Benton* (Chicago, 1969), 379–80. For the complex ambiguities of Benton's response to this crisis, see Michael L. Krenn, *Fall-Out Shelters for the Human Spirit: American Art and the Cold War* (Chapel Hill, N.C., 2005), 39–45, a thorough account.

49. Late in 1946 a group of forty-seven sculptors sent a petition to the State Department protesting the exclusion of sculpture from its cultural activities. They even offered suggestions concerning the merits of modern American sculpture and its "portability." *NYT*, Nov. 27, 1946, p. 23.

50. Hyman, *Lives of William Benton*, 381–83.

51. *NYT*, Oct. 3, 1946, p. 25; *NYT*, Oct. 6, 1946, sec. 2, p. 8; *NYT*, Nov. 24, 1946, sec. 2, p. 9.

52. Alfred M. Frankfurter, "O Pioneers! The Whitney Examines the Pathfinders of Modern Art in America," *ARTNews* 45 (Apr. 1946), 34–37, 65.

53. *NYT*, Oct. 1, 1948, p. 27; *NYT*, Oct. 3, 1948, sec. 2, p. 13; "A *Life* Round Table on Modern Art," *Life*, Oct. 11, 1948, pp. 56–79.

54. *NYT*, Jan. 1, 1950, pp. 1, 45, and "Attention to the American Artist," sec. 2, p. 8.

55. *NYT*, May 22, 1950, p. 15; "The Metropolitan and Modern Art," *Life*, Jan. 15, 1951, pp. 34–38; *NYT*, June 4, 1950, p. 95; *NYT*, July 4, 1950, p. 9.

56. *NYT*, June 15, 1950, p. 29; *NYT*, June 18, 1950, sec. 2, p. 6.

57. *NYT*, Oct. 18, 1950, p. 30; *NYT*, Dec. 6, 1950, pp. 1, 40; *NYT*, Dec. 8, 1950, p. 28. See *American Painting Today—1950: A National Competition Exhibition* (Ex. cat.: New York, 1950).

58. *NYT*, Dec. 10, 1950, sec. 2, p. 14

59. Anton Gill, *Art Lover: A Biography of Peggy Guggenheim* (New York, 2002), 297–98, 319–20, 327–28; Erika Doss, *Benton, Pollock, and the Politics of Modernism: From Regionalism to Abstract Expressionism* (Chicago, 1991), 398–99.

60. "A *Life* Roundtable on Modern Art," *Life*, Oct. 11, 1948, pp. 56–59, 75–79; Serge Guilbaut, *How New York Stole the Idea of Modern Art: Abstract Expressionism, Freedom, and the Cold War* (Chicago, 1983).

61. Quoted in Irving Sandler, *The Triumph of American Painting: A History of Abstract Expressionism* (New York, 1970), 96.

62. Donald Kuspit, "Modernism Undone," *Art in America* 74 (Feb. 1986), 22; "Symposium: What Abstract Art Means to Me," *Museum of Modern Art Bulletin* 18, no. 3 (Spring 1951), 12.

63. Piri Halasz, "Art Criticism (and Art History) in New York: The 1940s vs. the 1980s," *Arts* 57 (March 1983), 67–68.

64. Thomas Frick, "Revise and Dissent (Report from Boston)," *Art in America* 74 (Oct. 1986), 45.

65. Michael Kammen, *Robert Gwathmey: The Life and Art of a Passionate Observer* (Chapel Hill, N.C., 1999), 111; Mathews, "Art and Politics," 762–87.

66. Sandler, *Triumph of American Painting*; Florence Rubenfeld, *Clement Greenberg: A Life* (New York, 1997), chap. 15; Clement Greenberg, *The Collected Essays and Criticism*, ed. John O'Brian (Chicago, 1993), 4:107–14.

67. *NYT*, Dec. 5, 1961, p. 45.

68. *A Harmony of the Arts: The Nebraska State Capitol*, ed. Frederick C. Luebke (Lincoln, Neb., 1990), 88–89. Luebke's volume, thoughtful but celebratory, never mentions the hostile response generated by Evett's murals. In fact, Luebke claims that for many viewers Evett's murals are the most pleasing in the capitol! Perhaps by 1990 that was true.

69. *Omaha Sunday World-Herald*, May 16, 1954, p. B1; *Lincoln Sunday Journal and Star*, May 16, 1954, p. 1.

70. "Pawnee Citians Have Mixed Reactions to Evett Mural," *Lincoln Sunday Journal and Star*, June 20, 1954, p. D9; *Lincoln Evening Journal*, June 23, 1954, p. 12.

71. *NYT*, Feb. 23, 1955, p. 29. I am grateful to the Evett family for lending me their clipping file from 1954–55 Nebraska and New York newspapers along with personal correspondence related to the commission. Many of the clippings are undated.

72. Cunningham to Evett, June 12, 1954, Evett family papers.

73. Evett family clipping file from 1954–55.

74. "Baffling U.S. Art: What It Is About," *Life*, Nov. 9 and 16, 1959, pp. 74–86 and 68–80; Doss, *Benton, Pollock*, 400–01.

75. Carol Vogel, "Art World Is Not Amused by Critique," *NYT*, Oct. 4, 1993, p. C13.

76. Ibid.; and see Arthur C. Danto, "De Kooning's Three Seater," in Danto, *The State of the Art* (New York, 1987), 58–61.

77. Vogel, "Art World Is Not Amused."

78. Ibid.; and *NYT*, Oct. 11, 1993, p. A16. On December 20, 2004, Andy Rooney delivered an editorial essay on *60 Minutes* that exactly echoed the message of Safer's longer piece eleven years earlier.

79. For the best and most succinct exploration of these matters, see three classic essays by Arthur C. Danto, "Bad Aesthetic Times," "Masterpiece and the Museum," and "Narratives of the End of Art," in Danto, *Encounters and Reflections: Art in the Historical Present* (New York, 1990), 297–345.

Chapter 4: *Troubles with Murals*

1. For the history of murals during the earlier, "classical" period, mainly the nineteenth and early twentieth centuries, see Bailey Van Hook, *The Virgin and the Dynamo: Public Murals in American Architecture, 1893–1917* (Athens, Ohio, 2003); Edwin Howland Blashfield, *Mural Painting in America* (New York, 1913).

2. See Douglas Crimp, "Redefining Site Specificity," in Crimp, *On the Museum's Ruins* (Cambridge, Mass., 1993), 150–86.

3. Karal Ann Marling, *Wall-to-Wall America: A Cultural History of Post-Office Murals in the Great Depression* (Minneapolis, 1982), 81–83.

4. Bruce I. Bustard, *A New Deal for the Arts* (Washington, D.C., 1997), 16–17.

5. Ibid., 14–16; Marling, *Wall-to-Wall America*, 174–79.

6. Marling, *Wall-to-Wall America*, 62–71.

7. Ibid., 95–103; Bustard, *New Deal for the Arts*, 27.

8. Marling, *Wall-to-Wall America*, 53–54.

9. Ibid.

10. Ibid., 54–55.

11. Ibid., 213.

12. Ibid.

13. Ibid., 213–14.

14. Sue Bridwell Beckham, *Depression Post Office Murals and Southern Culture: A Gentle Reconstruction* (Baton Rouge, La., 1989), 247–48.

15. Ibid., 113–16.

16. Ibid., 139–42.

17. Ibid., 85–88.

18. Laurance P. Hurlburt, *The Mexican Muralists in the United States* (Albuquerque, N.M., 1989), 127–29, 157; Anthony W. Lee, *Painting on the Left: Diego Rivera, Radical Politics, and San Francisco's Public Murals* (Berkeley, Calif., 1999).

19. Hurlburt, *Mexican Muralists*, 158; Bertram Wolfe, *Diego Rivera: His Life and Times* (New York, 1939), 302–16.

20. Wolfe, *Diego Rivera*, chap. 26; Hurlburt, *Mexican Muralists*, 161.

21. Wolfe, *Diego Rivera*, 320.

22. Hurlburt, *Mexican Muralists*, 168.

23. Wolfe, *Diego Rivera*, 324–25.

24. Ibid., 325–27; Lucienne Bloch, "On Location with Diego Rivera," *Art in America* 74 (Feb. 1986), 102–23; Hurlburt, *Mexican Muralists*, 159–69.

25. Irene Herner de Larrea et al., *Diego Rivera: Paradise Lost at Rockefeller Center* (Mexico City, 1987); Wolfe, *Diego Rivera*, 331.

26. Ibid., 335–36; Hurlburt, *Mexican Muralists*, 170–93.

27. Hurlburt, *Mexican Muralists*, 163, 174.

28. *Los Murales de Siqueiros*, ed. Shifra M. Goldman and Agustín Arteaga (Mexico City, 1998), 39–71, esp. 62; Shifra Goldman, "Siqueiros and Three Early Murals in Los Angeles," *Art Journal* 33 (Summer 1974), 322–24.

29. Philip Stein, *Siqueiros: His Life and Works* (New York, 1994), 79–80; *Christian Science Monitor*, Apr. 27, 1935, p. 6; Shifra M. Goldman, "Tropical Paradise: Siqueiros's Los Angeles Mural a Victim of Double Censorship," *Artweek* 21 (July 5, 1990), 20–21.

30. Hurlburt, *Mexican Muralists*, 58–61.

31. Ibid., 62–74.

32. Ibid., 85–86.

33. Ibid., 86.

34. Ibid., 86–87.

35. Henry Adams, *Thomas Hart Benton: An American Original* (New York, 1989), 124–30, 156–207. For an excellent sense of the highly ambivalent response to the Whitney murals, see Henry McBride, *The Flow of Art: Essays and Criticisms*, ed. Daniel Catton Rich (New Haven, Conn., 1997), 295–97.

36. Adams, *Thomas Hart Benton*, chap. 14, esp. 258, 261.

37. Ibid., 268.

38. Ibid., 267–68.

39. Nancy Edelman, *The Thomas Hart Benton Murals in the Missouri State Capitol: A Social History of the State of Missouri* (Kansas City, Mo., 1975), 1–4; *NYT*, Jan. 13, 1937, p. L19; Adams, *Thomas Hart Benton*, 268–69.

40. Adams, *Thomas Hart Benton*, 270; *Art Digest*, Feb. 1, 1937, 10–11.

41. Adams, *Thomas Hart Benton*, 270–75; Edelman, *Benton Murals*, 9–10, 20, 33–36.

42. M. Sue Kendall, *Rethinking Regionalism: John Steuart Curry and the Kansas Mural Controversy* (Washington, D.C., 1986), 126–32; Calder M. Pickett, "John

Steuart Curry and the Topeka Murals Controversy," *Kansas Quarterly* 2 (Fall 1970), 30, 32.

43. Ibid., 35.

44. Ibid., 37–38; Kendall, *Rethinking Regionalism*, 106, 126.

45. Pickett, "Curry and the Topeka Murals Controversy," 38; Marling, *Wall-to-Wall America*, 246–47.

46. Pickett, "Curry and the Topeka Murals Controversy," 40; "Sons of Sunflower Strife: Curry's Murals of John Brown Create Storm in Kansas," *Newsweek*, July 7, 1941, p. 58.

47. Gary Brechin, "Politics and Modernism: The Trial of the Rincon Annex Murals," in *On the Edge of America: California Modernist Art, 1900–1950*, ed. Paul J. Karlstrom (Berkeley, Calif., 1996), 69–75.

48. Ibid., 75; Amy Robinson, "Refregier Paints a Mural," *ARTNews*, 48 (Oct. 1949), 32–34, 55–56.

49. Refregier to Victor Arnautoff, Nov. 4, 1947, Refregier Papers, box 25, AAA.

50. Refregier, undated typescript narrative of the Rincon project, p. 3, Refregier Papers, box 25, AAA; Refregier to A.E. Sanderson, June 26, 1948, Refregier Papers, box 25, AAA.

51. Resolution of the National Maritime Union of America, "San Francisco Post Office Murals," Apr. 1, 1948, Refregier Papers, box 25, AAA; Nixon to Charles E. Plant, July 18, 1949, Refregier Papers, box 25, AAA; Brechin, "Politics and Modernism," 69, 77–79; Amy Robinson, "Refregier Paints a Mural," *ARTNews*, 48 (Oct. 1949), 32–34.

52. Brechin, "Politics and Modernism," 79–81.

53. Ibid., 83–84.

54. Beckham, *Depression Post Office Murals*, 219–22.

55. Marling, *Wall-to-Wall America*, 282–88.

56. Ibid., 272–75.

57. Ibid., 276–77.

58. Ibid., 281–82. It is notable that this startling episode followed rather closely the plot of a novel by mystery writer Phoebe Atwood Taylor, *Octagon House* (New York, 1938).

59. Radio dedication of MoMA, May 10, 1939, *The Public Papers and Addresses of Franklin Delano Roosevelt*, ed. Samuel I. Rosenman (New York, 1941), 8:337–38.

60. Matthew Kangas, "Michael Spafford at the Seattle Art Museum," *Art in America* 70 (Nov. 1982), 126–27. I am indebted to Amy J. Kinsel of Shoreline Community College in Seattle for calling these murals to my attention and providing me with a large amount of journalistic reporting.

61. *Seattle Times*, June 8, 2001, p. A1. In addition to the *Times*, there has been extensive coverage in the *Seattle Post-Intelligencer*, the *Tacoma News-Tribune*, and the *Olympian* in Olympia.

62. *Seattle Times*, Sept. 3, 2003; Ron Glowen, "Consignment to Oblivion: Washington State's Long-standing Mural Controversy," *Artweek* 21 (July 5, 1990), 21–22.

63. For murals as manifestations of political divisiveness in contemporary Europe, see Kate Galbraith, "A Watcher of Walls," *Chronicle of Higher Education*, Oct. 31, 2003, p. A56.

64. Erika Doss, *Spirit Poles and Flying Pigs: Public Art and Cultural Democracy in American Communities* (Washington, D.C., 1995), chap. 5; Diane Neumaier, "Judy Baca: Our People Are the Internal Exiles," in *Cultures in Contention*, ed. Douglas Kahn and Diane Neumaier (Seattle, 1985).

65. *Richmond Times-Dispatch*, June 4, 1999, pp. A2, A17.
66. Jonathan I. Leib, "Robert E. Lee, 'Race,' Representation, and Redevelopment along Richmond, Virginia's Canal Walk," *Southeastern Geographer* 44 (Nov. 2004), 245, 251.
67. *Richmond Times-Dispatch*, June 14, 1999, p. B2; *WP*, June 17, 1999, pp. B1 and B4; *WP*, July 1, 1999, pp. A1 and A11.
68. *WP*, July 15, 1999, p. A1; *WP*, July 27, 1999, pp. A1 and A3; *Richmond Free Press*, Jan. 20, 2000, p. 1.

Chapter 5: Art Politicized: Ideological Issues

1. See Neil Harris, *The Artist in American Society: The Formative Years, 1790–1860* (New York, 1966).
2. Vivien Green Fryd, *Art and Empire: The Politics of Ethnicity in the United States Capitol, 1815–1860* (New Haven, Conn., 1992), 192–93.
3. Ibid., 193.
4. Ibid., 195. I am grateful to Richard Baker, historian of the U.S. Senate, for guiding me to pertinent passages in the shorthand journals of Montgomery Meigs, 1854–56.
5. Nathaniel Burt, *Palaces for the People: A Social History of the American Art Museum* (Boston, 1977), 75, 86–87, 105–06; Calvin Tomkins, *Merchants and Masterpieces: The Story of the Metropolitan Museum of Art*, 2nd ed. (New York, 1989), 16–20; Walter Muir Whitehill, *Museum of Fine Arts, Boston: A Centennial History* (Cambridge, Mass., 1970), 1:9; Sally M. Promey, *Painting Religion in Public: John Singer Sargent's "Triumph of Religion" at the Boston Public Library* (Princeton, N.J., 1999), 165.
6. Quoted in Walter J. Derenberg and Daniel J. Baum, "Congress Rehabilitates Modern Art," *New York University Law Review* 34 (Nov. 1959), 1233.
7. B. L. Reid, *The Man from New York: John Quinn and His Friends* (New York, 1968), 499.
8. Robert Henri, *The Art Spirit* (Philadelphia, 1923), 114; Annie Cohen-Solal, *Painting American: The Rise of American Artists, Paris 1867–New York 1958* (New York, 2001), 176, 267–68, 280; Erika Doss, *Benton, Pollock, and the Politics of Modernism: From Regionalism to Abstract Expressionism* (Chicago, 1991), 96; Lloyd Goodrich, "What Is American in American Art?" *Art in America* 46 (Fall 1958), 19–33.
9. Andrew Hemingway, *Artists on the Left: American Artists and the Communist Movement, 1926–1956* (New Haven, Conn., 2002), 123–32; Michael Kammen, *Robert Gwathmey: The Life and Art of a Passionate Observer* (Chapel Hill, N.C., 1999), 16, 20–21, 52, 55, 67, 110–11, 169, 171, 202.
10. Dickran Tashjian, *A Boatload of Madmen: Surrealism and the American Avant-garde, 1920–1950* (New York, 1995), 118.
11. George V. Sherman, "Dick Nixon: Art Commissar," *Nation*, Jan. 10, 1953, p. 21; Matthew Josephson, "The Vandals Are Here: Art Is Not for Burning," *Nation*, Sept. 26, 1953, pp. 244–48, the quotation is on 247.
12. George Dondero, "Communism in the Heart of American Art—What to Do About It?" 81st Cong., 1st sess., *Congressional Record* (May 17, 1949), 6375.
13. George Dondero, "Modern Art Shackled to Communism," 81st Cong., 1st sess., *Congressional Record* (Aug. 16, 1949), 11584.
14. Eugene McCarthy, "Modern Art," 81st Cong., 1st sess., *Congressional Record* (Aug. 18, 1949), 11980.
15. Ibid.

16. Emily Genauer, "Still Life with Red Herring," *Harper's* 199 (Sept. 1949), 89–91.

17. Peyton Boswell, "Abstract Red Herring," *ARTNews* 48 (Summer 1949), 15.

18. Alfred H. Barr Jr., "Is Modern Art Communistic?" *NYT Sunday Magazine*, Dec. 14, 1952, pp. 22, 28–30, the quotation is on 30.

19. Francine Carraro, "Seeing Red: The Dallas Museum in the McCarthy Era," in *Suspended License: Censorship and the Visual Arts*, ed. Elizabeth C. Childs (Seattle, 1997), 235.

20. Ibid., 236–38, 239–43.

21. Ibid., 239.

22. Ibid., 240.

23. Ibid., 245–52.

24. William Hauptmann, "The Suppression of Art in the McCarthy Decade," *Artforum* 12 (Oct. 1973), 51.

25. "Only Where Men Are Free Can the Arts Flourish and the Civilization of National Culture Reach Full Flower," May 10, 1939, *The Public Papers and Addresses of Franklin Delano Roosevelt*, ed. Samuel I. Rosenman (New York, 1941), 8:336.

26. George Dondero, "Communism Under the Guise of Cultural Freedom—Strangling American Art," 84th Cong., 2nd sess., *Congressional Record* (June 14, 1956), 9377–83.

27. Carraro, "Seeing Red," 254–55.

28. Ibid., 250–51.

29. Ben Shahn, "Nonconformity," *Atlantic Monthly* 200 (Sept. 1957), 41.

30. Carraro, "Seeing Red," 254.

31. "Within Limits," *Time*, Dec. 18, 1950, p. 49; Henry McBride, "Wyeth: Serious Best Seller," *ARTNews* 52 (Nov. 1953), 39–40; Aline B. Loucheim, "Wyeth—Conservative Avant-Garde," *NYT Sunday Magazine*, Oct. 25, 1953, p. 28.

32. Rachel E. Somerstein, "Biennale as Battlefield: The Museum of Modern Art and the CIA at the Venice Biennale, 1948–1956" (senior honors thesis in history, Cornell University, 2004); Serge Guilbaut, *How New York Stole the Idea of Modern Art: Abstract Expressionism, Freedom, and the Cold War* (Chicago, 1983).

33. John Russell, "Pop Reappraised," *Art in America* 57 (July 1969), 78–89, the quotation is on 84.

34. Benjamin Buchloh, *Neo-Avantgarde and Culture Industry: Essays on European and American Art from 1955 to 1975* (Cambridge, Mass., 2000), 467. But for the ways in which Warhol degraded notions of participation in art to the level of farce, see 482.

35. Robert Haywood, "Demon in the Kitchen: Oldenburg's Alterations," *Art in America* 83 (Oct. 1995), 86–93, 139; Russell, "Pop Reappraised," 84.

36. Russell, "Pop Reappraised," 81–84.

37. "The Artist and Politics: A Symposium," *Artforum* 9 (Sept. 1970), 35–39; Therese Schwartz, "The Politicization of the Avant-Garde," *Art in America* 59 (Nov.–Dec. 1971), 96–105; and *Art in America* 60 (Mar.–Apr. 1972), 70–79. See especially Lucy R. Lippard, *A Different War: Vietnam in Art* (Ex. cat.: Seattle, 1990), 17–18, 20–22, 29–34.

38. "A Haunting New Vision of the Little Big Horn," *American Heritage* 21 (June 1970), 101–03.

39. Ibid., 102; Robert M. Utley, *Custer Battlefield National Monument, Montana* (Washington, D.C., 1969), 35–37.

40. Robert M. Utley, *Custer and Me: A Historian's Memoir* (Norman, Okla., 2004), 114–17. According to Utley, the drawings "resonated with some kind of responsive

chord in the public. To the modern generation, Baskin's brooding portrayal is probably the best known of all the hundreds of representations, photographic and artistic alike, of George Armstrong Custer" (116).

41. Ray Baker and Melissa Cronyn (Publications Division of the National Park Service) to the author, Jan. 20, 2004; Robert M. Utley, *Custer Battlefield. A History and Guide to the Battlefield of the Little Bighorn* (Washington, D.C., 1987).

42. *Critical Issues in Public Art: Content, Context, and Controversy,* ed. Harriet F. Senie and Sally Webster (Washington, D.C., 1992), 237–40; *Chicago Tribune,* Aug. 16, 1967, p. 1. Coverage of his art in *Time* had long been obsessed about Picasso and Communism. See Aug. 25, 1947, p. 68.

43. *Chicago Tribune,* Aug. 16, 1967, p. 2; *Chicago Tribune,* Aug. 17, 1967, p. 2; Senie and Webster, *Critical Issues in Public Art,* 243–45.

44. John Canaday, "Picasso in the Wilderness," *NYT,* Aug. 27, 1967, sec. 2, p. 23.

45. Senie and Webster, *Critical Issues in Public Art,* 239.

46. Douglas Davis, "Public Art: The Taming of the Vision," *Art in America* 62 (May 1974), 84–85.

47. Ibid.

48. Gifford Phillips, "A Vote for the Highbrow Museum," *Art in America* 69 (Jan. 1981), 9.

49. Ibid., 10–11. For his earlier, more hopeful position, see Gifford Phillips, *The Arts in a Democratic Society* (Santa Barbara, Calif.: Fund for the Republic, 1966).

50. Donald B. Kuspit, "Art, Criticism, and Ideology," *Art in America* 69 (1981), 93–97, 147.

51. Timothy W. Luke, *Shows of Force: Power, Politics, and Ideology in Art Exhibitions* (Durham, N.C., 1992), 155–56, 169–77.

52. Rosalyn Deutsche et al., *Hans Haacke: Unfinished Business* (Cambridge, Mass., 1986); Hans Haacke, *Framing and Being Framed: 7 Works, 1970–1975* (Ex. cat.: New York, 1975).

53. *Boston Globe,* Sept. 10, 1995, p. A6.

54. Ibid; *Nation,* Jan. 26, 1998, p. 10.

55. "Respect the Flag," *American Monthly Magazine* 3 (1893), 447–49.

56. Ibid.

57. *Desecrating the American Flag: Key Documents of the Controversy from the Civil War to 1995,* ed. Robert Justin Goldstein (Syracuse, N.Y., 1996), 142.

58. Ibid., 143; http://www.cd.sc.ehu.es/FileRoom/documents/Cases/329dread .html.

59. Ibid; Goldstein, *Desecrating the American Flag,* 155–57.

60. "Floor Flag Artist Goes on the Carpet" (AP story), Feb. 1989. http:// portfolio.iu.edu/rreagan/floor_flag.html.

61. The well-illustrated sixty-three-page catalog is titled *Old Glory: The American Flag in Contemporary Art* (Cleveland, 1994).

62. *Cleveland Plain Dealer,* June 19, 1994, p. 3K; *Cleveland Plain Dealer,* Oct. 4, 1994, p. 11E.

63. *Phoenix New Times,* Apr. 4, 1996.

64. Ibid.

65. *NYT,* Apr. 29, 1996, p. A15; *Phoenix New Times,* May 2, 1996.

66. Ibid.

67. Lucy Lippard, "Out of the Safety Zone," *Art in America* 78 (Dec. 1990), 130–39.

68. Felix Guattari, "David Wojnarowicz," *Rethinking Marxism* 3, no. 1 (1990), translation at http://www.arts.monash.edu.au/visarts/globe/issue6/davwoj

.html; "Tongues of Flame," http://www.cd.sc.ehu.es/FileRoom/documents/Cases/340wojnarowicz.html.

69. "Art on the Cutting Edge," *Newsweek*, April 11, 1994, p. 79; *Washington Times*, June 24, 1994, p. A22; AP report, June 20, 1994, http://web.lexis-nexis.com/universe/printdoc.

70. Jan Breslauer, "The Body Politic," *Los Angeles Times*, July 2, 1994, p. F1.

71. *WP*, July 26, 1994, p. E1; Senator Daniel Patrick Moynihan to the author, Oct. 18, 1994.

72. Carol Becker, "The Brooklyn Controversy: A View from the Bridge," in *Unsettling "Sensation": Arts-Policy Lessons from the Brooklyn Museum of Art Controversy*, ed. Lawrence Rothfield (New Brunswick, N.J., 2001), 21.

73. Conducted by Research & Forecasts, Mar. 14–26, 1990 (USRF.90ART.R06.), RCPOR.

74. Center for Survey Research and Analysis, Apr. 3–26, 2000 and June 12–July 5, 2002 (USCSRA.00AMEND.R13 and USCSRA.02AMEND.R18), RCPOR.

75. Ibid., June 3–June 15, 2003 (USCSRA.03AMEND.R17), RCPOR.

Chapter 6: The Pivotal 1960s

1. See Clement Greenberg, *The Collected Essays and Criticism*, ed. John O'Brian (Chicago, 1993), 4: 75–84, 121–34, 176–83.

2. Diana Crane, *The Transformation of the Avant-garde: The New York Art World, 1940–1985* (Chicago, 1987), 53; *Pop Art: A Critical History*, ed. S. H. Madoff (Berkeley, Calif., 1997).

3. Arthur C. Danto, *Encounters and Reflections: Art in the Historical Present* (New York, 1990), 274, 299, and 50–56 for "disgust."

4. Robert Hughes, *Nothing If Not Critical: Selected Essays on Art and Artists* (New York, 1990), 396. For the wild escalation of art values in the 1970s and '80s and its impact upon artists and dealers, see Anthony Haden-Guest, *True Colors: The Real Life of the Art World* (New York, 1996).

5. Thomas M. Messer, "Impossible Art—Why It Is," *Art in America* 57 (May 1969), 30–31; Dorothy Gees Seckler, "The Artist in America: Victim of the Cultural Boom?" *Art in America* 51, no. 6 (1963), 27–39.

6. Jeffrey Deitch, "Issues and Commentary: The Warhol Product," *Art in America* 68 (May 1980), 9, 11, 13.

7. Peter L. Walsh, "This Invisible Screen: Television and American Art," *American Art* 18 (Summer 2004), 2–9.

8. Arthur C. Danto, *After the End of Art: Contemporary Art and the Pale of History* (Princeton, N.J., 1997), 46–47; Danto, "Art After the End of Art," in Danto, *Embodied Meanings: Critical Essays and Aesthetic Meditations* (New York, 1994), 321–33. For a typical endorsement see Corinne Robins, "Burnham's Burden: Art Is Over . . . Again," *Art in America* 60 (March 1972), 14–15.

9. Grace Glueck, "New York Gallery Notes: Who's Minding the Easel," *Art in America* 56 (Jan. 1968), 110. See also Jay Jacobs, "The Iceman Cometh—Symptoms of the Seventies," *Art in America* 58 (Jan. 1970), 62–67.

10. Lucy R. Lippard, *A Different War: Vietnam in Art* (Ex. cat.: Seattle, 1990), esp. 17–22, 29–34; *Modernism in Dispute: Art Since the Forties*, ed. Paul Wood (New Haven, Conn., 1993), 93; Susan Sontag, *Against Interpretation* (New York, 1966), 268; Robert Hughes, *American Visions: The Epic History of Art in America* (New York, 1997), 530.

11. Nancy Einreinhofer, *The American Art Museum: Elitism and Democracy* (London, 1997), chap. 6; Naomi N. Rosenblum, "A Retrospective Look at the Acceptance

of Photography as Fine Art," in *Master Photographs from PFA Exhibitions, 1959–1967*, ed. Cornell Capa (Ex. cat.: San Francisco, 1988), 30–39. See also 26–29.

12. Thomas Messer, "What Should a Museum Be?" *Art in America* 49, no. 2 (1961), 23.

13. Paul Wood et al., *Modernism in Dispute: Art Since the Forties* (New Haven, Conn. 1993), 122; Hans Haacke, "Museums, Managers of Consciousness," in *Hans Haacke: Unfinished Business*, ed. Brian Wallis (Ex. cat.: Cambridge, Mass., 1986), 35; Rosalyn Deutsche, *Evictions: Art and Spatial Politics* (Cambridge, Mass., 1996), 166.

14. Barbara Rose, "Blowup—The Problem of Scale in Sculpture," *Art in America* 56 (July 1968), 80–91, the quotation is on 80.

15. Judith Goldman, *James Rosenquist* (New York, 1985), 40–44; *NYT*, May 13, 1965, p. 39.

16. Kramer, "A New Hangar for Rosenquist's Jet-Pop 'F-111,' " *NYT*, Feb. 17, 1968, p. 2S.

17. John Canaday, "It Would Be Awfully Nice If We Were All Wrong About the Whole Thing," *NYT*, Feb. 25, 1968, sec. 2, p. 23; Danto, *Encounters and Reflections*, 75.

18. Arthur C. Danto, *Beyond the Brillo Box: The Visual Arts in Post-Historical Perspective* (New York, 1992), esp. 36–41; Danto, "BLAM! The Explosion of Pop, Minimalism and Performance, 1958–1964," in Danto, *The State of the Art* (New York, 1987), 8–12.

19. David Bourdon, *Warhol* (New York, 1989), 350–51.

20. Bruce Altshuler, *The Avant-Garde in Exhibition: New Art in the Twentieth Century* (New York, 1994), 214–19. Huntington Hartford, who disliked most contemporary art, snidely observed in 1964 that when Janis was starting out as a dealer he carefully selected artists like de Kooning and Kline whose flagrant novelty could make them notorious, and therefore highly visible and trendy. See his *Art or Anarchy? How the Extremists and Exploiters Have Reduced the Fine Arts to Chaos and Commercialism* (Garden City, N.Y., 1964), 140–41.

21. Irving Sandler, "The New Cool-Art," *Art in America* 53 (1965), 96–101; Octavio Paz quoted in Suzi Gablik, "Art on the Capitalist Faultline," *Art in America* 68 (Mar. 1980), 9, 11.

22. Danto, "Bad Aesthetic Times," in *Encounters and Reflections*, 297–312. For multiple examples of "master-baiting," see Anthony Julius, *Transgressions: The Offences of Art* (Chicago, 2002), 130, 133–35, 170, 204–05. For excellent examples by the African-American artist Robert Colescott, see "Paint Misbehavin'?—Robert Colescott's Black Stereotypes Draw Fire," *Seattle Times*, May 25, 1989, p. H1.

23. Emily Genauer, "A Critical Inquiry: The Purpose of Art in Our Time," *Art in America* 49, no. 4 (1961), 26–29. For a perspective that seems to have been headed in the opposite (and wrong) direction, see Gifford Phillips, *The Arts in a Democratic Society* (Santa Barbara, Calif.: Fund for the Republic, 1966), 7: "the evidence is impressive that the qualitative level of art presented to the public is rising."

24. Emily Genauer, *Rufino Tamayo* (New York, 1974), 22; Steven C. Dubin, *Displays of Power: Controversy in the American Museum from the "Enola Gay" to "Sensation"* (New York, 1999), 27.

25. Gerald Silk, "Censorship and Controversy in the Career of Edward Kienholz," in *Suspended License: Censorship and the Visual Arts*, ed. Elizabeth C. Childs (Seattle, 1997), 259–72.

26. Ibid., 281.

27. Ibid., 273–76.

28. Ibid., 275–76.

29. Ibid., 276–77.

30. Ibid., 277–78.

31. Ibid., 283–84. For his major retrospective at the Whitney Museum of American Art, see *NYT*, Mar. 1, 1996, sec. C, p. 21; for his obituary, *NYT*, June 13, 1994, sec. D, p. 10.

32. David Sylvester, *Jasper Johns Flags, 1955–1994* (London, 1996).

33. *Village Voice*, Apr. 14, 1966, p. 7.

34. Robert Justin Goldstein, *Saving "Old Glory": The History of the American Flag Desecration Controversy* (Boulder, Colo., 1995), 112–13.

35. C. C. Cunningham to Stephen Radich, Feb. 1, 1967; Lessing J. Rosenwald (National Gallery of Art) to Radich, Jan. 20, 1967, Stephen P. Radich Papers, box 8, AAA.

36. Goldstein, *Saving "Old Glory,"* 113; Laurie Adams, "Our Flag Was Still There: The People of the State of New York v. Stephen Radich," in Adams, *Art on Trial: From Whistler to Rothko* (New York, 1976), 141–68.

37. Goldstein, *Saving "Old Glory,"* 113; Hilton Kramer, "A Case of Artistic Freedom," *NYT*, Mar. 1, 1970, sec. D, p. 25.

38. Goldstein, *Saving "Old Glory,"* 113–14.

39. All of the incoming mail cited has been preserved in box 8 of the Stephen P. Radich Papers, AAA. I am also grateful to Radich for clippings and other documents that he sent me on several occasions during 2003.

40. Grace Glueck, "Oh, Say, Can You See . . ." *NYT*, May 21, 1967, sec. 2, p. 33.

41. *NYT*, Feb. 19, 1970, p. 49. Clippings are in Radich Papers, box 8, AAA.

42. Carl R. Baldwin, "Art and the Law: The Flag in Court Again," *Art in America* 62 (May 1974), 50–54.

43. Stephen Radich, interview by Paul Cummings, Feb. 18 and 29, 1972, TS. p. 83, AAA.

44. Goldstein, *Saving "Old Glory,"* 115–17.

45. Marc Morrel to Stephen Radich, Nov. 25, 1974, Radich Papers, box 8, AAA.

46. Goldstein, *Saving "Old Glory,"* 115.

47. *NYT*, Dec. 1, 1970, p. 61.

48. Lucy Lippard, "The Art Workers Coalition: Not a History," in Lippard, *A Decade of Art for Social Change* (New York, 1984), 10–19; Bradford D. Martin, *The Theater Is in the Street: Politics and Performance in Sixties America* (Amherst, Mass., 2004), chap. 4.

49. The text prepared for the open hearing of the Art Workers Coalition, April 10, 1969, and statements read by many artists (Hans Haacke, Sol LeWitt, Barnett Newman, and others) will be found in the Lucy Lippard Papers, box 8, AAA. Also the list of thirteen demands presented on Jan. 13, 1969, to Bates Lowry, the director of MoMA, and MoMA's point-by-point response in July 1969.

50. *NYT*, May 19, 1970, p. 30.

51. WSABAL press release dated June 24, 1970, Lippard Papers, box 8, AAA.

52. Copy in Radich Papers, box 8, AAA.

53. *NYT*, Jan. 17, 1969, p. 28. For Hoving's semiregretful version of the entire episode, see his autobiographical *Making the Mummies Dance: Inside the Metropolitan Museum of Art* (New York, 1993), chap. 11.

54. *NYT*, Jan. 12, 1969, sec. 2, p. 25; *NYT*, Jan. 17, 1969, p. 28; *NYT*, Jan. 19, 1969, sec. 2, p. 31.

55. *NYT*, Jan. 15, 1969, p. 41.

56. *NYT*, Jan. 17, 1969, pp. 1, 28.

57. *NYT*, Jan. 18, 1969, pp. 1, 32. Ten days later came the bizarre revelation that some of the young student's ideas and very words had been directly borrowed without

attribution from a well-known book coauthored by Nathan Glazer and Daniel Patrick Moynihan, *Beyond the Melting Pot: The Negroes, Puerto Ricans, Jews, Italians, and Irish of New York City* (Cambridge, Mass., 1963), 71–73, 77. The section concerning blacks and Jews was written by Glazer, who is Jewish. See *NYT*, Jan. 29, 1969, p. 22.

58. *NYT*, Jan. 21, 1969, p. 32; *NYT*, Jan. 22, 1969, p. 96.

59. *NYT*, Jan. 29, 1969, p. 30; *NYT*, Jan. 31, 1969, pp. 1, 77, 38. For a paid, half-page statement by the American Jewish Congress, see *NYT*, Jan. 1, 1969, p. 21.

60. *NYT*, Jan. 22, 1969, p. 46; *NYT*, Jan. 25, 1969, p. 28.

61. *NYT*, Jan. 27, 1969, p. 35; *NYT*, Jan. 30, 1969, p. 38.

62. *NYT*, Jan. 26, 1969, sec. 2, p. 31. Copyright © 1969 by The New York Times Co. Reprinted with permission.

63. *Whose Muse? Art Museums and the Public Trust*, ed. James Cuno (Princeton, N.J., 2003); Timothy W. Luke, *Shows of Force: Power, Politics, and Ideology in Art Exhibitions* (Durham, N.C., 1992); Karl E. Meyer, *The Art Museum: Power, Money, Ethics* (New York, 1979).

64. Brian O'Doherty, "Public Art and the Government: A Progress Report," *Art in America* 62 (May 1974), 44–49.

65. H. H. Arnason, *Robert Motherwell* (New York, 1977), 64–68; Jack D. Flam, *Motherwell* (New York, 1991), 128.

66. Motherwell with E. A. Carmean Jr., *Reconciliation Elegy* (New York, 1980), 72–73; H. H. Arnason, *Robert Motherwell* (New York, 1974), 67–68.

67. "Abstract Painting of JFK Death Scene Stirs Furor," *Boston Globe*, Aug. 12, 1966, p. 26.

68. Herbert A. Kenny, "Art Furor: Kennedy Painting Stirs Controversy— Misinterpreted, Says the Artist," *Boston Globe*, Aug. 12, 1966, late ed., p. 1.

69. Ann-Mary Currier, "Reaction: Confused . . . Appalled," *Boston Globe*, Aug. 12, 1966, p. 19.

70. Cathleen Cohen, "Artist Says Mural Doesn't Depict Death of Kennedy," *Boston Globe*, Aug. 13, 1966, p. 12.

71. Letter from Robert Nason, *Boston Globe*, Aug. 26, 1966, p. 18.

72. Anthony J. Yudis, "Dedication Sidelights," *Boston Globe*, Sept. 9, 1966, p. 36.

73. Donald Thalacker, *The Place of Art in the World of Architecture* (New York, 1980), xii.

74. Arthur C. Danto, "Public Art and the General Will," *Nation*, Sept. 28, 1985, pp. 288–90; Milton Esterow, "How Public Art Becomes a Political Hot Potato," in *Going Public: A Field Guide to Developments in Art in Public Places*, ed. Jeffrey Cruikshank and Pam Korza (Amherst, Mass., 1986), 240–43.

75. *Art in America* 57 (May/June 1969), Messer on 30–31, Shirley on 32.

76. Alloway, *Topics in American Art Since 1945* (New York, 1975), 258–59.

Chapter 7: The Dimensions and Dilemmas of Public Sculpture

1. William C. Seitz, *Art in the Age of Aquarius, 1955–1970* (Washington, D.C., 1992), chap. 8; Donald W. Thalacker, *The Place of Art in the World of Architecture* (New York, 1980); Kate Linker, "Public Sculpture," *Artforum* 19 (Mar. and Summer 1981), 64–73 and 37–42; *Going Public: A Field Guide to Developments in Art in Public Places*, ed. Jeffrey Cruikshank and Pam Korza (Amherst, Mass., 1986).

2. For a work that seeks to be prescriptive but without historical perspective, see Margaret A. Robinette, *Outdoor Sculpture: Object and Environment* (New York, 1976).

3. See Karal Ann Marling, *Wall-to-Wall America: A Cultural History of Post-Office Murals in the Great Depression* (Minneapolis, 1984).

4. For a brief but insightful discussion, see Lawrence Alloway, "The Public Sculpture Problem" (1972) in Alloway, *Topics in American Art Since 1945* (New York, 1975), 245–50.

5. John Beardsley, *Art in Public Places: A Survey of Community-Sponsored Projects Supported by the NEA* (Washington, D.C., 1981), 71.

6. Ibid., 72.

7. Thalacker, *Place of Art*, 26–31, 120–25.

8. Masayo Duus, *The Life of Isamu Noguchi: Journey without Borders* (Princeton, N.J., 2004), 334; Jiminez is quoted in John Beardsley, "Personal Sensibilities in Public Places," *Artforum* 19 (Summer 1981), 44.

9. George McCue, *Sculpture City: St. Louis* (New York, 1988), 88.

10. Ibid., 90–91. In 1871 a local sculptor carved two elderly gentlemen for the stone pediment of Bissell's Point Waterworks in St. Louis. He called them *Union of the Waters*, so Milles had a nonproblematic, mediating precedent. Ibid., 42.

11. B. H. Friedman, "Who's Afraid of Modern Art?" *Art in America* 52 (1964), 136.

12. Ibid., 138.

13. James Wines, "Public Art and Private Gallery," *Art in America* 58 (Jan. 1970), 74–75; Irving Sandler, *Mark di Suvero at Storm King Art Center* (New York, 1996), 28–29.

14. *NYT*, June 16, 1969, p. 60; Joan M. Marter, *Alexander Calder* (New York, 1991), 242.

15. Beardsley, *Art in Public Places*, 16.

16. Curt Wozniak, "The Birth of *La Grande Vitesse*," *Grand Rapids* 41 (June 2004), 14.

17. *Chicago Tribune*, Oct. 26, 1974, pp. 1, 4. See also *NYT*, Feb. 9, 1974, p. 33; *Chicago Tribune*, Oct. 24, 1974, sec. 3, p. 1.

18. Brian O'Doherty, "Public Art and the Government: A Progress Report," *Art in America* 62 (May 1974), 44.

19. Thalacker, *Place of Art*, 164.

20. Ibid., 165–66.

21. Ibid., 166–67; Beardsley, *Art in Public Places*, 20–21.

22. Thalacker, *Place of Art*, 8.

23. Ibid., 12.

24. Ibid., 13; H. T. Day, *The Shape of Space: The Sculpture of George Sugarman* (New York, 1981).

25. Thalacker, *Place of Art*, 14–15.

26. Ibid., 16–17.

27. Philip C. Johnson, "War Memorials: What Price Aesthetic Glory?" *ART-News*, Sept. 1, 1945, pp. 9–10, 24–25.

28. Jo Ann Lewis, "A Modern Medici for Public Art," *ARTNews* 76 (April 1977), 37–41.

29. Grace Glueck, "Art in Public Places Stirs Widening Debate," *NYT*, May 23, 1982, sec. 2, pp. 1, 30.

30. Thalacker, *Place of Art*, 48–51.

31. Ibid., 52–53.

32. Michael North, "The Public as Sculpture: From Heavenly City to Mass Ornament," in *Art and the Public Sphere*, ed. W.J.T. Mitchell (Chicago, 1992), 10–11.

33. Don Hawthorne, "Does the Public Want Public Sculpture?" *ARTNews* 81 (May 1982), 61.

34. Lawrence Alloway, "Public Sculpture for the Post-Heroic Age," *Art in America* 67 (Oct. 1979), 9–11; Beardsley, *Art in Public Places*, 18–19.

35. "Sculpture Out in the Open," *Newsweek*, Aug. 18, 1980, 70–71.

36. Glueck, "Art in Public Places," pp. 1, 30.

37. Douglas Stalker and Clark Glymour, "The Malignant Object: Thoughts on Public Sculpture," *Public Interest* 66 (Winter 1982), 3–15

38. Ibid., 15, 18–20.

39. "Dissent and Reply," ibid., 22–54.

40. Thalacker, *Place of Art*, 2–3.

41. Ibid., 3–4.

42. I am indebted to the research paper of a former student, Lucas Zier, "Portrait of the Bust That Was a Bust: An Examination of the George Moscone Sculpture Controversy" (Cornell University, 2003), Cornell University, Kroch Library, Special Collections.

43. Alan Temko, "What Went Wrong," *San Francisco Chronicle*, Dec. 10, 1981, p. C18.

44. Scott Winokur, "Artist Defends Moscone Statue as a 'Piece for the People,' " *San Francisco Chronicle*, Dec. 3, 1981, p. B6; Ellen O'Leary, "All Things Considered," National Public Radio, Dec. 18, 1981. I am obliged to Lucas Zier for locating this story.

45. Marshall Kilduff, "New Furor at Moscone Hall," *San Francisco Chronicle*, Dec. 3, 1981, p. A1.

46. Ibid.

47. Michael Grieg, "Statue Furor Heats Up," *San Francisco Chronicle*, Dec. 4, 1981, p. A1.

48. Thomas Albright, "Arneson's View of Life in Sculpture," *San Francisco Chronicle*, Dec. 4, 1981, p. A25; *San Francisco Examiner*, Dec. 8, 1981, p. A16.

49. *San Francisco Chronicle*, Dec. 8, 1981, p. 58; Michael Grieg, "Strong Dislike for Statue," *San Francisco Chronicle*, Dec. 10, 1981, p. A2; "In Memoriam, in Storage," *ARTNews*, 81 (Feb. 1982), 13–14.

50. Evelyn Hsu and Michael Grieg, "Moscone Sculptor Might Keep Fee," *San Francisco Chronicle*, Dec. 9, 1981, p. A1.

51. Jeff Jarvis, "How Artist Put S.F. (and Himself) On," *San Francisco Examiner*, Dec. 10, 1981, p. A1.

52. "In Memoriam, in Storage," *ARTNews* 81 (Feb. 1982), 13–14.

53. The most astute and judicious account of this episode remains Casey Nelson Blake, "An Atmosphere of Effrontery: Richard Serra, *Tilted Arc*, and the Crisis of Public Art," in *The Power of Culture: Critical Essays in American History*, ed. Richard Wightman Fox and T. J. Jackson Lears (Chicago, 1993), 247–89.

54. Dario Gamboni, *The Destruction of Art: Iconoclasm and Vandalism since the French Revolution* (London, 1997), 156–57.

55. Ibid., 157, 160; Blake, "An Atmosphere of Effrontery," 254–55.

56. Blake, "An Atmosphere of Effrontery," 264–65.

57. Rosalyn Deutsche, *Evictions: Art and Spatial Politics* (Cambridge, Mass., 1996), 265.

58. Calvin Tomkins, "Tilted Arc," *New Yorker*, May 20, 1985, p. 98.

59. Ibid., 99. Lane's testimony is never mentioned in *The Destruction of Tilted Arc: Documents*, ed. Clara Weyergraf-Serra and Martha Buskirk (Cambridge, Mass., 1991).

60. Ibid., 95, 100–01.

61. See Erika Doss, *Spirit Poles and Flying Pigs: Public Art and Cultural Democracy in American Communities* (Washington, D.C., 1995).

62. *Public Art, Public Controversy: The Tilted Arc on Trial*, ed. Robert A. Porter (New York, 1987), 24–25; Tomkins, "Tilted Arc," 100.

63. Blake, "An Atmosphere of Effrontery," 266, 268–69.

64. Ibid., 276–86; Gamboni, *Destruction of Art*, 157–63.

65. Hilton Kramer, "Richard Serra at MoMA," in *The New Criterion Reader: The First Five Years*, ed. Kramer (New York, 1988), 324.

66. See *Critical Issues in Public Art: Content, Context, and Controversy*, ed. Harriet F. Senie and Sally Webster (Washington, D.C., 1992), 241–42, 280–94; Elizabeth Kastor, "Arts Advocacy Heating Up; On the Eve of NEA Hearings, Artists Rally at Capitol," *WP*, Mar. 21, 1990, p. C1.

67. Hawthorne, "Does the Public Want Public Sculpture?" 62–63.

68. *NYT*, Mar. 7, 1986, p. C19; McCue, *Sculpture City: St. Louis*, 142, 147–49 (large color plates of *Twain*).

69. *NYT*, Mar. 7, 1986, p. C19.

70. Cruikshank and Korza, *Going Public: A Field Guide to Developments in Art and Public Places*, 164–65.

71. Arthur C. Danto, "Public Art and the General Will," in Danto, *The State of the Art* (New York, 1987), 118–23; *NYT*, Nov. 2, 1987, sec. A, p. 16.

72. Charlene Prost, "Public Art: St. Louis Puts Off Projects while Drawing Up a Policy," *St. Louis Post-Dispatch*, Oct. 21, 1990, p. 4B; *St. Louis Post-Dispatch*, Mar. 29, 1998, pp. E1, 5, 7.

73. *NYT*, Oct. 8, 1989, sec. 6, p. 39; *St. Louis Post-Dispatch*. Oct. 7, 2001, p. G1.

74. Eric Gibson, "Jennifer Bartlett and the Crisis of Public Art," (1990) in *Against the Grain: The New Criterion on Art and Intellect at the End of the Twentieth Century*, ed. Hilton Kramer and Roger Kimball (Chicago, 1995), 167. For the endurance of "plop art" in discussions of public sculpture, see Jeff Daniel, "Serra on Serra," *St. Louis Post-Dispatch*, Mar. 2, 2003, p. F1, an essay review of an exhibition of Serra's work at the Pulitzer Foundation for the Arts in St. Louis.

75. Patricia Failing, "After *Tilted Arc*, Richard Serra Thought He'd Found a Way to Protect His Public Commissions," *ARTNews*, 93 (Oct. 1994), 150–53.

76. Ibid.; for this and the next two projects I am indebted to a paper written by University of Chicago sociologist Kim M. Babon, "Why Is That *Here*? Context and Controversy in the City of Love" (2003), 2, 9–10.

77. Ibid., 11–13.

78. Ibid., 16–17.

79. Ibid., 20.

80. John McWilliams, *New England's Crises and Cultural Memory: Literature, Politics, History, Religion, 1620–1860* (New York, 2004), 114.

81. Ibid., 31.

82. See *NYT*, Nov. 7, 1997, p. E37; *Village Voice*, Nov. 18, 1997, p. 107; Thyrza Goodere and Barbara Kruger, "The Art of Public Address" (an interview), *Art in America* 85 (Nov. 1997), 92–99.

83. Michael Duncan, "Transient Monuments," *Art in America* 83 (Apr. 1995), 78–83; Kathryn Kanjo, *Nancy Rubins* (Ex. cat.: San Diego, Calif., 1995).

84. Jo Ann Lewis, "It's Called Art, But Some Say It Art Not" [sic], *WP*, July 17, 1982, p. B5; *WP*, July 31, 1982, p. B2.

85. *WP*, Dec. 18, 1982, p. C1.

86. McCue, *Sculpture City: St. Louis*, 161–62.

87. *Chicago Sun-Times*, Sept. 16, 1993, p. 21; *Chicago Sun-Times*, Oct. 25, 1993, p. 28; *Chicago Sun-Times*, Nov. 8, 1993, p. 3.

88. *Chicago Sun-Times*, Sept. 10, 1993, p. 20; ibid., Oct. 25, 1993, p. 28.

89. http://www.cd.sc.ehu.es/FileRoom/documents/Cases/212stella.html. I am grateful to the late Professor George Roeder of the School of the Art Institute for vis-

iting the Metcalfe Building in May 2004 and making inquiry of the security guards who were on duty at the time.

90. Judith H. Balfe and Margaret J. Wyszomirski, "The Commissioning of a Work of Public Sculpture," in Porter, *Public Art, Public Controversy*, 22.

91. John Beardsley, "Paradigms in Public Sculpture," *Public Interest* 66 (Winter 1982), 27.

Chapter 8: The Art Museum Transformed

1. Annie Cohen-Solal, *Painting American: The Rise of American Artists, Paris 1867–New York 1948* (New York, 2001), 284; Neil Harris, *Cultural Excursions: Marketing Appetites and Cultural Tastes in Modern America* (Chicago, 1990), chaps. 3, 7, and 9.

2. "Is This an Age of Museums?" *Salmagundi* 139 (Summer 2003), 117, 130.

3. "What Should a Museum Be?" *Art in America* 49, no. 2 (1961), 23, 29.

4. Ibid., 32–33. See also Harold Rosenberg, "Museum of the New," in Rosenberg, *Artworks and Packages* (New York, 1969), 144–50.

5. Harvey Einbinder, *An American Genius: Frank Lloyd Wright* (New York, 1986), 378–81.

6. John Canaday, "Wright v. Painting," *NYT*, Oct. 21, 1959, p. 1; Ada Louise Huxtable, "That Museum: Wright or Wrong?" *NYT Sunday Magazine*, Oct. 25, 1959, pp. 16, 91.

7. Neil Levine, *The Architecture of Frank Lloyd Wright* (Princeton, N.J., 1996), 299–301, 347.

8. Nancy Einreinhofer, *The American Art Museum: Elitism and Democracy* (London, 1997), chap. 6.

9. Karl E. Meyer, *The Art Museum: Power, Money, Ethics* (New York, 1979).

10. Cary Reich, *The Life of Nelson A. Rockefeller: Worlds to Conquer, 1908–1958* (New York, 1996), 101–03.

11. *NYT*, May 3, 1932, p. 19; *New York Herald Tribune*, May 3, 1932, p. 23; *New Masses*, June 1932, p. 29.

12. Reich, *Life of Rockefeller*, 104–05; Lincoln Kirstein and Julien Levy, *Murals by American Painters and Photographers* (Ex. cat.) in *American Art of the 20's and 30's* (New York: MoMA, 1969), pt. 3.

13. *Whistler's Mother: An American Icon*, ed. Margaret F. MacDonald (Aldershot, Hampshire, 2003), chap. 4; Leigh Eric Schmidt, *Consumer Rites: The Buying and Selling of American Holidays* (Princeton, N.J., 1995), chap. 5.

14. MacDonald, *Whistler's Mother*, 86–88, 96–99.

15. Nathaniel Burt, *Palaces for the People: A Social History of the American Art Museum* (Boston, 1977), 279–81; Howard Greenfield, *The Devil and Dr. Barnes: Portrait of an American Art Collector* (New York, 1987), 90–96; Stewart Beuttner, "Dewey and the Visual Arts," *Journal of Aesthetics and Art Criticism* 33 (Summer 1975), 383–91.

16. Greenfield, *Devil and Dr. Barnes*, 163–67. Mark Mattern makes the important point that while Dewey cared a great deal about art, he managed to erase conflict, negotiation, and contestation—in short, politics and power—from the world of art. "John Dewey, Art, and Public Life," *Journal of Politics* 61 (Feb. 1999), 55.

17. Burt, *Palaces for the People* 280–82; Greenfield, *Devil and Dr. Barnes*, 187–90. There are laudatory references to Barnes in Dewey's influential book *Art as Experience* (New York, 1934).

18. John Anderson, *Art Held Hostage: The Battle over the Barnes Collection* (New York, 2003); Greenfield, *Devil and Dr. Barnes*, 287–92.

19. Gabriella De Ferrari, "Private Art in Public," *NYT*, Oct. 21, 2002, p. A19;

"Barnes CEO says moving to Philly would help fulfill its mission," AP State and Local Wire, Dec. 9, 2003, http://www.barnesfoundation.org/load-date: Dec. 10, 2003.

20. Barry Hyams, *Hirshhorn: Medici from Brooklyn* (New York, 1979), 136–38.

21. Ibid., 138–53. Ripley had been a strong advocate for upgrading the educational role of American museums. See his collection of essays, *The Sacred Grove: Essays on Museums* (New York, 1969), chaps. 6–8.

22. Hyams, *Hirshhorn*, 155–56.

23. Ibid., 156.

24. Ibid.

25. Ibid., 158; Aline Saarinen, *The Proud Possessors* (New York, 1958), 269–86; Jay Jacobs, "Collector: Joseph H. Hirshhorn," *Art in America* 57 (July 1969), 56–71.

26. Hyams, *Hirshhorn*, 165–66.

27. Ibid., 166.

28. Ibid., 170–71.

29. Ibid., 171.

30. Ibid., 192–93.

31. Ibid., 193.

32. *WP*, May 6, 1979, sec. N, p. 1.

33. *WP*, Sept. 1, 1981, p. A1.

34. The quotation is from James W. Cook, *The Arts of Deception: Playing with Fraud in the Age of Barnum* (Cambridge, Mass., 2001), 73; and see Neil Harris, *Humbug: The Art of P. T. Barnum* (Boston, 1973).

35. Shirley Abbott, *The National Museum of American History* (New York, 1981); Steven Lubar and Kathleen M. Kendrick, *Collecting America's History at the Smithsonian* (Washington, D.C., 2001); George W. McDaniel, *Hearth and Home: Preserving a People's Culture* (Philadelphia, 1982), 3–28.

36. Ellen Roney Hughes, "The Unstifled Muse: The 'All in the Family' Exhibit and Popular Culture at the National Museum of American History," in *Exhibiting Dilemmas: Issues of Representation at the Smithsonian*, ed. Amy Henderson and Adrienne L. Kaeppler (Washington, D.C., 1997), 156–63.

37. Ibid., 164–66.

38. Ibid., 167–73; *WP*, Mar. 6, 1978, p. B1; *WP*, Sept. 20, 1978, p. D1; *NYT*, Nov. 6, 1978, p. 53.

39. James F. Clarity, "Editing Nation's Attic," *NYT*, July 4, 1985, p. A14.

40. Steve Rushin, "Memories Are Made of This," *Sports Illustrated*, June 28, 2004, p. 15. For the display of Jerry Seinfeld's "frilly" shirt at NMAH, see Owen Edwards, "The Shirt Off His Back," *Smithsonian*, Mar. 2005, 20–22.

41. Hilton Kramer, "The National Gallery Is Growing: Risks and Promises," *NYT*, June 9, 1974, sec. 2, p. 19.

42. Between August 6 and September 6, 1986, the *New York Times* ran at least eight lengthy news stories and features about this unfolding saga and all the attendant speculation as to what it meant. They continued with less intensity during the fall and winter.

43. Paul Richards, "The Wyeth Show as Money Magnet," *WP*, Feb. 4, 1987, p. D1; Michael Brenson, "The 'Helga Pictures' by Wyeth," *NYT*, May 24, 1987, sec. 1, part 2, p. 49.

44. Richards, "The Wyeth Show as Money Magnet," D1; John Wilmerding, *Andrew Wyeth: The Helga Pictures* (New York, 1987).

45. Brenson, "The Helga Pictures by Wyeth"; "The Wyeth Debate: A Great Artist or Mere Illustrator," *Newsweek*, Aug. 18, 1986, p. 52.

46. *NYT*, Feb. 3, 1987, p. C13; "Andrew Wyeth's Secret Obsession," *Newsweek*, Aug. 18, 1986, p. 48.

47. *NYT*, Oct. 9, 1987, p. C37.
48. William K. Stevens, "Sketching the Wyeth Dynasty," *NYT*, Nov. 23, 1986, sec. 2, p. 29.
49. *NYT*, Feb. 3, 1987, p. C1.
50. *WP*, Feb. 4, 1987, p. D1; *NYT*, May 24, 1987, sec. 1, pt. 2, p. 49.
51. Douglas C. McGill, "Art People," *NYT*, Oct. 9, 1987, p. C37.
52. See Steven C. Dubin, *Arresting Images: Impolitic Art and Uncivil Actions* (New York, 1992), 96–101, 170–92; Arthur C. Danto, *Playing with the Edge: The Photographic Achievement of Robert Mapplethorpe* (Berkeley, Calif., 1996); *Culture Wars: Documents from the Recent Controversies in the Arts*, ed. Richard Bolton (New York, 1992).
53. Carole S. Vance, "The War on Culture," *Art in America* 77 (Sept. 1989), 39–43; Lucy Lippard, "Andres Serrano: The Spirit and the Letter," *Art in America* 78 (Apr. 1990), 238–45.
54. *The Cultural Battlefield: Art Censorship and Public Funding*, ed. Jennifer Peter and Louis M. Crozier (Gilsum, N.H., 1995), 155–57; *Art Matters: How the Culture Wars Changed America*, ed. David Yenawine et al. (New York, 1999).
55. "Controversy vs. Quality," *Wall Street Journal*, May 21, 1990, p. A12.
56. Michael Brenson, "Is 'Quality' an Idea Whose Time Has Gone?" *NYT*, July 22, 1990, sec. 2, p. 1. See also Arthur C. Danto, "Quality and Inequality," in Danto, *Embodied Meanings: Critical Essays and Aesthetic Meditations* (New York, 1994), 334–48.
57. Florence Rubenfeld, *Clement Greenberg: A Life* (New York, 1997), 280–81; Brenson, "Is 'Quality' an Idea Whose Time Has Gone?"
58. Ibid.
59. Sontag, *On Photography* (New York, 1977), 126.
60. See Keith F. Davis, *An American Century of Photography from Dry-plate to Digital* (New York, 1995); Maria Morris Hambourg, *The New Vision: Photography Between the World Wars* (Ex. cat.: New York, 1987); *NYT*, June 18, 1950, sec. 2, p. 6; Nathan Lyons, "PFA and Its Controversy," and Naomi N. Rosenblum, "A Retrospective Look at the Acceptance of Photography as Fine Art," in *Master Photographs from PFA Exhibitions, 1959–1967*, ed. Cornell Capa (Ex. cat.: San Francisco, 1967), 26–39.
61. Russell Lynes, *Good Old Modern: An Intimate Portrait of the Museum of Modern Art* (New York, 1973), 156–59; Jonathan Green, *American Photography: A Critical History, 1945 to the Present* (New York, 1984), chap. 2; Eric J. Sandeen, *Picturing an Exhibition: "The Family of Man" and 1950s America* (Albuquerque, N.M., 1995), 169–70; Lili Corbus Bezner, *Photography and Politics in America: From the New Deal into the Cold War* (Baltimore, Md., 1999), 224–26.
62. John Szarkowski, *Looking at Photographs: 100 Pictures from the Collection of the Museum of Modern Art* (Ex. cat.: New York, 1973); Szarkowski, *Mirrors and Windows: American Photography Since 1960* (Ex. cat.: New York, 1978); Szarkowski, *Photography Until Now* (Ex. cat.: New York, 1989).
63. Eric Gibson, "Portrait Gallery Show Limited by the Narrow Focus of Annie's Lens," *Washington Times*, Apr. 18, 1991, p. E1.
64. Jill Lawrence, "On Show: Familiar Photos of the Famous Gathered for First Exhibit," AP Entertainment News, Apr. 22, 1991, Lexis-Nexis.
65. Steven C. Dubin, *Displays of Power: Controversy in the American Museum from the Enola Gay to Sensation* (New York, 1999), chap. 5; Eric Foner and Jon Wiener, "Fighting for the West," *Nation*, July 29, 1991, 163–66.
66. Kimmelman, "Old West, New Twist at the Smithsonian," *NYT*, May 26, 1991, sec. H, pp. 1, 27; Ron Tyler, "Western Art and the Historian," *Journal of Arizona History* 33 (Summer 1992), 207–24.
67. Alexander Cockburn, "Bush & P.C.—A Conspiracy So Immense," *Nation*,

May 27, 1991, p. 1; Alan Trachtenberg, "Contesting the West," *Art in America* 79 (Sept. 1991), 118–23, 152.

68. *History Wars: The "Enola Gay" and Other Battles for the American Past*, ed. Edward T. Linenthal and Tom Engelhardt (New York, 1996); "History and the Public: What Can We Handle? A Round Table about History after the *Enola Gay* Controversy," *Journal of American History* 82 (Dec. 1995), 1029–135.

69. The most balanced treatment will be found in the essays by Richard H. Kohn and Mike Wallace in Linenthal and Engelhardt, *History Wars*, 140–98. For a slightly different version by Wallace, see his *Mickey Mouse History and Other Essays on American Memory* (Philadelphia, 1996), 269–318.

70. Harwit's lengthy and comprehensive account of the affair, beginning early in the 1980s, acknowledges what he was up against in terms of politically unrealistic curators and powerful veterans' organizations. See Martin Harwit, *An Exhibit Denied: Lobbying the History of "Enola Gay"* (New York, 1996). For the ability of the Air Force Association to dominate the media and the weakness of the Smithsonian's tactical handling of the issue from the outset, see Tony Capaccio and Uday Mohan, "Missing the Target: How the Media Mishandled the Smithsonian *Enola Gay* Controversy," *American Journalism Review*, July–Aug. 1995, pp. 19–26.

71. Harwit, *Exhibit Denied*, 428. For the heat generated by the exhibition "Science in American Life," deemed insufficiently celebratory by the American Chemical Society and others who felt offended by *any* attention to the misuses of science and technology in the United States, see "Exploring life as we don't yet know it," a dialogue that appeared in *Nature* 380 (Mar. 12, 1996), 39–40.

72. Robert P. Newman, *"Enola Gay" and the Court of History* (New York, 2004); Robert C. Post, "A Narrative for Our Time: The *Enola Gay* and After That, Period," *Technology and Culture* 45 (Apr. 2004), 373–95; B. Byron Price, " 'Cutting for Sign': Museums and Western Revisionism," *Western Historical Quarterly* 24 (May 1993), 229–34.

73. Dubin, *Displays of Power*, 240–43; Ellen Wiley Todd, "Visual Design and Exhibition Politics in the Smithsonian's 'Between a Rock and a Hard Place,' " *Radical History Review* 88 (Winter 2004), 136–62.

74. *Anchorage Daily News*, May 3, 2003, p. B1.

75. *St. Louis Post-Dispatch*, May 7, 2003, p. A4; Holly Bailey, "Pictures of Controversy," *Newsweek*, May 5, 2003, p. 16.

76. "Dangerous Photos: Did Smithsonian Hide Arctic Wildlife Exhibit?" *Bergen* [N.J.] *County Record*, May 6, 2003, p. L16.

77. For analysis of how these trends are developing and becoming ever more problematic, see Michael Kimmelman, "What Price Love? Museums Are Putting Everything Up for Sale, from Their Artwork to Their Authority," *NYT*, July 17, 2005, sec. 2, p. 1.

78. Jim McCraw, "Art That Stands on Its Own Two Wheels," *NYT*, July 10, 1998, p. F1; Carol Vogel, "Latest Biker Hangout? Guggenheim Ramp," *NYT*, Aug. 3, 1998, p. A1.

79. Michael Kimmelman, "Machines as Art, and Art as Machine," *NYT*, June 26, 1998, p. E35.

80. Robert Hughes, "Going Out on the Edge," *Time*, Aug. 17, 1998, p. 75.

81. Peter Plagens, "Rumble on the Ramps," *Newsweek*, Sept. 7, 1998, p. 80.

82. Hilton Kramer and Thomas Krens are both quoted in ibid.

83. Jed Perl, "Leader of the Pack," *New Republic*, July 20, 1998, p. 42.

84. "Krens' Angels," *Economist*, July 4, 1998, p. 85; Carol Vogel, "Latest Biker Hangout? Guggenheim Ramp," *NYT*, Aug. 3, 1998, p. A1.

85. Carol Vogel, "Armani Gift to the Guggenheim Revives Issues of Art and Commerce," *NYT*, Dec. 15, 1999, p. E1. For a highly critical essay that places this issue in the larger context of museums neglecting art as traditionally understood in favor of trends in fashion and "historical society exhibits," see Roberta Smith, "Memo to Art Museums: Don't Give Up on Art," *NYT*, Dec. 3, 2000, sec. 2, p. 1.

86. See Chin-tao Wu, *Privatising Culture: Corporate Art Intervention Since the 1980s* (London, 2002).

87. Vogel, "Armani Gift"; and see Lee Seldes, *The Legacy of Mark Rothko: An Exposé of the Greatest Art Scandal of Our Century* (New York, 1974), 94–96.

88. *Unsettling "Sensation": Arts-Policy Lessons from the Brooklyn Museum of Art Controversy*, ed. Lawrence Rothfield (New Brunswick, N.J., 2001); Dubin, *Displays of Power*, 246–75.

89. Lynn MacRitchie, "Rude Britannia," *Art in America* 86 (Apr. 1998), pp. 36–39; Dubin, *Displays of Power*, 251–52; Alexander Cockburn, "Shit Happens," *Nation*, Oct. 25, 1999, p. 8.

90. *NYT*, Sept. 24, 1999, p. B1; *NYT*, Oct. 2, 1999, p. A14; *NYT*, Oct. 5, 1999, p. B1.

91. *NYT*, Oct. 16, 1999, p. B5; Margaret O'Brien Steinfels (editor of *Commonweal*), "Artists Have Rights and So Do Taxpayers," *NYT*, Sept. 25, 1999, p. A15; Eleanor Heartney, "A Catholic Controversy?" *Art in America* 87 (Dec. 1999), 39–41.

92. "Black Artist at Center of Furor over Brooklyn Museum Art Exhibit," *Jet* (Chicago), Oct. 18, 1999, pp. 14–16; Dubin, *Displays of Power*, 254.

93. *NYT*, Sept. 24, 1999, p. A26; *NYT*, Oct. 2, 1999, p. B2; *NYT*, Oct. 4, 1999, p. B3; *NYT*, Oct. 5, 1999, p. E1; *NYT*, Oct. 11, 1999, p. E3; poll conducted by Center for Survey Research and Analysis, Sept. 29–30, 1999 (USCSRA.99ART.R14), RCPOR.

94. *NYT*, Nov. 2, 1999, p. A26; *NYT*, Nov. 3, 1999, p. E1. For a legal critique of Judge Gershon's ruling, see Stephen B. Presser, "Reasons We Shouldn't Be Here: Things We Cannot Say," in Rothfield, *Unsettling "Sensation*," 52–71.

95. Dubin, *Displays of Power*, 253, 266–67; Rothfield, *Unsettling "Sensation*," 15–16, 124.

96. Frank Rich, "Pull the Plug on Brooklyn," *NYT*, Oct. 9, 1999, p. A17.

97. David Barstow, "Brooklyn Museum Recruited Donors Who Stood to Gain," *NYT*, Oct. 31, 1999, p. A1; *NYT*, Feb. 14, 2000, p. E1; Lee Rosenbaum, "The Battle of Brooklyn Ends, the Controversy Continues," *Art in America* 88 (June 2000), 39–43. Robert Rubin, chairman of the board at the Brooklyn Museum, defended its relationship with Charles Saatchi in a letter published in *NYT*, Dec. 17, 1999, p. A30.

98. Michael Kimmelman, "Cutting Through Cynicism in Art Furor," *NYT*, Sept. 24, 1999, p. B1.

99. Lee Rosenbaum, "Brooklyn Hangs Tough," *Art in America* 88 (Jan. 2000), 61.

100. Robyn Meredith, "Another Art Battle, as Detroit Museum Closes an Exhibit Early," *NYT*, Nov. 23, 1999, p. A14; *NYT*, Nov. 23, 1999, p. A11.

101. *NYT*, Mar. 18, 2002, p. B2.

102. Sarah Boxer, "Man Behind a Museum Tempest: A Curator Defends His Show Exploring Nazi Imagery," *NYT*, Feb. 6, 2002, p. E1.

103. Ibid.; Michael Kimmelman, "Show Looks Nazis in the Face and Creates a Fuss," *NYT*, Jan. 29, 2002, p. E1.

104. Joyce Purnick, "Leaving Art to Critics, Not Mayors," *NYT*, Jan. 14, 2002, p. B1; Barbara Stewart, "Jewish Museum to Add Warning Label on Its Show," *NYT*, Mar. 2, 2002, p. B1; Clyde Haberman, "Art, Tragedy, and the Eye of a Beholder," *NYT*, Mar. 13, 2002, p. B1.

105. Teri Thomson Randall, "Artistic Differences," *Santa Fe New Mexican*, May 18, 2003, p. A1.

106. Hilton Kramer, "Has Success Spoiled the Art Museum?" in *Against the Grain: The New Criterion on Art and Intellect at the End of the Twentieth Century*, ed. Hilton Kramer and Roger Kimball (Chicago, 1995), 34. The book is by Douglas Davis, *The Museum Transformed: Design and Culture in the Post-Pompidou Age* (New York, 1990).

107. Kramer, "Has Success Spoiled the Art Museum?" 38. For Douglas Davis's response to Kramer, see his "Multicultural Wars," *Art in America* 83 (Feb. 1995), 35–39.

108. Judith H. Dobrzynski, "Museum Attendance Keeps Rising in the U.S.," *NYT*, Feb. 1, 1999, p. E1.

109. For one among many examples of dramatic new museums being nixed, see the story about the Guggenheim Museum at the Wall Street ferry that never got beyond the planning phase. "The Museum Game," *NYT*, Apr. 17, 2000, p. 96. See also Frank Lloyd Wright's prophetic defense in 1956 of the design for the Guggenheim in Manhattan. Levine, *Architecture of Frank Lloyd Wright*, 347–48.

110. J. Mark Davidson Schuster, *The Audience for American Art Museums* (Washington, D.C.: NEA Research Division Report #23, 1991).

111. Michael Kimmelman, "The Solace in Sharing the Beauty of Great Art and Music," *NYT*, Sept. 17, 2000, p. E1.

112. Arthur C. Danto, "Whatever Happened to Beauty?" in Danto, *Embodied Meanings: Critical Essays and Aesthetic Meditations* (New York, 1994), 252.

113. Jerrold Seigel, *The Private Worlds of Marcel Duchamp: Desire, Liberation, and the Self in Modern Culture* (Berkeley, Calif., 1995), 202–07; Huntington Hartford, *Art or Anarchy? How the Extremists Have Reduced the Fine Arts to Chaos and Commercialism* (Garden City, N.Y., 1964), 133.

114. Arthur C. Danto, *Beyond the Brillo Box: The Visual Arts in Post-Historical Perspective* (New York, 1992), 12.

115. Robert Hughes, *Culture of Complaint: The Fraying of America* (New York, 1993), 194; *Whose Muse? Art Museums and the Public Trust*, ed. James B. Cuno (Princeton, N.J., 2004), 17.

Chapter 9: *Issues of Diversity and Inclusion*

1. Sheryl Gay Stolberg, "Face Value at the Capitol," *NYT*, Aug. 13, 2003, p. E1.

2. Judy Chicago and Edward Lucie-Smith, *Women and Art: Contested Territory* (New York, 1999), 58–59, 64–67; Arthur C. Danto, *Embodied Meanings: Critical Essays and Aesthetic Meditations* (New York, 1994), 60.

3. Eleanor Heartney, "Postmodern Heretics," *Art in America* 85 (Feb. 1997), 32–35, 37, 39.

4. Sally M. Promey, "Sargent's Truncated 'Triumph': Art and Religion at the Boston Public Library, 1890–1925," *Art Bulletin* 79 (June 1997), 217–50.

5. Sally M. Promey, *Painting Religion in Public: John Singer Sargent's "Triumph of Religion" at the Boston Public Library* (Princeton, N.J., 1999), 180.

6. Ibid., 182–83.

7. Ibid., 193–94.

8. Ibid., 207–12.

9. Ibid., 204–05.

10. *NYT*, July 13, 1988, p. C15; *NYT*, July 15, 1988, p. C30; *NYT*, Aug. 5, 1988, p. C13.

11. *NYT,* Aug. 24, 1988, p. C15.

12. *NYT,* July 21, 1988, p. C19; Greeley, "Blasphemy or Artistry?" *NYT,* Aug. 14, 1988, sec. 2, p. 1; Quindlen, "Life in the 30's," *NYT,* Aug. 18, 1988, sec. 2, p. 2.

13. *NYT,* Aug. 12, 1988, p. C1; Aljean Harmetz, " 'Last Temptation' Sets a Record as Pickets Decline," *NYT,* Aug. 15, 1988, p. C14.

14. Peter Steinfels, "Robertson Draws a Rebuke on Film," *NYT,* Aug. 24, 1988, p. A15; Aljean Harmetz, " 'The Last Temptation of Christ' Opens to Protests but Good Sales," *NYT,* Aug. 13, 1988, p. 11; To the Editor, *NYT,* Sept. 3, 1988, p. 22; Jimmy Carter, "Rushdie's Book Is an Insult," *NYT,* Mar. 5, 1989, sec. 4, p. 23.

15. *Newsweek,* Mar. 1, 2004, p. 60; *NYT,* Feb. 25, 2004, p. E1; *NYT,* Feb. 26, 2004, p. A16; *NYT,* Mar. 7, 2004, sec. 2, p. 21.

16. Chicago and Lucie-Smith, *Women and Art,* 18–19; "Carolee Schneemann," interviewed by Carl Heyward, in *Interventions and Provocations: Conversations on Art, Culture, and Resistance,* ed. Glenn Harper (Albany, N.Y., 1998), 192.

17. Heyward, "Schneemann," 192–93; Schneemann, *Imaging Her Erotics: Essays, Interviews; Projects* (Cambridge, Mass., 2002), 3–16.

18. Schneemann, *Imaging Her Erotics,* 151–61; Chicago and Lucie-Smith, *Women and Art,* 171 (with photograph); Brandon Taylor, *Avant-Garde and After: Rethinking Art Now* (New York, 1995), 26–27. *Interior Scroll* was first performed on August 29, 1975, in East Hampton, N.Y., for an audience composed largely of women. The last known performance took place in September 1977 at a film festival in Telluride, Colorado.

19. Heyward, "Schneeman," 197. Late in 1996 an exhibition of Schneemann's work, "Up to and Including Her Limits" (1958–94) appeared at the New Museum of Contemporary Art in New York. By that time she no longer performed in the nude, but her paintings, photographs, and some unsettling videos of her performances dating back to the early 1960s provided a narrative of her career. As one reviewer wrote, "In 1976, when Schneeman's most radical gestures were fresh, even the stalwart Lucy Lippard was guarded in her praise." Nancy Princenthal, "The Arrogance of Pleasure," *Art in America* 85 (Oct. 1997), 106–09. See also Grace Glueck, "Of a Woman's Body as Both Subject and Object," *NYT,* Dec. 6, 1996, p. C29; Anne Daly, "Body of Evidence: Schneemann Retrospective Exposes Subversive Gestures," *Village Voice,* Jan. 21, 1997, pp. 48–49.

20. Michael Brenson, "Effects of Men's Desires on the Lives of Women," *NYT,* May 21, 1990, p. C13; Marcelle Clements, "Karen Finley's Rage, Pain, Hate and Hope," *NYT,* July 22, 1990, sec. 2, p. 5.

21. Rowland Evans and Robert Novak, "NEA Faces Tough Funding Decisions," *Chicago Sun-Times,* May 11, 1990, p. 33; William H. Honan, "Arts Figures Denounce Endowment on Grants," *NYT,* July 12, 1990, p. C19; Hilary De Vries, "Karen Finley Has Become a Symbol in the Struggle over Public Arts Support," *Los Angeles Times,* Oct. 21, 1990, Calendar p. 3.

22. De Vries, "Finley Has Become"; *The Cultural Battlefield: Art Censorship and Public Funding,* ed. Jennifer Peter and Louis M. Crozier (Gilsum, N.H., 1995).

23. *National Endowment for the Arts, et al., Petitioners, v. Karen Finley, et al.* (524 US 569, 118 S. Ct. 2168), available online through Westlaw@westgroup.com.

24. Ibid.

25. Linda Greenhouse, "Justices Uphold Decency Test in Awarding Arts Grants, Backing Subjective Judgments," *NYT,* June 26, 1998, p. A17.

26. Judy Chicago, *Beyond the Flower: The Autobiography of a Feminist Artist* (New York, 1996), chap. 3.

27. Edward Lucie-Smith, *Judy Chicago: An American Vision* (New York, 2000), chap. 4.

28. Mark Stevens, "Guess Who's Coming to Dinner," *Newsweek*, Apr. 2, 1979, p. 92.

29. Ibid.; *NYT*, Apr. 1, 1979, p. 52. For ongoing protests of this nature, see Carole S. Vance, "Feminist Fundamentalism—Women Against Images," *Art in America* 81 (Sept. 1993), 35–37, 39.

30. Grace Glueck, "Judy Chicago and Trials of 'Dinner Party,' " *NYT*, Apr. 30, 1979, p. D10; *NYT*, Aug. 11, 1979, p. 10; *WP*, Aug. 9, 1979, p. D18; Chicago, *Beyond the Flower*, 100–01.

31. Judy Chicago, *The Dinner Party: A Symbol of Our Heritage* (Garden City, N.Y., 1979); Judy Chicago, *Embroidering Our Heritage: The Dinner Party Needlework* (Garden City, N.Y., 1980).

32. *WP*, Aug. 9, 1979, p. D18.

33. "Judy Chicago's Controversial Creation," *Newsweek*, Oct. 31, 1983, p. 14.

34. Suzanne Muchnic, *Los Angeles Times*, Feb. 25, 1985, Calendar, pt. 6, p. 1.

35. Alice Walker, *In Search of Our Mothers' Gardens* (San Diego, Calif., 1983), 373.

36. Lucy R. Lippard, "Uninvited Guests: How Washington Lost 'The Dinner Party,' " *Art in America* 79 (Dec. 1991), 39–49; Chicago, *Beyond the Flower*, 218–31. Organizations such as Concerned Women for America opposed feminist art. See Elizabeth Kastor, "Arts Advocacy Heating Up," *WP*, Mar. 21, 1990, p. C1.

37. "The Table Is Set at Last, in a Home," *NYT*, Sept. 8, 2002, sec. 2, p. 78; *NYT*, May 3, 2002, p. E2. In 2000 New York governor George Pataki announced a proposal to build a $125 million institution in lower Manhattan devoted to the history and future of women in America. Most of the cost would be raised from corporations, foundations, and private donors. By February 2005, nothing had been raised beyond the $2.2 million from the governor's office. *NYT*, Feb. 20, 2005, p. A39.

38. "Table Is Set at Last."

39. Roberta Smith, "For a Paean to a Heroic Woman, a Place at History's Table," *NYT*, Sept. 20, 2002, p. E34.

40. Ibid.

41. Lucie-Smith, *Judy Chicago*; Arthur C. Danto, "Women and Mainstream Art," in Danto, *Embodied Meanings*, 55. See the exhibition of work by Martha Mayer Erlebacher at the Forum Gallery in New York, Nov. 13–Dec. 13, 2003.

42. "Table Is Set at Last."

43. Danto, "Women and Mainstream Art," 56.

44. Roberta Smith, "Waging Guerrilla Warfare Against the Art World," *NYT*, June 17, 1990, sec. 2, pp. 1, 31; Guerrilla Girls leaflets and posters in Lucy Lippard Papers, box 8, AAA; *Ithaca Journal*, Dec. 3, 2003, p. 10B.

45. Judy Mann, "An Old Struggle Deserves a New Tribute," *WP*, May 7, 1997, p. C21.

46. Ibid.; James Brooke, "3 Suffragists (in Marble) Win a Niche in the Capitol," *NYT*, Sept. 27, 1996, p. A18; "Biddies in the Bathtub," *Washington Times*, Apr. 26, 1997, p. D9.

47. Courtney Workman, "*The Woman Movement*: Memorial to Women's Rights Leaders and the Perceived Images of the Women's Movement," in *Myth, Memory, and the Making of the American Landscape*, ed. Paul A. Shackel (Gainesville, Fla., 2001), 47–66; "Truth Deserves Spot in Capitol Rotunda," *Washington Times*, Feb. 25, 1997, p. C2.

48. *WP*, Apr. 14, 1997, p. A1; "Battle of the Statues," *Washington Times*, Feb. 15, 1997, p. A4.

49. Jennifer Bradley, "Suffragists Statue Finally Heading to New Home in Capitol Rotunda," Roll Call, Inc., May 8, 1997, http://web.lexis-nexis.com/universe: Stolberg, "Face Value at the Capitol."

50. Jennifer Bradley, "Women's Statue Joins Rotunda Boys' Club," May 15, 1997, http://web.lexis-nexis.com/universe.

51. My source is a tour guide who worked at the Capitol during the summer of 2002.

52. Katherine Rizzo, "Kaptur Wants to Balance Capitol Images," AP State and Local Wire, Mar. 12, 1999, http://web.lexis-nexis.com/universe.

53. Yvonne Scruggs-Leftwich, "Toward an Independence Day for all to Celebrate," *Women's News*, July 4, 2001, http://www.womensnews.org/article.cfm/dyn/aid/603/context/archive.

54. See Kirk Savage, *Standing Soldiers, Kneeling Slaves: Race, War, and Monument in Nineteenth-Century America* (Princeton, N.J. 1997); essays by Joan Waugh, David W. Blight, Kathryn Greenthal, and Kirk Savage in *Hope and Glory: Essays on the Legacy of the Fifty-Fourth Massachusetts Regiment*, ed. Martin Blatt et al. (Amherst, Mass., 2001), 52–93, 116–29, 156–67.

55. Guy McElroy, *Facing History: The Black Image in American Art, 1710–1940* (San Francisco, Calif., 1990).

56. Grace Glueck, "Images of Blacks Refracted in a White Mirror," *NYT*, Jan. 7, 1990, sec. 2, p. 1.

57. Robert Hughes, "Two Centuries of Stereotypes," *Time*, Jan. 29, 1990, p. 82; Jack Flam, "Review of 'Facing History' Exhibition," *Wall Street Journal*, May 25, 1990, p. A15; Maurice Berger, "Interview with Guy McElroy," in *How Art Becomes History: Essays on Art, Society, and Culture in Post-New Deal America*, ed. Maurice Berger (New York, 1992), 189.

58. Michael Kimmelman, "Black Images of the Past: Servile, Subhuman," *NYT*, Jan. 18, 1990, p. C21. For recent work responsive to some of Kimmelman's wishes, see Michael D. Harris, *Colored Pictures: Race and Visual Representation* (Chapel Hill, N.C., 2003).

59. Michael Brenson, "Black Images, American History," *NYT*, April 20, 1990, p. C30.

60. Glueck, "Images of Blacks"; Berger, "Interview with McElroy," 186–90. Early in 1995 the Whitney Museum mounted an exhibition titled "Black Male" that moved to Los Angeles during the spring. It featured art about black men created by whites and blacks, men and women, much of it overtly political in dealing with stereotypes. It did not receive very much press, and what did appear tended to be dismissive. For a very positive response, see Linda Nochlin, "Learning from 'Black Male,' " *Art in America* 83 (Mar. 1995), 86–91.

61. Steven C. Dubin, *Arresting Images: Impolitic Art and Uncivil Actions* (New York, 1992), 26–28.

62. Ibid., 29–34; "David Nelson's 'Mirth & Girth,' " http://www.cd.sc.ehu.es/FileRoom/documents/Cases/33onelson.html.

63. Karen De Witt, "After Protests, Library of Congress Closes Exhibition on Slavery," *NYT*, Dec. 21, 1995, p. A21.

64. Ibid.; *Chronicle of Higher Education*, Jan. 5, 1996, p. A13; *Jet*, Jan. 8, 1996, p. 4.

65. Steven C. Dubin, *Displays of Power: Controversy in the American Museum from the "Enola Gay" to "Sensation,"* 142; Linton Weeks, "Library of Congress's Freudian Flip; Exhibit Back in Works Despite Protests," *WP*, Feb. 28, 1996, p. B01; Sarah

Boxer, "When Verbal Resists Visual: Freud's Defense Against Art," *NYT,* Oct. 24, 1998, p. B9.

66. Michael Janofsky, "Mock Auction of Slaves Outrages Some Blacks," *NYT,* Oct. 8, 1994, p. A7.

67. Dan Eggen, "A Taste of Slavery Has Tourists Up in Arms," *WP,* July 7, 1999, pp. A1, 8–9.

68. *NYT,* June 18, 1995, p. 16; *Richmond Times Dispatch,* July 8, 1996, p. A1; *Roanoke Times and World,* July 11, 1996, p. A1; *Richmond's Monument Avenue,* ed. Sarah Shields Driggs (Chapel Hill, N.C., 2001), 88–95.

69. Liz Robbins, "Statue for Ashe Creates Confusion," *NYT,* Aug. 29, 2000, p. D4.

70. *San Diego Union-Tribune,* Sept. 3, 2000, p. C6; *Chicago Sun-Times,* Sept. 4, 2000, p. 89.

71. Jerry Magee, "It may be art, but it's not Arthur," *San Diego Union-Tribune,* Feb. 24, 2004, p. C2.

72. "Plans for U.S. Black Museum Advance," *NYT,* July 22, 2002, p. A10; Ta-Nehisi Coates, "Case History," *Washington City Paper,* Feb. 6, 1998, pp. 24–30; "Smithsonian Picks Notable Spot for Museum of Black History," *NYT,* Jan. 31, 2006, p. A16; Elizabeth Olson, "A Museum of Indians That Is Also for Them," *NYT,* Aug. 19, 2004, p. E1.

73. See Dubin, *Displays of Power,* chap. 3.

74. Charisse Jones, "Museum's Walls Tell a Story of Division," *NYT,* Feb. 1, 1996, p. B1.

75. Ibid.; Patrick Rogers, "A Great Day for the Irish?" *Irish Times,* Mar. 5, 1996, p. A11.

76. Jones, "Museum's Walls Tell a Story"; "Fighting Irish," *NYT,* Feb. 13, 1996, p. A20.

77. Rogers, "Great Day for the Irish,"; Jones, "Museum's Walls Tell a Story."

78. "Fighting Irish."

79. Paul Goldberger, "How the Irish Came and Overcame," *NYT,* Mar. 15, 1996, p. C1.

80. McGinnis, "Irish-Americans and What Might Have Been," *Wall Street Journal,* Mar. 19, 1996, p. A16; "City Museum: Our Irish Is Up," *Wall Street Journal,* Mar. 28, 1996, p. A15.

81. Harry Browne, "A mess of dull, Gaelic potage," *Irish Times,* May 14, 1996, p. 11.

82. Quentin Fottrell, "An Irishman's Diary," *Irish Times,* July 19, 1996, p. 15; Joe Carroll, "Controversy Breaks Out over 'Gaelic Gotham,' " *Irish Times,* May 24, 1997, p. 9; *The Gaelic Gotham Report: Assessing a Controversial Exhibition at the Museum of the City of New York* (New York, 1997).

83. James F. McManus Jr., " 'Gaelic Gotham' Exhibition Ignores an Irish Family of Influence," *NYT,* Aug. 17, 1996, p. A18.

84. Steven C. Dubin, *Arresting Images: Impolitic Art and Uncivil Actions* (New York, 1992), 97; *Critical Issues in Public Art: Content, Context, and Controversy,* ed. Harriet F. Senie and Sally Webster (Washington, D.C., 1992), 62–65.

85. Edward T. Linenthal, *Preserving Memory: The Struggle to Create America's Holocaust Museum* (New York, 1995), 117–20, 128, 166, 251.

86. Ibid., 229–30, 237.

87. Michael Kimmelman, " 'Helter Skelter' Reveals the Evil of Banality," *NYT,* Mar. 22, 1992, sec. 2, p. 37.

88. Paul Richard, " 'Helter Skelter': Naughty by Nature; Exhibit Brings Dark Side to Light," *WP,* May 22, 1992, p. G1.

89. David Joselit, "Poetics of the Drain," *Art in America* 85 (Dec. 1997), 65–70; Linda Ekstrom, "Gober's Mary Fires Debate on Art, Religion," *National Catholic Reporter,* Dec. 5, 1997, p. 18.

90. Ibid.

91. Ibid.

92. Devorah L. Knaff, "From Symbols in Chaos, a Reverent Chorus," *Sunday Press Enterprise* [Riverside, Calif.], Nov. 9, 1997, p. E2.

93. Catherine Fox, "Surveying the Whitney Biennial," *Atlanta Journal and Constitution,* Mar. 7, 1993, p. N4. Foreign-born artists who have come to live and work in the United States are often baffled by the American obsession with political correctness. See Ewa Kuryluk, "A Plea for Irresponsibility," in *The Subversive Imagination: Artists, Society, and Social Responsibility,* ed. Carol Becker (New York, 1994), 13–19.

94. Michael Kimmelman, "At the Whitney, Sound, Fury and Little Else," *NYT,* Apr. 25, 1993, sec. 2, p. 1; Eric Gibson, "Whitney Biennial: Two Wrongs Don't Make Art," *Washington Times,* Mar. 21, 1993, p. D2; Kenneth Baker, "Whitney Biennial Banalities," *San Francisco Chronicle,* May 13, 1993, p. E1; Carol Strickland, "Politics Dominates Whitney Biennial," *Christian Science Monitor,* Mar. 26, 1993, Arts p. 10.

95. Teri Thomson Randall, "Artistic Differences," *Santa Fe New Mexican,* May 18, 2003, p. A1.

96. Ibid.

97. Ibid.

98. Ibid.; Paul Weideman, "Southern Exposure," *Santa Fe New Mexican,* Jan. 23, 2004, p. 40.

99. "Controversial Arts Funding Survey," Sept. 29–30, 1999 (USCSRA.99ART. R14), RCPOR.

100. (USCSRA.99ART.R15), RCPOR.

101. (USCSRA.99ART.R04), RCPOR.

102. (USCSRA.99ART.R06), RCPOR.

103. (USCSRA.99ART.R11), RCPOR.

104. (USCSRA.99ART.R19A), RCPOR.

105. David Halle, "The Controversy over the Show 'Sensation' at the Brooklyn Museum, 1999–2000," in *Crossroads: Art and Religion in American Life,* ed. Alberta Arthurs and Glenn Wallach (New York, 2001), 156.

Chapter 10: *Comparisons and Closure*

1. Judith H. Dobrzynski, "Art Museum Attendance Keeps Rising in the U.S.," *NYT,* Feb. 1, 1999, p. E1.

2. Ibid.; National Endowment for the Arts, *2002 Survey of Public Participation in the Arts, Research Division Report no. 45* (Washington, D.C., 2004), 18, 55.

3. Aug. 9, 2004, http://msnbc.msn.com/id5570120/site/newsweek/.

4. Ibid. See the comments made by Susan Sontag at the 2001 symposium, "Is This an Age of Museums?" in *Salmagundi* 139 (Summer 2003), 180, 214.

5. Hans Belting, *Art History after Modernism* (Chicago, 2003), 37–44, 173; Erika Doss, *Benton, Pollock, and the Politics of Modernism: From Regionalism to Abstract Expressionism* (Chicago, 1991), 275. Gail Levin has pointed to earlier enthusiasm for primitivism in the United States. See her essay "American Art" in *"Primitivism" in 20th Century Art: Affinity of the Tribal and the Modern,* ed. William Rubin (New York and Boston, 1984), 452–73.

6. See, but with caution, Serge Guilbaut, *How New York Stole the Idea of Modern*

Art: Abstract Expressionism, Freedom, and the Cold War (Chicago, 1983). For the impact of Mondrian in New York, see Henry McBride, *The Flow of Art: Essays and Criticisms*, ed. David Catton Rich (New Haven, Conn., 1997), 386, 396–98.

7. *Theodore Dreiser's Ev'ry Month*, ed. Nancy Warner Barrineau (Athens, Ga., 1996), 34.

8. Walter Grasskamp, "Degenerate Art and Documenta I: Modernism Ostracized and Disarmed," in *Museum Culture: Histories, Discourses, Spectacles*, ed. Irit Rogoff and Daniel Sherman (Minneapolis, 1994), 163–94; Belting, *Art History after Modernism*, 42–44, 50–51.

9. See Ronald Hunt, "Art versus Democracy: Politics and Poetics," *Art in America*, 60 (Sept. 1972), 76–80.

10. Kate Galbraith, "A Watcher of Walls," *Chronicle of Higher Education*, Oct. 31, 2003, p. A56.

11. See *Cahier de Georges Braque, 1917–1947* (Paris, 1948).

12. David Halle, "The Controversy over the Show Sensation at the Brooklyn Museum, 1999–2000," in *Crossroads: Art and Religion in American Life*, ed. Alberta Arthurs and Glenn Wallach (New York, 2001), 182. Halle also observed that "one legitimate goal of contemporary art is to unsettle and disturb the audience, to push the limits of what is morally, politically, and socially acceptable" (p. 164).

13. Carrie Rickey, "Vito Acconci: The Body Impolitic," *Art in America* 68 (Oct. 1980), 122; AP file, Oct. 7, 1989, http://web.lexis-nexis.com/universe/printdoc.

14. Therese Schwartz, "The Politicalization of the Avant-Garde," *Art in America* pt. 1, 59 (Nov. 1971), 102. See also Dore Ashton, "Response to Crisis in American Art," *Art in America* 57 (Jan. 1969), 24.

15. Schwartz, "Politicalization of the Avant-Garde," 103.

16. Ibid., 105.

17. Ibid., pt. 2, 60 (Mar. 1972), 77; Bradford D. Martin, *The Theater Is in the Street: Politics and Performance in Sixties America* (Amherst, Mass., 2004), chap. 4.

18. John A. Walker, *Art and Outrage: Provocation, Controversy, and the Visual Arts* (London, 1999), 44–46.

19. Ibid., 57–61.

20. Michael Brenson, "Richard Serra Works Find a Warm Welcome in France," *NYT*, Nov. 3, 1985, sec. 2, p. 35.

21. Ibid.

22. Ibid. For Serra's deservedly triumphant installation at the Guggenheim in Bilbao, see Michael Kimmelman, "Abstract Art's New World, Forged for All," *NYT*, June 7, 2005, p. E1.

23. Dario Gamboni, *The Destruction of Art: Iconoclasm and Vandalism Since the French Revolution* (London, 1997), 133–34.

24. Douglas Crimp, *On the Museum's Ruins* (Cambridge, Mass., 1993), 169–75.

25. Donald Kuspit, "Beuys: Fat, Felt and Alchemy," *Art in America* 68 (May 1980), 78–89, the quotation at 81–82.

26. Gamboni, *Destruction of Art*, 299–301.

27. Belting, *Art History after Modernism*, 51–52.

28. David Galloway, "Beuys and Warhol: Aftershocks," *Art in America* 76 (July 1988), 113–23, provides an account of a posthumous exhibit of their work at the Darmstadt Landesmuseum in 1988, not long after both men had died. It was intended to be a very low-key affair, but was mobbed because of breaking scandals involving covert ownership and market manipulation of Beuys's work. Galloway writes that they symbolized to the media "that alchemical ability of artists to transform everyday objects into great value and wealth" (121).

29. David Bourdon, *Warhol* (New York, 1989); Kuspit, "Beuys: Fat, Felt and Alchemy," 88.

30. Gamboni, *Destruction of Art*, 168; for a misremembered version of this story, see David Ross in "Is This an Age of Museums?" special issue of *Salmagundi*, 125.

31. Ibid., 126.

32. Ibid., 126; Gamboni, *Destruction of Art*, 168.

33. Pierre Bourdieu and Hans Haacke, *Free Exchange* (Cambridge, Eng., 1995), 76–77.

34. Ibid., 77, 82. The intervening pages show pictures of a rally at the Nazi monument and Haacke's project in 1988.

35. Ibid., 79–80.

36. Ibid., 80.

37. Benjamin H. O. Buchloh, *Neo-Avant-garde and Culture Industry: Essays on European and American Art from 1955 to 1975* (Cambridge, Mass., 2000), 227–28. See also Timothy W. Luke, *Shows of Force: Power, Politics, and Ideology in Art Exhibitions* (Durham, N.C., 1992), chap. 11.

38. Michael Kimmelman, "Behind Sealed Doors, Opening Up the Past," *NYT*, Oct. 30, 2000, p. E1.

39. Ibid.

40. Ibid.

41. Mary Nolan, "The Politics of Memory in the Bonn and Berlin Republics," in *Memory and the Impact of Political Transformation in Public Space*, ed. Daniel J. Walkowitz and Lisa Maya Knauer (Durham, N.C., 2004), 111–17.

42. Teri J. Edelstein, "Sensational or Status Quo: Museums and Public Perception," in *Unsettling "Sensation": Arts-Policy Lessons from the Brooklyn Museum of Art Controversy*, ed. Lawrence Rothfield (New Brunswick, N.J., 2001), 107–08. For the political crisis and sad story of the Cuban Museum of Arts and Culture in Miami (1991–99), which anticipated key aspects of what happened in Brooklyn, see Mireya Navarro, "How Controversial Art Killed a Museum; In a Case That Parallels 'Sensation,'" Cultural Leaders Took on Miami," *NYT*, Oct. 23, 1999, p. B1.

43. Edelstein, "Sensational," 107. For a crisp color plate of *Myra*, see *Crossroads: Art and Religion in American Life*, ed. Alberta Arthurs and Glenn Wallach (New York, 2001), illus. 5.3.

44. Lynn Macritchie, "Rude Britannia," *Art in America* 86 (Apr. 1998), 37.

45. Ibid., 36–39.

46. Carol Vogel, "Australian Museum Cancels Controversial Art Show," *NYT*, Dec. 1, 1999, p. B3. Hans Haacke's contribution to the Whitney Museum's Biennial in 2000 was a work titled *Sanitation*, a fiercely satirical piece aimed at Giuliani and the role of censorship in "Sensation." Its intent was not clearly understood, people felt that Haacke had gone too far, and it became controversial. *NYT*, Mar. 12 and 24, 2000, pp. A43 and A20. Mrs. Marylou Whitney withdrew her financial support of the museum in protest and resigned from its national fund-raising council.

47. Jacques Peretti, "Burning Shame," *Guardian*, June 5, 2004.

48. Tristram Hunt, "A Latte and a Picasso to Go," *Observer*, Feb. 14, 2004.

49. Ibid.

50. Ibid.

51. Brandon Taylor, *The Art of Today* (London, 1995). See also Robert Hewison, *Future Tense: A New Art for the Nineties* (London, 1990), which is also written from a British perspective except for acknowledgment of American artists whose work has become extremely familiar in the U.K. (such as Rauschenberg, Mapplethorpe, and Holzer).

52. Julian Stallabrass, *High art lite: British art in the 1990s* (London, 1999), 91–93, 98, 129ff., 227–33, 265.

53. The richest source is the multiauthored *Arousing Sensation: A Case Study of Controversy Surrounding Art and the Erotic*, ed. Silvie Gilbert (Banff, 1999).

54. Ibid., especially Su Ditta, "The Summer of the Suiciding Nuns," 73–113, and Myrna Kostash, "Flesh and the Devil: Eroticism and the Body Politic," 117–27.

55. Ditta, "Summer of Suiciding Nuns," esp. 89–90, 93–95.

56. Ibid., 87.

57. "Sex Advertised and Sex Displayed," *Ottawa Citizen*, Aug. 12, 1988, p. A3.

58. Ditta, "Summer of the Suiciding Nuns," 89, 107.

59. Ibid., 107–08.

60. Henry J. Hyde, "The Culture Wars," *National Review*, Apr. 30, 1990, p. 25. For a slightly more tolerant view (but not much), see Alex Heard, "Mapplethorpe of My Eye," *New Republic*, Aug. 21, 1989, p. 11. And for a statement more intemperate than Hyde's, see Hilton Kramer, "Is Art Above the Laws of Decency?" *NYT*, July 2, 1989, sec. 2, p. 1.

61. Stephen Kinzer, "A Curator Who Doesn't Blush Easily," *NYT*, Jan. 30, 1996, p. A4; Oliver Bennett, "Sex Museums: All in the Best Possible Taste," *Observer* [U.K.], Feb. 9, 2003, "Escape pages," p. 6.

62. N. R. Kleinfield, "Sex Is Draw in New Museum. Really," *NYT*, May 30, 2002, p. B4.

63. Ralph Blumenthal, "Sex Museum Says It Is Here to Educate," *NYT*, Sept. 19, 2002, p. E1.

64. Steve Kurtz, "The Museum of Sex Spends Its First Year with a Headache," *NYT*, Oct. 12, 2003, sec. 14, p. 5.

65. "London Cool to 'Temptation,' " *NYT*, Sept. 10, 1988, p. A1.

66. Steven Greenhouse, "Police Suspect Arson in Fire at Paris Theater," *NYT*, Oct. 25, 1988, p. C21.

67. Clyde Haberman, "Scorsese's 'Last Temptation' Creates Furor at Venice Festival," *NYT*, Sept. 8, 1988, p. C17.

68. Ibid.

69. Peter Allen, "G marks the spot in Gucci ad," *Daily Mail*, Jan. 15, 2003, http://www.thisislondon.com/lifeandstyle/fashion/articles/2914456?source=Daily Mail.

70. Ibid.

71. Chelsea Holden Baker to author, Nov. 11, 2003.

72. Douglas Davis, "Multicultural Wars," *Art in America* 83 (Feb. 1995), 35–39.

73. Michael Kimmelman, "The Solace in Sharing the Beauty of Great Art and Music," *NYT*, Sept. 17, 2001, p. E1.

74. Michael Kimmelman, "In a Square, A Sense of Unity; A Homegrown Memorial Brings Strangers Together," *NYT*, Sept. 19, 2001, p. E1.

75. Ibid.; Michael Kimmelman, "Out of Minimalism, Monuments to Memory," *NYT*, Jan. 13, 2002, sec. 2, p. 1.

76. Michael Kimmelman, "Art in Ashes, Drama in Dust," *NYT*, Aug. 19, 2002, p. E1; Suzanne Fields, "Histrionic Bidders Should Not Win Historical Displays," *Washington Times*, Jan. 24, 2002, p. A19.

77. "After Complaints, Rockefeller Center Drapes Sept. 11 Statue," *NYT*, Sept. 19, 2002, p. B3.

78. See Kate Linker, "Public Sculpture: The Pursuit of Pleasurable and Profitable Paradise," *Artforum* 19 (Mar. and Summer 1981), 37–42 and 64–73; Dore Ashton, *The Unknown Shore: A View of Contemporary Art* (Boston, 1962), 19.

79. Quoted in Annie Cohen-Solal, *Painting American: The Rise of American Artists, Paris 1867–New York 1948* (New York, 2001), 115, 234.

80. Ibid., 176; A. Joan Saab, *For the Millions: American Art and Culture Between the Wars* (Philadelphia, 2004), 23; Sidra Stich, *Made in U.S.A.: An Americanization in Modern Art, the '50s and '60s* (Ex. cat.: Berkeley, Calif., 1987), 7; Eva Cockcroft, "Abstract Expressionism, Weapon of the Cold War," *Artforum* 12 (June 1974), 39–41; Barbara Rose, *An Interview with Robert Rauschenberg* (New York, 1987), 79.

81. See John Russell, *The Meanings of Modern Art* (New York, 1981); and for a critique of the blurring of taste levels by introducing an excess of fashion, objects, and hip-hop into supposedly serious art museums, see Roberta Smith, "Memo to Art Museums: Don't Give Up on Art," *NYT*, Dec. 3, 2000, sec. 2, p. 1.

82. See Anthony Haden-Guest, *True Colors: The Real Life of the Art World* (New York, 1996).

83. Richard Posner, "Art for Law's Sake," *American Scholar* 58 (Autumn 1989), 513.

84. See Marjorie Heins, *Sex, Sin, and Blasphemy: A Guide to America's Censorship Wars* (New York, 1993); *The Cultural Battlefield: Art Censorship & Public Funding*, ed. Jennifer A. Peter and Louis M. Crosier (Gilsum, N.H., 1995).

85. (USRF.90ART.R14H), RCPOR.

ACKNOWLEDGMENTS

Books of this nature are made possible by colleagues, friends, students, librarians, archivists, and institutional cooperation. This one actually got underway in 2001 when Stanley N. Katz invited me to speak about the politicization of American art at a conference sponsored by the Center for Cultural Policy and the Arts at Princeton University. He subsequently offered support from a Rockefeller Foundation grant to help in obtaining some of the necessary images. Dr. Steven J. Tepper, deputy director of the Center in 2001–2004, was graciously helpful with administrative logistics. Judy Throm, chief of Public Services at the Archives of American Art in Washington, D.C. (part of the Smithsonian Institution), patiently and cheerfully helped locate many collections that have been essential to my research. David Schuyler of Franklin and Marshall College generously shared several important leads concerning sources for the history of American monuments and memorials in the nineteenth century.

Quondam Cornellian David A. Langbart, long since an archivist at the National Archives and Records Administration, facilitated several arcane searches for me, as did Maja Keech, reference specialist at the Division of Prints and Photographs of the Library of Congress. Frances Pollard, senior librarian at the Virginia Historical Society, once again found indispensable materials for me relating to several controversies in Richmond. Stephen P. Radich, formerly the owner of an art gallery in New York City during the 1960s and '70s, generously gave me permission to use his papers at the Archives of American Art and then sent materials still in his possession that together provide the basis for my discussion in chapter six of an important legal episode that persisted between 1966 and 1974.

At Cornell University my debts are legion: to an exemplary staff at the Fine Arts Library, especially Carla E. Bahn, Ann Beyer, and Martha A. Walker; to Margaret N. Webster and Carol LaGrow in the splendid Cornell art and architecture slide collection; to Pam M. Baxter, data archivist at the Cornell Institute for Social and Economic Research, who patiently helped to locate the public opinion polling

data that I use throughout; to Julie Copenhagen who makes the inter-library loan system work so efficiently; to the family of the late Kenneth W. Evett for supplying private correspondence and clippings pertaining to the murals he painted for the Nebraska State Capitol in 1954–56; and to the members of my undergraduate seminars at Cornell in 2003 and 2004, and at Yale in 2005, who helped me think through many of the episodes and issues discussed in this project. By the time we finished, they surely felt inclined to agree with the sculptor George Sugarman: "Isn't controversy part of what modern art is all about?"

I have been blessed with three truly extraordinary research assistants at Cornell who helped locate all sorts of obscure materials in libraries, but especially from the Internet, where their ingenuity and persistence far exceeded my own: Alicia K. Anderson, Zachary A. Child, and Tad Bardenwerper. I am deeply grateful to them, especially, and fondly consider them unindicted co-conspirators. Jack Dickard runs Cayuga Digital Imaging with rustic informality to match his superb technical skills at enhancing images, checking resolutions, and providing CDs for quality printing.

The late George H. Roeder, Jr., whose devoted career at the School of the Art Institute of Chicago was tragically ended by his premature death in 2004, provided valuable information and insight concerning modernism, and especially works of public art in Chicago. I have been the particular beneficiary of innovative scholarship by Stephen C. Dubin and Karal Ann Marling and several of the latter's splendid Ph.D. students. My own former Ph.D. student Amy H. Kinsel called to my attention the controversial murals by Michael Spafford in Washington State, discussed in chapter four. Yet another former student, Mitch Kachun and his wife, Karen Libman, graciously checked out the public sculptures by Calder and di Suvero in Grand Rapids and gave me an update on how they are viewed more than a generation after their installation.

I enjoyed opportunities to present essential aspects of the project to the Visual Studies Seminar at Cornell in 2002; at the University of Lyon II, France, in 2003 and 2005; universities in Graz, Austria, and Halle, Germany, in 2005; and at a delightful conference held at Teltow, near Berlin, in May 2005. The thoughtful responses I received on those occasions are deeply appreciated.

Those who read the manuscript at different stages and provided critical feedback have my everlasting gratitude: artists Anne Abrons

and her husband David Sharpe, Laura J. Feller, James A. Hijiya, Elizabeth Johns, Carol Kammen, Bert Lazerow, and Gail Levin. Jane Garrett, a friend for four decades and my editor at Knopf since 1968, read several versions and provided her now legendary, judicious guidance. Her editorial assistant, Emily Owens Molanphy, is a marvel of efficiency and technical expertise. Kathryn Torgeson once again made the index with patience and good cheer.

Carol Kammen has survived this project, just has she has many others for the past forty-five years, all the while maintaining her own busy schedule and gracefully moving from one challenging achievement to the next. She has provided sage counsel and suggestions throughout, along with so many other life-sustaining gifts. What I can say in return, once again, is merely suggested by the dedication.

Above Cayuga's Waters, September 2005
MK

INDEX

abolitionism, 55, 56
 art and, 151
Abraham and Isaac, in public sculpture,
 232, 233
Abraham Lincoln (Barnard), 24, 25
Abs, Hermann J., 361–2
Abstract Expressionism, xxi, 62, 95, 110,
 111, 181, 187, 254, 255, 381–2
 changing attitudes toward, 112–13,
 116, 161–2, 200
 controversies over, 208, 210
 importance of, 353
 Pop Art and, 163, 188
 prices of, 182
Acconci, Vito, 355
Adams, Ansel, 108
Adams, Henry (1838–1918), 17
Adams, Henry (art historian), 50
Addison Gallery of American Art, 83–4
"Advancing American Art" (tour), xxvi,
 104, 106
African Americans, *see also* blacks
 artists' protests against neglect of, 201,
 202, 203–4, 283
 depiction in art, 147–8, 270, 271,
 329–37
 displayed in Senate, 305
 exhibition on, 329–31
 in Harlem, 202–7, 254, 260
 national museum for, 337–8
 photographs of, 333–4
African-American women
 memorials to, 329
 representation of, xv, 327
Aiken, South Carolina, mural dispute in,
 122, 123
Akron, Ohio, public art dispute in,
 231–2
Albers, Josef, 353
Albuquerque Museum of Art and
 History, 348
Allied Artists of America, 154
All in the Family (TV show), 270–71
Alloway, Lawrence, 187, 212, 267
America, the "New World" (Siqueiros), 134
America First movement, 102

American Abstract Artists, 99
American Architect and Building News, 17
American Artist, 161
American Artists Professional League,
 154, 156
American Art News, 90, 96
American Association of Art Museum
 Directors, 161
American Association of Museums, 298
American Battle Monuments
 Commission, 34, 35, 42–3
American Civil Liberties Union
 (ACLU), 195, 333
American Dream Goes to Pot, The
 (Millett), *xxiv*, 174–5, 176–7, 199
American Family Association, xix, 62, 80,
 278, 311, 373
American Federation of Arts, 158, 160
American flag
 as art theme, xx, xxi, xxiv, 34, 172, 173,
 192–4, 384
 perceived desecration of, 172–6,
 193–9
American Institute of Architects, 22
American Legion, 154, 157, 175
American Monthly, The, 172–3
American Museum of Natural History,
 286–7
American Place Gallery, 92
American Revolution, 31, 144
American Sculptors Society, 27
American Student of Art, The, 58, 61
American Watercolor Society, 154
Anarchy in Art (Bridgman), 89
Anderson Galleries, 95
Andrews, Leonard E. B., 274, 277
Angry Arts Week (1967), 200
Annenberg, Walter, 262
Anthony, Susan B., 325, 327
anti-Communism, xiii, 154–8
 role in art disputes, 141–2
Anti-Defamation League of B'nai B'rith,
 204
antimodernism, 62, 89, 92, 102–3, 192
anti-Semitism, 193, 196, 204, 205, 263
 in art, xx, 311

ALSO BY MICHAEL KAMMEN

"*Brilliant, idiosyncratic . . . presented with superlative style laced with refreshing wit.*" —The New York Times Book Review

MYSTIC CHORDS OF MEMORY
The Transformation of Tradition in American Culture

In this ground-breaking, panoramic work of American cultural history, the Pulitzer Prize–winning author of *A Machine That Would Go of Itself* examines a central paradox of our national identity: How did "the land of the future" acquire a past? And to what extent has our collective memory of that past—as embodied in our traditions—been distorted, or even manufactured? Ranging from John Adams to Ronald Reagan, from the origins of Independence Day celebrations to the controversies surrounding the Vietnam War Memorial, from the Daughters of the American Revolution to immigrant associations, and filled with incisive analyses of such phenomena as Americana and its collectors, "historic" villages and Disneyland, *Mystic Chords of Memory* is a brilliant, immensely readable, and enormously important book.

American History/Cultural Criticism/978-0-679-74177-0

VINTAGE BOOKS
Available at your local bookstore, or visit www.randomhouse.com